Jacopo della Quercia

VOLUME II

James Beck

COLUMBIA UNIVERSITY PRESS
NEW YORK

THE PRESS WISHES TO ACKNOWLEDGE THE GENEROUS AID
OF THE CITY OF BOLOGNA AND OF MAYOR RENZO IMBENI
IN THE PUBLICATION OF THESE VOLUMES.

Columbia University Press
New York Oxford
Copyright © 1991 Columbia University Press
All rights reserved

Library of Congress Cataloging-in-Publication Data

Beck, James H.
 Jacopo della Quercia / James Beck.
 p. cm.
 Includes bibliographical references and index.
 ISBN 0-231-07200-7 (SET). ISBN 0-231-07684-3 (VOL. I).
ISBN 0-231-07686-x (VOL. II).
 1. Jacopo, della Quercia, 1372?–1436. 2. Sculptors—Italy—
Biography. 3. Jacopo, della Quercia, 1372?–1436—Catalogues
raisonnés. I. Title.
NB623.04B39 1991
730'.92—dc20
[B] 90-22467
 CIP

Casebound editions of Columbia University Press books are Smyth-sewn
and printed on permanent and durable acid-free paper

Printed in the United States of America

c 10 9 8 7 6 5 4 3 2 1

Contents

VOLUME II

Jacopo della Quercia

VOLUME II

Illustrations

THE CHOICE of illustrations for this book has been predicated upon several considerations, including the realities of publication. I have not included comparative material by contemporaries of Jacopo or by assumed influences or sources. Specialized articles and books dealing with such issues may be consulted for illustrations of this type of work. I also opted not to illustrate those sculptures often associated with Jacopo but which I do not believe belong to him. These too are available in the earlier literature.

The illustrations—all, then, of works by Jacopo della Quercia—are presented in such a way as to offer an overview of the artist and the special nature of his creativity. At the same time, and this is especially the case with sculpture, the photographs never produce an entirely satisfactory introduction because of the infinite number of variables, including the diversity of angles that can be taken, the quality of the light, and the conditions in which the works themselves have survived. The photographs are not all of the same quality; a compromise has been made between, on the one hand, completeness of presentation, and, on the other, the effectiveness of the individual photographs.

A final point: in some instances the most informative photographs are not those of the original sculptures as they have come down to us, but of the plaster casts made sometime in the past, when the works were more complete. This is particularly the case for the various reliefs from the *Fonte Gaia*. The sculpture for the *Main Porta of San Petronio* offers a somewhat analogous situation. Since the cleaning and restoration of the 1970s, the art, in my opinion, often is better seen in pre-restoration photographs or in photographs of old casts. In this case, I have sought to supply a number of samples from both categories, leaving the reader-viewer to make up his or her own mind.

I am indebted to Charles Seymour, Jr., for giving me permission to use photographs that he took himself or had taken. My friend Aurelio Amendola has provided some excellent new examples, especially of the *Ilaria Monument*. The greatest portion of the illustrations, however, were supplied by the Superintendencies of Siena, Florence, and Bologna, or other Italian governmental agencies, to whom I am sincerely grateful; a small portion were taken by the writer himself.

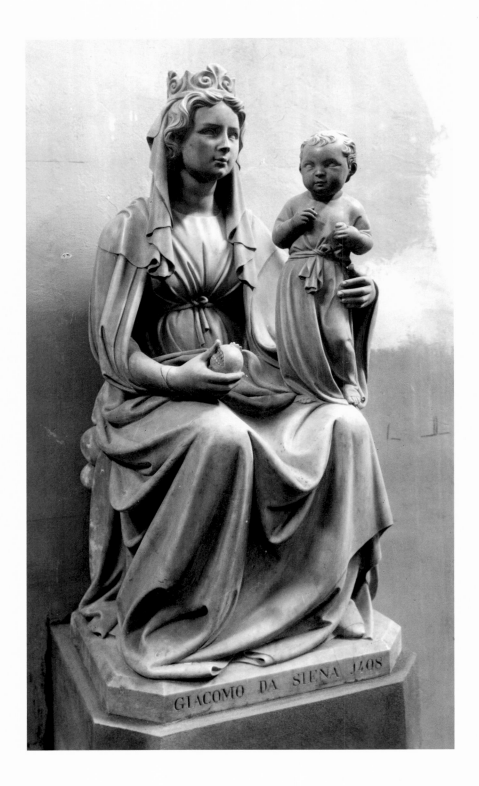

GIACOMO DA SIENA 1408

202

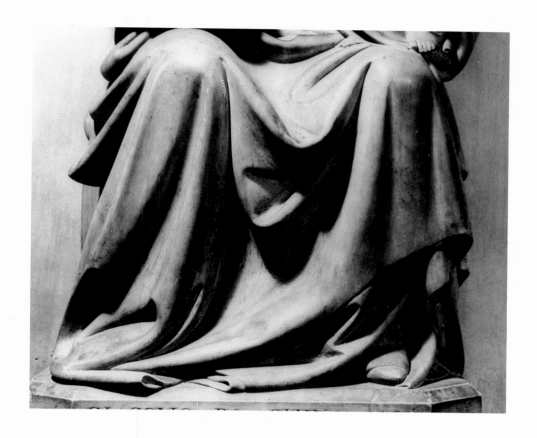

1. *(facing page) Ferrara Madonna.*

2. *Ferrara Madonna.* Detail.

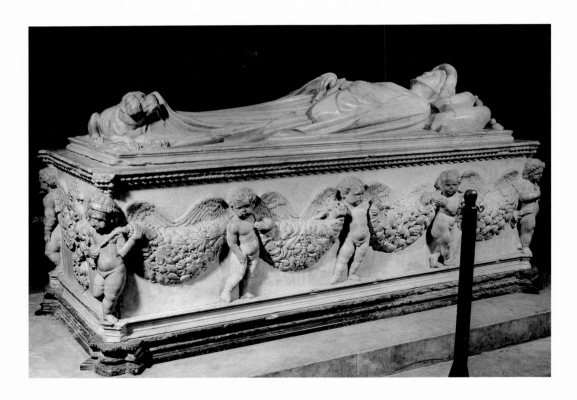

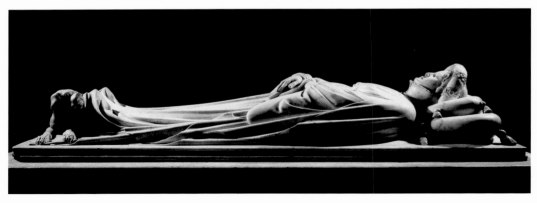

3. *Ilaria del Carretto Tomb Monument*. San Martino, Lucca. 1406–1408 (?). View from the south, including putti 1 to 5, reading from left to right.

4. *Ilaria Monument*. Effigy with dog, seen from the south.

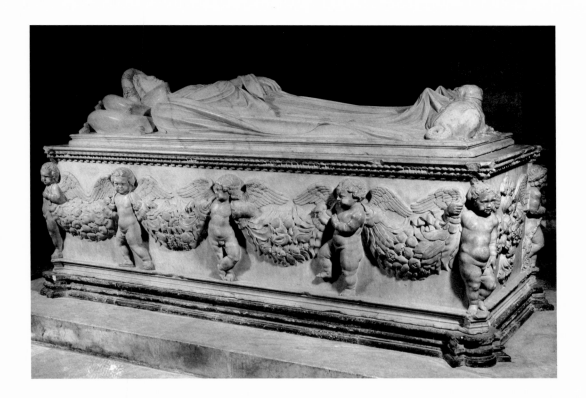

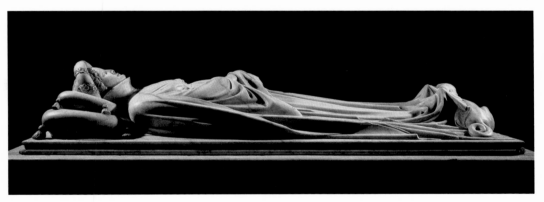

5. *Ilaria Monument*. View from the north, including putti 6 to 10, reading from left to
right.

6. *Ilaria Monument*. Effigy with dog, seen from the north.

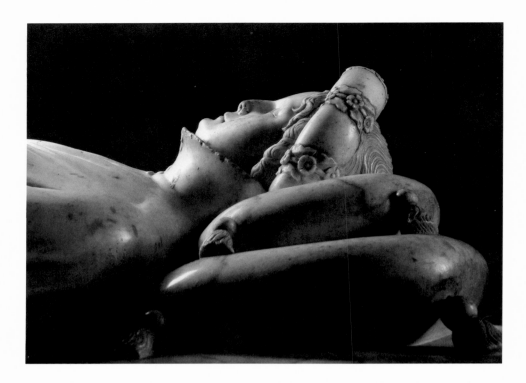

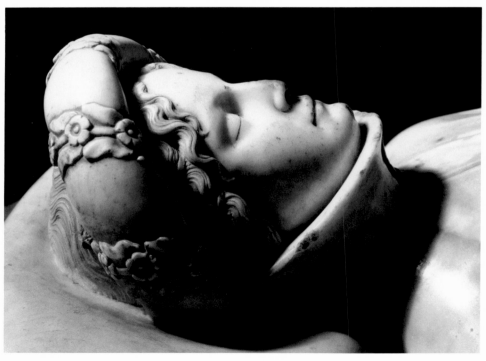

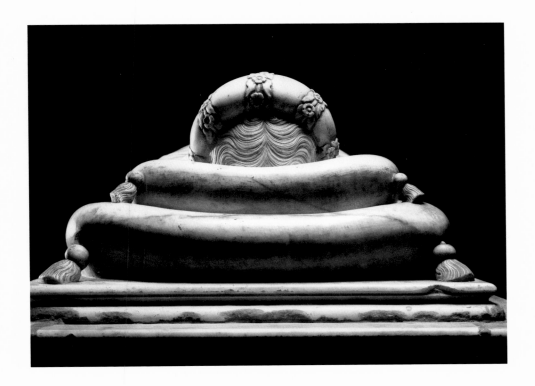

7. *(facing page top) Ilaria Monument.* Effigy seen from the south; detail.

8. *(facing page bottom) Ilaria Monument.* Effigy seen from the north; detail.

9. *Ilaria Monument.* View from the east; detail.

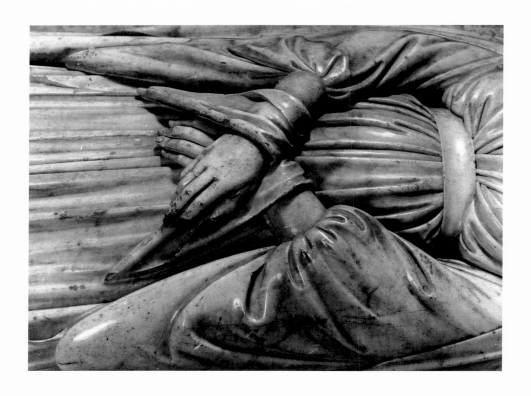

10. *Ilaria Monument*. Effigy seen from above; detail.

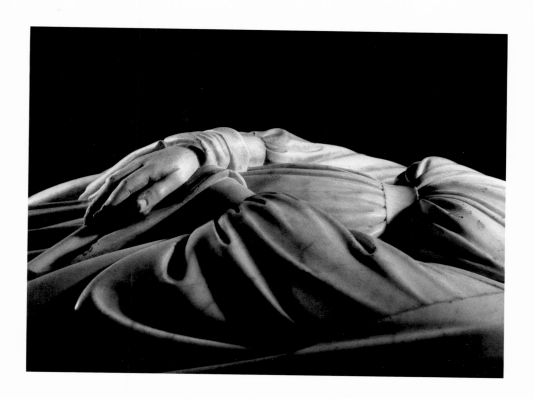

11. *Ilaria Monument.* Effigy seen from the south; detail.

12. *Ilaria Monument*. View from the east.

13. *Ilaria Monument*. View from the west.

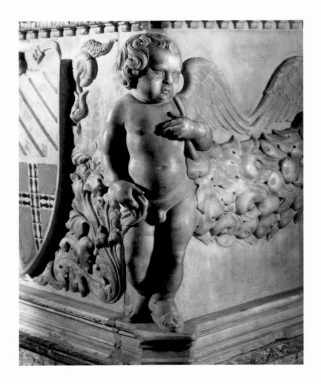

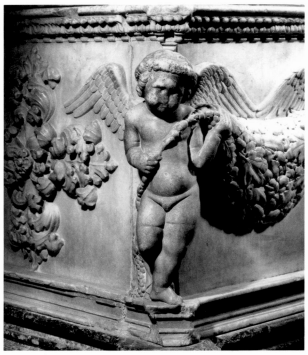

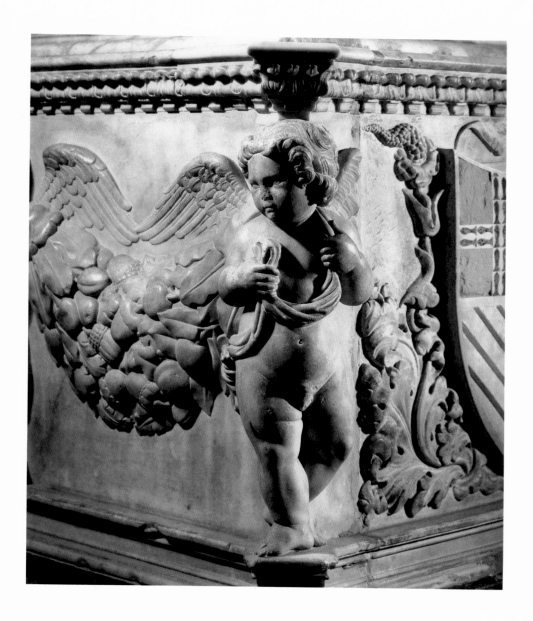

14. *(facing page top) Ilaria Monument.* View from the east; putto 5 on corner.

15. *(facing page bottom) Ilaria Monument.* View from the west; putto 1 on corner.

16. *Ilaria Monument.* View from the east; putto 6 on corner.

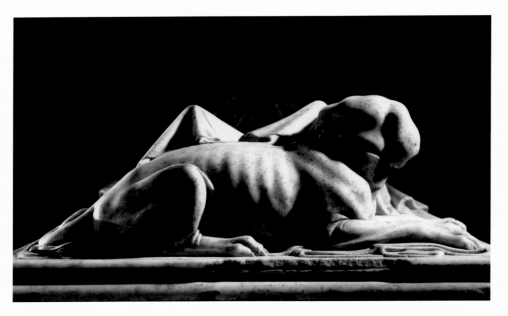

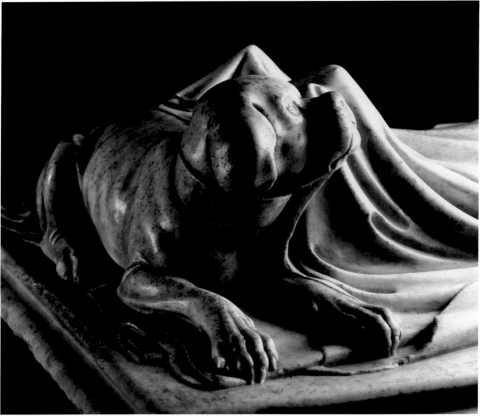

17. *(facing page top) Ilaria Monument.* View from the east; dog.

18. *(facing page bottom) Ilaria Monument.* View from the south; dog.

19. From *Ilaria Monument* (?). Lucca, Villa Guinigi. Executed by Giovanni da Imola.

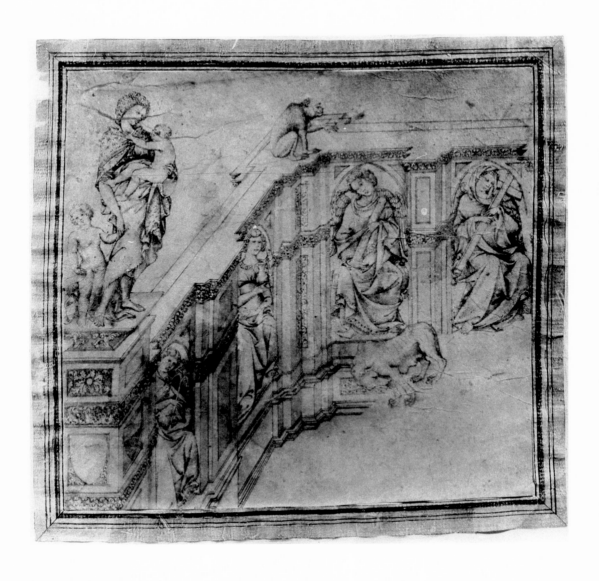

20. Drawing for the *Fonte Gaia* project. Section A, Metropolitan Museum of Art, New York. 1408.

216

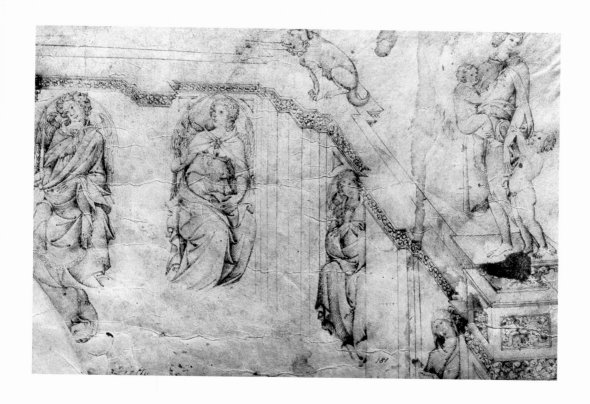

21. Drawing for the *Fonte Gaia* project. Section B, Victoria and Albert Museum, London.
1408.

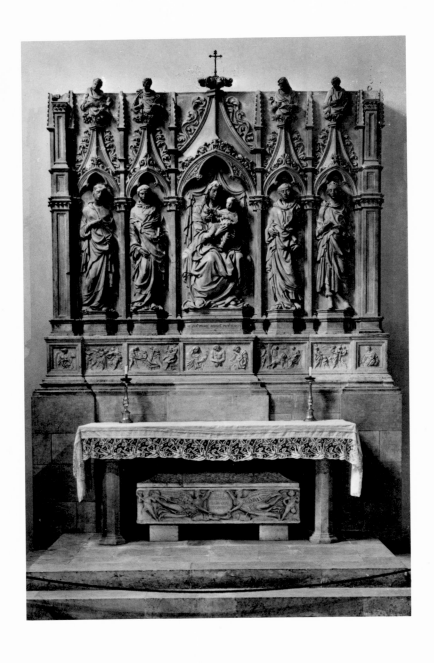

22. *Trenta Altar*. Cappella di San Riccardo, San Frediano, Lucca. 1410/1411–1422. General view.

218

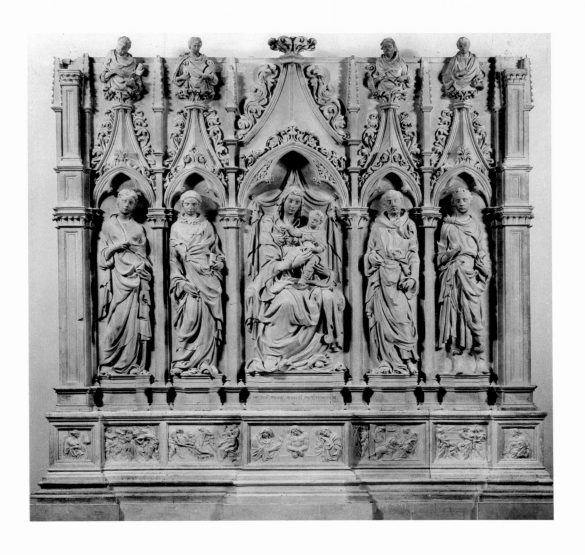

23. *Trenta Altar*. Whole view of altar.

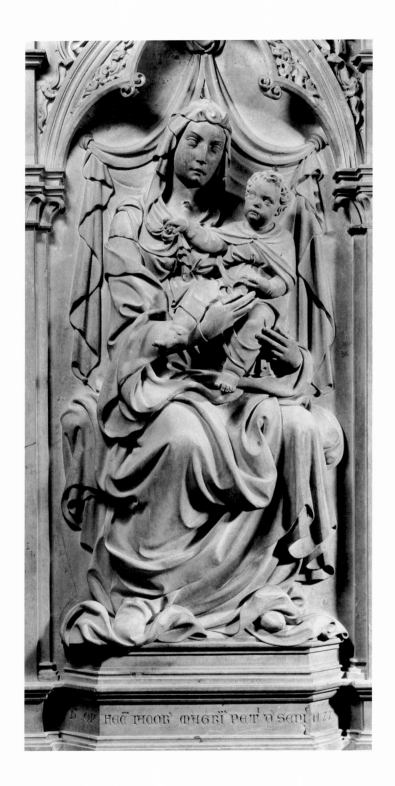

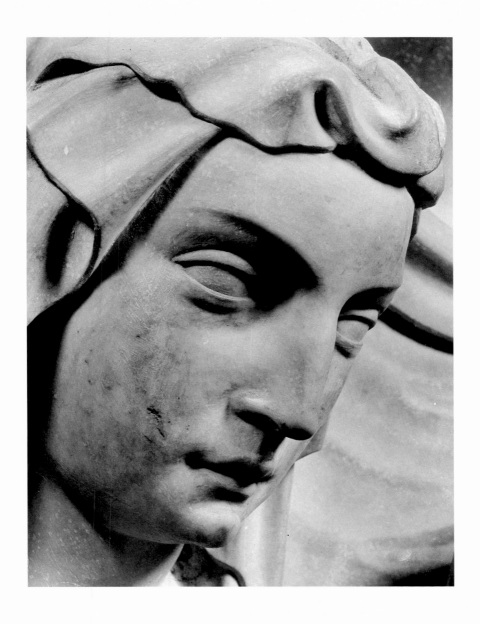

24. *(facing page) Trenta Altar*. Detail; Madonna and Child.

25. *Trenta Altar*. Detail; Madonna and Child (detail of head).

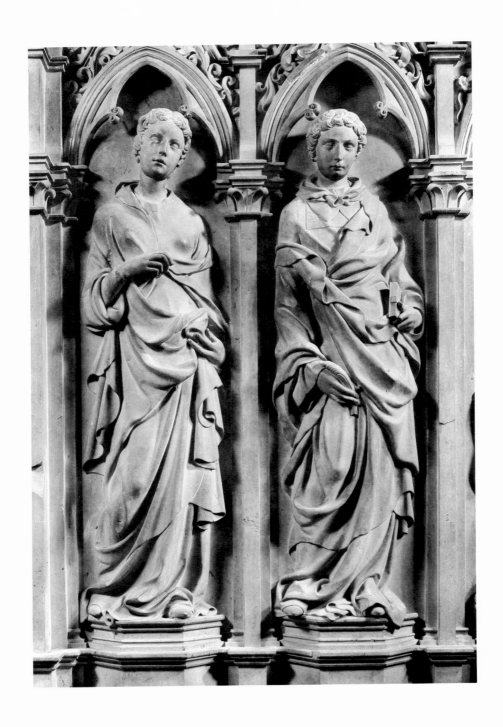

26. *Trenta Altar.* Detail, left side; saints Lucy and Lawrence.

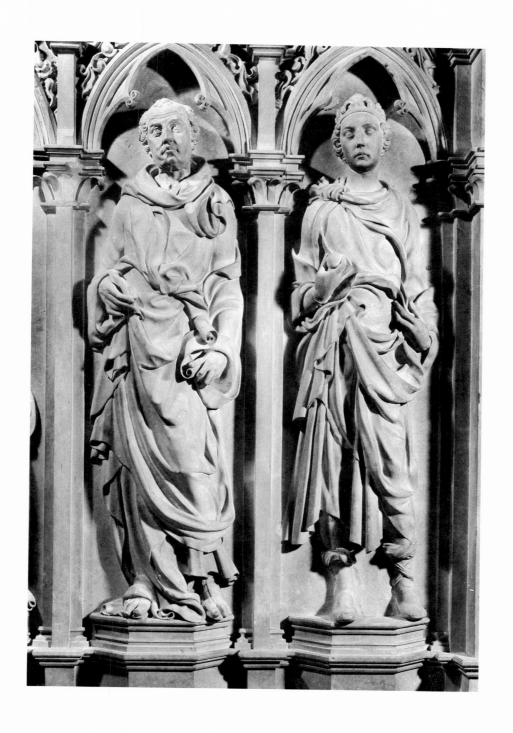

27. *Trenta Altar.* Detail, right side; saints Jerome and Richard.

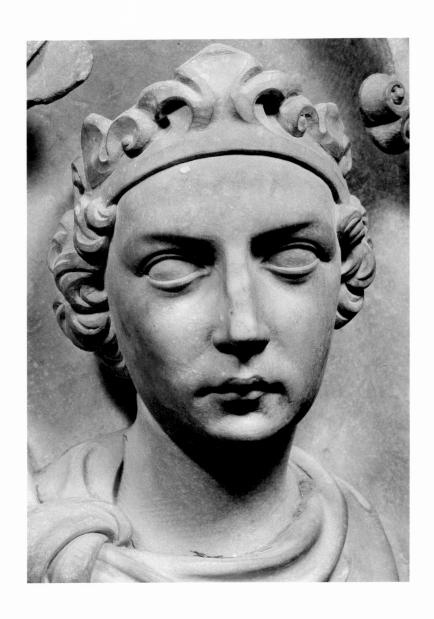

28. *Trenta Altar*. Detail, right side; head of Saint Richard.

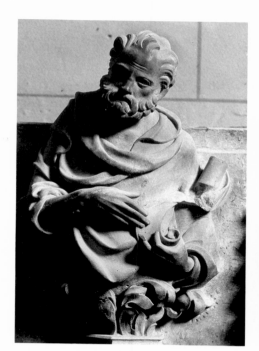

29. *Trenta Altar*. Detail; bust above Saint Lucy.

30. *Trenta Altar*. Detail; bust above Saint Lawrence.

31. *Trenta Altar*. Detail; bust above Saint Jerome.

32. *Trenta Altar*. Detail; bust above Saint Richard.

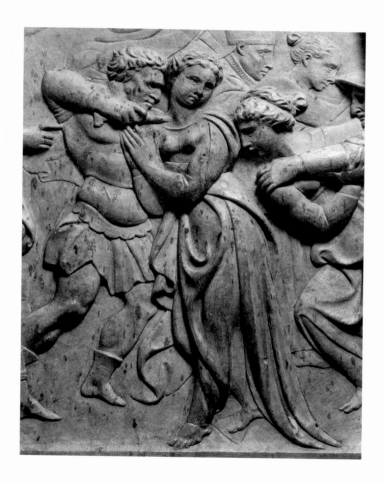

33. *Trenta Altar*. Whole predella.

34. *Trenta Altar*. Detail of the predella; Martyrdom of Saint Lucy (detail).

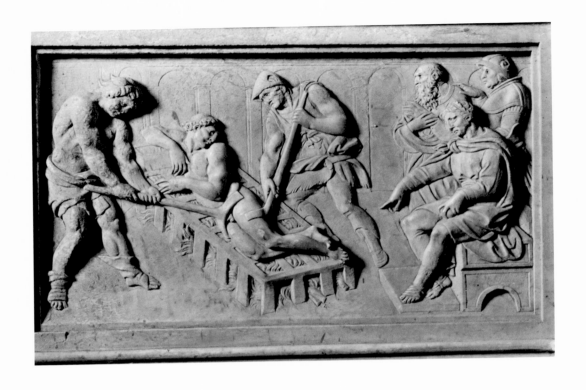

35. *Trenta Altar*. Detail of the predella; Martyrdom of Saint Lawrence.

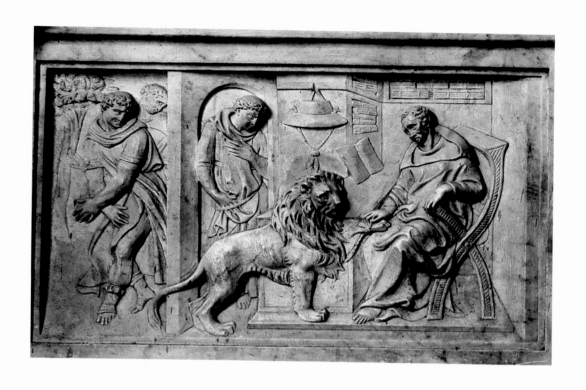

36. *Trenta Altar*. Detail of the predella; Saint Jerome and the Lion.

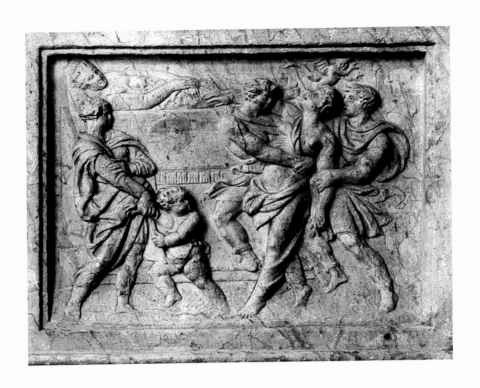

37. *Trenta Altar*. Detail of the predella; Miracle of the Body of Saint Richard.

38. *Trenta Altar*. Detail of the predella; Saint Cristina.

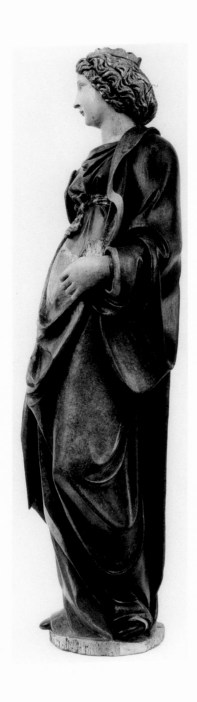

39. *Annunciate Virgin*. San Raimondo al Refugio, Siena. Ca. 1410.

40. *(facing page) Lucca Apostle*. Left transept, San Martino, Lucca. Ca. 1411–1412.

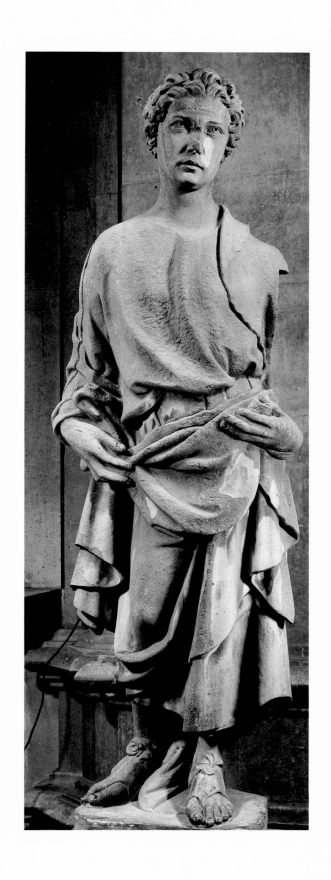

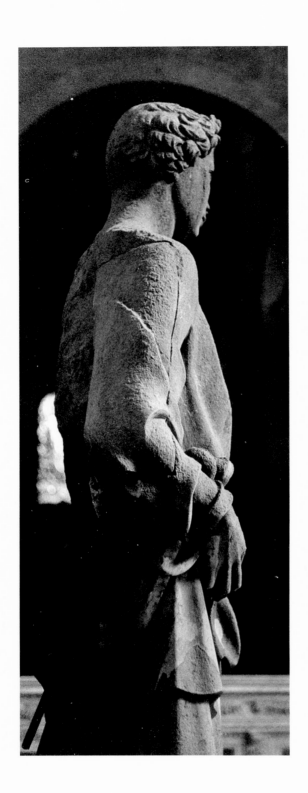

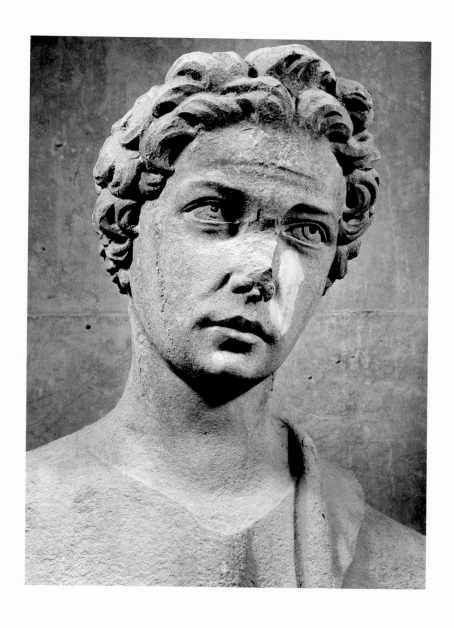

41. *(facing page) Lucca Apostle*. Detail.

42. *Lucca Apostle*. Detail.

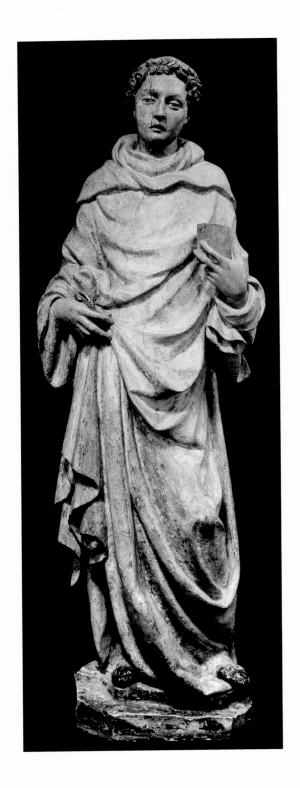

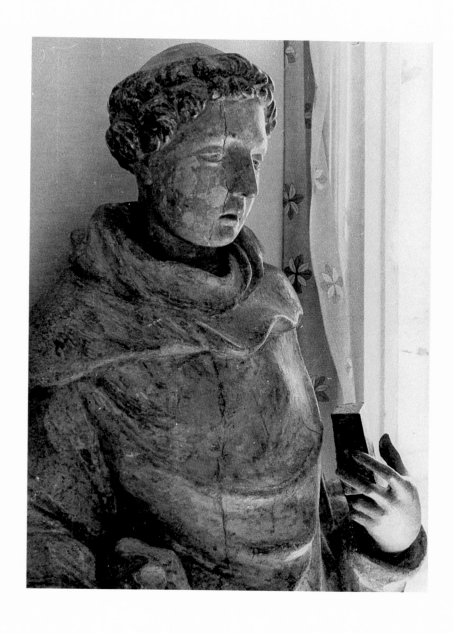

43. *(facing page) Benedictine Saint* (also called *San Leonardo*). Santa Maria degli Uliveti, Massa. Ca. 1412–1413.

44. *Benedictine Saint*. Detail.

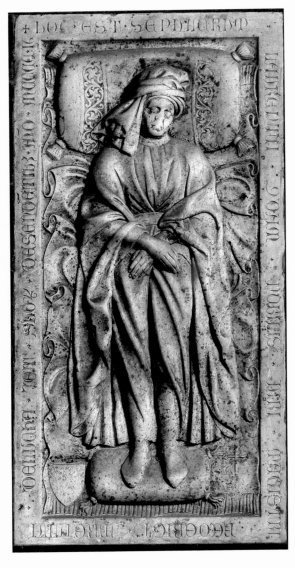

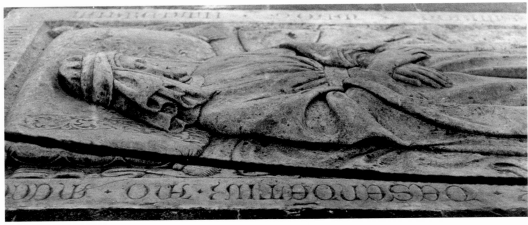

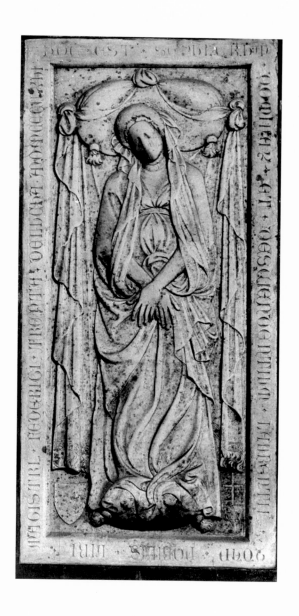

45. *(facing page top) Lorenzo Trenta Tomb Slab.* Cappella di San Riccardo, San Frediano, Lucca. 1416.

46. *(facing page bottom) Lorenzo Trenta Tomb Slab.* Detail; oblique view.

47. *Tomb Slab of Isabetta Onesti Trenta.* Cappella di San Riccardo, San Frediano, Lucca. 1416.

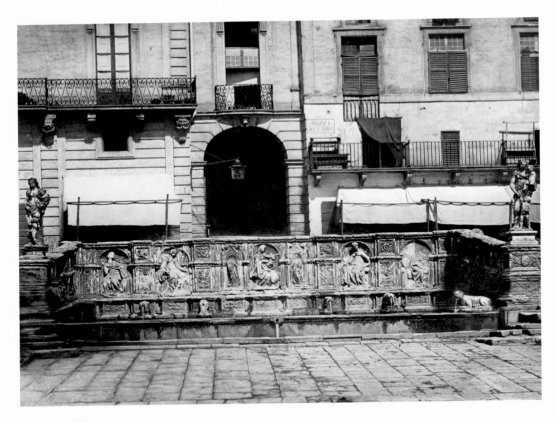

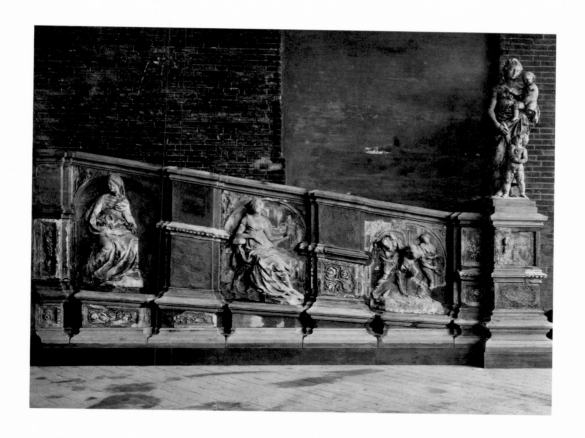

48. *(facing page top) Fonte Gaia.* Piazza del Campo, Siena. 1408–1419. Original appearance, before replacement.

49. *(facing page bottom)* Etching of the Piazza del Campo, Siena; detail showing the *Fonte Gaia*. Archivio di Stato, Siena. Ca. 1720.

50. *Fonte Gaia.* Loggia, Palazzo Comunale, Siena. Present location. Right section, as
reconstructed.

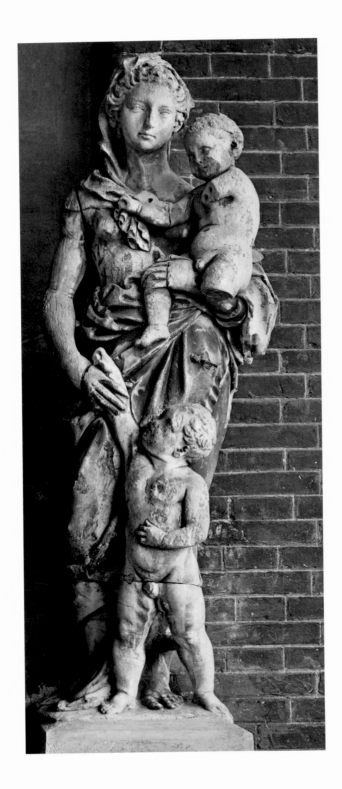

242

51. *(facing page) Fonte Gaia.* Public Charity (Amor Proximi).

52. *Fonte Gaia.* Public Charity (Amor Proximi); detail, seen from the right.

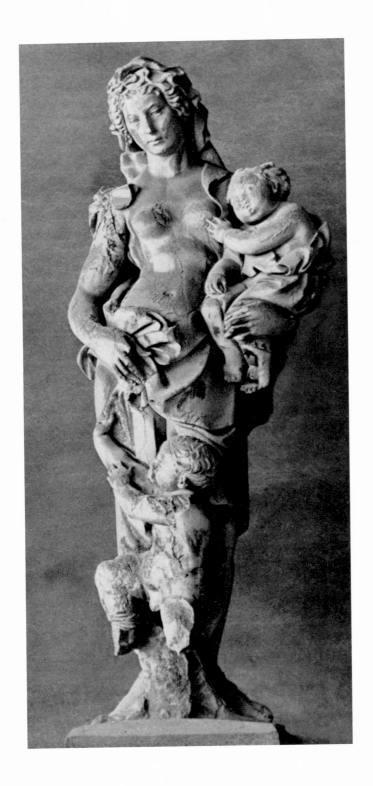

244

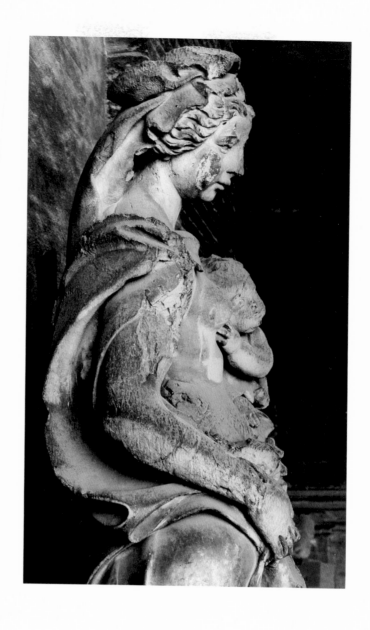

53. *(facing page) Fonte Gaia.* Divine Charity (Amor Dei).

54. *Fonte Gaia.* Divine Charity (Amor Dei); detail, seen from the left.

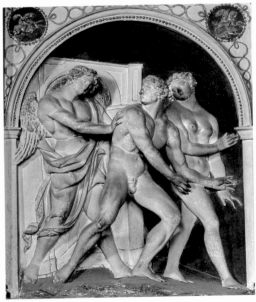

55. *(facing page top) Fonte Gaia.* Expulsion of Adam and Eve from Paradise.

56. *(facing page bottom)* Expulsion of Adam and Eve from Paradise. Plaster cast from the *Fonte Gaia.* Piccolomini Library, Duomo, Siena. Early sixteenth century.

57. *Fonte Gaia.* Expulsion of Adam and Eve from Paradise; detail, seen from the left.

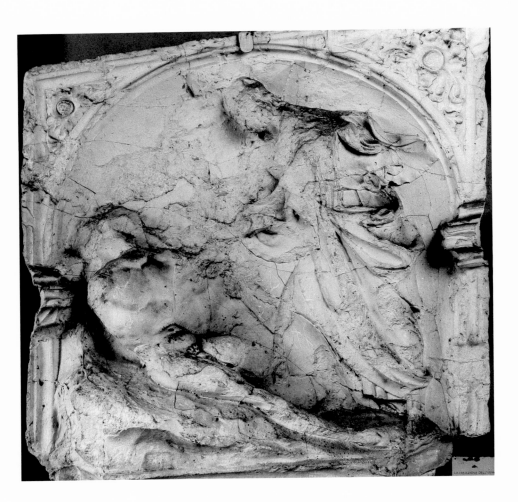

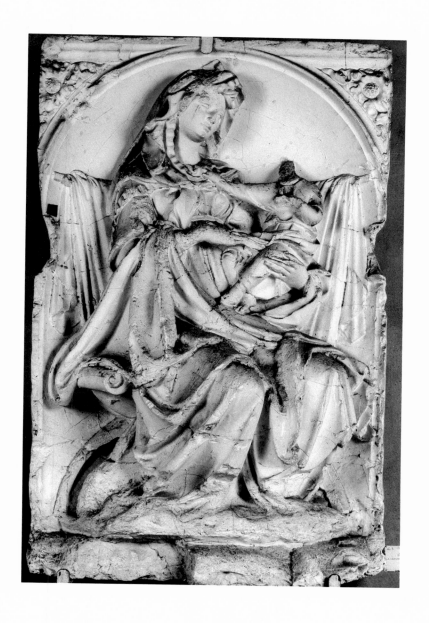

58. *(facing page top)* Creation of Adam. Plaster cast from the *Fonte Gaia*. Museum, Palazzo Comunale, Siena. Mid-nineteenth century.

59. *(facing page bottom) Fonte Gaia*. Creation of Adam; detail.

60. Madonna and Child. Plaster cast from the *Fonte Gaia*. Museum, Palazzo Comunale, Siena. Mid-nineteenth century.

249

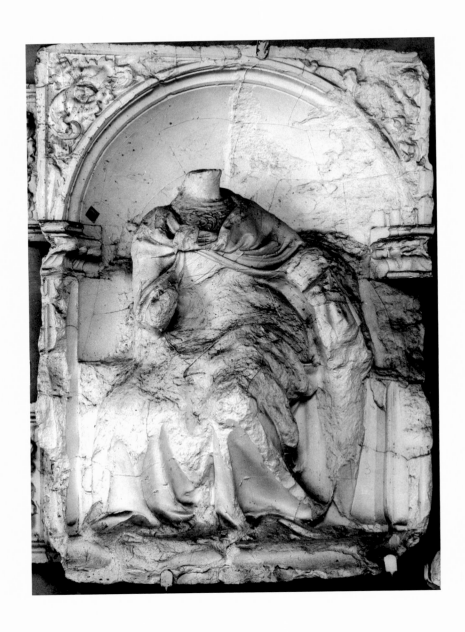

61. Fortitude. Plaster cast from the *Fonte Gaia*. Museum, Palazzo Comunale, Siena. Mid-nineteenth century.

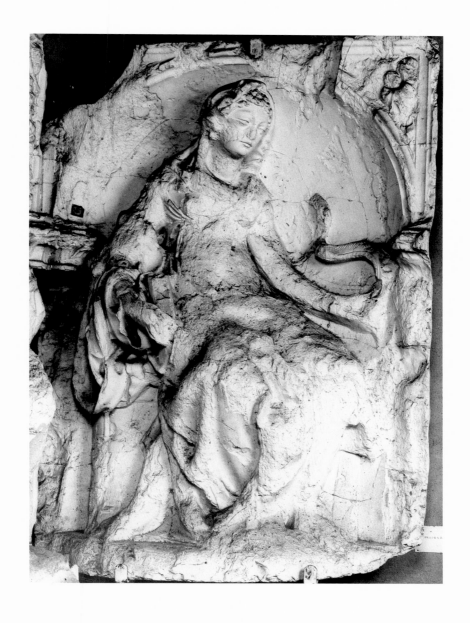

62. Prudence. Plaster cast from the *Fonte Gaia*. Museum, Palazzo Comunale, Siena. Mid-nineteenth century.

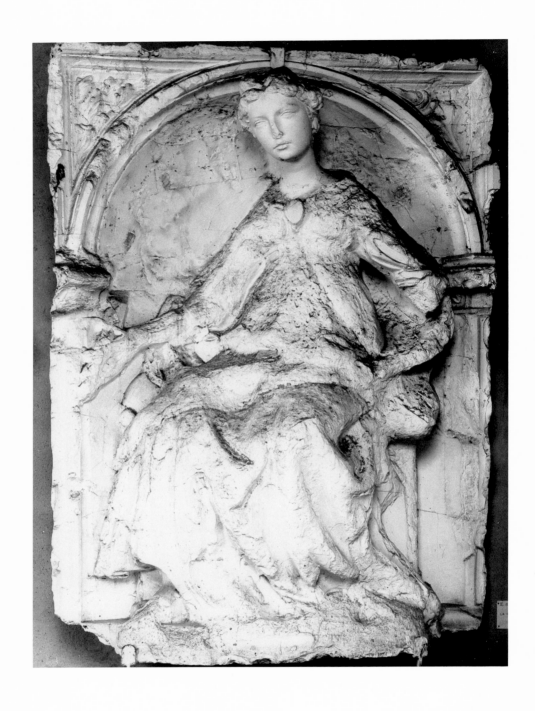

63. Justice. Plaster cast from the *Fonte Gaia*. Museum, Palazzo Comunale, Siena. Mid-nineteenth century.

252

64. *Fonte Gaia*. Justice; detail, seen from the left.

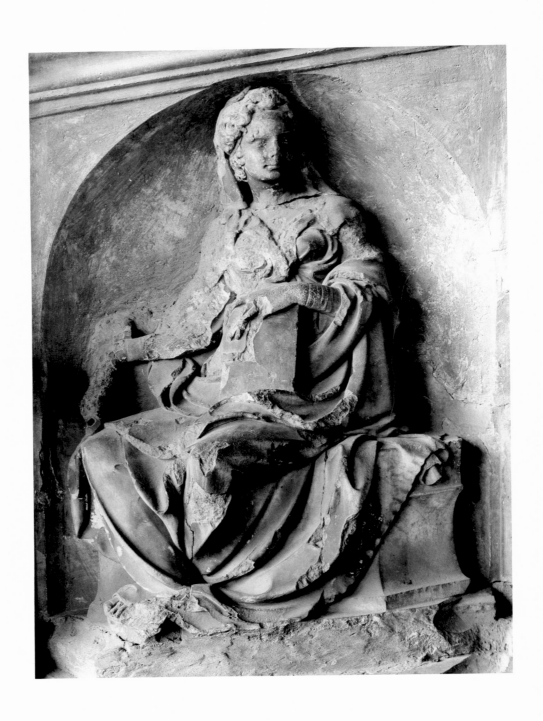

65. *Fonte Gaia*. Wisdom.

66. *Fonte Gaia*. Wisdom; detail, seen from the left.

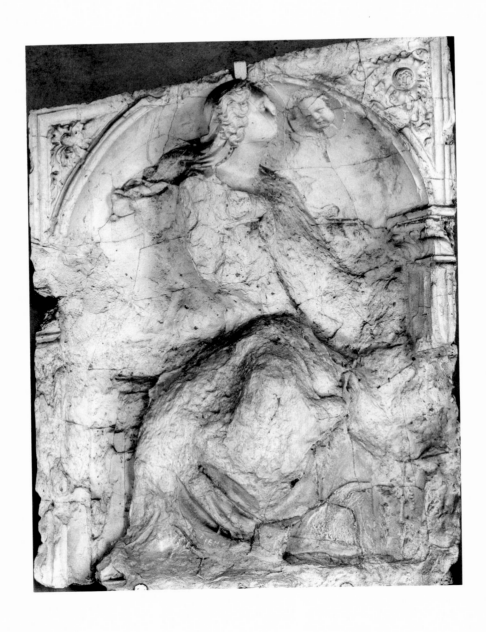

67. Hope. Plaster cast from the *Fonte Gaia*. Museum, Palazzo Comunale, Siena. Mid-nineteenth century.

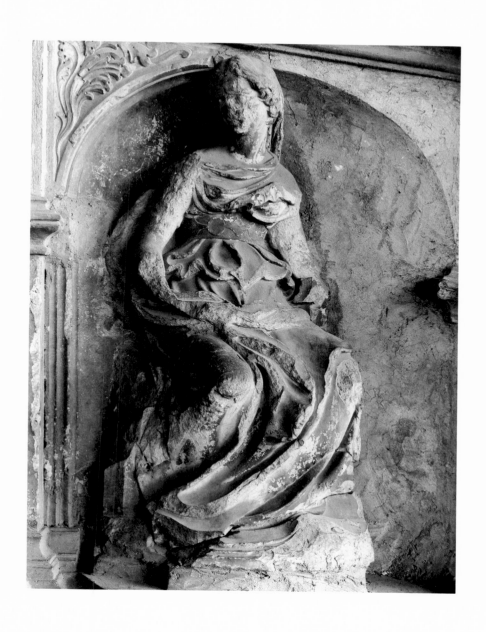

68. *Fonte Gaia.* Temperance.

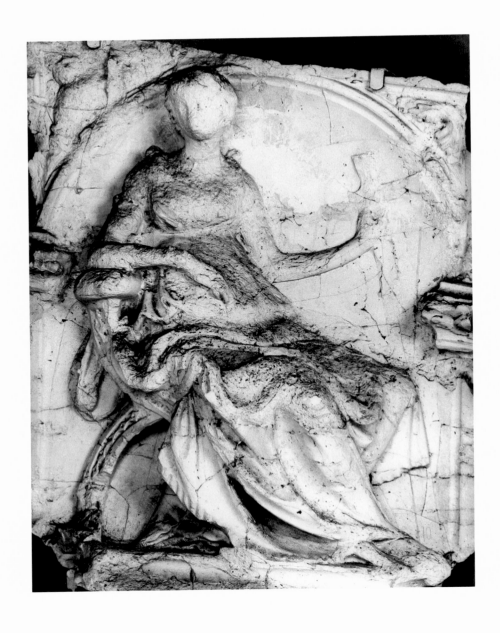

69. Faith. Plaster cast from the *Fonte Gaia*. Museum, Palazzo Comunale, Siena. Mid-nineteenth century.

70. *(facing page)* Angel, on left hand of the Virgin. Plaster cast from the *Fonte Gaia*. Museum, Palazzo Comunale, Siena. Mid-nineteenth century.

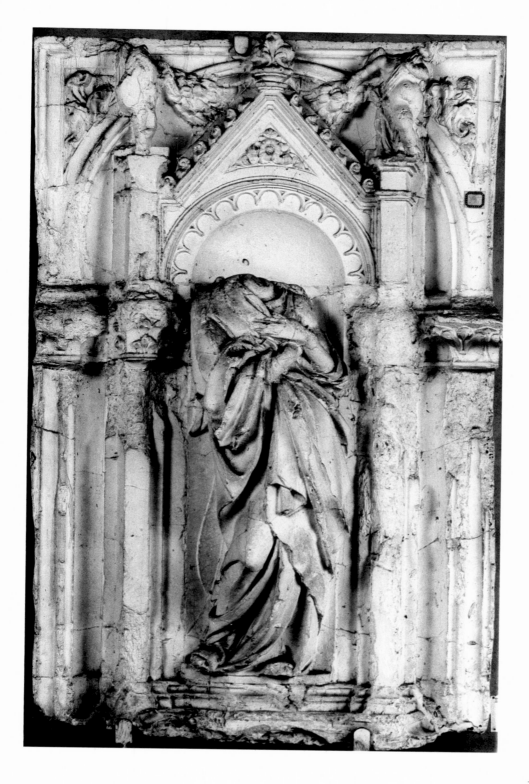

259

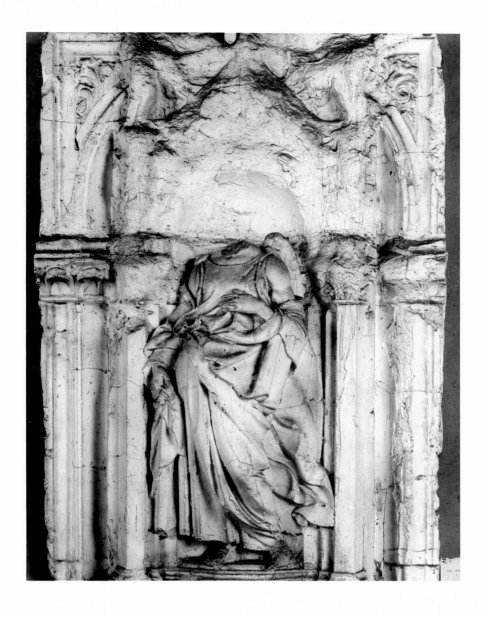

71. *(facing page top)* Putto, from angel niche on left hand of the Virgin. Plaster cast from the *Fonte Gaia*. Museum, Palazzo Comunale, Siena. Mid-nineteenth century.

72. *(facing page bottom)* Foliage. Plaster cast from the *Fonte Gaia*. Museum, Palazzo Comunale, Siena. Mid-nineteenth century.

73. Angel, on right hand of the Virgin. Plaster cast from the *Fonte Gaia*. Museum, Palazzo Comunale, Siena. Mid-nineteenth century.

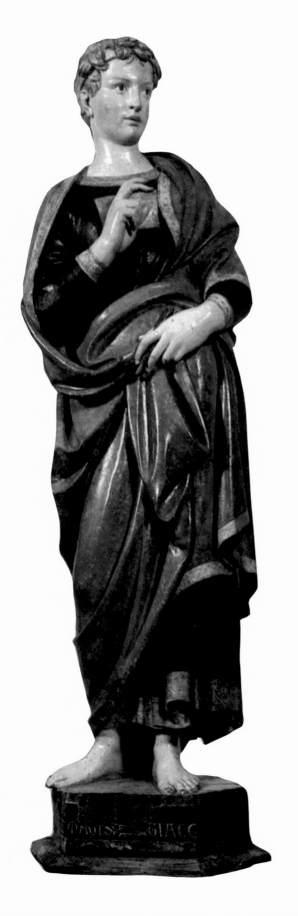
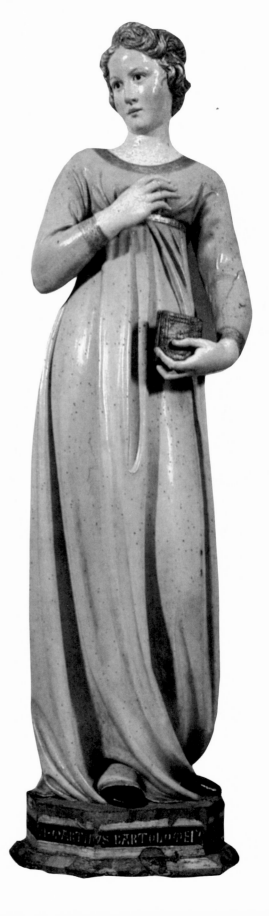

 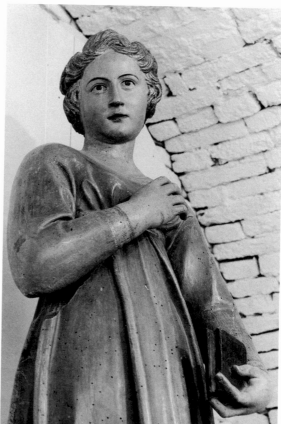

74. *(facing page) San Gimignano Annunciation*. Collegiata, San Gimignano. 1424–1426.

75. *San Gimignano Annunciation*. Detail of angel.

76. *San Gimignano Annunciation*. Detail of Mary.

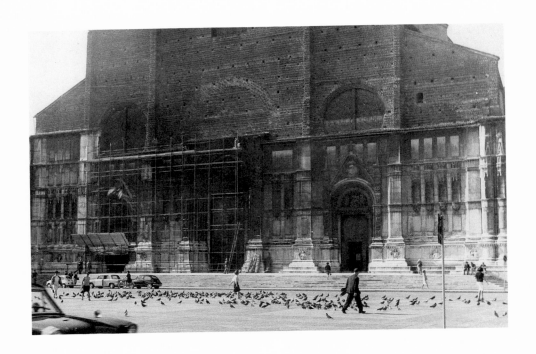

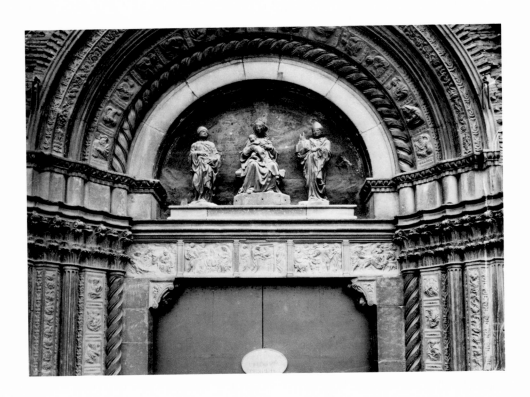

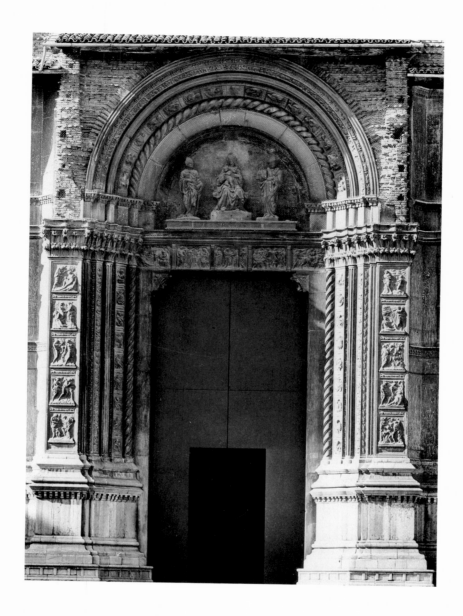

77. *(facing page top)* Façade of San Petronio, Bologna.

78. *(facing page bottom) Main Portal of San Petronio.* Detail with lunette.

79. *Main Portal of San Petronio.* San Petronio, Bologna.

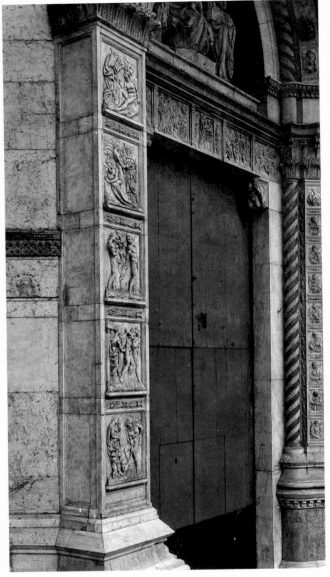

80. *Main Portal of San Petronio.* Detail of the left pilaster, as seen from the left.

81. *Main Portal of San Petronio.* Detail of the left pilaster, as seen from the left (after restoration).

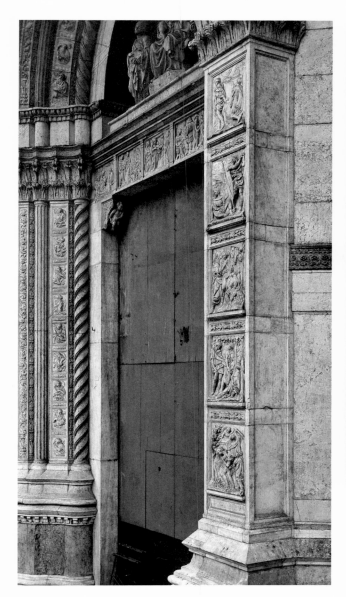

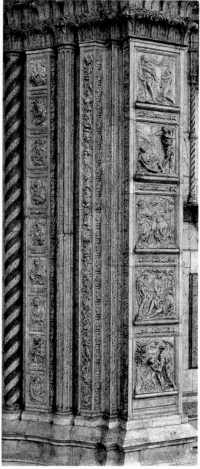

82. *Main Portal of San Petronio*. Detail of the right pilaster, as seen from the right (after restoration).

83. *Main Portal of San Petronio*. Detail of the right embrasure (after restoration)

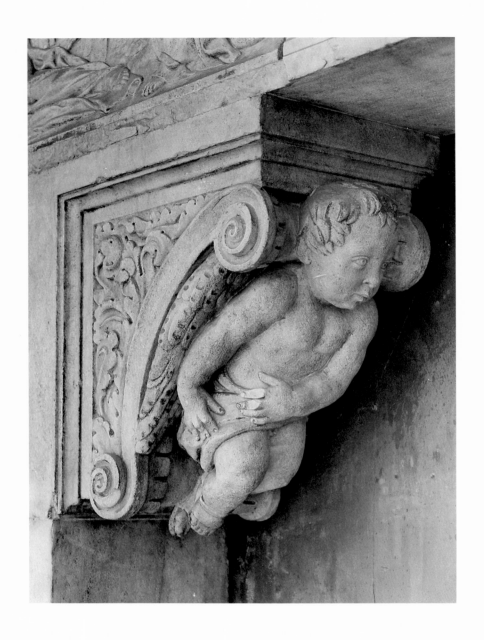

84. *Main Portal of San Petronio*. Putto console from the post on the left (after restoration).

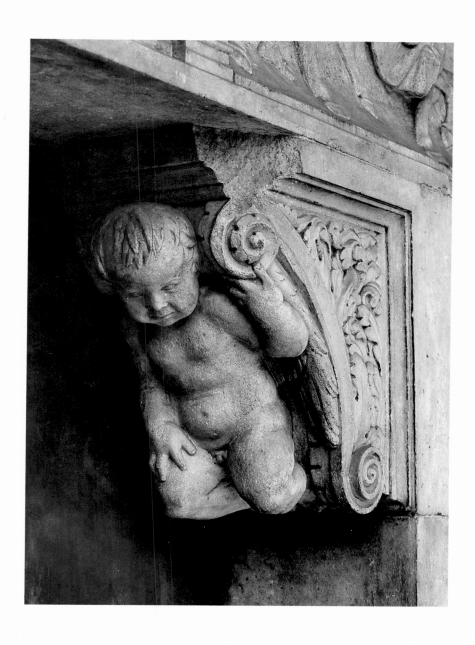

85. *Main Portal of San Petronio.* Putto console from the post on the right (after restoration).

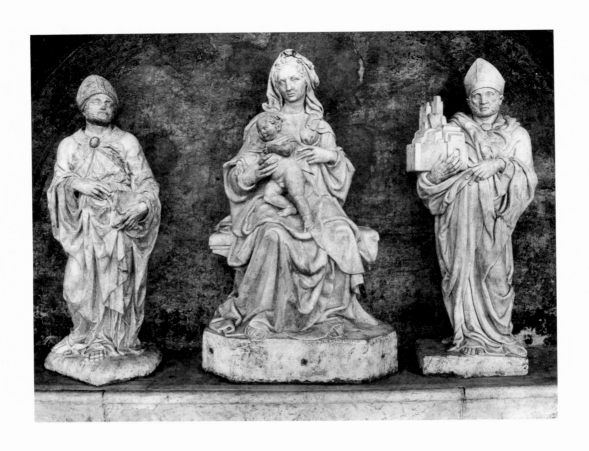

86. *Main Portal of San Petronio*. Detail; lunette figures (after restoration).

87. *(facing page) Main Portal of San Petronio*. Detail; Madonna and Child from the
lunette.

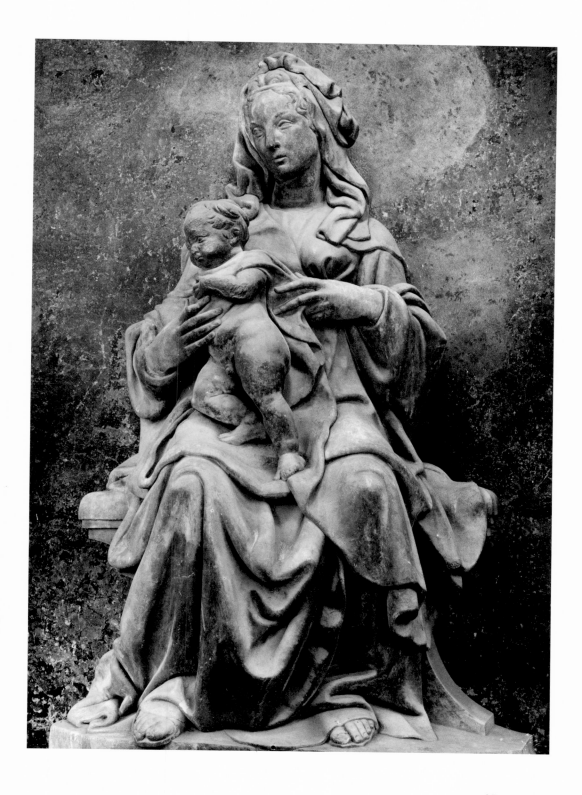

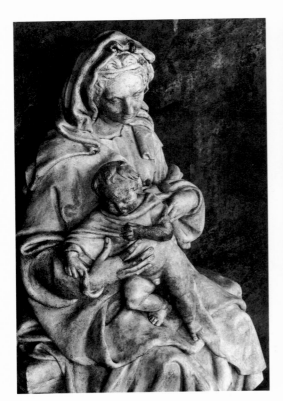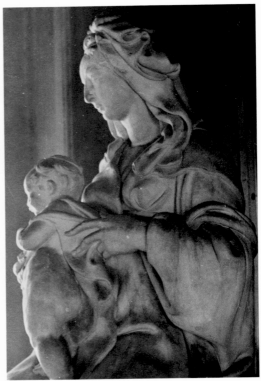

88. *Main Portal of San Petronio*. Madonna and Child from the lunette; detail (after restoration).

89. Madonna and Child from the lunette; detail, view from the right. Plaster cast from the
Main Portal of San Petronio.

90. *(facing page) Main Portal of San Petronio*. San Petronio, from the lunette.

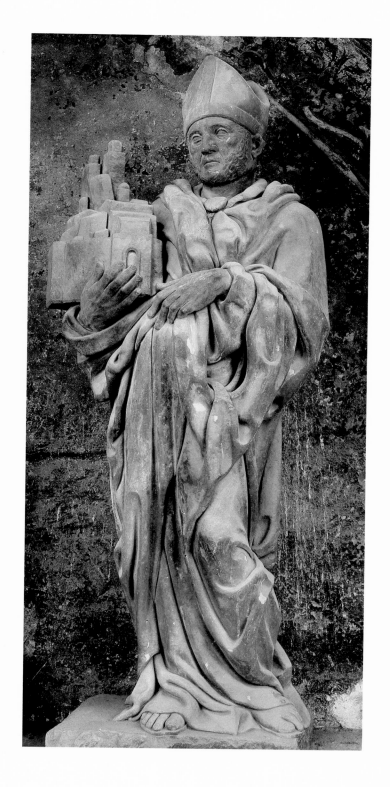

273

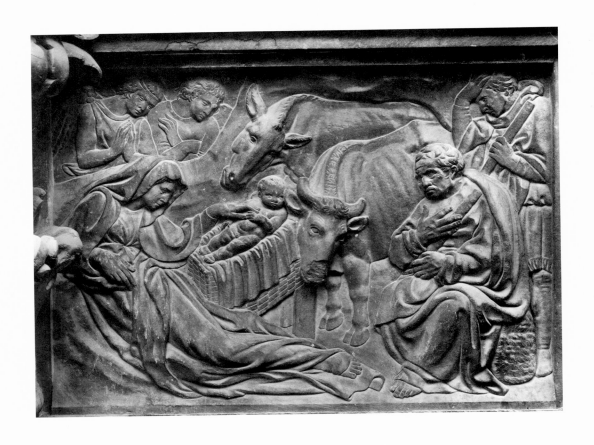

91. *Main Portal of San Petronio*. Detail of lintel; the Nativity.

92. *Main Portal of San Petronio.* The Nativity; detail (after restoration).

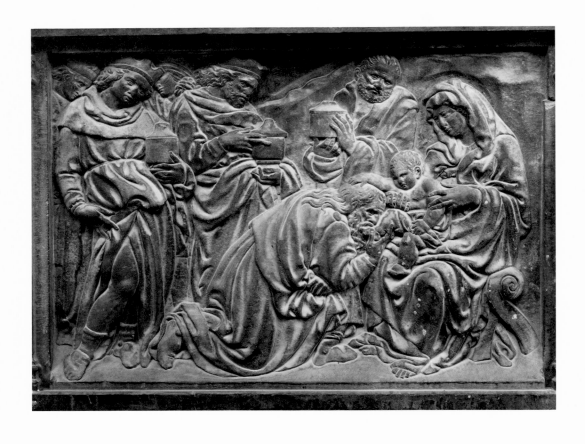

93. *Main Portal of San Petronio*. Detail of lintel; the Adoration of the Magi.

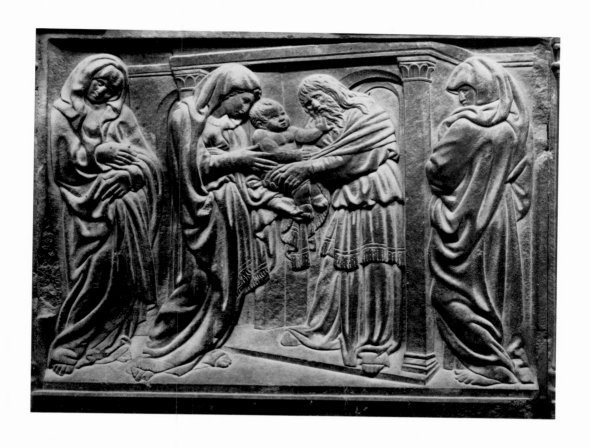

94. *Main Portal of San Petronio*. Detail of lintel; the Presentation in the Temple.

95. *Main Portal of San Petronio*. The Presentation; detail (after restoration).

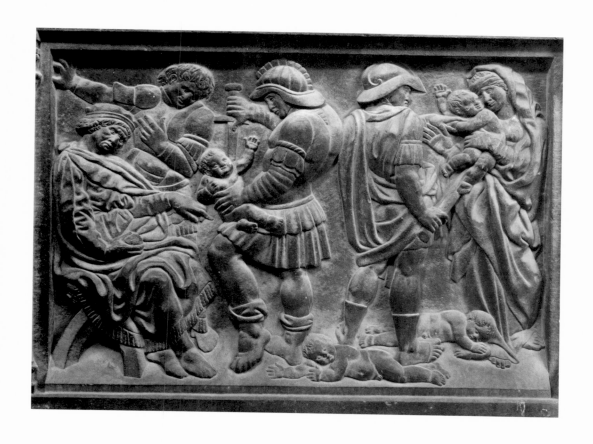

96. *Main Portal of San Petronio*. Detail of lintel; the Massacre of the Innocents.

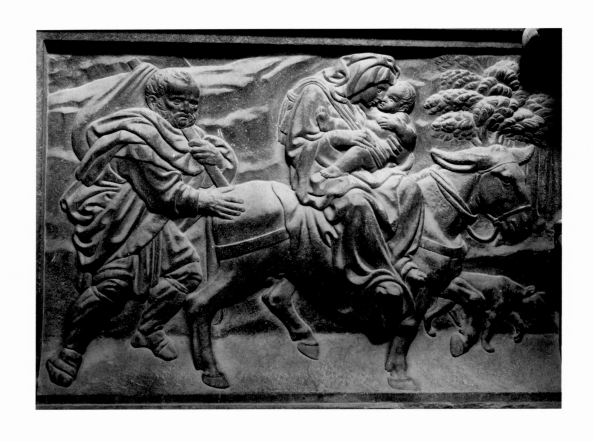

97. *Main Portal of San Petronio*. Detail of lintel; the Flight Into Egypt.

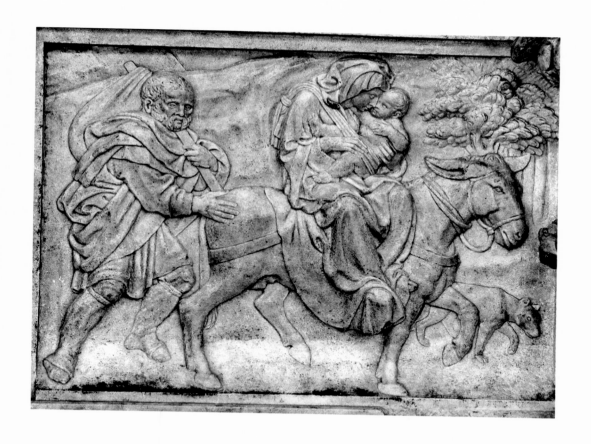

98. *Main Portal of San Petronio*. The Flight Into Egypt; detail (after restoration).

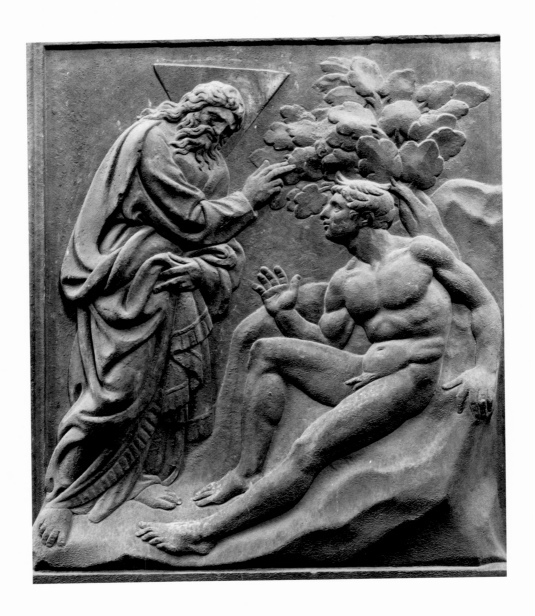

99. *Main Portal of San Petronio.* Detail of left pilaster; the Creation of Adam.

100. *(facing page top) Main Portal of San Petronio.* The Creation of Adam; detail (after restoration).

101. *(facing page bottom)* Engraving, after the Creation of Adam. First half of the nineteenth century (from a drawing by G. Guizzardi).

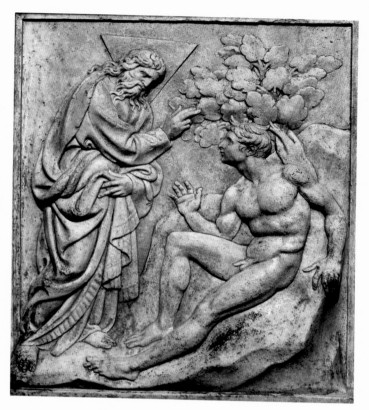

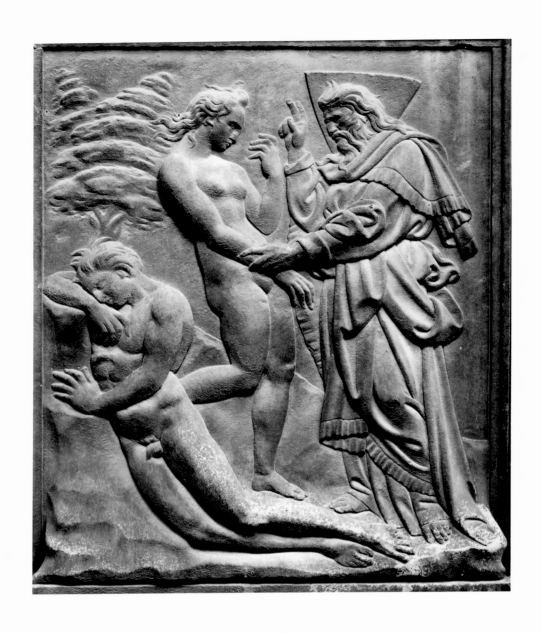

102. *Main Portal of San Petronio*. Detail of left pilaster; the Creation of Eve.

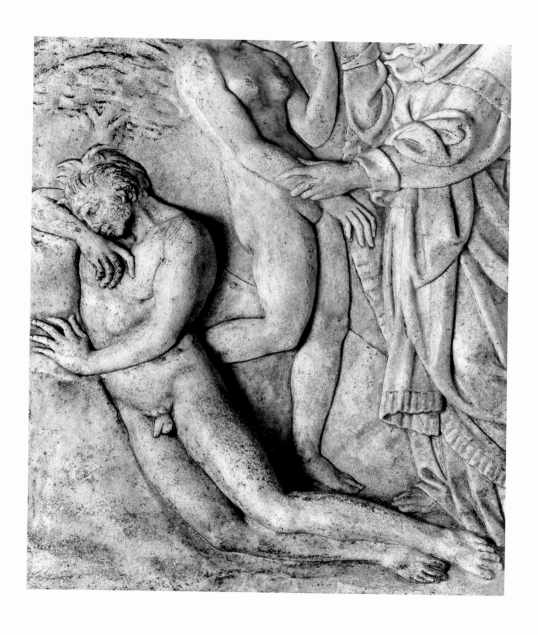

103. *Main Portal of San Petronio*. The Creation of Eve; detail (after restoration).

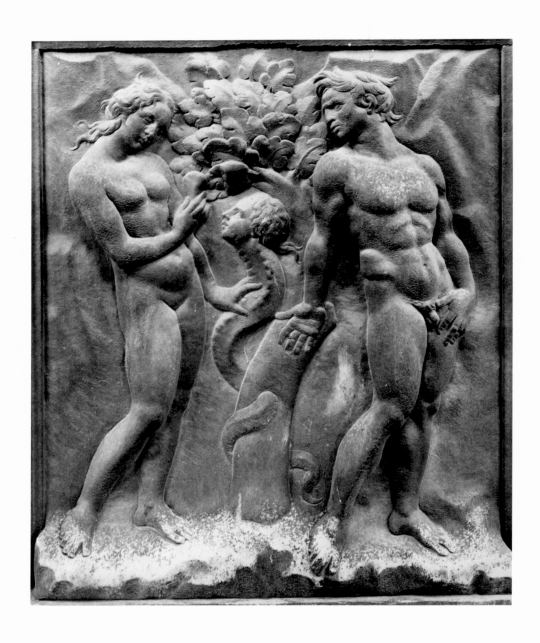

104. *Main Portal of San Petronio*. Detail of left pilaster; the Temptation and Fall.

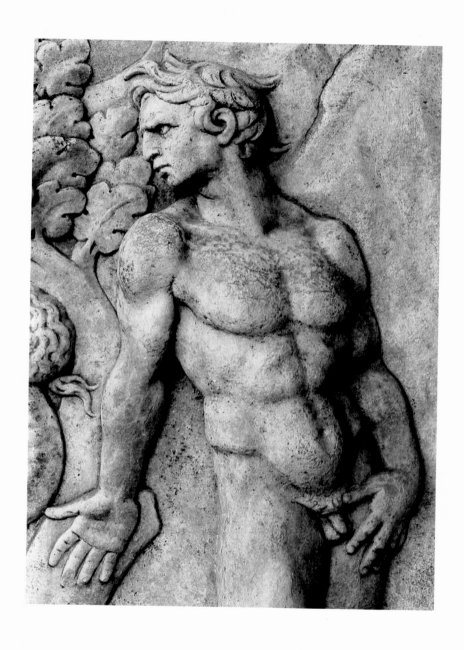

105. *Main Portal of San Petronio*. The Temptation and Fall; detail (after restoration).

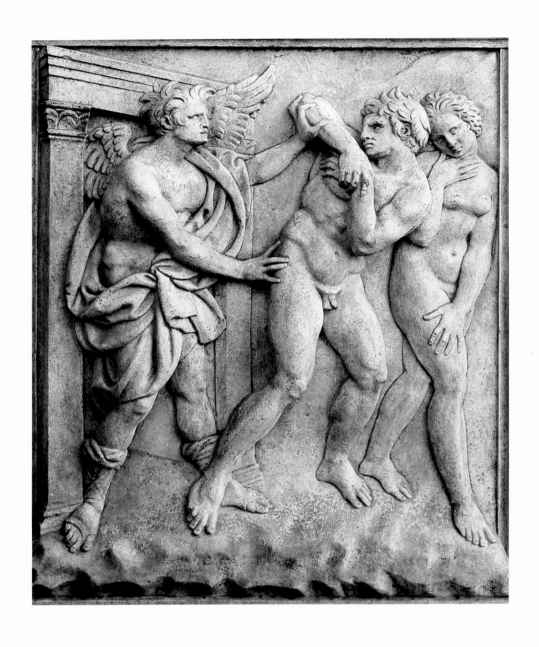

106. *Main Portal of San Petronio*. Detail of left pilaster; the Expulsion (after restoration).

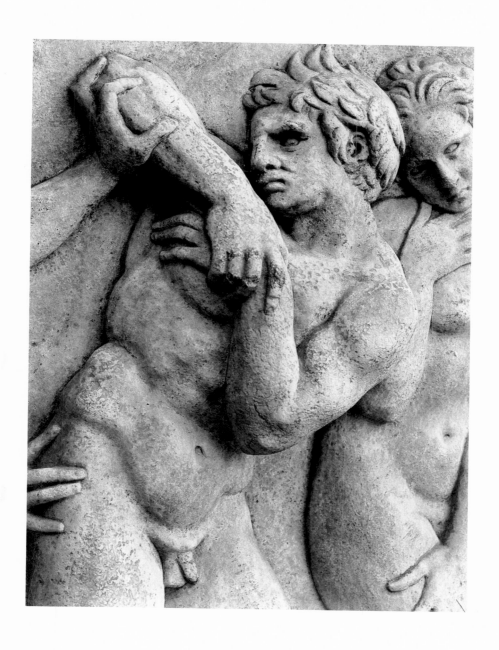

107. *Main Portal of San Petronio*. The Expulsion; detail (after restoration).

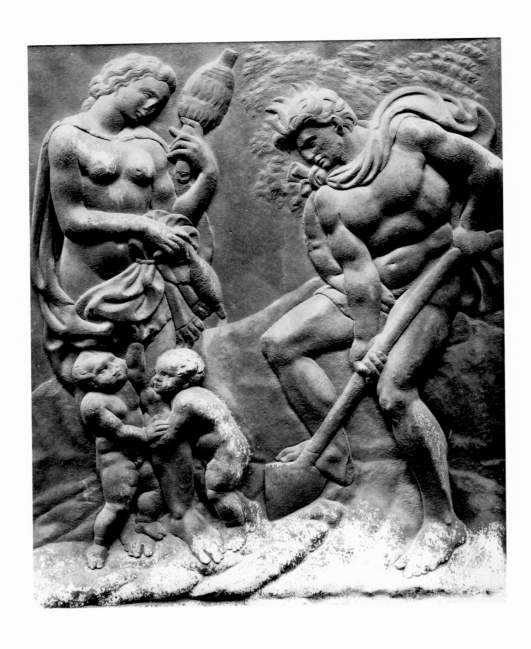

108. *Main Portal of San Petronio*. Detail of left pilaster; Adam and Eve at Work.

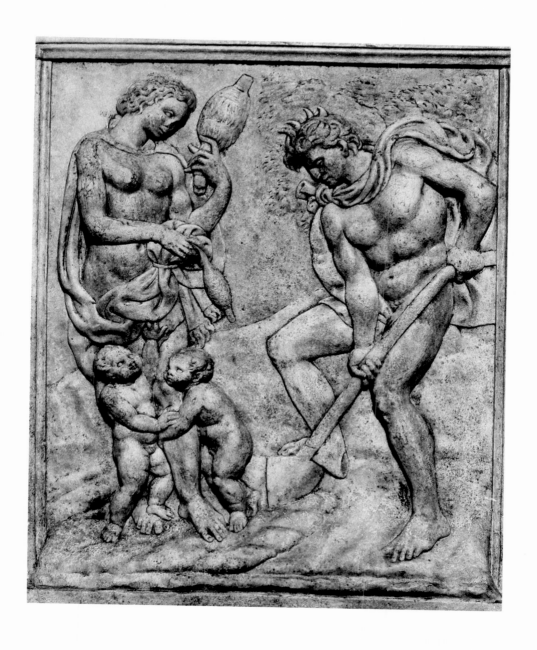

109. *Main Portal of San Petronio.* Adam and Eve at Work; detail (after restoration).

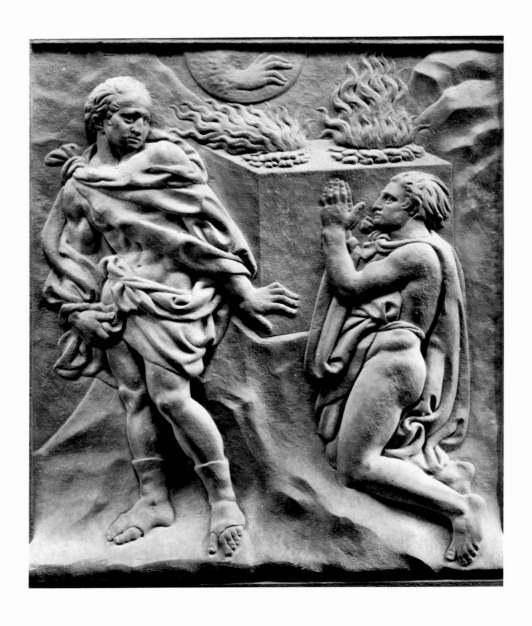

110. *Main Portal of San Petronio*. Detail of right pilaster; Cain and Abel Offering.

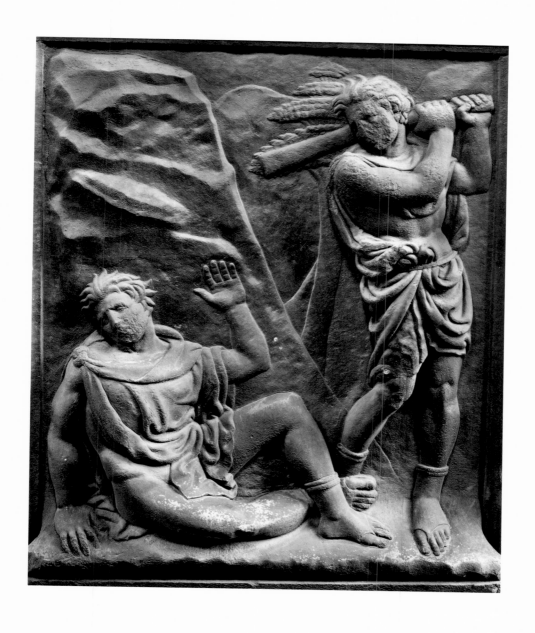

111. *Main Portal of San Petronio*. Detail of right pilaster; Cain Murdering Abel.

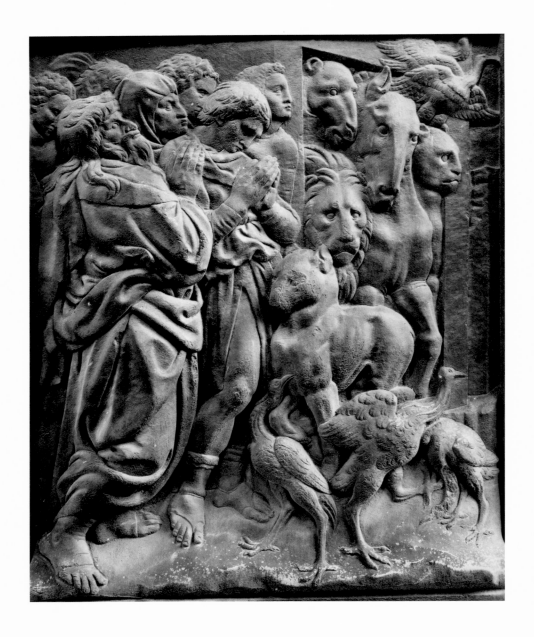

112. *Main Portal of San Petronio*. Detail of right pilaster; Noah Leaving the Ark.

113. *(facing page top) Main Portal of San Petronio*. Detail of right pilaster; the Drunkenness of Noah (after restoration).

114. *(facing page bottom) Main Portal of San Petronio*. The Drunkenness of Noah; detail (after restoration).

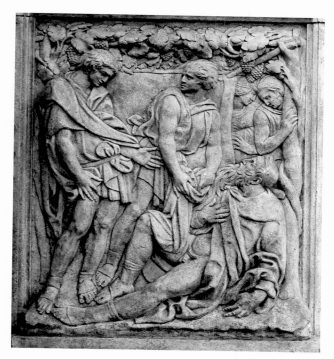

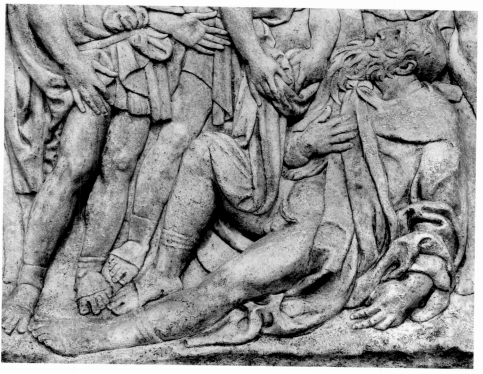

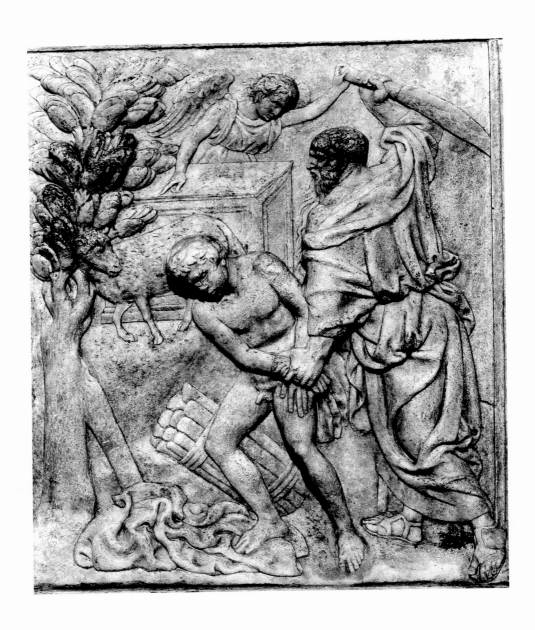

115. *Main Portal of San Petronio*. Detail of right pilaster; the Sacrifice of Isaac (after restoration).

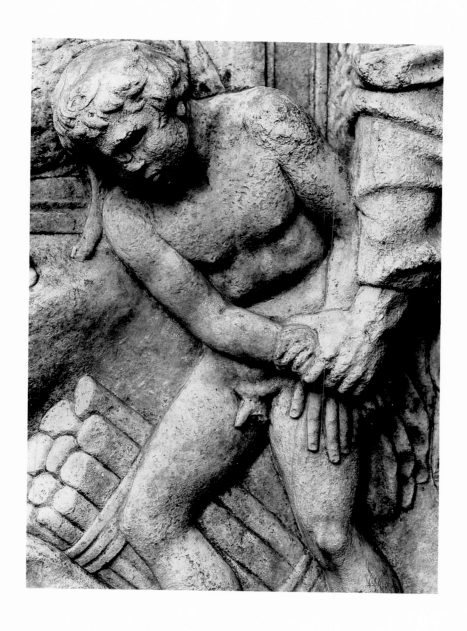

116. *Main Portal of San Petronio.* The Sacrifice of Isaac; detail (after restoration).

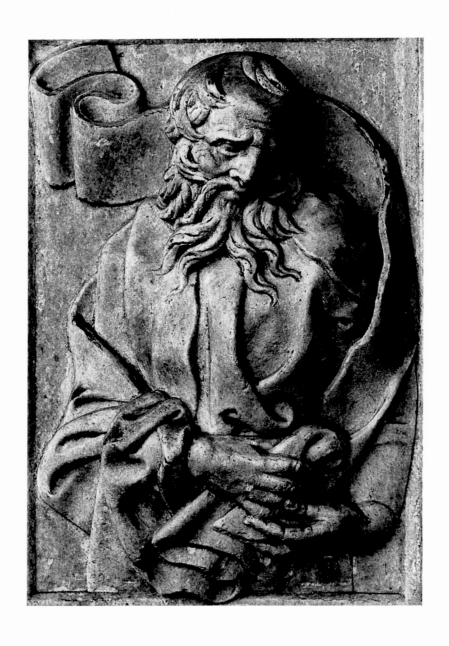

117. *Main Portal of San Petronio.* Detail of left pilaster strip; prophet 1 (beginning at the top; after restoration).

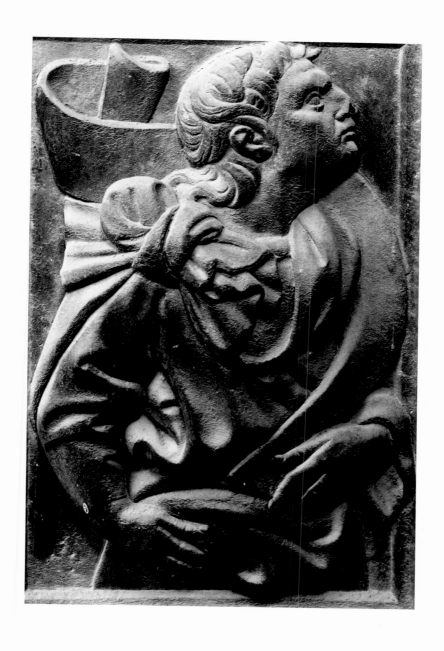

118. *Main Portal of San Petronio*. Detail of left pilaster strip, prophet 2.

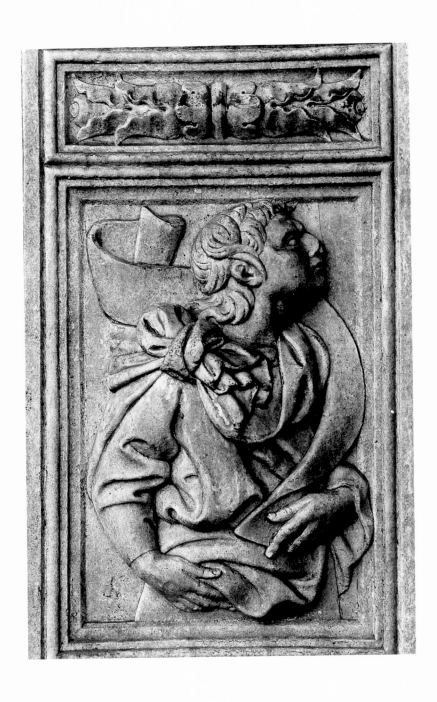

119. *Main Portal of San Petronio*. Detail of left pilaster strip; prophet 2 (after restoration).

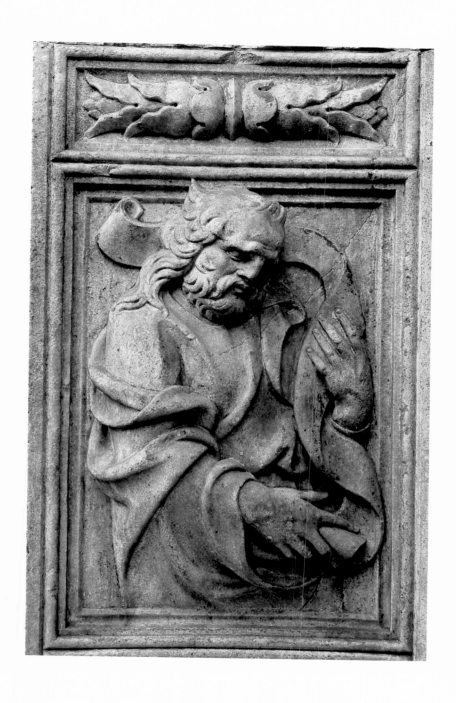

120. *Main Portal of San Petronio*. Detail of left pilaster strip; prophet 5 (after restoration).

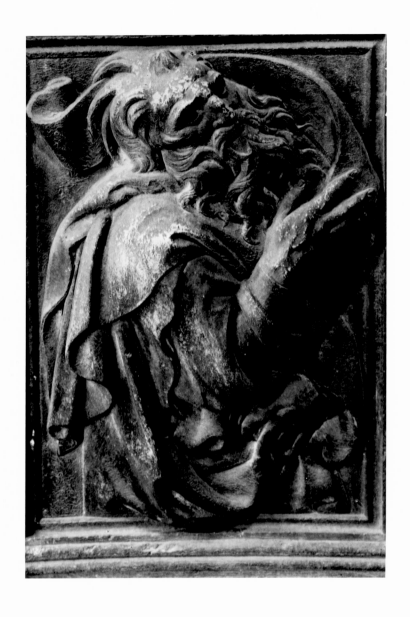

121. *Main Portal of San Petronio*. Detail of left pilaster strip; prophet 6.

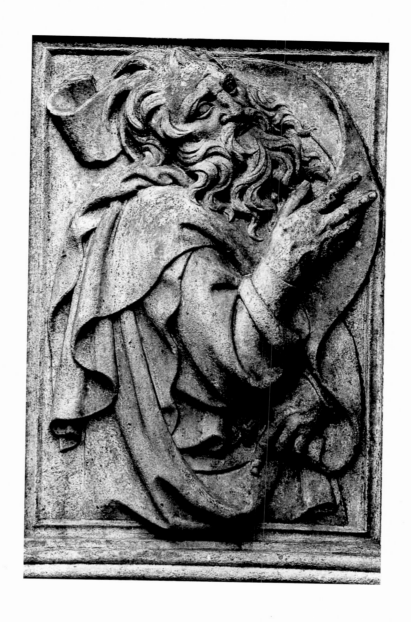

122. *Main Portal of San Petronio*. Detail of left pilaster strip; prophet 6 (after restoration).

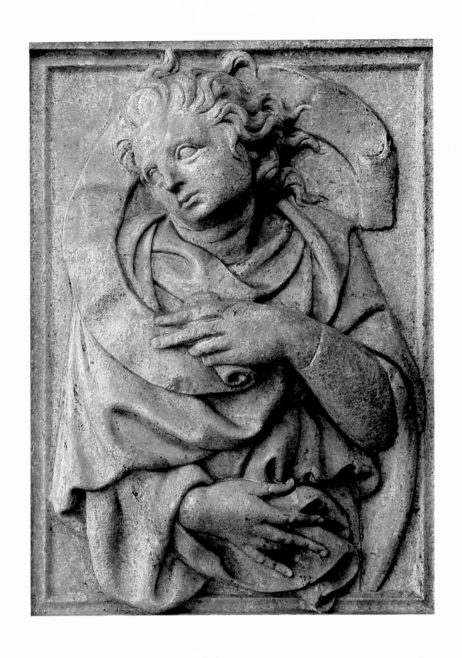

123. *Main Portal of San Petronio*. Detail of left pilaster strip; prophet 7 (after restoration).

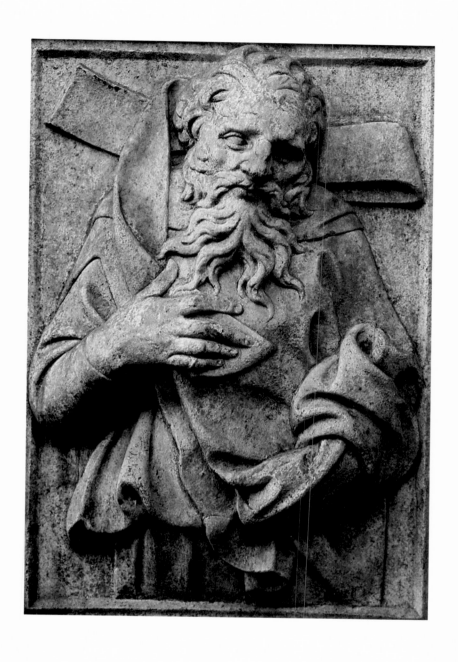

124. *Main Portal of San Petronio.* Detail of left pilaster strip; prophet 8 (after restoration).

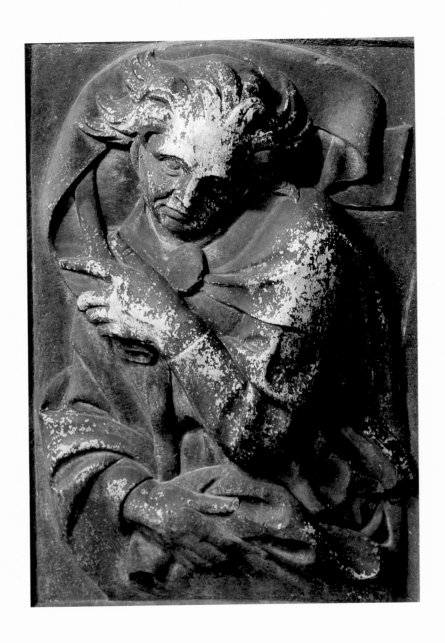

125. *Main Portal of San Petronio*. Detail of left pilaster strip; prophet 9.

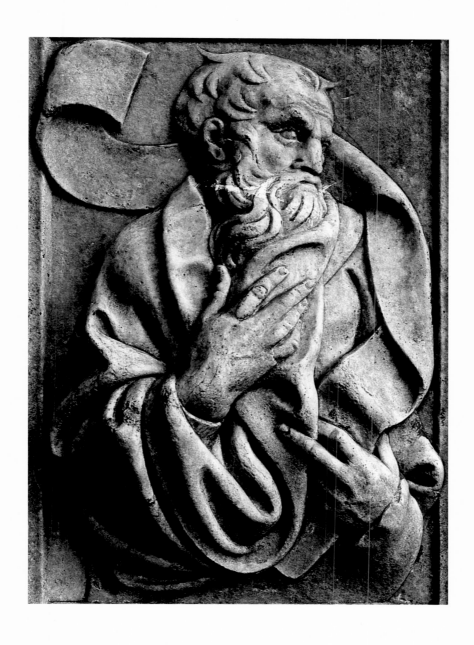

126. *Main Portal of San Petronio*. Detail of right pilaster strip; prophet 1 (beginning at the top; after restoration).

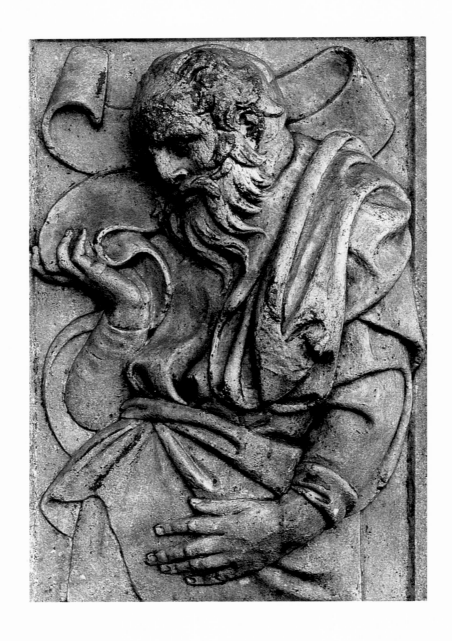

127. *Main Portal of San Petronio*. Detail of right pilaster strip; prophet 2 (after restoration).

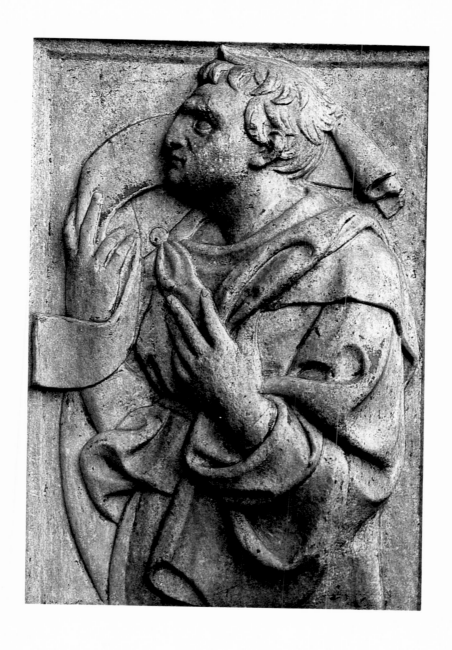

128. *Main Portal of San Petronio.* Detail of right pilaster strip; prophet 5 (after restoration).

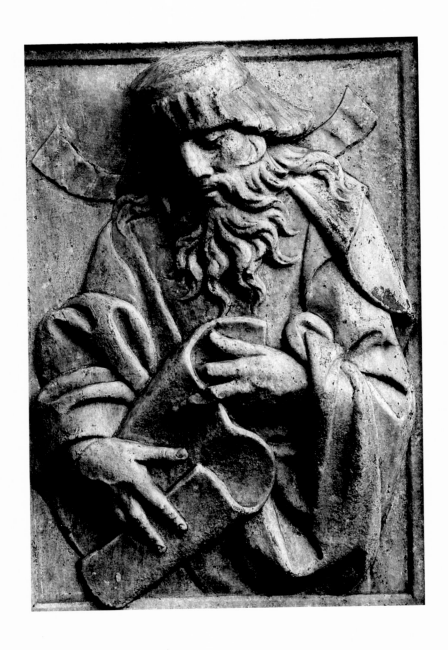

129. *Main Portal of San Petronio*. Detail of right pilaster strip; prophet 6 (after restoration).

130. *(facing page) Tomb of Andrea da Budrio*. San Michele in Bosco, Bologna. Ca. 1435.

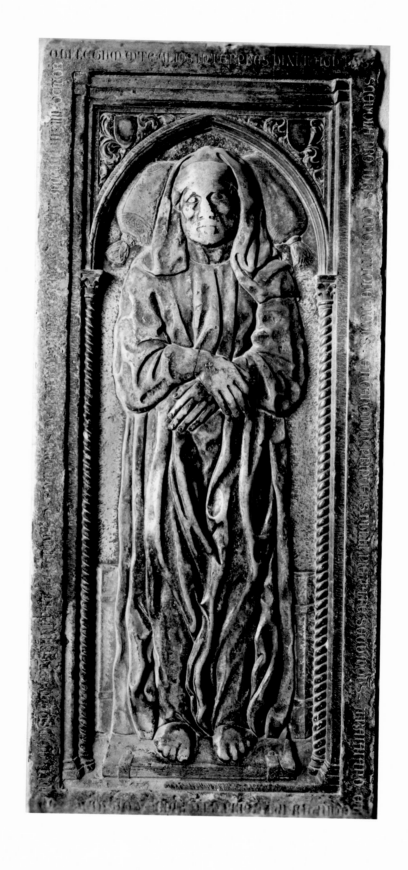

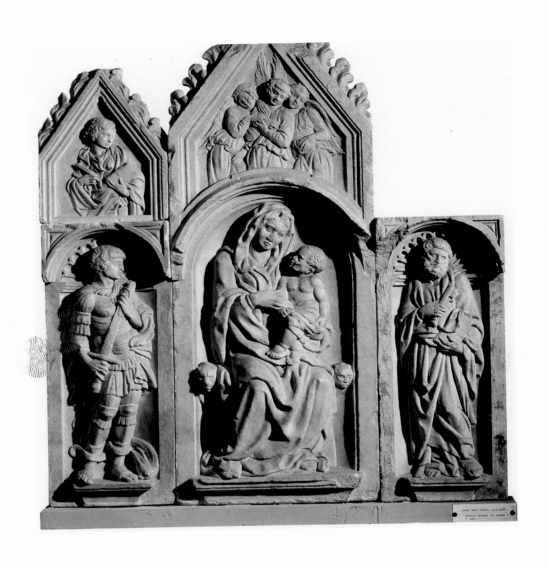

131. *Triptych with Madonna and Child, Saint George, Saint Peter, and Other Saints.* Museo Civico, Bologna. Ca. 1427–1428.

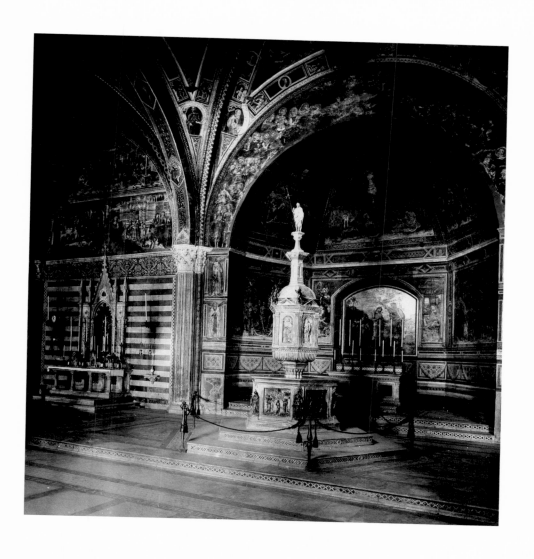

132. San Giovanni Battista, Siena; interior with view of *Baptismal Font*.

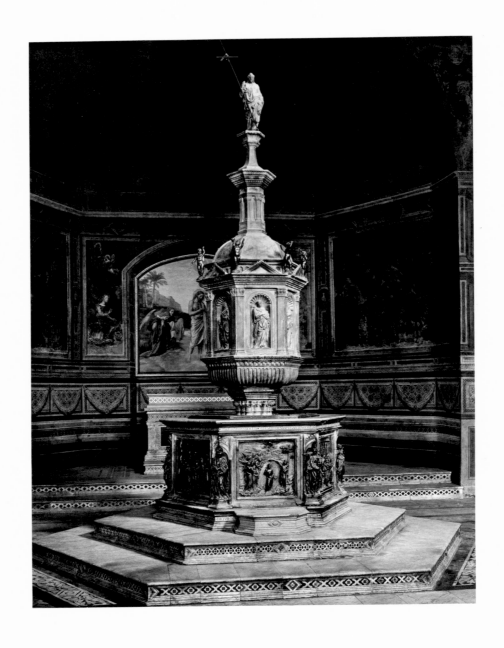

133. *Baptismal Font.* San Giovanni Battista, Siena. General view. 1416–1434.

134. *(facing page) Baptismal Font.* Detail; tabernacle. 1427–1428.

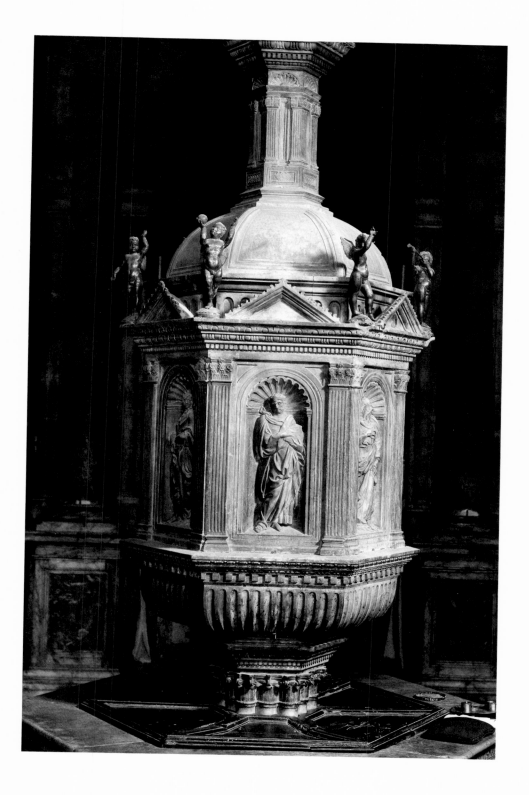

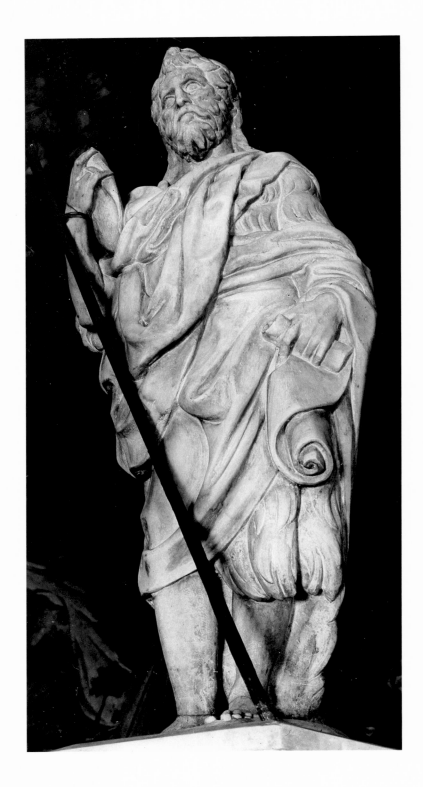

316

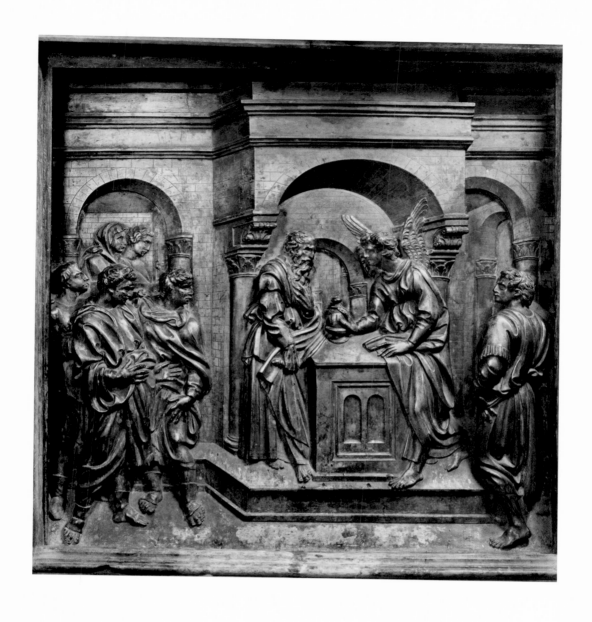

135. *(facing page) Baptismal Font.* Detail; Saint John the Baptist. 1428–1429.

136. *Baptismal Font.* Detail; the Annunciation to Zacharias in the Temple. 1428–1430.

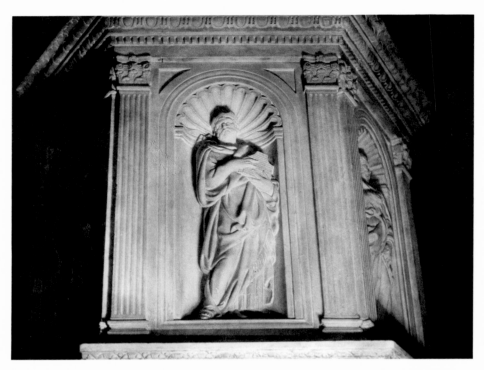

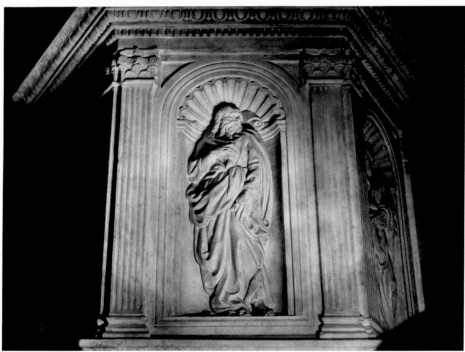

137. *Baptismal Font.* Detail; King David. 1427–1428.

138. *Baptismal Font.* Detail; bearded prophet. 1427–1428.

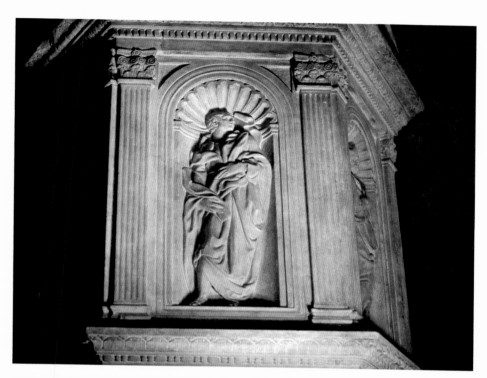

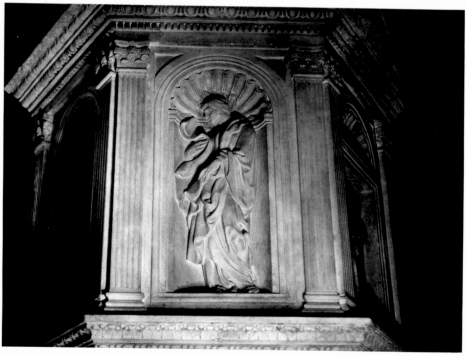

139. *Baptismal Font*. Detail; prophet looking upward. 1427–1428.

140. *Baptismal Font*. Detail; prophet looking to the left. 1427–1428.

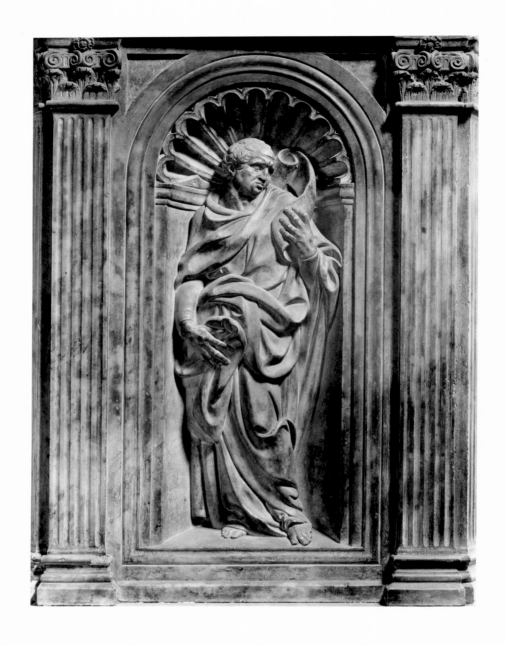

141. *Baptismal Font.* Detail; prophet looking down. 1427–1428.

142. *(facing page top) Madonna and Child with Saint Antonio and Cardinal Casini.* Museo dell'Opera del Duomo, Siena. Ca. 1437–1438.

143. *(facing page bottom) Madonna and Child with Saint Antonio and Cardinal Casini.* Detail.

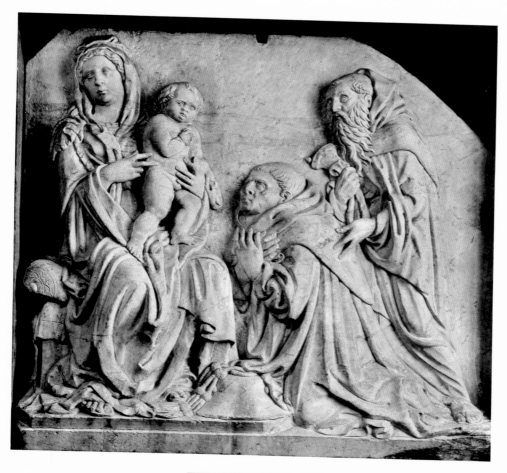

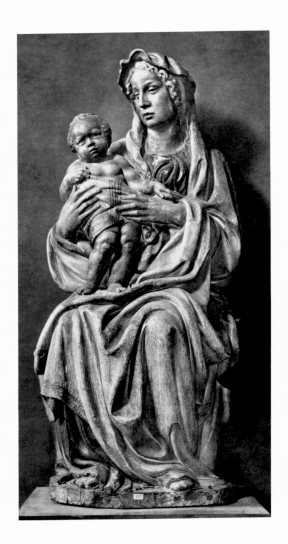

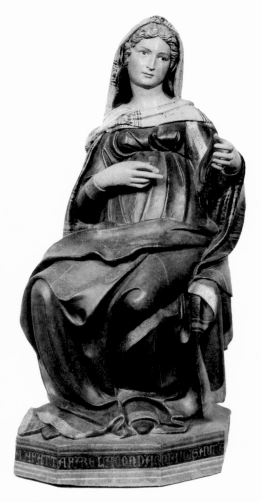

144. *Louvre Madonna*. Louvre, Paris. Ca. 1435.

145. *Anghiari Madonna*. Museo Statale di Palazzo Taglieschi, Anghiari. Ca. 1424.

146. *(facing page left) Saint John the Baptist*. San Giovanni, Siena. Ca. 1430.

147. *(facing page right) San Martino Madonna*. Museo dell'Opera del Duomo. Ca. 1423–1425.

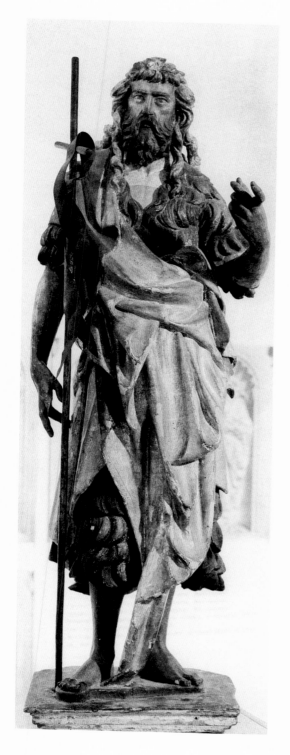
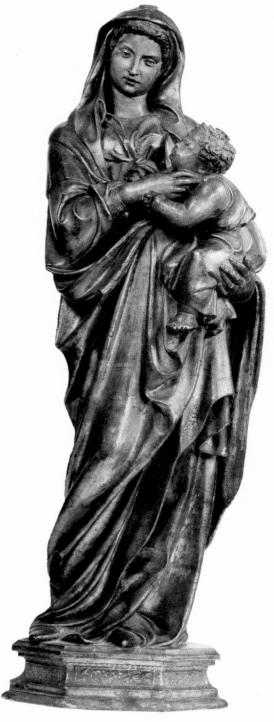

323

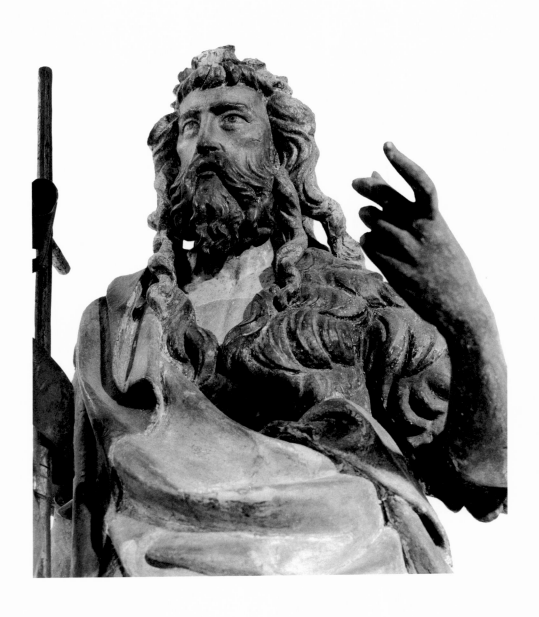

148. *Saint John the Baptist*. Detail.

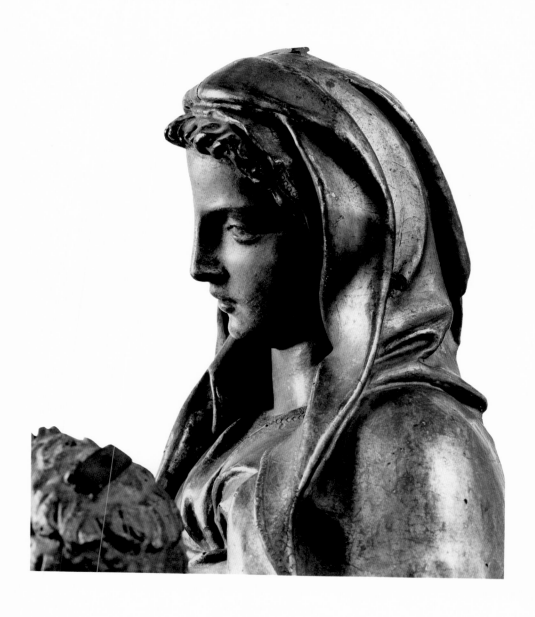

149. *San Martino Madonna*. Detail.

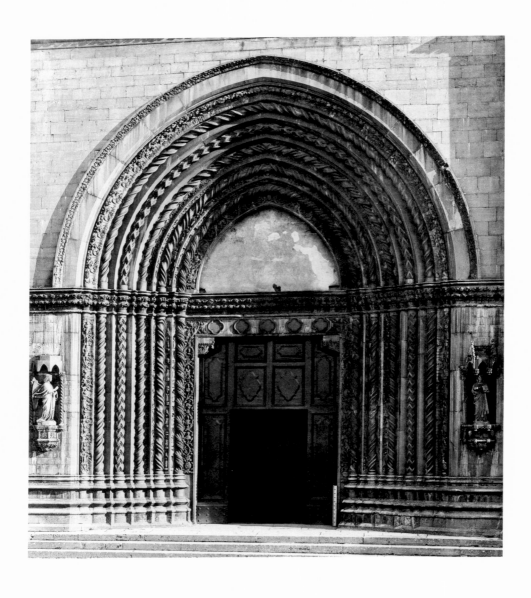

150. *Main Portal of San Fortunato*. San Fortunato, Todi.

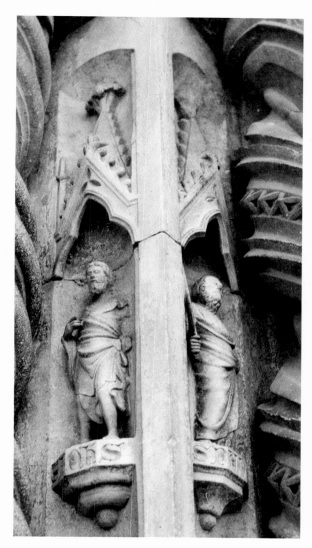 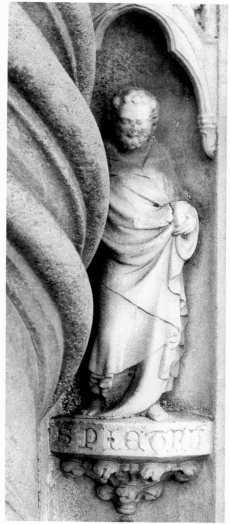

151. *Main Portal of San Fortunato.* Right embrasure, detail; saints John and Paul. 1416–1418.

152. *Main Portal of San Fortunato.* Right embrasure, detail; Saint Peter. Ca. 1416–1418.

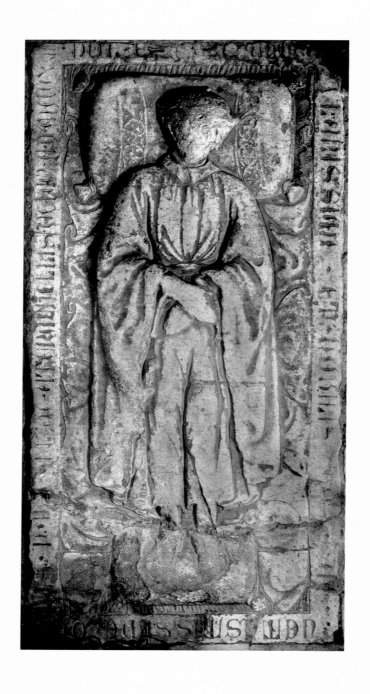

153. *Balduccio Parghia degli Antelminelli Tomb Slab.* Museo di Villa Guinigi, Lucca. 1423.

The Documents

THE FORMAT chosen for the presentation of the documents is similar to the format I developed in collaboration with Gino Corti for *Masaccio: The Documents* (Locust Valley, N.Y., 1978). For easy access, each document is numbered and dated; a short caption-summary in English is provided, followed by the transcription from the original manuscript (with limited exceptions). In some of the longer documents, paragraphs have been numbered consecutively (in brackets) for the convenience of the reader. In cases in which the document is entirely routine, as with simple salary advances, I have given merely a summary, without actually reproducing the full document. Data from diaries or chronicles is sometimes simply paraphrased in the summary heading. I have provided archival references and also bibliography, except, of course, in cases in which a document was previously unpublished.

The manuscripts have been checked in nearly every case, and whenever possible the transcription was verified. In this regard I wish to thank in particular Mario Fanti, Oscar Mischiati, Sonia Fineschi, Maria Grazia Pernis, and Gino Corti. The texts have been modernized to some extent. Corrections of previously published documents have been made so that the final result presented here is a coherent, correct, and homogeneous collection of data. Abbreviations in the originals have been expanded in most cases to create a readable and comprehensive text. Within the transcriptions, the equivalent modern date is indicated in brackets to avoid ambiguities resulting from differences in calculating the year in Siena and Florence during the fifteenth century and modern usage. (The new year was then calculated from March 25, so that dates that appear in the body of the documents falling between January 1 and March 24 are one year behind the modern year.)

In most cases the document is followed by a comment, in which issues raised by the document and its interpretation are treated and connections with other evidence are sometimes proposed.

CRITERIA USED IN THE TRANSCRIPTIONS

1. Minimal necessary punctuation has been added to facilitate clarity.

2. Individual words that were run together in the original manuscript are separated.

3. Accents, which in most cases do not appear in the original manuscripts, are provided according to modern usage.

4. Three dots (. . .) are used to indicate that a section of the document has not been reproduced.

5. The original spelling has always been preserved with no modernization or alteration.

6. Dropped vowels in the original text are indicated (when necessary for clarity) by an apostrophe, or by inserting the missing vowel in brackets. The same practice is followed for consonants or even entire syllables, in limited cases.

7. *Sic* in brackets *[sic]* is used sparingly, when the transcription reveals a particularly unusual and confusing variation from common usage.

8. Proper names, names of persons, months, saints, places, all geographical names, etc., are rendered with the first letter a capital, whether the original manuscript shows the capital or not.

9. Titles such as "ser," "messer," "vescovo," etc. are rendered using the lowercase regardless of how they appear in the original.

10. Numbers are reproduced as they appear in the original text, whether in roman numerals or arabic numerals, in sums, dates, or pagination, for example.

11. Words ending in *j* in the original as well as the final number in a series such as *iij* will be rendered simply as *i* or *iii*.

12. Days of the month when they are given in roman numerals will be shown using the lowercase, regardless of how they appear in the manuscript.

13. Whenever there is the possibility of ambiguity for the year of a particular date, the original is given as it appears in the manuscript, followed by the modern equivalent in brackets, as in "12 marzo 1420 [1421, modern]."

ABBREVIATIONS

WITHIN DOCUMENTS

f. or F. = florin, fiorino, fiorini
l. or L. = lira, lire.
s. = soldo, soldi.
d. = denaro, denari.
c. = carta

ARCHIVES

ASB = Archivio di Stato, Bologna.
ASF = Archivio di Stato, Florence.
ASFerrara = Archivio di Stato, Ferrara.
ASL = Archivio di Stato, Lucca.
ASP = Archivio di Stato, Pisa.
ASS = Archivio di Stato, Siena.
AODS = Archivio dell'Opera del Duomo, Siena.
AFSP = Archivio della Fabbrica di San Petronio, Bologna.
BCS = Biblioteca Comunale di Siena.

FREQUENTLY CITED BOOKS AND ARTICLES (SEE BIBLIOGRAPHY FOR FULL PUBLICATION DATA)

Bacci, *FdV* = P. Bacci, *Francesco di Valdambrino.*
Bacci, *Quercia* = P. Bacci, *Jacopo della Quercia.*
B-P, *Fonti* = F. Bargagli-Petrucci, *Le fonti di Siena.*
Beck, *Portale* = J. H. Beck, *Jacopo della Quercia e il portale di San Petronio a Bologna.*
Bongi, *Paolo Guinigi* = S. Bongi, *Di Paolo Guinigi e delle sue richesse.*
Gnudi, "Revisione" = C. Gnudi, "Per una revisione critica della documentazione."
Hanson, *Fonte Gaia* = A. C. Hanson, *Jacopo della Quercia's Fonte Gaia in Siena.*
Lazzareschi, "Dimora" = E. Lazzareschi, "La dimora a Lucca."
Milanesi, *Documenti* = G. Milanesi, *Documenti per la storia dell'arte senese.*
Milanesi, *Vasari* = G. Milanesi, ed., *Giorgio Vasari, Le vite de' più eccellenti pittori, scultori e architettori.*
Mostra = *Jacopo della Quercia nell'arte del suo tempo. Mostra didattica.*
Paoletti, *Font* = J. T. Paoletti, *The Siena Baptistry Font.*
RRIISS = L. A. Muratori, ed., *RRIISS (Rerum italicarum scriptores).*
Supino, *Scultura Bologna* = I. B. Supino, *La scultura a Bologna nel secolo XV.*
Supino, *Sculture Porte* = I. B. Supino, *Le sculture della porte di San Petronio in Bologna.*

Document 1. April 21, 1370
 Siena

*Piero d'Angelo, goldsmith and father of Jacopo della Quercia, receives a dowry of 180 lire
from Maddalena detta Lena, his future wife.*

Ser Iacobus Manni notarius de Senis denumptiat quod, die xxi mensis aprilis [MCCCLXX]:
Piero quondam Angeli Guarnerii aurifex, populi sancti Mauritii, recepit in dotem a
domina Magdalena vocata Lena sponsa futura dicti Pieri centumottuaginta libr. den. CLXXX
libr. den.

Location: ASS, Gabella Contratti, no. 61 (1369–70), fol. 68.

Bibliography: Bacci, *FdV*, p. 55.

Comment: Bacci also reports that Piero paid a tax of 3 lire and 15 soldi on June 20, 1370
for the registration of the dowry.

The information is of considerable importance for Quercia studies for several reasons, not
the least being its value in estimating Jacopo's date of birth, a question taken up at some
length in chapter 1. A date before the marriage (as Krautheimer and Krautheimer-Hess
suggest, *Ghiberti*, p. 140) is probably to be discarded. We need not assume that Jacopo was
born immediately after the marriage. In fact, the date offered in this study is ca. 1380.

From the record of the dowry, we learn that Jacopo's father Piero di Angelo had either a
grandfather named Guarniero and that he belonged to a family of the Guarnieri, or that he
was a member of a German "compagnia di ventura" active in the region during the mid-
fourteenth century.

Document 2. June 26, 1390
 Siena

*The condottiere Giovanni d'Azzo degli Ubaldini died and is buried at the altar of S. Savino
in the Sienese cathedral.*

Bibliography: *Cronica di Paolo di Tommaso Montauri*, vol. 15, part 6, p. 735 of *RRIISS;*
2:110*n1.*

Comment: This information is included here because of Vasari's claim that Jacopo had
made an equestrian statue of Giovanni d'Azzo degli Ubaldini. Vasari was incorrect, as
Milanesi determined (Vasari 2:110*n2*), since the Sienese had a painting and not a statue
commemorating that soldier of fortune. For political reasons the painting was removed from
the Chapel of S. Savino in 1404 (see doc. 13).

Document 3. February 24, 1394
 Lucca

Piero di Angelo in Lucca agrees to make a wooden Annunciation *for the Church of S. Maria
di Benabbio in the Val di Lima.*

Magister Pierus Angeli de Senis, Luce commorans, pictor hoc publico instrumento promisit et convenit Iohanni Balduccii de Menabbio [read Benabbio] vicarie Vallis Lime operario opere cante Marie de Menabbio plebis Contronis, presenti e recipienti pro dicta opera, facere et construere lignaminem scholpitum unam imaginem sancte Marie annunptiate et unam Angelum annuntiantem bene ad arbitrium boni et ydonei magistri et Benedicti Iohannis de Senis lucani civis pro pretio florenorum XXII auri de quibus habuit ab eo dicto nomine XI et hoc hinc ad XV dies Augusti et in dicto termine residuum, sub penam dupli etc.

Actum in apotecha domus fratrum Servorum posita Luce in brachio filiorum Becchafave, presentibus Granano Ciucchii et Iohanne Berretani de Luca testibus, die XXV Februarii [1394].

Location: ASL, Notari, ser Iacopo Vannini, no. 336, fol. 73v.

Bibliography: Lazzareschi, "Dimora," doc. 4; Bacci, *FdV*, pp. 84–85; Hanson, doc. 102; *Mostra*, doc. 1, p. 324.

Comment: For the semester February–July 1394, Piero di Angelo paid or had arranged to have paid in his name a small tax in Siena (Bacci, *FdV*, pp. 58–59). He could have and probably did go to Lucca sometime before 1394: he must have been there before the drawing of this document wherein he is described as "Luce commorans." Bacci (*FdV*, p. 33) suggests that Piero was in Lucca as a political refugee following the overthrow of the Malavolti in 1391. It should be noted that in the Lucchese document presented here Piero was called "pictor," but that does not mean in itself that he was actually a painter since the terminology at this time was often blurred. Donatello was also called a painter in a document of the Opera del Duomo of Florence (G. Poggi, *Il Duomo di Firenze*, Berlin, 1909, doc. 420). The *Annunciation* by Piero d'Angelo has been the subject of a paper by P. Cardile ("The Benabbio Annunciation and the Style of Jacopo della Quercia's Father, Piero d'Angelo.")

The contract must be understood as an *ante quem* for the carving and painting of the two figures.

Document 4.

May 28, 1394
Siena

On this date Domenico di Niccolò is mentioned as an artist: here he is listed along with Martino di Luca, hired to evaluate portions of the wooden choir of the Siena Cathedral.

Location: AODS, Libro 29 (according to Milanesi, *Documenti*, 1:372).

Bibliography: Milanesi, *Documenti*, 1:372.

Comment: Since the long career of Domenico criss-crosses that of Jacopo, I am including this, the earliest reference to his career, which already reveals him as an experienced master. There is no monographic study treating this worthy Sienese master, who was a sculptor, intarsia worker, and wood carver. For the most recent and thorough summary see A. Bagnoli, in Bagnoli and Bartalini, eds., *Scultura dipinta*, pp. 104–132.

Document 5.

February 1396
Siena

A commemorative statue of the condottiere Giovanni di Marco da Pietramala, known as Giovanni Tedesco, is erected in the cathedral of Siena.

E poi per memoria di detto Giovanni Tedesco féro e Sanesi uno cavalo co' la sua imagine di legno del naturale a modo come era armato e posesi in Duomo a capo la porta mezo da lato drento.

Bibliography: Cronaca di Paolo di Tommaso Montauri, vol. 15, part 6, p. 747, in *RRIISS;* Milanesi, *Vasari,* 2:110n2.

Comment: Giovanni Tedesco died in 1395, but this document must have been in the Sienese style, so that the year according to modern calculations is 1396 rather than February 1395. This no-longer-extant statue has been associated with Jacopo della Quercia by Vasari, though he confused the subject with another soldier, Giovanni d'Azzo. The statue was removed from its original setting in 1404. (See below, doc. 13.) Milanesi says that the statue was first located in the chapel of S. Sebastiano and then in 1404 placed on the inner face of the main portal of the cathedral, only to be removed definitively in 1506. On the other hand, Milanesi's account runs counter to the chronicle cited here, and probably represents a misinterpretation. It is not clear whether Vasari actually saw this statue (very unlikely, in my view), or whether his extensive description of the equestrian statue was based upon a second-hand report, presumably from a Sienese correspondent. Vasari used this opportunity to attribute to Jacopo the invention of a type of papier mâché *(carta pesta)* sculpture which utilized linen over a wooden armature. This attribution induced Valentiner ("The Equestrian Statue of Paolo Savelli in the Frari") to ingeniously ascribe the equestrian statue of Paolo Savelli (also a *condottiere)* in Venice to Jacopo della Quercia.

In 1395 the Florentines commissioned the painters Agnolo Gaddi and Giuliano Arrighi called Pisello to design tomb monuments in their cathedral for John Hawkwood and Pietro Farnese honoring both of these professional soldiers. See C. G. Cavalluci, *S. Maria del Fiore e la sua facciata* (Florence, 1887), pp. 154–155; G. Poggi, "Paolo Uccello e l'orologio di S. Maria del Fiore," in *Miscellanea di storia dell'arte in onore di I. B. Supino* (Florence, 1933), pp. 332–333; B. Cole, *Agnolo Gaddi* (Oxford, 1977), p. 66; and Y. Even, "Paolo Uccello's John Hawkwood: Reflections of a Collaboration Between Agnolo Gaddi and Giuliano Pesello," *Source: Notes in the History of Art* (1985), 4(4):6–8.

According to his own account, Vasari (Milanesi, *Vasari,* 5:644–645) mentioned that Domenico Beccafumi had supplied him with information about the life of Jacopo della Quercia. The description of a large-scale equestrian group by Beccafumi celebrating the Emperor Charles V using papier mâché is curiously like that ascribed to Jacopo della Quercia, and seems to have been based upon Beccafumi's sculpture, rather than a first-hand experience with the Giovanni Tedesco monument. Closer in time to Jacopo's period was a group by Domenico di Niccolò de' Cori, said to have been produced in 1447:

Domenico di Niccholò de' Chori fece la statua di Ardiccione al naturale insieme con il cavallo. Il detto Ardiccione era morto nella battaglia a Monte Merano nel 1441. Questa statua fu fatta nel 1447. Lo statuario stava a bottega vicino alla chiesa di S. Giorgio. Vedi il Diario antico appresso di noi.

Document 6. 1400
 Siena

Plague in Siena is described.

Bibliography: Cronaca di Paolo di Tommaso Montauri, vol. 15, part 6, p. 760 in *RRIISS.*

Document 7.

Jacopo della Quercia is mentioned among the contestants for the second set of bronze doors of the Florentine Baptistery.

... Condussonsi dette prove in un anno, e [a] quello [che] vinceva doveva essere dato le vittoria. Furono i combattitori questi: Filippo di ser Brunellesco, Simone da Colle, Nicolò d'Arezzo, Jacopo della Quercia da Siena, Francesco di Valdambrina *[sic]*, Nicolò Lamberti; fummo sei a fare detta prova, la quale prova era dimostrazione di gran parte dell'arte statuaria. Mi [i.e., Ghiberti] fu conceduta la palma della vittoria ...

Bibliography: Ghiberti, *I Commentarii*, p. 42; J. von Schlosser, *Lorenzo Ghibertis Denkwurdigkeiten zum ersten Male* (Berlin, 1912), 1:45–46, 2:168; Bacci, *FdV*, pp. 9ff.

Comment: The above citation must be regarded as the most reliable listing for the participants of this momentous competition. In his own account, Vasari incorrectly includes the name of Donatello. For a thorough discussion of the competition, see Krautheimer and Krautheimer-Hess, *Ghiberti*, 1:31ff. Vasari described Quercia's entry in the following terms: "In quella di Jacopo dalla *[sic]*, Quercia erano le figure buone ma non avevano finezza, sebbene erano fatte con disegno e diligenza" (Milanesi, *Vasari*, 2:226–227). I suspect that Vasari never saw the competition panel by Jacopo, if indeed one were ever actually made in bronze (which I doubt), and that he based his comments upon what he knew in general of Jacopo's art.

Ghiberti's language is intensely competitive, phrased as it is in terms of a *giostra* or even a real battle with "combattitori" and the "palma della vittoria." His mention of Jacopo's participation in the Baptistery project is the earliest information provided by a contemporary that we have about Jacopo's life. Here he already appears with his countryman Francesco di Valdambrino, who is known to have been a close collaborator in the years to follow. We may assume that the two young Sienese sculptors decided to compete together for the prestigious and lucrative commission in Florence. Presumably they both were present in Florence at least for a short time to get instructions and materials. We may also assume that they became acquainted with the sculpture being produced there, such as the Virtues for the Loggia dei Lanzi and the reliefs for the embrasures of the Porta della Mandorla. Vasari, in the first edition of *Le vite*, asserts that Jacopo had been in Florence for a period of four years before the competition, but because his chronology is untrustworthy and no such activity has been confirmed by documents, his claim should be disregarded. If a case can be made for Jacopo's participation at the Porta della Mandorla, as Brunetti has eloquently claimed ("Jacopo della Quercia and the Porta della Mandorla"), it must be purely on stylistic evidence. I do not believe that Jacopo had any role whatsoever in the Portal della Mandorla, but was simply an admirer of the work that had been carved there.

Revealing is Ghiberti's assertion that the competition reflected the skill of the contestants as sculptors of statues—not goldsmiths.

Document 8.

Piero d'Angelo is paid for a seal made for Paolo Guinigi in Lucca.

Die 16 Martii [1401] magistro Piero de Senis aurifici pro constuctione sigilli domini florenos sex auri in auro.

Location: ASL, Camarlingo Generale, no. 111, fol. 171.

Bibliography: Lazzareschi, "Dimora," p. 87*n;* Bacci, *FdV,* pp. 71, 87; S. Bongi, *Paolo Guinigi,* p. 19; *Mostra,* doc. 2, p. 324.

Comment: The seals mentioned, as far as I have been able to determine, have never been identified.

Document 9. April 19, 1401
 Lucca

A "master Jacopo" is recommended in a letter written by Paolo Guinigi to Giovanni Bentivoglio in Bologna.

Magnifico domino Iohannis de Bentevoglis, civitatis Bononie domino etc. Magnifico et potens domine . . . Magistrum autem Iacopum quem nobis tancta affectione tantque reco- mictitis caritate, placido vultu susceptimus, quem etsi suis meritis semper nobis caris extiterit, efficacissime tamen precas vestre fecere carissimum . . . Lucem, XVIIII Aprilis MCCCCI

Location: ASL, Governo di Paolo Guinigi, no. 5, fols. 27–27v.

Bibliography: *Il Marzocco,* June 17, 1928; M. Salmi, "La Giovinezza di Jacopo della Quercia," p. 178.

Comment: Perhaps this letter refers to Jacopo della Quercia. Since the earliest document we have locates him in Ferrara in 1403 (see doc. 11), one could concoct a situation in which Jacopo, having been in Emilia, requested a recommendation from Paulo Guinigi back home in Lucca, which could have been arranged through the intervention of his father. The "Magister" referred to here need not have been an artist at all, however, much less our Jacopo. On the other hand, a Bolognese connection before 1403 seems not only quite possible, but even likely.

Document 10. 1402
 Siena

Jacopo is said to be recorded in the painters' guild of Siena.

Nel 1402 è nominato il nostro artefice [i.e., Jacopo della Quercia] nel ruolo degli statuti pittorici . . .

Location: BCS, Romagnoli, III, fol. 617.

Comment: If there was a list of 1402, it is no longer to be found. Naturally the notice is tempting, but since Jacopo does not appear in the list of 1428, it would be a mistake to make much of this information. Furthermore, as is well known, Romagnoli's record for accuracy is not impeccable. Still, it cannot be excluded forthwith: Jacopo's brother Priamo was, to be sure, a painter, and as we have seen, their father was called "pictor" in Lucca. Romagnoli may have taken this item from Della Valle (*Lettere sanesi* 3:159), who says that there was apparently a Giacomo di Piero in the guild, perhaps in 1402.

Document 11.

A contract for a Madonna is drawn up between the executors of Virgilio dei Silvestri's will and Jacopo della Quercia, who was then present in Ferrara.

Die decimonono mensis Septembris, Ferrarie, in episcopali palatio ad bancum juris, presentibus domino Martino de Grignano, Basilio Sindico pauperum, domino Thoma de Pirandolis.

Bartholomeus Gutii et Iacopinus a Penia, commissarii ultime voluntatis quondam Virgili de Silvestris de Rodigio, promixerunt Magistro Iacopo Petri de Senis presenti et stipulanti dare et solvere eidem pro factura unius immaginis Virginis Marie altitudinis sedendo ipsa imagine quatuor pedum de episcopatu cum capitello corespondente eidem immagine quali [?] dicta imago debeat in episcopatu Ferrarie et in opere ponere suis expensis prout videbitur dictis commissariis et prout est annotatum in duabus scripturis designatis manu ipsius magistri depositis penes ipsos commissarios, cum pacto quod infra unum annum debeat ipsam figuram bene et sufficienter finisse infra unum [annum]. Et pro factura dare et solvere promixerunt eidem magistro ducatos centum septuaginta auri. Et ut ipse magister dictos lapides marmoreos de Craria nomine suo emat lapides, dare et solvere ducatos centum. Et tabernaculum et pes debeat esse de lapide g[i]allo pulc[h]erimo.

Pro quo quidem magistro Iacobo et eius precibus magister Thomaxinus de Baisio promixit se facturum et curaturum quod dictus magister Iacobus predicta observabit et faciet et si secus fiet promittit de rato et de suo, cum pacto quod dicti commissarii debeant dare pro lapidibus eidem magistro ducatos centum presentialiter, et pro labore suo ducatos centum septuaginta auri, de quo precio dare et solvere promixerunt eidem solvere presentialiter ducatos trigintaquinque, et hinc ad sex menses ducatos sexaginta septem cum dimidio amediato laborerio, et in fine dicti operis ducatos sexaginta septem cum dimidio pro integra solutione dicti operis sub pena ducatorum L.

Location: ASFerrara, Notai, notaio Domenico Bernardi, matr. 16, pacco 1, September 19, 1403, fols. 36v–37.

Bibliography: Rondelli, "Jacopo della Quercia a Ferrara; *Mostra*, doc. 3, p. 324.

Comment: This is the first time Jacopo's name occurs without ambiguity in a contemporary document (Ghiberti's reference was written decades after the fact). From the Ferrarese contract we learn that he was already a master by 1403, that his nationality was Sienese rather than Lucchese, and that he was then present in Ferrara. We must assume that he had already obtained a reputation of sorts as a marble carver in Emilia, and more specifically in Bologna. Any discussion of the stylistic and cultural origins of his early style must be mindful of these essentially North Italian connections. Another important clue is provided by this document: Jacopo's guarantor was the famous Modenese woodcarver, Tommasino da Baiso (or Abaiso), whose son Arduino became Jacopo's collaborator in Bologna more than two decades later.

Three days after this document was prepared, Tommasino's role was revised to that of a partner (see doc. 12). A reference is made to two drawings by Jacopo that were in the possession of the commissioners of the statue of the Virgin. Jacopo was required to produce a seated statue that was to measure 4 feet *(piedi)* in height, within one year, as it appears in the drawings ("duabus scripturis designatis"). He was to have 170 gold ducats for the work as well as another 100 ducats for Carrara marble that he was to supply. There was to be a

tabernacle and a base. The payments for the statue were to be made in three installments: 35
ducats with the signing of the agreement; 67 and a half ducats after six months; and the final
67 and a half ducats upon completion of the statue.

Document 12. September 22, 1403
 Ferrara

The contract for the Silvestri Madonna (the Ferrara Madonna) *is modified to make Tomma-
sino da Baiso a partner with Jacopo della Quercia.*

Die xxii mensis Septembris, Ferrarie, in contrata Sancta Pauli in Cambio quod tenet
Bartholomeum quodam Gucii, presentibus Antonio de Flesso filio quodam Dominici de
Flesso de contrata Bucecanalia, Basilio filio quodam Baldini de Baldinis de contrada Bucecan-
alia, et Ugone quodam Antonii a Carris de contrata Sancti Gregorii, et aliis.

Magister Thomasinus filius quodam magistri Iohannis de Baesio de Mutina et Magister
Iacobus de Senis filius q. [cancelled] magistri Petri, habitator Ferrarie in contrata Sancte
Agnetis, et quilibet ipsorum obligaverunt se et sua bona principaliter et in solidum fuerunt
contenti, confessi et bona in concordia cum Bartholemo filio quodam Gucii de contrada
Sancti Romani civitatis predicte Ferrarie et cum ser Iacopino de Guardasono, filio quondam
ser Guillelmi de Guardasono, habitatore Ferrarie in contrata praedicta Sancti Romani,
commissariis et executoribus testamenti et ultime voluntatis qundam Virgilii camarlingi
quondam ser Boetii ex testamento et codicillis ipsium quondam Virgilii supradicti, manu
publici notarii, et ut asserunt presentibus et stipulantibus commissario nomine predicto, se
ab eisdem commissariis dantibus et solventibus et numerantibus in presentia testium predic-
torum et mei notarii infrascripti in ducatis auri, boni et iusti ponderis, habuisse et recepisse
ducatos centumtrigintaquinque auri boni et iusti ponderis pro parte solutionis CCLXX
ducatorum auri, quos dicti commissarii dare et solvere promiserunt eisdem magistro Tho-
masino et magistro Iacobo de Senis, videlicet ducatos centum auri pro conducendo unam
lapidem marmoreum album de terra Carrarie de Thuscia, et pro conducta dicti lapidis, et
ducatos CLXX auri pro fabricatione et sculptura ymaginis et figure et laboratura et magis-
terio cappele, quam figuram dictis suis ultimis voluntatibus fabricari debere ad episcopium
civitatis Ferrarie iuxta legatum et relictum dicti quodam Virgilii, de quibus conventione et
promissione dixerunt dicte partes apparere per publicum instrumentum manu Dominici de
Bernardis notarii.

Et tum renuntiaverunt non habite etc. Et specialiter benefitio novarum etc, Et epistule divi
Adriani etc.

Constituerunt etc.

Et reficere etc. Et si non attendent etc. Et per pactum non se appellare etc.

Que ominia etc. Sub pena ducatorum C auri etc. Et iuraverunt etc.

Location: ASFerrara, Notari, notaio Pietro Loiano, matr. 21, pacco 1, September 22, 1403,
fol. 5.

Bibliography: Rondelli, "Jacopo della Quercia a Ferrara," pp. 132–134 (with minor differ-
ences in the transcription).

Comment: The commission is revised to include Tommasino as a full partner instead of
merely the guarantor. To measure the commission within a wider chronology, one should
recall that two months later, on November 23, 1403, Ghiberti and his stepfather were

commissioned to produce the first set of quattrocento bronze doors for the Florentine Baptistery.

In this second document for the *Ferrara Madonna*, unlike in the first, Jacopo is mentioned as "habitator Ferrarie," which need not be taken literally; it could also be interpreted that Tommasino is referred to as "habitator Ferrarie in contrata Sancta Agnetis". In fact, subsequent documents confirm the fact that Tommasino lived in that zone of the city (see for example doc. 15). Under any circumstances, there is little reason to believe that Jacopo was constantly living in Ferrara over the next few years, as is sometimes claimed. On the other hand, one might expect that he had done some other work in Ferrara in the time he was there, but nothing has surfaced dating from these years that might be identified as Jacopo's.

Document 13.

<div align="right">July 10, 1404
Siena</div>

The images of the condottieri Giovanni Tedesco and Giovanni d'Azzo are ordered removed from the Siena Cathedral.

Ancho fu consigliato per li detti [consiglieri] e simile obtenuto nel medisimo consiglio che si levasse via la dipentura di Misser Giovanni d'Azzo, la quale era nela cappella di Sancto Savino.

Ancho nel medesimo consiglio fu diliberato et obtenuto che si levasse via la fighura di Giovanni Te[de]scho, non obstante due lupini in contrario.

Location: AODS, no. 707 (Libro Rosso), fol. 10.

Bibliography: Milanesi, *Documenti,* vol. 2, doc. 11.

Comment: The decision concerning these images must be connected with the break between Siena and the Milanese after the death of Giangaleazzo Visconti in 1402, finalized only in 1404. According to an inventory of 1467, the statue of Giovanni Tedesco was not destroyed but merely moved to another place, namely, on the inner façade of the church near the central portal. (See Labarte, "L'Eglise cathédrale de Sienne et son trésor d'apres un inventaire de 1467," p. 285.) On the same date, the altars that had been added to the sides of the *coro* were also removed.

Document 14.

<div align="right">December 8, 1405
Lucca</div>

Ilaria del Carretto, second wife of Paolo Guinigi, Lord of Lucca, dies in childbirth.

Bibliography: Lunardi, *Ilaria del Carretto o Maria Antelminelli?;* Bacci, *FdV,* p. 97.

Comment: This information provides the *terminus post quem* for the planning and execution of Ilaria's tomb monument. There are, to be sure, frequent instances during the fourteenth and fifteenth centuries when tombs were prepared in advance of death, as with the Trenta markers in San Frediano. However, Ilaria's death in childbirth was surely unexpected.

Document 15. January 14, 1406
 Ferrara

Tommasino da Baiso seeks assurances of payment for work in Ferrara with Jacopo della Quercia.

Die quatrodecimo mensis Ianuarii Ferrarie, in Episcopali palatio Ferrariensi iuxta bancum offitii Iuris, presentibus Steffano Pavarato filio quodam Iohannis de contrata Bucecanalium, domino Ugone de Codegorio de contrata Sancti Gregorii, domini Petro quodam Nanini di de contrata Sancte Marie Nove archipresbitero Melarie.

Cum hoc sit quod magister Thomasinus quodam magistri Iohannis de Baiso habitator Ferrarie in contrata Sancte Agnetis obligaverit se una cum magistro Iacobo Petri de Senis ad faciendum unam imaginem de lapide marmoreo cum tabernaculo, prout apparet de dicta compositione dicte imaginis publicum instrumentum manu mey notarii infrascripti, de qua compositione dictus magister Thomasinus habuit ducatos centus trigentaquinque auri et cum pro parte solutionis, prout de dicta quantitate ducatorum 135 dicunt apparere instrumentum obligationis manu Petri de Loiano notarii, et cum dictus magister Thomasinus velit adimplere promissa per ipsum: eapropter ipsius instantia magister Iohannes de Budrio quondam Nicolai de contrata Sancte Marie Nove pro quantitate ducatorum sexaginta quinque, magister Philippus quodam Nicolay de Ambrosiis de contrata Sancta Agnetis pro quantitate ducatorum trigintaquinque auri, magister Iacobus de Manzolino quondam Delante, marangone de contrata Sante Agnetis, pro quantitate ducatorum trigintaquinque auri promixerunt et fideiuxerunt pro ipso magistro Thomasino predicto pro quantitatibus supra scriptis, prout supra est annotatum in casu quo dictus magister Thomasinus usque ad festum Sancti Michaelis proxime venturo *[sic]* non attenderet promissa per ipsum magistrum Thomasinum, Iacopino a Penna et Bartholomeo Gucii commissariis quodam Virgilii de Silvestris presentibus et instantibus. Reservato Iure predictis Bartholomeo Gutii et Ia[copino] quod habeant contra dictos magistrum Tho[masinum] et magistrum Iacobus vigore dicti instrumenti et pene contente in ipso. Renunciantes predictus magister Iohannes quanta [?] est pro suprascripta quantitate, et dictus Phylippus et magister Iacobus pro quantitatibus in quibus supra promisexunt, benefitiis de pluribus reis debendis, novarum constitutionum et epistule divi Adriani etc. et omni benefitio.

Location: ASFerrara, Notari, notaio Domenico Bernardi, matr. 16, pacco 1, See p. 493 January 14, 1406, fols. 6v–7.

Bibliography: Rondelli, "Jacopo della Quercia a Ferrara," pp. 134–135 (with minor differences in the transcription).

Comment: Tommasino da Baiso, for himself and for Jacopo della Quercia, who was not present at the signing this time, wants to be assured of payment for the Madonna and for the tabernacle. They promise to supply their work by Saint Michael's Day (September 29).

Document 16. June 5, 1406
 Lucca

Francesco di Valdambrino is mentioned in Lucca.

. . . Francisco de Senis intagl[i]atore . . .

Location: ASL, Curia del Fondaco, no. 193, fol. 137.

Bibliography: Bacci, *FdV*, p. 112.

Comment: Locating Francesco di Valdambrino, longtime associate of Jacopo, in Lucca as early as June 1406 and again in 1407 (docs. 19, 20) may be used as circumstantial evidence of a presumed collaboration with Jacopo on the *Ilaria Monument*. That this Francesco is indeed Valdambrino is confirmed by the later documents.

Document 17.

January 14, 1407
Ferrara

The commissioners of Silvestri's will obtain a postponement of a year for the final settlement with Jacopo della Quercia and Tommasino.

Location: ASFerrara, Notari, notaio Domenico Bernardi (at the date).

Bibliography: Rondelli, Jacopo della Quercia a Ferrara, p. 137.

Document 18.

January 19, 1407
Ferrara

The commission to decorate the Silvestri Chapel in the Cathedral of Ferrara is let, with Jacopo della Quercia present as a witness.

Die XVIIII Ianuarii in bancho cambiario Bartholomei Gutii in plateis Ferrarie presentibus magistro Iacobo Petri de Senis habitatore Ferrarie in contrata Sancte Agnetis, magistro Iohanne Marcolini muratore de contrata Sancti Salvatoris, Ritio filio quondam Ghirardi Taffuni de contrata Sancti Mathei et aliis.

Magister Michael pictor filius magistri Iacobi de Acurris de Ferraria de contrata Sancti Gregorii, obligando se et sua bona promiit providis viris Bartholomeo Gucci et Iacopino a Penna comissariis quondam Virgilii de Silvestri pingere omnibus suis expensis unam capella situatam in maiori ecclesia Ferrarie videlicet cum illis figuris que designate sunt per ipsum magistrum Michaelem in uno folio carte exhibitis ad videndum testibus, videlicet a latere imaginis Virginis Marie duos sanctos a quolibet latere et imaginem quondam Virgilii et supra dictam imaginem in summo capitelli Christum in tronis cum XII apostolicis genuflexis et desuper XII angelii et super oculo dicte capelle unum angelum, cum hoc quod in figura marmorea idem magister non teneatur ad aliquod faciendum nisi a parte posteriore dicte imaginis de azuro cum bono azuro de Allemania in bonitate qualis est in capella ser Anthonii Pendaghie. Et quod omnibus suis expensis facere debeat ipsam capellam et diademata de auro de ducato fino in omnibus figuris et frisos de auro fino de ducato et in frontespicio dicte capella ... [blank space in manuscript] cum azuro et sub volta deum patrem cum stelis in azuro usque ad capitelios de marmore et a capitelis infra a quolibet latere unam figura *[sic]*, cum capiteliis desuper [blank space in manuscript].

Et pro mercede ipsius magistri dare et solvere promixerunt ipsi comissarii dicto magistro Michaeli libras centum quinquaginta sex marchesinorum, videlicet terciam partem ad omnem voluntatem ipsius magistri Michaelis et ex tunc ipse magister Michael fuit contentus cum dictis comissariis habuisse et recepisse; aliam terciam partem amediato dicto labore, et reliquam terciam partem finito ipso laborerio. Quod laborerium promisit ipse magister Michael perfecisse ipsis comissariis presentibus et stipulantibus usque ad festum Sancti

Michaelis proxime futurum. Et per pactum etc. Que omnia etc. mandaverunt dicte partes etc., sub pena librarum quinquaginta marchesinorum.

Location: ASFerrara, Archivio Notarile, notaio Domenico Bernardi, January 19, 1407, fols. 5–5v.

Bibliography: Rondelli, "Jacopo della Quercia a Ferrara," p. 137–138 (with minor differences in transcription).

Comment: Jacopo is mentioned here as present for this contract and as "habitatore Ferrarie in contrata Sancte Agnetis." This will be the last time the sculptor is registered as being present in Ferrara for the project. Here, Jacopo's marble Madonna is described (as completed). Michele di Jacopo Cari's assignment was to integrate the statue and the niche, which was to have a blue background, with painted images, including a portrait of the deceased donor. Jacopo's statue was located then, within an elaborate painted program, with Christ enthroned and the twelve apostles and angels.

Rondelli ("Jacopo della Quercia a Ferrara," p. 139) considers the "Jacopo de Senis çellatore filio quondam ... [blank] habitatore civitatis Ferrarie," who is documented on October 9, 1407, as Jacopo della Quercia. This reference could not be to our sculptor, however, because among other factors, he is consistently called "magister" in the Ferrarese documents and because his father, whose name was known in another Ferrarese document as Piero, was alive. Perhaps this unidentified person was "Giacomo di maestro Giovanni orafo" who wrote to the Sienese Signoria from Rome in 1423 (see Gaye, *Carteggio inedito,* vol. 1, doc. 29).

Document 19. January 24, 1407
 Lucca

Francesco di Valdambrino is recorded in Lucca.

... Francischus Dominci magister lapidum ...

Location: ASL, Archivio dei Notari, no. 422, fol. 12v.

Bibliography: Bacci, *FdV,* pp. 113–114.

Comment: The fact that Francesco is called a master of stone here is, in my view, an important piece of evidence for giving him a role in the marble *Ilaria Monument,* even though his first known works were wooden figures. Often in documents the description of an artisan's medium indicates the project with which he was momentarily involved. In 1409, he was again called "magister lapidum" in Siena (B-P, *Fonti,* 2:311).

Document 20. July 2, 1407
 Lucca

Francesco di Valdambrino is recorded in Lucca.

[At the end of a notarile act is the following:] ... Actum Luce infrascripto loco coram Francischo Dominici de Senis, magistro lignaminis et marmorum Luce habitante etc., testibus.

Location: ASL, Archivio dei Notari, no. 422 (ser Giarino Taluccini), fol. 93.

Bibliography: E. Lazzareschi, "Angelo Puccinelli e gli altri pittori lucchesi del trecento," p. 140n9.

Comment: This notice, which is known to Bacci, gives further support to the theory that Francesco worked on the *Ilaria Monument*. Here described as living in Lucca, where he is documented for over a year, Francesco would have had occasion to assist his countryman with the important commission. In this archival note, he is specifically mentioned as a master of both marble and wood. Already on June 8, 1407 "Magister Franciscus Dominici de Senis" was given a final payment for the figure of San Niccolò of Tolentino for the church of Sant'Agostino in Lucca, a notice discovered by Paoli ("Una nuova opera documentata di Francesco di Valdambrino," pp. 68 and 74; and in *Arte e committenza,* pp. 155–157). Parenthetically, this fine sculpture, which Paoli associates with the payment, is located in the Lucchese church of Santa Maria Corteorlandini, and is currently (1990) being restored in Pisa.

Document 21.

June 18, 1408
Ferrara

The final settlement is made for the Ferrara Madonna.

1408. Indictione prima, die XVIII, mensis Junii Ferrariae—in episcopali palatio iuxta banchum offitii iuris, presentibus Lanzarolo de Villiono notario de contrata Sancti Salvatoris, Bonagratia de Belis notario de contrata Sanct Thome.

Bartolomeus Gutii campsor comissarius ultimae voluntatis quondam Virgilii de Silvestris, suo nomine et nomine Iacopini a Pena etiam comissarii, absolvit et liberavit magistrum Iacobus de Senis lapicidam et magistrum Thomasinum de Abaisio et Iohannem de Budrio draperium et magistrum Iacobum Mansolino, eius Iacobi fideiussores, pro toto eo in quo tenerentur ipsis commissariis occasione imaginis Virginis Mariae scultae in episcopatu ad altare ipsius Virgilii, maxime quia plenarie ipse magister Iacobus adimplevit promissa per ipsum eisdem comissariis, prout dixit dominus Bartolomeus praedictus vera esse, quam confessionem etc. Dominicus de Barnardis notarius rogatus.

Bibliography: Cited in Rondelli, "Jacopo della Quercia a Ferrara," p. 140. His transcription is based upon that in G. A. Scalabrini, "La Cattedrale di Ferrara," MS. Classe I, no. 447, vol. I, fol. 94 in the Biblioteca Civica Ariostea, Ferrara.

Comment: There is no compelling reason to assume that Jacopo was in Ferrara when this document, relieving the guarantors of their obligations, was drawn up.

Document 22.

December 15, 1408
Siena *(Fonte Gaia)*

The cost of the new Fonte Gaia *is not to exceed 1,700 florins.*

De fonte fiendo in campo [in the margin].

Remiserunt magnifici domini et capitaneus populi una cum dictis officialibus balie et vexilliferis magistri in infrascriptos quod concludant et capitulent cum quo debet facere campi in illis modis et formis de quibus eisdem videbitur, et fiat prout sicut capitulabunt et

concludent cum eo et promictere possint et oblighare et generaliter facere quicquid in predictis eisdem videbitur; in quos circa predicta exequenda et fienda eorum vice remiserunt concludentes et facientes ex nunc quicquid in predictis factum fuerit per ipsos. et mihi liceat scribere et significare et facere quicquid voluerit et in predictis factum fuerit. Ita tamen quod non possit excedere in pretio mille settigentorum auri Senensium.

Dominus capitaneus populi Aringherius domine Niccolay et Iacobus Iacobi.

Non obstante numero vel minus duos ex eis.

Location: ASS, Concistoro, no. 1403.

Bibliography: See Hanson, *Fonte Gaia*, doc. 1, for other references; also Bacci, *FdV*, p. 138.

Comment: In Bargagli-Petrucci, *Le fonti di Siena* under the same date, we find, "Magnifici et potentes domini, etc. locaverunt ad faciendum fontem campi cuidam magistro Iacobo cum pactis et modis . . ." Glasser *(Artists' Contracts of the Early Renaissance)* comments upon the contract for the *Fonte Gaia* (pp. 43ff) but draws conclusions that go beyond what can be implied from the documents. The exchange rate from florins to lire fluctuated over the years and from contract to contract. The officials here failed to fix the rate, which created problems.

Document 23. December 23, 1408
 Siena

Domenico di Niccolò dei Cori is godfather to a daughter of Martino di Bartolomeo.

Antonia di Maestro Martino di Bartolomeio si batezzò a di xxiii di dicembre, fu compare Domenico di Niccholo.

Location: ASS, Battezzati (December 23, 1408).

Bibliography: Bacci, *FdV*, p. 346.

Comment: Jacopo della Quercia acted as guarantor for Martino, who painted the wooden *Annunciation* figures for San Gimignano in 1420 (doc. 100). Domenico once again stood for Martino in 1425, for his son. These connections are indications of an artistic circle, which tended to link Jacopo with Domenico.

Document 24. December 31, 1408
 Siena

As representative from the Monte dei Riformatori, Terzo di San Martino, Jacopo, who is called "Magister Iacobus Pieri de la Guercia," is selected to be one of the consiglieri to the General Council from the period January 1, to June 30, 1409.

Location: ASS, Concistoro, no. 257 (Deliberazioni), fol. 25v.

Bibliography: Bacci, *FdV*, pp. 135–36; Hanson, *Fonte Gaia*, doc. 3.

Document 25.

The commission for the Fonte Gaia *between Jacopo della Quercia and the Sienese Comune is authorized.*

Pro fonte campi [in the margin].

Supradicti Domini et offitiales Baylie concorditer locaverunt fonte campi magistro Iacobo magistri Petri de Senis, presenti et conducenti, eo modo et cum forma designata in quadam carta que est apud notarium, pro quantitate duorum milium florenorum auri senensium, cum pactis, mensura et forma, de quibus notarius infrascriptus est rogatus [Niccolao di Lorenzo di Belforte], annullantes omnem aliam locationem et pacta, a quibus partes predicte tenerentur.

Location: ASS, Concistoro, no. 258, fol. 14.

Bibliography: Milanesi, *Documenti*, 2:100n; B-P, *Fonti*, 2:306; Bacci, *FdV*, p. 158; Hanson, *Fonte Gaia*, doc. 1; *Mostra*, doc. 6.

Comment: The drawing mentioned in this document may be the one now divided between the Metropolitan Museum of Art in New York and the Victoria and Albert Museum in London. In the inventories of the Opera, Bacci (*FdV*, p. 144) found mention of a drawing of the fountain, used as the cover of an account book dating from the period. This account book very likely contained a summary of the accounts of the *Fonte Gaia*. Seymour (in 'Fatto di suo mano,' pp. 93ff) has discussed the legal requirements of such a drawing: two are mentioned in the documents for the *Ferrara Madonna*.

The originally designated payment of 1,700 florins was increased to 2,000, apparently because the sculptor insisted upon a higher sum. To be sure, the amount was never clearly established, giving rise to a long controversy.

Document 26.

The terms of the contract for the Fonte Gaia *between Jacopo della Quercia and the Sienese Comune are spelled out in detail.*

In nomine Domini amen. Hic liber continet in se deliberationes et decreta que fiunt per infrascriptos magnificos et potentes dominos dominos priores gubernatores et capitaneum populi comunis Senarum nec non deliberationes reformationes et consilia sua per ipsos fient [=facta?] tam in consiliis ... [paper ruined] quam etiam in consiliis populi tempore eorum offitii videlicet de mense Ianuarii et Februarii MCCCCVIII [=MCCCCVIIII, modern] indictione secunda, tempore pontificatus sanctissimi in Christo patris et domini domini Gregorii divina providentia pape duodecimi, quibus duobus mensibus presederunt dicto magnifco et laudabili offitio dominorum priorum et capitanei populi dicte civitatis scriptas et notatas per me Nicolaum Laurentii de Belforte, civem Senensem, notarium publicum, pro dicto tempore notarium prefatorum dominorum et eorum consistorii, quorum quidem dominorum hec sunt nomina videlicet:

Dominum Iohannes Bandini legum doctor ⎫
Andreas Iohannis Bardi ⎬ de terzerio civitatis
Pietrus Vive aurifex ⎭

Paulus Iohannis Landi
Angelus Tofani } de terzerio Kamullie
ser Antonius Iohannis Gennarii

Andreas Augustini bacherius capitaneus populi

Andreas Ambrosii Bonelli
Franciscus Bucci pizicaiolus } de terzerio Sancti Martini
Antonio domini Guiglemi

Vexilliferi:
Magister Franciscus Albertini vexillifer terzerii civitatis
Iacobus Tommasii Chechi bancherius vexillifer magister terzerii Sancti Martini
Aldobrandinus Pietri Venturini vexillifer magister terzerii Camollie
ser Christoforus Andree notarius cancellarius et ser Pietrus Nerii Martini notarius domini capitanei, ser Nicolaus Laurentii de Belforte notarius consistorii dictorum dominorum die prima ianuarii domino Iohanne priore, magnifici et potentes domini priores gubernatores comunis et capitaneus populi civitatis Senarum simul more solito convocati, et cetera.

Nomina offitialium balie sunt infrascripta videlicet.
Dominus Iohannes domini Francisci de Belantibus legum doctor, Renaldus Andreocii de Petacciis, Paulus Minucii Bargagle, ser Iohannes Pieri Ture notarius, Antonius Bartholomei Saragniola, Aringherius domini Nicolai, dominus Carolus Angelini decretorum doctor, Iacobus Massaini legritterius, Iacobus Iacobi lanifex, pro sex mensibus electi die viii novembris et finendi . . . [blank]. Prefati magnifici domini vexilliferi magistri et offitiales balie concorditer et cetera . . . [paper ruined].

Die xxii Ianuari deliberaverunt magnifici Domini et Offitiales Balye quod fons Campi fiat per magistrum . . . [blank] eo modo et forma et prout designatus est. Et quod habeat duo mila florenos auri senenses non obstantibus quibuscumque, et quod promictat et se obliget etc. Et quod eidem magistro detur locus ubi possit laborare, etc. Item quod eidem explanentur vie sumptibus Comunis, ita quod conducat laborerium, etc.

Conventioni infra il magnifico Comune di Siena etc. e maestro Iacomo del maestro . . . [blank].

1. In prima, che maestro Iacomo predetto sia tenuto e debba fare o far fare uno disegno d'una fonte nella sala del Consiglio con intagliamenti, figure, fogliami, e cornici, gradi, pilastri, beccatelli, lupe e altri lavorii ragionati.

2. Item, ch' el detto maestro Iacobo sia tenuto e debba infra il termine di 20 mesi, cominciando in calende aprile proximo seguirà nel 1409, edificare, e avere edificata una fonte di marmo in sul Campo di Siena nel proprio luogo là du' è la fonte al presente, di longheza di braccia xvi e di larghezza di braccia otto, cho' le figure, foglame, e marmi che nel disegno soprascritto chiaramente si dimonstrano, non diminuendo alcuno lavorio, ma piùtosto miliorare e acresciare.

3. Item, che esso maestro Iacomo sia tenuto e debba fare e far fare la fonte predetta, così da l'acqua in giù come da l'acqua in su, e le sue proprie spese d'ogni lavorio; intendendosi che per infino a l'acqua e da inde in giù uno guazzo sia di marmo, e da inde in su di mattoni con certe pietre necessarie e oportune al difitio de la detta fonte, con iscialbi e muro ragionevoli per lo lavorio predetto.

4. Item, che a maestro Iacomo predetto sia lecito mettare e far mettare in Siena tutti marmi, calcina, calcestruzo e mattoni e qualunche altre cose fussero necessarie per lo detto lavorio, senza pagare alcuna cabella; e anco s'intenda essere francho e libero, se per lo soprascritto contratto uscisse alcuna cabella al comuno di Siena.

5. Anco, che del presente contratto, el detto maestro Iacomo, volendolo publico, el notaio ne sarà rogato non ne possa ne debba avere più che fiorini . . . [blank]

6. Item, ch' el detto magnifico Comuno di Siena sia tenuto e debba dare e pagare al detto maestro Iacomo, per lo lavorio predetto, quel prezo e quantità de pecunia sarà dichiarata da Francescho di Cristofano, al presente Capitano di Popolo e Gonfaloniere di Giustitia; non passando però la somma di fior. millese[i]cento senesi, ne da 1500 senesi in giù.

7. Item, ch'el prefato Comuno di Siena sia tenuto e debba dare e fare el detto pagamento di due mesi in due mesi, come tocca per rata della somma predetta, cominciando in kalende aprile proximo seguirà, ricevendo dall'operaio dell'acqua, con que' modi si pagano maestri e lavoranti, [che] lavorano ne' lavorii delle fonti.

8. Item, che al detto maestro Iacomo sia lecito e possa cavare e far cavare a ogni marmiera e petriera per lo lavorio predetto, senza alcuna contraditione, pagando el debito prezo secondo el costume de l'Uopera Sancte Marie.

9. Item, che tutto e' lavorio vechio de la muragl[i]a si levarà da la fonte vechia, sia e essere s'intenda del detto maestro Iacomo.

10. Item, ch' el detto maestro Iacomo sia tenuto e debba fare e curare che le figure de' lavorio soprascritto siena et essere s'intendano lustranti, second el corso de'buoni maestri, faciendo tutte le predette cose a buona fede e senza frodo.

Ego Cinus olim Guidonis de Belforte, civis Senensis publicus imperiali actoritate notarius et iudex ordenarius, id tutum quod supra continetur scriptum manu mei, litterali sermone usque in trigesima linea presentis instrumenti, scriptum inveni, vidi et legi in quodam libro sive memoriali facto in consistorio dominorum priorum civitatis Senarum, esistenti inter abreviaturas et protocolla ser Nicolai Laurentii notarii defuncti, et totum id quod supra continetur vulgari sermone a dicta trigesima linea infra scriptum inveni, vidi et legi in quodam folio bonbicino existenti in quadam filza gestorum in dicto consistorio, manu dicti ser Nicolai omnia premissa scripta fore cognovi ipsumque ser Nicolaum et eius scripturam bene novi et omnia et diligenter auscultavi et in predictis libro et folio. Et quia utrumque concordare inveni nil addito vel diminuto quod secundum mei notarii conscientiam mutet aut variet intellectum, ideo autoritate mihi secundum formam statutorum senensium concessa hic me publice subscripsi et publicavi anno dominice incarnationis millesimo quodrigentesimo duodecimo, indictione quinta secundum usum et cursum notariorum civitatis Senarium die prima mensis iunii, Romanorum imperatore, ut fertur Senis, vacante, et ad robur predictorum singnum et nomen meum aposui consuetum.

Ego Franciscus olim magistri Agustini de Senis publicus imperii auctoritate notarius et iudex ordinarius totum quod supra continetur et scriptum et exemplatum est manu dicti ser Cini, videlicet ab eius supra, scriptum inveni, vidi et legi in dicto folio bombicino existenti in quadam filza gestorum in dicto consistorio manu dicti ser Nicolai, quem ser Nicolaum et eius scriptum bene novi et ab eodem ser Nicolao scriptum fore recognovi et dictum sumptum cum dicta originali abreviatura simul et una cum dicto ser Cino diligenter legi et auschultavi, et quia utrumque ad invicem bene concordare invenimus, ideo ex commissione in me facta secundum formam statutorum Senarum propria manu scripsi et publicavi anno Domini, indictione, mense et die hic supra de proximo annotatis, vacante Romanorum imperatore, prout dicitur Senis, et cetera.

Die xx mensis octobris 1419 cassatum et cancellatum per me Anthonium Iohannis Gennari notarium de voluntate dicti magistri Iacobi ob liberationem factam domino Caterino operario, pro comune Senarum, opere Sancte Marie et dicte fontis de qua constat de manu mea.

Location: ASS, Opera metropolitana, Diplomatico, January 22, 1409.

Bibliography: B-P, *Fonti*, 2:306–308; Hanson, *Fonte Gaia*, doc. 15; *Mostra*, doc. 7.

Comment: Hanson discusses this document at considerable length, and dates it as June 1, 1412, since it was indeed copied and emended in that year. I prefer to place it under the original date of January 22, 1409 because it must be considered as an accurate, notarized copy, although there are, to be sure, areas of ambiguity. The introduction is unpublished. The inclusion of "lupe" (item 1) is significant for mapping out the early program for the *Fonte*, and the word has been left out of earlier transcriptions. The presence of female wolves makes redundant the identification of the two standing figures as Rhea Silvia and Acca Laurentia, as they are often called, but which are dropped in the present study.

Document 27. February 4, 1409
 Siena *(Fonte Gaia)*

A provision is made to lend Jacopo 100 gold florins as an advance for work on the fountain.

Pro magistro fontium [in the margin].
Quod magister Iacobus magister fontis campi habeat prestantiam centum florenorum auri senensium solenniter fuit per dominos [et officiales balie] deliberatum.

Location: ASS, Concistoro, no. 258 (Deliberazioni), fol. 19v.

Bibliography: B-P, *Fonti*, 2:309; Bacci, *FdV*, p. 159 (doc. 2); Hanson, *Fonte Gaia*, doc. 6.

Document 28. September 26, 1409
 Siena

A payment is made to Francesco di Valdambrino for carving the images of saints Ansano, Savino, Crescenzio, and Vittorio in wood for the cathedral, with boxes to contain their relics.

Location: AODS, no. 392 (Libro Rosso), fol. 235.

Bibliography: Milanesi, *Documenti*, 2:110; Bacci, *FdV*, pp. 162–163; Bacci, *Quercia*, pp. 62–63; Del Bravo, *Scultura Senese*, pp. 10–16.

Comment: These statues, of which three have been reduced to busts (the fourth, Saint Ansano, is lost), were painted by Benedetto di Bindo and Andrea di Bartolo in 1410. (See Bacci, *FdV*, pp. 168–69.) They represent the earliest documented works by Francesco di Valdambrino in Siena and are therefore crucial for a discussion of his stylistic development. They should also be related to Jacopo's first efforts at the *Fonte Gaia*. The wood for the figures was obtained on August 4, 1408 (Bacci, *FdV*, p. 161), and the commission for the sculpture seems to have been signed in March of 1409. There are other payments to Francesco around this time, including one dated November 5, 1409 for a "bambino" for the sacristy. In this document, Francesco is called simply "intagliatore," reflecting the nature of the assignment.

Document 29. October 8, 1409
 Siena

Francesco di Valdambrino is elected "operaio dell'acque" in Siena.

Location: ASS, Concistoro, no. 262 (Deliberazioni), fol. 30v.

Bibliography: B-P, *Fonti*, 2:309–312; Bacci, *FdV*, pp. 246–47; Hanson, *Fonte Gaia*, docs. 6–8.

Comment: Among the councilors to oversee the operations of the water commissioner were "Iacobus Iohannis Pini, Tucius Simonis Fecini, maigster Iohannis magistri Ciuli, Tomme Vannini, and magister Franciscus Iuncte."

Document 30.

1410
Siena

Jacopo's father is taxed for a small amount (2 denari) in Siena.

Piero d'Agniolo della Ghuercia lire dugento [reddito].
d. ii.

Location: ASS, Lira del 1410, Terzo di S. Martino, no. 43, fol. 46.

Bibliography: Bacci, *FdV*, p. 249.

Comment: Since Jacopo's name does not appear on this long list, of which only the single item has been excerpted here, one may assume that the tax was levied on the head of the family, though it was probably actually paid by Jacopo since Piero d'Agnelo was continuously in Lucca (by all that is known) during these years. This reference is, to my knowledge, the only place where Piero is also called "della Ghuercia." On the same page of these tax rolls and under the same year are also "Maestro Domenicho di Nicholò intagliatore lire dugento" and "Maestro Francescho di Valdanbrino intaglia[to]re lire dugento cinquanta," both thus represented as wood carvers.

The plague that raged in 1410 apparently spared Lucca, giving greater reason to assume that Jacopo was there during the year. During this year, Sercambi (Bongi, ed., 3:185) related that while there was *moria* in all Italy, "A Lucca Id[d]io dimostrò placabile che quazi di pestilentia sentio." In 1412 and again in 1414 "era gran moria di peste in Siena" *RRIISS*, vol. 19, cols. 424 and 425).

Document 31.

May 4, 1411
Lucca

In order to beautify the church, the officials of the Cathedral of Lucca decide to sell certain properties belonging to the cathedral for the sum of 1,000 florins.

Quoniam Lucana maior ecclesia, ad honorem omnipotentis Dei et Sante Crucis et beati Martini almifici confessoris, et ad decorem civitatis Lucane, novis hedificiis constuitur et in eius fabrica proceditur opere sumptuoso et diversis marmorum et lapidum sculpturis ornatur, sicut ex oculorum aspectu evidenter apparet; et quia redditus et proventus dicte opere non sufficiunt ad consumationem operis incohati: ideo sapientes viri Dinus de Guinigiis, Ciucchinus de Avocatis, Antonius de Quarto, Iohannes Iacobi ser Cambii, Tomasius Nicolai Narduccii et Bartholus Iuntini, cives Lucani, consiliarii dicte Opere et fabrice ecclesie supradicte simul congregati, premissis inter se diversis deliberationibus et tractatibus, deliberaverunt et ordinaverunt quod infrascripta bona inmobilia pertinentia ad Operam supradictam, vendantur et vendi debeant pro pretio et nomine pretii florenorum mille auri. Et ad hoc

moveatur ad hoc ut in opere incohato procedatur ad construendam septentrionalem partem dicte ecclesia quia hoc cedet ad honorem Dei et beati Martini et ad civitatis decorem, et ex predictis et aliis iustis et rationabilibus causis mosti, dederunt et concesserunt discreto viro Nuccio Iohannis, civi Lucano, Operario dicte Opere presenti et intelligenti, licentiam et omnimodam facultatem vendendi Comuni et hominibus de Anchiano, Lucani disticus, infrascripta bona in dicto Comuni Anchiani et Puticciani situata, ad que acquirenda homines dicti Comunis affectionem habent et propterea inde offerunt dictum pretium florenorum mille auri. Et propterea concesserunt dicto Operario plenam potestatem dictum pretium recipiendi et seu confitendi in una vice vel in pluribus, et ipsos emptores exinde dominos et procuratores in rem suam constituendi et corporalem possessionem eis tradendi et de defensione et evictione legiptima promictendi et propterea dictam Operam et eius bona obligandi et de predictis confici faciendi instrumentum cum obligationibus penis renumptiationibus et aliis clausulis consuetis . . .

[c. 68r] Et rogaverunt dicti consiliarii me Dominicum notarium infrascriptum ut de predictis omnibus publicum conficiam instrumentum. Actum Luce, in domo dicte Opere in qua dictus Operarius facit residentiam, in camera in qua dicti consiliarii consueverunt congregari, coram Sandro quondam Iacobi, pentorario, et Guaspario filio Iohannis Manni, pannario, et Meo quondam Nicolai Bettini, textore, omnibus Lucanis civibus, testibus ad predicta omnia adhibitis et rogatis, anno nativitatis Domini MCCCCXI, indictione IIII, die iiii May.

Et ego Dominicus notarius suprascriptus predictis omnibus interfui eaque rogatus scripsi et publicavi et ad fidem perpetuam premissorum me subscripsi.

Quoniam Lucana maior ecclesia, ad honorem omnipotentis Dei et almifice crucis et beati Martini confessoris atque pontificis et ad decorem civitatis Lucane novis hedifitiis decoratur et in eius fabrica proceditur opere sumptuoso et diversis marmorum et aliorum lapidum sculpturis ornato, sicut ex oculorum aspectu evidenter apparet; et quia redditus et proventus Opere et fabrice dicte ecclesie non sufficiunt ad predicta, necessarium est procedi ad venditionem rerum immobilium ut pretium inde percipiendum in hedifitiis dicte ecclesie integre convertatur. Idcirco sapiens vir Nuccius Iohannis, civs Lucanus, Operarius Opere et fabrice dicte ecclesie, impetrata licentia et obtenta a consiliariis Opere supradicte, de qua et prout patet per instrumentum publicum manu mei Dominici notarii infrascripti rogatum sub anno et indictione presentibus, die IIII presentis mensis Maii, utens omnibus et singulis potestate et balie sibi pro dicto operariatus offitio competentibus, et omnibus melioribus via, iure et modo quibus melius potuit, hoc publico instrumento ex sua certa et deliberata scientia et non per errorem, vendidit dedit tradidit cessit atque mandavit iure proprio et in perpetuum Nuto flio Pieri Nuti, Antonio Barsi, Dominico Michaelis et Baxio Nicolai de comuni Anchiani . . . sindicis et procuratoribus dicti comuni Anchiani . . . infrascripta dicte Opera bona mobilia et inmobilia, situata et posita in confinibus et territorio dicti Comunis Anchiani et comunis Pulicciani . . .

[c. 72r] Et hanc venditione et traditionem . . . fecit prefatus Nuccius operarius pro pretio et nomine pretii florenorum mille auri boni et puri iustique ponderis . . .

Actum Luce, in domo dicte Opere in qua dictus Operarius residentiam facit apud Lucanam maiorem ecclesiam, coram Ser Dominico quodam Tocti Turignoli, notario, et Guaspario quondam Iohannis Manni, pannario, Lucanis civibus, testibus ad predita omnia rogatis, anno nativitatis Domini MCCCCXI, indicatione III, die VI Maii.

Et ego Dominicus notarius suprascriptus predictis omnibus interfui eaque rogatus scripsi et publicavi et ad fidem perpetuam me subscripsi et meum signum apposui.

Location: ASL, Notari, no. 288, fols. 64v–72r.

Bibliography: E. Ridolfi, *L'Arte in Lucca studiata nella sua cattedrale,* p. 42; *Mostra,* p. 140.

Comment: Above, I give large selections of this long document, widely referred to by Lucchese scholars and subsequently by Quercia specialists to emphasize the fact that we are dealing with the limited sum of money of 1,000 florins. Baracchini and A Caleca *(Il Duomo di Lucca)* attribute the production of many sculptures to the effects of this sale, too many perhaps for the available funds. The document specifically refers to the north side ("septem-trionalem partem dicte ecclesie") where the prophet, now in the cathedral and carved by Jacopo, was located until recent times.

Document 32.

February 28, 1412
Lucca

Lorenzo Trenta is given permission to erect from the foundations the chapel of San Riccardo, also dedicated to Saint Girolamo and Orsola, in San Frediano, with the privilege to exhibit his arms, and for burial.

Bibliography: Summarized in Carelli, Notizie antiche di S. Frediano, fol. 20v. Cited in Ridolfi, *Della Basilica di San Frediano,* and in Hanson, *Fonte Gaia,* doc. 13.

Comment: According to Carelli, this act was notarized by ser Angelo della Vacca. I have failed to locate the original in the Lucchese archives.

Document 33.

January 1 to March 25, 1412
Siena *(Fonte Gaia)*

Jacopo is paid 120 florins for the Fonte Gaia.

Maestro Iacomo di Piero de la Ghuercia de'dare fiorini centovinti ci significò maestro Piero a lui innanzi, fol. 139.

Location: ASS, Biccherna, no. 447, fol. 29v.

Comment: Bacci notes *(FdV,* p. 326n3) that an equal sum had been paid to Jacopo by June 7, 1412, according to a deliberation of the Concistoro on that date, and he gives the following citation: ASS, Concistoro, no. 278, fol. 19.

Document 34.

June 14, 1412
Siena *(Fonte Gaia)*

The Operaio of the Duomo is ordered to pay Jacopo 180 florins.

Die XIIII Juni [1412]
Contra dominum Caterinum et operarium maioris ecclesie [in the margin]
Forma debita observata, deliberaverunt domini priores predicti quod mictatur pro domino Caterino operaio ecclesie cathedralis et pro Francisco Salimbenis de Petronibus camerario opere et detineantur in palatio donec solverint CLXXX florenos auri, convertendos in fonte campi, secundum forman deliberationis consilii generalis.

Location: ASS, Concistoro, no. 278 (Deliberazioni), fol. 22v.

Bibliography: Bacci, *FdV,* pp. 312–313.

Document 35. June 15, 1412
 Siena *(Fonte Gaia)*

The Concistoro selects three supervisors for the Fonte Gaia *and provides that Jacobo be advanced the 180 florins.*

Die XV dicti mensis Junii [1412]
Operarii pro fonta campi [in the margin]
Magnifici domini priores concorditer elegerunt infrascriptos prudentes viros prout alias electi fuerunt pro operariis sine salario ad faciendum et sollicitandum quod fons campi fiat secundum deliberationem factam super dictam materiam. Deliberantes quod dicti operarii pro predictis executioni mandandis habeant tantam auctoritatem et commissionem quantam habent ipsi domini priores, decernentes et facientes ex nunc quicquid per ipsos factum fuerit. Quorum nomina hec sunt videlicet: Ghinus Bartalomei Ghini, Thomas Vannini aurifex, Magister Dominicus magister opere.

. . .
Pro magistro Iacobo magistri Pieri [in the margin]
Et deliberaverunt dicti magnifici domini priores quod . . . camerarius Bicherne prestet magistro Iacobo magistri Pieri florenos CLXXX senenses ad rationem quatuor librarum et duorum soldorum pro quolibet floreno, convertendos in constructiones fontis campi, quos solvat del illis quos recepit ab operario maioris ecclesie.

Location: ASS, Concistoro, no. 278 (Deliberazioni), fol. 23v. See also AODS, no. 655 (Memoriale), fol. 10, where the advance is recorded on the same day, and Bacci, *FdV*, pp. 315–317.

Bibliography: B-P, *Fonti*, 2:316; Bacci, *FdV*, pp. 313–315; Hanson, *Fonte Gaia*, doc. 20.

Comment: Tommaso or Tomè di Vannino, a goldsmith, had other civic responsibilities in 1411 (see *RRIISS*, vol. 15, part 6, vol. 772); he was one of the supervisors of the water commissioner who was appointed in 1409.

Document 36. June 18, 1412
 Siena *(Fonte Gaia)*

The Operaio of the Duomo, Caterino Corsini, is ordered to pay for work done on the Fonte Gaia *from certain gabelles set aside for the purpose.*

Location: ASS, Concistoro, no. 278, fols 26v–27. (Another version is in AODS, for which see Hanson, *Fonte Gaia* doc. 93 and note.)

Bibliography: B-P, *Fonti*, 2:316–318; Borghesi and Banchi, *Nuovi documenti*, pp. 70–72, no. 36.

Document 37. October 29, 1412
 Siena *(Fonte Gaia)*

The Camerlengo of Biccherna is authorized to pay Jacopo for work on the fountain, provided he supplies a guarantor.

Die XVIIII mensis Ottobris [1412].

Pro Iacobo magistri Pieri.

Similiter deliberaverunt et decreverunt solemniter servatis servandis quod camerarius bicherne comunis Senarum solvat et solvere debeat, teneatur et possit libere sine nullo suo preiudicio vel danpo [sic] Iacobo magistri Pieri de Senis usque in quantitatem secum conventam et declaratam pro comune Senarum, pro faciendo fontem campi comunis Senarum de tempore in tempus secundum formam reformationis comunis predicti, cum prestatione tamen fideiussoris ydonei pro cautela comunis.

Location: ASS, Concistoro, no. 280, fol. 28.

Bibliography: Bacci, *FdV*, pp. 318–319; Hanson, *Fonte Gaia*, doc. 29.

Comment: The guarantor that Jacopo actually supplied was Francesco di Valdambrino.

Document 38.

November 12, 1412
Siena *(Fonte Gaia)*

Seventy-five florins are provided as payment for work on the fountain.

Location: AODS, no. 655 (Memoriale), fol. 10.

Bibliography: Bacci, *FdV*, pp. 319; Hanson, *Fonte Gaia*, doc. 30 (where the sum is given as 75 lire, instead of florins).

Comment: The exchange rate in this case was 78 soldi per florin, or slightly less than 4 lire.

Document 39.

May 12, 1413
Siena *(Fonte Gaia)*

Francesco di Valdambrino is ordered to make Jacopo della Quercia return to Siena to continue work on the fountain.

Die XII mensis maii.

Pro fonte Campi.

Contra Magistrum Franciscum [Valdambrini]

Domini priores et cetera . . . preceperunt magistro Francisco Valdambrini, presenti et intelligenti, quatenus infra VIII dies proxime venturos ita et taliter operetur quod magister Iacobus Pieri de la Guercia, qui cepit ad faciendum fontem campi, debeat venisse Senas ad prosequendum opus suum dicte fontis; aliter coghatur remediis opportunis ad restitutionem prestantiarum factarum dicto magistro Iacobo.

Et similater . . . preceperunt Laurentio balistario fideiussori carrarii qui ducit lapides pro dicto fonte marmoreas [sic] faciat eos duci Senas, alias restituet prestantias.

Location: ASS, Concistoro, no. 284 (Deliberazioni), fol. 8v.

Bibliography: Milanesi, *Documenti*, 2:100; B-P, *Fonti*, 2:320; Bacci, *FdV*, pp. 321–322; Hanson, *Fonte Gaia*, doc. 33.

Comment: In the next item in the Deliberazioni, Caterino Corsini, Operaio of the Duomo, is ordered to pay for the work executed on the fountain. In May 1413, according to a Sienese chronicler, "Era gran morìa e non era in Siena quasi nessuno." (See Lusini, *Il Duomo di Siena*, 2:7n2). We must suppose that Jacopo had been absent from Siena for many months at

the time of this deliberation, and was specifically in Lucca, where he was engaged in work on the *Trenta Altar* in San Frediano.

Document 40.　　　　　　　　　　　　　　　　　　　May 13, 1413
　　　　　　　　　　　　　　　　　　　　　　　　Siena *(Fonte Gaia)*

Jacopo is ordered to return to Siena within eight days.

Magistro Iacobo magistri Pietri scriptum est, quod infra octo dies se conferat ad presentiam Dominorum, pro perficiendo opere nove fontis, si caram habet gratiam prefatorum Dominorum; cum omnia alia ad dictum opus pertinentia, expedita sint.

Location: ASS, Concistoro, no. 1610 (Copialettere), fol. 49v.

Bibliography: Milanesi, *Documenti,* 2:100; B-P, *Fonti,* 2:320; Hanson, *Fonte Gaia,* doc. 34.

Document 41.　　　　　　　　　　　　　　　　　　　May 25, 1413
　　　　　　　　　　　　　　　　　　　　　　　　Siena *(Fonte Gaia)*

The Signoria writes a follow-up letter requesting Jacopo's return in order to continue work on the fountain.

Die XXV Maii [1413]
Magistro Iacobo magistri Pietri da Senis, habitator in Luca, scriptum est quod statim se conferat Senis pro perficiendo opere fontis campi, secundum quod est obligatum, alias cognatur eis fideiussor ad restitutionem omnium denariorum expensorum et ad solutionem pene in contractu convente.

Location: ASS, Concistoro, no. 1610 (Copialettere), fol. 53v.

Bibliography: Milanesi, *Documenti,* 2:100; Lazzareschi, "Dimora," p. 67*n*; Hanson, *Fonte Gaia,* doc. 36; *Mostra,* doc. 8, pp. 326–327.

Comment: This letter follows another order (dated May 24, 1413) to Francesco di Valdambrino to force Jacopo to return (Bacci, *FdV,* p. 322–323). Jacopo apparently ignored these orders. In fact, he seems not to have returned to Siena, even temporarily.

Document 42.　　　　　　　　　　　　　　　　　　November 15, 1413
　　　　　　　　　　　　　　　　　　　　　　　　Siena *(Fonte Gaia)*

In Lucca, Jacopo is again ordered to return to Siena.

Die XV Novembris [1413]
Magistro Iacobo magistri Pieri de la Guercia scriptum est quod visis presentibus et omni delatione remota statim se conferat ad prestiam dominorum.

Location: ASS, Concistoro, no. 1610 (Copialettere), fol. 142.

Bibliography: Milanesi, *Documenti,* 2:100; Lazzareschi, "Dimora," p. 76*n*; Hanson, *Fonte Gaia,* doc. 37; *Mostra,* doc. 9, p. 327.

Comment: Milanesi incorrectly transcribed "de la Guercia" as "de la Quercia."

Document 43.

Still in Lucca, Jacopo is again ordered to return to Siena within eight days.

Contra Magistrum Iacobum de la Guercia [in the margin]

Die XVII Decembris [1413]. Magnifici domini priores et capitaneus populi simul convo-cati et congregati in numero sufficenti ut moris est concorditer deliberaverunt quod dominus executor iustitie civitatis Senarum debeat formare inquisitionem contra magistrum Iacobus Pieri della Ghuercia qui obligatus est ad faciendum fontem campi cum certis pactis et modis prout promisit ex eo quod neglexit mandatis et licteris dominorum priorum et capitanei populi in vilipendium et dedecus comunis, et in casu quod no compareat in octo dies procedat contra eum prout sibi videbitur pro honore comunis.

Location: ASS, Concistoro, no. 287 (Deliberazioni), fol. 29.

Bibliography: Lazzareschi, "Dimora," p. 67n; Hanson, *Fonte Gaia,* doc. 38; *Mostra,* doc. 10, p. 327.

Comment: On December 26, Francesco di Valdambrino is ordered to return all money received by Jacopo within three days. But Jacopo appears not to be concerned with returning to the city despite the threats of investigations and action against him. This item is found on fol. 34v of Concistoro, no. 287 (see doc. 45). The reason Jacopo had been so reluctant to return to Siena can only be guessed; perhaps he was so occupied with the *Trenta Altar* and other activities in Lucca that he refused to leave until he was compelled by other circum-stances (for which see the next documents).

Document 44.

This letter to Paolo Guinigi, Lord of Lucca, from Giovanni Malpigli accuses Jacopo della Quercia and Giovanni da Imola of various forms of misconduct.

Magnifico e potenti domini domini P. de Guinigi domino Lucane civitatis etc. [on the front]

Magnifico Signor Mio,

E'mi sarebbe stato e anco sarebbe un grandissimo conforto alle mie pene, d'avere parlato una volta personalmente alla vostra Signoria, per avere lo vostro aiuto e consiglio, come sempre dalla vostra Signoria òe auto in tutte le mie fortune. Or io penzo che sia noto alla vostra Signoria dello abbominevole e vituperoso cazo occorsomi di mia cugnata, sia due volte per difecto e cagione di lei e operatione de'suoi parenti, cioè del cuzino carnale e di due altri ladroncelli senesi pichiapietre, per la quale operatione a me è stato per loro cavatomi di casa e rubatomi di massaritie e arnesi la valuta di più di fiorini 200, che niente posso rinvenire fino a qui. E a giunta m'anno ed inghanato e cavato di casa con tanto vituperо di notte tempo due volte lei, sichè io posso dire che m'anno rubbato l'avere, la persona e in tutto ogni honore di casa mia, senza nulla mia colpa e cagione, ma sotto la fidanza grande che io avea in lei e in parte di loro. E se sapeste la forma, e'l modo del tradimento, che il traditore di maestro Iacopo da Siena e di Simonello Sembrini suo cugino non dubito punto che lla vostra Signoria direbbe che mai Giuda non fecie a Xristo maggiore inganno e tradimento che costoro ànno facto a me. E quando il cazo primo venne, benchè a la mente

mi desse grandissimo affanno e passione e che mi fusse duro boccone a poterlo patire, pure a'preghi di più miei parenti e amici era contento.

E piglarla per occultare questa vergogna quanto più m'era possibile con li più acolorati modi che io avesse possuto. E praticando questa ritornata mae la seconda volta tradito e ingannato. E partitasi di nocte in su mattino di casa della madre mentre che ella dormia, e menata ed ingannata per li suddetti maestro Iacopo da Siena e per lo compagno a casa loro; e poi la menonno in nella sacrestia della cappella nuova di Lorenzo Trenta, dove loro lavorano, perche erano più presso alle mura e alla porta di borgo, che venia loro meglio a menarla via e la mattina che 'l compagno del decto maestro Iacopo fue preso, si fue sostenuto alla porta che se ne andava via e così loro se n'andavano e menavalla se no fusse il presto providimento che si fecie. Or dipoi essendo schoperto questo facto, per lo dicto preso fue con più onesto modo che si potè, cavato costei della decta sacrestia e conducta a quel tempo più onesto che si poteo a casa di Bernabò Arlotti suo parente, e per ricoprire la vergogna la quale è impossibile, perche è troppo manifesto, dichano che gli era a casa di una buona donna vedova a San Fridiano, la quale donna non à nome, né non si trova perché non si potre' trovare etc. Se questo fallo si fusse facto sì segreto che no llo sapesse che io o miei, dovete credere, signor mio, che non è homo al mondo che più l'ocultasse di me. E crepo e scoppio di dolore che mi convegnia per forsa palesarvi la manifesta ingiuria e vergogna, la quale m'è stato facto, della qual cosa mai in mia vita non saroe più lieto. Non posso più, conviensi per forsa ricorrere alla vostra Signoria, perche secondo il mio parere il vostro officiale, il quale àe questa materia in tra lle mani, mena questa materia troppo freddamente e per lunga, avendo le prime inditie tucte vere, per modo che prestamente potea tucto toccare con mano se ll'avesse voluto, o volesse riciercare come dovrebbe, e per curto che a ttanto grandissima materia quanto è questa, lui non ci procede come questo cazo richiederebbe; per la quale cosa ricorre alla vostra giustissima Signoria, domandando con grandissima verghogna ragione e giustizia, e pregando la vostra Signoria che vi piaccia provedere con quel modo più honesto che vi pare, che i cattivi forestieri che à facto o voleser fare danno e verghogna a' vostri ciptadini non abbino materia di perserverare a vituperarci tanto abominevolemente; notificandovi che il vostro capitano, il quale àe questa materia in nelle mani, àe mandato per me tre volte, e dicie che vuole che io dia l'acuza per scripto, sopra che malifitio voglia acuzare costui, altramente non vi prociederà a niente. E pertanto vegha acciò la vostra Signoria come vi pare che giusto è ragionevole sia, perché di molto minor facti di questi si sono proceduti per inquizizione. Or l'officiale àe informagione di costoro, oltra le rubbarie che m'ànno facto e adulterio commisso tanto manifesto, come sono di tanta vituperosa e dizonesta vita in nel peccato abovinevole di Sodoma; che se vorrà procedere come potrà in questo peccato solo, troverà per più indizi e prove, per modo che non bizognerà che per quest'altra forma prociada; non di meno io per me non mi curo che parte si pigli, perché la vergogna è tanto notoria e manifesta che mai in eterno non si può più ricoprire; siché provegha a cciò la vostra Signoria come li pare, avizandovi che io òe dicto allo officiale che io sono contento che tenga me, e se non trova chiaro che costoro sono largamente colpevoli in tutte le cose che io gli ò posto, faccia poi tagliare il capo a me. Altra acuza per scripto non sono disposto dare; facciane che li pare e all vostra Signoria lasso la coretione di tucto.

Ancho vi notifico che io òe da Lorenzo Trenta, avendomi parlato di questa materia come quel maestro Iacompo s'acuza peccatore, e come confessa che la verta è che l'avevano in nella sacrestia, e come ànno delle suoi cierte berecte di perle e altre cose, e che domanda perdono etc. Ora e' cci sono tanti indizii e tante cose che io per me non sarò mai più lieto in mia vita. Non dico più per non darvi tedio, benché assai ci resta a dire. Io sono in grandissimo affanno e agonia. Idio mi aiuti e alla vostra Signoria mi raccomando, pregandovi se el'è possibile che una volta vi piaccia in su questo volermi udire, perché tucto non si può né è

honesto a dire per lettera. Rimanendo sempre contento a ogni cosa che vi piaccia di fare a la vostra Signoria: e di questo e d'ogni altro mio facto pregandovi che io abbia risposta secondo che a voi pare che io abbi a sseguire. Che Xristo e la Madre vi conservi e acreschi in buono stato come la vostra Signoria desidera.

Vostro servo Iohanni Malpigli umilmente vi se raccomanda con grandissimo dolore etc.

A dì 18 dicembre 1413.

Location: Governo di Paolo Guinigi, Lettere originali, no. 12, pp. 933–934.

Bibliography: Lazzareschi, "Dimora," doc. 1; Hanson, *Fonte Gaia,* doc. 39; *Mostra,* doc. 11, pp. 327–328.

Comment: The letter is mentioned in Wittkower and Wittkower, *Born Under Saturn,* p. 158. Malpigli claims he was robbed of property worth 200 florins by his sister-in-law with the collusion of her cousin Simonello Sembrini, Jacopo della Quercia, and Giovanni da Imola. Furthermore, they were accused of taking the woman first to their home and then to the chapel of Lorenzo Trenta in the sacristy, where they had their workshop. There, they engaged the woman ". . . nel peccato abovinevole di Sodoma. . . ." It is not clear to me whether adultery or fornication is meant or the more strict meaning of this *peccato* was intended. When Giovanni was brought before the Lucchese Captain of Justice, he denied having known "carnaliter" Clara, who was there specifically identified. Judging from Malpigli's letter, one has the impression that the authorities were dragging their feet about prosecuting the case, perhaps because of Jacopo's powerful friends.

The letter supplies evidence that Jacopo and Giovanni da Imola were at work in Lorenzo Trenta's chapel in 1413, and it confirms the collaboration between the two sculptors. See also doc. 51, below.

Document 45.

December 26, 1413
Siena *(Fonte Gaia)*

The Concistoro orders Francesco di Valdambrino to return monies paid for the fountain within three days.

Die XXVI Decembris

Contra Franciscum Valdambrini [in the margin]

Magnifici domini priores, capitaneus populi civitatis Senarum, simil convocati in numero sufficienti in Concistorio palatii residentie ipsorum ut moris est, servatis inter eos debitis et opportunis solemnitatibus, solemniter deliberaverunt quod dominus executor iustitie civitatis Senarum mandet et precipiat magistro Francisco Valda[m]brini de Senis quod infra tertiam diem debeat restituisse comuni Senarum omnes denarios quos ipse recepit a comuni Senarum sive a domino Caterino, operario maioris ecclesie catedralis de Senis, solvente pro comuni Senarum pro edificatione et constructione nove fontis fiende per magistrum Iacobum Pieri della Ghuercia de Senis, et dicto tempore elapso faciat et teneatur facere executiones pro dictis denariis contra dictum magistrum Franciscum realiter et personaliter prout sibi videbitur ita quod cum effectu dicti denarii consignentur comuni Senarum.

Location: ASS, Concistoro, no. 287, fol. 34v.

Bibliography: Bacci, *FdV,* pp. 324–325.

Comment: Since the news of Jacopo's return to Siena had obviously not yet reached the Comune, they ordered his guarantor, Francesco di Valdambrino, to return all monies paid out for the *Fonte Gaia*.

Document 46. December 26, 1413
 Siena *(Fonte Gaia)*

The Comune of Siena writes to Paolo Guinigi in Lucca on Jacopo's behalf.

Paolo de Guinigiis, domino civitatis Lucane, Magnifice frater et amice carissime. Sentientes universum regimen nostre urbis dispositum ad omnia possibilia que vestre Magnificentie vota respicerent; larga facie audemus, cum casus emergunt, eamdem magnificentiam requirere ac gravare. Audivimus siquidem cum admiratione non modica, civem nostrum dilectum magistrum Iacobum magistri Pieri de la Guercia habitatorem civitatis vestre Lucane fuisse apud officiales vestros de receptatione quorumdam furtorum criminatum extitisse; quod nobis etiam videntibus adeo credere esset difficile, quod calamus nequiret exprimere. Tenemus enim quod sit omnibus moribus suffultus, et vitiorum maxime tam abhominabilium inimicus. Et cum credamus tam sue criminationis casum, quam persone conditiones et vitam vestre magnificentie notam esse; non intendimus longius in narratione negotii pervagari, sed solum concludere quod singulariter exoptamus; et hoc est, quod a vestre Magnificentie fraternitate cum purgatione sue infamie eum de singulari gratia petimus, et instantissme petimus, obsolutum ac liberatum; modum et formam per quas deveniatur ad id V.D. prudentissime relinquentes. Ad cuius beneplacita nos et comune nostrum in similibus et aliis quibuscumque offerimus semper promptos.

Location: ASS, Concistoro, No. 1610, fol. 153.

Bibliography: Milanesi, *Documenti*, vol. 2, doc. 9 (appendix); Hanson, *Fonte Gaia*, doc. 41 (Hanson has, for the first time, correctly dated this letter); *Mostra*, doc. 12, pp. 328–329.

Comment: The level of official support that Jacopo achieved is impressive. The question remains, however, whether the Comune was motivated by an genuine esteem for his moral character or whether they spoke up for him because he was engaged on the *Fonte Gaia*, the completion of which was much desired. On the other hand, the officials specifically defended Jacopo to the effect that he was an enemy of the "abhominabilium" vices.

Undoubtedly Jacopo must have appealed to the government for intervention.

Document 47. January 5, 1414
 Siena

Jacopo writes to Paolo Guinigi on behalf of Giovanni da Imola.

Die quinto Iannuraii [1413 = 1414, modern]
Magistro Iacobo Pieri concesse sunt lictere in forma comuni ad dominum Lucanum pro quodam Iohanne magistri Francisci de Imola, quod eum in iure suo foveat.

Location: ASS, Concistoro, no. 1611 (Copialettere), fol. 4v.

Bibliography: Lazzareschi, "Dimora," pp. 67–68n; Bacci, *FdV*, p. 291; Hanson, *Fonte Gaia*, doc. 42.

Comment: Jacopo's plea on behalf of Giovanni da Imola speaks for itself. It is certainly within his character to have supported his collaborators and *garzoni*. Various letters were, in fact, written on behalf of Giovanni including from the Sienese Signoria, the Lord of Imola (Gian Galeazzo Manfredi), and Niccolò da Uzzano, which offers a fascinating Florentine connection to the entire affair. For the letters see "Carteggio di Paolo Guinigi," 16:65 in *Memorie e documenti della storia di Lucca* (Lucca, 1925), p. 65.

Document 48.

January 27, 1414
Siena *(Fonte Gaia)*

Jacopo receives payment for work on the fountain.

Maestro Iacopo di Piero maestro de la fonte die dare a dì 27 giennaio lire otto contanti, prestò Doccio [di Iacomo] per detto di misser Caterino.

Location: AODS, no. 654, (Memoriale), fol. 15v.

Bibliography: Lusini, *Duomo,* 2:28n2.

Comment: Similar payments were made on the same date for 16 lire 1 soldi and again on March 1 for 35 lire 19 soldi, for a total of 60 lire, making January the time when following a long delay Jacopo took up work on the *Fonte Gaia* in earnest.

In 1414, according to the chronicler Paolo di Tommaso Montauri (see *RRIISS,* vol. 15, part 6, col. 781), "grandi caldi fu questo anno e molto asciuttore, che non piobe [= piove] e fu molta infermità di guarante e d'altre febbri, e morì vechi e fanciuli." Perhaps this situation put pressure on the Comune to move ahead posthaste on the fountain.

Document 49.

February 2, 1414
Siena

Caterino di Corsino, Operaio of the Cathedral, is also placed in charge of the Cappella del Campo.

Location: ASS, Concistoro, no. 288, fol. 27v.

Comment: The Operaio was one of the most influential and trusted persons in the city. He had enormous responsibilities over artistic projects, including that of the *Fonte Gaia,* the *Baptismal Font,* the Cappella del Campo, and the Duomo. Romagnoli (Biografia, vol. 3, fol. 624) recounts that "Nel 1413 con deliberazione concistoriale (vedi il tomo 242 di concistori a carta 11) del 10 Marzo [= 1414, modern] si danno Lire 1400 a Caterino di Corsino operaio del Duomo per spendersi nei lavori della fonte."

Document 50.

March 1, 1414
Siena *(Fonte Gaia)*

A payment is made to Jacopo.

A maestro Jacopo di Pietro de la Fonte a dì primo di marzo lire sesanta e quali dovrà dare a nostro memoriale a foglio 15, de' quali non si sbatteva una ragione di Nardo di Lodovico Piccogliuomini dove de' avere a lib[ro] rosso, perché questi sono danari de la fonte.

Location: ASS, Concistoro, no. 288, fol. 27v.

Comment: See payments from the "Memoriale" which began January 27, 1414. The 60 lire represent a subtotal.

Document 51. April 16, 1414
 Lucca

Giovanni da Imola denies charges before the Captain of Justice in Lucca.

Die XVI Aprilis [1414].

[1] Constitutus personaliter coram capitano custodie lucane civitatis [Anthonio Nisterni de Tuderto] magister Iohannes magistri Francisci de Ymola sculptor lapidum in quadam salecta parvula palatii residentie ipsius capitani, et primo interrogatus per dictum dominum capitanum si unquam carnaliter congnoverit domina Claram uxorem Nicolai Malpili de Luca, dixit et respondit quod non.

Item interrogatus si magister Iacobus magistri Petri de Senis sculptor lapidum habuit vel recepit aliquas quantitates rerum a dicta mona Clara videlicet indumenta ad usum ipsius domine Clare vel alias res aptinentes vel pertinentes dicte domine Clare vel suo marito, dixit et respondit quod dictus magister Iacobus comprestavit sub pignore a dicta domina Clara duos palandras vel cioppas videlicet unam coloris viridis et aliam vero coloris paonazzi ad usum dicte domine Clare.

[2] Item dixit etiam quod dictus magister Iacobus simili modo et forma habuit a dicta mona Clara duas cappellinas videlicet unam velluti nigri raccamatam cum certis aucelis albis et aliam setanini albi advellutatam velluti viridi.

[3] Item duos pectinos avolii et certos petios velluti parvulos coloris rubei azurri et albi, et certas quantitates sete modice coloris rubei albi nigri et viridi;

[4] Item duas anulas tessutorum cum certa quantitate argenti videlicet unam nigram et aliam rubeam;

[5] Item quendam agnusdeum argenteum actum ad ferendum pueri;

[6] Item dixit quod habuit tavoglietam in quo erant involuta duo pectia taffectani coloris rubei cangnatus [=castagno?] cum quatuor cuffis sive cappellis ad unum dicte domine Clare;

[7] Interrogatus pro quanta quantitatem dictus magister Iacobus sub pignore habebat imprestam ad dictam dominam Claram dixit et respondit pro quantitate sexdecim florenorum auri quos idem magister Iacobus mutuavit in pluribus vicibus prefacte domine Clare;

[8] Interrogatus in causa scientie dixit quod audivit dici pluribus et pluribus vicibus a dicto magistro Iacobo et etiam vidit Annam eclavam Nicolai Malpili mariti dicte domine Clare euntem in ecclesiam sancti Fridiani in loco ubi dictus magister Iacobus et ipse magister Iohannes laborabant ad petendum denarium dicto magistro Iacobo ex parte dicte domine Clare.

[9] Item interrogatus si dictas pannos et ceteras res suprascriptas vidit apud dictum magistrum in domo ubi ipse magister Iacobus et ipse magister Iohannes insimul habitabant posita Luce in contrata sancte Marie servorum in quadam cassa dicti magistri Iacobi, dixit quod sic, et tunc dictus magister Iacobus dixit et asseruit eidem magistro Iohanni quomodo dicta Clara dedit sibi sub pignore predictam quantitatem sex decim florenorum.

[10] Item interrogatus quomodo quando et qualiter dicta domina Clara accessit ad ecclesiam sancti Fridiani ad loquendum cum dicto magistro Iacobo et cum ipso magistro Iohanne dixit et respondit quod fuit de mense decembris preterito MCCCCXIII et quod una [die] dicti mensis tempestive dicta domina Clara accessit ad dictam ecclesiam sancti Fridiani

in quadam cappella dicte ecclesie Laurentii Trente ubi predcti magistri Iacobus et magister Iohannes laborabant, in qua tunc erant dictus magister Iohannes et quidam nomine Masseo, qui etiam laborabat in dicta cappella et intravit intus et subspinsit dictum magistrum Iohannem dicens: Ubi est magister Iacobus? el qual magistro Iohannes respondit: No ci è e verà addesso. Et statim magister Iohannes recessit de illo loco ne vederetur cum illa donna Clara, quia in ecclesia erant multi homines et mulieres, et modicum ambulans per ecclesiam invenit dictum magistrum Iacobum, qui veniabat causa laborandi. Cui dictus magister Iohannes protulit ista verba videlicet: E venuta equà monna Chiara de Nicolò Malpipi tucta acanuffata, el visu suo tucto tinto e inbractato e parme che sia de melagrane, e demanda de te. Tunc dictus magister Iacobus accessit ad dictam dominam Claram et cum ea multum rationatum fuit. Tandem magister Iohannes vocavit dictum magistrum Iacobum et dixit: Titubo fortier propter accessum istius domine Clare huc ne consanguinei sui cogitent malum contra me, ideao melius est quia pro nunc recedam; et finaliter inter multa verba inter eos habit concluderunt ut commode dictus magister Iohannes se assenteretur etc.

Interrogatus si dicta domina Clara sibi magistro Iohanni aliquam licteram unquam scripsit respondit quod sic et dixit quod sibi scripsit in pluribus et pluribus vicibus sex tenore et continentia inscripta videlicet: Io vorria, Magistro Iohanni, venire da voi in casa vostra e parlar con voi, per ciò che tutto el bene mio ve voglio e ardo per lo vostro amore. Pregove che ve sia raccomandata. E più altre parole, le quali el dicto magistro Iohanni dice se non recordare al presente.

Interrogatus si ipse habet aliquas licteras de supradictis dixit et respondit quod pro maiore parte delaceravit, se in domo magistri Iacobi supradicti in quam cassa debent esse duo vel tres.

Interrogatus si ipse magister Iohannes unquam aliquam responsionem dedit in scriptum dictis licteris eidem domine Clare dixit quod non, sed verbo a quadam fenestra in domo dicti magistri Iacobi esistente cum manibus et ore signum fecit prefate domine Clare, hostendens per signa qualiter alique modo nolebat et intendebat ipsa ibi accedere etc.

Location: ASL, Governo di Paolo Guinigi, Capitano del Popolo, no. 23.

Bibliography: Lazzareschi, "Dimora," doc. 2.

Comment: It is worth noting that the trial was conducted by one Antonio Nisterni of Todi, where Jacopo was called to work soon after.

We learn that Jacopo lent money to this Lucchese matron, taking fine dresses as collateral, as well as other valuables.

Document 52.

October 14, 1414
Siena *(Baptismal Font)*

A decision is made to construct a new baptismal font in San Giovanni, Siena.

Certi savi de la città di Siena, electi et assunti da' magnifici et potenti signori signori priori governatori del comune et capitano di popolo de la città di Siena, per vigore d'una rimissione in loro facta per lo consiglio del popolo della detta città, providero et ordinaro in questa forma, cioè:

. . .

Item, ["sexta," in the margin] conciò sia cosa e considerato che la città abi la chiesa sua cathedrale bella e molto bene impunto, come si confà a la città per onorare la regligione et magnificare el nome dello eterno Idio e de la sua gloriosisima madre madonna santa Maria,

advocata et difenditrice d'essa città di Siena. Et che in essa nostra ... [word obliterated] chiesa si può dire non essare battesimo altro che sozo e vituperoso, si come ... [word obliterated] è noto ad ogni cittadino, volendo la chiesa d'uno bello battesimo onorare, providero e ordinaro che misser Catherino, magiore operaio de la detta chiesa cathedrale, o altro se altro fusse, sia tenuto e deba, finita l'uopera del fonte del campo dela detta città, provedere insieme con suoi consiglieri et far fare una fonte di battesimo honorata, di marmo, in quello luogo che parrà a lui e suoi consiglieri e altri cittadini come a llui parrà, considerato che al presente ci sonno i maestri acti a fare el decto lavorìo. E questo sia tenuto fare sotto la pena di fiorini cento d'oro, da tòrsili per lo camarlingo dell'uopera, del suo salario et convertigli in bene dell'uopera predetta.

Location: ASS, Concistoro, no. 2113, fol. 34v (modern pagination).

Bibliography: Borghese and Banchi, *Nuovi documenti,* doc. 44 (listed under October 10, 1414); Paoletti, *Font,* doc. 2 (listed under October 10, 1414).

Comment: Although the new baptismal font was to be undertaken only after the *Fonte Gaia* was completed, actual work began before, presumably due to the delays with the fountain.

Document 53. January 3, 1415
 Siena *(Fonte Gaia)*

A dispute between Jacopo and the suppliers of stone for the Fonte Gaia *over marble is resolved.*

Anno Domini MCCCCXIIII [=1415, modern], indictione VIII, die tertia mensis Ianuari. Actum Senis in episcopali palatio, coram ser Iohanne ser Gerii et ser Antonio Ghuidonis de Calci, notariis, testibus presentibus et rogatis. Magister Iacobus magistri Pieri de Senis, magister lapidum ex una parte et magister Nannes magistri Iacobi de Luca, habitator Senarum et magister Nannes Iacobi, magistri lapidum, ex parte altera, eorum comuni concordia, commiserunt et compromiserunt omnem litem et questionem inter eos vertentem, occasione duorum lapidum de marmo conductorum Senis per fonte del campo que non receperunt bone et de duobus lapidibus marmoreis fodendis et cavandis de petreria marmoris per dictos magistros, scilicit Nannem magistri Iacobi de Luca et Nannem Iacobi de Senis, loco dictorum duorum lapidum, in providos viros dominum Caterinum, operarium ecclesie maioris, et magistrum Dominicum Nicolai, magistrum lignaminis de Senis, tamquam in eorum arbitros et arbitratores, quod habeant declarare de vectura et conducitura et foditura dictorum lapidum fiendorum de novo, bonorum et perfectorum, ad electionem suprascripti magistri Iacobi magistri Pieri et etiam lapidarum conductarum et de tempore; et quod debeant fodisse dictos lapides et etiam cuius debeant esse lapides non boni qui sunt Senis; ita tamen quod tempus fodiendi dictos lapides incipiat in kalendis Martii proxime venturi; dantes et etiam promittentes sub pena C librarum, obligantes per iuramentum et cum guarentigia; et voluerunt partes predicte dictum compromissum durare per tempus decem dierum, et non ultra.

Location: ASS, Notarile Antecosminiano, no. 225, (Bartolomeo di Giacomo da Radicondoli), at the date.

Bibliography: Milanesi, *Documenti,* vol. 2, doc. 43; B-P, *Fonti,* 2:322; Hanson, *Fonte Gaia,* doc. 48.

Comment: Note that the disagreement between Jacopo and the suppliers of marble had already surfaced on December 4, 1414, if not earlier (see Bacci, *FdV,* p. 330), when the

Concistoro turned the question over the Operaio of the Duomo. Domenico di Niccolò dei Cori seems to have been Jacopo's choice as arbitrator.

The Nanni di Iacopo da Lucca had been a collaborator of Francesco di Valdambino for a gesso "scafaja" in Siena six years before (Bacci, *FdV*, pp. 247–248), as Pasti reminds us ("Una nuova opera di Francesco di Valdambino," p. 76*n*39).

Document 54. January 18, 1415
 Siena *(Fonte Gaia)*

The program for the Fonte Gaia *is expanded.*

In nomini Domini, amen. Anno dominice incarnationis MCCCCXIIII [=1415, modern], indictione VIII, die vero Veneris xviii mensis ianuarii. Convocato et congretato generali consilio campane, dominus prior proposuit atque dixit, super petitione operariorum super fonte campi, noviter construendo per viam et modum proposite, cuius quidem petitionis tenor sequitur et est talis, videlicet:

Dinanzi a voi magnifici et potenti signori signori priori et capitano di popolo della città di Siena.

Exponsi con ogni debita reverentia per li vostri operai della fonte del campo che conciò sia chosa che, quando la decta fonte fu data a ffare, chi la de' a ffare, per grande volontà che ebbero della decta fonte si facesse, non ebbero tutta quella advertentia che bisogniava al decto lavorio, il perché il decto lavorio pate più defecti, e quali se non si correggessero, el detto lavorio verebbe male e a pocho contento de' cittadini. Et prima, nella decta allogagione della fonte non si fece mentione come la parte di fuore d'essa fonte dovesse essere facta, che è quella parte che più s' à a vedere e non mutando altrimenti e maestri la faranno piana e biancha, la quale chosa sarebbe diforme al bello lavorio che viene dalla parte dentro. E per questa cagione, noi operaii siamo stati con tutti quelli maestri che ci sono intendenti et divisato di farvi certo lavorio e adorno per modo che la decta fonte verrà bene et arà il suo dovere. Et ancho abbiamo divisato di fare la decta fonte più larga dalla parte dinanzi che di sopra, il perché dando il pendente a l'ale dallato [sarà, cancelled] sta hora viene a crescere alchuna chosa el decto lavorio; et facendo stima del costo che si crescie alla decta fonte, stimiamo sarà Fiorini CCCC o circa, la quale spesa non si può fare senza altra deliberatione. Et per tanto supplichiamo la magnifica Signoria vostra che vi degnate per gli vostri consegli opportuni far provvedere che la decta spesa si possa far, acciocché il lavorio della decta fonte abbia sua perfectione et sua ragione et sia al contento de' cittadini, altrimenti el decto lavorio seguirà secondo l'alogagione e sarà sozo, per modo dubitiamo non sia facto disfare a furia e sarà la spesa perduta.

Igitur si videtur et placet presenti consilio et consiliariis presentis consilii providere, ordinare, statuere et reformare quod presens petitio operariorum super fonte ca[m]pi per modum proposite approbetur et confirmetur actoritate presentis consilii generalis. Et quod sit, fiat, observetur et executioni mandetur in omnibus et per omnia prout et sicut in ipsa petitione per modum proposite continetur, similiter in Dei nomine consulatur.

Location: ASS, Consiglio Generale, no. 206, fols. 462–2v.

Bibliography: Borghesi and Banchi, *Nuovo documenti*, doc. 45; Hanson, *Fonte Gaia*, doc. 49; *Mostra*, doc. 14, pp. 329–330.

Comment: Among the corrections to the plan of the fountain provided for at this meeting were provisions for the decoration of the exterior faces of the fountain, and expansion toward the front in the size of the fountain. The added cost was seen to approximate 400

florins, and action had to await the approval of the Concistoro, which was given on August 4, 1515 (see doc. 56 below).

Document 55. May 28 to August 1, 1415
 Siena *(Fonte Gaia)*

A record of payments for the Fonte Gaia *is made by Caterino di Corsino, Operaio of the Duomo.*

Maestro Iachomo di Piero, maestro de la fonte, die avere per la fatura de la fonte fiorini 2000, no so che fiorini si sono, metoli di lire 4 l'uno, fiorini 2000 soldi . . . [blank] Anne auto in più partitte e promessa per lui di saldo ragione cho'lui infino a dì 28 Magio 1415, lib. 6250

Lire 6250.

Maestro Sano [die maestro Matteo] e maestro Nanni [di maestro Iacomo da Lucca] dieno avere per fatura del choncio de la fonte e muratura, fatto merchato cho' maestro Iachomo di Piero, lire dumilia dugiento, de'quali dieno avere Fiorini 20 il mese quando lavorano solicitamente . . . Fiorini

Lire 2200.

Anne auto infino a dì 6 di Luglio 1415 lire 1200, de'quali sono ne denari di sopra scritti a ragione di maestro Iachomo Fiorini

lire 1200

Restano avere lire 1000 quando sarà fatta la fonte. Di maestro Iachomo de la Fonte [on verso of sheet] per la ragione vechia

lire 5393 sol. 14

per la ragione nuova

lire 2641 sol. 0

Somma lire 8034 soldi 14 denari 0. I denari abiamo auti dal chomuno di Sena: In prima fiorini 120 diè il chomuno a maestro Iachomo

lire 480 soldi

. . .

Item, per chabella rischosse infino a questo dì primo di Agosto 1415, in più poste

lire 3686, soldi 5, denari 1.

Somma lire 5376 soldi 5 denari 1.

Location: ASS, Opera metropolitana, no. 38 (carte varie), at the date.

Bibliography: Bacci, *FdV*, pp. 325–326.

Comment: Another related sheet, not dated, which is also transcribed by Bacci (*FdV*, p. 327), reads:

El Chomune di Siena die dare:
A noi datte fiorini dumila sanesi per la fonte, lire 8200.
E die dare per l'onchescimento fiorini quatrociento lire 1600.

Somma lire 9800.

Anne datti per chabelle date—lire 7102, sol. 14. E per le vie e altre spese—lire 169, sol. 18.

Somma lire 7272 soldi 12.

Resta a dare lire 2528.

A maestro Iachomo per la fonte—lire 5393, soldi 14. e più del saldo inanzi—lire 1709, soldi . . . [blank] . . .

Notwithstanding internal ambiguities, such as the exchange rate of the lire, the evidence remains strong that Jacopo had received more than half the total for his share of the fountain at the time this document was drawn up. Of the 2,000 original florins and the 400 extra, totaling 2,400 florins (9,600 lire at 4 lire per florin), he had already in hand 6,250 lire, which represents two-thirds of the total. Presumably we may calculate that roughly that portion of the work had been executed. This does not necessarily mean he had actually executed two-thirds of the sculpture, however.

Document 56.

August 4, 1415
Siena *(Fonte Gaia)*

Jacopo's wages for the fountain are increased by 400 florins.

Die IIII Augusti [1415]
Pro fonte comunis
Deliberaverunt etc. dicti magnifici domini quod dominus Caterinus, operarius eclesie catedralis et etiam operarius fontis, det et solvat magistro Iacobo, magistro fontis, florenos quatuor centum ultra duobus milibus florenis, qui floreni, quatuor centum sunt ampliando fontem. Et quod eidem operario obbligate illemet intrate que sunt pro dictis duomilibus florenis, sint etiam obligate pro dictis quatuor centum florenis auri, quousque fuerit satisfactum de predicits.

Location: ASS, Concistoro, no. 297 (Deliberazioni), fol. 19.

Bibliography: Bacci, *FdV*, pp. 331–332.

Comment: The total price for the fountain has been increased to 2,400 florins, thereby recognizing the provisions for the expansion of the fountain as set forth on January 18, 1415.

Document 57.

February 16, 1416 [?]
Lucca

Lorenzo Trenta is given permission to reconstruct the altar of San Riccardo in San Frediano.

. . . Di poter rifare et renovare l'altare di S. Riccardo in detta cappella et in quella puonerci il corpo di S. Riccardo con questo che per l'avenire si chiamasse l'altare dei Santi Riccardo, Geronimo et Orsola, come per contratto per man di ser Pietro di ser Simone Alberti.

Location: Biblioteca Governativa di Lucca, MS. 415, P. Carelli, Notizie antiche di S. Frediano, fol. 20v.

Bibliography: Ridolfi, L'*Arte in Lucca*, p. 352; Campetti, L'Altare della famiglia Trenta," p. 293; Lazzareschi, "Dimora," p. 74; Hanson, *Fonte Gaia*, doc. 53.

Comment: This information is based upon a reading of documents from registers of the notary ser Pietro di ser Simone Alberti, which are missing for the year in question and

therefore impossible to check. If correct, the date might be considered that when the altar was first put to use. Lazzareschi has "remontare," not "renovare."

Document 58. February 18, 1416
 Lucca

Lorenzo Trenta is the procuratore *in an agreement involving the rental of a portion of a vast lake.*

1416 die XVIII Februarii, indictione 9a.

Vir nobilis et egregius Laurentius olim magistri Federigi Trenta, lucanus civis, procurator et procuratorio nomine Filippi, Andree et Iacobi, heredum olim Bini corum compagni[?] per cartam publice scriptam manu Iohannis Scadelin presbiteri tornacensis, rogatum sub anno ab incarnatione Domini 1417 *[sic]*, indictione Xa, mensis augusti 24 die . . . [illegible word] quod vidi et legi in . . . [illegible words], dicto nomine locavit ad pensionem Nicolao filio ser Guidonis de Petra Sancta, lucano civi, presenti et conducenti per se et suos heredes et successores, novem partes de quadragintaotto partibus unius lacus qui dicitur il laco di Massaciuccoli, inter suos confines, ad habendum, etc., hinc ad annos quatuor proxime futuros, ad reddendum ex eius partibus quolibet dictorum annorum nomine pensionis florenos sex auri boni, faciendo solutionem quolibet dictorum annorum in media quadragesima cuiusque anni. Et etc. Et versa vice dictus Nicholaus recepit et conduxit etc. Que quidem omni et singula etc.

Actum Luce, in ecclesia Sancti Fridiani, in cappella noviter constructa a Laurentio olim magistri Friderigi Trenta, coram Gerardo Spasa et Iohanne Fettori, lucanis civibus, testibus ad hec vocatis et rogatis, suprascriptis anno, indictione et die.

Location: ASL, Archivio Notari, no. 384 (ser Mazino di Bartolomeo Mazini), fol. 52v.

Comment: A certain confusion surrounds the actual date of this document. February 18, 1416 is given at the beginning and August 24, 1417 within the body of the text. For Jacopo della Quercia's studies the importance of the document rests on the information that the Trenta Chapel in San Frediano is mentioned as newly finished at the time of the act. The February 18 date corresponds to a notice given by Carelli (fol. 20v) that reads: "A dì 18 Ferraio 1416 fu con solennità collocato il corpo di S. Riccardo nel nuovo altare sodetto [i.e., the *Trenta Altar*] come si nota per mano di ser Mazino Bartolomei, et a dì 2 Novembre il detto anno il priore di S. Frediano rattificò la translatione del corpo di S. Riccardo fatto come sopra per mano di detto notaio." This reference is widely cited, without questioning. The fact that the date for the rental of the lake is the same as that of the document cited by Carelli, which also gives the name of the same notary, ser Mazino Bartolomei (see "Location," above), raises doubts about how Carelli put together his facts, especially since his reference has never been located in the papers of the notary in question. If the body of San Riccardo was placed in the new altar complex in 1416, the altarpiece was definitely not yet fully carved, as is attested to by the 1422 date inscribed upon it. Perhaps Carelli's assertions should be disregarded until (and if) corroboration is found.

Document 59. March 11, 1416
 Lucca

A safe conduct passport is given to Jacopo for his return to Lucca.

Magnificus dominus prefatus [Paulus de Guinigiis] concessit salvumconductum Iacobo magistri Petri de la Guercia de Senis, sculptori solito habitare in civitate lucana, veniendi ad et in muros civitatis lucane ibique morandi et pernoctanti ac indi discedenti libere et impune et sine nullis impedimentis in persona vel rebus eidem quolibet inferendis, non obstantibus quibuscunque bannis condennationibus culpis excessibus processibus vel delictis aut aliis quibuscunque causis vel rebus quibus esset obnoxius et que contra eumdem Iacobum possent quoquomodo obiici opponi vel adscribi. Mandans officialibus suis etc. Valiturum quatuor mensibus proxime futuris.

Location: ASL, Governo di Paolo Guinigi, no. 32, fol. 13v.

Bibliography: Lazzareschi, "Dimora," doc. 3; A. Venturi, *Storia dell' arte italiana,* 6:78*n*; Hanson, *Fonte Gaia,* doc. 54.

Comment: Jacopo is allowed to practice his art in Lucca, the city where he usually *("solito")* resided, according to the *salvacondotto.* Obviously he was being allowed to return to work for the Trenta family in San Frediano, where the tomb slabs are, in fact, dated 1416. One must suppose that the Trenta clan put pressure on the government to allow Jacopo to return to work.

Document 60.

June 28 to July 17, 1516
Siena *(Baptismal Font)*

Ghiberti, with two assistants is brought from Florence to Siena for consultation concerning the Baptismal Font.

Location: AODS, no. 660 (Memoriale), fol. 5v. See also the reference in AODS, Entrata e uscita, 1416, fol. 53.

Bibliography: Milanesi, *Documenti,* 2:91*n*; Krautheimer and Krautheimer-Hess, *Ghiberti,* doc. 131; Paoletti, *Font,* doc. 4.

Comment: Not only does this trip (there were three altogether for the same purpose) serve to introduce directly certain artistic ideas current in Florence to the Sienese, but these Florentine artists also became aware of Sienese innovations. They could hardly have remained unimpressed with Francesco di Valdambrino's polychromed wood sculpture for the cathedral, for example, or portions of the *Fonte Gaia* already completed by Jacopo.

Document 61.

November 2, 1416
Lucca

The rental of land to Lorenzo Trenta to build a factory is confirmed.

Anno MCCCCXVI, indictione Xa, die secundo mensis Novembris.
Convocatis congregatis et cohadunatis ad capitulum infrascriptis priore et canonacis cathedralis ecclesie monasterii Sancti Frediani de Luca, ad sonum campanelle in infrascripto loco, more solito et de mandato reverendi patris domini Doni olim Stefani de Podio, Dei gratia prioris dictis monasterii, in qua quidem convocatione congregatione et cohadunatione interfuerunt infrascripti prior et canonaci, quorum nomina sunt hec videlicet: dominus Dinus olim Stefani olim Iacobi de Podio, prior dicti monasterii, dompnus Anthonius Petri de Pesis, et dompnus Fredianus Luce de Luca, omnes professi dicti monasterii.

Qui quidem dominus prior et canonaci faciunt et representant totum capitulum et conventum dicti monasterii, cum plures vel alii ad presens canonici in dicto monasterio non existant, unanimes et concordes, nemine eorum discordante, pro bene cognita et evidenti utilitate et maxime dicti monasterii, hoc publico instrumento locaverunt et concesserunt ad pensionem, et ipse idem dominus prior cum consensu dictorum canonicorum locavit et concessit ad pensionem Geronimo, filio Laurentii olim magistri Frederigi Trenta, civi et mercatori Lucano, presenti et conducenti procuratorio nomine pro dicto Laurentio eius patre ad supra et infrascripta et alia facienda legiptime constituto per instrumentum publice manu mei . . . [blank space] notarii infrascripti factum et rogatum sub anno Domini MCCCVI, indictione nona, die XXa mensis Augusti, unam dicti monasterii petiam terre, que est cum hedificio unius tiratorii ad tirandum pannos et cum domibus in quibus fit purgum, super se. Que petia terre, que est cum predicitis super se est posita Luce, in contrata Sancti Frediani predicti, ex opposito dicte ecclesie et hospitalis eiusdem, et coheret ab oriente via publica, ab occidente et meridie coheret orto ecclesie Sancti Frediani suprascripti, vel si alii plures aut veriores sint confines suprascripte petrie terre cum predicits super se.

. . . Et rogaverunt me Mazinum notarium infrascriptum ut de predictis omnibus publicum conficerem instrumentum.

Actum Luce, in loco ubi capitulum dicti monasterii solitus est congregari, posito iuxta claustrum dicti monast[e]rii et cappellam beate Site, coram Anthonio olim Bartholomei de plebe Sancti Pauli, Bartholomeo Bonaiuti, et Iohanne olim Andree de Chaccia, textoribus, Lucanis civibus, testibus ad predicta omnia adhibitis, vocatis et rogatis, suprascriptis anno, indictione et die.

Location: ASL, Archivio Notari, no. 385, fols. 191v and ff.

Comment: The notary and the date correspond to an item carried by Carelli (see below, doc. 58, comment) for the confirmation of the translocation of the body of San Riccardo.

Document 62. November 17, 1416
 Siena *(Fonte Gaia)*

Provision is made for statues of two wolves with children seated on them, for the Fonte Gaia.

In nomine Domini, amen. Anno eiusdem Domini ab Incarnatione, millesimo quadringentesimo sexto decimo, inditione decima, die decima settima mensis novembris, vacante sede Romanorum Imperatoris, viri honorabiles et egregii Sanus Ture, Prior, dominus Petrus ser Antonii, Franciscus Cristofori et Iohannes Falarmi de Cerretanis, omnes domini Regulatores, Statuarii et maiores Revisores rationum Comunis Senarum, convocati et congregati in loco eorum solite residentie in numero sufficienti, secundum formam Statutorum civitatis Senarum, una cum prudentibus viris Tomme Vannini et magistro Dominico dell'Uopera, duobus ex tribus operariis fontis Campi civitatis Senarum, vigore remissionis facte per dominos Priores, Gubernatores et Capitaneum populi civitatis Senarum, de qua remissione constat manu ser Nicolai Dardi, notarii tunc Consistorii dictorum dominorum Priorum, deliberaverunt, quod lupe ponende in dicto fonte ad proiciendam aquam in dictum fonte, stent et ponantur ad iacendum, et fiat super unaquaque quidam puer qui sedeat super unaquaque dictarum luparum, et fiant de bono marmore, ita quod bene stent. Quas quidem lupas, ut superius dictum est, faciat magister Iacobus Pieri, cui concessa est factio et constructio dicti fontis; et sic promisit idem magister Iacobus facere in meliori forma qua melius fieri potest. Et de salario dictarum luparum et puerorum factorum libere remisit in operarios dicte fontis,

vel duos ex eis, declarationi et determinationi quorum promixerunt stare, et parere sine aliqua contradictione.

Et incontinenti, statim post predicta, dicti domini Regulatores et operarii supradicti, vigore dicte remissionis et eorum offitii, deliberaverunt et decreverunt quod inquiratur et perquiratur si aliquis denarius superest de denariis, qui expendi debent in constructione dicti fontis, et si non esset residuum aliquod, totum quod superest a denariis dicti fontis, set si non esset residuum aliquod, totum quod superest a denariis dicti fontis supra, solvat magister Franciscus Valdambrini, generalis operarius aque civitatis Senarum, de pecunia Comunis Senarum et de denariis deputatis pro dicto suo offitio, sine alio mandato aut deliberatione, sine apotissa et sine suo preiudicio aut danno. Et predicta fecerunt vigore dicte remissionis et eorum offitii et omni via, iure, modo et forma quibus melius fieri potest, et mandaverunt michi Angelo, notario infrascripto, quod de predicitis publicum faciam instrumentum.

Ego Angelus olim Guidonis Simonis, civis senensis, imperiali autoritate iudex ordinarius et notarius publicus, nunc notarius et offitialiis dictorum dominorum Regulatorum, predicitis interfui et ea rogatus, de mandato, scripsi et publicavi.

Die XX mensis Octobris 1419, cassatum et cancellatum per me Antonium Iohannis Gennarii, notarii Senarum, de voluntate dicti magistri Iacobi, ob liberationem per seum factam domino Caterino pro Comuni Senarum, operario Opere Sancte Marie et dicti fontis, de qua constat manu mea.

Location: ASS, Opera Metropolitana, Diplomatico, at the date.

Bibliography: Milanesi, *Documenti*, vol. 2, doc. 51; B-P, *Fonti*, 2:326–27; Hanson, *Fonte Gaia*, doc. 60.

Comment: Since she-wolves were already mentioned in the previous contract, the addition here may have been the childen seated upon them.

Document 63.　　　　　　　　　　　　　　　　　　　　December 11, 1416
　　　　　　　　　　　　　　　　　　　　　　　　　　Siena *(Fonte Gaia)*

The contract for the Fonte Gaia *is renewed.*

In nomine Domini, amen. Anno ipsius ab Incarnatione, millesimo quadringentesimo sextodecimo, inditione decima, secundum morem et consuetudinem loquendi notariorum civitatis Senarum, die vero undecima mensis decembris.

Magnifici et potentes domini domini priores, gubernatores comunis et capitaneus populi civitatis Senarum insimul cum dominis regulatores comunis et capitaneus populi civitatis Senarum insimul cum dominis regulatoribus dicte residentie, servatis inter eos servandis et omnibus que servari debent secundum formam Statutorum et Ordinamentorum Comunis Senarum, cum in dictos dominos Regulatores solenniter remissum fuerit ipsos debare perfici facere novum fontem Campi per magistrum Iacobum magistri Pieri de Senis, prout constat manu ser Nicolai Dardi, notarii Consistorii, de mense Iulii proxime preteriti, secundum locationem sibi factam de dicto fonte, et non appareat de nova locatione dicti fontis sibi facta et qua forma fieri debet et quid habere debeat pro dicto fonte, quia in instrumento sumpto et publicato ex abreviaturis ser Nicholai Laurentii, notarii defuncti et tunc notarii Consistorii, de mense Ianuarii et Februarii, anno Domini MCCCCVIII [=1409, modern], per ser Cinum Guidonis, notarium de Senis, contradicitur, et maxima contrarietas et differentia appareat ex eodem instrumento de dicta nova locatione, quia in principio dicti instrumenti continetur:

Quod fons Campi fiat per magistrum eo modo et forma prout designatum est; et non declaratur designum; et quod habeat duo milia florenorum auri senensium, non obstantibus quibuscumque etc. Et postea in quodam capitulo dicti instrumenti continetur inter alia; Quod Comune Senarum teneatur et debeat dare et solvere eidem magistro Iacobo, pro laborerio predicto, pretium et pecuniam declarandam per Franciscum Christofori capitaneum populi, no propterea excedendo summam millesexcentorum florenorum senensium neque descendendo de summa millequingentorum florenorum senensium; et cum ipse magister Iacobus asserat et dicat habere debere pro dicto fonte florenos duomila auri senenses et in auro, et nisi aliter declaretur aut provideatur prosegui non possit per dictos regulatores ad faciendum perfici dictum fontem, viso dicto instrumento et predictis in eo contentis et habita informatione quod ipsa sunt eadem capitula, quibus facta fuit prima conducta de dicto fonte de novo conficiendo per magistrum Iacobum, tempore quo era Capitaneus populi Franciscus Christofori, manu ser Iohannis Francisci, tunc notarii Consistorii, de mensibus Novembris et Decembris exinde immediate preteritis dicti anni MCCCCVIII, secundum formam primi designi facti in Palatio magnificorum dominorum Priorum in sala dicti Palatii tendenti versus Campsum fori, et quod postea fuit facta nova locatio, secundum novum designum factum manu dicti magistri Iacobi, prout constare debet manu dicti ser Nicholai Laurentii, tunc notarii Consistorii, de mensibus Ianuarii et Februarii predictis, declaraverunt, et determinaverunt, non proterea revocando dictam commissionem et remissionem in dictos dominos Regulatores, sed potius confirmando, quod dictus fons fieri debeat et confici per dictum magistrum Iacobum cum figuris, fogliaminibus, compassibus, armis, cornicibus, et aliis rebus ad dictum fontem pertientibus, et eo modo et forma et prout continetur et designatum est, et apparet in quadam carta edina [=?], manu dicti magistri Iacobi designata et facta, presentata per ipsos dominos Regulatores in Consistorio, que stare debeat insimul cum presenti deliberatione penes notarium infrascriptum.

Et quod habere debeat ipse magister Iacobus a dicto Comuni Senarum, pro dicto laborerio et pro dicto fonte, florenos duemilia auri Senarum, prout et sicut in dicta deliberatione et conducta in principio dicti instrumenti, manu dicti ser Cini, sumpti ex abreviaturis dicti ser Nicholai, continetur et apparet.

Et predicta ornia declaraverunt et determinaverunt omni modo, via, inure, cause et forma que et quibus melius potuerint, mandantes michi notario infrascripto quod de predictis publicum conficerem documentum.

Nomina autem dictorum magnificorum Dominorum sunt hec, videlicet:

Cinus Petri Castellani	
Antonius Pietri Francisci Nelli	} Terzerii Civitatis
Iacobus Iohannis Pini	
Georgius Guidonis ser Georgi, lanifex	
Ceccus Thommasii Cecchi, campsor	} Terzerii Sancti Martini
Silvester Nerii, vocatus Pagliaio	
Minuccius Mini Thommini	
Nannes Nicholai, aurifex et	} Terzerii Kamollie
Simon Barnabe, lanifex	

Ego Ambrosius filius Andree quondam Ambrosii de Donellis, de Senis, publicus imperiali auctoritate notarius et iudex ordinarius et notarius et scriba Consistorii dictorum mangificorum dominorum predictis omnibus interfui et ea de ipsorum commissione et mandato scripsi et publicavi signumque meum apposui consuetum.

Die XX mensis Octobris 1419 cassatur et cancellatur per me Anthonium Iohannis Gennarii notarium Senarum de voluntate dicti magistri Iacobi, ob liberationem per eum factam

domino Catharino pro comuni Senarum, operario Opere Sancte Marie, et dicti fontis, da qua patet manu mea.

Per la fonte del champo [on the front].

Location: ASS, Opera Metropolitana, Diplomatico, at the date.

Bibliography: Milanesi, *Documenti*, vol. 2, doc. 52; B-P, *Fonti*, 2:327–329; Hanson, *Fonte Gaia*, doc. 62; *Mostra*, doc. 16.

Comment: The discrepancies between the first and the second contract are clarified to some extent, but by no means completely. The sum due to Jacopo is set at 2,000, not 1,500 or 1,600 florins, but the increase is not specifically referred to, and questions will continue to be raised about the exchange rate (but see next document).

Document 64.

December 11, 1416
Siena *(Fonte Gaia)*

Conflicts raised by the various contracts are resolved.

Pro fonte [in the margin]
Magnifici Domini [etc.] Et insimul cum dominis regulatoribus in sufficienti numero congregati, servatis inter eos servandis etc., audita relatione facta per dictos dominos regulatores commissarios consistorii ad perficiendum facere fonte campi locatam magistro Iacobo, cum non possint prosequi eis in predictis commissa ex eo quod in instrumento locationis eidem magistro Iacobo facte, publicato et sumpto ex abreviaturis ser Nicholai Laurentii de Belforte per ser Cinum Guidonis, notarium, sit maxima contrarietas, cum in prima parte dicat quod ipse debeat habere duomilia florenos auri, et postea in uno capitulo dicit quod comune Senarum teneatur et debeat sibi dicto magistro dare pro laborerio predicto et solvere pretium et pecuniam declarandam per Franciscum Chistofori capitaneum popoli, non excedendo summam M. VI [C, above the line, = 1600] florenorum auri senensium, et non descendendo de summa M. V. [C, above the line, = 1500] florenorum senensium. Et habita informatione qualiter illa capitula sunt illa quibus facta fuit prima locatio manu ser Iohannis Francisci, notarii consistori, tempore quo supradictus Franciscus Christofori era Capitaneus Populi, et postea facta fuit alia locatio de novo manu dicti ser Nicholai Laurentii secundum novum designum et non secundum dicta prima capitula et pacta; declaraverunt quod dictus magister Iacobus debeat habere duomilia auri senenses, prout continetur in dicta deliberatione in dicto instrumento contenta.

Per la fonte del champo [on the front].

Location: ASS, Concistoro, no. 305 (Deliberazioni), fol. 21r.

Bibliography: B-P, *Fonti*, 2:330; Hanson, *Fonte Gaia*, doc. 62 and p. 10n1, for the correct date.

Comment: See previous document.

Document 65.

December 18, 1416
Siena *(Baptismal Font)*

Giovanni di Turino goes to Florence to consult with Ghiberti.

Anco spesi a dì xviii dicenbre [1416] quando Giovanni di Turino orafo andò a Fiorenza a maestro Lorenzo per lo fatto del batesimo. Lire IIII.

Location: AODS, no. 661 (Libro di Spese), fol. x.

Bibliography: Bacci, *Quercia*, p. 99; Krautheimer and Krautheimer-Hess, *Ghiberti*, doc. 136; Paoletti, *Font*, doc. 6.

Comment: On the same folio is the following item: "Ancho spesi a dì primo di Genaio [1416 = 1417, modern] per biada e per pescio per fare onore a maestro Lorenzo di Fiorenza che venne per lo fatto del batesimo. . . . Fiorini II" (in Bacci, *Quercia*, pp. 99–100).

Document 66. December 22, 1416
 Siena *(Baptismal Font)*

Evaluation of the florin for the contract of the Fonte Gaia *is offered.*

In nomine Domini, amen. Anno eiusdem Domini ab Incarnatione millesimo quardringentesimo sexto decimo, indictione decima, die vigesima secunda mensis Decembris, vacante sede Romanorum Imperatoris.

Viri nobiles et egregii Iohannes Falarmi de Cerretanis, Prior, dominus Petrus ser Antonii, legum doctor, et Sanus Luce, honorabiles cives senenses, tres ex dominis Regulatoribus, statutariis et maioribus revisoribus rationum Comunis Senarum, absente Francisco Christofori eorum quarto consotio, simul ad Consistorium convocati et congregati in loco eorum solite residentie, ut moris est, in numero sufficienti secundum formam statutorum civitatis Senarum, visa quadam deliberatione facta die vigesima secunda Ianuarii currentibus annis Domini millesimo quadrigentesimo octavo, per magnificos dominos, dominos priores Gubernatores Comunis, Capitaneum populi, Vexilliferos magistros et alios offitiales Balie Civitatis Senarum, tunc ad dicta offitia presidentes, in qua continetur in effectu, quod fiat fons super Campo Fori civitatis Senarum, secundum novum designum, quod designatum est in quadam carta pecudina per magistrum Iacobum Pieri Angeli de Senis, schultorem, et quod haberet pro edificatione, constructione, sive factura dicti fontis florenos duo milia auri senenses. Et considerato quod modo dicitur quod ipse habeat monetam ad rationem librarum iiii, soldorum ii pro quolibet Floreno, secundum quamdam deliberationem factam in domo Offitialium Mercantie civitatis Senarum per Consilium triginta sex civium, que quidem deliberatio facta fuit post deliberationem et promissionem dicti fontis et salarii, prout clare patet et ipsi de predictis omnibus sunt plenissime informati. Et quod considerantes quod leges condite extenduntur ad futurum tempus, nec respiciunt ad presteritum, et ideo lex sive deliberatio illa non habet obstare promissioni et deliberationi facte de dicto fonte faciendo; volentes predicta declarare et omne dubium et ambiguitatem tollere, ne lis aliqua oriatur, habito super predictis longo colloquio et deliberatione matura, vigore et autoratate eorum offitii, deliberaverunt et solenniter decreverunt omnes concordes quod prefato magistro Iacobo per illos ad quos spectat solvatur pro dictis duobus millibus florenis in moneta, si moneta data fuit aut dabitur in futurum ad rationem librarum quactuor soldorum quactuor et denarionum quactuor pro quolibet floreno, et sic eidem magistro Iacobo debeat observari. Et predicta fecerunt vigore et auctoritate dicti eorum offitii et omni via, iure, modo et forma quibus melius fieri potest. Mandantes predicta ab omnibus observari et michi notario infrascripto quod de predictis publicum faciam instrumentum.

Ego Angelus olim Guidonis Simonis civis Senarum, imperiali auctoritate iudex ordinarius

et notarius publicus, nunc notarius et officialis dictorum dominorum Regulatorum et comunis Senarum, predictis interfui et ea rogatus de mandato scripsi et publicavi.

Die xx mensis Octobris 1419, cassum et cancellatum per me Antonium Iohannis Gennarii, notarium de Senis, de voluntate dicti magistri Iacobi, ob liberationem per eum factam domino Caterino Corsini pro Comuni Senarum operario Opere Sancte Marie et dicti fontis, de qua patet manu mei dicti notari.

Charta dela dichiarazione dela fonte e de la valuta de' fiorini. [on the outside]

Location: ASS, Opera del Duomo, Diplomatico, at the date.

Bibliography: Milanesi, *Documenti*, vol. 2, doc. 49 (appears as 22 September); B-P, *Fonti*, 2:330 (appears as 22 September in transcription, but listed under December); Hanson, *Fonte Gaia*, doc. 63 and p. 101*n*2 (as December).

Comment: Hanson, following a typographical error in Bargagli-Petrucci, gives the first sum as 3 lire 2 soldi, instead of 4 lire 2 soldi. This error creates certain problems in her analysis. The exchange rate, as we have seen, was open to a certain margin of negotiation, and the amount was eventually increased to the favorable rate of 4 lire 4 soldi 4 denari.

Document 67.

February 1417
Siena *(Baptismal Font)*

Shipment of Ghiberti's bronze relief to Siena and back to Florence is recorded.

E die dare soldi otto, pagamo al camarlengho della some per cabelle d'una storia d'atone fecie venire misser Caterino e conseglieri da Firenze, è per lo fatto del Battesimo. s. viii.

E die dare per la vettura d'essa storia a Michele vetturale di qui a Firenze. s. xvi

Location: AODS, no. 660 (Memoriale), fol. 16v.

Bibliography: Bacci, *Quercia*, p. 101; Krautheimer and Krautheimer-Hess, *Ghiberti*, doc. 132; Paoletti, *Font*, doc. 8.

Comment: The relief sent by Ghiberti cannot be, in my view, either of the two he finally contributed to the font simply because he did not obtain the commission until May 21, 1417 (see Krautheimer and Krautheimer-Hess, *Ghiberti*, doc. 130). As Krautheimer (p. 140*n*7) suggests, it may have been a sample, perhaps of an existing work he had on hand.

Document 68.

February 19, 1417
Siena

Caterino di Corsino, Operaio of the Duomo, is ordered to supervise the construction of the Cappella and Loggia di San Paolo (Mercanzia).

Facta proposita super materia loggie fiende in reducto Saracenorum, seu apud Ecclesiam sancti Pauli de Senis, fuit victum et obtentum quod in ecclesia sancti Pauli predicta apud redductos Saracenorum, pro honore civitas Senarum ne locus sit tam turpis, fiat et fieri debeat una pulcra, honorobilis et ornata capella, in qua quolibet mane ad laudem omnipotentis Dei et beati Pauli appostoli et ad devotionem et comodum mercatorum celebretur missa per unum capellanum; ac etiam quod ibidem fiat et fieri debeat una loggia honorata et pulcra,

in qua mercatores et alii cives honorabiles possint se reducere et coloquia super mercantiis simul havere et aliis suis negotiis ad invecem convenire. Que omnia fiant et fieri debeant et executioni mandari per egregium militem dominum Caterinum Corsini, operarium ecclesie cathedralis et dicte ecclesie. Cum hoc tamen, quod in materia altaris vel ecclesie matande et ordinande capelle cum sit res sacra et ecclesiastica ne incurratur censuris, habeatur consensus in mutando et edificando reverendi in Christo patris et domini, domini Antonii, Dei gratia episcopi senensis.

Location: ASS, Concistoro, no. 2113 ("Savi cittadini . . ."), at the date.

Bibliography: Milanesi, *Documenti,* doc. 54.

Comment: These instructions for the building of the Loggia of the Mercanzia gave the Operaio of the Duomo his third project to manage, over and above his normal duties with regard to the cathedral, namely the *Fonte Gaia,* the *Baptismal Font,* and now the Loggia. He was also responsible for the Cappella del Campo, giving him extraordinary authority over the major artistic projects then being undertaken in Siena. Romagnoli reports (Biografia, vol. 3, fol. 634): "Nel 1417 il Consiglio Generale della Repubblica decretò che fossa fabbricata la Loggia degli Uffiziali della Mercanzia come lessi nel volume III, a carta 267. Questo lavoro fu diretto da Caterino di Corsino Operaio del Duomo e per le due nicchie dei pilastri medi disegnò Iacopo [della Quercia] le due statue figuranti Sant'Ansano and San Vittorio, non so però se in questa epoca . . ."

Document 69. March 10, 1417
 Siena (Baptismal Font)

Materials for the Baptismal Font *are mentioned.*

 Anco spesi adì x Marzo per VIII libre di torni per fare cholla per lo batesimo. s. iiii.
 Ancho spesi adì x di Marzo per XII libre di gesso per ibianchare el batesimo, da Angniolo chalcinaiulo. s. iii.

Location: AODS, no. 661 (Libro di Spese), fol. 12v.

Bibliography: Bacci, *Quercia,* p. 102; Paoletti, *Font,* doc. 9.

Comment: These materials, glue and gesso, were for a model (scale?) of the Font. Preparations for making the model began shortly before the relief by Ghiberti had arrived from Florence, which could have been fitted into the model for demonstration purposes (see Paoletti, *Font,* docs. 10 and 12).

Document 70. March 16, 1417
 Siena *(Baptismal Font)*

Design of the Baptismal Font *is mentioned.*

 Ancho spesi adì xi di Marzo per VIII braccia di channiccio per designiare el batesimo; desegnollo maestro Sano del maestro Mateio e maestro Papi da Fiorenza.

Location: AODS, no. 661 (Libro di Spese), fol. 12v.

Bibliography: Bacci, *Quercia,* p. 107; Krautheimer and Krautheimer-Hess, *Ghiberti,* doc. 133; Paoletti, *Font,* doc. 10.

Comment: Undoubtedly we are dealing here with a three-dimensional model of straw and gesso, apparently on a large scale. For Matteo see Gaye, *Carteggio,* 1:87, 100, 101, and C. Klapisch-Zuber, *Les maîtres du marbre Carrare, 1300–1600,* p. 85n41.

Document 71.

March 13, 1417
Siena *(Baptismal Font)*

Other materials are provided for the model of the Baptismal Font.

Maestro Sano di maestro Matteo che'ntaglia die dare a dì XIII di Marzo contanti Lire quatro, gli prestano per detto di messer Caterino Hoperario, disse per cagione della fonte del batesimo fa di giesso.

Lire IIII.

Location: AODS, (Memoriale, at the date), fol. 19.

Bibliography: Bacci, *Quercia,* p. 102; C. Paoletti, *Font,* doc. 12.

Comment: There are further payments to Sano for the model on April 1 and 10, for which see Paoletti, *Font,* doc. 12.

Document 72.

March 31, 1417
Siena

Jacopo is godfather to Mattia, son of the painter Martino do Bartolomeo.

Location: ASS, Battezzati, at the date.

Bibliography: Bacci, *Quercia,* p. 55; Borghesi and Banchi, *Nuovi documenti,* p. 112.

Comment: Domenico di Niccolò was godfather to a daughter of Martino born in 1410 (Bacci, *FdV,* p. 246). Such social interlocking among artists and artisans may be frequently observed in the fifteenth century.

Document 73.

April 16, 1417
Siena *(Baptismal Font)*

Jacopo's contract is drawn up for two panels for the Baptismal Font.

[On the outside] Instrumentum conducte duarum istoriarum baptismi, facte per magistrum Iacobum magistri Pieri.

In nomine Domini nostri Iesu Christi amen. Anno eiusdem Domini ab incarnatione millesimo quadrigentesimo decimo septimo, indictione decima, die autem sexta decima mensis Aprilis dicti anni, tempore Romanorum Imperatore sede vacante. Pateat omnibus evidenter quod prudens vir et magister Iacobus olim magistri Pieri, magister lapidum seu marmorum de Senis, ex certa scientia et non per aliquem errorem et omni via, iure, modo et forma quibus melius fieri potest, conduxit et recognovit et se conduxisse et recognovisse confessus

fuit egregio militi domini Catherino olim Corsini, honorabili operario maioris et cathedralis ecclesie Senensis, nec non venerabili viro domino Pietro Paolo olim Francisci de Senis, honorabili canonico Senensis et dicte maioris et cathedralis ecclesie Senensis, ac etiam Checcho Rosso olim Bartholomei de Petrucciis et Checcho olim Vanuccii ligritterio et Galgano olim Angeli Gani lanifici de Senis et civibus Senarum et honorabilibus consiliariis dicti operarii, presentibus et recipientibus atque locantibus; et ab sei *[sic]* locantibus conducenti et vice et nomine dicte opere, duas istorias battismi, quod debet fieri et poni in dicta maiori et cathedrali ecclesia Senensi et maxime subtus voltis Sancti Iohannis, cum infrascriptis pactis, conditionibus et modis, partim in volgari scriptis manu dicti operarii et partim scriptis manu mei notarii infrascripti, videlicit.

Ragunato l'oparario e suo consiglio nela sagrestia come dichiara[to] di sopra, allogaro et pacto fecero col savio maestro Iacomo del maestro Piero, cittadino di Siena, duo storie del detto battesimo o più, come piacerà al detto oparaio e suo consiglio, ad suo actone del detto maestro Iacomo, per fiorini cento octanta senesi di lire quatro e soldi quattro per ciascuno fiorino et per ciascuna storia. Et debba avere i denari e pagamento in questo modo, cioè il terzo del pagamento quando comincerà a lavorare in su le dette storie, cioè darne fatta una et compita fra l'anno, cioè in calende Maggio mille quatrocento diciotto [1418]; e così avere i pagamenti d'essa storia. La siconda, paga da ine a sei mesi, la terza paga compita et accettata la detta storia; et se piacerà et starà bene e accettata sarà per solenni maestri, debba seguire l'altra, come detto ène; et in quanto non fusse accettata et non stesse bene, esso maestro Iacomo la debba ritenere per sè e ristituire i denari avesse ricevuti, o veramente rifare la detta storia. Di ciò die dar buona e sufficiente sicurtà al detto oparaio. Questo inteso, che l'oparaio e suo consiglio debbano elegere quelli maestri, uno o più, a vedere et giudicare se dette storie staranno bene o non, come esso à promesso. Anco che l'oparaio e suo consiglio debba dare al detto maestro Iacomo le storie disegnate che più lo' piaccino, e debbono essere d'uno braccio e d'una oncio *[sic]* de largheza per quadra. Anco le die dare dorate con ariento vivo et realmente tutte le storie e campi, sì che sieno bene dorate a detto d'ogni orafo, ad oro d'esso maestro.

Preterea idem operarius et ipsi consiliarii superius nominati dictis nominibus promiserunt dicto magistro Iacobo stipulanti et recipienti, eidem dare et solvere et satisfacere dictam pecunie quantitatem in dictis pagis et dictis temporibus et modis, prout superius continetur et expressum est in vulgari, manu dicti domini Catherini operarii prescripti. Et dictus magister Iacobus promisit eisdem operario et consiliariis supra denominatis, stipulantibus et recipientibus nominibus antedictis, attendere et observare prout supra diffusius continetur et expressum est. Que quidem omnia et singula suprascripta ipse operarius et dicti ipsi sui consiliarii, nominibus antedictis et ipse magister Iacobus, partes prefate, promierunt et pacto solemni et conventione convenerunt ibi ad invicem et inter se, solemnibus stipulationibus hinc inde intervenientibus, attendere et observare et contra ea vel aliquid eorum non facere, venire nec contrafacienti vel venienti modo aliquo consentire per se vel alium, aliqua ratione vel cause de iure del de facto. Sub pena et ad penam duppli dicte pecunie quantitatis seu mercedis et vel pretii stipulantes in solidum et ninc inde dictis nominbus, promisse. Et dicta pena data, commissa, soluta vel non nicchilominus omnia et singula supradicta et in presenti contractu contenta, firma solida et rata mancant et perdurent ultroque citroque. Cum integra refectione damnorum et expensarum ac interesse hinc inde litis et extra et in iudicio sive extra. Et sub obligatione dictorum operarii et consiliarium eius, dictis nominibus, et successorum eorum et bonorum et rerum ipsius opere et etiam dicti magistri Iacobu et heredum et bonorum et rerum eius ominium presentium et futurorum, iure pignoris et ypothece. Renuntiantes dicte partes hinc inde exceptioni non facte conductionis et recognitionis, locationis promisse et obligate, actioni in factum rei sic dicto modo non geste, non sic celebrati

contractus, fori privillegio et omni alli iuris et legum auxilio vel favori. Quibus quidem operario et consiliariis eius et dicto magistro Iacobo, partibus suprascriptis, presentibus volentibus ad Sancta Dei evangelia corporaliter tactis scripturis, eadem firma et rara habere, ego Franciscus Iohannis notarius infrascriptus precepi nomine iura et guarentisie ipsos ad invicem observare plenarie debere secundum forman iuris et statutorum et ordinum dicti comunis Senarum, ut per singula capitulorum vel partium superius continetur.

Actum Senis, in sacrestia dicte maioris et cathedralis ecclesie Senensis, coram ser Mariano olim Iohannis, rectore Sancti Iacobi de Cuna et cappellano in dicta ecclesia Senensi, et ser Cristofano olim Antonii de Cortonio et cappellano dicti domini Pietri Pauli, et ser Iohanne olim Pauli cappellano etiam maioris ecclesia Senensis, testibus ad hec et premissa vocatis et rogatis.

Ego Franciscus filius olim Iohannis Andree de Asciano civisque Senensis, imperiali auctoritate notarius et iudex ordinarius et nunc notarius dicte opere, omnibus supradictis dum agerentur interfui et ea rogatus scripsi et consuete publicavi.

Location: ASS, Opera Metropolitana, Diplomatico, at the date.

Bibliography: Milanesi, *Documenti,* vol. 2, doc. 58; Lusini, *Duomo di Siena,* doc. 2; *Mostra,* doc. 17; Paoletti, *Font,* doc. 14.

Comment: This document has been published in the past as conflated with another of the same date for the same purpose concerning Turino di Sano and Giovanni di Turino, the Sienese goldsmiths. Noteworthy is the fact that the Turini as well as Jacopo della Quercia were given their assignments for the *Font* a month before Ghiberti had his, although the Florentine must have been regarded as the most expert.

Document 74.

April 20, 1417
Siena *(Baptismal Font)*

Sheepskin for a drawing of the Baptismal Font *is mentioned.*

E a dì 20 d'Ap[r]ile a Domenicho chartaio soldi venticinque per uno libriciuolo per sagrestani e per una carta di pecora, per fare uno disegnio per lo battesimo.

Location: AOS, Memoriale, 1416–17, fol. 19v.

Bibliography: Bacci, *Quercia,* p. 103; Paoletti, *Font,* doc. 16.

Comment: After the gesso model was constructed, it was necessary to provide a drawing to serve as a permanent record, presumably for use with the contract.

Document 75.

April 20, 1417
Lucca

Giovanni da Imola's fine is reduced from 300 to 100 ducats.

Location: ASL, Governo di Paolo Guinigi, no. 2, fol. 54v.

Bibliography: Lazzareschi, "Dimora," p. 71; Hanson, *Fonte Gaia,* doc. 66.

Comment: On June 17 the reduced fine was in fact paid by Girolamo Trenta, and Giovanni was released from prison.

Document 76.

May 1417
Siena *(Baptismal Font)*

A contract is drawn up for the construction of the Baptismal Font.

Sia manifesto a qualu[n]que persona legierà la presente schritta, chome misser Chaterino, operaio de la chiesa chatedrale di Siena e uopera Sante Marie e suoi consilieri, di chomune chonchordia diliberaro che la fonte del batesimo s'alogasse, cioè tutto i'lavorio del marmo, a maestro Sano del maestro Mateio e a maestro Nanni di maestro Iachomo e a maestro Iachomo di Corso, detto Papi da Firenze, per quello modo e patti a chondizioni e pregio che parà [e] piacierà al detto misser Chaterino. I nomi loro sono questi: misser Pietro Pauoli, chalonacho, Checo di Bartalomei Petrucci, Checho di Nuccio, ligritiere, Galgano d'Agniolo di Gano, lanaiuolo, tutti quattro cho[n]silieri del detto operaio, chome più chiarame[n]to apare per mano di ser Franchesco di Giovanni del Ba[r]buto, notaio de l'uopera Sante Marie.

E per metare in esecuzione la detta diliberazione e chomesione fatta i' me Chaterino, operaio predetto, ogi questo dì ... [blank] di Magio abiamo alogatto il detto lavorio a l'i[n]frasch[r]itti maestri, cioè: la metà d'esso lavorio a maestro Sano del maestro Mateio e a maestro Iachomo di Chorso l'una metà; l'a[l]tra metà a maestro Nanni di maestro Iachomo, l'a[l]tra metà per no' diviso: questo intesso che i sopradetti maestri debano il detto lavorio lavorare insieme l'una parte e l'altra e no' divisi nel detto lavorio.

[1] In prima, debano i detti maestri fare il detto lavorio bene e be' fatto e netto, chome sta quello de'ligìo di duomo, tutto lustrato bene i' tutte le parti s'àno a vedere, salvo i piani de' gradi, pomiciati senza lustrare: cioè cornici, base, tab[r]nacholi, gradi tarsia di marmo, in tuti le parti bisogniarà.

[2] Ancho, se bisognio fusse di fare alchuno cresime[n]to a noi sia licito, ise[n]do chonsa[l]vati, se fusse più; e se fusse meno, cho[n]salvare noi.

[3] La dima[n]da loro si è fiorini 90 de la fonte di sopra, senza i gradi; e de' gradi cho' conci e tarsia, lire 7 del braccio. E detti maestri il detto pregio ànno rimesso i' me Chaterino, operaio, come a me piacierà o parà. Di ciò abiamo piena rimessione de' detti maestri.

[4] Ancho, se a noi piacerà di da'llo' uno chapo maestro, el quale abi a provdere il detto lavorio cho' le mesure, modani, co[n]ponime[n]to, e fallo fare bene e diligietemente, a noi sia licito, ed essi il debano ubidire in ogni chossa.

[5] Ancho, finito il detto lavorio, ch' essi il debano murare o fare murare, e noi lo' dobbiamo dare chalcina, matoni e ogni altra chosa che s'abisognase a murare.

[6] Ancho, che i detti maestri sieno tenuti di trare a fine una de le sei faciate, overo quadra e murarla a secho per sagio se starà bene a detto d'ogni valente maestro, e se no' dieno esare pagati per essa faccia. Le predette chosse s'i[n]tendino a buona fe[de] senza frodo o malizia of difetto nisuno, a la pena di Fiorini 50 per ciaschuno di loro, ise[n]do obrigati il uno per l'a[l]tro in ogni chaso che so' ci fusse oservato per loro.

[7] Ancho lo'dobiamo dare i danari sichondo lavorano in sul detto lavorio.

[8] Ancho, intesso che la prima tarsia la quale sta a piei la fonte sia rimessa i' maestro Papi la facia a suo modo, stando bene e a piacimento de l'operaio.

[9] Ancho, che la tarisa de la po[r]porelle possa métare di stuccho vermilio lo schachetto di mezo.

[10] Ancho, l'a[l]tre due le die fare tutte di marmo, chome sono disegniate.

[11] Ancho, debano chavare tutti i marmi bisogniarano a la detta fonte e gradi, belli, be' bianchi senza pelo o vene nere e sozze; e dieno avere d'ogni braccio soto sopra, chornici, schalioni, piani di fuore e de[n]tro, e debano avere d'ogni braccio stesso, soldi trenta del braccio.

L'alogagione de la fonte del Batesimo [on the other side].

Location: AODS, no. 30 (insert), "Documenti che erano alla mostra, sec. XIV (1377–1399), no. 2 [as reported to me by Gino Corti].

Bibliography: Milanesi, *Documenti,* vol. 2, doc. 48; Bacci, *Quercia,* p. 80; Krautheimer and Krautheimer-Hess, *Ghiberti,* doc. 43; *Mostra,* doc. 15; Paoletti, Font, doc. 3.

Comment: The standard of quality was still Nicola Pisano's pulpit in the cathedral.

Paoletti (Font, doc. 3, *n1*) argues that this undated document must be 1416, as it has been taken by other writers who rely on Milanesi's suggested date. It must have followed, not preceeded, Ghiberti's consultation in 1416. Besides, the drawing mentioned in the contract could well have been by Ghiberti himself. On the other hand, I do not preclude the 1416 date as Paoletti argues, although no work is recorded on the basin until after May 1417.

Document 77.

May 20, 1417
Siena *(Baptismal Font)*

Ghiberti is in Siena for the Baptismal Font.

Ancho spesi a dì xx di Maggio per fare onore a maestro Lorenzo da Fiorenza quando venne a Siena a tollare le fighure de l'atone nel batesimo, per biada e strame e uno mezzo chapretto e per uova e chacio e due oncie di pepe e per pesegli e per uno pescio arostito e bacegli e pesegli . . . Lire III soldi v.

Location: AODS, no. 661 (Libro di Spese), fol. 15v.

Bibliography: Bacci, *Quercia,* p. 109; Krautheimer and Krautheimer-Hess, *Ghiberti,* doc. 137; Paoletti, *Baptistry Font,* doc. 17.

Comment: Ghiberti's arrival corresponded with the contract for the two reliefs the next day (Krautheimer and Krautheimer-Hess, *Ghiberti,* doc. 130; Paoletti, *Baptistry Font,* doc. 18). Ghiberti recived a down payment for his two histories on July 9, 1417 (see Bacci, *Quercia,* pp. 110–111). It should be understood that Jacopo's name does not appear in the documents at the planning stages of the *Font,* in which he evidently did not participate.

Document 78.

September 18, 1417
Siena *(Fonte Gaia)*

Jacopo promises to complete construction on the Fonte Gaia *within four months.*

Magister Sanus . . . [blank] magister lapidum de Senis, constitutus in presentia dominorum et capitanei populi, promisit dictis dominis recipientibus pro magistro Iacobi Pieri de la Guercia quod ipse perficiet totum laborerium quod tenetur facere ad fonte campi infra quatuor menses proxime secuturos, ita tamen quod dictus magister Iacobus fulciat eum hinc ad per totum diem XVIII presentis mensis Septembris, de rebus quas sibi dare tenetur, non obstante et ceterea, renuntians et cetera, cum iuramento, et cetera.

Ser Niccolaus, Ser Gregorius Pegoli, Ser Iacobus Andree Paccinellis et Matheus Iohannis Mattei, in solidum promiserunt quod si non faciet ut dictum est, ipsi in solidum solvere pro dicto magistro Iacobo aut unus de fideiussoribus debebit solvere florenos quiquaginta auri, et cetere, in solidum non obstante et cetera, renuntians et cetera, cum guarentisia et cetera.

Actum in palatio residentie dominorum priorum eoram Laurentio Iohannis vocato Formica et Comparozo de Tuderto testibus, et cetera.

Location: ASS, Concistoro no. 310, (Deliberazioni), fol. 9.

Bibliogjraphy: Milanesi, *Documenti,* 2:24*n*; B-P, *Fonti,* 2: 331; Hanson, *Fonte Gaia,* doc. 68.

Comment: Apparently the work was quite advanced, if four months were considered suffi-cient time for completion. But as we know, work dragged out for another two years. It is worth noting that one of the witnesses of the declaration was from Todi, where Jacopo had connections in these very years.

Document 79. October 12, 1417
 Siena *(Fonte Gaia)*

Three overseers of the Fonte Gaia *are to be selected.*

[. . .]
 VII. Item: fuit in dicto consilio provisum et reformatum in dicta proposita generali, quod magnifici domini priores et capitaneus populi eligant et eligere teneantur et debeant, quanto citius fieri potest, tres bonos et ydoneos cives civitatis Senarum, qui sic electi sint et esse intelligantur operarii ad faciendum pefici et compleri fontem campi fori civitatis Senarum, quem fontem et laborerium ipsius teneantur et debeant perfici facere et compleri et deduci ad debitum finem infra sex menses proxime secuturos, incipiendos die qua electis fuerint, et ut seguitur terminandos; sub pena florenorum C auri pro quolibet ipsorum, eis auferenda de facto per dominum executorum iustitie civitatis Senarum, salvo si haberant iustum et evidens impedimentum, de quo publice et notorie appareat, et habeant illam auctoritatem, officium, arbitrium et baliam, qualem et quantam habent presentes operarii dicti fontis: et quod operarii qui ad presens sunt, a dictor officio sint remoti, aliquo in contrarium non obstante.
 Que propositio hodie fuit obtenta in presenti consilio generali pro CLXXVIIII lupinos albos datos per *sic,* non obstantibus VII aliis nigris redditis pro *non* in contrarium predic-torum.

Location: ASS, Consiglio Generale (Deliberazioni), no.208, fol. 38.

Bibliography: Milanesi, *Documenti,* vol. 2, doc. 63; B-P *Fonti,* 2:332; Hanson, *Fonte Gaia,* doc. 69 and p. 103*n*.

Document 80. December 31, 1417
 Siena *(Fonte Gaia)*

Statement of accounts of the Operaio to Francesco di Valdambrino, Jacopo della Quercia and Sano di Matteo for the fountains of Siena is presented.

 . . . Uscita dela dicta ragione . . .
 E più aviamo trovato che à speso in spese extraordinarie, cioè marmo cavato et lavorato per lo fondo della fonte e per vectura d'esso marmo, correnti, stechone, candeli di sevo, aguti, corbelli e suo salario di due anni, a ragione di libre 100 l'anno, et altre cose apartenenti al suo offitio
 1474 libre, 8 soldi, 7 denari.
 E più aviamo trovato che il detto maestro Francesco à speso in spese extraordinarie facte intorno al rendare la decta ragione, come si vede manifestamente, et andare di rivedere e buctini di fonte gaia, in tucto, lire octo lire VIII.

. . .

Nota che dela somma di libre 1474, soldi 18, denari 7, se ne pone a maestro Iacomo di Piero d'Agnolo libre 72, soldi xi, che debbi dare.

<div align="center">72 libre, 11 soldi.</div>

Et per simile modo de la medesima somma de le libre 1474 si cava libre 14, soldi 9 perché sono poste che maestro Sano del maestro Mattheo debbi dare . . .

Location: ASS, Regolatori, no. 7, fol. 366v.

Bibliography: B-P, *Fonti,* 2:333.

Comment: Here the new fountain is referred to as the "fonte gaia" before its completion, reflecting the traditional name for the fountain from the previous century, which it was in the process of replacing.

Document 81.

<div align="right">December 31, 1417
Siena (Fonte Gaia)</div>

Payments for a provisional fountain are recorded.

Questa è una ragione renduta per Chimento di Biago, trombatore, d'una fonte che esso fece per la festa di Sancta Maria d'Agosto l'anno 1416 a piè el palagio de' magnifici signori priori, de la spese facte in essa fonte et etiamidio de la sua fadiga.

In prima ò trovato che 'l decto Chimento spese in XXII lire di cera per fare le figure de la fonte e tragietarle da Simone di Sano Tegliacci, libre [*sic*] dieci; et a due orafi che fecere le figure 22 d'essa fonte, libre VI, soldi xviii; a Giovanni di Turino orafo soldi 33, et per disegnature 33 figure, libre 4, soldi 10. Anco per le canne del piombo de la decta fonte a Checcho, stagnataio libre septe; maestro Martino per dipignitura de la concha et la collona et per la concha, libre 3. Anco per la collona et per lo pedistallo al maestro che la fece, soldi 44; a Nicholò di Giovanni Venture, pizichaiuolo, che fu con lui la nocte a conciare el decto magister, soldi 70; et per vino et poponi la nocte, soldi 16. Anco a trombatori suo' compagni, soldi dodici per vino perché sonarono quando si scoperse la fonte, et per sua fadigha, libre tre.

<div align="center">Somma in tucto 40 libre, 13 soldi.</div>

Location: ASS, Regolatori, no. 7, fol. 367.

Bibliography: B-P, *Fonti,* 2:334.

Comment: Among the artists mentioned in this facinating document, those who have direct connections with Jacopo include Giovanni di Turino and Martino di Bartolomeo, who had just served as one of the three priors for the Terzo di San Martino from November to December 1417 (ASS, Consiglio Generale, no. 208, fol. 38v.).

Document 82.

<div align="right">January 11 to 14, 1418
Siena (Fonte Gaia)</div>

An agreement is made to resolve previous controversies over the addition to the Fonte Gaia.

In nomine Domini, amen. Anno Domini ab ipsius salutifera incarnatione, millesimo quadringentesimo decimo septimo [= 1418, modern], indictione undecima, die undecima mensis Ianuarii, tempore pontificatus sanctissimi in Christo patris et domini Martini, divina

providentia Pape quinti, Romanorum Imperatore sede vacante, Vir prudens Ghinus olim Bartalomey, bancherius de Senis, unus ex quatuor operariis fontis Campi Fori Civitatis Senarum, declarator, decisor, desceptator et amicus comunis, electus, nominatus et assumptus ex remissione in eum facta a spectabilibus et honorabilibus viris domino Catherino olim Corsini, milite et operario Ecclesie maioris cathedralis civitatis Senarum, Thoma olim Vannini, aurifice, et magistro Domenico olim Nicolay, magistro lignaminis, de Senis, operariis fontis prelibati, magnificis et potentibus dominis, dominis Prioribus et Gubernatoribus Comunis Senarum et Capitaneo populi dicte civitatis ut dixerunt et michi notario infrascripto asseruerunt, electis, et ad dictam fonte construendam nominatis, dicto Ghino et consociis, ex una parte, et magistro Iacobo filio magistri Pieri, marmicida de Senis, ex alia parte, ad determinandum et decidendum et fine debito concludendum lites, causas, questiones et controversias inter dictos operarios recipientes et stipulantes pro dicto magnifico Comuni Senarum et magistrum Iacobum prefatum, vertentes occasione certi augmenti et additionis fontis supradicti, scilicet longitudine pro duobus braciis et duobus terziis, et totidem pro latitudine prout de dicta remissione in eum fact idem Ghinus et supradicti operarii eius consocii dixerunt et affirmaverunt michi notario infrascripto, sibi dicto Ghino antedicto remissionem fare, verbotenus facte diceas et asserens idem Ghinus plenam habere notitiam de dictis controversiis et remissione predicta et, ut dixit, visis juribus dictarum partium, et quinquid dicere et allegare coram eo voluerunt via amicabilem eligens, supra pedibus stans in loco qui infra dicetur, Christi nomine repetito, vigore dicte remissioni, judicavit, laudavit, decisit, declaravit et sententiavit, in hunc modum, videlicet:

Quod magister Iacobus antedictus pro dicto augmento et additione predicta habeat et habere debeat a Comuni Senarum, seu de ipsius Comunis Senarum pecunia, ducentos ottuaginta florenos, qui ducenti ottuagina floreni sint et esse intelligantur de illis florenis et illo valore, cuis valoris fuerunt et sunt quadringenti floreni additi prime locationi et condutioni factis de dicto fonte pro Comuni Senarum quodam reaugmento et readditione factis de antedicto fonte: hoc intellecto et declarato, quod dicta sententia, decisio, declaratio seu laudum non extendatur nec proteletur aliquo modo, iure vel causa neque aliquo colore quisito ad locationem et condutionem factam magistro Nanni magistri Iacobi de Lucha et magistro Sano magistri Matthei de Senis, lapicidis, pro reversione revolutionis, seu resuppinationis dicti fontis, presentibus dictis domino Caterino Thoma et magistro Dominico, operariis infrascripti fontis, recipientibus et stipulantibus vice et nomine Comunis Senarum, laudo sententieque ne declarationi et decisioni consentientibus, absente dicto magistro Iacobo. Et dictus Ghinus iudicavit et sententiavit atque declaravit eo modo et forma quibus melius fieri potest et debet, secundum eius remissionem, mandans michi Luce, notario infrascripto, quod de predictis prublicum conficiam instrumentum.

Lata et data fuit dicta sententia, declaratioque ac decisio et laudum, Senis in domo Opere Ecclesie cathedralis civitatis predicte in qua inciduntur lapides, in sala inferiori, in primo ingressu per infrascriptum Ghinum, anno indictione, die, mense, et pontificata infrascriptis, coram Battista Iohannis Personeta de Senis et magistro Bastiano Cursii, marmicida de Florentia et habitatore ad presens Senis, testibus presentibus et rogatis.

Anno, indictione et pontificatu suprdictis, die quarta decima mensis ianuarii, antedictus magister Iacobus magistri Pieri marmicida de Senis audito et intellecto tenore suprascripti laudi, sentente ac decisionis et declarationis ut asseruit, et de illo dicens et asserens se plenam habbere notiam dicti laudi, sententieque declarationis et contentionis in eo, ex certa scientia, spontanea voluntate et non pro errore, ratificavit, approbavit et emologavit in omnibus et in totum ut supra continetur; promietens michi notario infrascripto, tamquam publice persone, recipienti et stipulanti, vice et nomine magnifici Comunis Senarum, dictum laudum et sententiam perpetuo firmam ratam tenere et habere et contra non facere vel venire alqua ratione

iure, vel causa, de iure vel de facto, sub obligatione onmium suorum bonorum prestium et futurorum.

Actum Senis in Campo Fori, prope fontem dicti Campi, apud ritallium Maritani Buzichelli, coram ser Christforo Nannis de Menzano, notario, et Bartalomeo Bucciarelli, ritalliero de Senis, testibus presentibus et rogatis.

Ego Lucas filius Nannis Petri Giannini de Senis, pubicus imperiali auctoritate notarius et iudex ordinarius prelatione dicti laudi sententie et declarationis et eius ratificationi interfui eaque rogatus, scripsi et publicavi, signumque meum in fidem et testimonium premissorum apposui consuetum.

Die XX mensis Ottobris 1419 cassum et cancellatum per me Antonium Iohannis Gennari, notarium de Senis, de voluntate dicti magistri Iacobi ob liberationem per eum factam domino Catherino pro Comuni Senarum, operario Opere Sancte Marie et dicti fontis, de qua constat manu mea.

[On the other side] Charta di la dichiarazione delle storie.

Location: AODS, Pergamena no. 1440.

Bibliography: Milanesi, *Documenti*, vol. 2, doc. 64; B-P, *Fonti*, 2:334–36; Hanson, *Fonte Gaia*, doc. 72 (summary).

Comment: The signing took place in the lower room of the Opera del Duomo, "where stone is carved." Jacopo was not present but consented to the terms three days later, on January 14.

The purpose of this agreement was to resolve disagreements between Jacopo and the Operaio of the *Fonte Gaia* concerning the addition of two and two-thirds square braccia to his assignment. It is generally assumed that the addition mentioned here refers to the Genesis reliefs, namely the Creation of Adam and the Expulsion, confirmed by the reference to the "storie" on the back of the document. What remains unclear is the issue of dating the addition and therefore determining a precise *terminus post quem* for the carving of the reliefs.

This document might be considered as a confirmation of the agreement reached on January 18, 1415 (doc. 54) and certified on August 4, 1515 (doc. 56), which does not seem to have been operative. The amount is not the 400 florins stipulated in those documents, but 280 florins. On the other hand, the 400 florins mentioned may have referred to an addition to the 1,600 florins originally mentioned: in any event, ambiguities persist.

Document 83.
February 9, 1418
Siena

Jacopo is mentioned in a Payment.

Maestro Domenicho di Nicholò, che intaglia, de' dare a dì 9 di Feraio lire otto demo per lui a maestro Iachomo di Piero dela Guercia e per lui gli demo a Maestro Nanni del Maestro Iachomo e la detta posta iscrisi per detto di misser Chaterino di Corsino.
lire 8.
messi a libro rosso a fo. 117 a sua ragione e sono messi a nostra uscita a fo. 57.

Location: AODS, no. 662 (Memoriale), fol. 26v.

Bibliography: Bacci, *Quercia*, p. 122.

Comment: At this time, Domenico dei Cori was one of the Operai of the *Fonte Gaia,* suggesting that this payment may have had something to do with that work.

Document 84. April 26, 1418
Siena *(Fonte Gaia)*

The date for the completion of the Fonte Gaia *is extended to July.*

Pro fonte campi prorogatio termini operariis [in the margin].

In nomine Domini, amen. Anno dominice Incarnationis MCCCCXVIII, indictione XI, die vero martis, XXVI mensis Aprilis. In Consilio Generali Campane Comunis et populi civitatis Senarum fuit optentum et reformatum prout infra continetur . . .

[Item] tertio. Quod cum illi tres cives qui fuerunt electi et deputati ad faciendum fieri fontem Campi per tempus et in tempus sex mensium sub pena C Florenorum pro quolibet, si infra dictum tempus non compleretur, qui fecerunt circa eorum commissionem quicquid potuerunt et non steterunt per eos sed propter varia laboreria que supervenerunt, fuit victum et obtentum quod dictis officialibus et operariis prorogetur et ex nunc prorogatum sit tempus hinc ad per totum mensem Iulii proxime venturi, ad faciendum perfici dictum fontem, non obstante dicta eorum concessione et aliis quibuscumque contrariis quoquo modo. Quod victum fuit et optentum fuit per cclx consiliarios dicti Consilii reddentes eorum lupinos albos pro *sic,* non obtantibus lxxxx aliis consiliariis prefati Consilii qui reddiderunt lupinos suos nigros pro *non,* in contrarium predictorum.

Location: ASS, Consiglio Generale, no. 208, fols. 79–79v.

Bibliography: B-P, *Fonti,* 2:336–337; Hanson, *Fonte Gaia,* doc. 73.

Comment: This decision represents still another extension of the deadline for the completion of the *Fonte Gaia;* it was also not met.

Document 85. June 27, 1418
Siena

Jacopo receives partial payment for a wooden crucifix on which he was working.

Expendi pro predicta domina Anna [uxore domini Christofori de Castiliano] libras decem denariorum, quas dedi Iacobo de la Guercia sculptori, pro parte solutionis sculpture ymaginis crucifixi. Portavit dictam precuniam filius Bartoli magistri Laurentii die 27 Iunii.

Libr. 10, sol. 0, den. 0.

Location: ASS, Patrimonio dei resti ecclesiastici, no. 2175 (Memoriale di N. Galgani), fol. 25v.

Bibliography: V. J. Koudelka, O.P., "Spigolature dal memoriale di Niccolò Galgani, OPP. (+1424)," *Archivium fratrum praedicatorum,* (1959), 19:137.

Comment: S. Hough brought this citation to my attention. I would also like to thank Dott. Sonia Fineschi, who made the transcription for me.

The whereabouts of the statuette, if indeed it still exists, have not been ascertained. There seems little doubt that this wooden crucifix was polychromed. (See doc. 88 below for payments made for crucifix.) The 'filius Bartoli magistri Laurentii," who must have been a

garzone in Jacopo's shop, is Cino di Bartoli ("di maestro Lorenzo"). This document is the earliest mention, then, of this sculptor. Cino continued to work in Jacopo's shop until the latter's death more than twenty years later. (See *Dizionario biografico degli italiani*, s.v., for Cino.)

Document 86.

August 19, 1418
Siena *(Fonte Gaia)*

A three-month extension is granted to finish the Fonte Gaia.

Item, acciò che ala fonte del campo si dia debita expeditione, providero et ordinaro che gli ultimi operarii d'essa fonte sieno confermati con l'authorità usata per tempo di tre mesi, infra'l quale tempo debbano il lavorio d'essa fonte aver facto trare a expeditione et a perfectione, sotto pena di Fiorini XXV denari per ciascuno di loro . . .

Location: ASS, Consiglio Generale, no. 208, fol. 106.

Bibliography: Hanson, *Fonte Gaia*, doc. 75.

Comment: This information also occurs in other documents (ASS, Concistoro no. 2113, fol. 121; see also Borghese and Banchi, *Nuovi documenti*, p. 81*n*.)

Document 87.

August 30, 1418
Siena

Jacopo acts as guarantor for Jacopo di Corso detto Papi of Florence.

[In the margin] Posti a libro di due colonbe [*sic*] a fo. 559.
Ser Iohannes Poccii notarius denutiat quod die XXXa Augusti MCCCCXVIII, ind. XIa. Magister Iacobus Pieri della Guercia recepit obligationem a ser Niccolao Dardi et Urbano ser Michaelis de Florenis triginta auri ex causa promissionis facte per ipsum magistrum Iacobum magistro Papy de Florentia.

Florenos XXX auri.

Location: ASS, Gabella Contratti, no. 167, fol. 24v.

Bibliography: Bacci, *FdV*, p. 328–329.

Comment: In the same volume, at fol. 56v, is mention of a certain "Segna q. Nelli de Quercia grosso [*sic*]," indicating that "Guercia" is surely intended here and is not merely a confusion of the letters *G* and *Q*.
The Sienese notice represents still another example of Jacopo's connection with Florentine artists and craftsman, as well as his willingness to legally stand up for artists. In 1420 Papi entered into a partnership with another *scarpellatore*, as is demonstrated by documents (ASF, Mercaniza, no. 1275, fols. 205v–206; see also fol. 222).

Document 88.

September 16, 1418
Siena

Final payment to Jacopo for the wooden crucifix is recorded.

Item die 16 Septembris dedi magistro Iacobo, pro complemento sculpture crucifixi pro predicta domna [Anna uxore domini Christofori], libras decem. Portavit frater Iacobus Laurentii.

Lir. 10, sol. 0, den.0

Item dedi magistro Iacobo, pro pictura crucifixi, soldos 40.

Lir. 2, sol. 0, den. 0

Location: ASS, Patrimonio dei resti ecclesiastici, no. 2175 (Memoriale di N. Galgani), fol. 25v.

Bibliography: V. J. Koudelka, O.P., "Spigolature dal memoriale di Niccolò Galgani, OPP. (+1424)," *Archivium fratrum praedicatorum* (1959), 19:137.

Comment: Jacopo received 20 lire for the statuette plus 2 more for its painting, for a total of 22 lire. Further payments connected with the crucifix are recorded on October 6, 1418, when a tabernacle was also provided, which had hinges and a key (MS. cited above, fol. 26).

Document 89. November 28, 1418
 Todi (San Fortunato)

Jacopo's presence is requested by the priors of Todi to give advice concerning the decoration of San Fortunato.

Magnificis dominis capitaneo, gubernatoribus et communi civitatis Senarum, fratribus nostris honorandis.

Magnifici fratres honorandi. Quoniam cuiusdam magistri Iacobi Petri della Guercia plurimum indegemus, eique certa ornamenta lapidum in ecclesia nostra Sancti Fortunate noviter ordinandi volumus demo[n]strare et suum in hoc consilium consequentes, magnificam fraternitatem vestram actente rogamus, quatinus loco summe et singularissime complacentie nobis eundem magistrum Iacobum destinare velitis; nam nos illi de suo labore et contingno merito manualiter persolvemus, ad omnia vobis grata disponsiti toto corde.

Tuderti die XXVIII Novembris 1418

Location: ASS, Concistoro no. 1894 (lettere), insert no. 37.

Bibliography: Milanesi, *Documenti,* vol. 3, appendix, doc. 10; G. Gorrini, "Documenti di Jacopo della Quercia che ritornano a Siena," p. 310.

Comment: The year "1418" was added by another hand and corresponds to notations on the letter made following its arrival in Siena from Todi. There is no answer by the Comune among the *copialettere* of the Concistoro. Although the date cannot be taken with absolute certainty, and the letter could have been written a few years earlier, sculptural activity took place in Todi around this time. In any case the letter appears to date before the completion of the *Fonte Gaia,* since Jacopo is not referred to as "Jacopo della Fonte," as is common after 1419. Gorrini notes that the date was added, suggesting that it was done by the "cancelliere della Signoria senese." However it was achieved, the date appears to be based upon knowledge of the circumstances and makes perfectly good sense.

Document 90. December 16, 1418
 Siena

Payment to Domenico di Niccolò is collected by Jacopo.

Maestro Domenicho di Nicholò die dare a dì 16 Dicienbre lire oto, diemo per lui a maestro Iachomo di maestro Piero in sua mano per deto di misser Chaterino oparaio. Posti a libro roso a fo. 147 a'scita a fo. 57.

Lire viii.

Location: AODS, no. 633 (Memoriale), fol. 16.

Bibliography: Bacci, *Quercia*, pp. 121–122.

Document 91.

January 24, 1419
Siena *(Fonte Gaia)*

Jacopo promises to complete the Fonte Gaia *by April.*

In nomine Domini, amen. Anno dominice incarnationis MCCCCXVIII [= 1419, modern], indictione XII, die vero xxiiii martis, mensis Ianuarii. In concilio generali campane comunis et populi civitatis Senarum, solemniter convocato et congregato ... optentum et victum fuit quod fiat prout in infrascripta proposita continetur ...

Dinanzi a voi, magnifici et potenti signori signori priori et capitano di popolo de la città di Siena, con debita reverentia si spone per parte de' vostri figliuoli e servatori regulatori e statuarii del vostro comune, come per vostro comandamento che essendo stati insieme co' regulatori passati e con Nicholaccio e compagni, operarii stati sopra la fonte del campo, et con maestro Iacomo di Piero de la Guercia e praticato insieme sopra de la materia d'essa fonte, acciò che essa fonte abbia suo compimento et perfectione, secondo che al decto maestro Iacomo fu allogata, nel fine siamo rimasti d'accordo col decto maestro Iacomo, che esso prometterà et obbligarassi solennemente per tutto el mese d'Aprile prossimo che viene MCCCCXVIIII avere tracta a fine et perfectione, come è tenuto et obligato, la decta fonte, d'ogni suo lavorìo, a la pena di Fiorini trecento denari; et di questo darà buone et sufficienti ricolte et sicurtà da approvarsi per essi regulatori. Con questo inteso però che messer Caterino sia tenuto e debba, sopra un bancho, sicurare lui che esso, fornita la decta fonte come è detto, sarà pagato compitamente d'ogni suo resto, a ogni sua petitione e rechiesta senza alcuna exceptione o contrarietà. E perché potrebbe essere alcuno scropolo o dubio dal comuno vostro al decto maestro Jacomo di cosa che esso maestro Iacomo dice avere facto in esso lavoro fuore de la sua allogagione et non n'era tenuto et, e converso, d'altre cose che si vuole dire che lui doveva fare e non l'à facte, siamo insieme rimasti d'accordo che sia rimesso nell'officio de' regulatori et in Nicholaccio e compagni, operarii stati sopra la decta fonte, di poter dichiarare et terminare ogni differentia che fusse fra'l comune e lui per decta cagione o nel più o nel meno che fusse tenuto di fare, et simile di farlo pagare di ciò che dichiarato fusse se dovesse avere, et di farli rimettere se fusse tenuto. Et quello che per loro sarà dichiarato et facto, vaglia e tenga pienamente. Et più che i decti regulatori et operarii sieno tenuto al decto maestro Iacomo, se alcuno li fusse tenuto ad fare alcuna cosa per la decta cagione, prestarli aiuto e favore quanto sarà di bisgono et da lui saranno richiesti. Siché la decta fonte abbia, come è decto, sua perfectione et levisi tanta vergogna di comune.

Quod fuit obtentum in dicto consilio generali, per ccclxxxxi lupinos albos, non obstantibus lxii aliis nigris.

Location: ASS, Consiglio Generale, no. 208 (Deliberazioni), fols. 141–142.

Bibliography: Milanesi, *Documenti*, vol. 2, doc. 65; B-P, *Fonti*, 2:338–39; Hanson *Fonte Gaia*, doc. 77; *Mostra*, doc. 19.

Document 92. February 9, 1419
 Siena *(Fonte Gaia)*

The Fonte Gaia *and its decoration are set up in the piazza.*

Eadem quoque die [9 February 1419] Fons Gaius, in publico foro senensi constitutus,
marmoribus muniri ornarique cepit, et simulacra illius depromi. Ad id enim egregium opus
opifices, qui tres patria senenses, operam impenderunt, Iacobus Pietri della Quercia, Francis-
cus Valdambrinus, et Ansanus [Matthei], quorum opus ad multos perduravit menses. Sunt
tamen qui dicunt in primordio sequentis annis incohatum fuisse.

Location: BCS, MS. B.III.9, Sigismondo Tizio, Historiarum senensium, vol. 4, at the
date.

Bibliography: Della Valle, *Lettere sanesi,* 2:155 (listed under 1418); Bacci, *FdV,* p. 304;
Hanson, *Fonte Gaia,* doc. 78.

Comment: As Bacci points out, Tizio apparently obtained this information from a chronicle
contemporary with or at least close to the event, the chronicle of Paoli di Tommaso orafo,
which was recopied around 1490 by Antonio di Martino and is published in *RRIISS,* vol.
15, part 6, no. 9, fol. 792. The relevant portion, which was published by Bacci (*FdV,* pp.
303–304), reads:

> 1419. La Fonte dell chanpo di Siena si fornì di fare con fighure di marmo, con altro
> bello ornamento come si vede, co' mollta abondatia di acqua, le quali fighure furno
> fatte per maestro Iacomo di maestro Pietro della Ghuerca da Siena e lui conpose la
> Fonte e fe' tutte le figure e altri intagli come si vede; ancho maestro Francesco di
> Valdambrino da Siena fece una di dette figure e maestro Sano da Siena murò la fonte
> d'intorno l'anno 1419.

Probably from the same source is the notice carried in an eighteenth-century manuscript
(BCS, ser. N.S.I., no. 45, fol. 16), which reads:

> 1418. A dì 22 Febbraio [= 1419, modern] si cominciò a murare la fonte del campo di
> marmi e fare le figure intaglia di marmo; e maestri che all'hora fecero, furno questi:
> Maestro Jacomo di Piero della Quercia, maestro Francesco di Valdambrino, maestro
> Sano di maestro Pietro (Cf. *RRIISS,* 19, col. 428)

The indication that Francesco di Valdambrino had made one of the figures for the *Fonte
Gaia* has opened the way for an attribution to him of the so-called Rea Silvia, which many
critics believe differs stylistically from its pendant, the so-called Acca Larentia—the statues
that I refer to as Public and Divine Charity.

Document 93. May 4, 1419
 Siena *(Fonte Gaia)*

Jacopo is authorized to pay Nanni di Iacopo da Lucca for two bases and a platform.

Ser Iohannes Pocci de Casulis denuntiat quod die iiii Maii MCCCCXVIIII, ind. xii.
Magister Iacobus Pieri de la Guercia, magister fontis campi fori de Senis, recepit obligati-
onem a magistro Nanne magistri Iacobi scultore lapidum de civitate Lucana et habitante

Senis, de florenis viginti duobus, de 4 libris floreno, ex causa laborum et expensarum duarum bassarum et unius plane que circundant fontem campi a parte exteriori, etc.

flor. XXII auri de libris 4 floreno.

Location: ASS, Gabella Contratti, no. 168, fol. 47.

Bibliography: Bacci, *FdV*, p. 330; Hanson, *Fonte Gaia*, doc. 79.

Comment: These two bases may well have been for the two allegorical standing women, identified in the text as Charities, for either side of the fountain.

Document 94. September 2, 1419
 Siena

In Siena, Giovanni da Imola is paid for work done for the Opera del Duomo.

MCCCCXVIIII. Maestro Giovanni di maestro Franciescho da Imola, desengniatore e 'ntagiatore, die avere a dì di Settenbre lire vinti, e quali sonno per uno Spirito Santo che eso à intagliato e per sei disengni, quatro picholi e due grandi, e quali fecie fare misser Catterino e mandogli, dise, a Vinegia a mostrare a certi orrafi se stesone bene, imperché voleva fare fare tabernacholi per queli arlichuii veneno da Orbetello.

Location: ASS, Libro del Carmerlengo, 1419–1420, fols. 23v–24.

Bibliography: Bacci, *Quercia*, p. 129.

Comment: The patronage of the Operaio of the Duomo, who was also in charge of various major projects in Siena, may have been the result of Jacopo della Quercia's intervention on Giovanni's behalf. In any case it shows that Giovanni was in Siena in 1419 and indicates a complete disruption of activity on the *Trenta Altar*. Giovanni was again in Lucca during 1422, if not before; on May 5th of that year Piero d'Angelo entrusted his son Jacopo to deal with Giovanni—then termed "Habitante in Lucca"—for monies owed (see below, doc. 106).

Document 95. October 9, 1419 (and later)
 Siena *(Baptismal Font)*

Advances are made to Jacopo for the two histories for the Baptismal Font *(and payment is made to Donatello).*

Maestro Iachomo di Piero della Guercia de' dare per insino a dì VIIII d'Ottobre 1419 fiorini centovinti di lire quattro il fiorino, i quali ebe per due storie che ci debba fare per la fonte del battesimo; de' detti denari ce n'è richolta Guccio di Galgano Bichi, chome appare al memoriale segnato d'una croce, fo. 132, scritto Ghuccio di Ghalgano detto.

Lire CCCCLXXX.

[1423] E de' dare lire cinquanta soldi uno, e quagli demo per lui [i.e., Maestro Iachomo] a maestro Donato di Nicholò da Fiorenza, mesi a uscita di me . . . [name not read] a fo. 27.

Lire L soldi i.

Somma F. o, Lire 530, soldi 1, denari 0, posti inanzi [a] fo. 70.

Location: AODS, no. 708 (Libro Giallo), fol. 24v.

Bibliography: Bacci, *Quercia*, pp. 123 and 253; Paoletti, *Font*, doc. 312.

Comment: The second item refers to the well-known payment to Donatello. This version of the payment to Donatello, which is undated, must fall after the first item, and, in fact, may be located to May 1423 from evidence supplied by another account book (see doc. 109 below). The same two payments are also carried over in the same "Libro Giallo" at fol. 70v under the year 1425, and read: "Maestro Iachomo di Piero della Ghuerccia maestro di 'ntaglio de' dare lire cinqueciento trenta soldi uno, e qua[li] soldi à auti contanti, chome apare in questo indietro fo. 24. Ghuccio di Ghalghano Bichi banchiere è richolta di Lire quatrociento otanta de la soma sopra detta, come apare in essa ragione. Lire DXXX soldi 1."

The payment to Jacopo della Quercia of the 120 florins must have resulted from the renewal of the contract that he entered into around this time. Paoletti (*Font*, doc. 92) located the original document in the ASS (Diplomatico della Opera della Metropolitana, no. 1211) following a lead in Bacci, *Quercia*, pp. 251–253. It is particularly difficult to read, and besides has suffered from physical damage. As we already know, Jacopo does not seem to have begun work on these reliefs until after this date, and quite likely, long after this time.

On July 10, 1419 Turino di Sano and his son Giovanni di Turino went to Florence to purchase bronze because the quality was poor in Siena (see Lusini, *Il San Giovanni di Siena e i suoi restauri*, p. 98, and Paoletti, *Font*, doc. 86).

Document 96. October 20, 1419
 Siena (*Fonte Gaia*)

Obligations for the Fonte Gaia *are fulfilled and all previous contracts cancelled.*

[On the front] Carta di quietanza facta per maestro Iacomo di Piero della Ghuercia intagliatore, maestro della fonte del campo, fatta al comune di Siena e a misser Caterino operario dell'uopera Sancte Marie, del salaro d'essa fonte, ciò [= cioè] di 2280 fiorini senesi di 4 lire 4 soldi 4 denari per fiorino.

In nomine Domini, amen. Anno eiusdem Domini ab incarnatione millesimo quartringentesimo decimo nono, indictione tertia decima, die autem vigesimo mensis Octobris, tempore pontificatus sanctissimi in Christo patris et domini, domini Martini, divina providentia Pape quinti, sede Romanorum imperatoria, ut dicitur secundum comunem usum loquendi, Imperatore vacante. Pateat ominibus evidenter quod prudens vir magister Iacobus olim filius Pieri della Ghuercia, civis Senarum, schultor ac magister pro Comuni Senarum deputatus super constructione et fabrica novi fontis facti per Comune Senarum in Campo Fori dicte civitatis Senarum, per dictum magistrum Iacobum scultorem prefatum, sua, dicti magistri Iacobi, libera et spontanea voluntate et ex certa scientia et non per aliquem errorem et pacto solenni et legittima stipulatione interpositis nec vi, metu vel dolo adstrictus, sponte, deliberate et consulte, confessus fuit et recognovit egregio militi domino Caterino olim Cursini, sivi Senarum ac pro Comuni Senarum, operario Opere Sancte Marie maioris Ecclesie senensis ad quem expectat solutio salarii fabrice dicti fontis, ex forma reformationis Consilii Generalis Campane Comunis Senarum, presenti, recipienti et stipulandi pro se ipso et vice et nomine dicte Opere ac etiam vice et nomine Comunis Senarum et pro quolibet eorum et suis, et cuiuslibet eorum heredibus et successoribus, computatis omnibus solutionibus sibi factis vel alteri pro eo tam per Camerarios et Officiales Comunis Senarum quam etiam per dictum dominum Caterinum seu alios vice et nomine Comunis Senarum et dicte Opere, tam hodie quam ab hodie retro, sibi fuisse et esse integre et plenarie satisfactum de duobus milibus florenis auri senensibus, valoris quactuor librarum, quatuor solidorum et quactuor dena-

riorum pro quolibet floreno, sibi debitorum a Comuni Senarum pro salario et fabrica dicti fontis, secundum formam locationis sibi facte de fabrica dicti fontis per magnificos et potentes dominos, dominos Priores, Gubernatores Comunis et Capitaneum populi civitatis Senarum et officiales Balìe prefate civitatis, ut constat et apparet publico instrumento publicato et sunpto ex abreviaturis et protocollis ser Nicholai Laurentii, notarii defuncti, publici olim et tunc notarii Consistorii et dictorum dominorum, per ser Cinum Guidonis notarium publicum et secundum formam declarationum super predictis factarum per dominos Regulatores et Statuarios et maiores Revisores rationum Comunis Senarum, ac etiam secundum formam sententie late super premissis vigore reformationis Consilii Generalis Campane Comunis Senarum, de qua constat manu ser Iohannis Christofori olim et tunc notarii Reformationum Comunis Senarum, per dominos Regulatores et Statuarios et maiores Revisores rationum Comunis Senarum et Nicholaccium Terocci campsorem, socios quandam operarios super fabrica dicti fontis super superfluis ornamentis factis ultra designum dicti fontis per dictum magistrum Iacobum, conputatis cum obmissis et neglectis citra designum predictum, de qua quidem sententia patet manu Antonii notarii infrascripti, et in alia manu de ducentis octuaginta florenis auri sibi dicto magistro Iacobo debitis a Comuni Senarum de quibusdam figuris superadditis dicto fonti ultra dictum designum dicti fontis, ut de dicta superadditione constat publico instrumento scripto et publicato per ser Nicholaum Dardi, notarium Senarum publicum, et de ominibus et singulis superdictis et dependentibus ab opere dicti fontis, dicto magistro Iacobo debitis, ex causa prelibata, dictum dominum Caterinum operarium prefatum, presenti et, ut supra, dictis nominibus et quolibet dictorum nominum stipulanti, et me Anthonium notarium infrascriptum, tanquam publicam personam, presenti et stipulanti, vice et nomine Comunis Senarum et omnium et singulorum quorum interest seu intererit, quomodolibet in futurum per aquilanam stipulationem et acceptilationem de incontinenti liberavit et absolvit pactumque fecit de ulterius non petendo, et omnia et singula instrumenta et scripturas seu cirografa tam publica quam privata, manu cuiscumque notarii vel persone per quem seu quam comune Senarum esset quomodolibet obligatum ratione et causa fabrice dicti fontis et dependentium ab eis, esse voluit penes dictum Comune Senarum et dictum dominum Caterinum et dictam operum incisa et incisas, cassas et cancellatas et omni robore destitutas. Et promixit idem magister Iacobus dictis domino Caterino et notario infrascripto, presentibus et, ut supra, stipulantibus dictis nominibus et quolibet dictorum nominum, de predictis vel aliquo predictorum vel dependentium ab eis vel aliquo predictorum, nullam, de cetero, litem, brigam, questionem, petitionem vel repetitionem facere vel movere per se vel alium seu alios nec facienti modo aliquo consentire. Et quod de predicitis vel aliquo predictorum vel dependentium ab eis vel aliquo predictorum ius suum dicti magistri Iacobi in totem seu in partem nulli alii est datum, cessum, concessum seu modo aliquo alientum, sub pena et ad penam supli totius eius unde, seu de quo lix, briga, questio, petitio seu repetitio fieret vel moveretur et ius datum modo aliquo appareret quam penam idem magister Iacobus eidem domino Caterino et notario infrascripto prensentibus, ut supra, et stipulantibus, dare el solvere promisit si et quotiens commissa fuerit: et dicta pena commissa, soluta vel non, predicta firma tenere, cum integra refectione et restitutione damnorum interesse et expensarum litis et extra. Pro quibus omnibus et singulis firmiter observandis idem magister Iacobus obligavit expresse se impsum et suos heredes et successores et bona omnia presentia et futura eisdem domino Caterino operario predicto et dicto infrascripto notario, presentibus et stipulantibus, et cuilibet eorum et suis et cuiuslibet et eorum heredum et successorum; et renumptiavit expresse idem magister Iacobus in premissis exceptioni doli mali, condictioni indebiti et sine causa, actioni in factum et non facti, confessioni, liberationi, quietationi, promissioni et obligationi et rei dicto modo per singula non sic geste et non sic celebrati contractus et fori privilegio et omni aliis iuris et legum auxilio et favori.

Et iuravit sponte idem magister Iacobus ad sancta Dei evangelia, manu corporaliter, tacits scripturis, predicta omnia et singula perpetua observare et contra non facere vel venire de iure seu de facto, aliquo modo, iure vel causa; cui quidem magistro Iacobo presenti predicta omnia et singula sponte confitenti, precepi et mandavi ego Anthonius, notarius infrascriptus, nomine iuramenti et guarentisie, secundum formam Statuorum et Ordinamentorum Comunis Senarum, quatenus hoc instrumentum et omnia et singlua suprascripta observet dictis domino Caterino et notario infrascripto, presentibus et, ut supra, stipulantibus et dicto Comuni Senarum et Opere predicte, et suis et cuislibet eorum heredibus et successoribus per singula, ut superius continetur.

Actum Senis in palatio Comunis Senarum, in solito loco residentie dominorum Regulatorum et Statuariorum et maiorum Revisorum rationem Comunis Senarum, presentiibus Nanne Petri de Beringhucciis et Dominicho Michaelis de Senis, testibus presentibus et rogatis.

Ego Anthonius olim Iohannis Gennari, publicus, apostolica et imperiali actoritate, senensis notarius atque iudex ordinarius et nunc notarius, officialis et scriba Comunis Senarum et dictorum dominorum Regulatorum, predictis omnibus et singulis intefui eaque rogatus scripsi mandatoque dictorum dominorum Regulatorum publicavi.

Location: ASS, Diplomatico, Opera Metropolitana, at the date.

Bibliography: Milanesi, *Documenti*, vol. 2, doc. 67; B-P, *Fonti*, 2:339–342; Hanson, *Fonte Gaia*, doc. 81; *Mostra*, doc. 20.

Comment: In addition to this document all the other contracts connected with the fountain were cancelled as of the same date. Note that the rate at which the florin was calculated in this final accounting was the highest rate agreed upon in the past, namely, 4 lire 4 soldi 4 denari. A record of Jacopo's obligations for the *Fonte Gaia* is also known through the following document of 1420 (ASS, no. 13, Regolatori, fol. 99):

Notent successores in officio dominorum Regulatorum come maestro Iacomo di Piero della Guercia intagliatore al quale si allogò dal Comune di Siena la fabrica della nuova fonte per lui fatta et edificata sul Campo del Mercato della città di Siena, è tenuto così per vigore della sententia data infra el detto maestro Iacomo dall'una parte e lo egregio misser Caterino di Corsino operario et opera fu commesso la cura, sollecitudine et spendio d'essa fonte, sì come appare per mano dello spectabile huomo ser Iohanni Christofani, notaio della Riformagioni del Comune di Siena; per l'altra parte, per li egregi et honorevoli cittadini signori Regolatori e Statutarii et maggiori Riveditori delle ragioni del Comune di Siena et per li egregi et honorabili cittadini Nicholuccio di Teroccio, banchiere, Baptista di ser Lorenzo, lanaiolo, et Iacomo di Andreuccio orafo, operarii per lo Comune di Siena, deputati sopra el facimento d'essa fonte, per vigore di commissione in loro fatta per lo Consiglio Generale. La quale sententia fu data per essi signori Regolatori et operarii in absentia del nobile huomo Andrea di Salimbene Scotti, uno d'essi signori Regolatori, allora absente della città di Siena, la quale fu data a dì primo di Settembre 1419; per la quale sententia esso maestro Iacomo è tenuto ad obligarsi in forma valida che in caso che la detta fonte et figure d'essa per difetto di peli d'esso lavorìo ex [= e?] qualunque altra cagione infra el tempo di cinque anni allora prossimi a venire mancasse di non avere sua perfectione, come è al presente, esso maestro Iacomo è tenuto a rifare tale mancamento a tute sue spese si come d'essa sententia più largamente appare per mano di ser Antonio di Iohanni Gennarii notaio d'essi signori Regolatori. Doppo la quale sententia esso maestro Iacomo spontaneamente si obligò al detto messer Caterino, recevendo per lo Comune di Siena, a così

observare, sì come d'esso obligatione più diffusamente appare per mano d'esso ser Antonio notaro sopra e di sotto scritto.

Antonio Iohannis, tunc notarius dictorum dominorum Regulatorum, scripsi.

This document has been published by Borghese and Banchi (*Nuovi documenti,* doc. 47) and by Bargagli-Petrucci, (*Le fonti,* 2:342–343).

Document 97.

1420
Siena

Mention is made of Domenico di Bartolo, perhaps the painter.

Domenico di Bartalo garzone di butigha die dare lire due soldi uno contanti, à dare a libro rosso a fo. 149.

Location: AODS, no. 707 (Libro Rosso), fol. 16v. (Memoriale, 1420).

Comment: If this entry refers to the painter Domenico di Bartolo, it is the first document related to his career and places him within the setting of the cathedral workshop at an early date. Since Domenico had a close relationship with Jacopo della Quercia later on, the item is included here.

The account book that contains this reference is improperly catalogued (in fact, it is not listed). It was long ago tucked inside the oversize "Libro Rosso," where it remains.

Document 98.

May 11 to 14, 1420
Siena *(Fonte Gaia)*

Jacopo is paid for his work on the Fonte Gaia.

A maestro Iachomo dela Fonte lire cinquanta nove, soldi dieci e quali sonno per cierto resto del lavorio che gli fecie fare Guidoccio di Gionta operaio dell'aqua, che die stare apiè la Madonna e a così ci significhoro e regolatori che dovessemo acciendare et sonno al m(emoriale) S. a fo. 115.

Location: ASS, Biccherna, no. 303 (Entrata e Uscita), fol. 37.

Bibliography: B-P *Fonti,* 2:342; Baci, *Quercia,* p. 37; Hanson, *Fonte Gaia,* doc. 113.

Comment: Bacci suggests that this document refers to a support for candles or lamps beneath the central image of the Virgin on the fountain.

Document 99.

September to October 1420
Siena

Jacopo and Domenico di Niccolò dei Cori are elected priori *for the Terzo di S. Martino.*

Location: ASS, Concistoro, no. 2519, at the date ("pagamenti del concistoro"), fol. 37.

Bibliography: Bacci, *Quercia,* p. 38; Bacci, *FdV,* pp. 371–372.

Comment: In a document of the same period there is also a reference to Jacopo as "Magister Iacobus Pieri de la Ghuercia intalliator" (ASS, Concistoro, no. 1618, fol. 20).

Document 100. December 28, 1420
 Siena

Jacopo, with others, acts as guarantor for the painter Martino di Bartolomeo.

Location: ASS, Concistoro, Mallevadori de' Castellani, no. 2460, fol. 6v.

Bibliography: Bacci, *FdV*, pp. 371–372; Hanson, *Fonte Gaia*, doc. 115.

Comment: Subsequent to the completion of the *Fonte Gaia*, Jacopo was often called "dela Fonte," as is the case here, and later, in the Bolognese documents.

Document 101. January 28, 1421
 Siena

Jacopo, in Siena, acts as guarantor for Alberto di Betto da Assisi, intagliatore, *for four wooden figures to be placed in the Cappella del Crocifisso in the cathedral of Siena.*

+ Al nome di Dio, amen adi xxviii di Gienaio 1420 [= 1421, modern]

Sia manifesto a chi vedrà questa scrita, chome maestro Alberto di Betto d'Asisi, maestro d'intaglio, à tolto a fare da ser Ghalghano di Cierbone, citadino di Siena o vero da misser Turino di Matheo, hoparaio de l'uopara sancte Marie, per lui, per lo detto Ghalghano, quatro fichure di legnio bene fatte, e bene proporzionate a giudixio d'ogni buono ischolpi-tore; e dèbale fare del disegnio cho so' quale che so' a la chapella del Crociefisso sotto la voltarella del detto Crociefiso, tanto grande quanto è lo spazio che le de' ricievare sotto la voltarella; e deno esare poste sopra d'una basetta inchornicciatta, come schoglio drietto.

E le dette fichure ci à promesso di fare e trare a fine per tenpo di tre messi, ben fatte e ben conposte per lo modo detto. E deba avere de le dette fighure fiorini vinti d'oro, di lire quatro el fiorino, cominicando el di detto sopra. E detti denari deba avere in quatro paghe: la prima cominciando di fiorini cinque: l'altre di mano in mano, come conparirà co'lavorio, e de le dette cosse e denari gli entra sichurtà maestro Iachomo di maestro Piero e che le sarano fate a' detti tempi. E se no, sodisfare d'ogni dano e 'teresso, e di ciò soscrivarà eso maestro Iacomo qui di sotto di sua proprio mano.

Testimoni so' e presenti: a le parti, maestro Pauolo di Martino e Duccio di Iacomo, e quagli soscrivarano qui di loro mano e saranno testimoni. Ed io Nanni di Francesco Bertini ò fata questa scrita di mia propria mano e preghiera de le partti, e presenti e detti testimoni, a dì, anno soprascritto di sopra.

Ed io Iacomo del maestro Piero mi soscrivo di mia mano esa siqurtà e ricolta a tute le chose di sopra iscritte, farlle osservare ed osservare con buona diligienzia, ano, dì, di sopra detto.

Ed io Pauolo di Martini fui presente a la sopradetta inscritta, a dì ed ano sopradetto.

Ed io Duccio di Iachomo fui presente a la sopra detta scritta di opra, dì e anno e mese scritto di sopra.

[on the other side] Scritta di 4 fighuri di ser Ghalghano.

Location: AODS, Libro di Documenti Artistici, no. 41 (formerly).

Bibliography: Milanesi, *Documenti,* vol. 2, doc. 69; Bacci, *Quercia,* pp. 51–52.

Comment: Bacci was unable to find any information about this Alberti di Betto from Assisi. Enzo Carli (*Duomo di Siena* (Siena, 1979), pp. 102–103) has attributed to him the Lamentation group (consisting of four figures) located in the cathedral beneath the table of the altar of San Giovanni Evangelista. The heavily repainted figures are indeed of wood. Final judgement concerning the attribution must wait until the group has undergone cleaning. It can be said for now, however, that these figures have a distinctly northern, that is to say Burgundian, flavor. Good color photographs of the group (Scala, Florence) are in A. Cechi, *The Piccolomini Library in the Cathedral of Siena* (Florence, 1982), figs. 4 and 5. A group in San Francesco in Urbino, usually described as "mid-fifteenth century German," might well be by the same artist, who was perhaps an Umbrean with experience north of the Alps.

Document 102.

January 29, 1421
Siena (Loggia di San Paolo)

The Comune of Siena assumes part of the cost of the Loggia di San Paolo so that work on the tribune of the Cathedral and the Baptismal Font will not be hindered by lack of funds.

Location: ASS, Concistoro, Deliberazioni, at the date, fol. 14v.

Bibliography: Borghesi and Banchi, *Nuovi documenti,* doc. 50, p. 92.

Document 103.

April 2, 1421
San Gimignano *(Annunciation)*

Jacopo receives a payment for the Annunciation *group for the Collegiata of San Gimignano.*

E più pagamo per l'Annunziata che fecemmo intagliare con l'angiolo, la quale intaglia maestro Iacopo della Fonte da Siena e costalire cento dieci e soldi 10.

Location: Biblioteca Comunale San Gimignano, "Spoglio" from Libro d'Entrata e Uscita dell'Opera, 1417–1421, fol. 25.

Bibliography: Bacci, *Quercia,* pp. 34–35.

Comment: The notice was found in a *spoglio* of documents located in the Biblioteca cited, no. 60, collected in 1754. The following may be added to the portion published by Bacci:

L'imagini della Vergine Annunziata e dell'Angelo dette di sopra furono fatte l'anno 1421 come nel Libro d'Entrata e Uscita dell'Opera dal' anno suddetta 1417 al 1421, a c. 40 sotto dì 25 April. . . . La immagine della Nunziata e dell'Angelo vi erano ancora prima e ora l'ànno in convento le monache di S. Caterina.

There is no special reason to assume from this document that the sculpture was actually finished in 1421. On the contrary, I believe that the group dates from 1424–1425, judging from Jacopo's working habits and the style of the figures, which is close to the early works on the *Portal of San Petronio.* Jacopo probably finished his part, as carver, shortly before Martino di Bartolomeo undertook the painting and gilding in 1426 (the base of the Virgin bears Martino's signature and that date). Jacopo's signature, without a date, has been uncovered on the base of the angel.

Document 104. 1422
 Lucca

Jacopo's name and the year are carved on the Trenta Altar.

H[OC] OP[US] FEC[IT] IACO[BUS] MAG[IS]TRI PET[RI] D[E] SENI[S] 1422.

Location: Trenta Altar (inscription), Cappella di San Riccardo, San Frediano, Lucca.

Document 105. January 7, 1422
 Siena *(Fonte Gaia)*

A piece of marble is mentioned for the Fonte Gaia.

Anche paghai a dì vii di genaio a fare e rechare una pietra di marmo dala fonte del champo.

 Lire I soldi iii.

Location: AODS, no. 666, fol. xxvii.

Document 106. May 5, 1422
 Lucca

Piero di Angelo gives power of attorney to his son Jacopo to collect monies from Giovanni da Imola.

Anno et indictione suprascriptis [1422, XV] die quinta mensis maii. Magister Petrus quondam Angioli Guarnerii aurifex et intagliator [these two words written above the line] de Senis, Luce habitans, hoc publico instrumento ex sua certa et deliberata scientia et non per aliquem errorem omni via iure modo et forma quibus magis et malius potuit, fecit constituit creavit et ordinavit suum verum et bonum procuratorem actorem factorem et certum numptium specialiter et quicquid de iure melius esse potest magistrum Iacobum intaliatorem eiusdem magistri Pietri filium habsentem tamquam presentem ad infrascripta omnia et singula facienda et procuranda videlicet ad habendum petendum requirendum et nominatim a Iohanne . . . [blank] de Ymola intaliatore solitio habitare in civitate lucana; item ad liberandum et absolvendum etc. item ad compromictendum etc.; item ad agendum et causaudum etc.; item ad substituendum etc.; et generaliter etc. Et rogavit me Deodatum etc. notarium de predictis publicum conficerem instrumentum.

Actum Luce in suprascripta apotheca exercitii mei Deodati, coram Bartholomeo olim Iohannis tessitore et magistro Iacobo olim Iohannis barbitonsore de Luca testibus rogatis, suprascriptis anno indictione et die.

Ego Deodatus suprascriptus rogavi etc.

Location: ASL, Archivio dei Notari, ser Diodato Ammannati, no. 407, at the date (no pagination).

Bibliography: Lazzareschi, "Dimora," doc. V and p. 89; Hanson, *Fonte Gaia,* doc. 89.

Comment: As determined by Bacci (*FdV,* p. 356 and *n* 1), Giovanni da Imola was back in Siena by July 25, 1422, where he is on record once again on January 23, 1423 (modern), acting as a *compare* at baptisms.

Document 107.

Miscellaneous payments for work on the Baptismal Font *(and other work).*

Maiestro Nanni del maiestro Iacomo da Lucha [che] lavora il marmo, de' dare Fiorino uno Lire cinqueciento cinquantasette soldi diciesette, come apare indrietto a foglio 46.

Fiorino 1 Lire soldi xviii

[The sum of 569 lire 18 soldi is repeated in arabic numerals above the line, by way of correction.]

E die dare Lire setantuno soldi dicioto denari otto per danari contanti, come apare al memoriale di me Pietro di Nofrio, Kamarlingo, a foglio 16, e sono a mia escritta a foglio 32 . . .

Lire LXXI soldi xviii denari 8

esbattute queste setantuna Lire, però che sono nel'altra faccia. Anne datto tuto i'lavoro scritto qui di sotto per partito e in che modo: tredici pezi di tavole grandi di marmo, in tuto bracia vintuna e du' terzi, per soldi vinzei il braccio, montano lire vintoto soldi tre

Lire XXVIII soldi iii

diciesette pezi di tavole picholle, in tuto braccia undici e quarti tre, per soldi vinzei il braccio, montano lire diciesette soldi cinque

Lire XVII soldi v

dodici pezi di schalone no'lavoratto, in tuto braccia nove per soldi trentuno il braccio, montano Lire tredici soldi dicienove

Lire XIII soldi xviiii

due schaloni dela chiocciola, no' lavorato, per soldi tre[n]ta l'uno in tuto Lire tre

Lire III

uno schudo monta i tuto soldi vinti

Lire I

uno pezo di collona quadra, longa braccia due, per soldi vinzei il braccio, per tuto lire due soldi sedici

Lire II soldi xvi

dodici pezi di tavola del fregio, braccia sette e un terzo per soldi vinzei i' braccio, montano in tuto Lire nove soldi due

Lire VIIII soldi ii

vinzei pezzi di schalone sono nel' Uopara per lo batesimo, sono braccia sono braccia *[sic]* vinticinque terzi due, per soldi ventuno i' braccio in tuto lire trentoto soldi quindici

Lire XXXVIII soldi xv

cinque pezi di cornicie per l'orlo dela fonte de' batesimo, braccia nove quarti uno, per soldi trentuno i' braccio montano Lire quatordici soldi uno

Lire XIIII soldi i

sei capelette del batesimo braccia uno e un terzo, per soldi trenta l'uno in tuto Lire nove

Lire VIIII

sei schaloni dela chiocciola, per soldi trenta l'uno in tuto Lire nove

Lire VIIII

nove pezi di cornicie che vano intorno ale storie de'atone del batesimo, bracia nove quarti tre, per soldi trentuno i' braccio, per tuto lire quatordici soldi 13

Lire XIIII soldi xiii

sei pezi del primo grado de' batesimo, braccia undici e mezo per soldi trentuno el braccio, in tuto Lire diciessete soldi quindici

Lire XVII soldi xv

un pezo di marmo de' sopradetto grado, uno braccio soldi trentuno
Lire I soldi xi
sesantatre braccia e mezo di schaloni che sonno murati in San Giovanni, per soldi trentuno il braccio, in tuto Lire novantoto soldi oto
Lire LXXXXVIII soldi viii
vinticinque pezi di schalone, che sonno murati ala citerna, a misura bracia vintuna e mezo, per soldi trentuno i' braccio, in tuto Lire trentadue soldi dieci
Lire XXXII soldi x
. . . .
sette pezi di cornicie per l'orlo dela citerna, bracia dieci, terzo due Lire sedici soldi diece
Lire XVI soldi x
sei cantoragli ala bocha dela citerna, bracia due, soldi venzei i' bracio
Lire II soldi xii
quatro pezi di colonne murate in su la loggia, grosse mezo braccio, braccia quatro e un quarto, per soldi quaranta il braccio, Lire otto soldi dieci
Lire VIII soldi x
Somma Lire 336 soldi li denari o. Resta a dare Fiorino 1 Lire 233 soldi 6, posti 'nanzi del' altra faccia.

Location: AODS, N. 708 (Libro Giallo), fol. 42v.

Bibliography: Bacci, *Quercia*, pp. 143–144; Paoletti, *Font*, doc. 314.

Comment: Only the final item refers to work other than for the *Baptismal Font.* Presumably the payment was for the Loggia of San Paolo.

Document 108. March 26, 1423
 Siena

Jacopo, together with Ghino di Bartolomeo, maestro Lorenzo di Filippo, and Tommè di Vannino, is appointed to oversee three fortresses in Sienese territory.

Location: ASS, Concistoro, no. 343 (Deliberazioni), fol. 16.

Bibliography: Bacci, *FdV*, pp. 379–382; Hanson, docs. 117, 118, 119.

Comment: Documentation related to this mission continues until April 29 (see fol. 39), and the events may be followed in Concistoro no. 1621, fol. 40, dated April 7, 1423. It is noteworthy that Jacopo is called "Magister Iacobus della Fonte" or "maestro Jacomo di Piero" in these notices.
 Ghino and Tommè were two of the supervisors of work on the *Fonte Gaia.*

Document 109. May 1423
 Siena *(Baptismal Font)*

Payment is made to Donatello for one of the storia for the Baptismal Font.

A maiestro Iacomo di Piero de la Guercia Lire cinquanta soldi uno, e quagli demo per lui a maiestro Donato di Nicholò di Fiorenza, posti a una sua gaione a li[]ro gialo a fo. 24.
Lire L soldi i

Location: AODS, Entrata e Uscita, 1423, fol. 27.

Bibliography: Cornelius, *Jacopo della Quercia,* p. 38; Bacci, *Quercia,* p. 124; Paoletti, *Font,* doc. 118.

Comment: This payment, which passes on to Donatello part of Jacopo's advance for one of the two histories, is recorded in various forms. The payment to Donatello (AODS, no. 708, fol. 240) reads:

[Donatello di Nicholò da Firenze sculptore] Anne avuti Lire cinquanta soldi uno, e quagli ebe già più tempo per maestro Iacomo della Guercia, come apare indietro a ffo. 24 a ragione del detto maestro Iacomo, il quale maestro Iacomo doveva fare due historie cioè la sopradetta (quando fu recata la testa di San Giovanni ala mensa de' re) à fatto Donatello e un altra no la fece; posto a ragione del detto maestro Iacomo che n'abi dati indietro a ffo. 70 Lire L soldi i. (published by Milanesi, *Documenti,* 2:135)

See also doc. 95, above.

Document 110.

October 16, 1423
Siena

Jacopo receives guarantees for loans.

Ser Lucas Nannis notarius denuntiavit quod die xvi de mense ottobris anni predicti [1423]
Magister Iacobus magistri Petri vocatus magister Iacobus de la Fonte de Senis recepit obligationem a domina Dea filia olim Iohannis Nerii et uxore olim Neroccii Iohannis del Giga, clamidata Fratrum Minorum, de centumquinquaginta quattuor libris denariorum sen. ex causa mutui

lib. CL[IIII] den.

Magister Iacobus predictus dicta die recepit obligationem a domina Antonia, filia olim Cini domini Iacobus de Saracenis et uxore olim Bartoli Laurentii aurificis de Senis, de trigenta duabus libris ex causa mutui

lib. XXXII den.

Magister Iacobus prefactus dicta die recepit obligationem a domina Nanna, filia olim ser Iohannis de Montevarchi, comitatus Florentie, et uxore Iacobi Capaccini, de centum sessa-ginta lib. denariorum ex causa muti

libr. CLX den.

Location: ASS, Gabella Contratti, no. 158, fol. 57v.

Bibliography: Bacci, *FdV,* p. 411.

Comment: Jacopo had other dealings with the family of Bartolo di Lorenzo, the goldsmith whose son Cino was his *garzone.*

Document 111.

November 6, 1423
Siena

Payment is made for marble for the new pulpit in the cathedral.

[Maestro Bastiano di Corso da Firenze, maestro del marmo] Anne dato Lire 66, i quali furono per marmo che lui comprò a Firenze ciò fu Chararrese per detto di misser Bartalomei

operaio; el detto marmo fu per lo pergholo dove si predicha, avemo fede da maestro Domenicho di Niccholò, che fecie il decto pergholo.

<div align="center">Lire LXVI</div>

Location: AODS, no. 708, fol. 38.

Comment: The reliefs for this pulpit were assigned to Giovanni da Imola, but he died after finishing one (San Marco) and only just beginning another. This document provides us for the first time with the information that Domenico di Niccolò dei Cori was apparently responsible for the pulpit and perhaps even designed the reliefs.

Very possibly the marble that had been shipped can be connected with an unpublished document (Archivio dell'Opera del Duomo, Florence, codex II.1.83, Bastardello di deliberazioni . . . secondo semestre, 1423) generously passed on to me by Dr. Margaret Haines, who has transcribed it as follows: "Licentia marmi pro comuni Senarum. Antedicti operarii ut supra deliberaverunt quod concedatur marmum comunitati Senarum pro pretio usitato, prout in lictera transmissa a comunitate Senarum dictis operariis continetur et scriptum est."

Document 112. February 24, 1424
 Siena

Francesco di Valdambrino produces a model for the firm of Turino di Sano and Giovanni di Turino.

E die dare Lire sette contanti demo per lui [Turino di Sano orafo e Giovanni suo figliuolo] a maiestro Francisco di Valdanbrino per una figure fecie al detto Turino.

Location: AODS, Memoriale, 1423–1424, fol. 5v.

Bibliography: Bacci, *Quercia,* pp. 70–71; Bacci, *FdV,* p. 274.

Comment: Bacci has shown that Francesco supplied models for various artisans. On certain occasions, Francesco was called a "sculptor," and the possibility of his participation on the *Ilaria Monument* and on the *Fonte Gaia* appears to be strengthened. The Turini firm was paid for a silver figure of San Crescenzio on November 16, 1425; this figure is probably the one for which Francesco made the model mentioned in this document. Collaborations of this nature were common during this period in Siena. Such was probably the situation for several of the bronze putti for the *Baptismal Font.* Seymour (*Quercia,* p. 64), who based his opinion on material provided by J. Paoletti, believes that identical circumstances surround the so-called Fortitude, which was produced for the *Baptismal Font,* as well. Jacopo or even Donatello could have supplied a drawing or plastic three-dimensional *modello* for Goro di ser Neroccio, who was actually paid for the statuette.

Document 113. April 21, 1424
 Siena

Jacopo chooses the banker Guccio di Galgano as his procuratore *to collect 100 florins he had lent to Simone Saracini.*

Bibliography: Bacci, *Quercia,* p. 255, where the document is said to be located in the private archive of the Bichi-Ruspoli-Forteguerri.

Document 114. May 25, 1424
 Siena

Jacopo receives a dowry of 350 florins from Agnese, daughter of Giovanni (Nanni) di Domenico Fei.

Item [Ser Iohannes Nicholay Guidonis notarius] denuntiat quod die XXV Maii 1424
 Magister Iacobus magistri Pieri scultor de Senis fuit confessus habuisse a domina Eufrasia relicta Nannis Domenici Feiy pro dotibus domine Agnetis filie sue et olim dicti Nannis, sponse et future uxoris dicti magistri Iacobi, Florenos trecentos quiquaginta auri ad libras quatuor floreno, Florenos di sol. 80 Flor.
 Solvit fratri Iohanni Antonio camerario in fo. 26, die XXI Aprilis 1425 cum duplo pluris vigor reformationis generalis consilii, lib. XLVI, sol. xiii, den. iiii.

Location: ASS, Gabella Contratti, no. 177, fol. 78.

Bibliography: Bacci, *FdV*, p. 412; *Mostra*, doc. 21, p. 336.

Comment: There is no other mention of Agnese by name among the preserved documents concerned with Jacopo della Quercia. The amount of the dowery should be considered substantial for an artisan.

Document 115. January 20, 1425
 Siena

Payment is made to Nanni di Jacomo for Jacopo della Quercia.

 E die dare a dì 20 di Gienaio [1424, = 1425, modern] Lire sedici, i quali denari si danno a maestro Iachomo dela Fonte.

Location: AODS, Memoriale, at the date, fol. 10.

Bibliography: Paoletti, *Font*, doc. 127.

Document 116. March 25 to April 14, 1425
 Siena *(Baptismal Font)*

Payments are made to Jacopo for the Baptismal Font.

 Maestro Iachomo di Piero de la Ghuercia maestro di 'tagio die dare lire otto i quali diemo a misser Pietro da Monte Alcino per lo piato facievo chon eso l'uopera al podestà per lo batesimo, chome apare al memoriale di Salamone a fo. 18 ed a escita [= uscita] a fo. 66.
 Lire VIII
 E die dare Lire quatro le quali diei per la detta quistione a Lorenzo di Lapo chome apare al memoriale di Salamone a fo. 18 e a'scitta a fo. 66.
 Lire IIII
 E die dare a dì 14 d'Aprile Lire quatro, le quali portò Pauolo nostro a messer Pietro per la sua quistione

 Lire IIII
 Somma Lire 16.

Location: AODS, no. 708 (Libro Giallo), fol. 63.

Bibliography: Bacci, *Quercia,* p. 125; Paoletti, *Font,* doc. 315.

Comment: The purpose of the payments and the nature of the dispute are not known to me.

Document 117. March 28, 1425
 Bologna (Porta)

A contract is drawn up for the Portal of San Petronio *in Bologna.*

Locatio et Capitula pro porta magna construenda per Iacobum della Fonte.

Memoria che questo dì sopradetto il reverendissimo Padre e Signor nostro Arcivescovo d'Arli, Legato e Signore nella Città di Bologna, diede e concesse la manifattura della porta grande di mezo la chiesa di San Petronio a maestro Iacomo dalla Fonte da Siena, intagliatore e maestro del lavoriero di marmore, in su la forma che appare per un disegno fatto di sua mano e sottoscritto di sua propria mano; con quelli medesimi lavori e più vantaggiati che non si contengono nel disegno. Et oltre i detti lavorieri deve fare le infrascritte figure, con li modi e pacti che di sotto si contiene.

In prima, deve havere per manifattura della sopradetta porta Fiorini 3 mila e seicento di Camera del Papa, e così le promesse il sopra detto nostro Signore messer lo Legato, per tutta la fattura de la sopra detta porta, e di tutti i lavorieri che in quella si contengono, per questi patti e modi: che presente deve havere di denari della fabrica di San Petronio, per parte del sopra detto pagamento, fiorini centocinquanta d'oro di Camera, li quali denari si doveranno scontare nelli pagamenti che a lui si faranno, come di sotto si contiene; et per questi ci ha data per cautione e per sicurtà promessa Alberto di maestro Thomasino da Bressa, il quale promesse di pagare et di restituire alla detta fabrica ogni volta che il sopradetto maestro Iacomo ricusasse di venir a fare il sopradetto lavoriero, ad ogni requisitione di detti Ufficiali che per tempo saranno. E promesse il sopradetto messer lo Legato al sopra detto maestro Iacomo ch'egli sarà pagato di denari della detta fabbrica ogni volta ch'egli lavorerà il sopradetto lavoriero, ogni mese quella quantità di denari della sopra detta somma che havesse francato. Il qual lavoriero promesse d'haver compito al termine d'anni doi, dal dì che le pietre si haveranno e dal dì ch'egli cominciarà a lavorare successivamente.

[1] In prima, a'altezza della porta deve essere quaranta sino xliii piedi.

[2] Item, la larghezza sia quanto si richiede alla sua proportione, che è de la metà de la sua altezza, o veramente, alcuna particella, quanto parerà esser convenevole.

[3] Item, lo sporto che deve fare la porta in fuori sia tanto quanto sono li pilastri, o veramente il piè che cinge tutta la facciata della chiesa al presente, perché pare esser così convenevole.

[4] Item, li pilastri principali de la porta siano piè doi e mezzo larghi, perché così paiono esser recipienti all'edificio.

[5] Item, le colonne che vanno nella porta, intagliate o dritte o avolte, sian corrispondenti all'edifizio quanto per li lavorieri fatti per li gran maestri si costuma.

[6] Item, la colonna a tre quadri dove stanno li Profeti mesimamente corrisponda con l'altre cose a sè pertinente.

[7] Item, l'altra colonna a tre quadri, sfogliata, sia corrispondente alla sua debita forma.

[8] Item, le basi da piè delle cornici, i capitelli di sopra, tutti corrispondenti all'edificio et a suoi membri.

[9] Item, le historie quatordici che vanno in pilastri, del vecchio Testamento, siano le figure doi piedi di lughezza.

[10] Item, le tre historie che vanno nel cardinale, della Natività di Christo, siano doi piedi ciascuna figura.

[11] Item, li vinti otto mezi Profeti siano l'uno un piedi e mezo.

[12] Item, la Nostra Donna col suo Figliuolo in braccio sia alta, a sede[re], tre piedi e mezo: Nostro Signore messer lo Papa sia ritto tre piedi e mezo; messer S. Petronio sia quanto il Papa: scolpito ciascheduno a tutto rilievo. Le quali tre figure vanno sopra l'arco della porta: Monsignore in ginocchio, quanto si richiede grande.

[13] Item, li leoni che vanno da lati della porta siano grandi come sono li naturali leoni.

[14] Item, le due figure che vanno di sopra su i pilastri, cioè S. Pietro e S. Paolo siano d'altrezza di piè cinque l'uno.

[15] Item, Nostro Signore Giesù Christo portato da gli angeli sia a sedere alto piè quattro per sino a piè quattro e mezzo; con gli angeli volanti sia ciacheduno quattro piedi.

[16] Item, nostro Signore in croce posto, il quale sia sopra il fiorone sfogliato del frontespiccio, sia d'altezza di doi piedi.

Le quali tutte figure per sé siano rilevate intieramente, e le istorie dicisette dei pilastri o del cardinale siano rilevate quanto si richiede a loro bellezza.

[17] Item, tutti li Profeti rilevati per lo modo che si richiede a star bene nelle cose loro.

[18] Item, che tutte le cose della detta porta siano intagliate et ornate, come per il disegno di mano di maestro Iacomo appare, il quale è posto sopra carta di papiro, disegnato di penna, et etiamdio con più perfettione o ordine che 'l detto disegno non dimostra.

[19] Item, deve fare che nel detto disegno la colonna, la quale non è disegnata, delle sette historie, s'intenda essere come l'altra.

[20] Item, deve fare cinque figure che non sono nel disegno, cioè: la figure di Giesù Christo, e quattro altre figure al senno e volontà di Monsignore.

Location: AFSP, Libro + il primo, no. 2, fols. 61–63.

Bibliography: Milanesi, *Documenti,* 2:125–27; Davia, *Le sculture,* doc. A; Gatti, *La fabbrica,* doc. 37; Supino, *Scultura Bologna,* doc. 7; Supino, *Sculture Porte,* doc. 1; Beck, *Portale,* doc. 1.

Comment: There is an English translation of this document in Chambers, *Patrons and Artists in the Italian Renaissance,* pp. 3ff.

The Alberto di maestro Thomasino da Bressa mentioned as Jacopo's guarantor, and whose father was Jacopo's partner for the *Ferrara Madonna,* must be Arduino da Baiso, whose name occurs several times in the Bolognese documents, as pointed out by Matteucci, *La Porta Magna,* p. 13n7. The contract has been subjected to an attentive study by C. Gnudi, in "Revisione," pp. 13ff. Gnudi's conclusions, which are often at variance with mine *(Portale,),* are discussed at length in comments below and in the catalogue.

The drawing mentioned in the contract was considered an object of value. It was stolen by a later engineer of the *fabbrica,* as is confirmed by the following document, which is dated August 16, 1463 (AFSP, no. 567, 5, at fol. 19): "Richordo che questo dì 16 d'aghosto maestro Zoane Negro zi [= ci] chonfessò avere apreso di si [= se] el designio dela porta ghrande di San Petronio ch'è quello fa misser Iacomo dala Fonte." The drawing was probably colored to show the distinction between the red and white stone planned for the structure (see doc. 149).

Considering the degree of precision that marks this contract, it is at the least curious that the kind of stone for the new portal is not specifically mentioned. Perhaps there was another *scritto* with such details.

Document 118. April 16, 1425
 Siena *(Baptismal Font)*

Ghiberti writes to Giovanni di Turino about the bronze panels for the Baptismal Font.

Location: AODS, Libro di documenti artistici (formerly), currently on exhibit (1990).

Bibliography: Milanesi, *Documenti,* vol. 2, doc. 85; Krautheimer and Krautheimer-Hess, *Ghiberti,* doc. 155; Paoletti, *Font,* doc. 130.

Comment: In this letter, Ghiberti reveals a cordial friendship with Giovanni, who he calls a "dear friend"; he also sends his regards to Francesco di Valdambrino. Ghiberti asks Giovanni's assistance in securing the return of his drawings that had been lent to Goro di Neroccio but that subsequently were in the possession of Domenico di Niccolò dei Cori. Ghiberti seems to be on intimate terms with the artistic community in Siena with one notable omission: Jacopo della Quercia.

Indeed Ghiberti probably disapproved of Jacopo's action in turning over to Donatello one of the histories for the *Baptismal Font.* We are left with the impression that Jacopo had a close association with Donatello and Brunelleschi but a cool one with Lorenzo Ghiberti, who had been entirely eliminated by Jacopo from work on the upper portion of the *Font.* A connection existed between Jacopo's friend Mariano di Jacopo, called "il Taccola," and Brunelleschi; (see my *Mariano di Jacopo detto il Taccola,* p. 15 and *n*18, and my "Jacopo della Quercia and Donatello: Networking in the Quattrocento," *Source* (1987), 6(4):6–15.

After he had completed his two histories, Ghiberti, for his part, was anxious to obtain the commission for four of the Virtues on the lower portion of the *Baptismal Font* (see Bacci, *Quercia,* pp. 182–183). Instead, Donatello was granted part of the commission, with the remainder of the work given over to Giovanni di Turino and Goro di ser Neroccio. This rebuff occurred while Jacopo's influence was determining in Siena.

Document 119. April 21, 1425
 Siena

Jacopo pays a small tax in Siena for the registration of the dowry contract in the previous year.

Location: ASS, Gabella Contratti, n. 159, fol. 78.

Bibliography: Bacci, *FdV,* p. 413; Beck, *Portale,* doc. 2.

Document 120. April 23, 1425
 Bologna

The papal legate sends money for the transport of stone from Lago Maggiore.

Da Andrea Mezovilani ducati trenta de Venezia i quali pagò al ... [blank] de santo Antonio el quale mandò Monsignore lo Ligato a Ferara e Venezia e Mantova e Verona e Milano per lo transito delle prede de marmore che se dono fare vegnire da lago Mazore, a soldi 40 denari.

Lire LX

Location: AFSP, Giornale, at the date, fol. 49.

Comment: This notice refers to stone for the Basilica of San Petronio, but not necessarily for the Portal, which is not specifically mentioned; nor, for that matter, is Jacopo della Quercia. The windows on the flanks were being built at the time, and the stone may have been for them.

Document 121.

April 23, 1425
Bologna *(Portal of San Petronio)*

Payment is made to Jacopo of 10 florins.

Location: AFSP, Giornale, at the date, fol. 50v

Bibliography: Beck, *Portale,* doc. 3.

Comment: This is the first preserved notice for Jacopo's work on the Bolognese *Portal.*

Document 122.

May 23, 1425
Bologna *(Portal)*

A payment to Giovanni da Modena for preparing a drawing of the Portal *is recorded.*

A Zoane da Modena ave da Andrea Mezovilani per parte della fatura della porta de' depingere in la ghiexia de Sam Petronio Lire trenta.
Lire XXX

Location: AFSP, Giornale, at the date, fol. 53.

Bibliography: Beck, *Portale,* doc. 4.

Comment: This is the first of several payments made to this important Emilian painter. He must have been employed to render Jacopo's drawing to scale on a provisional wall in San Petronio. Apparently he worked closely with the sculptor in developing those parts of the original design that had not been fully articulated when submitted with the contract. In 1441 the wall was torn down to make way for the extension of the church and the workmen were not responsible for redoing the drawing elsewhere (see Gatti, *La basilica petroniana,* p. 314).

Document 123.

April 30, 1425
Bologna

Payment for the shipment of stone from Lago Maggiore is recorded.

A Guielmo Gatto le quali receve da Andrea Mezovilano ducati trenta veneciani senza detratione alcuna, ducati XXX per nolo de le prede de condure da Mergozo del Lago Mazore de Como.

Location: AFSP, Giornale, at the date, fol. 53v.

Comment: Since the *Portal* is not specifically mentioned (similar to doc. 120), as is done in virtually every payment for activity on it, this shipment was probably *not* for that part of the church decoration. Indeed the shipments must have predated Jacopo's active role. Of particular interest is the general confusion on the part of the bookkeeper about the localities from which the stone came and about geography in general, as the conflation of Lago Maggiore

and Como indicates. Mergozzo is a few kilometers from Candoglia, where C. Gnudi has suggested much of the marble for the portal originated (see Gnudi, "Revisione"). Candoglia marble is sometimes called the "marmo del Duomo di Milano" and has a distinctive rose cast; see M. Pieri, *I marmi d'Italia*, 3d ed. (Milano, 1964), p. 340.

Document 124. August 9, 1425
 Bologna *(Portal)*

Another payment to Giovanni da Modena for his work on the Portal *design is recorded.*

Da Andrea predetto [Mezovilani] i quali pagò a maestro Zohane da Modena depintore per parte del desegno dela porta.

Lire XXV

Location: AFSP, Giornale, at the date, fol. 61v

Bibliography: Supino, *Scultra Bologna*, p. 49; Supino, *Sculture Porte*, p. 12; Beck, *Portale*, doc. 5.

Document 125. August 18, 1425
 Siena *(Baptismal Font)*

Jacopo returns advances given to him for the relief of Zaccharias.

[Maestro Iachomo di Piero della Guercia maestro d'intaglio]
Anne dati a dì 18 d'Agosto 1425 Lire quatrociento otanta, e qua' denari ci ristituì Ghuccio di Ghalgano Bichi banchiere come richolta de la detta soma e per lui ci li dè Lonardo e Giovanni di Cristofano Turamini et compagni banchieri, dero contanti a me Pietro di Marcho, al presente camarlingo, e sonno a mia entrata fo. 9.

Lire CCCCLXXX

Location: AODS, no. 708 (Libro Giallo), fol. 70v.

Bibliography: Cornelius, *Jacopo della Quercia* p. 38; Bacci, *Quercia*, p. 125; Beck, *Portale*, Doc. 6; Cf. Paoletti, *Font*, doc. 135.

Comment: The repayment of advances for the relief for the *Baptismal Font* assigned to Jacopo was prompted by a notarile act, to which Bacci refers (*Quercia*, p. 254), with the date of November 5, 1424 (ASS, Diplomatico Primaziale, pergamena, 1424), after Jacopo had failed to finish the relief according to the stipulations of the contract. There is no reason to believe that he even began the relief, and since he had become occupied with the lucrative and prestigious Bolognese commission, he would have been unable to produce something quickly. Nor should we assume that Jacopo's relief was rejected by the Opera. He returned all monies simply because he had nothing to show and seemed unwilling to prepare something, unlike Donatello and Ghiberti.

Document 126. September 12, 1425
 Bologna *(Portal)*

A payment to a maestro Giovanni da Siena is recorded.

Da Andrea [Mezovilani] predetto, i quali pagò maestro Iacomo dala Fonte da Siena e per lui a maestro Zohane da Siena per parte de la soa soma, Lire quatro

<div align="center">Lire IIII</div>

Location: AFSP, Giornale, fol. 63.

Bibliography: Beck, *Portale,* doc. 7.

Comment: Supino considers a payment on September 27, 1425 to a Giovanni "da Pisa" (see below, doc. 127) a bookkeeper's error for Giovanni "da Siena." The question remains open: perhaps the name recorded for this payment is the error, and both payments were for a Giovanni from Pisa. If we are indeed dealing with two persons, neither of them recurs in the Bolognese documents.

Document 127. September 27, 1425
<div align="right">Bologna *(Portal)*</div>

A payment to a maestro Giovanni da Pisa is recorded.

Da Andrea [Mezovilani] i quali pagò maestro Iacomo dala Fonte da Siena e per lui a maestro Zohane da Pisa Lire tre.

<div align="center">Lire III</div>

Location: AFSP, Giornale, fol. 64v.

Bibliography: Supino, *sculture Porte,* p. 24; Beck, *Portale,* doc. 8.

Comment: Supino considers "da Pisa" an error for "da Siena." See my comment, doc. 126 above.

Document 128. October 3, 1425
<div align="right">Bologna *(Portal)*</div>

A payment of 50 lire is made to Jacopo.

Location: AFSP, Giornale, fol. 65v.

Bibliography: Beck, *Portale,* doc. 9.

Comment: The folio upon which this payment is recorded is partly corroded. However, it is clear that here Jacopo is called "maestro Iacomo de la Fonte," as he usually is in the Bolognese documents.

Document 129. October 13–18, 1425
<div align="right">Bologna *(Portal)*</div>

A payment of 150 lire is made to Jacopo.

A maestro Iacomo dalla Fonte da Siena Lire cento cinquanta, zioè Lire 50 di bolognini e Lire 100 di pichioni, ave da Francesco di Guidalotto contanti, per parte di quello de' avere per le fatiche sue durate a andare a Milano per la priete; ave per parte della dette fatiche Lire

100 e li Lire 50 per pagare l'opere di che farà metere per fare disgrossare le prete, arà di queste Lire 50 a rendere ragione.

<div align="center">Lire CL.</div>

Location: AFSP, Giornale, fol. 66v.

Bibliography: Gatti, *La fabbrica,* doc. 38; Supino, *Scultura Bologna,* doc. 9; Supino, *Sculture Porte,* doc. 2; Beck, *Portale,* doc. 10.

Comment: If the modern reader finds difficulty in understanding and interpreting this transaction, there is no need for surprise, since the entry became the source of a dispute between Jacopo and the Fabbrica that was resolved only in 1436. Gnudi ("Revisione," p. 31) said that this payment should be dated October 15, but the precise day, in fact, cannot be ascertained because of damage to the account book.

Document 130. October 20, 1425
 Bologna *(Portal)*

A payment of 10 lire is made to Jacopo, "per parte di soa soma."

Location: AFSP, Giornale, fol. 69.

Bibliography: Beck, *Portale,* doc. 11.

Comment: This payment was not actually registered in the "Giornale" until the 16th of November.

Document 131. November 12, 1425
 Bologna *(Portal)*

A payment to Cino di Bartolo is recorded.

Da Andrea predicto Lire undese li quali pagò a maestro Iacomo de la Fonte e per lui a Cino da Siena so lavoradore.

<div align="center">Lire XI</div>

Location: AFSP, Giornale, fol. 68v.

Bibliography: Supino, *Scultura Bologna,* doc. 10; Supino, *Sculture Porte,* doc. 3; Beck, *Portale,* doc. 12.

Document 132. November 16, 1425
 Siena

Payments are made to Turino di Sano and Giovanni di Turino.

Turino di Sano e Giovanni suo Figliolo, orafi dien dare . . .
Anne dato adì 16 Novenbre 1425, per una fighura d'arientto di Santo Crescienzio, la quale recho già più mesi, e fu partte doratta, pesò in tutto libre vintiuna e onccie due e uno

quar[t]o, cioè libre 21 oncie ii quarti i, a ragione di Lire III soldi o denari 4 l'oncia de'ariento, monta

<div align="center">Lire DCCLXVI soldi xviiii denari 8.</div>

[in the left margin] al inventario.

Anne dato ad detto Lire sesantesei soldi dodici, sonno per quatro choltella e quatro choltelini fiorn[ti] d'ariento smaltatto, e una cholteliera per l'uopera; pesò l'ariento smaltatto oncie XII d. vi, a Lire 5 l'oncia monta

<div align="center">Lire LXVI soldi xii denari o.</div>

[in the left margin] Inventario.

Anne dato adì detto Fiorini cinquantacinque, di soldi 80 [il] Fiorino, sonno per la fattura dela sopradetta fighura di Santo Crescienzio, d'achordo.

<div align="center">Lire CCXX.</div>

Anne dato Lire cinquanta soldi due, per doratura [del]la sopradetta fighura di Santo Crescienzio.

<div align="center">Lire L soldi ii denari o.</div>

Somma d'achordo Lire 1103 soldi 13 denari 8. Resta a dare Lire 891 soldi 15 denari 10. Posto inanzi, foglio 73.

Location: AODS, no. 708, fol. 56.

Comment: The silver statuette mentioned in this document has not been identified. As indicated above (doc. 112, comment), it appears to have been based upon a drawing by Francesco di Valdambrino. (See also Bacci, *Quercia*, p. 71.)

Document 133.

<div align="right">December 4, 1425
Bologna *(Portal)*</div>

A payment of 12 lire is made to Cino di Bartolo.

Location: AFSP, Giornale, fol. 70v.

Bibliography: Beck, *Portale*, doc. 13.

Document 134.

<div align="right">December 15–18, 1425
Bologna *(Portal)*</div>

A payment of 140 lire is made to Jacopo.

A maestro Iacomo de la Fonte da Siena per parte de la soa somma i quali receve da missere Alberto de li Alberti per parte de la soa somma, Lire centoquaranta.

<div align="center">Lire CXL.</div>

Location: AFSP, Giornale, fol. 71v.

Bibliography: Beck, *Portale*, doc. 14.

Comment: This "Alberto de li Alberti" who was treasurer of the Fabbrica of San Petronio must have been a member of the famous Alberti family of Florence, then exiled from their native city. An Alberto is mentioned by Leon Battista who was a student in Bologna at this

very time and who hosted him there. See G. Mancini, *Vita di Leon Battista Alberti,* 2d ed. (Florence, 1911), pp. 63–64.

Document 135. December 19, 1425
 Bologna *(Portal)*

Another payment to Giovanni da Modena for the design for the portal is recorded.

Da Andrea predetto [Mezovilani] i quali pagò a Maestro Zohanne da Modena, per parte del desegno dela porta, Lire diese.

 Lire X.

Location: AFSP, Giornale, fol. 71v.

Bibliography: Beck, *Portale,* Doc. 15.

Comment: Giovanni was paid a total of 65 lire for this drawing.

Document 136. January 9, 1426
 Bologna

A bed is purchased for Jacopo.

Da Andrea di Mezovilani e per lui a maestro Iacomo da la Fonte maestro dela porta e per lui a Zoane de Iacomo de Toue [?] per prexio de uno licto vendudo al detto maestro Iacomo de al Fonte Lire ventidue e soldi diexe, a lui in credito a fol. 129.

 Lire XXII soldi x.

Location: AFSP, Giornale, fol. 73v.

Bibliography: Beck, *Portale,* doc. 16.

Document 137. February 4, 1426
 Bologna

Orazio di Jacopo di Paolo is paid for painting in the palace of Louis Aleman in Bologna.

. . . Oratio magistri Iacobi pictori qui pinxit in palatio reverendissimi domini gubernatoris residentie videlicet in tinello ubi famillia sua comedit, ystoriam navicule apostolorum piscatorum inter quos dominus noster Ihesus Christus vocavit beatum Petrum per fluctus maris accedentem . . .

 Lire 17.

Location: ASB, Tesoreria, Giornale di Entrate e Spese, Registro del 1425–26, segnato XVI, fol. CIIII/a.

Bibliography: F. Filippini and G. Zucchini, *Miniatori e pittori a Bologna, Documenti del secolo XV,* (Rome, 1968), pp. 130–31.

Comment: The reference to Orazio is included because this painter was employed on the *Portal of San Petronio.* Furthermore, the Petrine subject of his painting for the papal

governor's residence has relevance for Jacopo's program for the *Portal*. Finally, it appears likely that Louis Aleman developed the program for the *Portal*, just as he had selected the subject for Orazio's painting. On the iconography of the *Portal*, see Beck, *Portale*, pp. 61–85.

Document 138.

February 6, 1426
Bologna *(Portal)*

Jacopo is paid 40 ducats as part of his salary ("per parte di soa somma").

Location: AFSP, Giornale, fol. 76.

Bibliography: Beck, *Portale*, doc. 17.

Document 139.

February 9, 1426
Siena

Payments to Giovanni di Turino for reliefs for the pulpit in the Sienese cathedral are recorded.

Giovanni di Turino horafo de' avere a dì viiii di Febrario Fiorini trentaquatro di soldi 80 [il] Fiorino, e qu' denari sonno per fattura di tre figure di marmo à fatte; cioè, una fighura di Santo Giovanni vangiolista e una di Santo Matteio e una di Santo Pauolo, e trasse a fine una fighura di Santo Lucha la quale aveva principiata maestro Giovanni da Imola; le quali quatro fighure si posero al pergholo el quale s'è fatto di nuovo in Duomo dove si predicha, d'achordo chon misser Bartalomeio nostro operaio; e sonno messi a uscita di me Pietro di Marcho camarlingo fo. 66. Somma Lire 136.

Location: AODS, no. 671 (Memoriale), fols. 27 (and 31).

Bibliography: Bacci, *Quercia*, p. 154; Lusini, *Il Duomo di Siena*, 2:24n; Hanson, *Fonte Gaia*, doc. 121.

Comment: Giovanni di Turino took over the assignment to produce the reliefs depicting the Evangelists. They had been first assigned to Giovanni da Imola, who executed the Saint Mark and began the Saint Luke before he died.

Document 140.

February 28–March 3, 1426
Bologna

A marble statue is mentioned at San Petronio.

All'i[n]frascritti maistri e manuoali per li infrascritti overe per le loro overe date ala fabrica a fare le menzese dala figura del marmore e prima a maestro Iacomo da I Capelli per overe siete e mezo a raxone de soldi nove l'overe Lire tre soldi siete.

Lire III s. 7.

Location: AFSP, Giornale, fol. 77v.

Comment: There is no indication what this marble figure might have been, or, for that matter, whether it was for the *Portal of San Petronio* or not.

Document 141. March 4–8, 1426
 Bologna *(Portal)*

A payment of 140 ducats is made to Jacopo as part of his salary.

Location: AFSP, Giornale, fol. 78.

Bibliography: Beck, *Portale,* doc. 18.

Document 142. March 22, 1426
 Bologna *(Portal)*

A payment for the shipment of marble is recorded.

A prede di marmore lire settecento quatordese, soldi dexesette, denari sei, per loro a Ghuglielmo Ghatto nochiero, per nolo de libbre duxento quatro millia e duxento sessanta sei de marmore à condotto da Lombardia qua per la fabricha di San Petronio, per lo lavoriero de la porta e sono in tutto piezi centosessanta sei, posti a creditto al ditto Ghugliemo.
<div align="center">Lire DCCXIIII soldi xvii denari vi</div>

Location: AFSP, Giornale, fol. 79.

Bibliography: Gatti, *La fabbrica,* doc. 39 (with wrong date); Supino, *Scultura Bologna,* doc. 11; Supino, *Sculture Porte,* doc. 4; Beck, *Portale,* doc. 19.

Comment: Apparently this marble was purchased by Jacopo in the previous year when he is known to have gone to Milan, although he may also have gone elsewhere as well for such purchases. Gnudi ("Revisione") suggests that there were even earlier shipments for work on the *Portal,* but none are documented. On the other hand, as mentioned elsewhere, the designation "Lombardia" is not necessarily to be taken in its modern sense, being at that time a fairly generic term for "northern Italy"; it need not mean Milanese stone. Gnudi takes this payment for shipment as fundamental for all of the figural sculpture for the *Portal.*

Document 143. April 9, 1426
 Bologna *(Portal)*

Jacopo is paid 30 ducats as part of his salary.

A maestro Iachomo dala Fonte ducati trenta d'or, i quali gli fe' dare per noi monsignor messer Lodovigho arceveschovo Arelaten[se] governador de Bologna, a creditto a lui.
<div align="center">Lire LX.</div>

Location: AFSP, Giornale, fol. 80v.

Bibliography: Gatti *La fabbrica,* doc. 40; Supino, *Jacopo della Quercia,* p. 54 (with wrong year); Beck, *Portale,* doc. 20.

Comment: The "Lodovigho" is Cardinal Louis Aleman, the papal legate.

Document 144. April 9–13, 1426
 Bologna *(Portal)*

Jacopo is paid 140 lire.

Location: AFSP, Giornale, fol. 81.

Bibliography: Beck, *Portale,* doc. 21.

Comment: At the same date, the sum of 5 lire for rental of Jacopo's workshop was appropriated. (See Beck, *Portale,* doc. 22).

Document 145.

April 27, 1426
Bologna *(Portal)*

A payment is made to Jacopo in Milan.

Location: AFSP, Libri d'atti civili della Fabbrica, vol. 3, fol. 98v.

Bibliography: Beck, *Portale,* doc. 23.

Comment: See below under the date July 10, 1436 (doc. 449), from where this information comes. From this and other documents, we learn that Jacopo had three principle sources for stone: the area around Milan, Verona, and Venice, where he obtained Istrian stone. Gnudi ("Revisione," p. 32) considers that this reference pertains to his trip to Milan of 1425.

Document 146.

May 18, 1426
Bologna *(Portal)*

Jacopo receives 80 lire.

Location: AFSP, Giornale, fol. 84.

Bibliography: Beck, *Portale,* doc. 24 (where the day is given as 17 May).

Document 147.

May 29, 1426
Bologna *(Portal)*

Jacopo receives 100 lire.

Location: AFSP, Giornale, fol. 86.

Bibliography: Beck, *Portale,* doc. 25.

Document 148.

June 10, 1426
Bologna *(Portal)*

A payment is made to Jacopo.

A maestro Iachomo da la Fonte per conto da parte Lire diexe, per noi da Andrea Mezovillani depositario, a lui a creditto; sono quando andò a Vinexia per comprare prede di marmore istriane.

Lire X.

Location: AFSP, Giornale, fol. 86v.

Bibliography: Supino, *Scultura Bologna,* doc. 12; Supino, *Sculture Porte,* doc. 5; Beck, *Portale,* doc. 26.

Comment: Since the payment refers to a trip to Venice for Istrian stone having occurred in the past, it could even relate to the large shipment of material that arrived in March (see above, doc. 142).

Document 149.　　　　　　　　　　　　　　　　　　　　　　　June 26, 1426
　　　　　　　　　　　　　　　　　　　　　　　　　　　　　　Verona *(Portal)*

Jacopo writes to the Fabbrica of San Petronio from Verona.

　　+ Al nome di Dio. 1426 a dì 26 Giunio.
　　Padri onorandi: le rachomandazioni chon umiltà molta prima a le vostre paternità per lo vestro servidor son fate.
　　Per questa saranno le vostre reverenzie avisate come giunto fui a Venegia, la littera di monsignore lo chardinale rapresentai ne le proprie mani di misser lo Dugio, aspetando avere l'effetto di quello si chonteneva ne la prefata lettara. Le faciende parevan grandi e chosì si diceva; le quali per lo misser lo Dugio si pratichavano: per la qual chosa non si veniva a breve ispedizione de le chose che per voi si cierchavano da la sua singnioria avere. E per tanto, l'aspettare che per me si poteva fare e facieva veniva troppo a progiudichare la nostra bisognia: ond'io partito presi di pagare le gabelle di ciento pe' di pietra istriana avevo comperata per pregio di duchati trenta e mezo; e le gabelle montavano duchati due e mezo, sechondo breve istima: sì che per avere libera bolletta a ciò che Guiellmo potesse chondurre, pagai i ditti due duchati e mezo e non volsi più dimo[ra]re in Vinegia, e chonvenimi chon Guielmo a soldi 18 la soma: condutte in Bolongnia per pregio di soldi 18 la soma.
　　E da poi partii da Vinegia e venni a Verona ed ò fatto chavare le pietre rosse dello imbasamento, avantagiate per pregio di duchati 47, e da dì 2 de l'altro mese saranno in pu[n]tto per charichare e verò via, ed ò veduto fare lo meglio m'è posibile e perciò alchun dì ò preso istare più che per l'achordo.
　　Anchora v'aviso chome le quattro cholonne rosse che vano ne la porta, de la misura propria che son le bianche, le quali son bracia 40, chostano duchati 40; e li archi due che vanno di sopra chostano duchati 35, e sono bracia 40. Altre pietre rosse che vano ne le parti, come si vede in disengnio, chostarebeno Fiorini 22; si che la ssoma saria Fiorini ciento due, ed ò fato il mercato, dove le reverenzie vostre sien chontente. E per tanto, se voleste il merchato andasse innanzi prima ch'io parte me n'avisate, e mandate duchati trenta per far lavorare, aciò che per tutto lo mese d'Agosto lo ditto lavorio posiate far condurre a Bolongnia. Anchora vi prigo che la mia brigata chostì vi sia rachomandata e che diate a Cino quello che vi domanderà, perché è di bisongnio ed è onesto. Avisateme presto chuello volete i' faccia prima parti di qui. Christo vi chonservi in onore e in vita.
　　Per lo vostro servitore Iachopo de la Fonte di Siena, a dì ditto di sopra, in Verona, nello Ostierio del Chapello.
　　[On the back] Espettabili et egregi offiziali de la fabbricha di San Petronio di Bolongnia. In Bolongnia detur.

Location: AFSP, Miscellanea, vol. 2, fasc. B, no. 1.

Bibliography: Davia, *Le sculture,* doc. B; Gatti, *La fabbrica,* doc. 41; Milanesi, *Documenti,* 2:132–133; Supino, *Scultura Bologna,* doc. 13; Supino, *Sculture Porte,* doc. 6; Beck, *Portale,* doc. 26A.

Comment: This is the first extant letter written by Jacopo in his own hand.

Document 150.

<div align="right">

July 1, 1426
Bologna *(Portal)*

</div>

A payment is made to Cino di Bartolo for Jacopo.

A maestro Iachomo da la Fonte da Siena Lire cinquanta di bolognini per noi d'Andrea Mizovilano I quali paghò per lui a Cino suo lavorante per parte dela sua somma, a creditto al detto Andrea.

<div align="center">Lire L.</div>

Location: AFSP, Giornale, fol. 87.

Bibliography: Beck, *Portale*, doc. 27.

Document 151.

<div align="right">

July 11, 1426
Bologna *(Portal)*

</div>

Payments are made for the shipment of stone.

A prede de marmore per la porta de mezo Lire quarantadoe soldi sie per loro a Ghuglielmo Ghatto nochiero per nolo de pezi xxxi de marmore bianche Istriane che pixono ventitre migliaia e seicento novatotto le quale ci à condoto da Venexa Bologna per soldi dexedotto la soma, a credito a lui.

<div align="center">Lire XLII soldi vi</div>

Location: AFSP, Giornale, fol. 88.

Bibliography: Beck, *Portale*, doc. 29.

Comment: On the same day, Jacopo was paid 24 lire (AFSP, Gionale, fol. 87). The subsequent item (unpublished) in the "Giornale" mentions marble from Lago Maggiore that had also been shipped by the same *nochiero,* but the page is partially corroded, making a complete reading impossible. The marble from Lombardia was apparently sent via Mantua, according to a payment of July 28, 1426, where we find the following (unpublished): "A Zoane Zamboni Lire cinque per noi da Andrea Mizovilani per mandarlo a Mantoa . . . a condur de Lombardia."

Document 152.

<div align="right">

July 17, 1426
Bologna *(Portal)*

</div>

A payment to Jacopo is made for Cino di Bartolo.

A maestro Iachomo dala Fonte da Siena Lire venticinque de bolognini, per noi da Andrea Mezovilano, a lui a credito per lui [a] Cino suo garzone.
<div align="center">Lire XXV.</div>

Location: AFSP, Gironale, fol. 90.

Bibliography: Beck, *Portale*, doc. 30.

Document 153. July 26, 1426
 Pietrasanta

Priamo della Quercia is located in Pietrasanta, where he rents a house for three months from the Hospital of San Antonio.

Location: ASL, Notari, ser Bartolomeo Orsucci, no. 333, fol. 23.

Bibliography: Lazzareschi, "Dimora," p. 88; E. Lazzareschi, "Il marmo Carrarese nel Rinascimento," *Il Marmo* (1926), vol. 6; Bacci, *Quercia*, p. 192; Bacci, *FdV*, p. 432.

Comment: Priamo, the brother of Jacopo, never seems to have been connected with Jacopo's Bolognese shop, and while the important early phase of the *Portal* was underway, Priamo was in the area of Lucca.

Document 154. July 29, 1426
 Bologna *(Portal)*

Jacopo receives 40 lire as part of his salary.

Location: AFSP, Giornale, fol. 89v.

Comment: On the same day is the following item: "Per parte dela pixon dela chaxa in la quale habita maestro Iachomo dala Fonte, la quale comenzò a dì primo di Mazio prossimo passato, per prexio e patto de Lire XXIIII l'anno . . ."

Document 155. August 23, 1426
 Bologna *(Portal)*

Jacopo receives 80 lire.

Location: AFSP, Giornale, fol. 92.

Bibliography: Beck, *Portale*, doc. 31.

Document 156. September 5, 1426
 Bologna *(Portal)*

A payment is made for marble.

[paper partially ruined] Iachomo dala Fonte da Siena [. . .] centovintecinque e mezo d'or [. . .] CXX d' or vinitiani glie come [. . .] pe lettera d'Andrea Mizovilano [. . .] da Cecho di Tomaxo e fratelli in fino adì x de Zugno prossimo passato per comprare marmor biancho istriano e rosso veronexe per lo imbassamento della porta di mezo di San Petronio, e quali denari ne deve rendere raxone el detto maestro Iachomo; posti a creditto al detto Andrea a soldi xl denari iii per bolognini.

 Lire CCLII soldi xi denari iiii

Location: AFSP, Giornale, fol. 93v

Bibliography: Beck, *Portale*, doc. 32.

Document 157.

Jacopo begins work on the basement level of the Portal of San Petronio.

Die x Septembris . . . pro aptando necessaria ad portam magnam Sancti Petronii quando magister Iacobus de Senis lapicidia incepit baxamentum dicte porte.

Location: AFSP, Libro di Spese, fol. 101v.

Bibliography: Supino, *Scultura Bologna,* doc. 15, p. 148; Gnudi, "Revisione," pp. 16–17.

Document 158.

Jacopo receives 100 lire.

Location: AFSP, Giornale, fol. 95.

Bibliography: Beck, *Portale,* doc. 33.

Document 159.

Payments for shipment of marble are recorded.

[A] prede de marmore per la porta de mezo, per le spexe apresso scritte le quale ci asigna Iachomo d'Ambruoxo de Ferrara aver paghate e furono pezi xxii de marmor rosso, el quale pesò libbre 322000, per datio dela stadera de Verona Lire XIII s. xvi de moneta di Virona, che sono de bolognini.

Lire VI soldi iiii

Per farle charichare a Virona Lire VI soldi x de detta moneta, che sono de bolognini.

Lire III soldi xii

Per nolo de Verona a Ferrara Lire XXXII de detta moneta, che sono de bolognini.

Lire XVI soldi xvi

Per datio dala scatta Lire sei de bolognini.

Lire VI.

. . . a Mateo de Firenze exator dela fabricha Lire sedexe soldi tredexe de bolognini per noi in Ferara da Iachomo d'Ambruoxo e compagno per far descharighare le marmore bianche de Lombardia che so[no] arivate de' dì passati ala Torre de la Fossa, di qual denari el ditto Mateo ne de' render raxone; posti a creditto al detto Iachomo sopradetto.

Lire XVI soldi xiii

Location: AFSP, Giornale, fol. 95v.

Bibliography: Beck, *Portale,* doc. 34.

Comment: The red and white marble in this shipment, came from Verona and perhaps from Venice as well. The use of the term "Lombardia," as we have seen, already encompassed the

Veronese area. The stone mentioned here was purchased by Jacopo during the previous June (see doc. 149).

Document 160. September 28, 1426
 Bologna *(Portal)*

Work is done on the foundation of the Portal.

A la fabrica di San Petronio Lire una soldi . . . [blank], per lei a Benedetto asenaro per some LXXXXVIII di sabione à data a la dita per lo fondamento s' è fatto posto a la porta grande di mezo, e per noi d'Andrea Mezovilano, a lui a creditto.
 Lire I soldi xii.

Location: AFSP, Giornale, fol. 96.

Bibliography: Cf. Gatti *La fabbrica,* doc. 42; Beck, *Portale,* doc. 35.

Document 161. September 28–29, 1426
 Bologna *(Portal)*

A payment is made to workers on the Portal.

A la ditta [fabrica] Lire dexesiete soldi tre, per lei a li infrascritti maestri e manoali li quali ànno lavorato al cavamento e fondamento fato apresso la porta de mezo de detta gliexa e per noi d'Andrea Mezovilano, a lui a creditto.
[Sono:] M° Chirino
 M° Bartolomeo Via
 M° Nati da Puti
 Zoane di Guido manole
 Piero de Roire [?] manole
 Ghalasso manole
 Polo da Zora
 Iachomo da Serra
 Michele da Iachomo
 Domenegho murador
 Bartolo di ventura
 Tomaxo di Zoane Lire XVII soldi iii.

Location: AFSP, Giornale, fol. 96.

Bibliography: Beck, *Portale,* doc. 36.

Document 162. October 7, 1426
 Bologna *(Portal)*

A payment of 40 lire is made to Jacopo.

Location: AFSP, Giornale, fol. 97v.

Bibliography: Beck, *Portale,* doc. 37.

Document 163.

October 8, 1426
Bologna *(Portal)*

Payments are made for shipment of marble.

A prede de marmore per la porta Lire una soldi dodexe, per loro a maestro Bartolomeo dale rode e maestro Antonio dal Pane per pixon de due carri matti per condur due prede di marmore bianche da Cortexella e per loro a Francesco de Matio caradore i quali soldi glie dè per noi d'Andrea Mezzovilani a lui a credito.

Lire I soldi xii.

Location: AFSP, Giornale, fol. 97v.

Bibliography: Beck, *Portale,* doc. 38.

Document 164.

October 10, 1426
Bologna *(Portal)*

Jacopo is sent to Ferrara to supervise the transport of the door jambs.

A maestro Iachomo dala Fonte Lire quartro di bolognini per noi d'Andrea Mezzovilani, a lui a credito, i quali denari sono per mandarlo a Ferara per far venire li stipiti dela porta; di quali denari ne de' rendere raxone.

Lire IIII.

Location: AFSP, Giornale, fol. 98.

Bibliography: Gatti, *La fabbrica,* doc. 43; Supino, *Scultura a Bologna,* doc. 16; Supino, *Sculture Porte,* doc. 8; Beck, *Portale,* Doc. 39.

Comment: The *stipiti,* or door jambs, are composed of several pieces, but they were thought of as whole architectural members. Their first mention is in this document; they were placed on the *Portal* in 1428.

Document 165.

October 16, 1426
Bologna *(Portal)*

Marble for the Portal *is mentioned.*

A prede de marmore per la porta de mezo soldi diexe i quali pagò Andrea Mezzovilani più e più dì fa a Antonio nochier che donozo [?] le due nave di marmo esser [?] de Sienata [?] a Casale Maore; posti a credito a detto Andrea.

Lire I soldi xii.

Location: AFSP, Giornale, fol. 92v.

Document 166.

October 20, 1426
Bologna *(Portal)*

Work on the Portal *is mentioned.*

A la fabricha di Sam Petronio Lire due soldi cinque di quadrini per lei a Bottino di Bottino manoale per nove overe datte a la fabricha in lo lavorer di preparamento dela porta de mezo, e per noi d'Andrea Mezovilani, a lue a credito.

Lire II soldi v.

Location: AFSP, Giornale, fol. 99v.

Bibliography: Beck, *Portale,* doc. 41.

Comment: Another payment for the work is located on the same folio and reads in part: ". . . per due overe aidare a maestro Iachomo dala Fonte a condure le marmore lavorade a la porta."

Document 167. October 31, 1426
 Bologna *(Portal)*

Payments are made for shipment of marble.

A le prede de marmore per la porta de mezo di San Petronio Lire trentacinque soldi quatro, per loro a Ghughielmo Gatto nochiero per nolo de piezi xxii de marmor rosso vironexe ci condosse insino del mixe de Febraio prossimo passato, pexono in tutto libbre 32200 a soldi undexe la soma monta d'accordo Lire XXXV soldi iiii posti acredito al detto Ghuglielmo.

Lire XXXV soldi iiii.

A le dette [prede de marmore] Lire trentaquatro soldi otto per loro a Ghughielmo Ghatto nochiero per nolo de colonne quattro de marmor biancho de Lagho Mazior che pesono libbre 21500, li quali el detto ci à condotto de la Torre de la Fossa qua in la fabrica de San Petronio, per soldi sedexe la soma, posti a creditto al ditto Ghuglielmo.

Lire XXXIIII soldi viii.

Location: AFSP, Giornale, fol. 101.

Bibliography: Beck, *Portale,* doc. 42 (second part).

Comment: On the same day, Jacopo received a payment of 80 lire (AFSP, Giornale, fol. 101; in Beck, *Portale,* doc. 43). The fact that the columns of white marble are from the Lago Maggiore region should be considered in relation to Gnudi's arguments ("Revisione") about the kind of stone used for the relief sculpture. The columns on the *Portal* now are definitely not Candoglia marble.

Document 168. November 12–15, 1426
 Bologna *(Portal)*

A payment is made for lime for use on the Portal.

Location: AFSP, Giornale, fol. 102.

Bibliography: Beck, *Portale,* doc. 44.

Comment: On November 16 (Giornale, fol. 102) there is a payment for sand, and Supino mentions that during the same month, "doe biette di ferro per lo stipite" (Supino, *Scultura Bologna,* docs. 19 and 20).

Document 169.

<div align="right">

November 29–December 2, 1426
Bologna *(Portal)*

</div>

A payment of 110 lire is made to Jacopo.

Location: AFSP, Giornale, fol. 103.

Bibliography: Beck, *Portale,* doc. 45.

Document 170.

<div align="right">

December 19, 1426
Bologna *(Portal)*

</div>

A payment for equipment for raising marble is recorded.

Adì xviiii de de decembre i quale ave maestro Iacomo da la Fonte per un paro de chiavestelle de ferro per le [?] tirare su le marmori, soldi v.

Location: AFSP, Libro di Spese, fol. 5.

Bibliography: Supino, *Scultura Bologna,* doc. 20; Beck, *Portale,* doc. 46.

Document 171.

<div align="right">

January 4, 1427
Bologna *(Portal)*

</div>

Arduino da Baiso is paid for consultations.

Ala fabricha di Sam Petronio Lire una soldi diexe de bolognini per lei ad Ardoino da Baixe per parte de più e più fadighe gli abiamo dato in più volte in farlo venire ala fabricha e per aver coloquio de lavoriere de la porta de mezo de Sam Petronio e più altri bisogni de detta fabricha.

<div align="center">

Lire I soldi x.

</div>

Location: AFSP, Giornale, fol. 106v.

Bibliography: Supino, *Scultura Bologna,* p. 77; Beck, (Portale, doc. 47.

Document 172.

<div align="right">

February 14–17, 1427
Bologna *(Portal)*

</div>

A payment of 130 lire is made to Jacopo.

Location: AFSP, Giornale, fol. 109.

Document 173.

<div align="right">

February 24, 1427
Siena *(Baptismal Font)*

</div>

A meeting of the masters of the Baptismal Font *is held in Siena.*

E die dare a dì 24 di Feraio Lire 0, soldi dodici e questo per vino e pane e cialdoni per fare onore a' maestri quando si raunaro a San Giovanni per lo batesimo.

Location: AODF, Memoriale, 1426–1427, fol. 35.

Bibliography: Bacci, *Quercia*, p. 164; Paoletti, *Font*, doc. 142

Comment: Although no specific names are offered, Jacopo was probably present, since he was the key personality involved in the project at the time. On the other hand, he had received a substantial payment only the week before in Bologna (see doc. 172).

Document 174.

March 10, 1427
Bologna *(Portal)*

Payment is sent to a stonecutter in Verona.

A maestro Zanino taiapiera da Sant'A[m]bruoxo di Valpolixella de Verona ducati sessantatre d'or veneziana i quali li remetemo per lettera di Dante da Castiglioni per Lire CXXVIIII soldi xviii denari viiii de bolognini, li de' per noi Andrea Mizovilani, posti a lui a creditto a soldi 41 denari 3 detti bolognini.

Lire CXXVIIII soldi xviii denari viiii.

Location: AFSP, Giornale, fol. 110v.

Document 175.

March 10, 1427
Bologna *(Portal)*

Preparations are made, and advances paid to Jacopo for a trip to Verona.

A le prede de marmore per la porta de mezo de San Petronio Lire due soldi otto per loro a Iachomo di Ghuido, hostier ala Corona, per vettura d'uno roncino presta ala fabrica per viii zorni per mandare maestro Iachomo dala Fonte a Verona per comprare el resto dele marmor rosse bixogna per la porta, e per noi d'Andrea Mizovilani, a lui a credito.

Lire II soldi viii.

A maestro Iachomo de Piero dala fonte Lire vinte de bolognini per noi d'Andrea Mezovillano a lui a creditto; e detti denari li facemo dare per mandarlo a Verona per le prede de marmor rosso, de' quali de' rendere raxone.

Lire XX.

Location: AFSP, Giornale, fol. 110v.

Bibliography: Gatti *La fabbrica*, doc. 45; Supino, *Scultura Bologna*, doc. 23; Supino, *Sculture Porte*, doc. 9; Beck, *Portale*, doc. 49.

Document 176.

April 2, 1427
Bologna *(Portal)*

A payment of 100 lire is made to Jacopo.

Location: AFSP, Giornale, fol. 112.

Bibliography: Beck, *Portale*, doc. 50 (where the sum is given incorrectly as 50 lire).

Document 177.

April 10, 1427
Bologna *(Portal)*

Jacopo is sent 123 lire in Verona.

A maestro Iachomo dala Fonte per conto da parte Lire centovintetre de bolognini per ducati LX d'or veneziani gli ci faciamo dar in Verona per lettera di Dante da Chastiglioni da Daniello di Nichollò Mafei, per altretanti ne à dato Andrea Mizovilano per noi a detto Danti; posti a creditto ad Andrea.

Lire CXXIII.

Location: AFSP, Giornale, fol. 112v.

Bibliography: Supino, *Scultura Bologna,* doc. 24; Supino, *Sculture Porte,* doc. 10; Beck, *Portale,* doc. 51.

Document 178.

April 15, 1427
Bologna *(Portal)*

A payment of 8 lire is made to Jacopo.

Location: AFSP, Giornale, fol. 112v.

Bibliography: Beck, *Portale,* doc. 52.

Document 179.

April 16, 1427
Bologna *(Portal)*

Columns of red marble are unloaded.

. . . Per deschareghare colone de marmore rosse, soldi v . . .

Location: AFSP, Libro di Spese, fol. 6v.

Bibliography: Supino, *Scultura Bologna,* doc. 25; Supino, *Sculture Porte,* p. 13; Beck, *Portale,* doc. 53.

Document 180.

April 26, 1427
Bologna *(Portal)*

Jacopo obtains the release from prison of one of his assistants.

A maestro Iachomo dala Fonte Lire una soldi quatordexe de quatrini per noi d'Andrea Mezovilani e per lui a Bartolomeo degli Albiroli per far cavar de preson Martino da Milan gharzon del maestro Iachomo; a credito ad Andrea.

Lire I soldi xiii.

Location: AFSP, Giornale, fol. 113.

Comment: This document demonstrates further evidence of Jacopo's loyalty to his *garzoni.*

Document 181. May 6, 1427
 Bologna *(Portal)*

A payment of 120 lire is made to Jacopo.

Location: AFSP, Giornale, fol. 113v.

Bibliography: Beck, *Portale*, doc. 56.

Document 182. May 6, 1427
 Bologna *(Portal)*

A consignment of red marble is unloaded.

 Adì vi de Marzo [read Maggio] per octo carra de prede rosse de marmora fe' descharegh-
are maestro Iachomo dala Fonte, ave lui soldi sedexe, zoè.
 soldi xvi.

Location: AFSP, Libro di Spese, fol. 7.

Bibliography: Supino, *Scultura Bologna,* doc. 26; Supino, *Sculture Porte,* p. 13; Beck,
Portale, doc. 55.

Document 183. May 16, 1427
 Bologna *(Portal)*

Rental of a cart to transport stone is mentioned.

 A le prede di marmore per la porta di mezo di San Petronio Lire una soldi quatro di
quatrini, per noi a maestro Bartolomeo de Pelegrin da le Rode per pixone de uno carro matto
per tri zorni a far adur tre prede di marmor biancho da Cortexella, e per noi d'Andrea
Mezovilani, a lui a creditto.
 Lire I soldi iiii.

Location: AFSP, Giornale, fol. 114v.

Bibliography: Beck, *Portale,* doc. 57.

Comment: These three pieces of marble must have been quite large; each had to be shipped
singly and therefore the cart was needed for three full days. They may have been part of the
white columns for the embrasures of the *Portal.*

Document 184. May 19, 1427
 Bologna *(Portal)*

Marble is unloaded for the arch.

 Item, ave maestro Iacomo dala Fonte per far scareghare pizi octo de prede rosse de
l'archo, in soma, soldi viiii.
 Item, ave el dito per fare schareghare charra sei de le dite marmore, in somma soldi nove,
zoè soldi viiii.

Location: AFSP, Libro di Spese, fol. 7.

Bibliography: Supino, *Scultura Bologna,* doc. 26; Supino, *Sculture Porte,* doc. 11; Beck, *Portale,* doc. 58.

Document 185.

May 31–Dec. 24, 1427
Siena *(Baptismal Font)*

Payments are made to Turino di Sano and Giovanni di Turino for the bronze histories for the Baptismal Font *and other works.*

Turino di Sano et Giovanni suo figlolo orafi dieno avere a dì 31 di Maggio Lire millecinquecento dodici, e quagli denari so' per due historie d'attone le quagli ci à fatte et consegnate questo dì detto per lo sacratissimo baptisimo ordinato di fare in San Giovanni per Fiorini cento ottanta l'uno a Lire 4 soldi 4 el Fiorino che vagliono fra 'mendue recato a Lire in tutto Lire 1512 e questo secondo la logagione e composizione fatta nel 1417 a dì 16 d'Aprile fra l'egregio cavaliere misser Caterino allora oparaio et suoi conseglieri et 'l detto Turino et Giovanni, come appare, carta per mano di sr Francesco del Barbuto notaio dell'uopara le quagli historie sono state approvate essere recipienti secondo la detta composizione per 4 maestri intendenti, electi per lo egregio cavaliere misser Bartolomeo di Giovanni Cechi al presente oparaio e suoi conseglieri, come di tutto appare carta per mano del sopradetto ser Francesco.

Lire MDXII.

Anne avuti Lire ventitre per uno errore d'uno figura di Santo Sano ci fece d'ariento, nella quale furono pesate certi viti di ferro per ariento, pesaro once sei. Et però per detto di misser Bartolomeo oparaio nostro et di consentimento del detto Turino et Giovanni ò qui n'abi avuti le dette Lire vintitre

Lire XXIII.

E ànno avuti Lire novecento ottantanove soldi undici denari otto, e quagli doveva dare, che à avuti in più volte, come apare indietro in questo, resta dar a ffo. 9.

Lire DCCCCLXXXVIIII soldi xi denari viii.

Et ànne avuti Lire quatrocento quaranta, come apare in più volte al memoriale di me Berto camarlengo a ffo. 7 et a escita di me Berto a ffo. 9.

Lire CCCCXL.

E ànne avuti a dì 24 di Dicembre Lire vintiquatro, demo per lui e per suo detto a Giovanni Pini banchiere, disse era per pigione di bottega, contanti in mano del detto Giovann e so'.

Lire XXIIII.

E ànne avuti a dì detto Lire trentacinque soldi otto denari quatro, demo contanti per resto della soprascripta ragione in mano di Giovanni figliolo del detto Turino soprascripto et so' a uscita di me Berto camarlengo a ffo. 9.

Location: AODS, no. 708, fol. 239v.

Bibliography: Milanesi, *Documenti,* 2: 58n and pp. 87–88; Lusini, *Il Duomo di Siena,* doc. 125; Paoletti, *Font,* doc. 329.

Document 186.

June 1, 1427
Siena

Jacopo is in Siena, where he acts as godfather to the son of Goro di Neroccio.

Location: ASS, Battezzati, 1379–1441, at the date.

Bibliography: Bacci, *FdV*, p. 367.

Document 187. June 20, 1427
 Siena *(Baptismal Font)*

Jacopo is commissioned to execute the upper portion of the Baptismal Font.

 Maestro Iachomo di Pietro dela Ghuercia s'è ogi a dì 20 di Giugno aloghatto a trare a fine il batesimo e fare le pile e mura[r]lo; dìelo fare bene e di buono marmo chararese; dì avere finito in tempo di XX mesi prossimi avenire; in chaso no' l'abi fatto al dito termine, die ridare i denari avesse avuto; el pregio del detto lavoro rimesso nel'operaio e suo' chonseglieri; [c]harta per mano di Iachomo di Muccio.

Location: ASS, no. 669 (Memoriale), fol. 12.

Bibliography: Milanesi, *Vasari*, 2:133; Bacci, *Quercia*, p. 174; *Mostra*, doc. 26, p. 338; Beck, *Portale*, doc. 60; Paoletti, *Font*, doc. 154.

Document 188. June 25, 1427
 Bologna *(Portal)*

A payment of 50 lire is made to Jacopo.

Location: AFSP, Giornale, fol. 117.

Bibliography: Beck, *Portale*, doc. 61.

Document 189. July 11, 1427
 Florence

Donatello lists Jacopo as a creditor in his Catasto for the sum of 48 florins.

 . . . Creditori . . .
 A maestro Iachopo di maestro Piero intagliatore da Siena, per chagione di quella storia per l'opera di Siena come disotto appare, Fiorini quarantotto.
 F. 48.
 A Giovanni Turini horafo da sSiena *[sic]*, per più tempo havuto in detta storia, Fiorini dieci.
 F. 10.

Location: ASF, Catasto, 1427, Quartiere di Santo Spirito, Gonfalone Nicchio, 17, fols. 555–555v.

Bibliography: Gaye, *Carteggio inedito*, 1:121ff; R. G. Mather, "Donatello debitore oltre la Tomba," *Rivista d'arte* (1937), 19:187; Caplow, "Sculptor's Partnerships in Michelozzo's Florence," esp. p. 149.

Document 190.

<div style="text-align:right">July 3, 1427
Bologna *(Portal)*</div>

A payment of 100 lire is made to Jacopo.

Location: AFSP, Giornale, fol. 118.

Bibliography: Beck, *Portale,* doc. 62.

Document 191.

<div style="text-align:right">August 6–8, 1427
Bologna *(Portal)*</div>

A payment of 120 lire is made to Jacopo.

Location: AFSP, Giornale, fol. 121.

Bibliography: Beck, *Porale,* doc. 63.

Document 192.

<div style="text-align:right">August 20–22, 1427
Bologna *(Portal)*</div>

Travel expenses are provided to Jacopo.

A maestro Iachomo de Piero dala Fonte da Siena per conto da parte ducati cento ducati veneciani gle mettemo in Venezia per letera de Lodovigho Muzarello e compagni da Ciecho di Tomazo e fratelli per la valuta n'ebe el detto Lodovicho sopradetto per noi d'Andrea Mezovillani, a soldi xli denari i, per ducato; posti a credito a detto Andrea, valgono.

<div style="text-align:center">Lire CCV soldi viii denari iiii.</div>

Al detto Lire vente mizi quatrini per noi d'Andrea Mizovilani, posti a lui a creditto, e detti denari sono per far speze per la via in andare e tornare da Venezia el detto maestro Iachomo, deli quali arà a rendere raxon.

<div style="text-align:center">Lire XX.</div>

Location: AFSP, Giornale, fol. 121v.

Bibliography: Gatti *La fabbrica,* doc. 46 (incorrect and incomplete); Supino, *Scultura Bologna,* doc. 27; Supino, *Sculture Porte,* doc. 12; Beck, *Portale,* doc. 119 (incomplete and incorrectly dated as 1428).

Document 193.

<div style="text-align:right">August 27, 1427
Bologna *(Portal)*</div>

Jacopo is sent 101 gold bolognini.

Ad detto [Andrea Mezovilani] bolognini cento uno d'or per noi da maestro Iachomo di Piero da la Fonte da Siena e per lo detto da Lodovicho Muzarello e compagni, i quali sono per lettera del cambio che el detto maestro à reportada adrieto, e resatuida [? restituita] al detto Lodovigho per caxon della moria che è in Vinizia; posti a creditto al detto maestro Iachomo; a soldi xl denari iiii per bolognini d'or, valgiono.

<div style="text-align:center">Lire CCIII soldi xiii denari viii.</div>

Location: AFSP, Giornale, fol. 121v.

Document 194. August 27, 1427
 Bologna *(Portal)*

Jacopo is advanced 100 Venetian gold ducats.

A maestro Iachomo dala Fonte da Siena per conto da parte ducati cento ducati veneciani
per noi d'Andrea Mezovilani posti a lui a credito, a soldi xli denari ii, per ducato. I quali
denari auti per andar a Venezia a comprare prede Istriane per la porta de mezo, de' quali ne
de' render raxon.

 Lire CCV soldi xvi denari vii.

Nota che ditta pardita si cassa perché non passa de questo mixe [= mese].

Location AFSP, Giornale, fol. 121v.

Bibliography: Gatti *La fabbrica*, doc. 47; Supino, *Scultura Bologna*, doc. 27; Beck, *Portale*,
doc. 65 (reported imprecisely).

Document 195. September 9, 1427
 Bologna *(Portal)*

A payment of 40 lire is made to Jacopo.

Location: AFSP, Giornale, fol. 122v.

Bibliography: Beck, *Portale*, doc. 66.

Document 196. September 19, 1427
 Bologna *(Portal)*

Wood is purchased to build scaffolding at the Portal.

A la fabricha de San Petronio Lire otto de quatrini per lei a Bartolomeo de gli Alberoli per
comparare palanche per far ponti a lavoriere dela porta, di quali denari ne de' render raxone;
per noi d'Andrea Mezovilani, a lui a creditto.

 Lire VIII.

Location: AFSP, Gironale, fol. 123v.

Document 197. October 8, 1427
 Siena *(Baptismal Font)*

Donatello obtains final payment for his relief for the Baptismal Font.

Donatello di Nicholò da Firenze sculptore de'avere a dì 8 d'Ottobre Lire settecento vinti,
e quagli denari sono per una historia d'attone la quale ci à fatta e consegnata el dì detto per
lo sacratissimo batesimo ordinato di fare in San Giovanni et è quella quando fu recato la
testa di San Giovanni ala mensa de' re. La quale historia fu una dele due era[n] state allogate
a maestro Iacomo del maestro Piero intagliatore, detto della Fonte, et fu dapoi data da misser
Bartolomeo oparaio nostro e suoi conseglieri al detto Donatello per prezzo di fiorini cento
ottanta di Lire 4 [il] Fiorino, vagliono a Lire in tutto Lire 720.

 Lire DCCXX.

Location: AODS, no. 708, fol. 240.

Bibliography: Milanesi, *Documenti*, 2:134–135; Bacci, *Quercia*, p. 178; Paoletti, *Font*, doc. 330.

Comment: This entry continues by mentioning the 50 lire 1 soldo advanced by Jacopo della Quecia to Donatello. At the conclusion is the following:

> E ànne avuti Lire secento sessantanove soldi dicinove, e quagli à avuti in più volte come apare partitamente al memoriale di me Berto camarlengo a sua ragione che die dare a ffo. 11 et ala mia escita a ffo. 64.
>
> Lire DCLXVIIII soldi xviiii.

Document 198.
October 10, 1427
Bologna *(Portal)*

A *payment of 110 lire is made to Jacopo.*

Location: AFSP, Giornale, fol. 124.

Bibliography: Beck, *Portale,* doc. 68.

Document 199.
October 30, 1427
Siena *(Baptismal Font)*

Final payment is made to Ghiberti for his reliefs for the Baptismal Font.

Maestro Lorenzo di Bartalo da Firenze orafo e scultore die avere a dì 30 d'Ottobre [1427] Lire mille seciento ottanta, so' per due historie d'attone dorate ci à fatte e consegnate el dì detto in Firenze a me Berto d'Antonio camarlengo dell'uopera per lo sacratissimo batesimo si die fare in San Giovanni; l'uno contiene quando San Giovanni batezò Iesu Cristo nel Giordano; l'altra quando e' re Herod commanda e fa mettare San Giovanni predetto da la famiglia sua in pregione. E questo per Fiorini dugento dieci l'una, a Lire 4 [il] Fiorino, che so' fra 'mmendue recati a Lire 1680. Del quale prezo di Lire 1680 per amendune historie fumo d'accordo in Firenze el detto maestro Lorenzo da l'una parte e io Berto a vice e nome dell'uopera del' altra. E questo per commissione pienamente fattami da misser Bartolomeo di Giovanni Cechi operaio nostro e Giovanni di Francino Patrizi, Nani di Piero di Guido e ser Bindotto di Giovanni notaio, al presente conseglieri del detto misser l'operaio e sopra el detto batesimo. Et così el sopradetto misser l'operaio e suoi conseglieri, absente misser Giorgio Talomei lor quarto compagno, ànno avuto rato e confermato nella mia tornata. E qui ò acceso il detto maestro Lorenzo creditore, di lor buon consentimento e volontà.

Lire MDCLXXX.

Location: AODS, 708, fol. 240.

Bibliography: Milanesi, *Documenti*, 2:92; Krautheimer and Krautheimer-Hess, *Ghiberti*, doc. 141; Paoletti, *Font*, doc. 331.

Comment: Ghiberti was paid at the rate of 840 lire for each relief, while Donatello was given only 720 Lire (180 florins) for his history. This discrepancy in pay is an interesting comment upon the preception of the Opera on the relative merit of the two masters.

Document 200. November 30–December 1, 1427
 Bologna *(Portal)*

A payment of 100 lire is made to Jacopo.

Location: AFSP, Giornale, fol. 128v.

Bibliography: Beck, *Portale,* doc. 69.

Document 201. December 1, 1427
 Bologna *(Portal)*

Payment is made to porters for carrying marble.

. . . per tri fachini i qua toxe maestro Iachomo dala Fonte per fare portare in la chamera del giglio certi pezi de marmore rosse.

 soldi viiii.

Location: AFSP, Libro di Spese, fol. 11.

Bibliography: Supino, *Scultura Bologna,* doc. 29; Supino, *Sculture Porte,* doc. 14; Beck, *Portale,* doc. 70.

Document 202. December 6, 1427
 Bologna *(Portal)*

A payment is made to Arduino da Baiso.

Ad Ardoino da Baixe Lire dodexe de quatrini, per noi d'Andrea Mezovilani a lui a creditto, sono per parte di suoi salarii del' ingegniaria de Sam Petronio e per vighore d'uno mandato a noi mandato e fatto per lo reverendissimo signor monsignor messer lo legato de Bologna [Louis Aleman], el quale ha data e registrado in lo libro negro de le compositioni a carta 74.

 Lire XII.

Location: AFSP, Giornale, fol. 128v.

Bibliography: Beck, *Portale,* doc. 71.

Document 203. December 11–18, 1427
 Siena *(Baptismal Font)*

Sassetta is paid for the designo *of the* Baptismal Font.

A maestro Stefano di Giovanni dipentore Lire quarantaquatro; so' per uno disegno fece nella chiesa di San Giovanni nostro della forma del batesimo si die fare. Et questo salaro et prezo gli fu fatto per la detta cagione da misser Bartolomeo operaio nostro et suoi conseglieri, apare al memoriale di me Berto camarlengo a fo. 13.

 Lire XLIIII.

Location: AODS, no. 402 (Entrata e Uscita), fol. 65.

Bibliography: Milanesi, *Documenti,* 2:244; Bacci, *Quercia,* pp. 82 and 197; Pope-Hennessy, *Sassetta,* pp. 43*n* and 46; Paoletti, *Font,* doc. 170

Comment: Sassetta's task must have involved the scale rendering of the design for the *Font* on a wall of the Baptistery, and especially the upper section, which was presumably based upon a drawing by Jacopo della Quercia (or by Pagno di Lapo). I do not believe that Sassetta designed the work himself. Since Jacopo was by then in charge, we should assume that it was he who choose Sassetta for the lucrative assignment. Although some scholars have insisted that the design paid for here was on paper or parchment and not on a wall to scale, the substantial price of 44 lire virtually proves that Sassetta was paid for a large-scale work.

Sassetta is known to have a connection with another sculptural project: in 1429 the *lupa* that was located in the piazza of the Sienese hospital was gilded by him (see Lusini, *Il Duomo di Siena,* 2:23*n*4).

Document 204.

December 22, 1427
Bologna *(Portal)*

A payment of 100 lire is made to Jacopo.

Location: AFSP, Giornale, fol. 129v.

Bibliography: Beck, *Portale,* doc. 72.

Document 205.

December 30, 1427
Bologna *(Portal)*

A horse is rented for Jacopo.

... per la vitura de uno chavallo per tri dì per maestro Iacomo da Siena per andare a Ferara per la fabrica.

soldi xviii.

Location: AFSP, Libro di Spese, fol. 11.

Bibliography: Supino, *Scultura Bologna,* doc. 30; Supino, *Sculture Porte,* doc. 15; Beck, *Portale,* doc. 73.

Document 206.

1428 [n.d.]
Siena

Names are given for those enrolled in the painter's guild in 1428.

Apresso di qui sarano iscritti tuti e dipentore che si truovarano nel'arte nel MCCCCXXVIII.
Andrea di Bartolo di Fredi
Lando di Stefano
G[i]ussa di Fruosino
Martino di Bartolomeio
Piero di Iachomo Pieri
Crisstofano di Benedeto
Nani di Giovanni [di] ser Ciechi

Iachomo di Ghuido
Fruosino di Nofri
Vicho di Lucha
Giovanni di Pauolo
Lazaro di Lonardo
Danielo di Lonardo
Antonio di maestro Simone
Stefano di Giovanni
Sanno di Pietro
Antonio di Grasso
Ghualtieri di Giovanni
Antonio di Filippo da Pistoie
Adamo d'Arcidosso
Micho di Pietro Michi
Piettro di Giovanni d'Anbbruogio [sic]
Iachomo di Mei da Magiano
Nani di Piero da Ravaciano
. . . Simone di Salvestro da . . .
Nicholo di Giovanni Venture
Lorennzo di Piero
Antonio di Bernardo
[hand changes, probably additions after original date]
Domenicho di Bartolo d'Ascanio
Nastagio di Guasparre orafo
Lonardo di Nanni barbiere
Domenicho di Christofano

Location: ASS, Arti, no. 59 (Statuti de' pittori), fol. 26.

Bibliography: Milanesi, *Documenti,* 1:48–49.

Document 207. January 1, 1428
 Siena *(Baptismal Font)*

A payment is made for marble for the Baptismal Font.

+ Al nome di Dio, a dì primo di Gienaio 1427 [= 1428, modern].

Sia manifesto a chi vedrà questa scritta, chome Agnolo di Papi da Quarrachi di quello di Firenze, chonfessa che già più e più dì s'aloghò da Pippo di maestro Giovanni di . . . [read Gante] maestro di pietra da Pisa, a rechare al Batesimo di San Giovanni da Siena, per prezo di soldi vintitre el centonaio de la metà et l'altra metà a Fiorini [read soldi] vintidue el centonaio; salvo che la pila, il quale è rimessa il pregio nell'operaio e ne' suoi chonsiglieri. El quale marmo ci à chondotto questo dì pezi vintisette cho' la pila; e l'avanzo promette chonduciare a Siena per di qui a mezo Febraio prossimo che viene, o prima, salvo giusto impedimento; e chosì s'obrigha di rechare e conduciare chome detto è di sopra el detto dì primo di Genaio. Chonfessò avere avuto per la detta vettura Lire sessantaquatro, e più e chompagni suo' Lire sedici: in tutto à ricievuto Lire ottanta. Ed io Neri di Vanoccio di Lippo ò fatta questa scritta di mia mano a preghiera de le dette parti, in presenzia di Giovanni di Franciescho Venture e di Nanni di Michele choiaio i quali si soscrivaranno qui di loro mano.

Io Angnolo di Papi da Quarachi sono cho[n]tento a la sopradetta schritta e però mi sochivo [-soscrivo?] di mia proprio mano, ano e mese e di sopra detto e dele otta Lire one atto da Pagolo fattore, Lire sessa[nta]quattro e Lire sedici ebono i chompagni miei da Pietro del Minela.

E io Givanni di Francescho Venture fui presente alla sopradetta escritta el dì e anno detto di sopra.

Ed io Neri di Michele choiaio fui presente a la sopradeta scrita, dì e ano e mese sopradeto.

Location: AODS, Libro di Documenti Artistici, no. 50 (formerly).

Bibliography: Milanesi, *Documenti*, 2:140–41; Lusini, *Il Duomo di Siena*, doc. 14; Paoletti, *Font*, doc. 173.

Comment: This transcription is based upon Milanesi's, which is, admittedly, problematic. I have been unable to locate the original document. Parallel information is found in the Memoriale (1427–1428) at the date.

Document 208.
<div align="right">January 2, 1428
Bologna *(Portal)*</div>

100 Venetian ducats are credited to Jacopo.

A maestro Iachomo dala Fonte ducati cento d'or vinitiani, per noi d'Andrea Mizovilani posti a lui a creditto. E de' detti denari ne de' rendere raxone quando tornarà da Veniza per comparare marmore istriano per la porta de mezo da lato dentro per ducati, vagliono.
<div align="center">Lire CCVI soldi v.</div>

Location: AFSP, Giornale, fol. 130.

Bibliography: Gatti, *La fabbrica*, doc. 49; Supino, *Scultura Bologna*, doc. 31; Supino, *Sculture Porte*, doc. 16; Beck, *Portale*, doc. 74.

Document 209.
<div align="right">February 7, 1428
Siena</div>

Vico di Luca is paid for two painted boxes and the marble statue of Sant'Andrea for the Cappella del Campo.

A Vico di Luca e compagni a dì vii di Febraio [1427 = 1428, modern] Lire quatro soldi dieci per dipentura di due cassette per porre in sul'altare magiore del duomo e per dipentura d'uno Santo Andrea di marmo per la la [sic] cappella del campo cioè fregi d'oro, contanti in mano del ditto Vico.
<div align="center">Lire IIII soldi x.</div>

Location: AODS, no. 402 (Entrata e Uscita, 1427), fol. 65.

Document 210.
<div align="right">February 8, 1428
Siena *(Baptismal Font)*</div>

Jacopo, in Bologna, is ordered to return to Siena.

Magistro Iacobo Pieri de la Fonte scriptum est ad petitionem operariorum baptismatis quod cum omnia marmora et materies tota sit in promptu, ipse, secundum obligationem suam, veniat ad perficiendum opus dicti baptismatis, ut est obligatus.

Location: ASS, Concistoro, no. 1630, fol. 13v.

Bibliography: Milanesi, *Documenti,* 2: 140*n*; Beck, *Portale,* doc. 75; Paoletti, *Font,* doc. 177.

Comment: Shipments of Carrara marble from Pisa were recorded on January 1 and 30, 1428 (see AODS, no. 402, fol. 66).

Document 211. January 13, 1428
 Bologna *(Portal)*

Payment is made for material for the Portal.

Item, per tre stanghe de frasseno e per cunzadura de dui mastegli da acqua e sechie overò [= adoperò] maestro Iacomo dala Fonte a la porta nova, se fa soldi quatro.

Location: AFSP, Libro di Spese, fol. 11v.

Bilbiography: Supino, *Scultura Bologna,* doc. 32; Supino, *Sculture Porte,* doc. 17; Beck, *Portale,* doc. 76.

Document 212. February 20, 1428
 Pisa

Jacopo is registered in Pisa.

Pippo [di maestro Giovanni di Gante] pichiapietre ebbe da me soldi vinti, portòli Ysaia suo figliuolo in botega mia [i.e., ser Giuliano di Cola], presenti ser Antone da San Iusto et maestro Jacopo picchiapietre, disse li volea per lo manovale che ssegnò la calcina, disse avea nome Vincenzo, a dì 20 di Ferraio 1428 [= 1428, modern].

Location: ASP, Opera del Duomo, no. 1306, fol. 197v.

Comment: The stonemason Pippo supplied the upper portion of the *Baptismal Font* in Siena. He was, in the very same years, employed by ser Giuliano di Cola, Masaccio's Pisan patron, and in fact this payment relates to the chapel where Masaccio's polytych was located. If the Jacopo mentioned is indeed Jacopo della Quercia, as I believe is the case, he must have known the Florentines active in Pisa at this time. As we have seen, he was already acquainted with Donatello. Pippo was paid on April 14, 1428 for a marble block "per una figura grande" for the *Baptismal Font,* undoubtedly for the figure of the Baptist by Jacopo (see below, doc. 220). It is readily imaginable that Jacopo had gone to Pisa to select the stone.

The Isaia mentioned here became an important sculptor active mainly in Rome, where he was known as Isaia of Pisa.

Document 213.

March 23, 1428
Siena *(Baptismal Font)*

A statement is given by Pietro di Tommaso detto del Minella to continue work on the Baptismal Font.

Anno MCCCCXXVIII indictione vi die vero xxiii mensis martii. Actum Senis apud banchum del cambio Guccii Galgani Bichi de Senis, coram Galgano filio dicti Guccii, Petro magistri Iohannis et Angelo Marzini del Maza, civibus Senensibus testibus et cetera.

Cum hoc sit quod per operarios in comuni Senarum electos et deputatos super fabrica et perfectione baptismatis fuerit fact locatio laborerii predicti magistro Iacobo Pietri de la Guercia de Senis cum certis pactis et modis, de quibus latius patet manu ser Iacobi Nuccini notarii publici; et dictus magister deinde fecerit certam compositionem cum Pietro Thomassi dicto del Minella, quod deberet laborare in dicto opere certo tempore et modis de quibus invicem convenerunt; et nunc dictus Pietrus velit certificare operarios prefatos de laborando continuo in ipso opere et laborerio, pro tanto ipse Pietrus exercens artem in se et super se et maior, ut iuris est et cetera, sua libera et spontanea voluntate, ex certa scientia et non per errorem, promisit et se solemniter et efficaciter obligavit honorabilibus et egregiis viris Iohanni Francini de Patriciis et Iohanni Pieri Guidi, civibus Senensibus, duobus ex operariis predictis, et mihi notario tamquam persone publice stipulantibus pro aliis operariis absentibus et pro omnibus quorum posset interesse, et cetera, quod durante laborerio dicti baptismatis et donec ipsum opus et laborerium fuerit perfectum, ipse Pietrus continuo laborabit et se exercet cum persona sua et tribus laborantibus ultra personam suam in opere predicto. Et sic se facturum iuravit et cetera. Et si secus faceret voluit per pactum expressum posse extrahi de quocumque alio laborerio in quo laboret et conveniri et conduci ad laborandum continuo in ipso laborerio cum tribus aliis laborantibus et cetera, et adimplendum omnia superscripta et cetera. Renumptians et cetera. Et hoc presente dicto magistro Iacobo et consentiente eidem Pietro vigore et occasione conventionis quam simul habuerunt, et cetera. Et quod liceat mihi notario extendere et cetera.

Location: ASS, Notarile Antecosimiano, no. 272 (ser Giovanni di ser Antonio Gennari), fol. 134.

Bibliography: Milanesi, *Documenti*, vol. 2, doc. 103; Bacci, *Quercia*, p. 199; Beck, *Portale*, doc. 75; *Mostra*, doc, 28; Paoletti, *Font*, doc. 178.

Comment: Obviously because of his involvement in Bologna, Jacopo entered here into a type of subcontracting, letting his share of the work on the *Font* be carried out by Pietro del Minella.

Document 214.

March 23, 1428
Bologna *(Portal)*

A payment is made to Cino di Bartolo.

A maestro Iachomo de Piero dala Fonte Lire vente de bolognini, per noi d'Andrea Mezovillani li quali dè per lo detto maestro Iachomo a Cino suo garzone; posti a creditto a detto Andrea.

Lire XX.

Location: AFSP, Giornale, fol. 135.

Bibliography: Beck, *Portale,* doc. 78.

Document 215. March 26, 1428
 Bologna *(Portal)*

Mention that a stipido *of the* Portal *is registered as being moved.*

 Item, a di del dito [Marzo] per fare mectere uno stipido de marmora grande che era fora
in la stantia da lavorare le masegne a dui fachini soldi uno denari sei.
 soldi i denari vi.

Location: AFSP, Libro di Spese, fol. 13.

Document 216. March 28, 1428
 Bologna *(Portal)*

A payment is made for material for the Portal.

 Item, per una chaza de ferro de tegnuda de zinquanta libre da colare piombo per la porta
nova, a maestro Iacomo magnano, soldi quindexe zoè.
 soldi xv.

Location: AFSP, Libro di spese, fol. 13.

Document 217. April 1428
 San Gimignano

*Ventura di Moro of Florence is paid for painting in the Chapel of San Fabiano in the
Collegiata, San Gimignano.*

 Ventura di Moro dipintore da Firenze debba avere a dì ... [blank] d'Aprile [1428] per
dipintura di parte della faccia della cappella di Sancto Fabbiano, cioè da piè de' discepoli in
giù, la quale debba dipigniere chon uno Idio Padre con trono d'intorno e con fregio d'intorno,
bello, e tucto debba mectere a azuro fine il resto, chone stelle d'oro, cioè il campo, per insino
a piè di stalli dove debba stare su la Innuntiata e l'Agniolo e i decti piè de stalli debba bene
dipigniere. Et più debba dipigniere due cappegli civoriati i quagli ànno a stare a chapo alla
Innuntiate e a l'Agniolo, e in essi debba fare quegli profeti v'anderanno e il resto tucto debba
mectere a oro fine, e le voltarelle de'decti capegli debba mectere d'azuro chone stelle d'oro. E
per tucte le decte cose fare, debba avere, come fu suo pacto e nostro, Fiorini trentuno d'oro.
 Fiorini xxxi.
 Et più debba avere dalla sagrestria le spese per sé e pe'l compagno [Maestro Marco del
Buono?] mentre venerà a fare il decto lavorio.

Location: Biblioteca Comunale, San Gimignano (Entrata e Uscita dell'Opera, 1428-1428,
Segnato QQ.1), at the date.

Bibliography: Bacci, *Quercia,* pp. 15-16.

Comment: This document indicates that the two figures of the *San Gimagnano Annunciation* were finished by this time, but not yet in place.

Document 218.

<div align="right">April 1, 1428
Bologna *(Portal)*</div>

A payment of 80 lire is made to Jacopo.

Location: AFSP, Giornale, fol. 135v.

Bibliography: Beck, *Portale,* doc. 79.

Document 219.

<div align="right">April 9, 1428
Siena</div>

Jacopo is godfather to Taccola's daughter.

Alba di ser Mariano di Jachomo di Tacchola si battezzò a dì viiii d'Aprile, fu chonpare maestro Iachomo di maestro Piero maestro di pietra, tenne per lui Pietro di maestro Giovanni Fittoso banchiere.

Location: ASS, Biccherna no. 1132 (Battezzati, 1379–1441).

Bibliography: Bacci, *FdV,* p. 386; Beck, *Mariano di Jacopo detto il Taccola,* p. 28; Beck, *Portale,* doc. 80.

Comment: Actually Jacopo was in Bologna and not available for the ceremony.

Document 220.

<div align="right">April 14, 1428
Siena *(Baptismal Font)*</div>

The marble block for the figure of Saint John the Baptist was purchased.

Maestro Filippo [detto Pippo] del maestro Giovanni da Pisa per infino a dì 14 d'Aprile Lire dieci, per uno pezo di marmo fu per una figura grande se de' fare per lo Battismo detto, e sono a ragione del detto maestro Filippo n' abi dati, al memoriale di me Berto camarlingo a fo. 21.

<div align="center">Lire X.</div>

Location: AODS, no. 402 (Entrata e Uscita, 1427–1428), fol. 68.

Bibliography: Bacci, *Quercia,* p. 191; Paoletti, *Font,* doc. 180.

Comment: Since there is only one figure on the *Font* to which this payment could relate, the statue of John the Baptist at the apex, this document offers a firm *terminus post quem* for the statue. Although hardly "grande" in an absolute sense, being less than a meter high, the figure is larger than the other sculpture on the monument, and is also distinctive as the only in-the-round statue there.

Document 221.

<div align="right">

April 23, 1428
Bologna *(Portal)*

</div>

A payment is made for scaffolding on the Portal.

Item, spexe lo dito Bartolomio adì predeto xxiii de Avrile, A Cristovalo da Panzano persie piane de rovere per fare ponti a la porta grande, soldi trenta octo, zoè.

<div align="center">Lire I soldi xviii.</div>

Location: AFSP, Libro di Spese, fol. 14.

Bibliography: Beck, *Portale*, doc. 81.

Document 222.

<div align="right">

April 26, 1428
Bologna *(Portal)*

</div>

A payment is made for work and materials for the Portal.

Item, per una asse de albaro grande piedi tri e mezo per fare una barra da tirare suxo le prede de marmore e per lo portadore che l' adusse, in somma, soldi octo denari quattro, zoè.

<div align="right">soldi viii denari iiii.</div>

Item, per doe lanze lunghe per tore e far sazi a la porta, ave maestro Iacomo da la Fonte, soldi quatordexe.

<div align="right">soldi xiiii.</div>

Item, per fare fare uno scarpello grande a maestro Iacomo laxagnolo ave maestro Iacomo da la Fonte per metere suxo la porta, soldi zinque, zoè.

<div align="right">soldi v.</div>

Item, per doe chazole da murare a maestro Iacomo magnano, ave maestro Iacomo da la Fonte per murare la porta, soldi quatordexe.

<div align="right">soldi xiv.</div>

Item, per sie stanghe defrassano per fare manoelle, ave maestro Iacomo da la Fonte per la porta, soldi sie.

<div align="right">soldi vi.</div>

Location: AFSP, Libro di Spese, fol. 14.

Bibliography: Supino, *Scultura Bologna,* doc. 33; Supino, *Sculture Porte,* doc. 18; Beck, *Portale,* doc. 82.

Document 223.

<div align="right">

April 30, 1428
Siena *(Baptismal Font)*

</div>

Advances totaling 520 lire have been given to Jacopo for the historia.

A maestro Iacopo del maestro Piero de la Fonte Lire cinquecentovinti gli ò dati contanti in più volte, apare al memoriale di me Berto camarlingo a fo. 7 et a sua ragione a libro giallo afo. 70.

Location: AODS, no. 402 (Entrata e Uscita, 1427–1428), fol. 67v.

Bibliography: Bacci, *Quercia,* p. 257; Paoletti, *Font,* doc. 182.

Comment: The only indication of a date appears on the first item of the folio, which says April 30, 1428. The payment to Jacopo is the last item, but no other dates appear. Bacci associates this item with a payment of 120 lire that Jacopo was given "più tempo fa." Thus it seems probable that the payment of 520 lire should be considered a total of payments to date, and not a sum paid in full at the time of the entry. The item conforms with a payment in the "Libro Giallo" at folio 70v, and the payment at folio 67 of the "Uscita," which reads: "E de' dare Lire cinquecentoventi, ò gli dati contanti in più volte io Berto d'Antonio camarlengo, come apare al mio memoriale a ffo. 7 et sono a la mia escita fo. 67. Lire DXX." Gnudi ("Revisione," p. 40) suggests that Jacopo was not in Siena at this date. There is no firm evidence either way, but apparently he was surely in Bologna only four days before.

Document 224.

May 4, 1428
Bologna *(Portal)*

A payment is made for work and materials for the Portal.

Item, adì iii del dito per cira se to[l]sse, ave maestro Iacomo da la Fonte per fare la forma da li guerzi grandi dela porta nova de Sam Petronio, soldi siete e dinari sie, zoè.

soldi vii denari vi.

Item, adì detto per fare portare a dui facini quatro prede lavorade per lo imbaxamento soldi uno dinari sie.

soldi i danari vi.

Location: AFSP, Libro di Spese, fol. 14v.

Bibliography: Supino, *Scultura Bologna,* doc. 34; Supino, *Sculture Porte,* doc. 19; Beck, *Portale,* doc. 84.

Comment: Other payments for the transport of worked marble for the *Portal* are found during these same days, including on May 6 (Supino, *Sculture Porte,* doc. 20), May 10 (Supino, *Sculture Porte,* doc. 20 and Gatti, *La fabbrica,* doc. 50), and on May 11 (Supino, *Sculture Porte,* doc. 20 and Supino, *Scultura Bologna,* doc. 35).

Document 225.

May 1–11, 1428
Bologna *(Portal)*

Payments for work on the Portal *are recorded.*

Item, adì x del deto [Mazo] a Ghirardo Varano per far togliare e alarghare lo muro vecchio de la porta grande per murare lo imbaxamento, soldi uno.

soldi i.

Item, a dì xi del dito a maestro Polo di Iacomo maestro de ligname per diexe tagliole nove per anovere [?] lo imbaxamento novo se mura per la prova, a raxon de soldi tri l'una, in tutto, soldi trenta.

Lire i soldi x.

Location: AFSP, Libro di Spese, fol. xv.

Bibliography: Gatti, *La fabbrica,* doc. 50 (first part); Supino, *Scultura Bologna,* doc. 35, Beck, *Portale,* doc. 84n.

Document 226. May 13, 1428
 Siena *(Baptismal Font)*

The pila *of marble for the* Font *is mentioned.*

 Marco Mathei magistro lignorum de Monticiano scriptum est preceptorie quod visis presentibus faciat quot pila marmorea quam debet conducere a Gallena pro baptismo, quod fit hic in sancto Iohanne, de presenti conducatur ut obligatum est.

Location: ASS, Concistoro, no. 1630, fol. 37 (according to Paoletti).

Bibliography: Milanesi, *Documenti,* 2: 140*n;* Lusini, *Il Duomo di Siena,* pp. 43–44*n*1; Paoletti, *Font,* doc. 184.

Comment: I have been unable to find the letter, but the evidence is such that it may be accepted as correct. The contents are confirmed by the payment found under the date of May 18, 1428 (doc. 230).

Document 227. May 14, 1428
 Bologna *(Portal)*

A "new design" for the Portal *is mentioned.*

 Item, adì predicto [14 Maggio] per uno staro di gesso per murare uno guerzo al' usso [= all'uscio] che è sotto lo dessegno novo de la porta grande, soldi uno denari sie, zoè.
 soldi 1 denari vi.

Location: AFSP, Libro di Spese, fol. 15.

Bibliography: Beck, *Portale,* doc. 85..

Document 228. May 15, 1428
 Bologna *(Portal)*

A metalworker is paid for work on the Portal.

 A conto delle prede.
 A la fabricha di San Petronio Lire otto soldi xiiii di quatrini, per lei a maestro Iachomo Grasso fabro, per due ghuerci ci fa per la porta grande di mezo li pixono libbre ccvi a soldi uno denari vi la libbra, e per noi d'Andrea Mizovilano, posti a lui a creditto.
 Lire viii soldi xiiii.

Location: AFSP, Giornale, fol. 138v.

Document 229. May 17, 1428
 Bologna *(Portal)*

Stone is moved to Jacopo's workshop.

Item, adì predicto [17 Maggio] per due fachini menono una preda istriana, era sotto la sezunta se desfé ora sovra le schale a la stanzia dove lavora maestro Iacomo da Siena le prede marmore, uno soldi e sei denari, zoè.

<div align="right">soldi 1 denari vi.</div>

Location: AFSP, Libro di Spese, fol. 15v.

Bibliography: Beck, *Portale*, doc. 86.

Document 230.

<div align="right">May 18, 1428
Siena *(Baptismal Font)*</div>

The pila *for the* Font *is mentioned.*

A le spese de la casa del'uopera si fanno per me Urbano di ser Michele camarlengho de'uopara dieno dare a dì 18 di Maggio soldi vinti, e quagli paghai a Pasquino fameglio de' singniori per una lettera a Monteciano a Marcho di Matteio bufalaio la quale gli commandava per parte de' singniori che esso fasse acareggiare la pila del battesimo.

Location: AODS, no. 673, fol 7v.

Bibliography: Bacci, *Quercia*, p. 203; Paoletti, *Font*, doc. 186.

Comment: The following payment for the marble itself, which occurs on June 10 (AODS, no. 403, fol. 51), reads:

A Marcho di Matteio da Monteciano a dì x di Giugnio Lire dugiento quaranta e quagli gli feci dare al bancho di Tomasso di Nanni e compagni banchieri per detto degli operai di San Giovanni, e quagli denari sono per conduciture della pila grande del battesimo de San Giovanni.

<div align="center">Lire CCXL.</div>

At the same date, there are further payments for the shipment of marble (see Bacci, *Quercia*, p. 204, and Paoletti, *Font*, docs. 189–190).

Document 231.

<div align="right">May 21, 1428
Bologna *(Portal)*</div>

Stone is brought to the Portal.

Item, adì xxi per dui fachini menono doe prede de marmore grosse ala ditta porta soldi dui.

<div align="right">soldi ii.</div>

Location: AFSP, Libro di Spese, fol. 15v.

Bibliography: Beck, *Portale*, doc. 87.

Document 232.

<div align="right">May 22-26, 1428
Bologna *(Portal)*</div>

A payment is made for work on the Portal.

A la detta, Lire una soldi quatro, per lei a Ghirardo de Piero Varano manoale per sgomberare schaighie de marmore suxo la scale de San Petronio e per portare prede nuove a la porta de meza e per portare sabbion con la caretta e per refare el muro defatto a secho da la capella dove fu messo in principio quando maestro Iacomo comenzò a lavorare a la porta; e per noi da Andrea Mizovilani, a lui a credito.

<div align="center">Lire I soldi iiii.</div>

Location: AFSP, Libro di Spese, fol. 15v.

Bibliography: Supino, *Sculture Porte*, doc. 22; Beck, *Portale*, doc. 88.

Document 233. May 28, 1428
 Bologna *(Portal)*

Work is done on the Portal, *including the "black" stone portions.*

Item, a dì xxviii del dito per de overe de dui fachini menono a la ditta capella, prede de marmore per lo dito imbassamento e repoxeno in la dita capelle prede negre di marmore ora sparguglade de fuora e per uno manoale glie aidò menare lo caretto matto pizolo, con le dite prede, soldi dexedotto, zoè.

<div align="right">soldi xviii.</div>

Location: AFSP, Libro di Spese, fol. 15v.

Bibliography: Beck, *Portale*, doc. 89; also at the same date the *ponte* at the *Portal* are mentioned, for which see Supino, *Scultura Bologna*, doc. 36.

Comment: The "prede negre" need not be understood as black but rather as dark, and could actually have referred to the red stone, in the same way that "vino nero" is one way of referring to red wine, and "pane nero" is usually light brown bread.

Document 234. June 4, 1428
 Bologna *(Portal)*

Work is done on the Portal.

Item, a dì iiii del dito per uno martello da murare, ave maestro Iacomo da la Fonte de' restituire soldi sei.

<div align="right">soldi vi.</div>

Item, per fare menare lo caretto basso de corte de monsignore Louis Aleman e la fabricha a dui fachini denari sei, zoè.

<div align="right">denari vi.</div>

Item, per dui fachini menono nove prede di marmore per lo imbassamento a la porta soldi quatro, zoè.

<div align="right">soldi iiii.</div>

Item, per do sponghe per la porta a murare lo imbassamento soldi uno, zoè.

<div align="right">soldi i.</div>

Location: AFSP, Libro di Spese, fol. 16.

Bibliography: Beck, *Portale*, doc. 90; Supino, *Scultura Bologna*, doc. 38.

Document 235.

Work continues on the Portal.

Item, per dui fachini menono nove prede ala dita porta de marmore tagliade per lo imbassamento soldi quatro denari sei, zoè.

soldi iiii denari vi.

Location: AFSP, Libro di Spese, fol. 16.

Bibliography: Beck, *Portale,* doc. 91.

Comment: On June 8 a substantial sum of lime was brought to the *Portal* (Giornale, fol. 139).

Document 236.

June 17–18, 1428
Bologna *(Portal)*

Stones for the arch of the Portal *and provision for glue are recorded.*

Item, a di xvii per uno manoale a deschalcinare le prede de'arco de la porta grande che s'averse soldi quatro.

soldi iiii.

Item, adì xviii del dito per mastexe ave maestro Iacomo da la Fonte per colla, uno pichione.

soldi i denari vi.

Location: AFSP, Libro di Spese, fol. 16v.

Bibliography: Supino, *Scultura Bologna,* doc. 39; Supino, *Sculture Porte,* doc. 23; Beck, *Portale,* doc. 90 (partial).

Document 237.

June 18, 1428
Bologna *(Portal)*

Payments to workmen at the Portal *are recorded.*

. . . a maestro Iachomo da I Chapelli per tre overe à date ala detta fabricha per lo lavorier dela porta per tuto dì x di Zugno presente, a soldi x l'overa . . .

Lire I soldi x.

soldi x. . . . a Simone da Luccha per due overe à date ala detta fabricha per lo lavorier de detta porta, a soldi otto l'overe, per tutto di x de presente.

soldi xvi.

Location: AFSP, Giornale, fol. 140.

Document 238.

June 19, 1428
Bologna *(Portal)*

Payments for scaffolding at the Portal *are recorded.*

Ala fabricha si San Petronio Lire uno soldi diexe de quatrini, per lei a maestro Iachomo da I Chapelli per tre overe à date ala detta fabricha per tuto dì 18 de detto mexe a fare la [*sic*] ponti a lavorer de la porta, a soldi x l'overe, e per noi d'Andrea Mizovilano, a lui a creditto.

Lire I soldi x.

A la detta Lire uno soldi quatro de quatrini, per lei a Simone da Lucha per tre overe à dade per fare la [*sic*] ponti de la porta San Petronio a soldi otto l'overa, e per noi d'Andrea Mezovilano, a lui a creditto, come apare nele dette due poste a libro nuovo dele spexe a ch[arta] . . . [blank]

Lire I soldi iiii.

A maestro Iachomo dala Fonte Lire uno soldi sedexe, per lui a Iacomo di Piero fornar per sei overe di manuale gli à dade a servirlo a la porta, furono per tuto dì 16 Zugno, e per noi d'Andrea Mezovilano, a lui a creditto.

Lire I soldi xvi.

Location: AFSP, Giornale, fol. 140.

Comment: On the same day we find the following item: "adì xviiii a Iacomo da Cremona per deschalcinare le prede sono dela dita porta quando se averse soldi sie, zoè soldi vi" (Libro di Spese, fol. 16v; in Beck, *Portale,* doc. 95). Between June 19 and 21 sand was brought to the *Portal* (Giornale, fol. 140v).

Document 239. June 25, 1428
Bologna *(Portal)*

A payment of 100 lire is made to Jacopo.

Location: AFSP, Giornale, fol. 140v.

Document 240. June 26, 1428
Bologna *(Portal)*

Stones are brought to the Portal.

Item, a dì xxvi del dito per tri fachini che menono lo stipido ala porta nova soldi sie, zoè.

soldi vi.

Item, per Simone Negro per unzere le taglie dinari sei.

denari vi.

Location: AFSP, Libro di Spese, fol. 16v.

Bibliography: Beck, *Portale,* doc. 96.

Document 241. June 30, 1428
Bologna *(Portal)*

Work proceeds at the Portal.

Item, a dì xxx del dito per dui fachini che aidono al arghano a rizare suxo lo stipido sovra l'altro, soldi 4.

soldi iiii.

Item, per Simone Negro per unzere le taglie dinari sei.

denari vi.

Location: AFSP, Libro di Spese, fol. 16v.

Bibliography: Supino, *Scultura Bologna,* doc. 39; Supino, *Sculture Porte,* doc. 23; Beck, *Portale,* doc. 98.

Comment: On the same day, Jacopo was paid 100 lire (Giornale, fol. 140v; in Beck, *Portale,* doc. 97).

Document 242.
July 4, 1428
Bologna *(Portal)*

Activity on the Portal *is recorded.*

Item, a zinque fachini che caregono lo stipido suxo lo charetto per menarlo a la porta, soldi dui e denari sei.

soldi ii denari vi.

Location: AFSP, Libro di Spese, fol. 17.

Bibliography: Beck, *Portale,* doc. 99.

Document 243.
July 4, 1428
Bologna

Jacopo writes to the Operaio of the Sienese Duomo concerning an appropriate architect for the Loggia di San Paolo.

[Address] Espettabili et egregio chavaliere misser Bartolomeo di Giovanni Ciec[c]hi, Hoperario de la chiesa di Siena, in Siena.
 + Al nome di Dio MCCCCXXVIII, adì iiii Luglio.
 Espettabile et egregio chavaliere: le rechomandazioni premisse et cetera.
 Per lo fante vostro ò ricievuto due vostre lettara [*sic*] contenentte e l'uno sopra al fatto del maestro del difizio e de la muraglia avete a far fare per la Logia di San Pauolo; avisandomi d'un maestro senese, el qual deb'essare in paese, sofiziente a la facienda. E per vostro aviso lo ditto maestro, il qual m' è noto si chiama maestro Giovan da Siena; lui è a Ferrara chol Marchese e si li chompone un chastello molto grande e forte drento da la città e di li dà duchati 300 l'anno e le spese per 8 boche. E questo so di cierto: quanto si venisse chostà, di' no, penso; e non è maestro chola chazuola in mano, ma chomponitore e 'giengiero.
 Ed è vero che qui in Bolongnia è un altro maestro, il quale si chiama Fieravante, quale à fatto un palagio belissimo al Chardinale e Lechato di Bolongnia, molto ornato e chostui fece lo chastello di Bracio in Perugia, ed è di bu[o]no ingenio ed adatasi più al pelegrino che non fa l'altro, quanto a la forma de le chose, e simile pocho aopera chazuola od altra manualità, ma molto fa fare bene sua opera. A questo ò parlato, e penso verrà per fin chostì, dove le Reverenzie vostre voglino: ed a informazione di quello che di lui vi scrivo; qui fia una sua lettara, e per voi fia intesa a diliberare poterete, come vi parrà.
 E perché il choriere istudiava il partire, non ò auto tempo da potermi informare di più inna[n]zi e di chi venissi a far bene la vostra faccienda, non tanto in Bologna quanto

d'altronde; ma io vi darò il pensiero e subito sarete avisati e non mancherà, s' a Dio piacie, che presto saprete di ciò che ci è di buono.

Per lo vostro servidore Iachopo del maestro Piero, in Bologna.

Location: AODS, Museum, Mostra, Sala di Documenti.

Bibliography: Milanesi, *Documenti*, vol. 2, doc. 108; Bacci, *Quercia*, p. 315; Beck, *Portale*, doc. 100; *Mostra*, doc. 29.

Comment: Paolo di Martino was eventually selected for the assignment, upon which he worked until his death in 1437. There is a small notebook (located in ASS, Opera Metropolitana, no. 38) with payments for the Loggia, probably kept by Paolo (called "maestro di pietra"), which covers the years 1429–1433, and contains the following names: "Giovanino di . . . [blank] Tuccio; Giovanni di Giusto da Firenze; Filippo di Giusto da Firenze; Giovanni di Sabattelo; Ciechino di Fiorenza [?]; Giovanni di Pietro da Chomo; and Biagio d'Andrea da Settignano." It is noteworthy that most of the stoneworkers were Florentines.

Document 244. Juny 6, 1428
 Bologna *(Portal)*

Work is done on the Portal.

Item, ad vi del dito per latta stagnata ave maestro Iacomo per metere sotto la stipido, soldi uno dinari sei.

 soldi i denari vi.

Location: AFSP, Libro di Spese, fol. 17.

Bibliography: Beck, *Portale*, doc. 101.

Comment: At the same date in the same account book is the following: "Item, per la far scrivere la litera di familiare [?] di Guglielmo Gato per andare in Lombardia, soldi tri. soldi iii."

Document 245. July 7, 1428
 Siena *(Baptismal Font)*

Jacopo's presence is requested in Siena.

Magistro Iacobo Piero sculptori lapidum scriptum est, quod cum laborerium Baptismi sibi locatum sit iam in termino, quod necesse sit presentia sua et etiam [cum] magister Nannes de Lucha et Petrum del Minella, quos ipse proposuerat dicto laborerio, habeant inter se maximam diferentiam, omnino precipitur ei quod subito sine aliquod interpositione temporis accedat huc ad perfectionem dandam laborerio antedicto.

Location: ASS, Concistoro, no. 1631 (Copialettere), fol. 3.

Bibliography: Milanesi, *Documenti*, vol. 2, doc. 109; Bacci, *Quercia*, p. 206; Beck, *Portale*, doc. 100; *Mostra*, doc. 30; Paoletti, *Font*, doc. 194.

Document 246.

A payment is made for a shipment of stone from Pavia.

A Ghuglielmo Ghatto nochiero Lire cinquanta, per noi d'Andrea Mizovilano a lui a credito, e detti denari sono per parte del nolo dele marmor che'l detto Ghuglielmo à tolto a condure da Pavia q [= qua?] a Bologna in la fabricha, a soldi 32 la soma.

<div align="center">Lire L.</div>

Location: AFSP, Giornale, fol. 141v.

Comment: The marble must be "Lombard" stone of some kind, and the payment for shipment here is only a partial one, indicating that a substantial amount of marble was sent to Bologna in 1428. Hence, the payment appears to be evidence against Gnudi ("Revisione"), who believed that all the "Lombard" stone for the *Portal of San Petronio* came to Bologna earlier. Indeed, Gnudi claims: "I documenti non parlano di nuovi acquisti di marmi in Lombardia di cui esisteva evidentemente ampia scorta fin dal primo e *unico* [my italics] trasporto degli anni 1425 e 26." The point takes on a certain importance for the scholar's argumentation concerning the chronology of work on the sculpture for the portal. Since the portal is not specifically mentioned, there is no certainty, however, that this payment was actually for the portal, although it does seem likely (see also doc. 244 below, comment).

Document 247.

Work continues on the Portal.

Item, adì vii del dito per dui fachini che adussono dal Veschoado una naspa grande e una chavestro, per sé ave im prestanza per tirare suxo lo stipido, soldi tri.

<div align="center">soldi iii.</div>

Item per nove fachini che menono lo stipido grande a la porta e certe prede per lo imbaxamento de la porta, soldi vintisepte, zoè

<div align="center">Lire I soldi vii.</div>

Location: AFSP, Libro di Spese, fol. 17.

Bibliography: Beck, *Portale*, doc. 103.

Document 248.

Work continues on the Portal.

Spese facte per lo dito Bartolomeo per la dita fabrica per quatro fachini che aidono a uno pizo di stipido ala porta e per tirarlo suxo, soldi sedexe.

<div align="center">soldi xvi.</div>

Location: AFSP, Libro di Spese, fol. 17.

Bibliography: Beck, *Portale*, doc. 103.

Document 249.

<div align="right">

July 12, 1428
Siena

</div>

An emmissary is sent to Jacopo in Bologna.

A Pauolo detto di Piero da Cietona, famiglio de' Singniori, Lire sette contanti, e quagli sono per sette dì andò a Bolongnia per uno maestro per San Pauolo, mandolo egli operaio di San Pauolo, andò a dì 5 di Luglio e tornò a dì 12 Luglio.

<div align="center">Lire VII.</div>

Location: AODS, no. 403. fol. 51v.

Document 250.

<div align="right">

July 14, 1428
Bologna *(Portal)*

</div>

Work proceeds on the Portal.

A maestro Iachomo de la Fonte Lire una soldi sedexe di quatrini, per lui a maestro Iachomo di Piero manoale per sie overe da manoale à dado a detto maestro Iachomo a lavorier dela porta per tutto dì x el detto mexe, e per noi d'Andrea Mezovilani a lui a credito.

<div align="center">Lire I soldi xvi.</div>

Location: AFSP, Giornale, fol. 142.

Bibliography: Beck, *Portale*, doc. 104.

Document 251.

<div align="right">

July 15, 1428
Bologna *(Portal)*

</div>

Materials are mentioned for the Portal.

Item, per vernixe e per olio de ruda [= ruta?] da unzere le colone rosse, soldi octo, ave maestro Iacomo da la Fonte.

<div align="center">soldi viii.</div>

Location: AFSP, Libro di spese, fol. 17v.

Bibliography: Supino, *Scultura Bologna*, doc. 40; Supino, *Sculture Porte*, doc. 24; Beck, *Portale*, doc. 105.

Document 252.

<div align="right">

July 17, 1428
Bologna *(Portal)*

</div>

Prophets are put in place on the Portal.

Item, a dì xvii del dito, per sie fachini che menono la colona di profetti per tirarla suxo, soldi ventiquattro

<div align="center">Lire I soldi iiii.</div>

Location: AFSP, Libro di Spese, fol. 17v.

Bibliography: Gatti, *La fabbrica,* doc. 51; Beck, *Portale,* doc. 106.

Comment: The "columns" (i.e., pilaster strips) that contained the prophet busts on either side of the *Portal* are each composed of several separate stones.

Document 253.

<div align="right">

July 19, 1428
Bologna *(Portal)*

</div>

Activity continues at the Portal.

Item, per tri fachini al mulinelle e al arghano a tirare le cholone, soldi cinque e dinari sie.

<div align="center">soldi v denari vi.</div>

Location: AFSP, Libro di Spese, fol. 17v.

Bibliography: Beck, *Portale,* doc. 107.

Comment: I believe that the stones mentioned here are part of the columns that contained the prophet busts, as in the previous document. The *mulinelle* and the *arghano* are machines used for lifting heavy loads.

Document 254.

<div align="right">

July 23, 1428
Bologna *(Portal)*

</div>

A column and scaffolding for the Portal *are mentioned.*

Item, adì xxiii del dito per quatro asse di albero per fare ponti ala porta, soldi quaranta quatro.

<div align="center">Lire II soldi iiii.</div>

Item, spese lo dito Bartolomeo adi preditto per tri fachini tirono suxo una colonna rossa, soldi quatro e denari sei, cioè

<div align="center">soldi iiii denari vi.</div>

Location: AFSP, Libro di Spese, fols. 17v–18.

Bibliography: Beck, *Portale,* doc. 108 (first part only).

Document 255.

<div align="right">

July 24, 1428
Bologna *(Portal)*

</div>

Work proceeds on the Portal.

Item adì xxiiii del dito per tri fachini menono una colona rossa achanolada, soldi tri, zoè.

<div align="center">soldi iii.</div>

Item, per sei fachini menono una colona biancha afogliada ala porta, soldi nove.

<div align="center">soldi viiii.</div>

Location: AFSP, Libro di Spese, fol. 18.

Bibliography: Supino, *Sculture Porte,* p. 14; Beck, *Portale,* doc. 109.

Comment: The "colona biancha" is mentioned again on July 26: "Item, xxvi del dito, per tri fachini aidono tirar la colona biancha afogliada al' arghano e al molinello, soldi tri . . . soldi iii" (AFSP, Libro di Spese, fol. 18).

Document 256. July 27, 1428
 Bologna *(Portal)*

Stones are brought to the Portal.

 Item, adì xxvii del dito, per dui fachini menono una colona rossa achanolada a la porta, soldi dui.

<div align="center">soldi ii.</div>

Location: AFSP, Libro di Spese, fol. 18.

Bibliography: Beck, *Portale,* doc. 110.

Document 257. July 28, 1428
 Bologna *(Portal)*

A payment of 100 lire is made to Jacopo.

Location: AFSP, Giornale, fol. 142v

Bibliography: Beck, *Portale,* doc. 111.

Document 258. July 29, 1428
 Bologna *(Portal)*

Payment is made to workers for labor on the Portal.

 . . . A Iacomo de Piero manoale per nove overe . . .
<div align="center">Lire II soldi xiiii.</div>
 . . . A maestro Iacomo da I Capelli maestro de legname per undexe overe . . . da dì 19 de Luio insino per tuto el presente mexe . . .
<div align="center">Lire V soldi x.</div>
 . . . A Bartolomeo da I Capelli per undese overe . . .
<div align="center">Lire IIII soldi xviiii.</div>
 Spexe facto per lo dito Bartolomeo digli Albiroli per la ditta fabricha, zoè per dui fachini che menono ala ditta porta prede di marmore istriane per lo imbaxamento soldi dui, zoè.
<div align="center">soldi ii.</div>

Location: AFSP, Giornale, fol. 143 (first three items); Libro di Spese, fol. 18v (last item).

Bibliography: Beck, *Portale,* docs. 112 and 113.

Document 259. August 11, 1428
 Bologna *(Portal)*

Further activity is recorded on the Portal.

Item, adì de Agosto per septe fachini che aidono menare uno pezo de stipido a la dita porta, soldi septe, zoè.

<div align="center">soldi vii.</div>

Item, adì de Agosto per septe fachini che aidono menare uno pezo de stipido a la dita porta, soldi septe, zoè.

<div align="center">soldi vii.</div>

Location: AFSP, Libro di Spese, fol. 18v.

Bibliography: Beck, *Portale,* doc. 114.

Document 260.

<div align="right">August 14, 1428
Bologna *(Portal)*</div>

Work continues on the Portal.

Item, adì de xiiii del dito, per sie fachini che menono a la dita porta una colona da fogliame, soldi nove.

<div align="center">soldi viiii.</div>

Item, per cinque fachini che aidono tirare suxo la dita colona, soldi sie.

<div align="center">soldi vi.</div>

Location: AFSP, Libro di Spese, fol. 18v.

Bibliography: Beck, *Portale,* doc. 115.

Comment: On the same day there are payments to maestro Jacomo da I Capelli and Simone da Lucha for work on the *Portal* (see Beck, *Portale,* doc. 116).

Document 261.

<div align="right">August 17, 1428
Bologna *(Portal)*</div>

Activity continues at the Portal.

Item, adì de xvii del dito, per tri fachini che menono una colona da fogliame a la dita porta, soldi quatro, zoè.

<div align="center">soldi iiii.</div>

Item, a dì dito, per dui fachini aidono tirare suxo la dita colona, soldi uno dinari quatro, zoè.

<div align="center">soldi i denar iiii.</div>

Item, a dito dì, per quatro fachini che aidono tirare suxo la colona rossa e menono una altra colona rossa, soldi sei, zoè.

<div align="center">soldi vi.</div>

Location: AFSP, Libro di Spese, fol. 18v.

Bibliography: Beck, *Portale,* doc. 117.

Document 262.

<div align="right">August 19, 1428
Siena *(Baptismal Font)*</div>

The Sienese Signoria writes to Jacopo in Bologna.

Die xviiii Augusti predicta—magistro Iacopo magistri Petri lapidum sculptori scriptum est preceptorie quod visis presentibus se conferat ad presentiam dominorum . . .

Location: ASS, no. 1631 (Copialettere), fol. 15.

Bibliography: Bacci, *Quercia,* p. 206-207; Beck, *Portale,* doc. 118; *Mostra,* doc. 31; Paoletti, *Font,* doc. 201.

Document 263. August 22, 1428
 Siena *(Baptismal Font)*

Jacopo writes to the Sienese Signoria, respectfully declining to return to Siena immediately.

[Address] Magnifici et excielsi singniori singniori et governatori della città di Siena.

Magnifici et excielsi singniori. Da la vostra singnioria ò ricievuta la chomandatoria lettara la qual vuole che quella veduta, senza etciezione a' piei de la vostra mangnificienza mi rapresenti; et chosi cho' la volontà dell'anima senza alqun distollere, io fedelissimo servitor vostro son sempre obedientissimamente representato; ma la corda de la ragione mi tien per lo presente qui legato in tal modo che mio onore et mia lieltà, partendomi, mancharei; per lo qual manchamento uno de' servi de la vostra singnioria a vostra magnificenzia farebe poco onore quando i' doventasse disleale. Ma quello che a' vostri egregii cittadini ò promisso, l'oserverò al termine et al tenpo. Umilissimamente pregando la chremenzia di vostra singnoria che al mio ingniorante parlare facia perdono l'Altisimo ne la felicie pacie vi conservi.

De la vostra singnoria, per lo pichol servo Iacopo del maestro Piero in Bolognia, adì xxii Agusto.

Location: ASS, Concistoro, no. 1614, n. 19.

Bibliography: Milanesi, *Documenti,* vol. 2, doc. 110; Milanesi, *La scritture di artisti,* vol. 1 (at the date); Supino, *Scultura Bologna,* doc. 41; Supino, *Sculture Porte,* doc. 25; Beck, *Portale,* doc. 120; *Mostra,* doc. 32; Paoletti, *Font,* doc. 202.

Comment: The formal courtesy of this letter has been commented upon by A. Conti, "L'evoluzione dell' artista," in G. Previtali, ed., *Storia dell'arte italiana* (Turin, 1979), 2:175.

Document 264. August 24, 1428
 Bologna *(Portal)*

Stones are brought to the Portal.

Item, adì de xxiiii del dito, per uno fachino che menò prede de marmore per lo imbaxamento di la porta, soldi dui.

 soldi ii.

Location: AFSP, Libro di Spese, fol. 18v.

Document 265. August 26, 1428
 Siena *(Baptismal Font)*

A decision is made to order Jacopo to return to Siena within ten days.

Die xxvi Augusti 1428.

Visaque inobbedientia commissa eidem magnificis dominis per magistrum Iacobus Pieri de la Fonte existentem Bononie, et precepto concistorii per eum spreto [?] in pluribus licteris ad eum transmissis etiam per proprium nuntium, de se coram ispe magnificis dominis personaliter presentando, et eius responsione, ac etiam contentu suo dictis licteris habito in vilipendium consistorii et totius comunis Senarum, concorditer et solemniter deliberaverunt et decreverunt quod scribatur iterum et de novo ad omnem contumaciam convincendam eidem magistro Iacobo per nuntium proprium expensis suis, et ei precipiatur quatenus inter x dies sub pena centum florenorum auri in qua ipso facto intelligatur ipsum incidisse et incidat, sicque eum usque nunc condemnaverunt et multaverunt si infra dictum tempus, a die receptarum licterarum computandum, se personaliter non presentabuit Consistorio prefato. Et eo non veniente, dicta multa denuntietur in Biccherna more solito.

Location: ASS, Concistoro, no. 374 (Deliberazioni), fol. 25v.

Bibliography: Milanesi, *Documenti*, vol. 2, doc. 111; *Mostra*, doc. 33; Paoletti, *Font*, doc. 204.

Comment: Milanesi gives the following note written in the margin under the date of September 15, 1428:

Die xv Septembris sequentis declaratum fuit per Consistorium dicto magistro Iacobo non veniente, ipsum incidisse in dictam penam et preceptum ser Iohanni Nicholai quod ipsum denuntiet in Biccherna, ut constat manu mei Iohannis Francisci notarii Consistorii.

The text of the letter actually sent to Jacopo is given in the next document (doc. 266).

Document 266. August 26, 1428
 Siena *(Baptismal Font)*

A letter is sent to Jacopo ordering him to return to Siena within ten days.

Magistro Iacobus magistri Pieri lapidum sculptori scriptum est quod per litteras eius nuper nobis redditas intelleximus ipsum variis excusationibus fugere hunc se conferre coram dominis. Quare tenore presentium stricte preciptitur ei quod sine [n]ulla exceptione infra terminum x dierum a die receptionis istarum; de qua receptione stabimus relationi famuli nostri; sub pena centum florenorum auri quam incidisse intelligatur statim et que in Bicherna pontetur et quod ipsum nunc pro tunc si non erit obediens condepnamus. Item quod solvat latori presentium pro labore suo libras otto denariorum et cet.

Location: ASS, Concistoro, no. 1631 (Copialettere), fol. 17.

Bibliography: Milanesi *Documenti*, vol. 2, doc. 111; Bacci, *Quercia*, p. 208; Beck, *Portale*, doc. 121; Paoletti, *Font*, doc. 200

Document 267. August 27, 1428
 Bologna *(Portal)*

Stone is brought to the Portal.

Item, adì predito [27 Agosto] per dui fachini per adure quatordixe prede de marmore a la porta, soldi quattro, zoè.

soldi iiii.

Location: AFSP, Libro di Spese, fol. 19.

Document 268. August 28, 1428
 Siena *(Baptismal Font)*

Jacopo responds to the Sienese Signoria.

[Address] Magnifici et potenti singiori singniori et governatori de la città di Siena.
Magnifici et potenti singniori.
La lettera de la vostra mangnificenzia questo dì ho ricievuta, comandandomi che infra dì x mi rapresenti a' piè d'essa, dove che no, in Fiorini ciento sarò condenato. I' mi ricordo che la iustizia de' singniori non fa ingiustizia nè a picioli né a grandi. Io non ò fallito nè a fallire intendo, ma fallo sarebbe al suo singnior disubidire ed io a desubidire non son desposto; ma ora e sempre la vostra mangnificienza con reverenzia obbedire. E pertanto quanto a Dio piacierà, mi sarò infra il termine del chomandamento offerto dinanzi a vostra giusta singnioria. Anchora mi chomandate che Lire otto al 'apportator di questa i' debia dare; sienli fatti dare de' denari del mio lavor chostì, ché al presente non ò il modo di ditti denari poter pagare, che mi sare' charo averne assai per poterne pagare a lui ed a altri. L'Altisimo con felicità la vostra singnioria e in stato conservi.
Per lo servo de la singnoria vostra Iacopo, a la qual si racomanda, a di xx[v]iii Agusto.

Location: ASS, Concistoro, no. 1914, n. 19.

Bibliography: Milanesi, II, doc. 112; Supino, *Scultura Bologna,* doc. 42; Supino, *Sculture Porte,* doc. 26; Bacci, *Quercia,* pp. 208–209; Beck, *Portale,* doc. 122; *Mostra,* doc. 33; Paoletti, *Font,* doc. 203.

Comment: This remarkable letter is undoubtedly a response to the Signoria's letter of August 26, although some scholars would date it before 23 August.

Document 269. September 1, 1428
 Bologna *(Portal)*

Jacopo and his workmen are paid for work.

A maestro Iachomo dala Fonte Lire quatrodexe soldi sedexe de bolognini, per lui a maestro Antonio d'Andrea da Lucha per so salario de uno mixe, che comenzò adì xxii de Luio e finì a dì xxii d'Agosto prossimo passato, e per noi d'Andrea Mizovillani, posti a creditto a lui.
Lire XIIII soldi xvi.
al detto [maestro Iachomo dala Fonte] Lire ottantacinque soldi quatro de bolognini, per noi d'Andrea Mizovillani, posti a lui a credito.
Lire LXXXV soldi iiii.
A maestro Iachomo dala Fonte Lire uno soldi sedexe, per lui a Iacomo deIani da Bolon-

zoni per sie overe a dado ai maestri del detto maestro Iacomo a lavorier dela porta, e per noi d'Andrea Mizovillani, a lui a creditto.

<div align="center">Lire I soldi xvi.</div>

Location: AFSP, Giornale, fol. 144v.

Bibliography: Supino, *Sculture Porte,* p. 25; Beck, *Portale,* doc. 124.

Document 270.

<div align="right">September 18, 1428
Siena *(Baptismal Font)*</div>

Pagno di Lapo is paid for work on the Baptismal Font.

Maestro Iachomo di maestro Piero, Maestro di pietra che lavora el battesimo, die dare adì 18 di Settembre Lire quaranta, e quagli paghai per detto degli oparai del battesimo a maestro Pangno di Lapo da Fiorenza, maestro di pietra, quagli gli die per parte di pagamento di mesi tre e mezo a lavorato nel detto battesimo in fino a questo dì detto, contanti in sua mano.

<div align="center">Lire XL.</div>

Location: AODS, no. 673 (Memoriale), fol. 23v.

Bibliography: Bacci, *Quercia,* p. 211; Paoletti, *Font,* doc. 206.

Comment: In the same *partita,* there is another payment to Pagno, dated March 8, 1429 [= 1430, modern?], which reads;

[Maestro Iachomo di maestro Piero, maestro di pietra] E die dare a dì 8 di Marzo Lire vintotto, e quagli paghai per lui et per suo detto a maestro Pangnio di Lapo da Fiorenza, maestro di pietra.

<div align="center">Lire XXVIII.</div>

The participation of Pagno is a further indication of Jacopo's association with Donatello during these years, since Pagno was Donatello's assistant and remained so for a long time.

Document 271.

<div align="right">September 23, 1428
Bologna *(Portal)*</div>

Jacopo's garzoni *are to be paid.*

Die vigesimo tertio mensis Septembris.

Ser Michael Parixii de Auro, Regulator iurium fabrice Sancti Petronii, de consensu volun-tate et mandato venerabilis viri domini Petri de Ramponibus, canonici Bononie, et Guasparis de Lupporis Officialium et Superstitum dicte fabrice et vice et nomine dictorum Superstitum promisit solvi facere per manus depositarii dicte fabrice, Zino Bartoli de Senis, Bartolo Antonii de Florentia, Iohanni Petri de Florentia et Dominico Antonii de Flexoli, ominibus lapicidis et garzonis magistri Iacobi Petri de la Fonte de Senis lapicide ibidem presentibus, libras quinqueginta bon. presente et volente predicto magistro Iacobo et nomine ipsius magistri Iacobi, in fine presentis mensis, pro salariis ipsorum quator garzionorum, compen-sandas predicto magistro Iacobo et in eius summa quam havere debet a dicta fabrica pro

constructione porte magne dicte fabrice. Qui magister Iacobus ibidem presens et predictis consentiens eximit, ellegit et deputavit predictos Zinum et Iohannem quibus dari et assignari voluit dictas quinqeginta libras bon. eorum propriis nominibus, et vice et nominibus predictorum Bartoli et Dominici.

Location: AFSP, Libro di' Atti Civili della Fabbrica, vol. 3, fol. 16.

Bibliography: Supino, *Scultura Bologna,* doc. 27; Beck, *Portale,* doc. 125.

Document 272. September 24, 1428
 Siena *(Baptismal Font)*

A drill for work on the Baptismal Font *was purchased.*

E dieno dare a dì 24 de Settenbre soldi vintisette e quagli sono per libre 8 oncie 11 d'acciaio avemmo da la buttigha di Petro di Lentino per mettere in una stampa per bucharare el chuscino che tiene la pila del battesimo, per detto degli operai del battesimo.
 Lire I soldi vii.

Location: AODS, no. 673 (Memoriale), fol. 21v.

Bibliography: Bacci, *Querci,* p. 234; Paoletti, *Font,* doc. 207.

Document 273. September 25, 1428
 Siena *(Baptismal Font)*

Donatello is sent partial payment for two figures for the Baptismal Font.

Donato di Nicholò da Fiorenza die dare infino adì 25 di Settembre Lire ciento, e quagli dipositai per detto di misser Bartolomeio al bancho di Ciecho di Tomaso fratelli et loro gli mandaro a Fiorenza al detto Donato, per parte di due fighure dorate per lo battesimo.

Location: AODS, no. 673, fol. 25v.

Bibliography: Milanesi, *Documenti,* 2:135; Bacci, *Quercia,* pp. 219–222; Paoletti, *Font,* doc. 210.

Comment: Other payments to Donatello for the same purpose follow in the same account book and appear as follows:

[October 26, 1428] E die dare a dì detto Lire cientosesanta e quagli demmo per detto di misser Bartalomei, cioè faciemoglili dare al bancho di Pauolo di Nanni di Salvi et sono a lui in questo indrieto al'altra faccia, e quagli sono per parte di due fighure dorate per lo battesimo.
 Lire CLX.

[March 12, 1429, modern] E die dare a dì 12 di Marzo Lire ciento quatro soldi quindici, e quagli gli facciemo dare in Fiorenza per lettera di Mariano di Nicholò et compangni banchieri.
 Lire CIIII soldi xv.

[April 1, 1429] E die dare a dì primo d'Aprile, Lire sedici, e quagli gli dei contanti per detto di misser Bartalomeio.

Lire XVI.

Somma Lire 2380 soldi 15, messi a uscita di me Urbano di ser Michele camarlengo, a fo. 54.

Bacci (Quercia, pp. 219-221) has published a portion of this material. The figures mentioned in the documents are usually considered to be the statues of Faith and Hope. Giovanni di Turino did the Charity as well as Justice and Prudence, while Goro di ser Neroccio was paid for the Fortitude. It would appear that Donatello was actually in Siena on April 1, 1429 when he was paid in cash, while the other payments were arranged through banks.

See also Paoletti, *Font,* doc. 321 for the payments to Donatello, as they are carried in the *Libro giallo.*

Document 274. September 26, 1428
 Florence

A letter written by the Sienese orators in Florence is brought to Siena by Jacopo della Quercia.

[Address on the front] Magnificis ac potentibus dominis dominis prioribus et capitaneo populi civitatis Senarum dominis nostris singularissimis et cetera.

Magnifici ac potentes domini domini singularissimi premissi debitis recommendationibus et cetera.

Perché noi siamo certi che la Signoria vostra è contenta e disidera sentire spesso novelle di quello che ci accorre. . . . Delle novelle da Bologna maestro Iacomo, che è l'aportatore di questa [lettera] et viene di la, informarà la Signoria Vostra. . . .

Ex Florentia die xxvi Septembris 1428 in mediis tertiis. E.M.D.V.

Servitores Antonius miles et Christoforus orates.

Location: ASS, Concistoro, no. 1914 (Lettere), insert 76.

Bibliography: J. Beck, "Jacopo della Quercia a Firenze," *Culta Bononia* (1974), 6:133–134.

Comment: The "maestro Iacomo" mentioned is definitely Jacopo della Quercia, who is known, in fact, to have reentered Siena on September 27, when he was ordered not to leave again without special permission (see doc. 275). Thus Jacopo, despite accusations of disobedience to the Signoria, was still in their service, and was evidently looked upon as a trusted citizen whose opinions were considered valuable.

Document 275. September 27, 1428.
 Siena *(Baptismal Font)*

Jacopo della Quercia is ordered not to leave Siena without permission.

Contra Magistrum Iacobum de la Fonte [in the margin].

Magnifici et potentes domini priores gubernatores comunis et capitaneus populi simul

convocati et congregati in numero sufficienti, concorditer et unanimiter preceperunt et man-
daverunt magistro Iacobo Pieri de Senis vocato magistro Iacobo de la Fonte licet absenti
quatenus non exeat vel exire audeat vel debeat aliquo modo de civitate Senarum absque
ipsorum expressa deliberatione et licentia et quod faciat et laboret in dicto baptismate
secundum locationem sibi factam de eo, sub pena et ad penam centum florenorum auri, in
qua ipso facto intelligatur incidisse et incidat si contra factum fuerit per eum in predictis
sicque huc usque ipsum magistrum Iacobum condemnaverunt et multaverunt si in predictis
et vel aliquod predictorum per eum contra factum fuerit, solvenda in biccherna comunis
Senarum. Postque statim post predicta ego Iohannes notarius suprascripto de mandato
dictorum magnificorum dominorum et capitanei populi eidem magistro Iacobo presenti et
advertenti ac intelligenti mandavi ut supra in dicto precepto continetur in omnibus et per
omnia, et cetera, presentibus Stusio . . . expensori palatii et Micchaele de Tatti familiare
dictorum dominorum ibidem presentibus et rogatis nos tamen omnes existentes prope can-
cellariam notarii reformationum, et cetera.

Location: ASS, Concistoro, no. 375 (Deliberazioni), fol. 21v.

Bibliography: Milanesi, *Documenti,* vol. 2, doc. 111*n*; *Mostra,* doc. 35; Beck, *Portale,* doc.
130. Cf. Paoletti, *Font,* doc. 212.

Comment: In *Portale* I listed this document under the wrong date, December 27, 1428.

Document 276. September 28, 1428
 Bologna *(Portal)*

Jacopo's assistants are paid.

Die vigesimo octavo Septembris.
Suprascripti Zinus Bartoli et Iohannes Petri, suis propriis nominibus et vice et nominibus
predictorum Bartoli Antonii et Dominici Antonii predictorum, habuerunt mandatum a pre-
dictis superstibus confectum in personam suprascripti magistri Iacobi Petri de la Fonte de
Senis de dictis quinqueginta libris bon., et directum depositariis dicte fabrice etc.

Location: AFSP, Libro d'Atti civili della Fabbrica, vol. 3, fol. 16.

Bibliography: Supino, *Sculture Porte,* doc. 27; Beck, *Portale,* doc. 126.

Document 277. October 27, 1428
 Siena *(Baptismal Font)*

Goro di Neroccio receives partial payment for a figure for the Baptismal Font.

Ghoro di ser Neroccio orafo die dare a dì 27 d'Ottobre Lire quaranta e quagli ebbe per
detto di misser Bartalomeo dal banco di Pauolo di Nanni e fratelli, e quagli denari sono per
parte di una fighure dorata à tolto a fare per lo battesimo. Messi a uscita d'Urbano camar-
lingo a fo. 55.

Location: AODS, no. 673 (Memoriale), fol. 26v.

Bibliography: Bacci, *Quercia,* p. 87. Cf. Paoletti, *Font,* docs.. 222–223.

Comment: Other payments to Goro for the same figure are transcribed by Bacci (*Querci,* pp. 87–89), with the final payment dating to August 13, 1431, for which see below doc. 332. The identification of the figure as "Fortezza" results from later documents. Paoletti (*Font,* pp. 122–128) believes that Jacopo della Quercia designed the statuette for Goro, a conclusion he arrives at on stylistic grounds.

Document 278.

November 9, 1428
Siena *(Baptismal Font)*

A payment connected with the Baptismal Font *is recorded.*

E dieno dare adì di Novembre [1428] soldi quindici, e quagli paghai per detto degli operai del battesimo a Ninnino. maestro di lengniame, per comettitura di due modegli di nocie e isfilatura e pulitura per dirizarvi su e' lavorio del battesimo.

soldi xv.

Location: AODS, no. 673 (Memoriale), fol 21v.

Bibliography: Bacci, *Quercia,* p. 235; Paoletti, *Font,* doc. 227. Sometime in November 1428, Jacopo is credited with 200 lire for the *Font* (see Paoletti, *Font,* doc. 224)

Document 279.

November 20-23, 1428
Bologna *(Portal)*

Cino di Bartolo is paid 4 lire.

Location: AFSP, Giornale, fol. 149.

Bibliography: Beck, *Portale,* doc. 127.

Document 280.

November 23, 1428
Bologna *(Portal)*

From Siena, Jacopo writes to the officials of San Petronio.

[Address] Espettabili et egregii Offizial: e maestri de la fabricha di San Petronio di Bolongnia.
Al nome di Dio.
Espettabili et egregi Ofiziali, le umili rechomandazioni a la vostra Reverenzia prima per me son fatte. In e dì passati ricievei lettera per lo vostro offizio, la quale me conteneva che nonostante aversità che abia l'amata città di Bolongnia, deliberato avete che lo lavoro de la porta de la chatedral chiesa di San Petronio si seguiti: e [c]hed io debbia venire chon un maestro o più di figure. A questo respondo, ched io ò un maestro e dovevo venire già fa un mese, ed è omasso [?] di none esser venuto sì per lo pericholo ched è per lo paese ed ezian perché se dicie esser ne la città morbo: de le qua' due chose qua si fa gran chaso; ma io son deliberato venire senza fallo, se da lato dello ofizio si farà quello che si richiede àlla ispedizione del difizio.
Prima, i' voglio aver la materia per poter sei o sette maestri far lavorare, e se non v'è i marmi vuolsi sollicitare sien rechati; che i ditti maestri abino in che operarsi, perched io non voglio ispendere a chonsumare costì i mie' dì in su la miseria: perché in ogni lu[o]go si può

trovar modo di misaramente istare. Apresso mi scrive Cino, che i buon giovani ched ànno lavorato chostì non sono istati mai pagati di lor pocha quantità. Pichola isperanza poson pigliare quegli che si den chondurre a lo lavoro: pregovi umilemente essi pagati sieno, e subito sarò chostì senza mancho. Chon beningnità vi priego Cino mie giovane vi sia rachomandato. Christo feliciemente vi conservi, pregando la sua somma pietà che la città liberi dall'averse fatighe sue, e i cittadini conducha a vera pacie, si che in riposo e la fama d'essa città in perpetuo rimanga [?]. Per lo vostro buon servitore Iachopo del maestro Piero de la Fonte di Siena, a dì 23 November 1428.

Location: AFSP, Miscellanea, vol. 2, fasc. B, no. 1.

Bibliography: Milanesi, *Documenti,* 2:150–151; Gatti, *La fabbrica,* doc. 52; Supino, *Scultura Bologna,* doc. 44; Supino, *Sculture Porte,* doc. 28; Beck, *Portale,* doc. 128.

Comment: Contrary to Gnudi's claim (in "Revisione"), there seems to have remained at this date a considerable amount of work to be done—enough, that is, to occupy six or seven master carvers.

Document 281. November 23, 1428[?]
 Bologna *(Portal)*

A messenger of the Sienese Signoria is paid to go to Bologna on behalf of Jacopo della Quercia.

 A Singniorello fameglio de' singniori Lire otto contanti per detto degli oparai del battesimo perché andò infino a Bolongnia per maestro Iacomo che fa el detto battesimol
 Lire VIII.

Location: AODS, Entrata e Uscita, fol. 52v.

Bibliography: Paoletti, *Font,* doc. 228.

Comment: This payment, which in date falls between November 8 and December 3, is probably for the delivery of Jacopo's letter (see previous document). Consequently I am dating it November 23.

Document 283. December 9, 1428
 Bologna *(Portal)*

Payments to Cino di Bartolo are recorded.

 A maestro Iachomo dala Fonte Lire quarantasei di bolognini, per lui a Cino di Bartolo suo garzon e per noi da Tomaxe dal Gambaro depositario dela fabricha, posti a lui a creditto.
 Lire XLVI.
 A la fabrica de San Petronio Lire uno soldi diese de quatrini per lei a Cino di Bartolo da Siena per tre opere a date ala fabricha preditta in conzare e fare d'asse sopra e'lavorio dela porta de mezo, e per noi da Tomaze dal Gambaro, posti a lui a creditto, quatrini.
 Lire I soldi x.

Location: AFSP, Giornale, fol. 149v.

Bibliography: Gatti, *La fabbrica,* doc. 53; Beck, *Portale,* doc. 129 (first part only).

Document 284. December 22, 1428
 Siena *(Baptismal Font)*

Preparations for the upper part of the Baptismal Font *are mentioned.*

E dieno dare a dì di 22 di decembre soldi sedici, e quagli sonno per libre quatro d'auti conparai per detto degli operai del battesimo per fare el'armadura intorno al Battesimo per ponarvi la pila.

 soldi xvi.

E dien dare a dì detto soldi quatro per una libra d'auti e quali mancharono a la detta armadura per lo battesimo.

 soldi iiii.

Location: AODS, no. 673, Memoriale, fol 21v.

Bibliography: Bacci, *Quercia*, p. 235–236; Paoletti, *Font,* doc. 238.

Document 285. January 2, 1429
 Bologna *(Portal)*

Total expenditures to date for the marble for the Portal *are entered.*

Prede de marmore per la porta de mezo de Sam Petronio deono dare a dì ii de zenaro Lire cinquemila quatrocento settanta quatro soldi dexesete de bolognini, per una raxon levata da libro negro segnato II a carta 343.

 Lire V^mCCCCLXXIIII soldi xvii.

Location: AFSP, Libro Mastro, fol. 72.

Bibliography: Beck, *Portale,* doc. 131.

Comment: This annotation is a carry-over from an earlier account book, which is lost. The total indicated here refers to the cost of the stone for the *Portal,* which was calculated as a separate account.

Document 286. January 2, 1429
 Bologna *(Portal)*

Total payments made to Jacopo to date for the Portal *are noted.*

Maestro Iacomo de Piero da la Fonte da Siena intagliatore de marmore e maestro de la porta de la ghiexa de Sam Petronio de' dare a dì ii de Zenaro Lire tremila novecento settanta soldi quindexe de bolognini, per una soa raxone levata da libro [negro] segnato II a carta 381.

 Lire III^mDCCCCLXX soldi xv.

Location: AFSP, Libro Mastro, fol. 88.

Bibliography: Beck, *Portale,* doc. 132.

Comment: If the total sum agreed upon in the original contract of 1425 of 3600 florins (that is, 7,200 Bolognese lire, or in fact slightly more) remained unchanged, then Jacopo had

received more than half the amount by the end of 1428. He must have completed by then about half of the work, but the question remains of precisely which parts he had actually carved.

Document 287. January 2, 1429
 Bologna *(Portal)*

A payment to Arduino da Baiso is carried over.

Arduino de maestro Tomaxino maestro de legname de' dare a dì ii de Zenaro Lire tre per una soa raxone levata da libro negro segnato II, a carta 370.

Lire III.

Location: AFSP, Libro Mastro, fol. 88.

Bibliography: Beck, *Portale,* doc. 133.

Document 288. February 1429
 Siena *(Baptismal Font)*

A payment to Jacopo for his share in the cost of a contract for the Baptismal Font *is recorded.*

E die dare [Maestro Iachomo di maestro Piero maestro di pietra] a dì ... [blank] di Febraio Lire quatro, e quagli paghai per lui e per suo detto a ser Iacomo di Nuccino per la sua parte de la carta prubica { = pubblica] del' aloghagione del battesimo.

Lire IIII.

Location: AODS, no. 673 (Memoriale), fol. 23v.

Bibliography: Bacci, *Quercia,* p. 175; Paoletti, *Font,* doc. 244 (and doc. 245, for the corresponding entry in the Entrata e Uscita).

Document 289. March 5, 1429
 Siena *(Baptismal Font)*

The upper portion of the Baptismal Font *is prepared.*

E dieno dare a dì v di Marzo [1428 = 1429, modern] soldi sedici per lire [libbre] quatro auti di più ragione come per detto degli operai del battesimo per fare l'armadura et palchetto per murare el battesimo, da la pila che tiene l'a[c]qua in su.

soldi xvi

Location: AODS, no. 673 (Memoriale), fol. 22.

Bibliography: Bacci, *Quercia,* p. 238; Paoletti, *Font,* doc. 248.

Document 290. March 8, 1429
 Siena *(Baptismal Font)*

A payment to Jacopo is turned over to Pagno di Lapo.

E dieno dare (Maestro Iachomo di maestro Piero maestro di pietra) a dì 8 di Marzo Lire vintotto, e quagli paghai per lui e per suo detto a maestro Pangno di Lapo da Fiorenza, maestro di pietra.

Location AODS, no. 673 (Memoriale), fol. 23v.

Bibliography: Bacci, *Quercia*, p. 212; Paoletti, *Font*, doc. 249.

Document 291. March 20, 1429
 Siena *(Baptismal Font)*

Work around the Baptismal Font *is recorded.*

E dieno dare a dì 20 di Marzo [1428 = 1429, modern] Lire sei d'avuti de quagli ne furono libbre 4 di 60 per libbra et libbre 2 di 36 per libbra, per fare lo stechato di corenti e di steconi d'intorno al battesimo.

Lire I soldi viii denari iiii.

Location: AODS, no. 673 (Memoriale), fol. 22.

Bibliography: Bacci, *Quercia*, p. 238; Paoletti, *Font*, doc. 255.

Document 292. March 22, 1429
 Siena *(Baptismal Font)*

The Baptistery is cleaned up after work is completed.

E dieno dare a dì 22 di Marzo [1428 = 1429, modern] soldi vintidue e quagli a due manovagli che isghonbrarono e tavoleti et tutti e' ritaglio del marmo et ongni altra cosa che era in San Giovanni.

Lire I soldi ii.

Location: AODS, no. 673 (Memoriale), fol. 22.

Bibliography: Bacci, *Quercia*, p. 240; Paoletti, *Font*, doc. 256.

Document 293. April 1, 1429
 Bologna *(Portal)*

Rent is paid for Jacopo's house in Bologna.

A Zoanne Ghaleazo di Ghaluti Lire undexe soldi quatordexe de quatrini, per noi da Tomaxo da Gambaro depositario dela fabrica di Sam Petronio, positi a lui a creditto, e detti soldi sono per resto dela pixon dela caxa dove abitta maestro Iacomo dela Fonte e suo' gharzoni per un ano che finirá per tutto el presente mexe di Aprile.

Lire XI soldi xiii.

Location: AFSP, Giornale, fol. 152v.

Bibliography: Supino, *Scultura Bologna*, doc. 45; Supino, *Sculture Porte*, doc. 29; Beck, *Portale*, doc. 134.

Comment: In *Portale,* I mistakenly wrote "a' suo' gharzoni" instead of "e suo' gharzoni." From the correct version, it appears that Jacopo's assistants lived with him in Bologna.

Document 294. April 22–30, 1429
 Siena *(Baptismal Font)*

Payments are made to Donatello for the Baptismal Font.

 Donato di Niccholò da Fiorenza die dare a dì 22 d'Aprile Lire vinti, e quagli gli dei contanti per decto degli operai del battesimo, per parte di paghamento de lo sportello del battesimo.

 Lire XX.

 E die dare a dì 16 (read 26) d'Aprile Lire quatro soldi sedici per libre dodici di ciera gli conperai per fare le forme di cierti fanciulini inudi per lo battesimo, per detto deli operai del battesimo.

 Lire IIII soldi xvi.

 E die dare a dì 27 d'Aprile Lire trentotto, e quagli gli dei contanti per detto degli operai del battesimo per comperare attone.

 Lire XXXVIII.

 Soma Lire 62 soldi 16, messi a uscita di me Urbano di ser Michele camarlengo de'uopara, a fo. 56.

 A Donato di Nicholò da Fiorenza a dì detto [30 Aprile] Lire sesanta due e quagli avuti in più volte come appare al memoriale di me Urbano camarlingo a fo. 39 e sonno a lui a Libro Giallo a fo. 90

 Lire LXII soldi xvi.

Location: AODS, no. 673 (Memoriale), fol. 38v, and Entrata e Uscita, fol. 56 (last item).

Bibliography: Bacci, *Quercia,* p. 223, 242–243 266–269, (incomplete); Paoletti, *Font,* Docs. 225–30.

Comment: The *sportello* was actually rejected by the officials of the Baptistery because "non fu buono," and the job was eventually given to Giovanni di Turino. One can only speculate about the reason for the rejection: perhaps the cast proved to be faulty, or the design was too unusual. See also Paoletti, *Font,* pp. 136–138, for a discussion of the *sportello.*

Document 295. April 30, 1429
 Siena *(Baptismal Font)*

Sano di Pietro paints portions of the Baptismal Font.

 A Sano di Pietro dipentore a dì detto [30 d'Aprile] Lire vintidue, e qu' so' per dipentura del battesimo à dipento a suo oro e a suo azurro e a ongni sua ispesa per detto degli operai del battesimo.

 Lire XXII.

Location: AODS, no. 403 (Entrata e Uscita), fol. 55v.

Bibliography: Milanesi, *Documenti,* vol. 2, doc. 300 (with wrong date); Bacci, *Quercia,* p. 241; Pope-Hennessy, *Sassetta,* p. 44*n*53; Paoletti, *Font,* doc. 273; *Mostra,* doc. 37.

Comment: The payment is substantial, and the use of gold and blue pigment must have been for actual painting and gilding done on the marble monument and not for coloring Sassetta's drawing, which is sometimes claimed.

Document 296.

April 30, 1429
Siena *(Baptismal Font)*

A payment is made to Jacopo for the Baptismal Font.

A maestro Iacomo di maestro Piero, maestro di pietra a dì detto, Lire seicento in più volte, come appare al memoriale di me Urbano di ser Michele, camarlingo del' uopera a fo. 24 e sono a Li(b)ro Giallo a fo. 92.

Location: AODS, no. 403 (Entrata e Uscita), fol. 56.

Bibliography: Bacci, *Quercia*, p. 265; Paoletti, *Font*, doc. 275 (and for corresponding entries, see his docs. 275 and 325).

Document 297.

May 4, 1429
Bologna *(Portal)*

The rent for Jacopo's house in Bologna is paid on the occasion of his return.

E de' dare adì iiii de Magio Lire trentasie de bolognini, per noi da Tomaxo dal Gambaro depositario de la fabrica de Sam Petronio, posti a lui a creditto in questo a carta 96, i qual denari ebe in inanci el mexe de comission degli oficiali per posserse fornire la caxa de vituaria per la retornada à fatto da Siena per lavorare a le istorie e lavorier de la porta de mezo de Sam Petronio.

Lire XXXVI.

Location: AFSP, Libro Mastro, fol. 88.

Bibliography: Supino, *Scultura Bologna,* doc. 47; Supino, *Sculture Porte,* doc. 30; Beck, *Portale,* doc. 136.

Comment: The same information is also found in the "Giornale," but in less detail. From this document it is clear that Jacopo had returned by this date, ready to work again on the *Portal* (cf. Gnudi, "Revisione," p. 35). In addition, it is evident that the reliefs on the portal, the "istorie," were not all finished, since they are specifically mentioned as needing to be worked.

Document 298.

May 9, 1429
Bologna *(Portal)*

Rent is paid for Jacopo's house in Bologna.

A Zoanne Ghaleazo di Ghaluti Lire quatro di quatrini, per noi da Tomaxo da Gambaro depositario dela fabrica, posti a lui a credito, i quali denari sono per parte de Lire VIII che'l detto deve avere dala fabrica per mixi cinque che cominzono a dì primo del presente mexe e finirano per tutto Settembre prossimo che virà, per pixon dela chaza al presente abita maestro

Iacomo dela Fonte, la quale ci fermò per dito tempo Cino da Siena garzone del detto maestro Iacomo e per detto prexio.

Lire IIII.

Location: AFSP, Giornale, fol. 154.

Bibliography: Beck, *Portale*, doc. 137.

Document 299.

June 7, 1429
Bologna *(Portal)*

A payment of 36 lire is made to Jacopo.

Location: AFSP, Giornale, fol. 154v; Libro Mastro, fol. 88.

Bibliography: Beck, *Portale*, doc. 138.

Document 300.

June 9, 1429
Bologna *(Portal)*

A payment for work on the Portal *is recorded.*

A la fabricha de Sam Petronio Lire una per lei a Fioriano de maestro Iacomo maestro de legname per tolere otto cirelle grande da li mazoni nove e grandi fatti per uno preda de taglie per lo lavorier dela porta grande de Sam Petronio, e per noi da Tomaxo del Gambaro, a lui a creditto.

Lire I.

Location: AFSP, Giornale, fol. 154v.

Bibliography: Beck, *Portale*, doc. 139.

Document 301.

August 4, 1429
Bologna *(Portal)*

Jacopo is paid 36 lire.

Location: AFSP, Giornale, fol. 156v; Libro Mastro, fol. 88.

Bibliography: Beck, *Portale*, doc. 140.

Document 302.

August 27, 1429
Bologna *(Portal)*

Marble is transported to the Portal.

Item, adì predetto per dui fachini per adure quatordexe prede de marmore ala porta per lo imbassamento, soldi.

soldi iiii.

Location: AFSP, Libro di Spese, fol. 19.

Bibliography: Beck, *Portale*, doc. 141.

Document 303.

September 22, 1429
Bologna *(Portal)*

A payment of 4 lire to Cino di Bartolo "taiapreda" is recorded.

Location: AFSP, Giornale, fol. 157v.

Bibliography: Beck, *Portale*, Doc. 142.

Comment: That Cino was actually an independent stone carver is established by this document. Although there is no documented work that can be associated with him, he must have made some of the sculpture for the *Portal* and other works in Bologna.

Document 304.

September 23, 1429
Bologna *(Portal)*

A payment to Jacopo of 36 lire is recorded.

Location: AFSP, Giornale, fol. 157v; Libro Mastro, fol. 88.

Bibliography: Beck, *Portale*, doc. 143.

Document 305.

October 24, 1429
Bologna *(Portal)*

A contract is drawn up for the inner side of the Portal.

Conventio inter Iacobum dalla Fonte et Officiales Fabrice pro constructione Porte Magne. In nomine Domini, millesimo quatrigentesimo vigesimo nono, die 24 Octobris.

In questa presente scritta, a ciascheduna persona che leggerà, sia manifesto come questo dì, li spettabili et egregi Ufficiali della fabrica di San Petronio di Bologna, cioè messer Piero di Ramponi, Giovanni di Griffoni, Gasparo Lupari merchante, hanno fatto certo patto e conventione con esso me Iacopo di maestro Piero della Fonte da Siena, scultore di marmo, di un lavoro et ornamento che si de' fare e fassi per la parte dentro della porta magna di marmo di San Petronio, la quale per me Iacopo sopradetto si costruisse. E questo deve essere fatto, composto e formato secondo un disegno fatto in papiro e dessignato per me Iacopo, il quale tengono i prefati Ufficiali appresso di loro, intendendosi con questi patti e modi.

[1] In prima, che 'l detto lavoro il devo fare e dar fatto a tutte mie spese di pietre istriane, lavorato e murato, et eccetto che la sopradetta fabrica di San Petronio deve pagare o veramente salvarmi della gabella di Ferrara e di Bologna; et etiam di pagare la sopra detta fabrica pietre rotte e calcina e li ponti di legname et altro che ci andasse, e io Iacomo sopradetto di pagare le sopradette pietre istriane di compra, di gabelle di Vinetia, di nolo di nave, di carregio, di condurle per fino a San Petronio in Bologna. Et devo havere per pretio e salario del sopra detto lavoro, nella forma e modo che di sopra è detto dover fare, ducati seicento d'oro, i quali ducati seicento ho d'havere in più e in più volte, secondo che bisogna, per le spese necessarie e fatture manuali.

[2] Et più ho d'havere senza alcuna imputazione di costo, certe pietre istriane le quali si sono havute dalla fabrica, vecchie, laborate per me Iacopo e poste nel sopradetto lavoro.

[3] Et questi patti e conventioni fatte con li egregii e soprascritti Ufficiali fu nella loro residentia in San Petronio, presenti gli honorevoli huomini ser Michele dall'Oro, scrittore della fabrica, e ser Guido Gandoni notaro della sopra detta fabrica, dell'anno, mese e dì sopra detto. Et io Iacopo soprascritto ho fatto questa scritta di mia propria mano, come di sopra si contiene, per volontà de gli antedetti Ufficiali di San Petronio.

[4] E intendendosi il sopradetto patto e conventione soprascritta di ducati seicento d'oro fatto del sopra detto lavoro, che ducati 50 che io Iacomo dovevo havere dalla fabrica di San Petronio per l'andata fatta per me Iacomo in Lombardia più volte per marmi, essi ducati cinquanta gli ho lasciati alla fabbrica di San Petronio per l'anima mia.

[5] E più, che nel numero di ducati seicento del sopra detto mercato fatto, vi s'intenda io haver havuto per parte di pagamento del sopra detto prezzo che costorono le dette pietre comprate in Vinetia per me Iacomo dell'anno passato, e condotte per Guglielmo Gatto in San Petronio.

[6] E di tutte queste cose soprascritte io Iacomo soprascritto mi son contentato, e per chiarezza di ciò ho scritto di mia propria mano, a dì et anno soprascritto.

Nota quod de dictis pactis et conventione in dicta scripta descriptis, patet publicum instrumentum rogatum per me Guidonem de Gandonibus notarium dicte fabrice, die 6a mensis Decembris, 1429, prout in libro novo actorum 1428, fol. 44.

Location: AFSP, Libro + il Primo, no. 2, pp. 59–61.

Bibliography: Milanesi, *Documenti,* 2:153–154; Davia, *Le sculture,* doc. E; Gatti, *La fabbrica,* doc. 55; Supino, *Scultura Bologna,* doc. 47; Supino, *Sculture Porte,* doc. 31; Beck, *Portale,* doc. 144.

Comment: In the contract, which was written originally in Jacopo's own hand, he waives an old claim to 50 ducats. In this case, as in the previous contract, there is no mention of Candoglia marble.

Document 306. November 3, 1429
 Bologna *(Portal)*

A payment to Jacopo of 36 lire is recorded.

Location: AFSP, Libro Mastro, fol. 88; Giornale, fol. 159v.

Bibliography: Beck, *Portale,* doc. 145.

Document 307. December 6, 1429
 Bologna *(Portal)*

A payment to Jacopo of 72 lire is recorded.

Location: AFSP, Libro Mastro, fol. 88; Giornale, fol. 161v.

Bibliography: Beck, *Portale,* doc. 146.

Document 308.

A payment to Jacopo for the inner side of the Portal *is recorded.*

A maestro Iacomo de Piero de la Fonte Lire trenta de bolognini e per noi da Tomaxo del Gambaro posti a lui a creditto e de' detti denari ne de' rendere raxone, per l'andata che fa a Vinixa questo dì per comprare marmi istriani per la porta dentro de San Petronio la quale questo dì à tolto sopra di sé a farla, come apare per carta di Guido Gandone nodaro de li officiali de la fabricha apare a libro degli atti a carta 44.

<div align="center">Lire XXX.</div>

Location: AFSP, Giornale, fol. 161v.

Bibliography: Gatti, *La Fabbrica*, doc. 56; Supino, *sculture Porte*, p. 86; Beck, *Portale*, doc. 147.

Document 309.

The contract for the inner side of the Portal *is ratified.*

Eodem millesimo CCCCXXVIIII, die sexta, mensis Decembris.

Venerabiles et circumspecti viri dominus Petrus de Ramponibus, canonicus Bononie, Iohannes ser Iacobi de Griffonibus, Bononie civis, Guaspar Venturini de Lupporis et Michael ser Parizii de Auro, regulator iurium fabrice Sancti Petronii Bononie, omnes Superstites et Officiales ipsius fabrice, primo et ante omnia protestatione hac per eos et quemlibet eorum premissa quod per aliqua infrascripta non intendunt se nec aliqua eorum bona obligare, sed solum bona et iura fabrice antedicte omni meliori modo, via, iure et forma quibus magis et melius potuerunt, sponte pro se et eorum in dicto officio successoribus dederunt, concesserunt, et locaverunt ad sculpendum, fabrichandum, murandum, construendum et fine debito perficiendum et complendum quoddam laborerium marmoreum et seu ornamentum inceptum a parte interiori porte magne marmore ecclesie Sancti Petronii predicti, construendum de lapidibus marmoreis istrianis, pactis, modis, et conventionibus perficiendum in quadam scripta privata magistri Iacobi infrascipti scripta etc., contentis, Magistro Iacobo quandam Petri de la Fonte de Senis, lapicide, scultori et fabricatori et constructori porte magne marmore ipsius ecclesie Sancti Petronii ab extra, presenti et conducenti, que scripta scripta fuit manu ipsius magistri Iacobi de anno presenti, sub die vigesimo quarto mensis Octobris proxime preteriti, et est penes me Guidonem notarium infrascriptum et prout apparet in quodam designo designato in papiro manu ipsius magistri Iacobi, quod designum est penes Officiales predictos dicte fabrice etc., prout de dicta locatione et pactis latius patet in libro nigro compositionum a ff. LXXXI.

Location: AFSP, Libro d'Atti Civili della Fabbrica, vol. 3, fol. xlv.

Bibliography: Supino, *Scultura Bologna*, doc. 48; Supino, *Sculture Porte*, doc. 32; Beck, *Portale*, doc. 148.

Document 310. December 6, 1429
 Bologna *(Portal)*

Payments to Jacopo are recorded.

Maestro Iacomo de Piero da la Fonte, maestro de la porta de mezo de Sam Petronio, per conto da parte, de' dare adì de Dexembre Lire trenta de bolognini, per noi da Tomaxo del Gambaro depositario de la fabricha de Sam Petronio, posti a lui a creditto in questo a carta 136, e detti denari glie sono dati per l'andata da Ferara a Venezia a fare degrossare le nostre prede che sono a la Tore de la Fossa e simelle a degrossare certe prede Istriana de' comperare a Venezia a petition de la fabricha de Sam Petronio, e detto ne de' rendere raxon.

E de' dare adì detto ducati duxento d'oro viniciani per LXX de grossi glie remetemo in Venexa da Agnolo Ghaddi e Domenicho de Tomaxo e compagni per lettere de Bertoldo degli Alberti e compagni per bolognini CCIIII d'or abiamo a conto de' detti Bertoldo e compagni, in questo a carta 142; de la sopra detta quantitade de dinari la quale gli abiam fatto dare in Venexa ne de' rendere raxone; el resto che li avanzarà de le spexe fatte per la fabricha de San Petronio in fuori, si sono per la compoxitione fatto con lo detto de' lavoriero de la porta da lado dentro, de prede istriane, com' apar per rogazon de Guido Gandone a libro degli atti a carta 45.

Location: AFSP, Libro Mastro, fol. 141; cf. Giornale, fol. 161v.

Bibliography: Beck, *Portale,* doc. 148.

Document 311. December 20, 1429
 Bologna *(Portal)*

A payment for tools is recorded.

E de' dare adì xx de Dexembre Lire una soldi cinque dinari sie de quatrini, per uno mazo de ferro e biette de ferro glie comperamo per le man de Bartolomeo de gli Alberoli per tagliar e degrossar le prede de marmore che sono a la Torre da la Fossa, posto li denari Tomaxo del Gambaro a lui a creditto.

 Lire I soldi v denari vi.

Location: AFSP, Libro mastro, fol. 141; Giornale, fol. 162v.

Bibliography: Beck, *Portale,* doc. 150.

Document 312. December 24, 1429
 Bologna *(Portal)*

Corrections in the accounts for work on the Portal *are recorded.*

E de' dare adì xxiiii de Dexembre Lire trexento ottantuna soldi cinque dinari otto de bolognini, per costo e spexe e nolo de piè cccc de marmo istriano comprato per lo detto maestro Iachomo in Vinexa a petition de li oficiali de la fabricha in fino del mexe de Zenaro 1428 com' apar a libro negro de debituri a carta 335 a creditto a uno conto da parte del detto maestro Iacomo. E perché le prede de marmore ne fun fatte debitrixe a libro negro sopradetto a carta 343, però ne faciam credidrixe le dette prede de marmore in questo a carta

72 e debitor qui el detto maestro Iacomo per caxon de la compoxition fatta con lui co' apar a libro de gli atti a carta 44.

<div align="center">Lire CCCLXXXI soldi v denari viii.</div>

E de' dare adì detto [xxiiii de Dexembre] Lire duxento quarantasette soldi diexe dinari tre de bolognini, per ducati CXX soldi v a ducato viniciani, posti a creditto qui a rincontro, a soldi xli per.

<div align="center">Lire CCXLVII soldi x denari iii.</div>

Location: AFSP, Libro Mastro, fol. 141.

Bibliography: Beck, *Portale,* doc. 151.

Document 313.

December 24, 1429
Bologna *(Portal)*

Corrections in the accounts for stone on the Portal *are recorded.*

Prede de marmore per la porta de mezo de Sam Petronio deono aver adì xxiiii de Dexembre Lire trexento ottantuna soldi cinque dinari otto de bolognini, per altretanti posti a debitto a dette prede in due partide adì vii e adì viii de Zugno 1428 a apar a libro negro segnato 2 a carta 343, li quali denari deono esser posti a debitto a maestro Iacomo da la Fonte per caxon de una compoxitione fatta con lui com' apare a Libro degli atti de la fabrica a carta 44, posti a debitto al detto maestro Iacomo in questo a carta 141.

<div align="center">Lire CCCLXXXI soldi v denari viii.</div>

Location: AFSP, Libro Mastro, fol. 141.

Bibliography: Beck, *Portale,* doc. 151.

Document 314.

December 24, 1429
Bologna *(Portal)*

Corrections in the accounts for stone on the Portal *are recorded.*

E deono dar adì detto ducati diexe e un quarto d'or de Venezia per ghabella de Venezia e per desgrosadure e per altre spexe fate a la sopradette prede per maestro Iacomo da la Fonte com' apre a lui a creditto a conto da parte, in questo a carta 141.

<div align="center">Lire XXI soldi iiii denari vi.</div>

Location: AFSP, Libro Mastro, fol. 72.

Bibliography: Beck, *Portale,* doc. 153.

Comment: This entry should be read in conjunction with the two preceding entries.

Document 315.

December 24, 1429
Bologna *(Portal)*

Payments for the purchase of Istrian stone are recorded.

E deono dar adì xxiiii de Dexembre ducati sessanta nove e mezo d'or de Venezia per pie LXXX de prede istriane grosse di Ruigno [= Rovigo?] de più fatta, per lo imbassamento de

la ghiexia apresso la porta sopradetto e per pie x de dette prede per li dalati de li pilastri del'istorie de detta porta, li quali pezi sono alti zachuno pie uno, le quale prede ci asegna maestro Iacomo da la Fonte maestro de detta porta avere comperato, posti a lui a creditto a conto da parte, in questo a carta 141; a soldi xli denari v per ducato vagliono.

<div align="right">Lire CXLIII soldi xviii denari v.</div>

Location: AFSP, Libro mastro, fol. 72.

Bibliography: Beck, *Portale,* doc. 157.

Comment: In *Portale* (pp. 46–47) I assumed that the ten stones mentioned in this document and the next were in fact for the ten Old Testament reliefs that comprise the exterior faces of the pilasters at the side of the portal, and that consequently these documents provide a *terminus post quem* for these famous reliefs. Cesare Gnudi ("Revisione," *passim*) has sought to show, instead, that these blocks were not for the reliefs but were for the outer side of each pilaster. Gnudi also asserts, not without some justification, that grammatically the phrase "li dalati de li pilastri del'istorie" is more fittingly interpreted as he has done. On the other hand, we rarely find grammatical precision in account books such as the ones involved here (see doc. 401 for a similar phrase). In fact, such a description was an effort on the part of the accountant to identify and justify expenses, and nothing more. There is no reason to believe, for example, that the official who kept these books knew the exact destination of these stones in any technical architectural sense, or, for that matter, precisely how the project's pilasters were to have been pieced together. Furthermore, if the phrase is read with modern punctuation, the sense might be clearer: "li dalati de li pilastri, de l' istorie," the comma signifying something like "cioè" (which frequently appears in the documents), as an explanation or modification of the "pilastri." Also operating against Gnudi's explanation is the thickness (one *piede,* or nearly half the width of the pilasters) of the blocks of stone referred to here, which would have been needed for the undercutting of the relief sculpture, but not for a thin frame or facing element; to have used these blocks for such a purpose would have involved an uncharacteristic vast waste. Nor do they appear to have been cut down, for the sides of each pilaster do have five stones each.

It is claimed by Gnudi and others that all the sculpture on the central portal of San Petronio is of marble and not of Istrian stone (a fairly subtle distinction and a one clearly not made during the construction of the portal, when Istrian stone is consistently called marble); furthermore, it has been assumed that the marble all came from the Lago Maggiore region, including the material for the Old Testament reliefs. If this were the case, then the ten stones mentioned in this document could not have been for the reliefs, and this is precisely what Gnudi has strongly asserted. He maintains categorically and repeatedly that the marble came from Candoglia, although no document points with that kind of precision to the origin of the stone from "Lombardia."

In 1970, a scientific examination of the stone on the portal was undertaken in preparation for a complete cleaning and restoration. The results were presented in a lecture given by Dr. R. Pellizzer and Dr. R. Rossi Manaresi, subsequently published in *Atti dell'Accademia delle Scienze di Siena detta de' Fisocritici* (1970), series 14, vol. 2. The specialists confirmed my opinion, namely that the stone for the reliefs was Istrian. A later analysis, however, apparently suggested to these experts that the pilaster reliefs and all the other sculpture is in fact of marble and not Istrian stone. Although the origin of the marble has not been specifically ascertained by comparative tests, Dr. Rossi Manaresi holds to the opinion that it came from Lombardi (see Rossi Manaresi, "Indagini scientifiche e techniche," in Rossi Manaresi, ed., *Jacopo della Quercia e la facciata di San Petronio a Bologna,* p. 227 and especially *n*4). It is not clear to me what controls, if any, were used in the testing process, and whether marble

from "Lombardia"—for example, that used for the cathedral of Milan—was used for comparison. It seems to have been the case that the analysis showed that the white stone from the basement level of San Petronio, which is known for certain to be Istrian stone and which was put on the monument toward the end of the trecento, is different from the stone used for the Old Testament reliefs. Given the ambiguous and inconclusive results of the testing thus far, caution seems to be in order.

I continue to believe that the stones mentioned in the document above are those from which the reliefs were carved, since they correspond to the dimensions. Furthermore, one must recognize that there were different quarries in Istria with differing mineral components, and even in a single locality, there could have been different varieties. (On the color variations, see F. Rodolico, *Le pietre delle città d'Italia*, pp. 184–185.)

Even if the stones for the Old Testament reliefs turn out unequivocally to be Lombard marble and not Istrian stone, the chronology I have sketched out (*Portale*, pp. 39ff) is hardly affected. The document reported here may still be thought of as the beginning date for the entire pilaster, which must have been approached as a single project in a single phase of work. If the stones mentioned here were for the outer side faces of the pilasters as Gnudi claims, their mention still signals an early stage in working out the pilaster as an architectural and decorative element. Furthermore, as is mentioned in the text, part of the outer sides of the pilaster form a portion of the frame for the reliefs and could not have been conceived without a planned rapport between the two elements.

Finally, it should be pointed out that Lombard marble ("marmore milanexe"; see doc. 317) is spoken of in the payments of the exact same date contrary to Gnudi's assertion that there was only a single massive importation of such material back in 1425/1426. These stones could also have been for the pilaster reliefs, since they are mentioned on the same day as the "dalati." The main point of this discussion is that the Old Testament scenes date to 1430 and after.

Document 316. December 24, 1429
Bologna *(Portal)*

Payment similar to previous ones for the purchase of Istrian stone are recorded.

Maestro Iachomo de Piero da la Fonte per conto da parte de' avere adì xxiiii de Dexembre ducati sessantanove e mezo d'or veneziani, i quali ci asigna avere spexe in pie LXXX de prede istriane di Ruigno [= Rovigo?] grosse de più fate per lo imbassamento atorno la porta de mezo de San Petronio e più in pieci x de prede istriane d'alteza de pie tri e mezo e largho pie due e mezo lo pezo e de grosseza circha un pie per li dalati di pilastri del'istorie de detta porta; posti a debitto a le prede de marmore per la porta in questo, a carta 72.

Location: AFSP, Libro Mastro, fol. 72.

Bibliography: Beck, *Portale*, doc. 158.

Document 317. December 24, 1429
Bologna *(Portal)*

Various payments for stone are recorded.

E deono dar adì detti [xxiiii de Dexembre] Lire vintuna soldi dexenove de bolognini, per lor a maestro Iacomo da la Fonte, posti a lui a creditto a conto da parte in questo, a carta

141, i qual denari sono per spexe à fatte a fare desgrossar marmore milanese c' era a la Torre de la Fossa.

<div align="center">Lire XXI soldi xviiii.</div>

E deono aver adì detti [xxiiii de Dexembre] Lire vintuna soldi dexenove de bolognini, i quali ci assegna avere spexe a fare desgrossar e scavizar sie pezi de marmor milanexe che era del nostro a la Torre de la Fossa in soma de pesi nove, li quali savezadi che furon tornoron pezi xii, e per subie d'aciaro fe' far in Ferara che i mancoron a schavezar dette marmore; posti a debitto a le prede per la porta de mezo in questo, a carta 72.

<div align="center">Lire XXI soldi xviiii.</div>

E deono aver adì detti [xxiiii de Dexembre] ducati diexe e un quarto d'or de Venezia cioè per ghabella de Venezia dele sopradette prede Istriane ducati sie, e per desgrossar le sopra dette prede ducati tre, e per più altre spexe in cargare e descargare e redur insieme tutte le sopradette prede ala nave, ducati uno e quarti uno: sono in tuto ducati X soldi v a oro; posti a debitto a le prede per la porta de mezo in questo, a carta 72.

Location: AFSP, Libro Mastro, fol. cxli.

Bibliography: Beck, *Portale*, docs. 154–156.

Comment: The Milanese marble mentioned here proves that stone from Lombardy was not all shipped and worked in Bologna by 1426, as Gnudi claimed. The pieces mentioned here may have been stored at Torre de la Fossa for some time, however.

Document 318. January 21, 1430
 Bologna *(Portal)*

A payment to Jacopo of 36 lire is recorded.

Location: AFSP, Libro Mastro, fol. 88.

Bibliography: Beck, *Portale*, doc. 159.

Document 319. February 10, 1430
 Bologna *(Portal)*

Money is exchanged for Jacopo for his trip to Venice.

A la fabricha di Sam Petronio soldi dodexe di quatrini e per lui a Antonio Guarnieri, per so fadiga a cambiare ducati 200 d'or per Venezia per mandar maestro Iachomo dala Fonte a comperare prede istriane le quali ducati 200 à tenuto suxo li retorri due mixi, e per noi da Tomaxo da Gambaro, a lui a creditto.

<div align="center">soldi xii.</div>

Location: AFSP, Libro mastro, fol. 88.

Bibliography: Beck, *Portale*, doc. 160.

Document 320. March 31, 1430
 Bologna *(Portal)*

An advance of 120 lire is made to Jacopo in the form of a loan.

A maestro Iachomo dala Fonte Lire centovinti de bolognini per noi da Ghuaspare Lupori in prestanza, tolti a costo per due mixi in somma di bolognini cento d'or, posti a lui a credito.
Lire CXX.

Location: AFSP, Libro Mastro, fol. 88; Giornale, fol. 168.

Bibliography: Beck, *Portale*, doc. 161.

Document 321.

May 18, 1430
Bologna *(Portal)*

A payment to Jacopo of 40 lire is recorded.

A maestro Iachomo dala Fonte Lire quaranta de bolognini, per noi da Tomaxo dal Ghambaro a lui a creditto; fu fato el mandato insino a dì xvi de detto mixe.
Lire XL.

Location: AFSP, Giornale, fol. 171; Libro Mastro, fol. 88.

Bibliography: Beck, *Portale*, doc. 162.

Document 322.

June 18, 1430
Bologna *(Portal)*

A payment to Jacopo of 50 lire is recorded.

Location: AFSP, Giornale, fol. 172; Libro Mastro, fol. 88.

Bibliography: Beck, *Portale*, doc. 163.

Document 323.

June 27, 1430
Bologna

Pestilence mentioned as raging in Bologna.

Bibliography: Giovanni di M[aestr]o Pedrino depintore, *Cronica del suo tempo*, ed. by G. Borghezio and M. Vattasso, notes by A. Pasini (Rome, 1929), vol. 1 (1411–1436), p. 254 (Studi e testi, no. 50).

Document 324.

July 3, 1430
Siena *(Baptismal Font)*

Payment is made for gilding Jacopo's relief for the Baptismal Font.

A maestro Iachomo di Piero, detto de la Fonte, a dì iii di Luglio Lire centoquindici, soldi uno, denari otto e quali ebe contanti, per detto di misser Bartolomeo operario, disse per dorare la storia la quale lui aveva facta al battesimo in Sancto Giovanni; e sono posti a sua ragione a libro giallo a ffo. 249.
Lire CXV soldi i denari viii.

Location: AODS, no. 405 (Entrata e Uscita), fol. 37.

Bibliography: Bacci, *Quercia*, p. 258; Paoletti, *Font*, doc. 281.

Comment: This payment represents a *terminus ante quem* for the completion of the casting and perfection of the Zacharias relief. The corresponding entry in the "Libro Giallo" (AODS, no. 708, fol. 249v; Cornelius, *Jacopo della Quercia*, p. 39; Paoletti, *Font*, doc. 332) reads:

> [Maestro Iachomo di Piero detto de la Fonte] E ànne auti infino a dì iii di Luglio Lire centoquindici, soldi uno, denari otto, e quali gli dei contanti io Galgano di Guccio camarlengo e so' a mia uscita a ffo. 37. I detti denari pagai per detto di misser Bartolomeo operaio, disse maestro Iacomo voleva per dorare la detta storia.
>
> Lire CXV soldi i denari viii.

Document 325. July 31, 1430
 Siena *(Baptismal Font)*

The final payment for the Zacharias relief for the Baptismal Font *is recorded.*

Maestro Iachomo di Piero, detto de la Fonte, intagliatore, die avere a dì xxxi di Luglio Fiorini centoottanta di soldi 84 il Fiorino e quali so' per una historia la quale ci à fatta e consegnata per lo sacratissimo battesimo ordinato da farsi in Sancto Giovanni; e questo sicondo la logagione fattali in fino a dì xvi d'Aprile 1417 per l'egregio cavaliere misser Caterino, alora operaio e suoi conseglieri, come apare carta per mano di ser Franciescho di Giovanni d'Andrea d'Asciano; la quale historia disse misser Bartolomeo di Giovanni operaio aprovarla e stare recipiente sicondo la logagione, e così io, Galgano di Guccio [Bichi] camarlengo, per detto et comandamento del detto misser Bartolomeo, ò aconcia la detta posta e recati i Fiorini a Lire, vagliono Lire DCCLVI.

Location: AODS, no. 405 (Entrata e Uscita), fol. 37.

Bibliography: Bacci, *Quercia*, p. 258.

Comment: This payment corresponds to the item in the "Entrata e Uscita" dated August 1, 1430 (AODS, no. 405, fol. 37v; cf. Paoletti, *Font*, doc. 283) reads:

> A maestro Iachomo di Piero, detto de la Fonte, a dì primo d'Agosto Lire cinquecento vinti, soldi diciotto, denari quatro, e quagli gli dei contanti per detto di misser Bartolomeo operaio, furo' per resto d'una hystoria la quale aveva a ffare per lo battesimo e so' a sua ragione a libro giallo, a fo. 249.

Document 326. July 31, 1430
 Siena *(Baptismal Font)*

Another version of the final payment for the Zacharias relief is recorded.

E ànne auti [maestro Iachomo di Piero, detto de la Fonte], a dì primo d'Agosto Lire cinquecentovinti, soldi diciotto, denari 4, e quagli denari gli dei contanti per detto di misser Bartolomeo operaio, furo' per resto di pagamento dela sopradetta historia e so' a uscita di me Galgano di Guccio camarlingo, a ffo. 37.

Lire DXX soldi xviii denari iiii.

Location: AODS, no. 708 (Libro Giallo), fol. 249v.

Bibliography: Bacci, *Quercia*, p. 259; Paoletti, *Font*, doc. 332.

Comment: In the same book, at fol. 70v, the payments occur somewhat differently in date, with 120 lire credited on July 31, 1430 and 400 lire credited on August 5, 1430. Furthermore, there was a sum of 16 lire and 11 soldi that were carried over and paid, perhaps as late as 1432 (in Libro Giallo ms. cited, fol. 119v).

Document 327.

August 5, and 6, 1430
Siena *(Baptismal Font)*

Jacopo receives final payment for the upper section of the Baptismal Font.

Maestro Iachomo di Piero, detto de la Fonte die avere a dì v d'Agosto Lire millequattrocento, soldi 0, e quali so' per factura et sua fadigha della fonte del sagratissimo battesimo fatto in Santo Giovanni e questo per un lodo dato per Iacomo d'Andreuccio chiamato per misser Bartolomeo operaio et suoi compagni sopra ciò, cioè Nanni di Piero di Guido, Giovanni d'Agniolo e Nanni di Francino, et per Stefano di Vicho di Riccio chiamato per lo detto maestro Iacomo: a quali arbitri guidicaro che del detto lavoro del marmo fatto per sua mano dovesse avere et abia Fiorini 350 di Lire 4 il Fiorino, come n'apare rogo per mano di ser Francesco del Barbuto notaio.

Lire MCCCC.

Anne auti a dì vi d'Agosto Lire millequattrocento, soldi 0, so' per altretanti che abiamo posti che lui abia dati a una sua ragione in questo a ffo. 92; so' per saldo in questa ragione della fonte del marmo del battesimo. E questo aconciamo per detto di misser Bartolomeo et per vigore de'lodo, chome apare di sopra a l'avere.

Lire MCCCC.

Location: AODS, no. 708 (Libro Giallo), fol. 249v.

Bibliography: Bacci, *Quercia*, p. 262–263; Paoletti, *Font*, Doc. 333.

Comment: The work on this portion of the *Baptismal Font* was contracted for on June 29, 1427. By April 30, 1429, Jacopo had received payments totaling 600 lire, with the remainder paid on August 5, 1430 (400 lire) and on August 6, 1430 (another 400 lire). For these payments from the "Libro Giallo" (fol. 92), see Paoletti, *Font*, doc. 325.

Under the year 1428, a Sienese chronicle (*RRIISS*, vol. 15, part 6, col. 811) has the following entry, which must have been compiled after 1435, when Jacopo was made Operaio of the Duomo:

El batesimo si fornì di fare nel mezo della chiesa di San Giovanni sotto el Duomo, el quale à la magiore parte le figure di marmo caraese, el quale compose maestro Iacomo maestro del'uopera di Duomo, ed èvi ancora d'intorno 6 storie d'ottone dorate, cioè due di mano di detto maestro Iacomo da Siena e due di mano di Giovanni di Sano Turini orafo da Siena, e due di mano di Donatello da Fiorenza, l'anno 1428."

We must assume that there was some sot of rapport between Jacopo and Stefano di Vicho di Riccio, who was Jacopo's choice for evaluating his work on the *Font*.

Document 328.

August 7, 1430
Bologna *(Portal)*

A payment to Cino di Bartolo of 10 lire is recorded.

Location: AFSP, Libro Mastro, fol. 88; Giornale, 137v.

Bibliography: Beck, *Portale*, doc. 167

Document 329. August 14, 1430
 Bologna *(Portal)*

Paolo Guinigi was overthrown as lord of Lucca. He was imprisoned in Milan, where he died fifteen months later.

Bibliography: Mancini, *Storia di Lucca*. Florence, 1950, p. 195.

Document 330. October 21, 1430
 Bologna *(Portal)*

Jacopo's house in Bologna is mentioned.

MCCCCXXX, die vigesimo primo Octobris.
 Constitutus coram ser Michaele Parixii de Auro, Regulatore iurium fabrice Sancte Petronii Bononie et altero ex Supersitibus et Officialibus suprascripte fabrice, nec non in presentia mei Guidonis de Gandonibus notarii antedicte fabrice et testium infrascriptorum.
 Iohannes Galeaz, filius quondam domini Francisci de Galuciis, Bononie civis, ad petitionem et instantiam magistri Petri Guidonis piliparii, capelle Sancte Blasii, sponte voluit et consensit ex nunc quod de pensione librarum decem et septem bon. quas ipse Iohannes Galeaz debet habere a dicta fabrica, pro anno presenti inchoato in festa Sancti Michaelis, mensis Septembris proxime preteriti, pro quadam domo quam hactenus habitavit et de presenti inhabitat magister Iachobus Petri de la Fonte de Senis lapicida et scultor porte magne dicte fabrice, posta in capella Sancte Marie de Galutiis, in cortili illorum de Galutiis, iusta suos confines, a veniente termino paschatis Rexurrectionis Domini nostri Ihesu Christi proxime venture, libere fiat et fieri debeat per ipsos Officiales mandatum librarum octo et solidorum decem bon. dicto magistro Petro Guidonis pro dicto termino pensionis suprascripte domus. Et hoc pro pretio unius pellecile nove date et vendite per ipsum magistrum Petrum predicto Iohanni Galeaz.
 Presentibus ser Manno Henrici de Savigno et Iohanne Michaelis de Argenta familiaribus fabrice predicte, testibus etc.

Location: AFSP, Libro d'Atti civili della Fabbrica, fol. 3, vol. 59v.

Bibliography: Supino, *Sculture Porte*, doc. 34; Beck, *Portale*, doc. 168.

Comment: There is a similar document under the date January 13, 1431. From the evidence, it is not clear whether Jacopo actually was in Bologna at this date, but since no direct payments to him are registered in the account books of the Fabbrica, I suggest that, in fact, he was not present during these months. His whereabouts at this time, however, are not known.

Document 331. December 15, 1430
 Bologna *(Portal)*

A payment for the transport of stone is recorded.

E de' dare adì de Dexembre soldi cinque de quatrini per spexe de Bartolomio degli Albiroli in fin a Aghosto prossimo passato per fare menar prede comune per lo 'mbassamento mancava apresso e lavorier de la porta de mezo de Sam Petronio in due volte, com' apar a libro dele spexe a carta 27; posti a creditto a la fabrica in questo a carta 198.

soldi v.

Location: AFSP, Libro Mastro, fol. 88.

Bibliography: Beck, *Portale,* doc. 169.

Document 332.
August 13, 1431
Siena *(Baptismal Font)*

Goro di Neroccio receives final payment for the Fortezza *for the* Baptismal Font.

Anne date a dì 13 d'Agosto 1431 una fighura d'attone dorata la quale è posta questo dì in San Giovanni al batesimo, la quale fu Fortezza, de la quale deba avere Lire dugento quaranta d'acordo col detto misser Bartalomeio.

Lire CCXL.

Location: AODS, no. 708 (Libro Giallo), fol. 91.

Bibliography: Milanesi, *Documenti,* 2:148–50; Bacci, *Quercia,* p. 89; Paoletti, *Font,* doc. 322.

Document 333.
August 23–30, 1431
Bologna

A payment to Cino di Bartolo of 4 lire is recorded.

Location: AFSP, Giornale, fol. 184v.

Document 334.
August 23–30, 1431
Bologna *(Portal)*

A payment to Jacopo of 18 lire is recorded.

Location: AFSP, Libro Mastro, fol. 88; Giornale, fol. 185v.

Bibliography: Beck, *Portale,* doc. 170.

Comment: This is the first direct payment to Jacopo in Bologna for over a year, since June 18, 1430. Apparently during this interval he did not work on the *Portal* at all, and since payments to his *garzoni* are extremely limited as well, they too must have been quite inactive on the project.

Document 335.
September 26, 1431
Siena *(Baptismal Font)*

Payments to Giovanni di Turino for the Baptismal Font *are recorded.*

Giovanni Turini orafo die avere per infino a dì 26 di Settenbre 1431 per tre fighure d'attone doratte, cioè una Charita e una Giustizia e una Prudenzia, deba avere del' una Fiorini sesanta di denari di Lire quatro per Fiorino, che monta Fiorini ciento otanta; rechati Fiorini a Lire, monta Lire sette cientovinti, le quali fighure sono poste al batesimo.

Lire DCCXX.

Et die avere per tre angnioletti inudi d'attone doratti per lo detto batesimo, per fiorini vinti l'uno, montano Fiorini sesanta; rechati Fiorini a Lire, monta Lire dugiento quaranta.

Lire CCLX.

Et die avere per insino a dì detto per sette pezi di fregi ismalttati di rame dorati e cho' lettere intorno al detto battesimo, per Fiorini sei l'una, che montano Fiorini quarantadue; rechatti Fiorini a Lire, montano Lire ciento sesantotto.

Lire CLXVIII.

Location: AODS, no. 708 (Libro Giallo), fol. 254v.

Bibliography: Bacci, *Quercia*, pp. 226–27; Paoletti, *Font*, Doc. 334.

Comment: Since the three Virtues and at least two of the *puttini* listed here can be identified, they become important dated works of this period in Siena by the master who stylistically stands somewhat curiously and not very effectively between Ghiberti and Donatello.

Document 336. October 8, 1431
 Bologna *(Portal)*

A payment to Jacopo of 18 Lire is recorded.

Location: AFSP, Libro Mastro, fol. 88; Giornale, fol. 186v.

Bibliography: Beck, *Portale*, doc. 171.

Document 337. November 16, 1431
 Bologna *(Portal)*

Payments to Jacopo (36 Lire) and for the shipment of stone are recorded.

E Ghuielmo Gato a dito dì Lire trenta quatrini per nui da Tomaxe dal Gambaro a lui acredito e sono per nolo de prede de marmo per la porta di Sam Petronio

Lire XXX.

Location: AFSP, Libro Mastro, fol. 88; Giornale, fol. 188.

Bibliography: Beck, *Portale*, doc. 172.

Document 338. December 14, 1431
 Bologna *(Portal)*

A payment for the shipment of stone is recorded.

E deono dar dito dì Lire cinque soldi dexenove denari dui per nolo de libre 1726 de marmo che remaze in schare a la Tore de la Fossa, a soldi sedexe la soma a Guielmo Gato, in questo a carta 64.

Lire V soldi xviiii denarii ii.

Location: AFSP, Libro Mastro, fol. 72.

Bibliography: Beck, *Portale,* doc. 173.

Document 339.

December 14, 1431
Bologna *(Portal)*

Payment for the shipment of a single block is recorded.

E deono dar dito dì Lire cinque soldi dodexe denari sete per nolo de libre 1760 de marmo in uno pezo in forma d'una pila a soldi 32 la soma a Guielmo Gato, in questo a carta 64.
Lire V soldi xii denari vii.

Location: AFSP, Libro Mastro, fol. 72.

Bibliography: Beck, *Portale,* doc. 174.

Document 340.

December 14, 1431
Bologna *(Portal)*

Payment for the shipment of ten stones is recorded.

E deono dar dito dì xiiii de Dexembre 1431 Lire centotre soldi cinque denari sei per nolo de pieci diese de marmo biancho de pexo libre 322744, a soldi 32 la soma, per dite prede a Guielmo Gato nochiero, in questo a carta 64.
Lire CIII soldi v denari vi.

Location: AFSP, Libro Mastro, fol. 72.

Bibliography: Beck, *Portale,* doc. 175.

Comment: Neither the source or the destination of these ten stones is given, but they could be the ten blocks of white marble for the Old Testament reliefs.

Document 341.

December 20, 1431
Bologna *(Portal)*

A payment to Jacopo of 54 Lire is recorded.

Location: AFSP, Libro Mastro, fol. 88; Giornale, fol. 189.

Bibliography: Beck, *Portale,* doc. 176.

Document 342.

February 7, 1432
Bologna *(Portal)*

Payments are recorded to Jacopo for 61 lire 10 soldi 7 lire 10 soldi and 45 lire.

Location: AFSP, Libro Mastro, fol. 88 and lxxxviii; Giornale, fol. 192.

Bibliography: Beck, *Portale,* docs. 177–179.

Document 343.
April 5, 1432
Bologna *(Portal)*

A payment to Jacopo of 40 lire is recorded.

Location: AFSP, Libro Mastro, fol. 88.

Bibliography: Beck, *Portale*, Doc. 180.

Document 344.
April 16, 1432
Bologna *(Portal)*

Advances are given for a trip to Verona for stone.

E de' dare adì d'Aprile Lire diexe quatrini, de' quali ne de' rendere raxon in spexe ne farà per la fabricha de San Petronio ad andare a Verona a chomparare prede per fare i chapiteli per la porta de mezo de San Petronio, per nui da Tomaxe da Gambaro, a credito a lui in questo a carta 219.

Lire X.

Location: AFSP, Libro Mastro, fol. 88.

Bibliography: Cf. Supino, *Scultura Bologna*, doc. 53; Supino, *Sculture Porte*, doc. 37; Beck, *Portale*, doc. 182.

Comment: The corresponding payment in the "Giornale" (fol. 193v) reads: "A maestro Iachomo dala Fonte . . . Lire diexe quatrini ne de' rendere raxon in ispexe . . . per andare a Verona a chomparare prede per la porta de mexo de San Petronio . . ."

Document 345.
April 16, 1432
Bologna *(Portal)*

A payment for stone is recorded.

E de' dare a dito adì ducati quaranta de Venexia per comparare marmi per dentro da la porta de mezo de San Petronio, per nui da Tomaxe da Gambaro, a lui a credito in una posta de ducati 100 in questo, a carta 219 de valuta a Bologna ducati 40.

Lire LXXXIIII soldi x.

Location: AFSP, Libro Mastro, fol. 88; Giornale, fol. 194.

Bibliography: Beck, *Portale*, doc. 181.

Document 346.
April 17–27, 1432
Bologna *(Portal)*

A payment for stone is recorded.

A la fabricha de San Petronio a dito dì, bolognini d'oro cento di quatrini per ducati cento de Vinexia, per lei a maestro Iachomo da la Fonte da Siena, zoè duchati sesanta in Verona, per comperare prede de marmo per li chapiteli per la porta de mezo de San Petronio de

Bologna, et ducati quaranta in Vinexia per comparare marmo per dentro la dita porta, i quali ducati quaranta vano a chonto de maestro Iachomo da la Fonte sopradito, ducati 40 per nui da Tomaxe da Gambaro, a lui a creditto.

<div align="center">Ducati 100.</div>

Location: AFSP, Giornale, fol. 194.

Bibliography: Supino, *Scultura Bologna,* doc. 54; Supino, *Sculture Porte,* doc. 38; Beck, *Portale,* doc. 183.

Document 347. May 10, 1432
<div align="right">Bologna *(Portal)*</div>

A payment to Cino di Bartolo is mentioned.

A Maestro Iachomo da la Fonte a dì x di Mazo Lire diese quatrini senza detractione, per lui a Cino so nevode, per nui da Tomaxe da Gambaro, a lui a creditto.

<div align="center">Lire 10.</div>

Location: AFSP, Giornale, fol. 184v; Libro Mastro, fol. 88.

Bibliography: Beck, *Portale,* doc. 184.

Comment: It is curious to find that Cino is here called Jacopo's nephew, which does not seem to be the truth.

Document 348. May 14, 1432
<div align="right">Bologna *(Portal)*</div>

A payment for stone is recorded.

E de' dare adì xiiii de Magio Ducati sesanta veneciani per altri tanti le [?] posti a la fabricha in questo a carta 22, e posti qui a maestro Iachomo a rendere raxon in spexe ce farà in prede [de] marmo rosso per fare i chapitelli de la porta de mezo de San Petronio a Bologna, ducati 60.

<div align="center">Lire CXXVI soldi xv.</div>

Location: AFSP, Libro Mastro, fol. 88.

Bibliography: Beck, *Portale,* doc. 185.

Document 349. April 17–27, 1432
<div align="right">Bologna *(Portal)*</div>

Jacopo's travel expenses are listed.

. . . [a] Vinexia e a Verona per fare chav[are marmi] rossi per li chapiteli de la porta de mezo [de San Pet]ronio. In prima dixe de' avere, per andare da Vinexia a Padoa per nave, sono miglia 25, per la spexa de bocha.

<div align="center">soldi iiii.</div>

In Padoa per uno dexenare		soldi iiii.
Per un chavalo da Padoa a Vicenza, migla 20.		soldi x.
Per la cena in Vicenza		soldi iiii.
Per uno chavalo da Vicenza a Verona, arimonta miglia 30.	Lire I	soldi ii
Per spesa in via e per dexinare.		soldi v.
Per una cena in Verona.		soldi iiii.
Per uno chavalo da Verona a Valpulixella, 12 miglia in due zorni.		soldi xii.
Per desinare per via		soldi iiii.
Per zorni quatordexe lui stete a la montagna a fare chavare e digrosare li marmi rossi, in somma in tute spexe e di bocha.	Lire III	soldi xi.
Per una chavalchadura da la montagna a Verona.		soldi viii.
Per una cena in Verona.		soldi iiii.
Per uno chavalo da Verona a Ferara, miglia 65.	Lire II	soldi xvi.
Per la spesa in due dì per lo chavalo.	Lire I	soldi ii.
Per una cena in Ferara.		soldi iiii.
Per uno chavalo da Ferara a Bologna.	Lire I	soldi viii
Per spexa in via da Ferara a Bologna.		soldi v.
Per uno paro de speroni.		soldi iiii.
[Total]		soldi 8.

Location: AFSP, Giornale, fol. 196.

Bibliography: Supino, *Scultura Bologna,* doc. 55; Supino, *Sculture Porte,* doc. 39; Beck, *Portale,* doc. 186.

Comment: These small payments are informative for an insight into the cost of living during Jacopo's time.

Document 350.

June 3, 1432
Bologna *(Portal)*

A payment for red marble for the capitals of the Portal *is recorded.*

E deono dare adì iii de Zugno 1432 Ducati zinquanta per otto peci de marmo rosso per li chapiteli de la porta de mezo, e per degrossare e alezerire e achareghare dite petre, Ducati dui terzo uno; per ghabela in Verona e condure al ponte a le nave in Verona, Ducati quatro; per loro a detto Iachomo de Piero da la Fonte, a lui in questo, a carta 88, soma Ducati 56 ⅓.

<div align="center">Lire CXVIIII soldi o denari i.</div>

Location: AFSP, Libro Mastro, fol. 88.

Bibliography: Supino, *Scultura Bologna,* doc. 55; Supino, *Sculture Porte,* doc. 39; Beck, *Portale,* doc. 187.

Document 351.

<div align="right">June 3, 1432
Bologna *(Portal)*</div>

A *payment to Jacopo of 90 lire is recorded.*

Location: AFSP, Giornale, fol. 196; Libro Mastro, fol. 88.

Bibliography: Beck, *Portale,* doc. 188.

Document 352.

<div align="right">June 7, 1432
Bologna *(Portal)*</div>

Scaffolding is set up at the Portal.

A maestro Iachomo da I Chapelli, maestro de legname, adì vii de Zugno Lire quattro quartini, per otto overe e soldi cinquantasie, quali à maestro Zuliano de Domenico so compagno, e soldi diexe, quali à Àgnelo manoale per overe poste ala porta de San Petronio in fare ponti; per nui da Tomaxe dal Gambaro, a lui a credito.

<div align="center">Lire VII soldi vi.</div>

Location: AFSP, Giornale, fol. 196.

Comment: The scaffolding was prepared so that stones could be placed on the portal, possibly including some of the reliefs.

Document 353.

<div align="right">July 2, 1432
Bologna *(Portal)*</div>

Payments are credited to Jacopo.

A maestro Iachomo de Piero da la Fonte a dì ii de Luio Lire cinquanta, quali senza detracione per nui da Tomaxe da Gambaro, a lui a credito.

<div align="center">Lire L.</div>

A dito dì per nui a dito maestro Iacomo Lire 9 soldi 7 denari 6, quali lazò de Lire 225 a soldi 10.

<div align="center">Lire VIIII soldi vii denari vi.</div>

Location: AFSP, Libro Mastro, fol. 89; Giornale, fol. 197.

Bibliography: Beck, *Portale,* doc. 189.

Comment: Under July 1432 but without any indication of the precise day appears the following payment (Libro Mastro, fol. ccxxxv):

E de' avere adì [. . .] de Luio, Lire 209 soldi 9 denari 9 bolognini per una chompra de marmi istriani e veronexi per la porta de mezo per fuora, sopra i chapiteli e spexe per i dete marmi; apare al zornale rosso segnato +, a carta 213.

Document 354. July 2, 1432
 Bologna *(Portal)*

Accounts are rectified.

E de' avere a dito dì Lire cinquanta quatrini per altretanti posti de rechontro che dono essere e sono scrite Piero di rinchontro adì li de sopra dito Luio. Posto in questo a carta 235 che debia dare per resto de questa raxone.

Lire VmCLXXX denari XI.

Location: AFSP, Libro Mastro, fol. lxxxviii, fol. 88.

Bibliography: Beck, *Portale,* doc. 190.

Document 355. July 16–18, 1432
 Bologna *(Portal)*

A payment for a door hinge is recorded.

A la fabricha de San Petronio a dito dì, soldi trenta uno denari sei, per lei a Zohanne de Patolaro per uno querzo per la porta de San Petronio; per nui da Tomaxe dal Gambaro, a creditto a lui.

Lire I soldi xi denari vi.

Location: AFSP, Giornale, fol. 198v.

Bibliography: Beck, *Portale,* doc. 191.

Comment: On the same day, 126 *libbre* of lead for the *Portal* was also mentioned.

Document 356. August 2, 1432
 Bologna *(Portal)*

Jacopo is paid 50 lire.

Location: AFSP, Giornale, fol. 199.

Bibliography: Beck, *Portale,* doc. 192.

Document 357. August 8, 1432
 Bologna *(Portal)*

A payment for the transport of red marble is recorded.

E de' dare infino a dì viii d'Agosto 1432 Lire tredexe soldi tri bolognini, per lui a Christovalo d'Ambroxo, per nolo de otto pexi di marmo rosso da Verona a Ferara anche el Ganaxo nochiero da i diti d'Ambroxo; per nui da Thomaxe dal Gambaro, a creditto a lui in questo, a carta 245.

<div align="center">Lire XIII soldi iii.</div>

Location: AFSP, Libro Mastro, fol. 72.

Bibliography: Beck, *Portale,* doc. 193.

Comment: The payment was posted in 1433.

Document 358.

<div align="right">August 22, 1432
Bologna *(Portal)*</div>

A payment for work on the Portal *is recorded.*

E de' dare a dì xxii d'Aghosto Lire tredexe soldi quatro, per lui a Agnolo da Fiorenza manoale, per impastare la chalcina per pore marmi a la porta, ovre quaranta quatro a soldi 6 l'ovra, a credito a' sopradeto Angolo in questo, a carta 228.

<div align="center">Lire XIII soldi iiii.</div>

Location: AFSP, Libro Mastro, fol. 88.

Bibliography: Beck, *Portale,* doc. 194.

Document 359.

<div align="right">September 3, 1432
Bologna *(Portal)*</div>

Jacopo is paid 50 lire.

Location: AFSP, Libro Mastro, fol. 88.

Bibliography: Beck, *Portale,* doc. 195.

Document 360.

<div align="right">September 9, 1432
Bologna *(Portal)*</div>

A payment is made to a transporter of stone.

E de' dare a dì viiii Setembre Lire otantatre quatrini, per lui a Ghuielmo Ghato nochiero, e per nui da Thomaxe dal Gambaro, a creditto a lui in questo, a carta 227.

<div align="center">Lire LXXXIII.</div>

Location: AFSP, Libro Mastro, fol. 88; Giornale, fol. 200v.

Bibliography: Beck, *Portale,* doc. 196.

Document 361. September 15, 1432
 Bologna *(Portal)*

A payment for material is recorded.

A Mixo de Domengho da i chiodi a dì xv Setembre Lire cinquantauna quatrini senza detrazione, per resto de prede de feramenti per lui dato ala fabricha per la porta de San Petronio; per nui da Thomaxe dal Gambaro, a creditto a lui.

Lire LI.

Location: AFSP, Giornale, fol. 201.

Bibliography: Beck, *Portale*, doc. 197.

Document 362. October 8, 1432
 Bologna *(Portal)*

Jacopo is paid 46 lire.

Location: AFSP, Libro Mastro, fol. 88; Giornale, fol. 202.

Bibliography: Beck, *Portale*, doc. 198.

Document 363. October 13, 1432
 Bologna *(Portal)*

Stones are brought to Jacopo's shop.

Item die 13 dicti mensis cuidam fachino qui removit lapides marmoreos de turi et portavit in stantiam ubi laborat magister Iacobus de la Fonte.

soldi iiii.

Location: AFSP, Libro di Spese, fol. 37v.

Bibliography: Supino, *Scultura Bologna*, doc. 56; Supino, *Sculture Porte*, doc. 40; Beck, *Portale*, doc. 199.

Document 364. November 5, 1432
 Bologna *(Portal)*

Payment to Jacopo is paid 46 lire.

Location: AFSP, Libro Mastro, fol. 235; Giornale, fol. 204.

Bibliography: Beck, *Portale*, doc. 201.

Document 365. December 9, 1432
 Bologna *(Portal)*

Jacopo is paid 46 lire.

Location: AFSP, Libro Mastro, fol. 235; Giornale, fol. 205v.

Bibliography: Beck, *Portale,* doc. 201.

Document 366.

December 30, 1432
Bologna *(Portal)*

Jacopo is paid 46 lire.

Location: AFSP, Libro Mastro, fol. 235; Giornale, fol. 206v.

Bibliography: Beck, *Portale,* doc. 202.

Document 367.

December 30, 1432
Siena *(Baptismal Font)*

An account is given of the expenses for the Baptismal Font.

Apresso sarà scritto e denari che maestro Nanni et maestro Pietro del Minella àno avere da l'uopara per denari spesi et loro andata et compre fatte per lo battesimo et vedute et rischontrate per noi sopra a batesimo, cioè lo spetabile chavaliero misser Bartolomeo di Giovanni Cecchi, Giovanni di Grancino et Nanni di Piero et Giovanni d'Angiolo abiamo limitate et vedute come apresso diremo infino a dì 24 di Sette[m]bre 1427.

[1] In prima andamo maestro Nanni et Maestro Pietro detti a Pisa a dì 18 di Settembre 1427, andamo a Charara et tornamo a Pisa et aloghamo a charatori; in tutto stemo dì 13 et chosì ne siamo chiari, a soldi 40 el dì per chavallo, che viene Lire 4 il dì, soma in tutto.
Lire 52.

[2] Andamo, cioè maestro Pietro, a dì 24 di Novembre 1427 a Pogi Bonsi a portare denari a' charatori, no' potevano venire senza denari, ste' a dì due.
Lire 4.

[3] Ancho demo Fiorini dieci a maestro Franciescho detto Fiaschetta da Settigniano, di quello di Firenze, per una pila del batesimo, cioè per quella di sopra.
Lire 40.

[4] Ancho abiamo avere per 20 migliaia di marmo, cioè 20 migliaia et libbre 366 di marmo chararese in più pesi per fare detto batesimo, a Lire 8 il migliaio, posto in Pisa, monta Fiorini 40 soldi 56, a soldi 80 Fiorino. monta.
Lire 162 soldi 16.

[5] Ancho uno peso di marmo vene co' marmi di Francesco di maestro Marcho, faciemone la porticulla de la pila del battesimo, pesò libbre 700, a Lire 8 migliaio.
Lire 5 soldi 12.

[6] Ancho abiamo avere Fiorini 16 per la pila di sotto, cioè il fondo del batesimo, d'accordo col' oparai.
Lire 16.

[7] Ancho abiamo avere per braccia 24 di schaloni, cioè per cavatura per trare in fine el primo schalone del batesimo, a soldi 33 il braccio, d'acordo chol'opara.
Lire 39 soldi 12.

[8] Ancho per acconciature el chondotto del batesimo et una canna di rame avemo da Giovanni di Tofano.
Lire 7 soldi 10.

[9] Ancho per 2 pesi di schaloni si ghuastarono quando s'aconciò el detto chondotto, e quali si rifeciono.

Lire 3.

[10] Ancho per fare lo stecato intorno a' batesimo, stero dì due.

Lire 2.

[11] Ancho dobiamo avere per metare la pila del fondo del batesimo, aitòci maestro Pietro et due suoi gharzoni et noi cho' due nostri gharzoni, in tutto stemo uno dì.

Lire 6.

[12] Ancho dobiamo avere Libre 3 soldi 13, e quali denari sono per chambio di Fiorini vinticinque sono posti a loro ragione, rimisi i denari a Pisa al bancho di Luca di Piero Ranucci.

Lire 3 soldi 13.

Somma Lire 390 soldi 3.

Io Nanni di Piero, uno de li operai d'esso batesimo, aprovo della sopradetta soma Lire 382.

Et io Giovanni di Francesco Patrici, uno de' detti hoperai, approvo e so' contento come di sopra si contiene, cioè di Lire 382, et a ffede di ciò scrivo qui di mia propria mano ogi dì 30 di Dicembre 1432.

Io Giovanni d'Agniolo son contento come di sopra si contiene, dì et ano deto.

Location: ASS, Opera Metropolitana, at the date (formerly no. 38).

Bibliography: Borghesi and Banchi, *Nuovi documenti,* doc. 58; Paoletti, *Font,* doc. 293 with the reverse.

Document 368. February 4, 1433
 Bologna *(Portal)*

Payments totaling 57 lire and 13 soldi are made to Jacopo.

Location: AFSP, Libro Mastro, fol. 235; Giornale, fol. 207v.

Bibliography: Beck, *Portale,* doc. 203.

Document 369. March 10 and April 4, 1433
 Bologna *(Portal)*

Jacopo is paid 46 lire on two occasions.

Location: AFSP, Libro Mastro, fol. 235; Giornale, fol. 209 and 209v.

Bibliography: Beck, *Portale,* Docs. 204–205.

Document 370. April 7, 1433
 Bologna *(Portal)*

An advance is given to Jacopo for travel expenses to purchase stone.

E de' dare a dì vii Aprile ducati cento d'oro, per nui da Thomaxe dal Gambaro, de' quali ne de' rendere [raxone] in spexe ne farà in prede per la fabricha; a creditto a Thomaxo dito, in questo, a carta 237, a soldi 42 denari 9, ducati 100.

Lire CCXIII soldi xv.

E de' dare a dito dì ducati d'oro diexe per spexe de andare a Vinexia e a Verona per chompara[re] prede per la fabricha per la porta de San Petronio, per nui da Thomaxe dal Gambaro, a credito a lui a carta 237, ducati 10.

Lire XXI soldi vi.

Location: AFSP, Libro Mastro, fol. 235; Giornale, fol. 209v.

Bibliography: Beck, *Portale,* doc. 206.

Comment: The payment as registered in the "Giornale," fol. 209v, makes it quite clear that the money is given to Jacopo in the form of a "litera de chambio in Venexia" and that the funds "sono per comprare prede marmore per la porta."

Document 371. April 20, 1433
 Bologna *(Portal)*

Payments for the shipment of stone are recorded.

E deno dare a dì xx Aprile Lire vintiotto soldi dodexe quatrini, per loro a Guilemo Gato nochiero per nolo de li sopra deti marmi rossi de pexo some cinquantado a soldi undexe la soma da Ferara a la fabricha, a creditto a dito Guilemo in questo, a carta 231.

Lire XXVIII soldi xii.

E deno dare a dito dì Lire tre soldi diexe quatrini, pagato Guielmo Gato per gabela de dite prede rosse al passo de Ferara, a credito a lui in questo a carta 231.

Lire III soldi x.

Location: AFSP, Libro Mastro, fol 72; Giornale, fol. 210v.

Bibliography: Beck, *Portale,* doc. 207.

Comment: In the Libro Mastro there is another payment of 13 lire for a similar purpose.

Document 372. May 20, 1433
 Bologna *(Portal)*

Jacopo is paid 46 lire.

Location: AFSP, Libro Mastro, fol. 235.

Bibliography: Beck, *Portale,* doc. 208.

Document 373. May 28, 1433
 Bologna *(Portal)*

A payment for the shipment of stone is recorded.

Ghuielmo Gato da Ferara nochiero de' avere a dito dì Lire trentaotto soldi otto quatrini per nolo de peci 34 de marmo istriano de pexo some sesanta quatro a soldi dodexe la soma, le quale prede sono per ornare la porta de mezo da lato di fuora sopra i chapiteli rossi, a debito alle prede.

Lire XXXVIII soldi viii.

Location: AFSP, Libro Mastro, fol. 72; Giornale, fol. 211.

Bibliography: Supino, *Scultura Bologna*, doc. 58; Supino, *Sculture Porte*, doc. 41; Beck, *Portale*, doc. 209.

Document 374. July 21, 1433
 Bologna *(Portal)*

Jacopo is paid 46 lire.

Location: AFSP, Libro Mastro, fol. 235; Giornale, fol. 212.

Bibliography: Beck, *Portale*, doc. 210.

Document 375. July 24–28, 1432
 Bologna *(Portal)*

Jacopo's travel expenses are listed.

. . . per la fabricha de . . . per una andada . . . manda Oficiali de dita fabricha a Vinexia e a Verona per cho[m]parare prede istriane e marmi per sopra dita porta.
Prima da Bologna a Ferara, per vitura d'uno chavolo e spexe.

Lire I	soldi iiii.
Per una cena in Ferara.	soldi iiii.
Per uno roncino da Ferara a Francholini.	soldi vi.
Per una dexenare a Venexia.	soldi iii.
Per la nave da Francholino a Venexia.	soldi xii.
Per spexe de bocha.	soldi xvi.
Per spexe de tri dì in Venexia.	
Lire I	soldi iiii.
Per barcha a andare cerchando marmo.	soldi v.
Per nolo da Venexia a Padova e per spexa.	soldi xiii.
Per una cena e uno dexenare in Padova.	soldi viii.
Per ventura d'un chavalo da Padova a Vicenza.	soldi xiiii.
Per una cena in Vicenza.	soldi iiii.
Per uno chavalo da Vicenza a Verona.	
Lire I	soldi iiii.
Per uno dexenare e per lo chavalo.	soldi v.
Per bexogno stare in Verona dì 4, per spexa.	
Lire I	soldi iiii.

Per uno chavalo da Verona a Ferara.

Lire II	soldi iiii.	

Per spexe de dui dà per lui e per lo chavalo.

	soldi xviiii.	

Per un paro de speroni, soldi 4; per nave, soldi 1.

	soldi v.	

Per scharegare le prede uno dì e una sira.

	soldi xii.	

Per uno chavalo da Ferara a Bologna e spexa.

Lire I	soldi iiii.	

E de' avere per chompra de pie' setanta veneciani de pietre istriane grose de midolo, duc. 42, valgono a Bologna, a sol. 42.

Lire LXXXXIII	soldi xv	denari vi.

E per charegare le dite prede in nave, ducato 1.

Lire II	soldi ii	denari viiii.

E per gabela de le dite prede, ducati 4.

Lire VIII	soldi xi.	

Per nolo di le dite prede da Venexia a Ferara per soma 43, a soldi. 5 la soma.

Lire X	soldi xv.	

Per scharegare dite prede a la Tore de la Fossa.

Lire I	soldi viii.	

E de' avere per compra de pie' quaranta de marmi bianchi de Verona, ducati 35.

Lire LXXIV	soldi xvi	denari iii.

Per gabela de diti marmi, ducati tri.

Lire III	soldi viii	denari iii.

Per charegarle in nave, bolognini 24.

Lire I	soldi iiii.	

De le quale chompre e spexe n'apare una scrita de mano del sopra deto maestro Iachomo, posta in filza, a debito a le prede.

[total]	Lire 209	soldi 9	denari 9.

Location: AFSP, Giornale, fol. 212v.

Bibliography: Supino, *Scultura Bologna*, doc. 58; Supino, *Sculture Porte*, doc. 42; Beck, *Portale*, doc. 211.

Comment: The same list is found in the "Libro Mastro" (fols. 72 and CCXXXV), where the stone mentioned is described as "per la porta de mezo per di fuora."

Document 376.

July 24–28, 1433
Bologna *(Portal)*

Payments are made for a slab ("piola") of marble.

E de dare a dì . . . de Luio per gabela e nolo d'una piola de marmo che lo chodusse chon quele del la fabrica Lire tre soldi sie bolognini, apare al zornale rosso segnato +, a carta 213, a credito a la fabricha in questo, a carta 248.

Location: AFSP, Libro Mastro, fol. 248.

Bibliography: Beck *Portale*, docs. 212–213.

Comment: The corresponding entry in the "Giornale" (fol. 212v) reads:

A maestro Iachomo da la Fonte a dito dì Lire 1 soldi 16, per lui a Guielmo Ghato nochiero, per lui a Iachomino so fradelo, per nolo d'una piola da una archa de pexo some tre a soldi 12 la soma dalla Tore dalla Fossa a Bologna.

<div align="center">Lire I soldi xvi.</div>

E de' dare per ghabela de Vinexia de dita piola e per charicharla.

<div align="right">soldi xvi.</div>

E de' dare per nolo dela sopra dita piola de Vinexia a Ferara.

<div align="right">soldi xv.</div>

A portion of these entries is found in Supino, *La scultura a Bologna,* doc. 58 and Supino, *Le Sculture delle porte,* doc. 42. The "piola" has been connected with the effigy figure on the *Vari Tomb* in San Giacomo sometimes attributed to Jacopo. Referring to a form more like a slab than a block, the term was used to refer to an altar table in the contract for the main altarpiece of 1388 for San Francesco (see R. Roli, *La pala marmorea di San Francesco in Bologna,* p. 102). On the other hand, the slab may well be associated with the *Tomb of Andrea da Budrio* (cat. 13), which was finished in 1435.

Document 377. <div align="right">August 27, 1433
Bologna *(Portal)*</div>

Jacopo is paid 60 lire.

Location: AFSP, Libro Mastro, fol. 235; Giornale, fol. 213v.

Bibliography: Beck, *Portale,* doc. 214.

Document 378. <div align="right">September 2, 1433
Bologna *(Portal)*</div>

A payment for preparing tools is made to Jacopo.

[Beltrame di Ghuglielmo fabro] E de' avere a dì ii de Settembre per conzadura de tri scarpirgli, ave maestro Iacomo da la Fonte.

<div align="right">soldi iiii.</div>

Location: AFSP, Libro di Spese, fol. 155v.

Document 379. <div align="right">September 30, 1433
Bologna *(Portal)*</div>

Jacopo is paid 60 lire.

Location: AFSP, Libro Mastro, fol. 214.

Bibliography: Beck, *Portale,* doc. 215.

Document 380. October 30, 1433
 Bologna *(Portal)*

Jacopo is paid 60 lire.

Location: AFSP, Libro Mastro, fol. 235; Giornale, fol. 216.
Bibliography: Beck, *Portale,* doc. 216.

Document 381. December 3, 1433
 Bologna *(Portal)*

Jacopo is paid 60 lire.

Location: AFSP, Libro Mastro, fol. 235; Giornale, fol. 217.
Bibliography: Beck, *Portale,* doc. 217.

Document 382. December 30, 1433
 Bologna *(Portal)*

Jacopo is paid 60 lire.

Location: AFSP, Libro Mastro, fol. 235; Giornale, fol. 217v.
Bibliography: Beck, *Portale,* doc. 219.

Document 383. January 5, 1434
 Bologna *(Portal)*

Jacopo is assigned 6 ducati but is never paid them.

Location: AFSP, Libro Mastro, fol. 253; Giornale, fol. 218.
Bibliography: Beck, *Portale,* doc. 220.

Document 384. January 26, 1434
 Siena *(Baptismal Font)*

Jacopo is freed from earlier condemnation by the Sienese government.

Intellecto et viso quatenus in anno domini 1428 magister Iacobus Pieri sculptor lapidum fuit condennatus in Florenis C auri cum tertio pluris, prout patet in libro unius Ricii a fo. 134 in Biccherna, quia fuerat inobediens literis M. D. et consistorii qui ipsum requiri fecierunt ad perficiendum opus batismatis sancti Iohannis ut facere tenebatur, et non comparuit; ideo fuit condennatus in dictis Florenis C. Et viso quatenus in anno domini 1428 de mense Decembris in consilio generali campane fuit deliberatum quod dictus magister Iacobus sit liber a dicta condennatione et de ea cassetur, si et in quantum perficeret dictum opus antequam recederet civitate, prout constat manu ser Barnabei notari reformationum. Et habitata plena fide, quatenus dictus magister Iacobus antequam recederet a civitate perfecit opus prefatum, et omnia fecit ad que tenebatur—volentes quod gratia eidem concessa a

consilio generali locum habeat in predicts—deliberaverunt—quod dictus magister Iacobus sit liber a condennatione prefata.

Location: ASS, Consistoro (according to Milanesi, among loose volumes).

Bibliography: Milanesi, *Documenti,* vol. 2, doc. 115 (note); Paoletti, *Font,* doc. 295.

Comment: I was unable to locate this document, but nevertheless find no reason to doubt Milanesi's authority. It is revealing that Jacopo was actually condemned for his laxity back in 1428.

Document 385. January 26, 1434
 Siena

Jacopo is paid by the Opera.

[Maestro Iacomo di Piero dela Guercia] A dì xxvi di Gienaio 1433 [= 1434, modern] dise misser Bartalomeo di Giovanni Ciechi oparaio che la deta posta s'abatese che in 'l detto maestro Iachomo aveva dati cierti servizi al'uopara e però voleva che questa posta s'abatese.
 Lire VIII.

Location: AODS, no. 708 (Libro Giallo), fol. 119v.

Bibliography: Bacci, *Quercia,* p. 269; Beck, *Portale,* doc. 221; Paoletti, *Font,* Docs. 326 and 294.

Comment: Perhaps to be dated around this time is the following item given by Romagnoli (Biografia, vol. 3, fol. 686):

> 1434. Dell'anno stesso è un contratto riguardante il Guercia registrato nel protocollo di ser Giovanni di Benedetto a carta 24, esistente nell'archivio della Gabella de- 'Contratti e da quello rilevasi che maestro Iachomo di maestro Pietro della Fonte comprò per Fiorini 400 da Goro di Francesco. Vedi Ducale a carta 21.

Document 386. February 2 and 9, 1434
 Siena (Loggia di S. Paolo)

Jacopo obtains the assignment to procure marble for six statues for the Loggia di S. Paolo and to execute two or three of them himself.

Sarà manifesto ne la scripture come agli egregii huomini et operari de santo Pauolo, ser Christofano d'Andrea, Giovanni di Mino Cicerchia, et ser Giovanni di Guido di Nino, è stato promesso per me Iachopo del maestro Piero dicto de la Fonte, di dovere dare condocti pezi sei di marmo charrarese; i quali pezi sieno ciascheduno di lungheza di braccia tre et quarri uno, et grossi a la correspondenza d'una figura naturale, et sieno netti più che si può di vene et schietti et saldi d'ogni pelo, dentro da Siena; per pregio di Fiorini vintisei d'oro ciascheduna pezo; et se più costasseno, m'obrigo pagare del mio proprio; et se meno, se ne faccia quello che parrà a la discretione de' sopradetti cittadini.

E sopradetti marmi si den' dare posti ne la città di Siena per lo sopradetto modo, per infino a uno anno proximo che de' venire; cominciando l'anno lo proprio dì ch' e sopradetti spectabili huomini daranno il modo a' principi possibili a mectare in efecto la sopra detta promissione, cioè lo denaro che s'adomandarà per arra per li maestri che caveranno li

sopradetti marmi: intendendosi ch' i' sia libero de le gabelle di Siena.

Ancora, io Iacopo sopradecto prometto a' soprascritti cittadini di fare o due or tre figure de' soprascritti marmi, et più e meno, quanto a loro reverentie piacerà; promectendo fare le decte figure sculpite et per modo lavorate, che sieno accieptate a magistero da ciascheduno di que' maestri che portan fama non bugiarda in Italia d'avere el magistero o la practica de la scultura. Et se per me si conserva la decta promissione, che co'laudabile magistero l'opera de la figura sia per me conducta, voglio o veramento intendo avere lo pagamento d'esse immagine che si costuma dare a que' presenti maestri et famosi che ne la città di Fiorenza ànno lavorato et lavorano, ed anco più et meno quanto piacerà et parrà a la discreta prudenza di quegli officiali et cittadini parrà et piacerà, et cominciare lo primo dì dell'anno [= 26 Marzo 1434?].

In nomine Domini nostri Iesu Christi amen. Anno ab ipsius salutifera Incarnatione millesimo quadringentesimo trigesimo tertio, Inditione duodecima—die vero nona mensis Februarii—omnibus et singulis presens instrumentum . . . [word missing] publice pateat evidenter quod spectabiles et egregii viri, ser Chrisophorus Andree, Iohannes Mini de Cicerchiis, et ser Iohannes Nicolai Guidonis de Senis, operarii opere et fabrice sancti Pauli—locaverunt supradicto magistro Iacobo presente et conducenti supradictos sex petrios marmi carrarensis pro dictis figuris faciendis pro dicta opera et totum supradictum opus et laborerium in supradicta scripta descriptum et nominatum, cum pactis modis et conditionibus in dicat scripta appositis et contentis et secundum quod in dicat scripta apparet. Et promiserunt— eidem magistro Iacobo—omnia adimplere et observare ad que in dicta scripta tenentur et obligati sunt et non alteri locare, durante tempore in dicta scripta contento, dictum opus sub penis et obligationibus infrascriptis. Et dictus magister Iacobus—omnis et singula contenta in scripta predicta observare et adimplere pro parte sua et in dicto tempore in scripta predicta apposito.

Actum Senis in Campo Fori ante apotecam Landuccii Marci merciarii, coram prudentibus viris Angelo Filippi Boninsegne, Mariano Marci Mei et Checho Vannis de Monte Laterone, civibus Senarum, testibus. Ego Deius Silvestri de Senis notarius rogatus, scripsi et publicavi.

Location: AODS, Pergamena, no. 1492 (according to Milanesi).

Bibliography: Milanesi, *Documenti,* vol. 2, doc. 119; Beck, *Portale,* doc. 222.

Document 387. March 1, 1434
 Bologna *(Portal)*

Jacopo is paid 60 lire.

Location: AFSP, Giornale, fol. 220v; Libro Mastro, fol. 235.

Bibliography: Beck, *Portale,* doc. 223.

Document 388. March 27, 1434
 Bologna *(Portal)*

Jacopo is paid 60 lire.

Location: AFSP, Libro Mastro, fol. 235.

Bibliography: Beck, *Portale,* doc. 224.

Document 389. April 29, 1434
 Bologna *(Portal)*

Jacopo is paid 60 lire.

Location: AFSP, Libro Mastro, fol. 235; Giornale, fol. 222.

Bibliography: Beck, *Portale,* doc. 225.

Document 390. May 28, 1434
 Bologna *(Portal)*

A payment is made for setting up certain marbles.

. . . e soldi quatordexe per lei [i.e. la fabbrica] a Zohanne d'Argzento per dare a 4 fachini per drizare marmi a maestro Iacomo da la Fonte, per nui da Tomaxe a lui.
 Lire I soldi xiii.

Location: AFSP, Giornale, fol. 222.

Bibliography: Beck, *Portale,* doc. 226.

Document 391. June 17, 1434
 Siena

Jacopo's name is selected by lot to serve as an official representing the Terzo di San Martino in place of Clemente di Pietro Ugolini, who had died.

Location: ASS, Concistoro, no. 410, (Deliberazioni), fol. 33.

Document 392. June 23, 1434
 Bologna *(Portal)*

Jacopo is paid 60 lire.

Location: AFSP, Libro Mastro, fol. 235; Giornale, fol. 222v.

Bibliography: Beck, *Portal,* Doc. 227.

Document 393. July 14, 1434
 Bologna *(Portal)*

Scaffolding at the Portal *is mentioned.*

Beltrame di Ghuglielmo fabro de' avere adì xiiii di Luglio per xi ferri [?], pixono libbre v a soldi l denari l la libbra, monta soldi cinque denari el quale feramento avemo principado tor da lui per lo ponte e per lo lavoriero dela porta de mezo di San Petronio.
 soldi v denari v.

Location: AFSP, Libro di Spese, fol. 155.

Document 394.

July 20, 1434
Bologna *(Portal)*

A payment for lime is recorded.

Zoane de' Grassi fornaxaro de' aver adì xx de' Luio per corbe due de' calcina, mandò ala fabrica per lo lavoriero dela porta de mezo dela ghiexa de San Petronio, a soldi nove la corbe, monta.

soldi xviii.

Location: AFSP, Libro di Spese, fol. 108.

Bibliography: Beck, *Portale,* doc. 228.

Comment: Further payments for "calcina" are found around this time, on the following dates: July 1; August 8, 13, and 23; and September 1, 6, and 9. These payments may indicate the affixing of marble blocks (with reliefs?) on the *Portal,* perhaps the Old Testament scenes.

Document 395.

August 3, 1434
Bologna *(Portal)*

Jacopo is paid 60 lire.

Location: AFSP, Libro Mastro, fol. 235.

Bibliography: Beck, *Portale,* Doc. 229.

Document 396.

August 14, 1434
Bologna *(Portal)*

The statue of San Petronio is raised onto the Portal.

Location: AFSP, Giornale, fol. 229v, item no. 2.

Comment: See docs. 406 and 408 below and the comments. Given the date, the day before the Feast of the Assumption of the Virgin, we can safely assume that the statue was put in place as part of the festivities.

Document 397.

August 28, 1434
Bologna *(Portal)*

Jacopo is paid 60 lire.

Location: AFSP, Libro Mastro, fol. 235; Giornale, fol. 224.

Bibliography: Beck, *Portale,* doc. 230.

Document 398.

September 2, 1434
Bologna *(Portal)*

Tools are prepared for Jacopo.

E de' avere [Beltrame di Ghuglielmo] adì ii de Settembre, per conzadura di tri scrapirgli, ave maestro Iacomo dela Fonte.

<div align="right">soldi iiii.</div>

Location: AFSP, Giornale, fol. 225.

Document 399.

<div align="right">September 24, 1434
Bologna (Portal)</div>

A worker is paid for a freize of red marble.

A maestro Iacomo dela Fonte, maestro dela porta de mezo de San Petronio, Lire una soldi cinque de quatrini, per lui a Agnolo de Mei [da Firenze] manoale per 5 overe gli à dado a' lavoriero del frexo rosso de fuore de la porta, e per noi da Tomaxo dal Gambaro, a lui a credito.

<div align="right">Lire I soldi v.</div>

Location: AFSP, Giornale, fol. 225; Libro Mastro, fol. 235.

Bibliography: Gatti, *La Fabbrica*, doc. 62; Supino *Scultura Bologna*, doc. 59; Supino, *Sculture Porte*, doc. 43; Beck, *Portale*, doc. 231.

Document 400.

<div align="right">October 9, 1434
Bologna (Portal)</div>

Jacopo is paid 60 lire.

Location: AFSP, Libro Mastro.

Bibliography: Beck, *Portale*, doc. 232.

Document 401.

<div align="right">October 9 and 10, 1434
Bologna (Portal)</div>

A worker is paid for a frieze of red marble.

A maestro Iacomo ... [paper partially ruined] ... de San Petronio Lire ... [Thoma]xe dal Gambaro posti a ... I detti denari sono per soa manefatu[ra del] frixe de marmore rosso el quale lui à fa[to] da lato di pilastri istoriadi de detta porta, com'apare per una conventione fatta con li detti officiali de San Petronio a libro negro de li compoxitioni, a carta 84.

<div align="right">Lire XL.</div>

Location: AFSP, Giornale, fol. 236.

Bibliography: Gatti, *La fabbrica*, doc. 62; Supino *Scultura Bologna*, doc. 59; Supino, *Sculture Porte*, Doc.. 43; Beck, *Portale*, doc. 233.

Comment: It seems that the historical pilasters were in place by this date.

Document 402. October 21, 1434
 Bologna (Portal)

Scaffolding is removed from the Portal.

[A dì xxi d'Ottobre] A la ditta [la fabrica di Sam Petronio], Lire otto soldi diexe de
quatrini, per lei a Zoane d'Argenta e a Zoane Canacci per compoxition fatta con li oficiali
dala fabrica a desfare el ponte de fuora dela porta de mezo e per far e desfare le tendi per la
festa di San Petronio prossimo pasado, e per noi da Tomaxe dal Gambaro a lui a credito.
 Lire VIII soldi x.

Location: AFSP, Giornale, fol. 226.

Comment: This document, not published in my work previously, marks the end of a phase
of activity on the *Portal*. Probably one stage of work was brought to a conclusion to coincide
with the feast day of San Petronio on October 4.

Document 403. October 25, 1434
 Bologna *(Portal)*

Jacopo is paid 60 lire.

Location: AFSP, Libro Mastro; Giornale, fol. 227v.

Bibliography: Beck, *Portale,* doc. 234.

Document 404. November 13, 1434
 Siena

A statue of San Giovanni is mentioned.

Il Sancto Giovanni e la pila et lo spazo [in the margin].
 Anco deliberarono che il deto misser lo operaio insieme con misser Pietro di Tommè del
Besso cannonico, consigliere, possino comprare uno certo Sancto Giovanni, cioè certo diseg-
nio o sculpito facto a immagine di Sancto Giovanni et certa pila per lo migliore modo et a
più utilità et honore della deta opera sarà possible. Et che certo spazo cominciate per lo deto
misser lo operaio, si finisca.

Location: ASS, no. 21, (Deliberazioni), fol. 6v.

Comment: The San Giovanni mentioned here must have been a statue and not a drawing.
On other occasions, it has become quite clear that the terminology for such objects is not
always fixed in the language of the early quattrocento, but since the word *sculpito* follows
disegnio, it explains or modifies the previous word. Furthermore, the object apparently had
a base or stand (i.e., *pila*); Precisely which statue was purchased, if one was finally purchased
at all, has not been determined.
 The term *spazo* refers to the pavement.

Document 405.

November 22, 1434
Bologna *(Portal)*

Jacopo is paid 24 lire.

Location: AFSP, Libro Mastro; Giornale, fol. 228.

Bibliography: Beck, *Portal*, doc. 235.

Document 406.

November 22, 1434
Bologna *(Portal)*

A payment for raising of the statue of San Petronio on the Portal *is recorded.*

E de' dare adì detto soldi nove de quatrini, per lui a più fachini che aidono a drizare la preda de la imagine de Sam Petronio, e per noi da Tomaxo del Gambaro, a lui a carta 259 in somma de Lire 30 soldi 17 denari 1.

soldi viiii.

Location: AFSP, Libro Mastro, fol. 235.

Bibliography: Beck, "An Important New Document," and Beck, *Portale*, doc. 236.

Comment: It appears from Document 408 below that the statute of San Petronio was placed on the *Portal* on August 14, presumably for the Feast of the Virgin on the 15th, but that the expenditures were not reported until sometime later. Gnudi ("Revisione," p. 47) thinks the payment referred to here is merely for the raising of the San Petronio to an upright position, but the fact that there were "più fachini" and that the sum was 9 soldi (nearly half a lira) indicates otherwise. In any event, the sculpture appears to have been finished by August 14, and there was scaffolding at the *Portal* at that time. Although this document reads "la preda de la imagine de Sam Petronio," in the other entry that refers to the same payment (doc. 408) we find the words "la imagine di Sam Petronio," which serve to contradict Gnudi's reading.

As for the question of the lunette with the Madonna and San Petronio, at least two possible interpretations may be put forward: (1) that the statues were placed on the *Portal* when they were completed or soon afterward, as I believe, and then removed temporarily in 1510 when the entire portal was dismantled and then reassembled and replaced (this reconstruction of events means that the two figures were in the lunette when Michelangelo's statue of Julius II was set up in February 1508); or (2) that the two statues by Jacopo were placed on the portal for the first time only after the cinquecento reconstruction of 1510–1511.

For a history of Michelangelo's bronze colossus and an account of the documents as well as the texts by contemporaries, see M. Butzek, *Die Kommunalen Represantationsstatuen der Papste des 16 Jahrhunderts in Bologna, Perugia und Rom* (Bad Honnef, 1978), pp. 77–101 and 335–354. According to the chronicle of Friano degli Ubaldini (Butzek, p. 336), the three statues of the Madonna and Child, San Petronio, and Sant'Ambrogio—the last-mentioned finished only shortly before—were put over the doorway on November 18, 1510. (For a brief chronology of work on the *Portal* at this time see Matteucci, *La 'Porta Magna,'* pp. 104–106.) Gnudi ("Revisione"), following Supino (*La scultura a Bologna,* p. 68), maintains that this was the first time the statues—actually any statues—were placed in the lunette.

Friano also comments that a majority of the people said it was a mistake to place Julius II

above the Madonna. (Friano's remarks must be seen as referring at least obliquely to the Bolognese disapproval of Julius' rule and not merely to a question of religious conviction, since San Petronio was the civic church of the city.) But in a letter of 1508 from her agent, Isabella d'Este is informed that Pope Julius had placed his statue above "una Nostra Donna, la quale cum Iesù Christ in braccia parea li stresse sotto li piedi" (see Butzek, p. 96n71). Hence when the statue of Julius was put up, the Madonna was already in the lunette—that is, before February 1508.

Previous to the discovery of the contract for the complete dismantling of the portal in 1510 (see Beck and Fanti, "Un probabile intervento di Michelangelo," n27), it was easier to interpret Friano's statement that the statues were put up in November 1510. But since we now know that the entire portal was dismantled stone by stone, if the statues of San Petronio and the Madonna and Child had been in place already, they were, *per force,* taken down and put up again, this time with the just-finished Sant'Ambrogio.

Over and above the somewhat inconclusive evidence concerning precisely when the statues were first put onto the *Portal,* it does seem to me that, given the fact that the Madonna and the San Petronio—which all agree were finished before Jacopo's death—were available, they would have been used, rather than leaving the lunette empty for nearly a century. Furthermore, these sculptures seem to have been well known to artists, including Niccolò dell'Arca and Michelangelo, and were almost certainly on public view.

Document 407. December 18, 1434
 Siena

The Opera del Duomo of Siena donates two stones with his coats of arms to Cardinal Casini.

[in the margin] Che l'operaio doni al cardinale di Sancto Marcello due pietre.

E sopradetti misser lo operaio et conseglieri, absente Andrea, ragunati etc. di comune concordia deliberaro che misser lo operaio predetto dia et doni al reverendissimo in Cristo padre e signore misser . . . [blank] del titolo di Santo Marcello prete cardinale benemerito, a suo mandato due pietre di marmo sculpite della arma del detto reverendissimo in Cristo padre misser . . . [blank] predetto etc., esso misser lo operaio s'indenda essare e sia pienamente rimesso ale spese della detta opera.

Location: AODS, no. 21, (Deliberazioni, E. 5), fol. 7.

Comment: Although there is no indication whatsoever who may have carved these stones, it is at least tempting to consider Jacopo as a candidate, since he did, after all, work on the Cardinal's chapel shortly thereafter.

Document 408. December 20–24, 1434
 Bologna *(Portal)*

Payment is made for work on the Portal.

A la fabrica di San Petronio Lire trenta soldi dixesette denari uno de quatrini, per lei a più persone e per noi da Tomaxe dal Gambaro in fino più dì fa, per spexe de più raxoni fatte per dita fabrica come apare qui de sotto partida . . . per far revenir li maestri da la porta
 soldi iii.

. . . per fachini che aidono a maestro Iacomo dala Fonte a drizare la imagine de Sam Petronio a dì 14 d'Agosto per la man di Zoane d'Argenta

soldi viiii.

. . . per piombo per la porta a dì 18 d'Agosto.

soldi x.

Location: AFSP, Giornale, fol. 229v.

Bibliography: Beck, *Portale,* doc. 237.

Comment: This document provides evidence for dating the statue of San Petronio before August 14, 1434, when it was placed on the *Portal.* There is also a small payment for "olio de Somente per la porta" in this same document. I am not aware precisely what kind of oil this is or its purpose. Rossi Manaresi ("Indagini scientifiche e tecniche," in Rossi Manaresi, ed., *Jacopo della Quercia e la facciata di San Petronio a Bologna*) believes Jacopo himself or his assistants applied a substance to the surface of the *Portal* that was instrumental in preserving it over the centuries.

Document 409. January 1, 1435
 Siena

Jacopo is sworn in as priore *for the Terzo di Città for the months of January and February.*

Location: ASS, Consiglio generale, no. 218, fol. 104v.

Bibliography: Milanesi, *Vasari,* 2:133; Bacci, *FdV,* p. 425.

Document 410. January 22, 1435
 Siena

A figure by Jacopo for the Cappella del Campo is discussed.

A dì xxii di Gennaio MCCCCXXXIIII [= 1435, modern] . . .

Et inteso che certa figura di marmo, la quale misser lo operaio già fece in parte lavorare per ponare ala cappella del campo, si domanda per maestro Iacomo di . . . [blank] detto de la Fonte, el quale dice el detto marmo et figura essere sua et lui averlo fatto conduciare a Siena a sue spese et àllo domandato in iudicio et seguitati certi acti a la corte et cet., deliberaro di concordia, che sia et essare s'intenda pienamente rimesso in Salimbene, uno dei detti consiglieri, fare concordia col detto maestro Iacomo della detta figura et marmo, et essa figura allogare a esso maestro Iacomo a fornire in quello migliore modo et in più vantaggio della opera che fare potrà; deliberanti per infino da mo' tutto quello che per lo detto Salimbene sarà fatto ne le cose predette etc.

Per maestro Iacomo dela Fonte [in the margin].

Location: AODS, no. 21 (Deliberazioni), fol. 10.

Bibliography: Milanesi, *Documenti,* vol. 2, doc. 123; Beck, *Portale,* doc. 239.

Document 411.
February 4, 1435
Siena

Jacopo is a candidate for rector of the Hospital of Santa Maria della Scala but is not elected.

Location: ASS, Concistoro, no. 414, fols. 20v, 22, 23; see also no. 1407/8, fol. 42.

Bibliography: Bacci, *FdV*, p. 425–426; see also Banchi, ed., *Statuti senesi*, 3:239.

Comment: Bernardino degli Albizzeschi, the future San Bernardino, was also a candidate. Giovanni di Francesco Buzzichelli was elected sometime before March 24, 1435; this man was to be an unsuccessful choice for Operaio. (See also next document.)

Document 412.
February 8 and 9, 1435
Siena

Jacopo is elected operaio *of the Duomo.*

[The voting was reported as follows:]

Nannes Checchi Buxichelli	81.
Magister Iacobus magistri Pieri de la Fonte	119.
Iohannes Petri Ghezi	72.
Antonius magistri Luce	59.
Urbanus Pietri del Bello	75.
Pietrus Mini Pacinelis	26.

Location: ASS, Concistoro, no. 1408/09, fol. 46v. and Concistoro no. 414, fol. 24v.

Bibliography: Milanesi, *Vasari*, 2:133; Bacci, *FdV*, p. 426.

Comment: The chronicle of Tommaso Fecini (*RRIISS*, vol. 15, part 6, col. 849) gives the following: "A dì primo d'Agosto fu fatto cavaliere misser Iacomo di maestro Piero della Guercia per le mani di messer Angniolo Martinozzi, e poi fu fatto operaio in iscambio del detto di sopra [messer Bartalomeo di Giovanni Cecchi]."

Document 413.
February 10, 1435
Siena

The commission for a figure by Jacopo for the Cappella del Campo is annulled.

A dì x di Febraio.
Salimbene di Petri di Agnolo uno de' detti consiglieri costituto nella detta residentia et presenti e soprascripti altri conseglieri et Giovanni camarlingo predetto; veduta la remissione in lui facta, come appare nella faccia precedente, et conciosiacosaché la allogagione che per lui si doveva fare a maestro Iacomo di maestro Piero della Fonte, d'una figura di marmo, come là si dichiara, venga annullata per la electione nuovamente facta del detto maestro Iacomo in operaio della detta opera etc., per ogni migliore modo etc., dichiarò che'l camarlengo predetto, senzo suo preiudicio, o danno, dia et paghi al detto maestro Iacomo de' denari d'essa opera, Lire cinquanta di denari per lo detto marmo et figura principiata, per vigore della detta remissione etc.

Location: AODS, 21 (Deliberazioni), fol. 10v.

Bibliography: Milanesi, *Documenti,* vol. 2, doc. 123; Beck, *Portale,* doc. 242.

Comment: Considering the relatively small amount of money given for the statue, which included the cost of the marble, it can be assumed that Jacopo did little of the actual carving of the figure, which is usually associated with a San Giovanni widely thought to be by Giovanni Turini. For this monument, still insufficiently studied, see A. Cairola and E. Carli, *Il Palazzo Pubblico di Siena* (Rome, 1963), pp. 44–45.

Document 414. February 11, 1435
 Siena

Jacopo is charged with commissioning the metal grating for the Cappella del Campo.

Dicti magnifici domini et capitaneus populi, habita inter eos diligenti et matura examinatione, et cognoscentes quod capella palatii eorum est satis bene honorata et perpulcre edificata et ornata, sed quod deficit perfectioni suae quaedam craticula ferrea in introytu suo cum ianua eisdem craticule cum bona decentia, sicut requirit et exigit locus ille; iam solemniter et concorditer deliberaverunt et decreverunt quod dicta graticula ferrea cum hostio suo seu ianua expedienti fieri et apponi debeat ad dictam capellam expensis comunis senensis, perpulcra et decens, sicut requiritur. Et remiserunt in magistrum Iacobus magistri Petri de la Fonte eorum collegham, qui dictam craticulam locare debeat per illum modum et formam, de quibus sibi videbitur decentius et honorabilius, et etiam cum quanta minori expensa fieri poterit. Et quicquid per eum factum fuerit etc. nunc approbaverunt ac si factum esset per totum eorum colegium et offitium.

Location: ASS, Concistoro (Deliberazioni), at the date (according to Milanesi).

Bibliography: Gaye, *Carteggio inedito,* 2:439; Milanesi, *Documenti,* vol. 2, doc. 124; Beck, *Portale,* doc. 243.

Comment: On this grill see G. Cecchini, "Vicende di tre opere d'arte, fra l'ordinazione e il loro compimento," *Bullettino senese di storia patria* (1955–1956), 42–43: 1–2. The commission was turned over to Niccolò di Paolo, *fabbro,* on February 25, 1435.

Document 415. February 16, 1435
 Siena

Jacopo issues a statement on the occasion of his election as Operaio of the Duomo.

Proposuit et dixit: cum etiam magister Iacobus Magistri Petri de la Fonte, electus per consilium Populi in nomine operarii opere sancte Marie, interrogatus utrum velit acceptare an non, asserat se obligatum esse Bononiae pro quodam laborerio magne sue fame et maximi pretii, in quo intra sex, vel septem mensis expediri posset quiquid pro dunc fieri potest in illo, et propter hoc ipse vellet differre honorari militia dictos sex vel septem menses, quo tempore vellet se exercere posse partim in Bononia et partim in Senis, prout utilius et commodius fieri posset pro utriusque Ecclesie bonificatione; dicatque etiam, priusquam acceptare deliberet, se certificare velle si de bonis suis committere debet aliquid in dictam Operam et quantum, ut deliberare possit super dictam acceptationem, cum fuerit electus secundum cetas provisiones, quae lecte fuerunt in consilio, ex quarum tenore non specificatur quid committi debeat per

operarium, nisi quod solum dicitur: Quod operarius habeat Florenos C auri de salario donec vixerit, et non transeat ad vitam uxoris, quod uxor solum habeat usufructum de illis M Florenis vel plures, quos committeret, et sic tante [?] videtur quod debeat committere Flor. M. Sed cum postea ad declarandum super dictam commissionem fuerit ordinata quedam provisio, qua specifice declarabatur de Flor. M, et fuit perdita, unde dicta materia remanet confusa, et ipse magister Iacobus cupiat clare vivere et unumquemque clarum facere, et nollet cogi ad committendum de bonis suis plus quam sibi placeret, cum nullum bonum sit bonum nisi sit volontarium; sed per verba sua multum clare cognosci potest quanta est eius bona affetio erga dictam operam, unde sperari posset persona sua futura multum utilis ipsi opere. Igitur etc., super dictis materiebus seu petitionibus, et etiam super portatione birreti, quod nollet cogi ad portandum plus quam de suo processerit beneplacito, similiter in Dei nominie generaliter et specialiter consulatur.

Location: ASS, Consiglio Generale, no. 218, fol. 120v.

Bibliography: Gaye, *Carteggio inedito,* 2:439; Milanesi, *Documenti,* vol. 2, doc. 125; Bacci, *FdV,* p. 426; Beck, *Portale,* doc. 244.

Document 416. February 16, 1435
 Siena

Special conditions are arranged for Jacopo as Operaio of the Duomo.

Die xvi Februarii 1434 [= 1435, modern].

In consilio populi et popularium civitatis Senarum solemniter convocato et congregato in numero sufficienti et cetera.

Et facta in eo proposita super certis causis, que allegate sunt pro parte egregii viri magistri Iacobi Pietri de la Fonte, electi pro novo operario opere Sancte Marie, circa eius acceptatione vel non acceptatione, videlicet super honore militie differendo usque in sex vel septem menses quibus se exercere posset partim in Bononia pro expeditione certi laborerii per eum illie conducti et partim in Senis pro utilitate dicte opere, prout commodius fieri posset; ac etiam ut absolverent a portatione birreti et ut declararent materiam commissionis per eum fiende in dictam operam, et redditis pluribus consiliis et missio, partito, fuit tandem victum, obtentum et reformatum in dicto consilio, quod sit et esse intelligatur plene remissum in magnificos dominos et capitaneum populi et in vexilliferos magistros, qui intellecto dicto magistro Iacobo et examinata diligenter materia, possint in omnibus partibus providere, ordinare et deliberare prout eis vedebitur utilius fore et honorabile pro dicta opera et pro comuni Senarum, preter quam absolvere eum de portando birretum. Et quicquid per eos factum fuerit valeat et teneat pleno iure.

Location: ASS, Concistoro, no. 414 (Deliberazioni), fol. 27v.

Bibliography: Gaye, *Carteggio inedito,* 2:439; Milanesi, *Documenti,* vol. 2, doc. 124; Beck, *Portale,* doc. 243.

Comment: See previous document.

Document 417. February 27, 1435
 Siena

Jacopo fulfills requirements as new Operaio of the Duomo, including a deposit of 1,000 lire.

[In left margin:] Pro Operaio duomi.

Vigore remissionis eis facte per opportuna consilia circa hanc materiam declaraverunt et deliberaverunt et decreverunt, simul cum vexilliberis quod magister Iacobum magistri Pietri de la Fonte, electus in operarium et pro operario opere maioris ecclesie cathedralis committere debeat de bonis suis in dictam operam libras mille denariorum quas dicta opera consequi debeat post mortem suam et non ante, et precise consequi illas debeat et non sub condictione. Et sic ipse ex nunc commisisse intelligatur et quod habeat terminum usque ad menses septem proxime futuros de accipendo militiam et birretum, quo tempore septem mensium possit ipse magister Iacobus personam suam exercere partim in Senis, ad utilitatem dicte opere, et partim in Bononia pro expeditione laborerii ibidem per eum conducti prout ipse compartiendo tempus utilius facere poterit pro utraque ecclesia et comodius. Et quod dictum operarium cum conditionibus predictis et cum salario Florenorum centum auri pro quolibet anno et aliis modis consuetis ipse ex nunc acceptet. Et sic eum elegerunt ad vitam et diligenter exercere promisit et iuravit ad laudem die et beate Marie etc. Rogantes etc.

Actum in consistorio, coram ser Mariano Mei Santis notario domini capitanei populi, et Paulo Capre de Senis et Antonio Iacobi de Calabria, domicellis dictorum dominorum, testibus rogatis, et cetera.

Location: ASS, Concistoro, no. 414 (Deliberazioni), fol. 36v.

Bibliography: Bacci, *FdV*, pp. 426–427 (summary).

Document 418. March 1, 1435
 Sienna

Jacopo assumes the position of Operaio of the Duomo.

A dì primo di Marzo 1434 [= 1435, modern] misser Iacomo di maestro Piero incominciò a exercitare lo officio di operaio della chiesa cathedrale sopra detta.

Location: AODS, no. 21 (Deliberazioni), fol. 11.

Document 419. March 1, 1435
 Siena

Repairs to the cathedral are ordered.

Che l'operaio faccia conciare la tribuna et el campanile [in the margin].

Misser Iacomo operaio predetto et misser Petro del Besso, Giovanni de ser Neri et Andrea di Giorgio conseglieri predetti, absente Salinbene loro collega, congregati et cetera, veduto al manchamento della pupola *[sic]* overo tribuna della chiesa cathedrale predetta et etiamdio veduto el difecto et manchamento del campanile d'essa chiesa et cetera, di concordia deliberaro che sia pienamente remisso et conmesso nel detto misser l'operaio fare et far fare tutte quelle cose che vedrà essare expedienti al aconcime et reparatione della detta pupola over tribuna et del detto campanile. Et perssino da hora deliberaro ch' el detto camarlingo paghi de' denaro d'essa opera per li detti aconcimi et reparatione tuto quello che gli sarà detto per lo detto misser l'Operaio senza suo preiudicio danno, et cetera.

Location: AODS, no. 21 (Deliberazioni), fol. 11.

Document 420.

<div align="right">March 21, 1435
Siena</div>

Jacopo chooses two consiglieri *to conduct the business of the Opera during his absence.*

Anno domine MCCCCXXXIV [= 1435, modern]; V indi. x die vero xxi Martii.

Dominus Iacobus operaius—omni modo etc., cum statuit se absentare a civitate senensis pro quodam tempore et non possit interesse oportunitatibus opere ecclesie prefate, substituit et in eius locum posuit dominum Petrum del Besso, canonicum, et Andream Georgii, consiliarios—et in eo ambos suas vices commisit, ut admodo in eius absentia facere possint omnia que facere posset ipse dominus Iacobus operarius—si personaliter interesset etc. volens et declarans predicti eius substituti non possint aliquo modo pro vocem ipsius domini operarii removere Paulum Iacobi factorem ipsius opere ab eius officio seu exercitio, nec ei aliquid diminuere etc., damnas etc.

Actum Senis, in apoteca domini Guidonis de Guidarellis et fratrum aromatariorum in Campo fori ad buccham Casti, coram ser Mariano Iacobi alias Taccola de Senis et Domenico Bartoli pictore de Asciano testibus, etc.

Location: AODS, no. 21 (Deliberazioni), fol. 14.

Bibliography: Milanesi, *Documenti*, vol. 2, doc. 126.

Comment: The two witnesses for Jacopo, who were important in their own right in the artistic world of Siena, must have been his friends.

Document 421.

<div align="right">April 14, 1435
Bologna *(Portal)*</div>

Accounting adjustments are entered for the work on the Portal.

Maestro Iachomo de Piero da la Fonte da Siena, maestro de la porta de mezo de la ghiexia de Sam Petronio, de' dare a dì xiiii d'Aprile Lire siemilia trexento ottantacinque soldi dexedotto denari diexe de bolognini, per resto d'una soa raxone levata in questo a carta 235.

<div align="center">Lire VI^mCCCLXXXV soldi xviii denari x.</div>

Postò in questo, a carta 273, che 'l detto maestro Iacomo debia dare Lire XIII soldi iiii de quatrini per una posta de ducati sie d'or che ave in sino adì 5 de Zenaro 1434 da Tomaxe dal Gambaro, come apre qui da lado, a una posta segnada +, la quale no fo tirada fuore.

Location: AFSP, Libro Mastro, fol. 273 and CCXXXV; Giornale, fol. 234.

Bibliography: Beck, *Portale*, docs. 147–149.

Comment: Jacopo is also paid 30 lire on this day.

Document 422.

<div align="right">April 28, 1435
Siena</div>

Pietro di Tommè del Besso is to instruct Domenico di Bartolo on the histories in the sacristy.

Per dipegnare in sacrestia [in the margin].

Et deliberaro che sia pienamente rimesso in messer Pietro detto ordinare et dichiarare che storie Domenico di Bartolo dipentore che dipegne nela detta sacrestia, depegna in essa et cet.

Location: AODS, no. 21 (Deliberazioni), fol. 16.

Bibliography: Cf. Brandi, *Quattrocentisti senesi*, p. 211.

Comment: On June 29, 1435 in a similar meeting, Domenic was advanced 12 lire as a loan (fol. 18). On August 18, 1435, Jacopo is instructed to fix the salary of Domenico, who painted the Sant'Ansano fresco in the sacristy: "Et deliberaro che sia pienamente rimesso et commesso in misser lo operaio detto fare storiare la sacristia et fare el salario a Domenico di Bartolo dipentore della storia dei Santo Sano che à facta nela detta sacrestia" (fol. 20).

The commission for painting the sacristy was continued after Jacopo's death, when on March 2, 1439 the *consiglio* of the opera deliberated as follows:

Similmente veduto che la buona anima di misser Iacomo operaio proximo passato fecie cominciare a dipegnere la sagristia a maestro Domenico dipentore d'Asciano, volendo che si dipignesse tutta dintorno come è cominciata: et considerato che e il decto lavorio non si traesse affine, sarebbe vergogna dela chiesa e de' suoi rectori, e volendo a cciò obviare, solennemente e tuti d'accordo, i prefati operaio, consiglieri e camarlingo, assente el prefato Iacomo, deliberaro che il prefato maestro Domenico seguiti nel decto lavorio come à principiato ne' modi ordinati. Et che il camarlingo de' uopera gli possi prestare a pocho a pocho come gli parrà essere ragionevole e come servirà, infino la quantità di dieci Fiorini a Lire 4 il Fiorino de' denari dela decta opera. Et hoc facerunt omni meliori modo, via etc. (AODS, no. 211 [Deliberazione], fol. 40v.)

The final section was finished on September 7, 1439 (fol. 51v).

Document 423. May 17, 1435
 Bologna *(Portal)*

Jacopo is paid 50 lire.

Location: AFSP, Libro Mastro, fol. 273; Giornale, fol. 235.

Bibliography: Beck, *Portale*, doc 250.

Document 424. May 21, 1435
 Bologna *(Portal)*

Corrections are made in the accounts.

A la fabrica de San Petronio Lire due de quatrini, per lei a maestro Bartolomeo dela Bella, maestro de legname, per fare due inbassamenti de tera per caxon de la differentia abbia' con maestro Iacomo dal la Fonte per lo lavoriero dela porta; e per noi da Tomaxe dal Gambaro, a lui a creditto, sono.

 Lire II.

Location: AFSP, Giornale, fol. 235.

Bibliography: Supino, *Scultura Bologna,* doc. 61; Supino, *Scultura Porte,* doc. 45; Beck, *Portale,* doc. 251.

Document 425. June 23, 1435
 Bologna *(Portal)*

Work on the internal side of the Portal *is recorded.*

E de' dare adì xxiii de Zugno soldi dodexe, per lui a Zoanne d'Arzenta per due ovre glie de' a' manoali prede e calcina a lavorier de la porta de mezo de San Petronio da lado dentro, e per noi da Tomaxe dal Gambaro, a lui in questo a carta 272.

 soldi xii.

Location: AFSP, Giornale, fol. 236; Libro Mastro, fol. 273.

Bibliography: Beck, *Portale,* 252.

Comment: On June 21, there is a payment for hooks for the inner portal (Libro di Spese, fol. 156v).

Document 426. July 4, 1435
 Bologna *(Portal)*

Work on the internal side of the Portal *is recorded.*

E de' dare adì iiii de Luglio soldi sei, per lui a Zoanne d'Arzenta per una overa a montar calcina e a servirli al lavorier de la porta de lado dentro de la ghiexia; e per noi da Tomaxe dal Gambaro, a lui a creditto in questo a carta 272.

 soldi vi.

Location: AFSP, Giornale, fol. 231v; Libro Mastro, fol. 274.

Bibliography: Beck, *Portal,* doc. 253.

Comment: On the same day there are also small payments for lead.

Document 427. July 8, 1435
 Siena (Loggia di San Paolo)

Marble is provided for the tabernacles for San Paolo.

Item, che sia rimesso pienamente in Petro di Lantino et nel detto camarlengo, e quali faccino conduciare a Santo Pauolo quello marmo che bisogna al presente per fare e tabernacoli et che 'l camarlengo paghi.

Location: AODS, no. 21 (Deliberazioni), fol. 19.

Comment: This provision serves as a *terminus post quem* for the tabernacles of the Loggia of the Mercanzia. It is quite possible chronologically that they were actually designed by Jacopo della Quercia; stylistic confrontations confirm the attribution.

Document 428. July 14, 1435
 Bologna *(Portal)*

Jacopo is paid 30 lire.

Location: AFSP, Libro Mastro, fol. 273.

Bibliography: Beck, *Portale,* doc. 254.

Document 429. July 18, 1435
 Bologna *(Portal)*

Work on the internal side of the Portal *is recorded.*

 Zoanne di Biaxio di Grassi da la calcina de' aver adì 18 de Luglio per corbe due di calcina,
mandò ala fabrica per la porta di mezo da lado dentro, a soldi viii la corba.
 soldi xvi.

Location: AFSP, Libro di Spese, fol. 108v.

Bibliography: Beck, *Portale,* doc. 255.

Document 430. July 21, 1435
 Bologna *(Portal)*

Corrections in the accounts for earlier work are recorded.

 A la fabrica de San Petronio Lire due de quatrini, per noi a maestro Bartolomeo d'Andrea
di Somenti, maestro d' intaglio de legname, per fare de fadighe personale à durade per detta
fabrica in far l'inbassamenti de tera e altre cose per dechiarire la differentia tra maestro
Iacomo e li oficiali dela fabrica per caxon del lavorer dela porta de mezo de San Petronio da
lado fuor; e per noi da Tomaxe dal Gambaro, a lui a creditto.
 Lire XIIII.

Location: AFSP, Giornale, fol. 237.

Bibliography: Gatti, *La fabbrica,* doc. 64; Supino, *Scultura Bologna,* doc. 62; Supino,
Sculture Porte, doc. 46; Beck, *Portale,* doc. 255.

Comment: Bartolomeo della Bella and Bartolomeo di Andrea Somenti are one and the same
person. This woodworker became "ingegniero de la Fabrica" in the 1440s (see Gatti, *La
fabbrica,* pp. '80ff.)

Document 431. August 20, 1435
 Siena

*Following his death, Francesco di Valdambrino's name is deleted from the list of nominees
for* priore.

Location: ASS, Consiglio Generale, no. 218, fol. 187v.

Bibliography: Bacci, *FdV,* p. 424.

Document 432.

August 31, 1435
Bologna *(Portal)*

A payment for work on the Portal *is recorded.*

A la fabrica de San Petronio soldi dodexe de quatrini, per lei a maestro Francesco de Ghiro e maestro Bartolomeo, maestri de legname, per uno ponte feno a la porta da lato de fuora, e per noi da Tomaxe dal Gambaro, a lui a creditto.

soldi xii.

Location: AFSP, Giornale, fol. 237v.

Bibliography: Beck, *Portale*, doc. 257.

Document 433.

October 22, 1435
Siena

The Comune of Siena writes to Jacopo in Bologna to return and take up his duties as Operaio of the Duomo.

Magistro Iacobo Pieri electo operaio etc. sic scriptum est, videlicet. Spectabilis vir concivis noster dilectissime.

Come sete a pieno informato, voi dovevate infino del mese proximamente passato pigliare la militia et fare le cose promesse circa la materia dello officio dell'uopara della chiesa nostra catedrale a voi conferito per li nostri consegli. Aviamo aspectato e noi et i vostri conseglieri, che almeno per tutto el mese promixe passato predecto doveste ritornare, sì per satisfatione dello honore del nostro comune, et sì per li bisogni ancho [= anzi] necessità occorenti a la detta huopara. Hora siamo a dì xxii d'Octobre et non pare ne facciate pensiero. Idio sa le grida quali so' et le murmurationi de' cittadini. Donde aviamo deliberato per le presenti scrivarvi, che senza alcuna exceptione et senza mettare più tempo doviate ritornare personalmente a fare el debito vostro; et non manchi per nulla; però che sarebbe troppo grande admiratione et inconveniente, se così non faceste.

Location: AODS, Copialettere, vol. 48 (according to Milanesi).

Bibliography: Milanesi, *Document,* vol. 2, doc. 127.

Document 434.

October 22 (ca.), 1435
Siena

A letter of the Consiglieri of the Opera del Duomo implores Jacopo's return.

Die . . . [blank] mensis Octobris MCCCCXXXV.
Spectabilis viri consiliarii prefati operarii in eorum solita residentia collegialiter convocati et congregati pro factis opere utiliter peragendis et pertractandis; viso quod dominus Iacobus operarius supradictus est in civitate Bononie et non revertit ad civitatem Senarum ad eius officium exercendum, in maximum detrimentum dicte opere; deliberaverunt omnes concorditer quod scriberetur eidem domino Iacobo in hac forma, videlicet:
Spectablis vir . . . Per altra nostra lectera vi scrivemo quanto c'era di necessità che voi retornaste qua ad exercitare l'officio a che sete deputato, né sete anco venuto; di che abbiamo

preso non piccola maraviglia, et non solamente noi, ma tutto questo popolo. Et però di nuovo, perché fra li cittadini et anco in Palazo sono di vari parlar del vostro non tornare; considerato quanto è necessario di provvedere intorno allo officio medesimo, e a li lavori necessari da farsi in questa chiesa; strectamente quanto possiamo vi preghiamo, che per contento di tutti li cittadini, per bene de questa huopara et per honore vostro vi piaccia a la riceuta de questa, la quale vi mandiamo per questo fante proprio, essare mosso et ritornare a la patria ad exercitare l'officio vostro a che sete deputato. Il che facendo, farete il vostro debito et honore et il contento del Concistoro et generalmente di tutti li cittadini, et di tutto pensiamo sarete anco advisato da' nostri magnifici Signori. Et per l'apportatore, di vostra ultima intezione vi piaccia rendarci, benché insieme a lui aspetiamo la vostra tornata, pienamente advisati; offerendoci a' piaceri vostri apparechiati. Ex Senis.

Location: AODS, no. 21 (Deliberazioni), fol. 21.

Bibliography: Milanesi, *Documenti*, vol. 2, doc. 128.

Comment: Although no day is given in the deliberation, it must have taken place at about the same time as the letter from the Signori (see previous document), which is referred to in the text. Jacopo seems to have actually left Bologna around this time, not as a result of these letters, however, but because of a long-standing feud with the officials of the Fabbrica of San Petronio (see doc. 347).

Document 435. November 28, 1435
 Bologna *(Portal)*

Work on the internal side of the Portal *is recorded.*

A la fabrica de San Petronio soldi diexe de quatrini, per lei a Simone da Lucha maestro de legname, per so salario de certa overe scavizade dade a la fabrica in conzar el centro dela porta dentro e altre cose; per noi da Tomaxe dal Gambaro, a lui a creditto.
 soldi x.

Location: AFSP, Giornale, fol. 241.

Bibliography: Beck, *Portal*, doc. 259.

Document 436. December 10, 1435
 Siena (Loggia di San Paolo)

A payment to Pagno di Lapo for seven blocks of marble for statues is recorded.

MCCCCXXXV.
Pang[n]io di Lapo da Fiesole die dare a dì Dicienbre Lire ottantta, le qualli se li diè per misser Iachomo oparaio per sette pezi di marmo per fare fighure di ttre *[sic]* bracia el pezo, e qualli ricievé in Firenze; e deti denari dei in mano di misser Iachomo oparaio. Posti a Liro [= Libro] Gialo a foglio 155, e a uscita di me Vanni di Franciescho a foglio 33.
 Lire LXXX

Location: AODS, no. 676 (Memoriale), fol. 22.

Bibliography: Bacci, *Quercia*, pp. 212–213.

Comment: This payment refers to the six blocks for figures Jacopo was contracted to supply for the Mercanzia; the seventh block is perhaps for the Cappella di Campo. On the other hand, there may have been plans for seven figures for the Loggia (see below, doc. 498), after the original commission. The payment is also carried in the other corresponding books, as follows: "Pagno di Lapo da Fiesole, che lavora di marmo, die dare a dì 20 d'Aprile Lire ottanta autti chontantti da me Vanni di Franciescho, chome apare al mio memoriale a fo. 22 e a uscita di me fo. 33; e quali denari dei io Vanni in mano di misser Iachomo oparaio, e per suo deto io Vanni feci questa inscrittura" (Aods, no. 708, fol. 33v.; see also fol. 155).

As has been mentioned elsewhere, Pagno had a close rapport with Donatello, and in fact is referred to as "Pagno di Lapo garzone di Donato" in a document of August 18, 1434 (AODS, no. 21, fol. 3).

Document 437.
December 10, 1435
Bologna *(Portal)*

A payment to Orazio di Jacopo is recorded.

A la fabrica de San Petronio Lire diexe de quatrini, per lei a maestro Oratio dipintore per so salario a vedere differentia tra maestro Iacomo da la Fonte e li oficiali de la detta fabrica per caxon de la porta che'l detto maestro fabrica; e per noi da Tomaxe dal Gambaro, a lui a creditto.

Lire X.

Location: AFSP, Giornale, fol. 241v.

Bibliography: Supino, *Sculture Porte*, p. 90; Beck, *Portal*, doc. 260.

Document 438.
December 21, 1435
Siena

A description is given of the Chapel of San Sebastiano (Cardinal Casini) in the cathedral.

La cappella di Santo Bastiano con una tauola con sua figura del martirio e più altre figure; con tende vermigle e frangie e predele a' piei a due gradi; con uno sedio alato al detto altare, con tauoletta, una n'è in telaio de' Magi offrenti e di Giuseppe e Santo Ambruogio e altri santi; a capo el deto sedio, due candelieri di ferro; quatro more [?] atacate dinanzi a detta chapella, cioè due in tauole et due in panno con più figure di santi.

Location: AODS, no. 510, fol. 18.

Bibliography: Bacci, *Quercia*, p. 328 (partial).

Comment: At this time the marble lunette that Jacopo and his shop were to produce for the altar had not been completed. Nor is it known exactly where it was put in place, although this document should be considered a *terminus post quem*. The lunette is mentioned in a document of October 20, 1458 (Bacci, *Quercia*, pp. 329–30) as follows: "Con Nostra Donna, da chapo a detto tauola, di marmo, et altre fichure di marmo: con una chapella di marmo adornata di più intagli et figure, parte dorate, con l'arme di Rev.mo Cardinale Monsingniore di Sancto Marciello" (AODS, no. 510, fol. 25v). In the later inventories the figures are specified as three in number, leading to the conclusion that the present lunette in

the Museo dell'Opera is missing a piece containing another (standing) figure, as Bacci has assumed. The chapel was demolished at the beginning of the seventeenth century.

Document 439. December 21, 1435
 Siena

Jacopo submits an inventory of the Duomo, in one section of which are listed the objects in his residence as Operaio.

... [fol. 25]
Sequita pure nel luoga della residentia dell'operaio.
Due piei de calici de rame, vechi.
Una finestra di vetro in uno telaio, con quatro figure.
Una sedia con due goffani, tarsiata, bella; nel uno de' goffani sonno molte scriture e brevileggi *[sic]*.
Uno bancho da scrivare dinanzi ala sedia, con pano lino rosso dina[n]zi.
Uno cassone doppio nuovo, lungo braccia cinque, dove stano e palii.
Yhs
[fol. 25v] Séguita pure nel luogo della risidentia del'operario.
Tre soppediani dove stanno e palli e altre cose, antichissimi, con serature e con chiavi.
Uno goffano buono, longo braccia tre e quar[t]o, con seratura e chiave.
Due cassette di piastre di ferro, circa a braccia una l'una.
Due tabernacoli da altare, civoriati, di lengname.
Una cassette a ricorsoio, piccola.
Due canpanette, una piccola et l'altra magioretta.
Uno sportello di ferro da tabernacolo del corpo di Christo.
Una banca regolata, di circha braccia cinque.
Uno baccino, fu d'uno lanpanaio.
Quindici pelli di montoni nuovi, d'aconciare altari.
Sette figure di lengname, di quarri tre l'una, sei di Nostra Donna e uno di Santo Crissto-fano, disgrossate.
Una testa di metallo, di donna.
Due cassette a ricorsoio, un d' uno braccio, l'altra di tre quarri.
Una finestra di filo di ferro al banco, co' la finestra del vetro nel telaio un poca rotta.
Due banbocci di lengname.
Due cassette ritratti a capistro, circa braccia uno l'uno.
Una canpaneta staccata al banco.
Uno armario a capo la sedia, intarsiato.
Sette scatole tra grandi e piccole.
Dodici candelieri di ferro, tutti a ponte.
Una cioppa d'azurino e verde, tutta tingnata e bucarata.
Uno focolare di ferro, lungo due terzi di braccio.
Sette tovagliuole in breve, a tre verghe, di più ragioni, fresche.
Uno gonfalone vermegl[i]o di frana, vechio, soleva portarsi a procesione. Uno pezo [in the margin]
Uno goffanuccio d'avorio, intag[i]ato, a più figure, di circa braccio mezo. In sagrestia [in the margin]
Due colteliere con quatro coltella e quatro coltelini di arie[n]to doarato e smaltato, co' l'arme di meser Bartolomeo operaio.

Otto chuidieri d'ariento, con lioncelli da capo.

Uno taschuccio d'azurro, pesa libre quatro e oncie cinque. [in the margin] Netto è libre 3 oncie 2.

Una fodara di bocchacino biancho [later addition: adoparala per parame[n]ti].

[fol. 26] Yhs

Séguita le cose che sono nella risidentia, cioé nella camera della risidentia dell'operaio.

Uno paio di maniche di cremusi, fodarate di boccacino bianco.

Una libra e mezo di frangie di seta, di cremusi et altri colori, che furono conprate per onorare el cavalo overo fornimento del cavallo del papa.

Uno paio di manichette di drappo vermeglio, a oro, sdrucite.

Clinque braccia di zondada di grana, vinitiano.

Uno penonciello piccolo, di zondado azuro e bianco, co' la crocie e istelle.

Una borsa di seta raccamata, con una fonte in mezo, con più altre cose.

Un pezo di sciamitello azurro, circha braccia tre. [added: vecchio]

Un viletto di seta, vergato di più colori, di braccia sei.

Uno viletto tutto di seta, tutto vergato a oro e di più colori.

Quatro pezi di fregi d'oro, figurati, nuovi, dela figura di Nostro Singnore e altre figure [added: sono 2 picoli]

Uno pezo di fregio d'oro, di Nostra Donna in su l'asinello.

Uno pezo di drappo vermeglio, broccato ad oro, con figure azurre, nuovo, braccia 2 ¾.

Uno pezo di drappo ad oro, bianco, brocato, nuovo co' f[i]oretti verdi, lungo braccia due o circa.

Due pezi di fregio vermeglio e verde, meso a oro, nuovo, di braccia due e mezo.

Sette peze di sciamitello ve[r]de, vechio e trissto. [added: e straciato, braccia 1 ½]

Uno pezo di sciamitello morello, vergato, in tre pezi attacato. [added: braccia 5]

Uno pezo di sciamitello vergato tutto. [added: vechio, verde, verghato di rosso e biancho]

Vinticinque scudiciuoli di più armi, vecchio. [added: 20 rotti e tristi, di pocha valuta]

Vinticinque scudiciuoli, co' l'arme del comuno e popolo, e più altre armi.

Uno cordone di seta, di quatro braccia.

Una carte [?] di pelo di cremusi verde e altri colori.

Undici bande nuove de'arme del comuno e popolo, e più altre armi.

Uno sciugatoio a tre verghe, grande, di braccia quatro.

Uno viletto nuovo, meso a oro, di braccia tre e mezo.

Otto viletti di banbagia, vergati e non vergati, di banbagia, vechi.

Tre pezi di drappeloni a giglli e armi.

Uno pezo di grangia bianca, circa braccia dieci [added: braccia 6 ½]

Una sachetta di più ritaglli e inbratarelli.

Una sachetta dentrovi paternostri minuti, azuri e altri colori, circha libre dieci.

[fol. 26v] Séquita pure nella residentia del' operaio.

Sei pezi di crisstallo inn *[sic]* uno sachetto, di più ragioni, con una crocietta di rame e più botoncini.

Uno giglio e uno pezo di patena da pieviale, d'ottone dorati.

Trentuno bracio di pannolino da camicio sottilissimo. [added: braccia 40 a canna]

Uno smalto di rame coll'Asunsione di Nostra Donna.

Tre bandinelle vechie, circa braccia sei.

Due smalti d'ariento co' l'Angnolo e Anunziata di Nostra Donna.

Sie pertiche o circha, per la camera, intorno al'armario.

Uno armario di tavole, dove si tiene e libri e doppieri: sonvi più libri.

Uno baccino bello e grande, col pedestallo.

Tre libri con coverte di tavole, dipinti al'arme del'Uopara, sovi scritte le ragioni del'Uopara.

Un libro dipento santo Michelangnolo, con insegngna del'Uopara.

Uno memoriale di messer Caterino.

Uno memoriale di messer Antonio di Tano.

Una tovagllia grande, a tre verghe, nuova, di circa bracia dieci.

Uno bottone da pieviale, d'attone dorato.

Location: AODs, no. 867, fols. 25–26v. (the entire inventory runs from fol. 1 through 44v.)

Bibliography: Bacci, *FdV*, p. 427 (for the reference).

Comment: From this portion of the inventory we learn of Jacopo's surroundings as Operaio. Apparently his residence was used to keep objects belonging to the Opera as well as his own things. The seven blocked out wooden statuettes are unquestionably Jacopo's, and so too, apparently, is the metal head of a woman (see Beck, *Portale*, doc. 302, and herein, below).

The existence of the seven statuettes is of particular interest because they reveal an activity by Jacopo late in his career that is often overlooked. Furthermore, the "mass-produced" aspect of these statuettes is unexpected.

Following the election of Giovanni di Grezi de Borghesi as Operaio of the Duomo after Jacopo's death, we learn that the residence was in particularly poor condition, giving notion of Jacopo's (bohemian?) mode of living. The *consiglieri* and the new Operaio agreed on November 16, 1438: ". . . veduto che lo operaio, sicondo le provisioni nuovamente facte, è obligato habitare nella casa della detta opera et veduto che essa casa à bisogno essare aconcia volendo potere habitare con qualche commodità *[sic]* e ancho per se medesima, deliberaranno dacordo de remettare e remessero e commissero pienamente nel detto misser lo operaio che essa case facci aconciare in quelli luoghi e per quello modo che a lui parrà essere di bisogna . . ." (AODS, no. 21, fol. 33v).

Document 440. 1436
 Siena

Plague breaks out in Siena, and is especially virulent from April through November.

Bibliography: *RRIISS*, vol. 15, part 6, col. 849.

Document 441. January 22, 1436
 Siena

Jacopo wishes to leave Siena for a period of days.

Misser Iacomo operaio predetto, conciosiacosa che si vogli absentare per alquanti dì da la città di Siena per sue necessarie facende, substitutì in suo luogo e suoi conseglieri predetti tutti e quattro, volendo che in absentia sua possino disponare quanto potrebbe lui se fusse presente et cet.

Location: AODS, no. 21 (Deliberazioni), fols. 21v.

Document 442.

January 9, 1436
Bologna *(Portal)*

A payment for lime is recorded.

Zoanni de Biaxio dela calcina d'avere adì 9 de Zenaro per corbe una de calcina ce dè per lo lavorier dela porta da lado dentro, a soldi nove la corbe.

soldi viiii.

Location: AFSP, Libro di Spese, fol. 108v.

Bibliography: Beck, *Portale,* doc. 262 (listed as 26 March).

Document 443.

March 26, 1436
Parma

Jacopo writes to the officials of San Petronio from Parma.

[Address] Espettabili et egregi Offiziali de la Fabrica di San Petronio in Bolongnia. Yhesus.

Espetatissimi et egregi Ofiziali Santo Petronio: Per lo vostro servitore Iacopo le recomandazion fidelisime per me prima sien fatte. Egli è così la verità, ched io son partito di Bolongnia e da la reverenzia di vostro magistrato, non per partire nè fugire il debito e la ragione, ma per esser libero e non preso; inperchioché l'uom preso non è inteso nè udito. E pertanto le vostre reverenzie sieno avisate che io fui e sono desposto far tutte quelle chose a le quali la ragione m'obriga ed à obrigato: nè mai mi partirò da conservare la gi[u]stizia e 'l mio onore. Le parti per voi e come che nel passato trattate intorno alla parte dell'acordo non reprico: tutto sa vostra reverenzia e non à possuto aver luogo: e pertanto fo mia conclusione, che se da mme *[sic]* volete il debito, eschomi presto; ed ora e quando vorete me troverete aparechiato. Ma cuando la passione e la invidia è finita, la ragione e il vero è manifesto tanto quanto besognia a fare le menti contente. Nè più sopra a questo dirò. Sapiete, reverendi e laudabili Ofiziali, ched io mi ritrovo in Parma, nè più dappresso me potei porre per le nove costituzion fatte intra reverendissimo Singniore el Legato misser Daniello e 'l Singnor Marchese de Ferara: son qui ed ispetterò 3 dì vel 4 la resposta di vostre reverenzie. Quanto che a mme *[sic]* non se responda, prederò il chamino a Sena. Pur tuttavia, se 'l nostro Singniore Iddio vorrà ch' io liveri il mio defizio, nol potrà la prava mente dinegare; e sapiate, padri reverendi, che al Singnior misser lo Legato iscrivo questa medesima materia. Nè più per questa: che Christo con felicità vi conservi. Per lo vostro Iacopo e servitore a voi, in Parma, a dì 26 Marzo 1436.

Location: AFSP, Miscellanea, vol. 2, fasc. B, no. 1.

Bibliography: Davia, *Le sculture,* doc. H; Milanesi, *Documenti,* vol. 2, doc. 129; Gatti, *La fabbrica,* doc. 65; Supino, *Scultura Bologna,* doc. 64; Supino, *Sculture Porte,* doc. 49; Beck, *Portale,* doc. 263.

Document 444. April 20, 1436
 Siena

Jacopo, as Operaio, is mentioned in the affairs of the cathedral.

Location: AODS, No. 708 (Libro Giallo), fol. 154v.

Document 445. April 27, 1436
 Siena

Jacopo acts as godfather to a son of Paolo di Martino.

Pietro di maestro Pauolo di Martino maestro di pietra si battezzò a dì xxvii d'Aprile
[MCCCCXXXVI], fu chonpare misser Iachomo di Pietro, oparaio del Duomo di Siena.

Location: ASS, Battezzati, at the date.
Bibliography: Bacci, *FdV*, p. 427; Beck, *Portale*, doc. 264.

Document 446. May 26, 1436
 Siena

The conseglieri *of the Opera del Duomo write to Jacopo in Bologna.*

A dì xxvi di Maggio.
Lettera a misser lo Operaio per lo predicatore [in the margin]
Per deliberatione de' detti conseglieri tutti fu scripto a misser lo operaio predetto a
Bologna che risponda se à preveduto del predicatore per la quaresima prossima che verrà o
no, et in che modo li piace si provegha.

Location: AODS, no. 21 (Deliberazioni), fol. 23.

Comment: On May 8, Jacopo had been given permission to absent himself from Siena. From
this letter, we learn that he had indeed left for Bologna to continue his work on the *Portal*.
Frate Bernardino was choosen but apparently he did not accept the invitation.

Document 447. June 6, 1436
 Bologna *(Portal)*

*A new contract is drawn up between Jacopo and the officials of San Petronio for the
completion of the* Portal.

Instrumentum conventionum inter Officiales fabrice et Iacobum dalla Fonte.
Millesimo quadrigentesimo trigesimo sexto. Indictione quarta decima, die sexta mensis
Iunii. Tempore Pontificatus sanctissimi in Christo patris et domini nostri domini Eugenii diva
providentia Pape quarti. Cum sit quod alias de et super litibus, causis et questionibus
controversiis et differentiis vertentibus tunc inter Officiales, tunc Presidentes fabrice ecclesie
nove Sancti Petronii de Bononia et eiusdem officio, de et pro una parte, et magistrum
Iacobum quodam Petri della Fonte de Senis lapicidam et seu sculptorem marmoreorum
lapidum, nunc vero militem effectum, ex una et pro alia parte, deventum fuerit ad certam

compositionem, transactionem et concordiam et ex publico instrumento scripto et rogato per Christophorum de Bellabuschis notarium de anno proxime elapso et mense Augusti dicti anni, in quo instrumento transactionis dictus magister Iacobus, pro observatione omnium et singulorum in dicto instrumento transactionis contentorum expresse et specialiter, obligavit dictis Officialibus, inter alia, libras quadringentas bononienorum in quatrenis, quas tunc, ut in dicto instrumento transactionis continetur, assertum fuit fuisse et esse Verzusium de Ludovisiis quondam Pauli de pecuniis dicti magistri Iacobi.

Et quas libras quadringentas dominus Verzusius in presentia et ad petitionem dicti magistri Iacobi et dictorum Officialium, tunc ibidem presentium et instantium, dixit, asseruit et confessus fuit penes se habere in depositum a dicto magistro Iacobo pro cautione dicte fabrice, et ut eidem fabrice posset satisfieri usque ad dictam quantitatem in et pro eo quod teneretur dictus magister Iacobus dicte fabrice; cum pacto etiam tunc in dicta transactione apposito quod predicte quadringente libre bon. in quatrenis penes Verzusium predictum remanere deberent, quousque idem magister Iacobus tantum laboreriorum operis porte magne dicte fabrice laudandum et aprobandum per arbitros dictarum partium faceret, quod ascendat ad valorem quantitatum pecuniarum per dictum magistrum Iacobum habitarum occasione dicte porte et eius operis usque in diem dicte facte transactionis et latius et plenius, ut in dicto instrumento transactionis continetur. Et cum in rei veritate, tempore confessionis dicti depositi librarum quadringentarum apud dictum Verzusium de pecuniis dicti magistri Iacobi, non forent nec essent nisi libre trecente quinquaginta, licet dictus Verzusius, modo et forma pactis ad instatiam dictorum tunc Officialium et dicti magistri Iacobi, confessus fuerit dictam quantitatem librarum quadringentarum ex causa ed modo et forma presentis, velitque et intendat de presenti dictus dominus Iacobus miles factus prosequi in laborerio dicte porte et pro sua parte adimplete ea que tenetur et debet vigore dicti instrumenti transactionis et contentorum in eo, si in modo eidem domino Iacobo detur comoditas, quod idem dominus Iacobus uti possit tanta quanitate pecunie quanta fuit et est dicta quantitas librarum trecentarum quinquaginta ut supra deposita. Qui dominus Iacobus dictis Officialibus dixit et asseruit et dicit et asserit quod Bonsignore Andree de Senis, habitator Bononie in capella Sancte Cecilie, precibus et instantia dicti domini Iacobi, pariformiter se obligabit ad et pro dicta quantitate librarum trecentarum quinquaginta bononienorum in quatrenis et pro cautione et securitate dicte fabrice, sicut fuit et erat obligatus dictus Verzusius in quantum de voluntate dominorum Officialium dicta quantitas librarum trecentarum quinquaginta bon. in quatrenis in veritate existens penes dictum Verzusium eidem Bonsignore per eumdem Verzusium solvatur et deponatur, et quod dictus Bonsignore postea ex gratis concedet dicto domino Iacobo, eiusdem Bonsignore periculo, uti dicta quantitate librarum trecentarum quinquaginta, vel tantumdem quantitatis de pencuniis dicti Bonsignore, pro necessitate fabrice porte antedicte, prout reverendus pater dominus Iohannes Galeaz de Pepulis, abbas Nonantulanus et egregius miles dominus Iacobus de Aldrovandis, prior Sancte Marie de Castro Brittonum, diocesis Bononie, et circumspecti viri Ioannes de Griffonibus et Andreas de Battaliis, omnes Superstites et Officiales dicte fabrice ex parte una, et dictus dominus Iacobus de Senis ex parte altera, et utraque dictarum partium, videlicet una ad petitionem alterius, et e contra predicta omnia et singula sic vera esse et fuisse dixerunt, asseruerunt ac recognoverunt.

Et volentes predicti Officiales pro eorum posse providere ita et taliter quod in dicto opere prosequatur per dictum domium Iacobum de Senis, attento maxime proposito et intentione sanctissimi Domini nostri Pape, videlicet quod in dicta fabrica omnino prosequatur et insistatur: considerantesque quod in dicta fabrica de presenti non extant pecunie ex quibus provideri et seu dari possit modus aliquis prefato domino Iacobo de Senis ut in eodem laborerio prosequi et insistere possit nisi modo predicto, intendentes insistere ut in eodem

laboreri prosequatur omini modo, iure, via et forma quibus magis et melius fieri potest; cum protestatione tamen per eosdem Officiales expressa et in qualibet parte huius contractus repetita, quod ipse non intendunt preiudicare dicto alias facto instrumento transactionis, nisi quantum et solum et duntaxat respectu mutationis persone, videlicet persone domini Verzusii depositarii in rei veritate dicte quantitas librarum trecentarum quinquaginta ad personam dicti Bonsignore et quantum est quod ubi alias in dicto alias facto instrumento transactionis dictum fuit dipositas fuisse libras quadrigentas, per presens instrumentum recognoverunt et recognoscunt dictam quantitatem duntaxat fuisse in quantitate usque ad quantitatem libra-rum trecentarum quiquagina, adeo quod dictus Bonsignore obligatus pariformiter ramanere debeat in dicta quantitate librarum trecentarum quinquaginta ex causa dicti depositi, prout et sicut erat obligatus dictus Verzusius in dicta quantitate librarum quadringentarum bon. in quatrenis. Existentes predicti Officiales in presentia prefacti domini Iacobi de Senis presentis et infrascriptis omnibus et singulis volentis et instantis expresse mandaverunt prefati Offi-ciales nomine fabrice antedicte, nec non predictus dominus Iacobus de Senis prefato Verzusio presenti antedicti et intelligenti, quod idem Versusius dictum quantitatem librarum trecen-tarum quinguaginta ut super alias penes eum depositam, illico et incontenenti dare, consig-nare et numerare debeat dicto Bonsignore Andree modo et forma predictis retinenendam. Qui Verzusius, predictis auditis et intellictis, animo et intentione consequendi absolutionem et liberationem a dicto deposito alias penes ipsum Verzusium ut supra facto de dicta quanti-tate librarum trecentarum quinquaginta, presentibus testibus et notario infrascriptis, nec non in presentia dictorum Officialium, et dicti domini Iacobi de Senis, expresse volentium et consentieneum, dedit, solvit et numeravit dicto Bonsignore presenti et manualiter recipienti dictam quantitatem librarum quinquaginta bon. in quatrenis, ac etiam dicenti, confitenti et asserenti tantam esse et fuisse dictam quantitatem pecunie librarum trecentarum quinqua-ginta, et ipsas libras trecentas quinquaginta totas et integras habuisse, recepisse ac sibi integre datas, solutas, traditas et numberatas fuisse et esse a dicto Verzusio. Renuntians predictus Bonsignore exceptioni sibi non date, non habite, non recepte, sibi non tradite, non solute, non numerate et penes eum non dimisse totius dicte quantitatis pecunie librarum trecentarum quinquaginta bon. in quatrenis abs eodem Verzusio et ex causa infrascripta.

Et hoc in deposito et ex causa depositi custodiendi et salvandi causa, omni ipsius Bonsignore periculo et casu fortuito furti, rapine, violentie, aggressus latronum, incendii, naufragii et inundationis aquarum et cuiuslibet alterius casus fortuiti, qui dici et excogitari posset. Et insuper prelibatus Bonsignore depositarius antedictus, solenne stipulatione et pact se et sua bona obligando; promisit per se et suos heredes dictis Officialiibus et mihi notario, ut publice persone stipulanti et recipienti, vice et nomine dicte fabrice, dictam quantitatem librarum trecentarum quinquaginta apud se tenere, custodire et salvare ut supra, ad petiti-onem dictorum Officialium et dicti domini Iacobi de Senis et pro cautione dicte fabrice et pro observatione omnium et singulorum promissorum per predictum dominum Iacobum de Senis in dicto instrumento transactionis et per omnia modo et forma quibus alias dicta quantitas deposita fuit penes dictum Verzusium in dicto alias facto instrumento transactionis. Et ipsam quantitatem librarum trecentarum quinquaginta solvere et exbursare predictis Officialibus fabrice in quantum et in casu quod dictus dominus Iacobus de Senis non observaret et adimpleret premissa et conventa per eum in dicto alias facto instrumento transactionis, specialiter in civitate Bononie et Senarum, Florentiae, etc., et generaliter etc., cum pacto presentationis pignorum etc., pena librarum trecentarum quinquaginta bon. in quatrenis stipulatione premissa etc., solvenda infra decem dies etc., qua soluta etc., cum refectione damnorum etc., expensarum sub obligatione omnium suorum bonorum etc., et debitis re-nunciatione beneficiorum etc., et sacramento more maiorum prestito etc. Qui dominus Iacobus de Senis etiam solenniter promisit et convenit dictis Officialibus presentibus ed ut

supra stipulantibus, deponere penes dictum Bonsignore libras quinquaginta bon. quatrenorum de primis lucris, que faciet cum dicta fabrica, penes dictum Bonsignore in depositum retinendas pro cautione dicte fabrice et per omnia modo et forma quibus dicta quantitas librarum trecentarum quinquaginta fit et est ut supra deposita. Quibus ut supra expenditis, incontinenti et in eodem instanti prefati Officiales, nomine dicte fabrice, absolverunt et liberaverunt predictum Verzusium presentem, pro se et suis heredibus stipulantem, a dicto alias penes eum ut supra facto deposito in dicto instrumento transactionis et ab omni eo et toto, quod ab eodem Verzusio peti posset vigore contentorum alias in dicto facto instrumento transactionis. Que omnia et singula supracripta et infrascripta etc., cum promissione vicissim de rato etc., adictione pene vicissim librarum quingenarum bon. etc., stipulantione vicissim premissa etc., solvenda vicissim infra decem dies etc., que soluta etc., cum refectione vicissim damnorum etc., obligatione vicissim bonorum etc., bonorum dicte fabrice et dicti domini Iacobi etc., et debitis renuntiationibus beneficiorum etc., et sacramento per predictos dominum abbatem et dominum Iacobum de Aldrovandis supra pectus suum prestito more maiorum et per dictos Ioannem et Andream Officiales manu tactis scripturis more maiorum et etiam per eumdem dominum Iacobuim de Senis etiam more maiorum prestito. Actum Bononie, in domibus Ecclesie nove Sancti Petronii, in solita et consueta audientia predictorum dominorum Officialium dicte fabrice, presentibus Petro quondam Galeotti de Mezzovillanis campsore, Bononie cive, capelle Sancti Iacobi de Carbonensibus, qui dixit et asseruit se dictas partes et contrahentes congnoscere; Bonsigore Nicolai de Cecca, habitatore Bononie in dicta capella Sancte Cecilie; Bolognino Basacomatris de Basacomatribus, capelle Sancti Martini de Porta Nova et Michaele Parisii de Auro, Bononie cive, capelle Sancte Marie de Clavica: testibus omnibus ad predicta adhibitis, vocatis atque rogatis.

Ex instrumento mei Guidonis quondam domini Gardini olim ser Bartolomei de Grandonibus, civis et notarii Bononie de predictis omnibus rogati.

Location: AFSP, Libro + il Primo, pp. 63–67.

Bibliography: Davia, *Le sculture,* doc. 1; Milanesi, *Documenti,* vol. 2, doc. 129; Supino, *Scultura Bologna,* doc. 65; Supino, *Sculture Porte,* doc. 50; Beck, *Portale,* doc. 265.

Comment: Jacopo was required to provide "una cauzione," which was assigned to a third party as a guarantee to the officials of the Fabbrica for work Jacopo owed them (see also Gnudi, "Revisione," pp. 48–49).

Document 448. June 21, 1436
Bologna *(Portal)*

A wall is prepared for new designs.

E de' avere [Zoanne da la Calcina] adì de Zugno per corbe due de calcina ce mandò per smaltar una faza de una capella per designar certe misure de prede bixogna mandar a tor per la porta grande.

soldi xviiii.

Location: AFSP, Libro di Spese fol. 108v.

Bibliography: Beck, *Portale,* doc. 266.

Document 449. July 10, 1436
 Bologna *(Portal)*

An agreement is reached between Jacopo and the officials of San Petronio resolving past differences.

Eodem millesimo, in die decimo mensis Iulii.

Reverendus prior dominus Iohannes Galeaz de Pepolis, abbas Nonantulanus et providi viri ser Iohannes de Griffonibus et Andrea de Bataglis Officiales et Superstites fabrice ecclesie nove Sancti Petroni in Bononie. Scientes et cognoscentes fore et esse descripta quidam computus et sturatio [?] plurium et diversarum postarum et partitarum diversarum summarum et quantitatum pecuniarum habitarum et receptarum per magistrum Iacobum magistri Petri de la Fonte de Senis, nunc effectum millitem, inquibus dictus magister Iacobus est debitor dicte fabrice in quodam libro et seu campione vocato: el campioni generale negro segondo dicte fabrice, in folio CXXVIII, in qua ratione inter diversas partitas predictas sunt descripte infrascripte due partite infrascriptarum summarum infrascripti tenoris, videlicet:

Maestro Iacomo de maestro Piero da la Fonte da Siena de' dare a dì xxvii de Marzo MCCCCXXV etc., E de' dare lib. 150, a dì xv de Otovre, le quale receve da Francesco de Guidalotto, per parte de quello de' avere per le fathiche soe durate per l'andare a Milano per le prede, ave per parte de le dette fatiche Lire C[ent]o. E le Lire L per paghare le oppere che farà mettere per fare degrossare le priete, arà de queste Lire L a rendere raxon, a conto de Franceschio, a fol. 160 . . . Lire CL soldi . . . [blank].

E de' dare a dì xxvii de Aprile MCCCCXXVI, Lire L de bolognini, li quali glie fe' dare in Milano misseri lo comandadore de Sancto Antonio, per le mani de Sigieri Galerani, e fo quando el detto comandadore se partì da Milano, posti a credito al detto comandadore, in questo a fol. 226. Lire L.

Et scientes ipsum dominum Iacobum esse descriptum per debitore in dicto campione in quantitatibus et summis pecuniarum in dicta ratione et partitis contentis et descriptis, et ipsum non fore descriptum in eodem campione per creditore dictarum quantitatum pecuniarum, videlicet librarum ducentarum descriptarum in suprascriptis duabus partiti aliqua ratione vel causa. Et scientes predictum dominum Iacobum reddidisse rationem dicte fabrice de libris centum bon. per ispum expensis et distributis pro factis dicte fabrice, prout apparet in quadam scripta manu dicti domini Iacobi scripta, de solutione et distributione dictarum centum librarum bon. que est in filcia existente penes Regulatorem iurium dicte fabrice, vigore et auctoritate eorum officiaii et omni meliori modo iure, via et forma quibus melius potuerunt et possunt, commisserunt ser Michaeli de Auro, Regulatori iurium predicte fabrice presenti, quod dictas centum libras expensas de distributas per ipsum dominum Iacobum pro factis dicte fabrice contentas in dicta scripta debeat ponere ad computum dict domini Iacobi. Et alias libras centum pro laboribus suis, pro eundo et stando Mediolanum, pro lapidibus marmoreis cavandis pro dicta fabrica et conducendis Bononie etc.

Location: AFSP, Libro d'Atti Civili della Fabbrica, vol. 3, fol. 98v.

Bibliography: Supino, *Sculture Porte*, doc. 51; Beck, *Portale*, doc. 266.

Document 450. July 10, 1436
 Bologna *(Portal)*

Accounts are corrected in Jacopo's favor.

E de' dare adì x de Luglio 1436 Lire ottantaquatro soldi diexe de bolognini per ducati XL d'or gli dè per noi Tomaxe dal Gambaro in fino adì sei d'Aprile 1432, de qual denaro ne fu fatto debitor al suo conto corente in questo a carta 88.

E dovevano esser posti qui a questo conto, perché gli ebe per comperare prede istriane per la porta da lado dentro; posti a credito al suo conto corente in questo, a carta 273.

<div align="center">Lire LXXXIIII soldi x.</div>

Location: AFSP, Libro Mastro, fols. 141 and CCLXXIII.

Bibliography: Beck, *Portale,* doc. 268.

Document 451. July 23, 1436
 Bologna *(Portal)*

An advance is given for the purpose of purchasing marble.

E de' dare adì xxiii de Luglio Lire cinquantatre soldi due denari sie de bolognini per ducati XXV d'or de Vinexa glie dè per noi Tomaxe dal Gambaro de la fabrica de San Petronio, posti a lui a creditto in questo a carta 297, de' qual ducati el detto maestro Iacomo n'arà a rendere raxon in una compera de prede farà per la deta fabrica a Vinexa.

<div align="center">Lire LIII soldi ii denari vi.</div>

Location: AFSP, Libro Mastro, fols. 273.

Bibliography: Supino, *scultura Bologna,* doc. 67; Beck, *Portale,* doc. 269,

Document 452. July 26, 1436
 Bologna *(Portal)*

A wall of a chapel in San Petronio is prepared for drawings of the Portal's *arches.*

E de' dare adì xxvi de Luglio Lire una de quatrini, per lui a maestro Antonio de Domenego murador per un'ovra per lui e una per uno manoale à dado a deta fabrica per smaltar uno pezo di muro in una capella, per far certi designi per gli archi de la porta, e per noi Tomaxe dal Gambaro a lui in questo a carta 297.

<div align="center">Lire I.</div>

Location: AFSP, Libro Mastro, fols. 294.

Bibliography: Beck, *Portale,* doc. 270.

Document 453. August 8, 1436
 Siena

Jacopo conducts affairs of the Opera in Siena.

Location: AODS, no. 21, fol. 24.

Document 454. August 16, 1436
 Siena

Jacopo acts as godfather to the son of maestro Niccolò di Paolo fabro.

Mariano Muccio di maestro Nicholò di Pauolo frabbo [sic] si battizzò a dì xvi d'Aghosto [MCCCCXXXVI], fu chonpare misser Iachomo di Piero, oparaio del Duomo di Siena.

Location: ASS, Battezzati, at the date.

Bibliography: Bacci, *FdV*, p. 427; Beck, *Portale* doc. 271.

Comment: On the following day Jacopo, acting as Operaio, made the following payment: "Misser Iachomo di maestro Piero hoparario de' dare adì xvii d'Aghosto soldi trenta, per lui al Aldino rachamatore per fregio d'oro" (AODS, no. 678, fol. 13v.).

There are many similar payments by Jacopo during these years. This one has been selected for presentation here because it deals with embroidery, and I have reason to believe that Jacopo himself supplied designs for such works from time to time. There were a number of "fregi" in his residence, according to the inventory of 1435 (doc. 439).

Document 455. September 6, 1436
 Siena

Jacopo, as Operaio, lends a mitre belonging to the Opera to the Cardinal of Chiusi.

Adì 6 di Settembre [1436] prestai la . . . [blank], per detto di misser Iachomo hoperaio, la mitera a Cristofano d'Andreia per misser Veschovo di Chucio [= Chiusi].
Tornò la mitera.

Location: AODS, no. 986, fol. 8v.

Comment: The item was cancelled, presumably at the time that the mitre was returned.

Document 456. October 4, 1436
 Siena

Jacopo acts as godfather to the son of maestro Giovanni di Niccolò, a notary.

Nicholò Franciescho di ser Giovanni di Nicholò di Ranieri Sabbolini notaio si battizzò a dì iiii d'Ottobre [MCCCCXXXVI], fu chonpare misser Iachomo di Piero, oparaio del Duomo di Santa Maria.

Location: ASS, Battezzati, at the date.

Bibliography: Bacci, *FdV*, p. 427; Beck, *Portale*, doc. 272.

Document 457. October 25, 1436
 Siena

Jacopo is to establish Domenico di Bartolo's salary for two frescoes.

A dì xxv d'Ottobre.
Per la sacrestia dipegnare e fornire [in the margin].
Misser lo operaio et conseglieri predetti, absente Damiano, ragunati deliberaro di concordia che sia e essare s'intenda pienamente rimesso et remissero e commissero in misser lo

operaio predetto che facci e fare possi el salario a maestro Domenico di . . . [blank] dipentore el quale à dipento nella sacrestia due storie, cioè quella di Santo Sano e di Santo Vettorio e farlo paghare. Et che'l detto misser l'operaio facci sequire di storiare e dipegnare la detta sacrestia come a lui pare. Et similmente d'altri lavori e fornimenti così di legname come d'altra qualunche cosa che fusse honore di dio e ornamento di detta sacrestia, come parrà al detto misser l'operaio et cet.

Location: AODS, no. 21 (Deliberazioni) fol. 25. (cf. Milanesi, *Documenti,* 2:172).

Document 458. November 27, 1436
 Bologna

A payment to Cino di Bartolo is recorded.

A la fabrica de Sam Petronio Lire tre soldi diexe de quatrini, per lei a Cino da Siena per sette overe à messo a far le piaghe e canali per li ferri da metere la finestra del vedro al' ochio segondo de verso el palazo de nodari; e per noi da Tomaxe da Gambaro, a lui a creditto.
 Lire III soldi x.

Location: AFSP, Giornale, fol. 273.

Bibliography: Beck, *Portale,* doc. 273.

Comment: There are payments to Cino at San Petronio during the next two years for works of a general sort, and not necessarily for the *Portal.* (See Beck, *Portale* docs. 276, 278, 286, 298, and 301.) This entry, incidentally, helps to document the progress of work on the windows of the basilica.

Jacopo was in Siena during this time, and he is recorded as present on November 24, 1436 when a silk fringe was purchased (AODS, no. 677, fol. 9).

Document 459. January 21, 1437(?)
 Siena

The Sienese Signoria writes to the bishop of Bologna on behalf of Jacopo.

Episcopo Concordia ac Bononie gubernatori scriptum est, ei recommendando dominum Iacobum de la Fonte novellum militem et operarium maioris ecclesie Senensis, qui asserit omino velle perficere opus Sancti Petronii de Bononia. Sed qua multa plura fiunt, et fieri necesse est, quam continerit pacta, in illis pluritatibus et maioritatibus rerum commendamus ut ei discrete solvatur.

Location: ASS, Copailettere, no. 49, at the date.

Bibliography: Milanesi, *Documenti,* vol. 2, doc. 132; Supino, *sculture Porte,* doc. 48 [listed as 1435].

Comment: I was unable to locate this document. The date is clearly a problem, and it may well date to 1436 (modern) rather than 1437. In any case, it must have been written at the request of Jacopo della Quercia.

Document 460. February 27, 1437
 Siena

The Signoria accepts the inventory of the Opera submitted by Jacopo.

Location: AODS, Inventari, no. 410, fol. 42.

Bibliography: Bacci, *FdV*, p. 428.

Document 461. April 4, 1437
 Bologna

Jacopo writes to the Sienese Signoria.

[Address] A'Mangnifici e potenti domini singniori, singniori priori e ghovernatori de la città di Siena.

Magnifici e potenti domini, domini mei singularissimi. Fatte prime le fideli et servili recomandazioni so' cierto che le mangnificienzie vostre ànno per chiaro le nove di paese; pur niente di meno, secondo il parlare di Bolongnia, per me servo della Vostra Mangnificienza sarà notificato quello che qui si dichiara. E vero che qui si dicie, tiensi cierto che lle brigate de' Veniziani venero al fiume Ada con quatro ponti di lengniame e con quatro bastie tutte recate segretamente, perché segretamente furon fatte, e teseno un ponte sopra al ditto fiume per lo quale pasaro persone circa a quatromilia a pè e a cavallo e menàro di qua dal fiume le quatro bastie. Presentito il duca di Milano le cose preditte, ordinò al tempo che una c[hi]atta di lengniame, charica di sevo e di più cose da ardare, venisse per lo ditto fiume, la qual c[h]iatta istava legata a un galeone che veniva drieto a essa, e quando g[i]unse apresso il ponte uscìro due omini dal galeone e dero il foco alla c[h]iatta e lasarola andare per infino al ponte e ivi fu retenuta dal galeone, siché il foco d'essa c[h]iatta tutto avampò ed arse il ponte sopra ditto. Seguitò che quelle brigate del Duca ch'erano aparechiate a l'ordine dato, asaliaro i loro nemici e tutti furo presi morti queli che di qua dal fiume eran pasati e così romase le quatro bastie prese e i quatro ponti tutti areseno; l'altra brigata de veniziani si tornaro per i fatto loro.

Apresso seguitò che più galeoni del Duca son venuti per Po e iti in Mantovana ed ànno fatto molto danno in su quel contado di guastare ed ardare le cose a loro posibili.

E più si dicie qua ch'el giorno di Domenica d'Olivo il dugho di Gienova andò alla chiesa di sancto Domenico a prendar l'olivo con sua conpangnia, misser Batista da Campo Fregoso suo fratello corse alla piaza e gridò "viva il Duca di Milano e lla libertà di Gienova" e fu seco parte del populo di Gienova ed è romaso il dugio in nel suo palagio e misser Batista e a casa sua el populo di Gienova è sotto l'arme. El capitano Nicolò Pic[in]ino è tratto in paese e diciesi à prese due chastella di Gienova. E queste novelle son qui; se altro presentiremo, avisaremo la Mangificienzia Vostra.

Per lo servo de la Singnoria Vostra, Iacopo cavaliere ed operaio de la katedral chiesa senese.

Data dì 4 Aprile, 1437.

Location: ASS, no. 1938, at the date.

Bibliography: Milanesi, *Documenti*, vol. 3, Appendix doc. 13; Gorrini, "Documenti di Jacopo della Quercia" pp. 310–311; Beck, *Portale*, doc. 278A; *Mostra*, doc. 55.



Comment: For the history of this fascinating letter, see Gorrini, "Documenti." This letter reveals Jacopo as a keen observer of the contemporary scene.

Document 462. April 8, 1437
 Bologna *(Portal)*

Advances are given to Jacopo for a trip to Verona.

E de' dare adì viii d'Aprile 1437 Lire dexesette soldi quatro de quatrini, per Fiorini de carli; diede per noi Tomaxe dal Gambaro, a lui a creditto in questo a carta 338; de' qual denari ne da rendere raxone in spexe faran ad andar a Verona per marmi per la porta.
 Lire XVII soldi iiii.

Location: AFSP, Libro Mastro, fol. 273.

Bibliography: Beck, *Portale,* doc. 279.

Document 463. April 9, 1437
 Siena

A payment (loan?) is made to Priamo di maestro Piero della Quercia.

Mastro Priamo di maestro Piero dipintore die dare adì 9 d'Aprile 1437 Lire quaranta contanti da me Salvestro di Neri camarlingo a fo. 11, chome apare al mio memoriale, per detto di misser Iachomo, e sono a mia uscita a fo. 31; et per lui promise Giovanni di Meucio e Chastoro di Nanni, maestri de pietra.
[added later] Posti a li[b]ro Rosso a fo. 18, a ragione di misser Iacomo suo fratello.

Location: AODS, no. 708, fol. 182v.

Comment: This entry was taken from no. 679 (Memoriale), fol. 11v. The guarantors for Priamo were both longtime associates of Jacopo.

Document 464. April 11, 1437
 Bologna *(Portal)*

A payment for the transport of marble is recorded.

A Guglielmo Gatto nochiero Lire vintecinque de quatrini, per noi da Tomaxe dal Gambaro, a lui a creditto,i quale denari sono prestandi [?] al detto Ghugliemo, per scontare in noli de prede de marmo che conduxe da Virone [a] qui in la fabrica per la porta de mezo de San Petronio.
 Lire XXV.

Location: AFSP, Giornale, fol. 273.

Bibliography: Beck, *Portale,* doc. 280.

Document 465. April 22, 1437
 Bologna *(Portal)*

Jacopo is sent money in Verona.

E de' dare adì xxii d'April Lire trexento vintecinque soldi quatordexe denari sie, per Fiorini CL de camera, li mandamo a ricever in fino adì 9 de detto mexe in Verona da . . . per lettera de Bonifatio de' Fantuci, per Fiorini CLI soldi x de camera n'ebe qui in Bologna per noi da Tomaxe dal Gambaro, a lui a carta 343, a soldi xliii per Fiorino, vaglion.

 Lire CCCXXV soldi xiiii denari vi.

Location: AFSP, Libro Mastro, fol. 273; Giornale, fol. 274.

Bibliography: Beck, *Portale.* doc. 281.

Document 466. April 24, 1437
 Bologna *(Portal)*

Other funds are sent to Verona.

E de' aver adì xxiii d'April 1437 Lire trexento vintinove de quatrini, per Fiorini LX de or de camera ce restituì de una somma de Fiorini CL da camera le remeteremo a Verona in fino adì 9 de deto mexe per comprar marmore; li quali denari demo a Tomaxe dal Gambaro, a lui a carta 343, a soldi xliii per Fiorino.

 Lire CCCXXVIIII.

Location: AFSP, Libro Mastro, fol. CCLXXIII.

Bibliography: Beck, *Portale,* Doc. 282.

Document 467. May 8, 1437
 Siena

Jacopo is present at the Opera in Siena.

Ser Lazaro di Benedetto notaio debbe avere adì viii di Maggio per braccia septantatre di pannolino bello e sottile vendei al opera per soldi xv el braccio, misurollo Pauolo in presentia di misser Iacomo, montano.

 Lire LIII soldi xv.

Location: AODS, N. 677 (Memoriale), fol. 8.

Document 468. May 20, 1437
 Siena

Jacopo conducts official business of the Opera in Siena.

Location: ASS, Gabella dei Contratti, no. 175, fol. 71.

Bibliography: Bacci, *FdV,* p. 428; Beck, *Portale,* doc. 283.

Document 469.

June 5, 1437
Siena

Permission is requested for Jacopo's sister and niece to leave Lucca and reside in Siena.

Die v Iunii 1437.
Comiti Francisco Sfortie scriptum est.
Qualiter accedit illuc dominus Iacobus operarius cathedralis Ecclesie senensis ut impetret at eo gratiam quod possit extrahere de civitate Lucensi Lisabettam et Caterinam eius filiam et conducere eas Senas et ideo orando quod concedit eis salvum conductum pro dicto effectu.

Location: ASS, Reformagione (Copialettere), no. 51, at the date (according to Milanesi).

Bibliography: Documenti, Milanesi, vol. 2, appendix doc. 13.

Comment: Jacopo's sister had maintained her residence in Lucca long after his own departure and the death of their father. Thus almost until the end of his life Jacopo maintained a continuous link with Lucca.

Document 470.

July 3, 17, and 19, 1437
Siena

Jacopo conducts official business of the Opera in Siena.

Location: AODS, no. 21, fols. 27–27v.

Document 471.

August 31, 1437
Bologna *(Portal)*

Payment for expenses in Verona is recorded.

E deono dar adì xxxi d'Agosto 1437 Ducati sei d'or de Vinexa, per lor a Veronexe da Verona e per noi da Tomaxe dal Gambaro, a lui a carta 358, de' quali denari ducati V d'or ne fo paghado la gabella de Verona de marmore andò a comperare per la fabrica misser Iacomo da la Fonte, a Ducato I d'or per resto de certe altre prede condotte per detta caxon; a soldi xlvi a quatrini per ducato, vaglion.

Lire XIII soldi xvi.

Location: AFSP, Libro Mastro, fol. 72; Giornale, fol. 286.

Bibliography: Beck, *Portale,* doc. 285.

Comment: The entry as it appears in the "Giornale" makes it quite clear that these materials were for the *Portal* "da lado di fuori," and that both red and white marble was involved.

Document 472.

September 3, 1437
Siena

Jacopo is conceded a month's leave to go to Bologna.

[in the margin] Domini Iacobi operarii licentia.

Magnifici et potentes Domini . . . concorditer concesserunt licentia spectabili militi dom-
ino Iacobo, operaio maioris ecclesie catedralis Senarum, discendendi de civitate Senarum et
eundi Bononiam duraturam toto presenti mense; cum hoc quod si dictus dominus Iacobus
non reverteret ad civitatem Senarum per totum presentem mensem, perdat omne salarium
quod deberet habere a dicta opera pro rata temporis ab hac presenti die in antea quousque
reverteretur. Et sic dicta deliberatio notificata fuit domino Iacobo presenti et acceptanti, pro
dominos priores.

Location: ASS, Concistoro no. 430 (Deliberazioni) fol. 3v.

Bibliography: Milanesi, *Documenti*, 2:176; Bacci, *FdV*, p. 428; Beck, *Portale*, doc. 287.

Document 473. September 26, 1437
 Bologna *(Portal)*

An account of payment is entered for marble acquired in Verona during April.

A prede de marmor Lire dexedotto soldi quatro de quatrini, per lei a misser Iacomo dala
Fonte, maestro dela porta de mezo de Sam Petronio, per più spexe asigna aver fatte in victura
de uno cavalo e spexe de bocha ad andar a Virona per comparar marmi per la porta de mezo
de detta gliexa, la qual andata fè in fino adì 9 d'Aprile prossimo passado; posti a creditto al
ditto maestro Iacomo, tornò adì 22 del detto mixe.
 Lire XVIII soldi iiii.
A dette prede de marmor per la porta de mizo de Sam Petronio, per l'infra[scritte]
marmore Ci à signata misser Iacomo dala Fonte aver conprate in Verona e prima:
Per piè xxxiiii de marmor biancho per l' archo stipitario.
per piè xxvi oncie—de marmor rosso per l'archo canelado dirtto.
Per due modiglioni dove starà suxo li lioni.
Per pie xii de marmo per la ratta.
Montano in tutto Fiorini LXXXX de camara, posti a creditto al detto messer Iacomo a
soldi xliii a quatrini per Fiorino, vagliono Lire.
 Lire CLXXXIII soldi x.

Location: AFSP, Giornale, fol. 289; cf. Libro Mastro, fol. 72 and CCLXXIII.

Bibliography: Supino, *Scultura Bologna*, doc. 69; Supino, *Sculture Porte*, doc. 54; Beck,
Portale, doc. 288.

Document 474. September 27, 1437
 Bologna *(Portal)*

Further accounting of payment for marble acquired in Verona during April is recorded.

A prede de marmor per la porta de mezo de Sam Petronio Ducati vinticinque de Vinixa, i
quali ci à signato misser Iacomo dala Fonte aver spexi in piè xxxvi quadri de marmo bianco
veronexe per le sopra baxe che vanno sopra li chapitelli dela porta e per due prede grandi de
marmo biancho per due lioni per ducati X e le predette pietre ducati XV, che so' in tutto
Ducati XXV, posti a creditto al ditto maestro Iacomo; a soldi xlii denari vi per Ducati,
vagliono.
 Lire LIII soldi ii denari vi.

Location: AFSP, Giornale, fol. 289v; Libro Mastro, fol. 72 and CCLXXIII.

Bibliography: Supino, *Scultura Bologna,* doc. 70; Supino, *Sculture Porte,* doc. 55; Beck, *Portale,* doc. 289.

Comment: Although there was a provison for lions on the *Portal* in the contract of 1425, this document gives the first information about them. They do not appear in Peruzzi's drawing. There seems no doubt that they were to have been carved from Istrian (or Veronese) stone, not stone of Candoglia. They appear to have been planned for the upper ranges of the *Portal* at this point, since the material mentioned at this time was all for that area of the *Portal*. It is virtually certain, however, that they were never carved.

Document 475. September 27, 1437
 Bologna *(Portal)*

Accounts for the Portal *are adjusted.*

E deono dar adì xxvii d'Settembre Lire cento dexenove soldi sedexe denari nove de bolognini, per altre tante de che fo fatto creditore per errore in questo a carta 235, in una soma de Lire CCVIIII soldi viiii de bolognini. El quale errore si schiarisse per lo zornale rosso segnato + a carta 213 e una asignation fatto per lo detto maestro Iacomo de prede istriane e de marmo bianco comperò a Vinexa d'April 1433 de la quale asignatione ne tocha la detto maestro Iacomo le dette Lire 119 soldi 16 denari 9 per la compra de le dette prede istriane comperò per lo suo lavor proprio de la porta da lado dentro e la mettà de le spexe per lui asignate in andar e tornare in caroza, detta partida d'accordo questo con lo detto maestro Iacomo e Michele de Loro calculo del governadore de la fabrica de Sam Petronio, posti a credito a le prede in questo, a carta 72.

 Lire CXVIIII soldi xvi denari viiii.

Location: AFSP, Libro Mastro, fol. 273 and fol. LXXII.

Bibliography: Beck, *Portale,* doc. 290.

Comment: On the same date there is a payment to Jacopo of 12 lire AFSP, Libro Mastro, fol. 273 and fol. LXXII, and Giornale, fol. 289v.).

Document 476. October 10, 1437
 Siena

Jacopo's salary in Siena is withheld.

Die X mensis Octubris [1437].
 Magnifici et potentes Domini ... concorditer deliberaverunt quod camerarius opere maioris ecclesie catedralis Senis teneatur ed debeat sub pena centum libr. exequi et executioni mandare deliberationem per ipsos factam sub die iii mensis Ottobris proxime preteriti ...
 Ita quod domino Iacobo operario maioris ecclesie catedralis senensis per dictum camerarium opere retineatur et retineri debeat totum salarium quod dictus dominus Iacobus habere deberet a dicta opera a die qua discessit a civitate Senarum, que fuit die terita, vel quarta dicti mensis Septembris, per usque ad diem dictus dominus Iacobus rediet.
 [added later] Die ii Decembris 1437 redivit Senas.

Location: ASS, Concistoro no. 430 (Deliberazioni), fol. 22.

Bibliography: Milanesi, *Documenti*, 2:137.

Comment: See doc. 480, below (February 5, 1438), for restoration of Jacopo's salary.

Document 477. October 10, 1437
 Siena

Jacopo is requested to return to Siena.

Location: ASS, Concistoro no. 1649 (Copialettere), at the date.

Bibliography: Milanesi, *Documenti*, vol. 2, doc. 135.

Document 478. November 21, 1437
 Bologna *(Portal)*

A payment of 4 lire to Jacopo is recorded.

Location: AFSP, Libro Mastro, fol. 273; Giornale, fol. 296.

Bibliography: Beck, *Portale*, doc. 294.

Comment: This document provides the last record of Jacopo's presence in Bologna.

Document 479. December 2, 1437
 Siena

Jacopo returns to Siena.

Location: ASS, Concistoro no. 430, fol. 22.

Bibliography: Milanesi, *Documenti*, vol. 2, doc. 137.

Document 480. February 5, 1438
 Siena

Jacopo's salary is restored.

Die quinta Februarii.
Cum spectabilis miles dominus Iacobus operarius et gubernator ecclesie cathedralis Senensis die secunda Septembris habuerit licentiam a concistorio discedendi et absentandi a civitate et eundi versus Bononiam per totum dictum mensem Septembris, cum conditione quod si no reverteretur infra dictum tempus, perderet salarium pro toto tempore quo staret absens; et considerato quod in dicto itinere fuit inpeditus et infirmatus fuerit, et habuerit accidens, et supersedit per pluries edomodas occasione dicte infirmitatis, pro ut fidem habuerunt; deliberaverunt dictam deliberationem et condictionem revocare et revocaverunt. Et quod camerarius opere predicte sibi solvat de salario pro dicto tempore non obstante deliberatione et condictione predicte, et cetera.

Location: ASS, Concistoro no. 432 (Deliberazioni), fol. 19v.

Bibliography: Milanesi, *Documenti,* vol. 2, doc. 137; Bacci, *FdV,* p. 429; Beck, *Portale,* doc. 297.

Comment: We learn that Jacopo had been very ill in Bologna the previous fall and probably did no sculpture.

Document 481. February 21, 1438
 Siena

Jacopo writes to the Comune on behalf of Pietro del Minella for his work on the Loggia di San Paolo.

Dinanzi a voi magnifici et potenti signori, signori priori governatori del comune et capitano di popolo della città de Siena.

El vostro minimo servidore Iacomo, cavaliere et operaio del'opera del maggiore chiesa cathedrale della vostra manificha città, reverentemente dicie et expone chome è noto, à facto et fa lavorare sancto Pauolo al quale lavorio à deputato maestro Pietro detto del Minella, cittadino nostro, per la cui industria spera el detto lavoro spedita et laudabile perfectione. Et conciò sia chosa che esso maestro Pietro sia uscita per bossolo castellano di Capalbio; per la qual cosa andando lui al decto uffitio, per aventura el decto lavoro arebe mancamento et troppo indugio, maximamente perché al presente non c'è altri maestri sufficienti al lavorare d'intaglio e di fogliame quanto al detto lavorio e opera si richiede; et pertanto non volendo provedere di maestri forestieri che sarebbe assai più indugio e di maggiore spesa; esso exponente supplica le magnifici signori vostri che vi piaccia solennemente provedere et riformare per li vostri opportuni consegli, ch' el detto maestro Pietro sia rimesso nel detto bossolo; et che per due anni almeno per detta cagione s'intenda e abbia vacatione al detto ufficio, et in questo mezo, mediante la gratia di Dio, degli altri vostri buoni cittadini colla loro buona sollecitudine e industria intendenti nella detta arte, aranno impreso a suficentia quanto sarà expediente alla perfectione d'esso lavoro; et quello che nella predette cose farete, mi riputarò a gratia singulare dalle vostra magnifica signoria la quale l'Altissimo conservi et feliciti quanto desiderate.

Location: ASS, Concistoro no. 2137, fol. 35.

Bibliography: Gaye, *Carteggio inedito,* vol. 1, doc. 134; Milanesi, *Documenti,* vol. 2, doc. 138; Bacci, *Quercia,* p. 318.

Comment: This letter has been dated February 2 by previous scholars. On the same day (February 21) Jacopo took part in several official acts in his capacity as Operaio (see Bacci, *FdV,* p. 429).

Document 482. March 26, 1438
 Siena

Jacopo acts as godfather to the son of Mariano di Giovanni d'Angnolo.

Mariano di Giovanni d'Angnolo di maestro Vanni zondadaio si battizzò a dì xxvi d'Marzo [MCCCCXXXVIII], fu chonpare misser Iachomo di Piero, oparaio del Duomo di Santa Maria et ser Mariano rettore di Santo Pietro a Uvile, el quale naque a dì xxiii de Marzo.

Location: ASS, Battezzati, at the date.

Bibliography: Bacci, *FdV*, p. 429–430.

Document 483. April 28, 1438
 Siena

Payment is made for a black suit for Jacopo.

Et die dare adì 28 d'Aprile 1438 Lire vinti soldi otto, demo per lui [i.e., misser Iachomo]
a Ghuido Salvani per resto di uno suo vestito di veluto nero; e sonno a uscitta di me Salvestro
di Neri kamarlengo a fo. 33.

 Lire XX soldi viii.

Location: AODS, no. 708, fol. 180v.

Bibliography: Bacci, *FdV*, p. 429–430.

Document 484. April 28, 1438
 Siena

Jacopo is nominated to serve as an ambassador but is not chosen.

Location: ASS, Concistoro, no. 433, fol. 51.

Bibliography: Bacci, *FdV*, p. 430.

Document 485. April 30, 1438
 Siena

Jacopo assigns Giovani di Paolo to restore a small crucifixion that was at one time on the
main altar of the cathedral.

Location: AODS, Entrata e Uscita, at the date, fol. 28–35 (according to Bacci).

Bibliography: Bacci, *Documenti e commenti*, p. 78; Bacci, *Quercia*, p. 420.

Document 486. April 28, 1438
 Siena

Jacopo is nominated to serve on a secret commission of the Comune but is not elected.

Location: ASS, Concistoro, no. 434, fol. 16–17.

Bibliography: Bacci, *FdV*, p. 430.

Document 487. June 6, 1438
 Bologna *(Portal)*

Corrections are made to earlier accounts.

E'de' dare Lire setantazinque soldi sette denari uno, per più spexe paghatte a minutto per lui da di 8 d'Otobre 1426 sino adì 5 de Setembre 1428, chomo apare in più partitte a libro de le spexe e apare per una scritta mano de Michelle da Lore ch' è in la filza de Bartolomeo Zanzifabri, a creditto a la fabrica in questo a carta 443.

Lire LXXV soldi vii denari i.

E de' dare Lire zinque soldi dodexe denari sette, per più masarizie à autto de quelle de la fabricha per le mani di Bartolomio de i Albiruolii, chomo apare per la sopraditta scritta, a creditto a la fabrica in questo a carta 443.

Lire V soldi xii denari vii.

E per uno pallo de fero e uno mazo de fero e vi biette de fero li prestamo e mai ze le rexe, apare a la vachetta prima a carta 31, a credito a la fabrica in questo a carta 443.

Lire IIII soldi iiii.

E dei' dare Lire quindexe soldi otto per più pezi di mexegne e marmori che per metere a lavorio de la porta di mezo da latto dentro da la porta, che apare partitamente a la vachetta seghonda a carta 9; a credito a la fabrica in questo [a carta] 443.

Lire XV soldi viii.

Location: AFSP, Libro Mastro, fol. 273.

Bibliography: Beck, *Portale*, doc. 300.

Document 488. June 10, 1438
 Siena

Jacopo, as Operaio, is ordered to investigate certain old errors of accounting in the records of the Opera.

Yhs.

Seguitaremo noi reveditori, cioè Nicolò Foscherani et Meo d'Angnolo di Gino et Giovanni di ser Neri, tutte quelle cose le quali di Volontà et consentimento de' nobili et egregii homini singnori et la diterminatione regolatori et statutarii rimettiamo et lassiamo la dichiarazione nello egregio kavaliere messer Iacomo, operaio della Opera Sante Marie, nuovo operaio della detta Huopara Sante Maria. El quale infra 'l tenpo che gli sarà statuito per li sopradetti regolatori debba diligentemente investigare et examinare in ritrovare la verità delle sottoscritte cose, le quali per noi non s'è potuto invenire la verità perché non si truova per li libri otentichi *[sic]* né de' camarlenghi stati, né per altro modo scritture di poterle per noi riveditori terminare. Et perché il sopra detto operaio è tenuto et debba ritrovare conservare e beni della detta Huopara, la rimetiamo in lui, acciò che l'abbia la sua ragione e non sia nelle sottoscritte cose difraudata et nel'altre che si trovassano, et ritrovato la verità debba fare debitori in su' libri dell'Opera quello tale che l'arà a rifare.

Frutti di posizioni [in the margin]

[1] E prima ch' 'l detto messer Iacomo operaio debba diligentemente ritrovare tutti e frutti anualmente delle posizioni del'Uopara, se sono venuti nel'utilità dalla casa o nno, e se alcuno se ne resta avere o di pigioni o d'altro, il debbi fare debitore, perché di molte non se ne vede l'entrata ordinaria ne' libri otentichi della case, etc.

Opii [in the margin].

[2] Ittem *[sic]*, che 'detto operaio, cioè messer Iacomo, debba diligentemente fare ritrovare il mancamento di centotrenta oppi, e quali mancano a due lame che conprò Bartolomeo di Giovan Cecchi, inperò che per noi riveditori, veduto la quantità degl'oppi conprati et quelli

che sono logri et venduti et segati, troviamo mancano, et prima contati quelli che sono dritti, mancano oppi centotrenta. E anco quello che s'è fatto de' ritaglli degl' oppi tagliati, acciò che l'Opera della Vergine Maria abbia il suo debito, però che i ritagli erano del'Uopera.

Dottori conventati [in the margin].

[3] Ittem, che il detto messer Iacomo debba diligentemente fare examinare e trovare se' dottori che si sono conventati in Duomo ale tre porte et in coro, se gl' anno fatto alcuna offerta ala chiesa, o dono per gli' aconcimi che si fanno fare ale spese del'Uopara, conciosia che mentre che noi riveditori vedavamo la ragione del' Uopera, se ne convento due et pagarono, et non si mettevano a 'ntrata se' riveditori non se ne fussono aveduti. Et pensando gl' altri, debino pagare et non trovandone niuno a 'ntrata, dichiariamo si debino ritrovare, acciò che l'Uopara abbia il debito suo.

Debito di messer Katerino [in the margin].

[4] Ittem, dichiariamo che 'l sopradetto messer Iacomo operaio debba con ongni studio et diligentia invenire de' beni di messer Caterino, operaio stato, el quale si truova debitore in questo Libro Giallo fori di Fiorini XV et Lire 614 soldi 16 denari 8, acciò che la casa della Vergine Maria abbia il debito suo etc.

Maestro Giorgio, Mateo Bichi [in the margin].

[5] Ittem, che il detto messer Iacomo operaio debba fare con effetto che le Lire centotredici soldi sei che maestro Giorgio da Como ressta a dare al' Uopara per denari li furono prestati per Matteo di Galgano [Bichi] detto, perché non può presstare e danari del' Uopara sanza ricolta etc. La quale possta è in questo Libro Giallo, foglio 131 et a foglio 144. Et per simile modo appiei la possta di Chino di Manghanese de' denari ln furo presstati, mettere per ricolta il camarlengo li pressto, che son al detto Libro Giallo, foglio 144.

Maestro Agustino [in the margin].

[6] Ittem, che 'l detto messer Iacomo facci tornare a dovere la posta ch' è a libro de'fitti, foglio 157, la quale Polonto di Guido, alotta camarlengo, fecie creditore Agusstino di Scapra. Parci in danno dell' Uopara. Vedere la verità del fato, etc.

Comune di Masa, Guidocio di Gionta [in the margin].

[7] Ittem, ch 'l detto messer Iacomo facci vedere la possta che è a Libro Giallo, foglio 89, dove il comuno di Massa è debitore di Lire 25, et dicie sono nelle mani di Guidoccio di Gionta, e Guidoccio alega avere mandato a messer Bartolomeo lengname per le dette Lire 25, et noi no' ne troviamo niuna scriture. Che il detto messer Iacomo faccia cercare la verità del detto lengname et in che s'è convertito, et che questa posta s'aconci come porta el dovere.

Cose mancano al'inve[n]tario fe' Salinbene [in the margin].

[8] Ittem, ch 'l detto messer Iacomo operaio abbia a ffare diligente examinatione d'uno panno di raza, d'uno calicie, di due teribili e una naviciella, et di cinquanta sciugatoi, et d'una maza, et uno mazapichio, et tre astroncielli et uno trespi[e]de grande et uno martello grosso et quatro cangnuoli da botti et uno veltro et uno pala di ferra et tre tovagllie et una pietra di smeraldo d'uno anello di Nostra Donna. Le quali cose mancano al'inventario fatto per Salimbene et Mateo d'Antonio di Guido et Batista di ser Lorezno, el quale è apresso de' regolatori, scritto per mano di ser Lazaro, acciò che la casa abia il suo debito e che la Vergine Maria non sia defraudata. E sono per partito dirinpetto, foglio 189.

Debitori di sensi [in the margin].

[9] Ittem, diciamo, dichiariamo et giudichiamo noi riveditori sopradetti che conciosia che troviamo che ne' libro di due + de' censi sono da foglio 4 insino foglio 227, posste 317 de' debitori de' censi fidati, e quali per non essare stati costretti a pagare si sonno debitori dal 1432 adietro, che montano Fiorini 998 a Lire 16686 soldi 2 denari 4, che stimiamo ve ne sia circa la metà a ppiù da doversi resquotare se saranno solecitati, e però diciamo che per lo detto messer Iacomo, nuovo operaio, sia fatto fare uno libro di questi censi fallati, acciò che

quelli che vi sonno buoni si faccino risquotare, per modo che la chiesa abbia il suo dovere, che son Fiorini 998, Lire 16686, soldi 2 denari 4.

Sbatesi la detta possta, perché n'è fatta nuova conclusion, come si vede a Libro Rosso nuovo, a ffoglio 28,29.

Yhs.

Anco troviamo che al'inventario fatto nel'anno 1429 per Salinbene di Petro et Batissta di ser Lorenzo Venturini et Matteo d'Antonio di Guido, el quale e apresso de'regolatori, et nella fine del detto inventario escritto per mano di ser Lazaro notario a quello tenpo de' regolatori, molti mancamenti, che' sopradetti Salinbene e conpagni dicono che mancano, etc. El quale mancamento ci pare a nnoi Nicolò Foscherani e Giovanni di ser Neri e Meo d'Angnolo Ghani che si debino ponare di quelo o quelli che sono tenuti asengnare l'aministratione della detta Opera, et non lasarli diposti in su' libri, perché questo viene in danno della casa. Et però rimetiamo la diliberatione ne' singnori regolatori e in chi è soperiore, a dichiarare chi s'ara a fare debitore. La scritura del'inventario di mano di ser Lazaro dicie così, videlicet.

Qui apresso faremo ricordo e memoria d'alcune cose mancano dal' inventario vechio al nuovo, sicondo a nnoi Salinbene, Batissta e Matteo sopradetti pare.

[1] Uno panno di razo si poneva ala graticola di Santo Sano, dietro a' Singnori, quando andavano ala messa. Dicono e sagresstani che si perdé.

[2] Uno chalicie. Dicono e sagrestani che 'l dierono per comandamento del Concistoro, al tenpo di Bartolomeo biadaiuolo e conpangni.

[3] Due teribili. Dissono e sagrestani si venderono.

[4] Una naviciella di rame, co' detti teribili, cinquanta sciugatoi, fra grandi e piccoli.

[5] Uno anello d'oro aticciato, el quale era della Vergine Maria. Disse messer Bartolomeo averlo auto lui e averlo perduto. [in the left margin] Questo anello noi riveditori l'abiamo posto a ragione di messer Bartolomeo per stimma di Lire 32, in questo, foglio 166.

[6] Otto letta, otto capezali, nove materazi, nove coltri, otto paia di lenzuola, delle quali cose dissero n'erano arse quando s'apigl[i]ò il fuoco, et non sapevano quante, del ressto non sanno asengnare ragione. [in the left margin] Nota che noi faciemo examinare a' regolatori chi v'era qua[n]do arsono, e faciano del tutto debitore messer Bartolmeo, in questo, foglio 166, di Lire 240 soldi 1.

[7] Una maza, uno mazapicchio, tre astrociegli, uno resp[e]de grande, uno martello grosso, quatro covignuoli da botti, uno veltro, tutti di ferro. Disse il fatore niente aparne.

[8] Uno palo di ferro. Disse il fattore fu furato.

[9] Tre tovagli[e], èvi di molte trisste, a pezzi.

[10] Una pietra di smiraldo, el quale troviam meno a uno ganbo d'anelo di Nostra Donna.

[11] Dicienove camici, metando i disfati per le vesste degl'angnoli.

Di queste cose noi riveditori sopradetti n'abiamo posso a ragione di messer Bartolomeo per l'anello aticciato Lire trentadue, in quessto, foglio 166. E più l'abiamo fato debitore in questo, foglio 166, per le letta che si provò a'regolatori non erano arse, come apare nel' examino di ser Antonio d'Angnolo di Minuccio di Giugno 1438, quando era notaio a' regolatori, e stimatole Lire 240, e così abian fato debitore messer Bartolomeo a foglio 166, in questo. E di tutte l'altre cose abiam rimeso a messer Iacomo operaio le deba certiorare o porle a conto di chi ne fu atteneva l'aministratione, apare qui dirinpetto, foglio 188.

E io Niccolò d'Antonio Foscherani, uno de' sopradetti riveditori, ò scritto di volontà di Meo d'Angnolo di Ghano et di Giovanni [di] ser Neri, miei magiori conpagni e riveditori della sopradetta ragione, e quali si sottoscrivarano qui di sotto, di loro mano, esser contenti, e così di tutta quesste s'è dato la ragione a detti regolatori, la quale ànno aprovata come appare per mano di ser Antonio d'Angniolo loro notaio adì . . . [blank] di Giugnio 1438.

Ed io Meio d'Agniolo di Ghano, uno de' detti rividitori, apruovo la detta ragione escritta di mano di Nicholò Foscherani, come di sopra si contiene, dì, mese et anno sopra scritto.

E io Giovanni di ser Neri diser Giovanni, uno de' detti riveditori, apruovo la sopradetta ragione iscritta di mano di Nicholo Foscherani, come di sopra si contiene, anno e dì detto di sopra.

Anno Domini 1438, indictione prima, die x, mensis Iunii etc. lecta fuit dicta ratio per dictos revisores in regula, coram dominis regulatoribus probantibus.

Ego Antonius Angeli Minucci, notarius dominorum regulatorum, de predictis rogatus propria manu subscripsi etc.

Isbatesi la detta possta perché n'è ffatta nuova conclusione, come si vede al Libro Rosso nuovo, a ffoglio 28, 29.

Location: AODS, no. 708 (Libro Giallo), fols. 188v-189.

Comment: The examination of the books of the Opera revealed a laxity that went as far back as the time of Caterino. Thus Jacopo's omissions, or those that seem to have occurred during his term as Operaio, should not appear extraordinary. Indeed, his burden was all the greater, in that certain responsibilities of past Operai were passed on to him, at a time when he had been seriously ill, and was in fact soon to die.

Document 489. June 30, 1438
 Siena

Jacopo, as Operaio, lends a book to the Bishop of Chiusi.

Adì di Giugno 1438, per detto di misser Iacomo, prestamo a misser Alexo, veschovo di Ghiuci [= Chiusi] prestamo *[sic]* uno liro [=libro] chiamato l'Epistole di Sancto Girolamo. Portollo.

Die dare.

Location: AODS, no. 986, fol. 84v.

Comment: A few days later, on July 8, Jacopo in his capacity as Operaio was involved in the sale of a house for the Opera (ASS, Gabella dei Contratti, no. 178, fol. 7; cited in Bacci, *FdV*, p. 431).

Document 490. August 30, 1438
 Siena

Jacopo, as Operaio, writes to the Bishop of Cortona.

Domino Episcopo Cortonensi fuerunt scripte littere infrascripti tenoris, videlicet:
Reverende in Christo pater et maior honorandissime, recommendationibus premissis. Cum nostra cathedralis ecclesia ydoneum ac sufficientem predicatorem requirat pro Quadregesima proxime ventura et consuetum sit nos ad id consuetium debere, suadentibus nobis bona fama et optimis moribus vestre reverende paternitatis et tam in predicationibus quam in aliis quibuscumque, duximus eandem reverendam paternitatem versam tam pro honore ipsius cathedralis ecclesie et eiusdem reverende paternitatis tam etiam pro augmento devotionis populi ipsam ecclesiam visitantis ... [word not legible] fore requirendam. Qua de recipsam [?] eandem reverandam paternitatem vestram ad ipsum exeritium predicationis pro dicta Quadragesima in eadem ecclesia sufficientissimam elegimus et specialiter deputavimus,

confusi tamen quod dicta vestra reverenda paternitas propter eius soliteam et humanissimam benignitatem non denegabit tale onus suscipere. Ideirico dignetur vestra reverenda paternitas hanc electionem assumere et de acceptatione eiusdem per proprias litteras nos reddere certiores, qui de salario consueto congruo tempore providebimus, offerentes nos ad omnia reverende paternitati vestre grata promptissimos. Ex Senis etc.

Iacobus miles, Operaius Opere Sancta Marie ecclesie cathedralis Senensis et . . . [blank] ipsius operarii consiliarii.

Location: AODS, Deliberazioni, E. fol. 33.

Document 491. September 13, 1438
 Siena

A payment to Papi di Piero da Firenze is recorded.

E de' dare insino adì 13 di Settembre Lire dieci soldi quindici e quagli si dièro per lui [misser Iacomo di maestro Piero] e per suo detto a maestro Papi di Piero da Firenze scharpelatore che lavorava cho' lui, diè Spinello per detto di Missere.
 Lire X soldi xv.

Location: AODS, no. 680 (Memoriale), at the date.

Bibliography: Bacci, *FdV*, p. 329.

Document 492. October 3, 1438
 Siena

Jacopo della Quercia makes his will.

Ser Iacobus Andree Paccinellis notarius denu[m]ptiat quod die veneris, tertia Ottobris.
Spectabilis miles dominus Iacobus olim magistri Pieri della Guercia, decto maestro Iacomo della Fonte, operarius opere maioris ecclesie sancte Marie civitatis Senarum, suum ultimum conditit testamentum, in quo inter cetera de bonis suis disposuit ut infra, videlicet:

Die xii Ianuarii 1438 [= 1439, modern] habuimus fidem a Paulo Iacobi Pacis et Castore magistri Nannis ipsum dominum Iacobus decesisse die xx Ottobris 1438.

Tertio, lassa a maestro Piero del Minella Fiorini dieci, iure legati.
 Fiorini X.

Solvit die xvii Ianuari 1438 [= 1439, modern] Iohanni Francini camerario cabelle a ffo. 7, soldi 33 denari 4 et cum quarto.

Quarto lassa a maestro Cino di Bartholo da Siena, Fiorini dieci.
 Fiorini X.
Et più lassa al detto Cino Fiorini cinquanta, iure legati.
 Fiorini L.

Solvit dictus Cinus et pro eo Honofrius Bartoli, die 28 Novembris 1438, Blaxio Leonardi camerario lib. VIII, ad eius introitum fo. 49.

Quinto, a Castore di Nanni Fiorini 5, reliquit iure legati.

Notificatum fuit ei die prima Novembris 1438 in persona. Solvit die xi Decembris 1438 Blaxio Leonardi camerario cabelle et pro eo Antonius Ieronimi, soldi 31 denari 4, ad eius introitum fo. 55.

Item decimo, reliquit iure legati et lassa de bonis suis et dispone Fiorini quatrocento a Caterina, sua nipote, per le sue dote, et che l'abbi a maritare misser Bastiano, maestro Piero et maestro Cino, et se ella morisse innanzi al matrimonio che i detti denari se ne mariti fanciulle, et a luoghi piatosi rimangino sicondo che e detti dispensaranno.

<div align="center">Fiorini 400.</div>

Tertiodecimo, lassa a Giovannino, a Sabetello et Antonio Nanis manovale, a ognuno per sé, Fiorini tre per uno capuccio, et al cìntolo uno Fiorino.

<div align="center">Fiorini VII per tutti.</div>

Notificatum per personam dicti Iohannis die 15 Novembris 1428. Solvit dictus Iohannes die 29 Decembris 1438 Blaxio Leonardi a ffo. 63, soldi otto. Solvit dictus Iohannes Nannis die 13 Ianuarii 1438 [= 1439, modern] Iohanni Francini camerario cabelle, fo. 8, soldi x cum quarto.

Ancho lassa a Pauolo Fiorini quatro per uno cappuccio.

<div align="center">Fiorini IIII.</div>

Solvit die xii Ianuarii 1438 [= 1439, modern] Iohanni Francini camerario cabelle, fo. 7, soldi 13 denari. 4.

Ancho lassa a Tonio di Baccio per uno capuccio Fiorini cinque.

<div align="center">Fiorini V.</div>

In libro duarum stellarum, fo. 306.

In omnibus autem bonis suis eius heredes universales instituit infrascriptos, videlicet:

Lassa sue universali herede Priamo suo fratello et monna Lisabetta sua suoro sue erede universali, ; et vuole che e denari che si trovaranno nella heredità se ne facci due parti et che monna Lisabetta sua sorella carnale, ne compri una posessione, la quale essa non possi né alienare né contractare, ma debbila lasare dietro alla sua vita alla [sic] figliuole, et se nissuna ereda non ci fuse, lassa al fratello, et se 'l fratello non ci fuse, rimanghi allo spedale di Sancta Maria della Schala.

Et vuole che etiamdio che 'l fratello conpri de' denari contianti, cioè della sua metà, un'altra posessione, la quale per nissuno modo si possi contractare né alienare, ma dietro alla sua vita rimanere et che esso la debbi lassare alla sorella; et se la sorella non ci fusse, lassi a Caterina, o sue erede, et se di queste non ci fusse, vuole rimanghi allo spedale di Sancta Maria della Schala.

Et di tutto e' resto fare etiandio due parti et ogniuno tengha la sua parte.

In libro duarum stellarum, fo. 306.

Location: ASS, Gabella dei Contratti, No. 196, fols. 62–62v.

Bibliography: Milanesi, *Documenti*, vol. 2, doc. 139; Beck, *Portale*, doc. 302.

Comment: This version of the will, the only one known, is obviously incomplete. The original was notarized by ser Iacomo di Andrea Paccinelli, whose account books have not survived.

The notations that appear throughout the document, between the lines in the manuscript, were not published by Milanesi.

Coincidentally, Cardinal Casini, Jacopo's last patron, made his will on October 2, 1438, but he outlived the sculptor by a few months, dying on February 4, 1439 (modern).

Insight into the nature of Jacopo's *bottega* and his property may be gained from a declaration of 1439 by Priamo (Milanesi, *Documenti*, vol. 2, doc. 151, said to be located in the ASS, Scritture, Concistoriali, filza 113), which reads:

> Dinanzi da voi, egregi et honorevogli arbitri arbitratori electi fra maestro Priamo di Piero et Cino di Barthalo, maestro Priamo come rede di messer Iacomo suo fratello, adomanda le infrascritte cose:
>
> In prima, domanda uno lucho di ciambellecto e' quale fu di misser Iacomo; e più la stima d'uno chavallo. Più domanda fiorini 4, e quagli sono per uno lodo data fra loro; e più domanda fiorini 7, e quagli maestro Priamo à paghati a l'uopera; e più domanda queste cose, le quagli Cino si rechò a le mani de' beni di misser Iacomo, ch'erano ne l'uopera: una covertina da chavalo nuova; una berreta di scharlato fodarata di mandorle di drento e fuore; uno paio di stivali nuovi, fod[e]rati di rosso; uno testa di vecchio di metallo; due inudi di metallo; uno lenzuolo; una carta d'animagli da disegno; una casa con più di ciento ferri acti ad intaglio; e più uno chusdiere di'ariento; uno anello d'oro, el quale Cino chavò di mano a messer Iacomo, due paia di pianelle di scharlato cho' le fibie d'ariento dorate; uno staio et uno crivello.
>
> Et più domanda fiorini dugento di massarizie, le quagli el deto Cino ebe di chasa di misser Iacomo in Bologna; e quelle portò e fecie come volse.
>
> Item, domanda fiorini ottocento, e quagli el dito Cino si rechò a le mani di denari contanti del deto misser Iacomo in una borsa fra fiorini et grossi, e quagli so' ritenuti et ritiene indebitamente; cavògli d'una cassa di casa di messer Iacomo.
>
> Riservato ogn'altra ragione ch'egli avesse contra el dito Cino.

Jacopo must have been a rich man; he earned substantial sums from his work as a sculptor and perhaps augmented this income by investments (possibly moneylending). That he died with an ample amount of money in gold and silver on his person, fully 800 florins according to Priamo, recalls the circumstances of Michelangelo's death.

Document 493. October 6, 1438
 Siena

Cino di Bartolo marries Caterina, Jacopo's niece.

Location: Unknown.

Bibliography: Bacci, *FdV*, p. 433.

Comment: Cino appears to have been active during this year in both Siena and Bologna. Evidence of his activity is revealed by payments from the Sienese Opera (AODS, no. 68, fols. 13v; cf. no. 708, fol. 196) as follows:

> Maestro Cino di Bartolo di maestro Lorenzo che lavora di marmo cho' l'uopara Santa Maria, de' dare ad) primo d'Aghosto Lire dodici chontanti; portò Pauolo mostro.
> Lire XII.

> E de' dare adì 4 di Settenbre Lire vinti contanti, per noi Petro di Giovanni Turamini a frategli banchiere e so' a loro al bast[ardello] a ffo. 8.
> Lire XX.

E de' dare adì 9 d'Aprile Lire sette soldi cinque, per lui a Spinello di Giovanni per uno porcho ebe da lui.

<div align="center">Lire VII soldi v.</div>

Evidently Jacopo brought Cino back to Siena to help him at the Opera.

Document 494. October 20, 1438
 Siena

Jacopo dies.

A dì vinti d'Ottobre 1438 misser Iacomo operaio passò di questa vita. La cui anima si riposi in pace.

Location: AODS, no. 21 (Deliberazioni, E 5), at the date.

Bibliography: Milanesi, *Documenti*, 2:179; Bacci, *FdV*, p. 431

Comment: Jacopo was buried in the cloister of the convent of Sant'Agostino. Bacci gives a partial and incorrect transcription of the document concerning Jacopo's burial (see below, doc. 496).

Document 495. October 21, 1438–May 5, 1439
 Siena

The deposit made by Jacopo upon becoming Operaio is released.

Messer Iachomo di maestro Piero, oparaio stato del'uopara, die dare adì d'Ottobre 1438 Lire mille le quagli Lire 1000 chomisse insino adì 27 di Feraio 1434 [=1435, modern] quando aciettò l'ufizio de'oparaio, per patto fecie chol chomuno di Siena che dovese lasare ala detta uopara Lire mile doppo la vita sua, e lui morì adì 20 d'Ottobre 1438 roghato ser . . . [blank].

<div align="center">Lire M.</div>

[The same entry continues during the following year:]

Anne dato adì 17 d'aprile 1439 Lire trecientosettantaquatro soldi dicienove, ci diè maestro Priamo suo fratello, e per lui Nanni di Piero di Ghuido kamarlingo de' Paschi del comune di Siena, de quagli mi diè chontanti lui Lire 298 soldi 7, e Lire 76 soldi 12 mi fecie dare al banco di Gheri di Nicholò Bolgharini e chonpagni, chome apare a escita di deto Nanni che m'abi in due poste, a foglio 60, e sono a entrata di me Iachomo di Giovanni di Spinello kamerlingo, a foglio 11.

<div align="center">Lire CCCLXXIIII soldi xviiii.</div>

Anne dato adì detto [17 d'Aprile 1439] Lire quatrocientov[e]nticinque soldi uno, per lui Nanni di Piero di Ghuido kamarlingo de' Paschi de' quagli ci asegna in queste tre dette: Andrea del Masaio da Radichofani in Lire 220, e Banbo di Puccino merchantante in Lire cientovintoto, e Tomasso di Buonaventura Cholonbini in Lire settantasette soldi uno, in tuto Lire 425 soldi 1, e sono per paschi che loro debano dare al chomune di Siena, e sono a escita di detto Nanni kamerlingo, a foglio 60, in una posta. E le sopradette Lire 800 sono per denari che 'l detto misser Iacomo avena prestati de' suoi al chomuno di Siena. E abiano che Banbo, Andrea del Masaio, Tomasso Cholonbini devino dare ina[n]zi, ognuno di per sè,

a foglio 195. Le quagli dette ò prese per detto di misser Giovanni di Petro, operaio; e maestro Priamo di maestro Piero promette farle buone dal'uopara.

<div align="center">Lire CCCCXXV soldi i.</div>

Anne datto adì 5 Magio 1439 Lire dugie[n]too, e quali ci promise Aghustino e frateli di Franciesco di Lucha Berti banchieri s sono a loro [posto] debino dare a noi inna[n]zi, a foglio 199.

<div align="center">Lire CC.
Somma Lire M.</div>

Location: AODS, no. 708 (Libro Giallo), fol. 190.

Document 496. October 22, 1438
<div align="right">Siena</div>

Jacopo is buried in the cloister of the church of Sant'Agostino.

Incipit liber sepultorum conventus Sancti Augstini de Senis, sub anno Domini MCCCLXXXII die xvi Iulii. Le sepulture del porticho dela chiesa. Primo ordine . . . Misser Iacomo di maestro Piero decto dala Guercia, operaio di dhuomo *[sic]*, cogniato di Frate Tomasso d'Arcolano, et la moglie di Giovanni orafo da Lucigniano, et Mona Cristofana.

Location: Archivio arcivescovile di Siena, no. 3554, Sepoltuario di Sant'Agostino, fols. 1–1v.

Bibliography: Cf. Bacci, *FdV*, p. 431.

Comment: Although this information was known to nineteenth-century scholars, the complete text has never been published before, perhaps because it is somewhat puzzling. Apparently there were four persons buried in the same location at the portico.

Document 497. January 12, 1439
<div align="right">Bologna *(Portal)*</div>

Priamo writes from Siena to the officials of San Petronio.

Magnifici Singnori Officiali de Santo Petronio, prego le vostre reverensie, per l'amore di Dio, che vogliate avere chonpenso a la ragione ed apreso a me per amore di mio fratello che s'ingingnò chon ogna sua insutria fare famosa la vostra chiesa si che li suoi meriti in alquanto vi debiate arichordare, e non in tutto ispone a chui e per lui chome so' io Priamo suo fratello, lo qual so' romaso sensa suoi bene. Or per voi e per Cino e per altri so' fuore de suo redità; pareva a me che voi aveste asa' di capitale avendo la sipoltura ch'era a ricievere Fiorini dugiento cinquanta perché i dugiento Fiorini ch'era in sul bancho di Buonsignor d' Andrea, no li doveno pigliarli. Non piacie a santo Petronio la fatigha di messer Iachopo. Pregho le vostre charità ch'io vi sia rachomandato, ma se mai mi poso . . . are dell'ereda di Buono Signor d'Andrea dimonstrerò chome i ditti denari li dove tener per me. Ed anchora me meraviglio delle masarisie della casa di misser Iachopo: sichondo dicie Cino l'avete pigliate; ma io non credo che voi l'avate prese, ma più tosto lui; ed erano di valuta di Fiorini otanta, e chosì trovo per lo aventario lo quale io tengo. Vi prego, se l'avete voi o se l'à Cino, non vi sia a sdengno avisarmi, perch'io posa gravare in chi dovessi cho' ragione. Pregovi vi sia

rachomandato anchora una fighura di Santo Aghustino di lingnanme. Priamo vostro servo vi si rachomanda. In Siena a dì 12 Gienaio.

[On the other side] Spetabili huomini Officiali ed Operari della chiesa di Santo Petronio in Bologna.

Location: AFSP, Miscellanea, vol. 2, no. 1.

Bibliography: Cf. Milanesi, *Documenti,* 2:183; Supino, *Scultura Bologna,* doc. 73.

Comment: Although the year that the letter was written is not given, 1439 appears to be correct. This letter is valuble because it mentions two particular works by Jacopo: (1) a tomb, and (2) a wooden statue of Saint Augustine. The tomb has been associated with the Vari-Bentivoglio monument in San Giacomo. The Saint Augustine is apparently lost.

Priamo shows himself to be distrustful of Cino di Bartolo who had married his niece; but in a later letter of February 11, 1439, he asks for a safe-conduct pass to return to Bologna to finish the *Portal* and asks permission to bring Cino with him (see Milanesi, *Documenti,* 2:184; Supino, *Scultura Bologna,* doc. 74). A final settlement between Priamo and the officials of San Petronio occurred only in 1442. See also doc. 492, Comment.

Document 498. January 12, 1439
 Siena

The Opera writes to Giovanni di Piero of Florence, a stoneworker, concerning a shipment of marble for the Loggia of San Paolo.

A dì xii di Genaio.

Giovanni di Piero lastraiuolo da Firenze fu fatto risposta in questa forma, cioè:

Amico carissimo, ècci stata presentata una vostra lettera, la quale si diriza agli oficiali dela Mercantia, nela quale si contiene alogatto da la buona memoria di misser Iacomo, mio precessore nel'ofitio, a fare sette pietre di marmo Ferarese [*sic;* read "Cararese"] e che sete asai innanzi del decto lavorio ma voreste essare avisato se il decto lavorio doveste seghuire, perché seghuire fareste [?] si potrebono conducese a Siena nela prossima 'state. Et però avendo intesa questa vostra lettera, vi faciamo risposta per questa ch'è nostra intentione e seguire lavorio e che faciate quanto sete obligato et observarvi quanto per lo decto misser Iacomo vi sia stato promesso. Unde piacciavi trarra a fine il lavorio e fare quanto sete obligato, e noi operaremo che per parte del' opera nostra vi si farà il dovere con effecto. Data etc.

Giovanni cavaliere operaio etc.

Location: AODS, no. 21 (Deliberazioni), fol. 35v.

Bibliography: Cf. Milanesi, vol. 2, doc. 143.

Comment: Giovanni di Piero of Florence had been an assistant of Jacopo's in Bologna (see Beck, *Portale,* p. 139) and had also apparently assisted Bernardo Rossellino in Arezzo during the years 1433 and 1434.

Document 499. March 13, 1439
 Siena

Provisions are made to continue work on the grill for the pulpit in the cathedral.

Pro graticula perguli [in the margin].

Die tertiadecima martii predicti [March 13, 1438 = 1439, modern]. Misser operario e conseglieri e camarlingo antedecti, assente Iacomo d'Andreuccio uno de' decti conseglieri, convochati nela loro usata residentia etc. Inteso come misser Iacomo, Operaio proximo passato d'essa Huopera, fece cominciare una certa graticula per mettare dintorno al pergholo da piè d'essa chiesa magiore et in essa spese assai denari. Et considerato che se il decto lavorìo non andasse innanzi sarebbe vergongna di Comune e danno dela decta opera, et volendo che le spese facta non si perda e fare l'adorneza d'essa chiesa solennemente, tutti d'acordo, deliberoro che la decta graticula si seguiti infino al fine, paghandosi per lo camarlingo le spese necessarie de' denari dela decta Huopera, senza suo preiudicio o danno. Riservato il fare del salario overo il premio del maestro o prezo nel Operaio, conseglieri e camarlingo predecto. Et hoc fecerunt omini meliori modo etc.

Location: AODS, no. 21 (Deliberazioni), fol. 38v.

Bibliography: Lusini, *Il Duomo di Siena*, 2:24–25 and *n1*.

Comment: The work was produced by Niccolò di Paolo "chiavaio," perhaps on the basis of a design produced by Jacopo. The pulpit has long since been dismantled and the grill has disappeared. Two years before, Jacopo had been godfather to this artisan's son.

Document 500. March 13, 1439
 Siena

Work on a psaltery ordered by Jacopo is to be continued.

Pro salterio [in the margin].

Item, veduto che il prefato misser Iacomo operaio antedecto fecie cominciare uno salterio per la chiesa magiore, d'assai valuta, e che in esso c[i]oè in carte et altre cose bisognevoli, s'è spesi molti denari e non seguitandolo sarebe danno e verghogna di chi reggie essa ed essa chiesa, e volendo a cciò obviare, solennemente tutti d'acordo i prefati operaio, e camarlingo deliberoro che sia pienamente rimesso in nel'operaio antedecto e in misser Giorgio de' decti conseglieri, e quali possino far seghuire essa salterio come a lloro parà. Et che il camarlingo paghi quegli denari che in ciò saranno necessarii, de' denari del' uopera, senza suo preiuditio etc.

Location: AODS, no. 21 (Deliberazioni), fol. 38v.

Comment: It would be fascinating to discover who Jacopo had originally hired for the psaltery, perhaps Sassetta.

Document 501. June 27, 1439
 Siena

A statement of Jacopo's debts to the Opera is recorded.

Ragione di Messer Iacomo operaio [in the right margin].
Al nome di Dio, amen. 1439 adì xxvii di Giungnio.

In questo quaderno detto carte apparrà dichiarata tutta la regione e cose dell'Uopera Sante Marie della chiesa catedrale, nel tempo di messer Iacomo di Piero operaio passato della

detta Hopera, era operaio e governatore d'esse con camarlenghi, per Neri Monte di Cristofano Montucci, canonico di Siena, Dino di Bertoccio de' Marzi, Pietro di Franciesco di Goro et Goro di Giovanni dei Massaini, riveditori e calculatori della detta Opera et suoi bene et dell'operaio e camarlenghi predetti, per vigore d'authorità et balìa a noi data da' singniori regolatori statuari et maggiori riveditori della ragioni del comune, e quali furono e savi et prudenti cittandini Neri de' Marzi e conpangni, rogato ser Petruccio loro notaio, facendo debitore il detto messer Iacomo di tutte quelle cose che secondo el nostro giuditio debba essere fatto. Et prima.

Di tutte le cose mancano all'inventario, le quali apparranno in questo a foglio 1.

Item di tutti denari o cose della detta Opera gli fusson pervenuti alle mani oltra el debito suo, e quali apparranno in questo a foglio 3.

Item di tutti denari e cose avesse male spese o administrate della detta Opera, in grave danno e pregiudicio dell'Opera, le quali apparranno in questo a foglio 6.

Qui di sotto faremo debitore missere Iacomo predetto di tutte le cose mancano all'inventario.

[1]

Missere Iacomo di maestro Pietro, cavalieri, oparaio passato dell Uopera Sante Marie, debba dare ristituire e rendere o fare buone all'uopera le infrascritte cose, le quali mancano al suo inventario, parte per mala custodia avuta d'esse, et parte perché in lui proprio pervennoro.

Uno calice colla patena d'ariento, pesava libre 1 uncie v.

Allo Biagio e Baldo.

Una coppa d'uno calice d'ariento, perchè uno calice doveva avere la coppa d'ariento e àlla di rame, uncie 3.

<div align="center">Lire X [XI ?] soldi x.</div>

Perle minute a uno battone grosso d'uno peviale, potevano essere uno quarto.

<div align="center">Lire XIII.</div>

Due cusdieri d'ariento si tenevano nelle navicelle dello incenso[,] pesavano uncie due.

<div align="center">Lire VII.</div>

Uno leggio da tenere libri si portava 'n coro donòllo el detto misser Iacomo a certi frati.

<div align="center">Lire IIII.</div>

Una pianeta di colore di cavoli [?] la quale manca a' suoi paramenti, dice ser Barna sagrestano perché era stracciata la disfece per fare brusti.

Una pianeta di sciamitello bianco, buona, era alle Serre. E tornata.

Uno pannicello da leggìo da coro: erano sedici, e hora sono quindici, manca uno di pannilino.

<div align="center">soldi vi.</div>

Una capsetta lunga tre quarri, a ricorsoio. E tornata.

Uno pezo di drappo vermiglio, broccato a oro, nuovo, con figure azurre, lunga braccia 2 quarti 3.

<div align="center">Lire XXXII.</div>

Due finestre impannate. Sonsi trovate.

Uno quadro di ferro, lungo braccia 3, di peso di libre 100, non famo [?] per scripture, s'adoperò a Corte Canpano.

<div align="center">Summa in tutto Lire 57 soldi 16.</div>

Uno staio di ferro, da misurare grano.

<div align="center">Lire III soldi vi.</div>

Una lanterna.

<div align="center">soldi vi.</div>

Una capsetta qu[a]dra, da tenervi dentro denari. E ritrovata.

Uno coppo da oleo.

soldi xiii.

Uno barlecto di staia 1½.

soldi xiiii.

Una pianeta di velluto azurra, manca a' paramenti.

Lire XXVIII.

Una Lira [=libra] uncie sette d'ariento manca all'Assuntione di Nostra Donna che fu furata. Trovamo che mancano certi ferri che tenevano gli angnioletti.

Due picconi buoni.

soldi xii.

Una pianeta di velluto azurro, manca a' suoi paramenti.

Scripta una altra volta.

Una croce d'ariento, manca uncie tre.

Lire X soldi x.

Due candellieri d'ariento, fece Pietro di Viva, manca libre una uncie otto. Non si vede però che sieno tocchi. Fur per errore.

Somma in tutto Lire XLIIII soldi 1.

Qui di sotto faremo debitore missere Iacomo predetto di tuti denari o cose dela Uopera gli fussono pervenuti alle mani.

In prima.

[2]

Misser Iacomo di maestro Piero, cavaliere, operaio stato dell'Uopera Sante Marie, de' dare Lire milletrecento ottanta quatro soldi sedici denari due, e quali à avuti in più poste da più camarlenghi, come partitamente appare al Libro Giallo e al libro de' camarlenghi et per diverse cagioni, et apare l'ultima posta che somma tutte l'altre, al Libro Giallo, a foglio 180.

Lire 1384 soldi 16 denari 2.

[3]

E die dare Lire settanta una soldi dicenove denari quatro, e quali sono per più e diverse cose e lavori di lengniame fece fare a casa sua et per essa sua casa a Matteo di Domenico et a Pasquino di Michele, maestri di lengniame, stanno coll'Uopera a salario, et di lengniame dell'Uopera, facemmo stimare e detti lavorii fatti coll'opera e colla materia [dell'Opera] a' due maestri e ponere e pregi, e quali datici scripti di loro mano e pregi e la stima scripta giurono alle Sante Dio guangniere montare ongni cosa la detta somma di Lire 71 soldi 19 denari 4. Et per[ché] tutte l'opere et lengniame era dell'Opera e lui le convertì a sua utilità, et però nel facciamo debitore.

Lire 71 soldi 19 denari 4.

[4]

E die dare missere Iacomo predetto alla detta Opera Lire dodici soldi quindici denari sei, e quali sono per più diverse cose ebbe da maestro Iacomo chiavaio, le quali ebbe per se proprio et lui fece pagare de' denari dell'Uopera come se l'avesse avute per l'Opera. Le quali cose appaiono su una scripta partitamente per mano di Pauolo factore dell'Opera, et così dice et afferma el detto Pauolo con giuramento. Et però nel facciamo qui debitore.

Lire 12 soldi 15 denari 6.

[5]

Missere Iacomo di maestro Piero, stato operaio dell'Uopera Santa Marie, predetto, die dare s. [read f.] settantacinque di Lire 4 [il] Fiorino, e quali sono per nove mesi ste' a Bolongnia in più volte, o più, sichè secondo noi per questi nove mesi non die avere salario, perché monta a ragione di Fiorini cento l'anno la detta soma di Fiorini 75. Non contentando

[= contando] fra questi nove mesi sette mesi perché nel principio quando fu creato operaio, perché nella sua creazione gli fu concesso che per sette mesi avenire potesse andare a spacciare certi suoi lavorii, dipoi pigliasse la militia et la biretta et attendesse a' fatti dell'Uopera, et lui intese s' lavorii da Bolongnia, siché non debba avere salario per quello tempo. Però nel poniamo debitore.

<div align="center">Lire 300.</div>

[6]

Et die dare missere Iacomo predetto Lire trecentoquarantadue soldi quatordici, e quali sono perché lui tolse a fare una cappella del cardinale di Santo Marcello, et tieniamo che tutti e lavorii d'essa cappella sono de' marmi de'Uopera et lavorati in maggiore parte per maestri salariati dell'Uopera. Et tieniamo che esso missere Iacomo ebbe Fiorini cento quaranta per parte di pagamento della detta cappella overo lavorio della cappella del detto cardinale. Unde noi, misurato el marmo et facto scrivare la valuta d'esso lavorio et magisterii dell'opera loro, et fatti stimare a essi maestri, che monta in somma fra l'opere loro e 'l marmo, son per tutto con giuramento giudicato montare la detta somma di Lire 342 soldi 14. Però nel poniamo qui debitore.

<div align="center">Lire 342 soldi 14.</div>

[7]

Et die dare ala detta Opera el detto misser Iacomo Lire quindici, e quali sono perché noi troviamo che Lorenzo d'Andrea, el quale stava per garzone coll'Uopera a salario di Lire trenta l'anno, ste' a servire el detto misser Iacomo mesi sei per utilità del detto misser Iacomo, secondo che aviamo trovato per lo detto suo proprio et di tutti e maestri et fattori con giuramento. Monta e mesi sei la detta somma Lire quindici, però nel facciamo debitore.

<div align="center">Lire 15.</div>
<div align="center">Somma in tutto Lire 657 soldi 14.</div>

[8]

Missere Iacomo cavaliere, operaio passato predetto, die dare alla detta Opera Lire cinquanta sei soldi undici denari quatro, i quali sono perché Castorio, maestro salariato dall'Opera per Fiorini 43 l'anno, col giuramento disse et affermò avere dato a missere Iacomo, in utilità d'esso misser Iacomo, convertito fra l'andare de Bolongnia fece per lui et con lui et a Fiorenza et alla Vinegia di Cino et in casa del detto missere Iacomo, in più volte, cento sei dì di quegli che lui si ricorda. Che sarebbe centosei dì, mesi quatro lavorati o più: che monta a ragione di Fiorini 43 l'anno, Lire 56 soldi 13 denari 4 e detti iiii messi. Et perchè el detto messere Iacomo pagò el detto Castorio di questi quatro mesi de' denari della'Opera, però nel facciamo debitore.

<div align="center">Lire 56 soldi 13 denari 4.</div>

[9]

E die dare missere Iacomo predetto alla detta Opera Lire otto, e quali sono perché Matteo di Domenico, salariato per maestro dall'Uopera a ragione di Fiorini 40 l'anno dè e convertì a utilità del detto misser Iacomo opere sedici, senza certi lavori gli fece, e quali appaiono di sopra a foglio 3 ala seconda posta, che montano a uno digrosso sedici opere Lire otto, come è detto, e però nel facciamo debitore.

<div align="center">Lire 8.</div>

[10]

E die dare Lire otto, e quali sono perché Pasquino di Nicholò, salariato dall'Opera per Fiorini XXXI l'anno, contiti [= convertì] in utilità del detto misser Iacomo opere vinti secondo per lui, perché era infermo, ci mandò a dire per Matteo detto di sopra: che montan opere 20, che sono dì forse 24, la detta quantità di Lire otto.

<div align="center">Lire 8.</div>

[11]

E die dare el detto misser Iacomo alla detta Opera Lire tre soldi sei denari otto perché Antonio di Federigo garzone dell'Opera a salario di Lire 40 l'anno, convertì in utilità del detto missere Iacomo quando ebbe male, uno mese: et troviamo che quello mese fu pagato de' denari dell'Opera. Monta la detta somma Lire 3 soldi 6 denari 8, et però nel facciamo debitore.

<div align="center">

Lire 3 soldi 6 denari 8.
</div>

[12]

Messere Iacomo di maestro Piero, cavaliere et operaio stato dell'Opera Sante Marie predetto die dare alla detta Opera Lire vinti le quali sono per maestro Pietro del Minella, salariato dall'Opera a ragione di Fiorini 70 l'anno, convertì in utilità del detto missere Iacomo quando ebbe male, uno mese secondo lui proprio con giuramento disse, et etiandio abiamo

dagli altri maestri che monta in uno mese la detta somma Lire vinti. Et perché el detto denaro missere Iacomo pagò de' denari dell'Opera, però nel facciamo debitore.

<div align="center">

Lire 20.
</div>

[13]

Et die dare missere Iacomo Lire undici, quali sono perché Giovanni di Mencio, salariato dall'Opera a ragione di Fiorini 35 l'anno, convertì in utilità detto missere Iacomo opere vintiquatro, secondo che con giuramento confermò esso Giovanni predetto, che monta in uno mese la detta somma di Lire undici. Et perché esso missere Iacomo per quello mese pagò de' denari dell'Opera, però nel faciamo debitore.

<div align="center">

Lire 11.
</div>

[14]

Et die dare missere Iacomo predetto alla detta Opera Lire sette, perché Nanni di Nichola, salariato dall'Opera a ragione di Fiorini vintiotto, et secondo che lui ferma con giuramento, dice avere convertito in utilità del detto missere Iacomo una opera. Item dice che maestro Cola di Nanni perdé certe opere et dichiarato poi da altre e quali troviamo essere opere dieci o più. Avevano di salario Fiorini cinquanta quatro. Monta e detti dì fra ongni cosa Lire sette dette di sopra. Et perché lui gli pagò de' denari dell'Opera, però nel faciamo debitore.

<div align="center">

Lire 7.
</div>

[15]

Et die dare el detto misser Iacomo alla detta Opera Lire nove soldi sei denari otto, e quali sono perché Bartholomeo di Domenico, manovale, salariato dall'Opera a ragione di Fiorini 28 l'anno, convertì in utilità del detto missere Iacomo uno mese secondo che troviamo, che monta la detta somma. Et perché lui gli pagò de' denari dell'Opera, nel faciamo qui debitore.

<div align="center">

Lire 9 soldi 6 denari 8.

Somma Lire 47 soldi 6 denari 8.
</div>

[16]

Messer Iacomo di maestro Piero, cavaliere et operaio dell'Opera Sante Marie predetto die dare alla detta Opera Lire dicenove soldi sei denari otto, e quali sono perché Antonio di Nanni, manovale, salariato dall'Opera a ragione di Fiorini 29 l'anno, secondo che pienamente siamo informati, convertì in utilità di missere Iacomo due mesi, per che monta la detta somma Lire dicenove soldi sei denari otto. Et perché lui el pagò de' denari dell'Opera, però nel poniamo debitore.

<div align="center">

Lire 19 soldi 6 denari 8.
</div>

[17]

Et die dare el detto misser Iacomo alla sopradetta Opera Lire tre, i quali sono per tre barili di vino, dè di quello dell'Opera a G[i]annino di Tanio [Antonio] da Como, el quale

lavorava con lui proprio nella camera nel lavorio della detta cappela del cardinale. Et però nel poniamo qui debitore.

<div align="center">Lire 3.</div>

[18]

Et die dare Lire quatordici, e quali sono per moggia uno di vino logrò di quello dell'Opera quando era infermo et etiamdio a casa sua quando era sano. Perché aviamo trovato et investigato che Pauolo gli portava ongni dì vino a casa, secondo che dice el factore et famigli alogrò dell'Opera el detto moggio di vino. Et perché egli non debba lograre el vino dell'Opera, però nel facciamo debitore.

<div align="center">Lire 14.

Somma Lire 35 soldi 6 denari 8.</div>

Somma la prima faccia a foglio 1	Lire 57 soldi 16.
la seconda a foglio 2	Lire 44 soldi 1.
la terza foglio 3	Lire 1469 soldi 14.
la quarta, foglio 3	Lire 657 soldi 14.
la quinta a foglio 4	Lire 76
la sesta faccia, foglio 4	Lire 47 soldi 6 denari 8.
la septima, foglio 5	Lire 36 soldi 6 denari 8.
l'ottava, a foglio 6	Lire 202.

<div align="center">Somma della somme Lire 2591 soldi 5 denari 4.</div>

Anne dati el detto misser Iacomo per suo salario d'anni tre, mesi sette, dì vintitre, a ragione di Lire 400 l'anno, Lire 1458, soldi 1, denari 2 cioè 1458 soldi 1 denari 2. Resta a dare Lire 1133 soldi 4 denari 2.

E più de' dare due botti sono in casa sua, di stima di Lire 16.

[19]

Qui di sotto faremo debitore misser Iacomo di maestro Pietro predetto di tutti denari o cose avesse male spesi et in danno et pregiudicio della detta Opera.

Messer Iacomo di maestro Piero, cavalieri, operaio stato dell' Opera di Santa Maria detta di sopra, die dare Lire dugentodue e quali sono per maestro Polo di maestro Michele di Belagiunta [da Bologna], garzone di misser Iacomo predetto, et conducto per maestro dall'Uopera a salario di Fiorini vinti [or 28?] l'anno prima, et poi per Fiorini 36. Troviamo che non lavorava niente o poco, anco andava continuamente a spasso, et etiamdio non lassava lavorare gli altri. Examinati più et più maestri e quali erano presenti, famigli et factori dell'Opera, con giuramento dicono alcuni che lui lavorava poco o nulla. Ultimamente, fatto stimare tutto el lavorio fece al suo tempo, non monta Fiorini venti. Et perché el detto misser Iacomo, contra ongni debito, el teneva a salario et etiamdio trovamo che 'l detto misser Iacomo proprio à ricevuto questo salario nelle mani, però nel facciamo qui debitore, dando a Polo sopradetto, come giudicano e maestri sopradetti, Lire ottanta. Siché avendo avuto il detto Paolo Lire dugento ottantadue, giudichiamo che il detto misser Iacomo debbi ristituire le dette Lire dugentodue, et però nel poniamo qui debitore.

<div align="center">Lire 202.

Somma Lire 202.</div>

Et io Monte di Cristofano Montucci, canonico di Siena, uno de' detti rivisditori, ò scripta [sic] di volontà e consentimento de' miei maggiori compangni Pietro di Francesco di Gaio,

Goro di Giovanni di Massimo et Dino de' Marzi, tutto questo quaderno. Et in fede di ciò me so' soscripto qui di mia propria mano, et così si soscriveranno e miei maggiori compangni qui di sotto.

Et io Dino di Bertoccio de' Marzi, uno de' detti riveditori, aprovo quanto di sopra è scripto per messer Monte di Cristofano Montucci, uno de' detti riveditori, anno e dì di sopra scripto.

Et io Pietro di Francesco di Goro, uno de' detti riveditori, aprovo quanto di sopra si contiene, scripta [sic] di mano di messer Monte, anno e dì detto di sopra.

Anno Domini MCCCCXXXVIIII, indictione IIª die xxvii Iunii. Lecta dicta ratio per dominum Montem predictum suo nomine et nomine Pietri Francisci Gori et Dini Bertocci, eius sociorum presentium et consentientium, et vice et nomine Gori Iohannis Massimi eius socii absentis, et aprobata et confirmata per regulatores statuarios et maiores revisores rationum comunis Senarum, coram Meo Nannis Marci et Nanne ser Lodovici testibus.

Ego Iohannes Peccii, notarius dectorum dominorum regulatorum, rogatus subscripsi.

Location: ASS, Regolatori, no. 8, fols. 146r–149r.

Comment: This report of the "Regolatori" was reproduced in the "Libro Giallo" (AODS, no. 708, fols. 200–200v) and partially published by Bacci (*Quercia*, pp. 297–300). (See also next document.)

Document 502. June 27–30, 1439
Siena

Jacopo's debt is carried in a book of the Duomo.

Qui disotto sarà posto debitore misser Iachomo di maestro Piero operaio passato dell-'Opara Sante Marie e Kavaliere, di tutti denari o cose avesse avute dalla detta Opara indebitamente et etiam di tucte le cose mancano al suo inventario et più di tucti denari avesse male spesi et in danno et preiuditio della detta opara, per noi misser Monte di Cristofano Montucci cononicho di Siena, Dino di Bertoccio de' Marzi, Pietro di Francesco di Goro et Goro di Giovanni de' Massaini, riveditori et calculatori dell' inventario et della ragione del deto misser Iachomo per vigore et actuorità et balìa a noi data da' signori regulatori et statuari del comune di Siena al tempo di Neri de' Marzi et de' compagni, la quale ragione et calculo, fu aprovata da' sopradetti signori regulatori al tempo di savi cittadini Richardo Saracini, Salimbene di Petro d'Agnolo, Goro di Francesco, Biagio di Francisco di Dini. Adì xxvii di Giugno nel detto anno rogato ser Giovanni Pocci loro notaio et prima . . .

Location: AODS, N. 708, fols. 200–200v.

Bibliography: Bacci, *Quercia*, pp. 297–300 (partial transcription).

Comment: The remainder of the text follows rather faithfully that of doc. 501, and therefore is not repeated.

Document 503. 1440
Siena

A review of Jacopo's debt to the Opera del Duomo is presented.

+ al nome di Dio, amen, anno 1440.

Apresso sarà scritta la ragione dello spetabile [c]havaliere misser Iacomo di maestro Piero dela Guercia, hoparaio passato del' Uopara Sancte Marie per tenpo d'anni tre e messi sette e dì vintitre, la qualle altra volta fu rivedutta per misser Monte di Crisstofano Montuci, kalonacho di duomo et conpagni.

Et perché maestro Priamo, frattello carnale del sopradetto Misser Iacomo e sua ereda, disse essare gravatto in più parti e feciene p[et]itione al conseglio genarale, del qualle conseglio nacque che l'offitio de' regolatori dovesse fare rivedere le dette parti là due [= dove] si teneva gravatto, et dappoi essi regolatori ci àno datto comessione che doviamo rivedere di nuovo et da chapo e di fondo in tutte le parti, et per noi misser Federigho Petrucci, calonaco di duomo, et Filippo del Gorgiera et Dino di Bertoccio de' Marzi e di *[sic]* Tomasso di Giovanni Franciesschi abbiamo rivedutta e calculatta la detta ragione, di comesione degli egregi e nobilli huomini Crisstofano di Checho Montucci et conpagni, signori regolatori et magiori riveditori dele ragioni del comune di Siena, e per essa ragione el facciamo debittore d'ogni d'ogni *[sic]* quantità di denari e di qualunque altra cossa li fusse pervenutta alle manni dela huopara Sancte Marie.

[1]

Et prima dìe dare el detto misser Iacomo oparaio sopradetto Lire ciento una soldi diciesette denari o, e quali sonno per più cosse mancaro al suo inventario, come si vede a Libro Giallo de l'Uopara, a fo. 200, chome fu rivedutta per gli altri riveditori la qualle aproviamo con questo intesso che le rede di detto misser Iacomo abbino e' rigresso sopra a' sagrestano ricevero da llui le dette cosse.

<div align="center">Lire 101 soldi 17</div>

[2]

Et die dare Lire mille treciento ottantaquatro soldi sedici denari due, riciévé da più kamarlenghi de' Uopara a ffo. 180, e così fu riveduta per gli altri riveditori. Et cossì aproviamo chome apare al decto Libro Giallo a ffo. 200.

<div align="center">Lire 1384 soldi 16 denari 2.</div>

[3]

Et die dare Lire settantuna soldi dicienove denari quatro, e qualli sonno per più cosse e lavori fatti de le cosse e per li maestri del'Uopara nela sua casa et in fatti suoi propri, chome si vede la stima fatta per altri maestri per gli altri riveditori al detto Libro Giallo, a ffo. 200, la quale aproviamo.

<div align="center">Lire 71 soldi 19 denari 4.</div>

[4]

Et die dare Lire dodici soldi quindici denari sei, per più cosse e feramenti autii per se proprio da maestro Iacomo chiavaio, paghatti de' denari dela detta huopara, rivedutta per gli altri riveditori la quale aproviamo, appare al detto Libro Giallo, a ffo. 200.

<div align="center">Lire 12 soldi 15 denari 6.</div>

[5]

Et die dare Lire treciento, et quagli sonno per e quagli sonno *[sic]* per messi nove ste' fuor di sSiena in più voltte, conputtatto messi sette quando fu criatto, de' quagli abbiamo trovato ebe licientia de' consegli, che a ragione di Fiorini ciento di Lire quatro el Fiorini l'ano, viene le dette Lire treciento et cossì troviamo per li detti riveditori essar fatto debittore al detto Libro Giallo, a ffo. 200. Et perché a noi riveditori sopradetti è statto produtto uno dicreto di conciestorio di mano di ser Anbrugio Bonegli nel' ano 1437 et qualle si diriza al chamarlengho del' Uopara che no' li ritengha il suo salario di due messi che andò a Bolognia e stette infermo circha a messi due, che montano a ragione di Fiorini 100 l'anno Lire 66 soldi 13 denari 4, da cavarsi dele dette Lire 300. Resstano Lire 233 soldi 6 denari 8, e di tanti

laciendiamo debitore in però parte de' riveditori passati dicono esso dicreto no' lo' fu notto, et cossì no' l'aproviamo.

<div align="center">Lire 233 soldi 6 denari 8.</div>

[6]

Et die dare Lire treciento quaranta e due, soldi quatrodici, denari 0, e quagli sonno per marmi e huopare de' maestri salariati del' Uopara misse nella chapela del cardenalle di Sancto Marciello, el quale era suo lavorio proprio, così fu aprovatto per li riveditori passatti al detto Libro Giallo a ffo. 200 e cossì l'aproviamo noi.

<div align="center">Lire 342 soldi 14 denari 0.</div>

[7]

Et più troviamo era fatto debitore per Lorenzo d'Andrea, garzone del' Uopera a Lire trenta l'anno, avesse servito nelle cosse proprie di misser Iacomo messi sei, el quale tempo era statto messo nela soma di sopra Lire 342 soldi 14, come si vede nela stima de' maestri, e però l'annuliamo ché sarebe due voltte, che monta Lire quindici.

[8]

Et die dare Lire cinquantasei soldi tredici denari quatro, e quagli sono per più huopara e dì per più andatte nelle facie[n]de di misser Iacomo et quando stete infermo, chome si vede nella ragione rivedutta pe' gli altri riveditori al detto Libro Giallo, a ffo. 200. Trassene Lire nove soldi dieci, perché abbiamo veduto che sso' mesi certi dì per huopare e quessto ène del salario di Chasstoreo, che era salariato et maestro de l'Uopara, siché resta Lire 46 soldi 13 denari 4, et cossì aproviamo.

<div align="center">Lire 46 soldi 13 denari 4.</div>

[9]

Et die dare Lire otto, sonno perché Matteo di Domenicho, salariatto de' Uopara a Fiorini 40 l'anno, dè huopare sedici nele cosse proprie di misser Iacomo oltre a quelle dela chapella di Sancto Marciello, et cossì fu fatto per gli altri riveditori et cossì s'apruova *[sic]* per noi al detto Libro Giallo a ffo. 22.

<div align="center">Lire 8 soldi 0 denari 0.</div>

[10]

Et die dare Lire otto, sonno perché Pasquino, salariato del' Uopara a Fiorini 31 l'anno, dè huopare 20 nele cosse di misser Iacomo oltre a quelle dela chapella di Sancto Marciello, et cossì et cossì fu fatto per gli altri riveditori e cossè s'apruova per noi al detto Libro Giallo a ffo. 200.

<div align="center">Lire 8 soldi 0 denari 0.</div>

[11]

Et die dare Lire tre soldi sei denari 8, perché Antonio di Federigho, gharzone del' Uopara a Lire 40 l'anno, servì uno messe in cassa di misser Iacomo quando era infermo, e così fu fato per gli altri riveditori e così s'approviamo al detto libro a ffo. 200.

<div align="center">Lire 3 soldi 6 denari 8.</div>

[12]

Et die dare Lire vinti, cioè Lire 20, perché maestro Piero del Minela, salariato del' Uopara a Fiorini 60 l'ano, servì uno messe in cassa di misser Iacomo quando era infermo, e così fu fato per gli altri riveditori e così s'aproviamo al detto libro a ffo. 200.

<div align="center">Lire 20.</div>

[13]

Et die dare Lire undici perché Giovanni di Meucio, salariato del' Uopara a Fiorini 35 l'ano, dè huopare 24 ne' fatti prop[r]i di misser Iacomo, e così fu fatto per gli altri riveditori e cossì s'aproviamo al detto libro a ffo. 200.

<div align="center">Lire 11.</div>

[14]

Et die dare Lire sette perché Nanni di Niccolò, salariatto del' Uopara, e altro maestro dissero aver datte huopare undici ne' fati del' Uopara, e cossì feciero gli altri riveditori e così s'aproviamo noi, al detto libro a ffo. 200.

<div align="center">Lire 7.</div>

[15]

Et die dare Lire nove soldi sete denari otto perché Bartalomeo di Domenico, manovale salariato del' Uopara a Fiorini 28 l'ano, convertì ne' fatti di misser Iacomo uno me[se] et cossì aprovarò gli altri riveditori e cossì aproviamo noi, al detto libro a ffo. 200.

<div align="center">Lire 9 soldi 7 denari 8.</div>

[16]

Et die dare Lire dicienove soldi sei denari otto perché Antonio di Nanni, manovale salariato del' Uopara a Fiorini 29 l'ano, dicono e sopradetti riveditori avere datto ne' fatti di misser Iacomo messi due, e da misser Monte avemo chome non fu esaminato, di che l'abiamo disaminato noi; col sacramento disse avere datto dì 15 a governare el cavallo di misser Iacomo, e due huopere a conciargli el tetto de la cassa e una huopara a spezare legnia, che so' e' detto tenpo e di questo l'acidendiamo debittore; e' ressto faciero gli altri riveditori l'anuliamo al detto libro a ffo. 200.

<div align="center">Lire 6 soldi 15 denari 0.</div>

Volle ché resto ène nela faccia di questo fo. 16.

Seguita el dare.

[17] Et die dare per tre barigli di vino ebe Gianino, stava co' lui, di quello del' Uopara, che monta Lire tre, logròlo nela chappella del cardenale di Sancto Marcielo, e cossì el mìssero gli altri riveditori e cossì aproviamo noi al detto Libro Giallo, a ffo. 200.

<div align="center">Lire 3.</div>

[18] Et die dare per uno moggio di vino logrò quando ebe male e in altro tenpo, di quello del' Uopara. E gli messo el detto vino Lire quatordici, cossì faciero gli altri riveditori e cossì aproviamo noi al detto Libro Giallo, a ffo. 200.

<div align="center">Lire 14.</div>

[19]

Et die dare Lire dugiento due, e quagli sonno per lo sa[la]rio di Pollo da Bolognia, ch'ebbe a primo anno Fiorini 28, el secondo anno ebbe Fiorini 36, di che troviamo che 'l detto Pollo à servito messi sei a' lavorio di Sancto Pauolo e altri lavori el primo anno che so' Lire 56; el sicondo anno, per disaminationi che si vede per gli altri riveditori, servì in lavorare chapitelli, Lire ottanta, et più troviamo che nella chappella del cardenale di Sancto Marcielo servì in più magisteri con altri maestri, Lire 40, che ne li tocha el terzo, che so' Lire 13 soldi 6 denari 3, che si vogliono cavare de le dette Lire 202, che sso' per resto di soprapresso di suo salario, Lire 69 soldi 6 denari 8; siché ressta solamente a restituire el detto misser Iacomo Lire 132 soldi 13 denari 4, perché troviamo venero nele mani di detto misser Iacomo, e questo aproviamo nonestante gli altri riveditori l'avessero aciesso i' Lire 202 al detto Libro Giallo a ffo. 201.

<div align="center">Lire 132 soldi 13 denari 4.</div>

[20]

Et de' dare Lire cinque, e quagli sono per moli sei di sei braccia, e per quatro moli di 5 braccia, e per due some di tavole vechie, stimate le dette Lire 5, le quagli mandò el detto misser Iacomo ala vigna di Cino di Bartolo di maestro Lorenzo, le quagli li lasiamo e' rigresso ale rede potere adomandare al detto Cino e simile potere dimandare Lire cinque per sei huopare di maestro e una huopara di manovale, che cierti maestri e manovali lavorarono ala

detta vigna, stavano col'Uopara. So' posti a ragione di misser Iacomo nela soma di Lire 56 soldi 14 denari 4 nela detta facia.

Lire 5.

[21]

Et de' dare per uno lenzuolo ebe in pressta misser Iacomo del' Uopara, el quale teneva nela sua chamara quando lavora, chome appare a uno libriciuolo di Pauolo fatore del'Uopara, stimato Lire tre.

Lire 3.

[22]

Et de' dare Lire ottanta, e quagli ricievé misser Iacomo da Vanni di Franciesco oraffo, kamarlengho del' Uopara, de' quagli fecie scrivare Pagno di Lappo da Fiesole, cavatore di marmi, de' quagli si vede a' Libro Giallo del'Uopara, a ffo. 153, e quagli denari sonno per parte di Fiorini 70 che l'Uopara doveva dare a misser Iacomo di sette pietre da fighure per la logia di Sancto Pauolo quando fussero chondotte in Pisa. E perché aviamo informatione per lettare, abiamo veduto del detto Pagnio le dette sette pietre essare chavate a Charara e offerasi a metarle in Pissa quando sarà sicuro in Pissa dareli Fiorini 20 chome s' ubrighò al detto misser Iacomo. Et però, quando le rede di misser Iacomo arano condotte le dette pietre sicondo l'aloghazione che à dal'Uopara, si vorano scontare le dette Lire ottanta.

Lire 80.

[23]

Et de' dare Lire sedici, sono per due botti, l'una di staia 14 e l'altra di staia 17½, ebe di quelle de l'Uopara a mandòsele a chassa, le quagli erano frescha *[sic]*, sonno stimate le dette lire sedici et cossì l'ànno amesso gli altri riveditori e cossì l'aproviamo noi.

Lire 16.

[24]

Et de' dare Lire dieci soldi otto, per più spese fatte nella apelagione dela riveditura dela ragione della qualle ebbe la sententia contra e però debba ristituire le spese, cossì chondeniamo.

Lire 10 soldi 8 denari 0.

Soma per tutto, come si vede per la facia di là e questa di sopra di questo foglio, avere presso di quello del'Uopara il detto misser Iacomo Lire 2531 soldi 1 denari 8.

Location: AODS, no. 709 (Libro Rosso Nuovo, 1439–1457), fols. 16–16v.

Comment: Some portions of this review are given in Bacci, *Quercia,* pp. 306–308.

The effort at fairness as well as the functioning of the appeals system demonstrated by this review, which incidentally cost something over 10 lire, is striking. (See also next document.)

Document 504. 1440
Siena

The heirs of Jacopo della Quercia are debited.

Rede di misser Iacomo di maestro Piero, operaio passato, die dare per denari contanti in più volte, chome apare al memor[i]ale di Salamone, a fo. 14, i quali si spesero nel' apellagione che fecie maestro Priamo suo fratello a' quatro et a' seguitori.

Lire X soldi viiii.

Posti inanzi, a ragione di messer Iacomo, a fo. 18.

Location: AODS, no. 709, fol. 6.

Document 505.　　　　　　　　　　　　　　　　　　　　　　1440
　　　　　　　　　　　　　　　　　　　　　　　　　　　　　Siena

Further accounting for Jacopo della Quercia at the Duomo is recorded.

Misser Iacomo di maestro Piero, Hoparaio sopradetto, de' avere Lire mille quatrociento cinquantaotto soldi uno denari due, sonno per suo salaraio di tre anni sette messi e dì vintitre è statto Oparaio, a ragione di Fiorini ciento di Lire quatro el Fiorino, monta per lo detto tenpo la detta soma et cossì la missoro gli altri riveditori et cossì l'aproviamo noi, come si vede a Libro Giallo del'Uopara affo. 201.

　　　　　　　　　　　　Lire 1458 soldi 1 denari 2.

Et de' avere per infrascritti maestri et manovagli e quagli servirono misser Iacomo nella sua infermittà, de' quagli troviamo essare fatto debitore per dì perdutti, insieme con altre huopare di misser Iacomo, come si vede essare posso debitore nel presente libro. E avendo bene intesso ed esaminatto le dette cosse, conciò sia cossa che Pauolo fattore del'Uopara, al qualle s'apartiene tutte l'Uopara che per li maestri si perdono ed etiamdio abiamo da ppiù persone che misser Iacomo detto se comandò che dovesse pontare qualunque maestro o manovalle perdesse tenpo, di che troviamo che nela infermità di misser Iacomo detto, niuno né fu pontato né avisatto el chamarlengho che lo' ritenessi el salario del tenpo perdero nela infermittà di detto misser Iacomo. Et anche autta buona informatione da chi si trovò al testamento di misser Iacomo, che disse che quegli che avevano perduto tenpo nella sua infermittà gli voleva rimeritare, et così troviamo che à lasato per suo testamento agl'infrascritti qui di sotto gl'infrascritti denari, e quagli è parutto non s'apartenesse a paghare al detto miser Iacomo perché d'uno medessimo tenpo arebero el salario da misser Iacomo e dal'Uopara, e però ne l'aciendiamo creditore. E quagli denari lassiamo a rigresso al'Uopara poterlli mande per tenpo perduto, chom' è ragionevole a detti maestri.
　　Pietro del Minella perdé uno messe nela infermittà di misser Iacomo detto aveva di salario Fiorini 60 l'anno, che monta Fiorini 5, troviamo li lassò misser Iacomo Fiorini 10.
　　Chasstorio di maestro Nanni da Luccha perdé uno messe nella infermittà di misser Iacomo, aveva di salario Fiorini 42 l'ano, che monta Fiorini 3½, troviamo li lassò misser Iacomo Fiorini 5.
　　Lorenzo d'Andreia perdé uno messe, aveva di Lire 30 l'ano, lassò misser Iacomo Fiorini 1; tocha al detto messe soldi 50; monta questi tre, Lire 36 soldi soldi 10 e cossì gli ametiamo.

　　　　　　　　　　　　　Lire 36 soldi 10.

Soma, chome si vede quello debba avere Lire 1494 soldi 11 denari 2.
Soma à ricievuto, chome si vede nela facia di là.

　　　　　　　　　　　　Lire 2531 soldi 1 denari 8.

Et più chome si vede el dare ce l'avere Lire 1036 soldi 10 denari 6, e quessto è quela some rimane debitore le rede di misser Iacomo detto al'Uopara Sante Maria.
　　Et io Dino di Bertoccio di Marzzii, uno di sopradetti riveditori, apruovo la sopradetta ragione essare bene riveduta e stare bene in tutte le parti chome è scritta di mano di Filippo di Pietro del Gurgiera.

Et io Filippo di Pietro del Gorgiera, uno de' sopradetti riveditori, ò scritta la detta ragione di volontà di misser Federigho Petruci, calonacho di Duomo, et di Dino di Bertocio de' Marzi e di Tomasso di Giovanni Francieschi, miei magior compagni, la qualle apruovo star bene ed esare bene riveduta.

Et io misser Federigo di Renaldo Petrucci ca[no]nico apruovo la detta ragione co' è decto di sopra, ano mese dì di sopra.

Et io Dino di Berttoccio de' Marzzii, uno di sopradetti riveditori, apruovo la sopradetta ragione essare bene riveduta e stare bene in tutte le parti, chome è scritta di mano di Filippo di Pietro del Gurgiera.

Posti innanzi debi dare in questo, fo. 18.

Location: AODS, no. 709, fol. 17.

Document 506. 1441
 Siena

Further accounting is entered for Jacopo della Quercia at the cathedral.

Misser Iacomo di Piero, operaio stato della Opera, de' dare Lire milletrentassei soldi dieci denari vi, per resto di suo ragione ultimamente riveducta a parte a questo in dicto fo. 17 in tre faccie.

<div align="center">Lire MXXXVI soldi x denari vi.</div>

E die dare Lire quaranta soldi 0, chome apare a Libro Giallo a fo. 182, scripto mestro Priamo suo fratello e quali el detto misser Iacomo gli aveva fatti prestare, come pare al detto libro.

<div align="center">Lire XL.</div>

E die dare per una sua ragione, come apre indietro scritto rede di misser Iacomo, a fo. 6.

<div align="center">Lire X.</div>

Location: AODS, no. 709, fol. 17.

[APPENDIX I]

Giorgio Vasari, Iacopo della Quercia Sanese Scultore. (1550)

INFINITAMENTE È DA credere che nella vita sua pruovi grandissima conten-
tez[z]a colui che per mez[z]o delle fatiche fatte con la virtù sua si senta, o
nella patria o fuori, onorare di dignità o guiderdonare di premio fra gli altri
uomini, crescendone per le lode e per gli onori in infinito la virtù sua. Ciò
intervenne a Iacopo di maestro Piero di Filippo della Quercia scultor sanese, il
quale per le sue rarissime doti nella bontà, nella modestia e nel garbo meritò
degnamente di esser fatto cavaliere, il qual titolo onoratissimamente ritenne
vivendo, onorando del continovo la patria e se medesimo. Per il che quegli che
dalla natura dotati sono di egregia et eccellente virtù, quando accompagnano
con la modestia de' costumi onorati il grado nel quale si trovano, sono testimoni
i quali al mondo mostrano d'essere assunti al colmo di quella dignità che si
riceve dal merito e non da la sorte, come veramente e degnissimamente mostrò
Iacopo; il quale alla scultura attendendo, di quella perfettissimo divenne e con
eccellenzia dimostrò del continovo l'opere sue, le quali in Siena furono prima
due tavole in legname di figure tonde, con grazia di disegno e d'intaglio affati-
cate da lui. In Lucca fece per la moglie a Paolo Guinigi, signor di quella città,
nella chiesa di San Martino una sepoltura (la quale alla cappella della Comunità
è restata et in quel luogo), alcuni fanciulli in un fregio con festoni di marmo e la
cassa e la figura morta, all'entrata della sagrestia; la quale con diligenza lavor-
ando, a' piedi di essa fece nel medesimo sasso un cane di tondo rilievo, per la
fede portata al marito.

Transferissi poi a Bologna, dove gli fu allogato dagli Operai di San Petronio
la porta principale di quel tempio, di marmo a figure e storie e fogliami lavorata;
nella quale, ne' pilastri che reggono la cornice e l'arco, sono cinque storie per
pilastro, le quali condusse di basso rilievo; e nello a[r]chitrave ne fece altre
cinque, le quali furono e sono tenute cosa lodevole, e dentro a quelle intagliò da
la creazione del mondo fino a Noè; e nell'arco fece tre figure di tondo rilievo: la
Nostra Donna e il Putto, con due Santi da lato. La quale opera fu da lui

lavorata con grande amore e con somma diligenzia, e fu cagione di cavare d'uno errore i Bolognesi, che non pensavano che si potessi far meglio che una tavola fatta da' maestri vecchi quale è in San Francesco all'altar maggiore nella città loro, qual fu di mano di alcuni Todeschi che doppo i Gotti lavororono della maniera vecchia più che altri che facessero in que' tempi; de' quali si vede ancora opere assai per Italia fatte da loro, come la facciata di Orvieto, e la tavola di marmo del Vescovado di Arezzo, et in Pisa nel Duomo, et a Milano nel Duomo, e per la città in diversi luoghi.

Ora, mentre che la fama di Iacopo si andava così dilatando, egli venne in Fiorenza, e sopra la porta del fianco di Santa Maria del Fiore, che va a la Nunziata, fece di marmo una Assunta; la quale con tanta grazia e con tanta bontà a fine condusse che oggi quella opera è guardata dagli artefici nostri per cosa maravigliosa, et in ogni età il medesimo sempre è stata tenuta. Veggonsi le movenzie delle sue figure con una grazia e con una bontà espresse e le pieghe de' panni suoi con bellissimo andare di falde e maestrevole circondar d'ignudo, a perfetta fine mirabilissimamente condotte. Figurò in tale opra Iacopo un San Tomaso che la Cintola piglia, e dall'altra banda fece uno orso che monta su un pero, del significato del quale, perché variamente sentono gli uomini, dirò sicuramente io ancora una mia opinione, lasciandone tuttavolta il guidizio libero a chi sa trarne miglior costrutto. Pare a me che e' volesse intendere che il Diavolo, significato per l'orso, ancora che egli salga nelle cime degli alberi, cioè a la altezza di qualsivoglia Santo, perché in ciascuno truova qualche cosa del suo, non riconosce nientedimanco in questa Vergine gloriosissima né vestigio né segno alcuno dove egli abbia punto che fare; e però, ancora che inalberato, si rimane giù basso, dove ella ascende sopra le stelle. E chi di questo non si contenta, contentisi almeno de la risposta che a Luciano già fece Omero del principio del suo poema, cioè che gli venne allora a proposito di fare così. Ècci opinione di molti che questa opera fusse di mano di Nanni d'Antonio di Banco fiorentino; la qual cosa non può essere: prima, perché Nanni non lavorò le cose sue in tanto perfezzione; l'altra, la maniera è da la sua differente, et alle cose di Iacopo molto più somiglia. Trovasi nella allogazione delle porte di San Giovanni Iacopo essere stato di quelle in concorrenza fra i maestri ch'a tal lavoro furono eletti in far saggio d'una storia: et era egli stato in Fiorenza quattro anni innanzi che tale opera s'allogasse; dove non si vedendo altra opra di suo se non questa, è sforzato ognuno a credere che ella sia più condotta da Iacopo che da Nanni.

Tornatosene poi a Siena, e in quella dimorando, dalla Signoria di detta città gli fu fatta allogazione della superba fonte di marmo fatta su la piazza publica dirimpetto al palazzo loro, la quale opra fu di prezzo di ducati duo milia e dugento; et in quella usò artificio e bontà, che gli diede tanto nome che sempre fu nominato, e vivo e morto, Iacopo de la Fonte sanese. Intagliò in detta opera le Virtù teologiche con dolce e delicata maniera nelle arie loro, con istorie del Testamento Vecchio: cioè la creazione d'Adamo e d'Eva, il lor peccar nel pomo, dove egli fece alla femmina una aria nel viso sì bella e di tanta benigna grazia et

una attitudine della persona tanto dolce verso di Adamo nel porgergli il pomo, ch e' pare al tutto impossibile che e' lo possa mai recusare; senzaché tutta l'opera è piena di bellissime considerazioni, con infiniti altri ornamenti, tutti dalla dilicata mano di Iacopo con amore e con grandissima pratica condotti a perfezzione. La quale opera fu cagione che dalla Signoria della città predetta fu fatto cavaliere, et in breve spazio divenne operaio publico del Duomo di Siena e sopra tutte le cose della spesa di quella fabbrica. E così in quello ufficio tre anni visse con molta grazia di quella città, e fu utilissimo per quel tempio e per quella fabbrica, la quale non fu mai prima così ben maneggiata da alcuno, essendo egli molto gentil persona. Ora, per le fatiche già fatte stanco e vecchio divenuto, di questa vita all'altra passò, et in Siena, da' suoi cittadini con amare lagrime onorato, meritò sepolcro nel Duomo, non cessando eglino con epigrammi latini e rime volgari inalzare con debite lode le bellissime opere, la vita e gli onestissimi costumi suoi, l'anno MCCCCXVIII. Il che hanno fatto ancora gli strani, come si vede per questo epitaffio:

IACOBO QUERCIO SENENSI EQUITI CLARISSIMO STATUARIAEQUE ARTIS PERI-TISS. AMANTISSIMOQUE UTPOTE QUI ILLAM PRIMUS ILLUSTRAVERIT TENE-BRISQUE ANTEA IMMERSAM IN LUCEM ERUERIT AMICI PIETATIS ERGO NON SINE LACHRYMIS P.

Aggiunse Iacopo all'arte della scultura un modo molto di bella maniera, e levò gran parte di quella vecchia che avevano usata gli scultori inanzi a esso, nel fare le figure in maestà senza torcersi e svoltare le attitudini; e morbidamente s'ingegnò gli ignudi di maschi e di femine far parere carnosi, e di leccatezza pulitamente il marmo cercò finire con diligenza infinita.

una attitudine della persona tanto dolce verso di Adamo nel porgergli il pomo, ch e' pare al tutto impossibile che e' lo possa mai recusare; senzaché tutta l'opera è piena di bellissime considerazioni, con infiniti altri ornamenti, tutti dalla dilicata mano di Iacopo con amore e con grandissima pratica condotti a perfezzione. La quale opera fu cagione che dalla Signoria della città predetta fu fatto cavaliere, et in breve spazio divenne operaio publico del Duomo di Siena e sopra tutte le cose della spesa di quella fabbrica. E così in quello ufficio tre anni visse con molta grazia di quella città, e fu utilissimo per quel tempio e per quella fabbrica, la quale non fu mai prima così ben maneggiata da alcuno, essendo egli molto gentil persona. Ora, per le fatiche già fatte stanco e vecchio divenuto, di questa vita all'altra passò, et in Siena, da' suoi cittadini con amare lagrime onorato, meritò sepolcro nel Duomo, non cessando eglino con epigrammi latini e rime volgari inalzare con debite lode le bellissime opere, la vita e gli onestissimi costumi suoi, l'anno MCCCCXVIII. Il che hanno fatto ancora gli strani, come si vede per questo epitaffio:

IACOBO QUERCIO SENENSI EQUITI CLARISSIMO STATUARIAEQUE ARTIS PERI-
TISS. AMANTISSIMOQUE UTPOTE QUI ILLAM PRIMUS ILLUSTRAVERIT TENE-
BRISQUE ANTEA IMMERSAM IN LUCEM ERUERIT AMICI PIETATIS ERGO NON
SINE LACHRYMIS P.

Aggiunse Iacopo all'arte della scultura un modo molto di bella maniera, e levò gran parte di quella vecchia che avevano usata gli scultori inanzi a esso, nel fare le figure in maestà senza torcersi e svoltare le attitudini; e morbidamente s'ingegnò gli ignudi di maschi e di femine far parere carnosi, e di leccatezza pulitamente il marmo cercò finire con diligenza infinita.

[APPENDIX 2]

Giorgio Vasari, Vita di Iacopo dalla Quercia: Scultore Sanese. (1568)

Fᴜ ᴀᴅᴜɴQᴜᴇ Iacopo di maestro Piero di Filippo dalla Quercia—luogo del contado di Siena—scultore, il primo, dopo Andrea Pisano, l'Orgagna e gl'altri di sopra nominati, che operando nella scultura con maggior studio e diligenza cominciasse a mostrare che si poteva appressare alla natura, et i primo che desse animo e speranza agl'altri di poterla, in un certo modo, pareggiare. Le prime opere sue da mettere in conto furono da lui fatte in Siena, essendo d'anni xix, con questa occasione. Avendo i Sanesi l'essercito fuori contra i Fiorentini, sotto Gian Tedesco, nipote di Saccone da Pietramala, e Giovanni d'Azzo Ubaldini capitani, ammalò in campo Giovanni d'Azzo, onde, portato a Siena, vi si morì; per che, dispiacendo la sua morte ai Sanesi, gli feciono fare nell'essequie, che furono onoratissime, una capanna di legname a uso di piramide, e sopra quella porre di mano di Iacopo la statua di esso Giovanni a cavallo maggior del vivo, fatta con molto giudizio e con invenzione, avendo—il che non era stato fatto insino allora—trovato Iacopo per condurre quell'opera il modo di fare l'ossa del cavallo e della figura di pezzi di legno e di piane confitti insieme e fasciati poi di fieno e di stoppa, e con funi legato ogni cosa strettamente insieme, e sopra messo terra mescolata con cimatura di panno lino, pasta e colla. Il qual modo di far fu veramente et è il miglior di tutti gl'altri per simili cose; perché, se bene l'opere che in questo modo si fanno sono in apparenza gravi, riescono nondimeno, poi che son fatte e secche, leggeri, e, coperte di bianco, simili al marmo e molto vaghe all'occhio, sì come fu la detta opera di Iacopo. Al che si aggiugne che le statue fatte a questo modo e con le dette mescolanze non si fendono, come farebbono se fussero di terra schietta solamente. Et in questa maniera si fanno oggi i modelli delle sculture con grandissimo comodo degl'ar- tefici che, mediante quelle, hanno sempre l'essempio inanzi e le giuste misure delle sculture che fanno: di che si deve avere non piccolo obligo a Iacopo che, secondo si dice, ne fu inventore. Fece Iacopo dopo questa opera in Siena due tavole di legno di tiglio, intagliando in quelle le figure, le barbe e i capegli con

tanta pacienza, che fu a vederle una maraviglia. E dopo queste tavole, che furono messe in Duomo, fece di marmo alcuni Profeti non molto grandi che sono nella facciata del detto Duomo; nell'Opera del quale averebbe continuato di lavorare, se la peste, la fame e le discordie cittadine de' Sanesi, dopo aver più volte tumultuato, non avessero malcondotta quella città e cacciatone Orlando Malevolti, col favore del quale era Iacopo con riputazione adoperato nella patria.

Partito dunque da Siena, si condusse per mezzo d'alcuni amici a Lucca, e quivi a Paulo Guinigi che n'era signore fece per la moglie, che poco inanzi era morta, nella chiesa di S. Martino una sepoltura, nel basamento della quale condusse alcuni putti di marmo che reggono un festone tanto pulitamente che parevano di carne, e nella cassa posta sopra il detto basamento fece con infinita diligenza l'immagine della moglie d'esso Paulo Guinigii che dentro vi fu sepolta, e a' piedi d'essa fece nel medesimo sasso un cane di tondo rilievo, per la fede da lei portata al marito. La qual cassa, partito o più tosto cacciato che fu Paulo l'anno 1429 di Lucca, e che la città rimase libera, fu levata di quel luogo, e per l'odio che alla memoria del Guinigio portavano i Lucchesi, quasi del tutto rovinata. Pure, la reverenza che portarono alla bellezza della figura e di tanti ornamenti gli ratenne, e fu cagione che poco appresso la cassa e la figura furono con diligenza all'entrata della porta della sagrestia collocate, dove al presente sono, e la capella del Guinigio fatta della comunità.

Iacopo intanto, avendo inteso che in Fiorenza l'Arte de' Mercatanti di Calimara voleva dare a far di bronzo una delle porte del tempio di S. Giovanni, dove aveva la prima lavorato, come si è detto, Andrea Pisano, se n'era venuto a Fiorenza per farsi conoscere, atteso massimamente che cotale lavoro si doveva allogare a chi nel fare una di quelle storie di bronzo avesse dato di sé e della virtù sua miglior saggio. Venuto dunque a Fiorenza, fece non pur il modello, ma diede finita del tutto e pulita una molto ben condotta storia, la quale piacque tanto, che se non avesse avuto per concorrenti gli eccellentissimi Donatello e Filippo Brunelleschi—i quali in verità nei loro saggi lo superarono—, sarebbe tócco a lui a far quel lavoro di tanta importanza.

Ma essendo andata la bisogna altramente, egli se n'andò a Bologna, dove col favore di Giovanni Bentivogli gli fu dato a fare di marmo dagl'Operai di San Petronio la porta principale di quella chiesa, la quale egli seguitò di lavorare d'ordine tedesco per non alterare il modo che già era stato cominciato, riempiendo, dove mancava, l'ordine de' pilastri—che reggono la cornice e l'arco—di storie lavorate con infinito amore nello spazio di dodici anni che egli mise in quell'opera, dove fece di sua mano tutti i fogliami e l'ornamento di detta porta con quella maggiore diligenza e studio che gli fu possibile. Nei pilastri che reggono l'architrave, la cornice e l'arco sono cinque storie per pilastro, e cinque nell'architrave, che in tutto son quindici. Nelle quali tutte intagliò di basso rilievo istorie del Testamento Vecchio, cioè da che Dio creò l'uomo insino al Diluvio e l'arca di Noè, facendo grandissimo giovamento alla scultura, perché

dagl'antichi insino allora non era stato chi avesse lavorato di basso rilievo alcuna cosa, onde era quel modo di fare più tosto perduto che smarrito. Nell'arco di questa porta fece tre figure di marmo, grandi quanto il vivo e tutte tonde, cioè una Nostra Donna col Putto in collo molto bella, San Petronio e un altro Santo molto ben disposti e con bele attitudini; onde i Bolognesi, che non pensavano che si potesse fare opera di marmo, nonché migliore, eguale a quella che Agostino et Agnolo Sanesi avevano fatto di maniera vecchia in San Francesco all'altar maggiore nella loro città, restarono ingannati vedendo questa di gran lunga più bella. Dopo la quale, essendo ricerco Iacopo di ritornare a Lucca, vi andò ben volentieri, e vi fece in San Friano, per Federigo di maestro Trenta del Veglia, in una tavola di marmo, una Vergine col Figliuolo in braccio, San Bastiano, Santa Lucia, San Ieronimo e San Gismondo, con buona maniera, grazia e disegno, e da basso nella predella di mezzo rilievo, sotto ciascun Santo, alcuna storia della vita di quello: il che fu cosa molto vaga e piacevole, avendo Iacopo con bella arte fatto sfuggier le figure in su'piani, e nel diminuire più basse. Similmente diede molto animo agl'altri d'acquistare alle loro opere grazia e bellezza con nuovi modi, avendo in due lapide grandi, fatte di basso rilievo per due sepolture, ritratto di naturale Federigo padrone dell'opera e la moglie. Nelle quali lapide sono queste parole: HOC OPUS FECIT IACOBUS MAGISTRI PETRI DE SENIS 1422.

Venendo poi Iacopo a Firenze, gl'Operai di Santa Maria del Fiore, per la buona relazione avuta di lui, gli diedero a fare di marmo il frontespizio che è sopra la porta di quella chiesa, la quale va alla Nunziata; dove egli fece in una mandorla la Madonna, la quale da un coro d'Angeli è portata, sonando eglino e cantando, in cielo, con le più belle movenze e con li più belle attitudini— vedendosi che hanno moto e fierezza nel volare—che fussero insino allora state fatte mai. Similmente la Madonna è vestita con tanta grazia et onestà che non si può immaginare meglio, essendo il girare delle pieghe molto bello e morbido, e vedendosi ne' lembi de' panni che e' vanno accompagnando l'ignudo di quella figura, che scuopre coprendo ogni svoltare di membra; sotto la quale Madonna è un San Tommaso che riceve la Cintola. Insomma questa opera fu condotta in quattro anni da Iacopo con tutta quella maggior perfezione che a lui fu possibile, perciò che oltre al disiderio che aveva naturalmente di far bene, la concorrenza di Donato, di Filippo e di Lorenzo di Bartolo, de' quali già si vedevano alcune opere molto lodate, lo sforzarono anco davantaggio a fare quello che fece; il che fu tanto, che anco oggi è dai moderni artefici guardata questa opera come cosa rarissima. Dall'altra banda della Madonna, dirimpetto a San Tomaso, fece Iacopo un orso che monta in sur un pero: sopra il quale capriccio come si disse allora molte cose; così se ne potrebbe anco da noi dire alcune altre, ma le tacerò per lasciare a ognuno sopra cotale invenzione credere e pensare a suo modo.

Disiderando dopo ciò Iacopo di rivedere la patria, se ne tornò a Siena, dove arivato che fu, se gli porse secondo il desiderio suo occasione di lasciare in

quella di sè qualche onorata memoria. Perciò che la Signoria di Siena, risoluta
di fare un ornamento ric[c]hissimo di marmi all'acqua che in sulla piazza
avevano condotta Agnolo et Agostino sanesi l'anno 1343, allogarono quell'o-
pera a Iacopo per prezzo di duemiladugento scudi d'oro; onde egli, fatto un
modello e fatti venire i marmi, vi mise mano e la finì di fare con molta
sodisfazione de' suoi cittadini, che non più Iacopo dalla Quercia ma Iacopo
dalla Fonte fu poi sempre chaimato. Intagliò dunque nel mezzo di questa opera
la gloriosa Vergine Maria—avvocata particolare di quella città—un poco
maggiore dell'altre figure, e con maniera graziosa e singolare. Intorno poi fece
le sette Virtù teologiche, le teste delle quali, che sono delicate e piacevoli, fece
con bell'aria e con certi modi che mostrano che egli cominciò a trovare il buono
[ne] le difficultà dell'arte, et a dare grazia al marmo levando via quella vecchiaia
che avevano insino allora usato gli scultori, facendo le loro figure intere e senza
una grazia al mondo: là dove Iacopo le fece morbide e carnose, e finì il marmo
con pacienza e delicatezza. Fecevi, oltre ciò, alcune storie del Testamento Vec-
chio, cioè la creazione de' primi parenti et il mangiar del pomo vietato, dove
nella figura della femmina si vede un'aria nel viso sì bella, et una grazia e
attitudine della persona tanto reverente verso Adamo nel porgergli il pomo, che
non pare ch'e' possa ricusarlo; senza il rimanente dell'opera, che è tutta piena
di bellissime considerazioni e adornata di bellissimi fanciulletti e altri orna-
menti di leoni e di lupe, insegne della città, condotti tutti da Iacopo con amore,
pratica e guidizio in ispazio di dodici anni. Sono di sua mano similmente tre
storie bellissime di bronzo della vita di San Giovanbattista, di mezzo rilievo, le
quali sono intorno al battesimo di San Giovanni, sotto il Duomo; et alcune
figure ancora tonde e pur di bronzo, alte un braccio, che sono fra l'una e l'altra
delle dette istorie: le quali sono veramente belle e degne di lode.

Per queste opere adunque come eccellente, e per la bontà della vita come
costumato, meritò Iacopo essere dalla Signoria di Siena fatto cavaliere, e poco
dopo operaio del Duomo. Il quale uffizio esercitò di maniera che né prima nè
poi fu quell'Opera meglio governata, avendo egli in quel Duomo—se bene non
visse, poi che ebbe cotal carico avuto, se non tre anni—fatto molti acconcimi
utili et onorevoli. E se bene Iacopo fu solamente scultore, disegnò nondimeno
ragionevolmente, come ne dimostrano alcune carte da lui disegnate che sono
nel nostro libro, le quali paiono più tosto di mano d'un miniatore che d'uno
scultore. Et il ritratto suo, fatto come quello che di sopra si vede, ho avuto da
maestro Domenico Beccafumi pittore sanese, il quale mi ha assai cose raccon-
tato della virtù, bontà e gentilezza di Iacopo. Il quale, stracco dalle fatiche e dal
continuo lavorare, si morì finalmente di anni sessantaquattro, et in Siena sua
patria fu dagl'amici suoi e parenti, anzi da tutta la città, pianto et onoratamente
sotterrato. E nel vero non fu se non buona fortuna la sua, che tanta virtù fusse
nella sua patria riconosciuta: poi che rade volte adiviene che i virtuosi uomini
siano nella patria universalmente amati et onorati.

Fu discepolo di Iacopo Matteo, scultore lucchese, che nella sua città fece

l'anno 1444 per Domenico Galigano lucchese, nella chiesa di San Martino, il tempietto a otto facce di marmo, dove è l'imagine di Santa Croce, scultura stata miracolosamente, secondo che si dice, lavorata da Niccodemo, uno de' settantadue discepoli del Salvatore; il quale tempio non è veramente se non molto bello e proporzionato. Fece il medesimo di scultura una figura d'un San Bastiano di marmo tutto tondo di braccia tre, molto bello, per essere stato fatto con buon disegno, con bella attitudine e lavorato pulitamente. È di sua mano ancora una tavola, dove in tre nicchie sono tre figure belle affatto, nella chiesa dove si dice essere il corpo di S. Regolo, e la tavola similmente che è in S. Michele, dove sono tre figure di marmo, e la statua parimente che è in sul canto della medesima chiesa dalla banda di fuori, cioè una Nostra Donna, che mostra che Matteo andò sforzandosi di paragonare Iacopo suo maestro.

Niccolò Bolognese ancora fu discepolo di Iacopo e condusse a fine, essendo imperfetta, divinamente fra l'altre cose l'arca di marmo piena di storie e figure che già fece Nicola Pisano a Bologna, dove è il corpo di S. Domenico, e ne riportò oltre l'utile questo nome d'onore, che fu poi sempre chiamato maestro Niccolò dell'Arca. Finì costui quell'opera l'anno 1460, e fece poi nella facciata del palazzo dove sta oggi il Legato di Bologna, una Nostra Donna di bronzo alta quattro braccia, e la pose su l'anno 1478. Insomma fu costui valente maestro e degno discepolo di Iacopo dalla Quercia sanese.

Fine della Vita di Iacopo scultore sanese.

Selected Bibliography

Ady, C. M. *The Bentivoglio of Bologna*. London, 1937.

Agnolo di Tura del Grasso. *Cronica senese*. Ed. by A. Lisini and F. Iacometti. Vol. 15, part 6 of Muratori, ed., *RRIISS* (q.v.). Bologna, 1931.

Agostini, G., and L. Ciamnutti, eds. *Niccolò dell'Arca. Semmario di studi. Atti*. Bologna, 1989.

Albertini, F. *Memoriale di molte statue e pitture di Firenze*. Florence, 1510.

Alidosi, G. N. *Li dottori forestieri che in Bologna hanno letto teologia, filosofia, medicina e arti liberali*. Bologna, 1623.

Antica arte senese (Exh. cat.). Siena, 1904.

Antonio di Martino da Siena. *Cronaca dal 1170 al 1431* (Copied 1490). MS., Biblioteca Comunale, Siena, A. VII.

Arias, P. E., E. Cristiani, and E. Gabba. *Camposanto monumentale di Pisa. Le antichità*. Pisa, 1977.

Aronow, G. "A Documentary History of the Pavement Decoration in Siena Cathedral, 1362 through 1506." Ph.D. diss. Columbia University, New York, 1985. 2 vols.

Ascheri, M. *Siena nel Rinascimento*. Siena, 1985.

Arslan, E. *Venezia gotica*. Milan, 1970.

Azzi, C. degli, L. Fumi, and E. Lazzareschi, eds. *R. Archivio di Stato di Lucca: Regesti*. Pescia, 1903–1933.

Bacci, P. *Alcuni documenti nuziali de artisti senesi del XIV e XV secoli*. in *Nozze Andrucci-Bruchi*. Siena, 1934.

——"L'Altare della famiglia Trenta in San Frediano in Lucca," *Bollettino storico lucchese* (1933), 5:230–236.

——Introduction. *Catalogo della mostra di scultura d'arte senese del XV° secolo—Nel V° centenario della morte di Jacopo della Quercia (1438–1938)*. Siena, 1938.

——"La 'Colonna' del Campo e la lupa di Giovanni e Lorenzo Turini, orafi senesi (1428–1430)," *Rassegna d'arte senese e del costume* (1927), 1:227–231.

——*Documenti e commenti per la storia dell'arte*. Florence, 1944.

——"Elenco delle pitture, sculture e architetture di Siena compilato nel 1625–26 da Mons. Fabio Chigi poi Alessandro VII," *Bulletino senese di storia patria* (1939), 10:197–213, 297–337.

Bacci, P. *Francesco di Valdambrino, èmulo del Ghiberti e collaboratore di Jacopo della Quercia.* Siena, 1936.

——*Jacopo della Quercia: Nuovi documenti e commenti.* Siena, 1929.

——"Le statue dell'Annunciazione intagliate nel 1421 da Jacopo della Quercia," *La Balzana* (1927), vol. 1 (n.s.), pp. 149–175.

Bagnoli, A. "Su alcune statue lignee della bottega di Jacopo." In Chelazzi Dini, ed., *Jacopo della Quercia fra Gotico e Rinascimento. Atti* (q.v.), pp. 151–162.

Bagnoli, A. and R. Bartalini, eds., *Scultura dipinta: Maestri di legname e pittori a Siena, 1250–1450* (Exh. cat.; Siena, Pinacoteca Nazionale, 1987). Florence, 1987.

Baldinucci, F. *Notizie de' professori del disegno.* Florence, 1681.

Banchi, L., ed., *Statuti senesi scritti in volgare ne'secoli XIII e XIV.* 3 vols. Siena, 1863–1877.

Banchi, L., C. Carpellini, and A. Pantanelli. *La Fonte Gaia.* Siena, 1869.

Banchi Bandinelli, R. "Appunti attorno a Jacopo della Quercia," *Rassegna d'arte senese* (1924), 17:65–78.

Banti, A. "Una sibilla del Duomo di Orvieto," *Paragone,* (March 1953), 4(39):39–40.

Baracchini, C. and A. Caleca. *Il Duomo di Lucca.* Milan, 1973.

Bargagli-Petrucci, F. *Le fonti di Siena e i loro acquedotti.* 2 vols. Siena, 1906.

——"Jacopo della Quercia" (unpublished proofs with corrections by the author, from Alfieri and Lacroix). Milan, 1915. Unique copy in the Library of the Istituto di Storia dell'Arte, Universita di Bologna.)

Barocchi, P., ed. *La vita di Michelangelo, in G. Vasari, Le vite de'più eccellenti pittori, scultori e architettori' nelle redazioni del 1550 e del 1568.* 5 vols. Milan-Naples, 1962.

Baroni, C. *L'arte dell'umanesimo: Appunti delle lezioni di storia dell'arte.* Milan, 1956.

——"La Scultura gotica." In *Storia di Milano,* 5:727–812. Milan, 1955.

——*Scultura gotica lombarda.* Milan, 1944.

Barsali, I. Belli, *Guida di Lucca.* 2d ed. Lucca, 1970.

Baxandall, M. *The Limewood Sculptors of Renaissance Germany.* New Haven and London, 1980.

Becherucci, L. and G. Brunetti. *Il Museo dell'Opera del Duomo a Firenze.* 2 vols. Venice, 1969.

Beck, J. H. "A Document Regarding Domenico da Varignana," *Mitteilungen des Kunsthistorischen Instituts in Florenz* (1964), 11:193–94.

——"Donatello and the Brancacci Tomb in Naples." In K-L. Selig and R. Somerville, eds., *Florilegium Columbianum: Essays in Honor of Paul Oskar Kristeller,* pp. 125–145. New York, 1987.

——"An Effigy Tomb Slab by Antonio Rossellino," *Gazette des Beaux-Arts* (May 1980), pp. 213–217.

——"Ghiberti giovane e Donatello giovanissimo." In *Lorenzo Ghiberti nel suo tempo,* 1:111–143. 2 vols. Florence, 1980.

——"The Historical 'Taccola' and Emperor Sigismund in Siena," *Art Bulletin* (1968), 50:309–320.

——"An Important New Document for Jacopo della Quercia in Bologna," *Arte antica e moderna* (1962), 18:206–207.

——"Jacopo a Todi." In Chelazzi Dini, ed., *Jacopo della Quercia fra Gotico e Rinascimento. Atti* (q.v.), pp. 104–108.

——"Jacopo della Quercia's Design for the 'Porta Magna' of San Petronio in Bologna," *Journal of the Society of Architectural Historians,* (1965), 24:115–126.

——"Jacopo della Quercia's Portal of San Petronio in Bologna," Ph.D. diss. Columbia University, New York, 1963.

——*Jacopo della Quercia e il portale di San Petronio a Bologna.* Bologna, 1970.

——*Mariano di Jacopo detto il Taccola, 'Liber teritius de ingeneis ac aedifitiis non usitatis.'* Milan, 1969.

——"Reflections on Restoration: Jacopo della Quercia at San Petronio, Bologna," *Antichità viva* (1985), 24 (ns. 1/2/3):118–123.

——Review of A. C. Hanson, *Jacopo della Quercia's Fonte Gaia,* in *Art Bulletin* (1966), 48:114–115.

——Review of O. Morisani, *Tutta la scultura di Jacopo della Quercia,* in *Arte antica e moderna* (1962), 20:456–457.

——"A Sibyl by Tribolo for the 'Porta Maggiore' of San Petronio." In D. Fraser, H. Hibbard, and M. J. Lewine, eds., *Essays in the History of Art Presented to Rudolf Witkower,* pp. 98–101. London, 1967.

Beck, J. H. and A. Amendola. *Ilaria del Carretto di Jacopo della Quercia.* Milan, 1988.

Beck, J. H. with G. Corti. *Masaccio: The Documents.* Locust Valley, N.Y., 1978.

Beck, J. H. and M. Fanti. "Un probabile intervento di Michelangelo per la 'porta magna' di San Petronio," *Arte antica e moderna* (1964), 27:349–354.

Bellini, F. *I disegni antichi degli Uffizi. I tempi del Ghiberti* (Exh. cat.). Florence, 1978.

Bellosi, L. "Ipotesi sull'origine delle terracotte quattrocentesche." In Chelazzi Dini, ed., *Jacopo della Quercia fra Gotico e Rinascimento. Atti* (q.v.), pp. 163–179.

——"La 'Porta Magna' di Jacopo della Quercia." In M. Fanti et al., eds., *La Basilica di San Petronio,* 1:163–212. Bologna, 1983.

Berenson, B. "Tre disegni di Giovan Battista Utili da Faenza," *Rivista d'arte* (1933), 15:15ff.

Bergstein, M. "The Sculpture of Nanni di Banco." Ph.D. diss. Columbia University, New York, 1987.

Berliner, R. "A Relief of the Nativity and a Group from an Adoration of the Magi," *Art Bulletin* (1953), 35:145–149.

Bernheimer, R. "Gothic Survival and Revival in Bologna," *Art Bulletin* (1954), 36:263–284.

Bertaux, E. "Trois chefs-d'oeuvre italiens de la collection Aynard," *Revue de l'art ancien et moderne* (1906), 19:81–96.

Bertini, A. "Calchi della Fonte Gaia," *Critica d'arte* (1968), vol. 15 (n.s.), pp. 35–54.

——*L'Opera di Jacopo della Quercia: Appunti delle lezioni a cura di A. Quazza e A. Solaro.* Turin, 1966.

Bertini, S. "Un'opera sconosciuta di Andrea da Fiesole," *L'Arte* (1931), 34:506–512.

Biagi, L. *Jacopo della Quercia.* Florence, 1946.

Bisogni, F. "Un disegno della Fonte Gaia," *Storia dell'arte* (1980), 38/40:13–17.

——"Sull'iconografia della Fonte Gaia." In Chelazzi Dini, ed., *Jacopo della Quercia fra Gotico e Rinascimento. Atti* (q.v.), pp. 109–118.

Bober, P. P. and R. O. Rubinstein. *Renaissance Artists and Antique Sculpture: A Handbook of Sources.* New York and Oxford, 1986.

Bode, W. *Denkmaeler der Renaissanceskulptur Toscanas.* 8 vols. Munich, 1892–1905.

——*Florentiner Bildhauer der Renaissance.* Berlin, 1910.

——*Die Italienische Plastik.* Berlin, 1911.

Bongi, S. *Bandi lucchesi del secolo decimoquarto.* Bologna, 1863.

——*Di Paolo Guinigi e delle sue ricchezze.* Lucca, 1871.

—— ed. *Le croniche di Giovanni Sercambi, lucchese.* 3 vols. Rome, 1892.

Bonnell, J. K. "The Serpent with a Human Head," *American Journal of Archaeology* (2nd series, 1917), 21:255ff.

Borghesi, S. and L. Banchi. *Nuovi documenti per la storia dell'arte senese.* Siena, 1898.

Borselli, G. *Cronica gestorum ac factorum memorabilium civitatis Bononie.* Ed. by A. Sorbelli. Vol. 33, part 2 of Muratori, ed., *RRIISS* (q.v.). 1911–1929.

Bottari, S. "Jacopo della Quercia," *Emporium* (1938), 88:182–194.

———"Per Andrea di Guido da Firenze," *Arte antica e moderna* (1958), 3:285–290.

———*La pittura in Emilia nella prima metà del'400*. Text by Carlo Volpe. Bologna, 1958.

Brandi, D. *Quattrocentisti senesi*. Milan, 1949.

Brieger, P., M. Meiss, and C. S. Singleton. *Illuminated Manuscripts of the Divine Comedy*. 2 vols. Princeton, 1969.

Brogi, F. *Inventario generale degli oggetti d'arte della provincia di Siena (1862–65)*. Siena, 1897.

Brunetti, G. "Dubbi sulla datazione dell'Annunciazione di San Gimignano." In Chelazzi Dini, ed., *Jacopo della Quercia fra Gotico e Rinascimento. Atti* (q.v.), pp. 101–103.

———"Jacopo della Quercia a Firenze," *Belle arti* (1951), 3–17.

———"Jacopo della Quercia and the Porta della Mandorla," *Art Quarterly* (1952), 15:119–131.

———"Oreficeria del quattrocento in Toscana," *Antichità viva* (1987), 26(4):21–38.

———"Sull' attività di Nanni di Bartolo nell' Italia Settentrionale." In Chelazzi Dini, ed., *Jacopo della Quercia fra Gotico e Rinascimento Atti* (q.v.), pp. 189–191.

Burresi, M. *Andrea, Nino e Tommaso scultori pisani*. Milan, 1983.

———"Incrementi di Francesco di Valdambrino," *Critica d'arte* (July–Sept. 1985), pp. 49–59.

———*Restauro di sculture lignee nel Museo di S. Matteo (Pisa)* (Exh. cat.). Pontedera, 1984.

Buscaroli, R. "Il Fonte Battesmale di Dozzo e Domenico di Aimo da Varignana," *Atti dell' Assoc. per I mola storico—artistica* (1957), 8:51–58.

———*La scultura senese del Trecento e Jacopo della Quercia*. Bologna, 1951.

Campetti, P. "L'altare della famiglia Trenta in S. Frediano di Lucca." *In Miscellanea di storia dell'arte in onore di I. B. Supino*, pp. 271–294. Florence, 1933.

Caplow, H. McNeil. *Michelozzo*. 2 vols. New York and London, 1977.

———"Sculptors' Partnerships in Michelozzo's Florence," *Studies in the Renaissance*, (1974), 21:145–175.

Caratti, E. [R. Longhi]. "Un'osservazione circa il monumento d'Ilaria," *Viva artistica* (1926), 1:94–96. Reprinted in R. Longhi, *Saggi e richerche, 1925–1928*, pp. 49–520, Florence, 1967.

Carelli, P. Notizie antiche di S. Frediano. MS, Biblioteca Governative di Lucca, no. 415.

Cardile, P. "The Benabbio Annunciation, and the Style of Jacopo della Quercia's Father, Piero d'Angelo," *Antichità viva* (1978), 17(2):25–32.

Carli, E. *Capolavori dell'arte senese*. Florence, 1946.

———"Due Madonne senesi (fra il Ghiberti e Jacopo della Quercia)," *Antichità viva* (1962), 1(3):9–17.

———"Un inedito quercesco." In Chelazzi Dini, ed., *Jacopo della Quercia fra Gotico e Rinascimento. Atti* (q.v.), pp. 141–146.

———*Jacopo della Quercia*. Milan and Florence, 1952.

———"Una primizia di Jacopo della Quercia," *Critica d'arte* (1949), 8:17–24.

———*La scultura lignea italiana*. Milan, 1960.

———*La scultura lignea senese*. Milan and Florence, 1954.

———"Le sculture del coro del Duomo di Siena," *Antichità viva* (1978), 16:25–39.

———"Sculture senesi del Quattrocento," *Emporium* (1938), 88:280–83.

———*Gli Scultori senesi*. Milan, 1980.

Carpellini, C. F. *Di Giacomo della Quercia e della sua Fonte nella Piazza del Campo*. 2d ed. Siena, 1869.

Casini, B. *Il Catasto di Pisa del 1428–29*. Pisa, 1964.

Caspary, H. *Das Sakraments Tabernakel in Italien bis zum Konzil von Trent*. Munich, 1964.

Castelfranchi Vegas, L. *International Gothic Art in Italy*. London, 1968.

Castelnuovo, E. and G. Romano, eds. *Giacomo Jaquerio e il gotico internazionale*. Turin, 1979.

Catoni, G. and S. Fineschi. *L'Archivio arcivescovile di Siena*. Rome 1970.

Chambers, D. S. *Patrons and Artists in the Italian Renaissance*. Columbia, S.C., 1971.

Chelazzi Dini, G., ed. *Il Gotico a Siena* (Exh. cat.; Siena, July 24– October 30, 1982). Florence, 1982.

——ed. *Jacopo della Quercia fra Gotico e Rinascimento. Atti del convegno di studi* (Siena, 2–3 Ottobre 1975). Florence, 1977.

Chiarelli, R. *Jacopo della Quercia*. I maestri della scultura, no. 5. Milan, 1966.

Christiansen, K. L., L. B. Kanter, and C. B. Strehlke. *Painting in Renaissance Siena: 1420–1500*. New York, 1988.

Ciardi Duprè dal Poggetto, M. G. *L'Oreficeria nella Firenze del Quattrocento*. Florence 1977.

——"La scultura di Amico Aspertini," *Paragone* (Nov. 1965), 189:3–25.

——"Sul ruolo di Jacopo della Quercia nella scultura del cinquecento." In Chelazzi Dini, ed., *Jacopo della Quercia fra Gotico e Rinascimento. Atti* (q.v.), pp. 235–247.

Cicognara, L. *Storia della scultura in Italia*. 4 vols. Venice, 1813–1823.

Ciomi Liserani, E. *Sigilli medievali senesi*. Florence, 1981.

Cohn-Goerke, W. "Recensione al catalogo della mostra quercesca," *Rivista d'arte* (1939), 21:187–92.

Conti, A. "Un libro di disegni della bottega del Ghiberti," *Lorenzo Ghiberti nel suo tempo*, 1:147–164. 2 vols. Florence, 1980.

Cornelius, C. *Jacopo della Quercia: Eine kunsthistorische Studie*. Halle, 1896.

Dami, L. *Siena e le sue opere d'arte*. Florence, 1955.

D'Amico, R. and R. Grandi. *Il Tramonto del Medioevo a Bologna: Il cantiere di San Petronio* (Exh. cat.; Bologna, October–December 1987). Bologna, 1987.

Davia, V. *Cenni istorico-artistici intorno al monumento di Antonio Galeazzo Bentivoglio esistente nella chiesa di San Giacomo in Bologna*. Bologna, 1835.

——*Le sculture delle porte della basilica di San Petronio*. Bologna, 1834.

David, H. *Claus Sluter*. Paris, 1951.

De Bartholomaeis, V. *Origini della poesia drammatica italiana*. 2d. ed. Turin, 1952.

Degenhart, B. and A. Schmitt. *Corpus der italienischen Zeichnungen, 1300–1450*. 4 vols. Berlin, 1968–1982.

——"Gentile da Fabriano in Rom und die Anfange des Antikenstudiums," *Munchner Jahrbuch der bildenden Kunst* (1960), 11:59–151.

Del Bravo, C. "Jacopo della Quercia at Siena," *Burlington Magazine* (Sept. 1975), pp. 624–628.

——Review of J. H. Beck, *Jacopo della Quercia e il portale di San Petronio*, in *Antichità viva* (1971), 10(1):64–65.

——*Scultura senese del Quattrocento*. Florence, 1970.

De Giovanni, N. *Ilaria del Carretto*. La Donna del Guinigi. Lucca, 1988.

Della Valle, G. *Lettere sanesi sopra le belle arti*. 3 vols. Rome, 1785–1786.

De Nicola, G. "Studi sull'arte senese. I. Priamo della Quercia," *Rassegna d'arte* (1918), 18:29–74 and 153–154.

Didron, E. and J. Durand. "Iconographie du baptistère de Sienne," *Annales archéologiques* (1859), 19:297–306.

Dizionario biografico degli italiani. Rome, 1960–.

Donini, D. *La metrologia europea comparata con quella di Roma, di Bologna, e di Parigi.* Terni, 1835.

Einem, H. von. *Masaccios Zinsgroschen.* Cologne, 1967.

——"Die monumental Plastik des Mittelalters und ihr Verhältnis zur Antike." In *Antike und Abendland,* 3:125ff. Hamburg, 1948.

Esche, Sigrid. *Adam und Eva, Sündenfall und Erlösung.* Dusseldorf, 1957.

Fabriczy, C. von. "Kritisches Verzeichnis toskanischer Holz und tonstatuen bis zur Beginn des Cinquecento," *Jahrbuch der preussischen Kunstsammlungen* (1909), 30:1–88 and appendix.

——"Pagno di Lapo Portigiani," *Jahrbuch der preussischen Kunstsammlungen* (1903), 24:119–139.

Faleoni, C. *Memorie historiche della Chiesa bolognese e suoi pastori.* Bologna, 1649.

Falletti-Fossati, C. *Costumi senesi nella seconda metà del secolo XVI.* Siena, 1881.

Faluschi, G. *Breve relazione delle cose notabili della città di Siena.* Siena, 1784.

Fanti, M. *La fabbrica di S. Petronio in Bologna dal XIV al XV secolo—storia di una istituzione.* Rome, 1980.

——*Il Museo di San Petronio: Catalogo.* Bologna, 1970.

Fanti, M. et al., eds. *La Basilica di San Petronio.* 2 vols. Bologna, 1983–1984.

Ferrali, S. *L'Altare argenteo di S. Jacopo nella cattedrale di Pistoia: guida storico-artistico.* Florence, 1956.

Ferrara, M. and F. Quinterio. *Michelozzo di Bartolomeo.* Florence, 1984.

Filarete [Antonio Averlino]. *Trattato di architettura.* 2 vols. Ed. by A. M. Finali and L. Grassi. Introduction by L. Grassi, Milan, 1972.

Filippini, F. "Michele di Matteo da Bologna," *Croniche d'arte* (1924), 1:183–193.

——"Nicolò Lamberti e il monumento di Alessandro V in Bologna," *Il Comune di Bologna* (November 1929), pp. 3–6.

——"Notizie di pittori fiorentini a Bologna nel '400." In *Miscellanea di storie dell'arte in onore di I. B. Supino,* pp. 417–433. Florence, 1933.

——*S. Petronio di Bologna.* Bologna, 1948.

Fink, K. A. "Martin V und Bologna (1428–1429)," *Quellen und Forschungen aus italienischen Archiven und Bibliotheken* (1931/1932), 23:213 ff.

——"Die politische Korrespondenz Martins V nach den Brevenregistern," *Quellen und Forschungen aus italienischen Archiven und Bibliotheken* (1935/1936), 26:172ff.

Foratti, A. "I. B. Supino e le sculture delle porte di S. Petronio," *L'Archiginnasio* (1914), anno 9.

——"Jacopo della Quercia." In U. Thieme and F. Becker, eds., *Allgemeines Lexikon der bildenden Künstler von der Antike bis zur Gegenwart,* vol. 27, s.v., pp. 513–516. Leipzig, 1933.

——"Jacopo della Quercia in S. Petronio e la critica moderna," *L'Archiginnasio* (1932), 27:141–154.

——"I profeti di Jacopo della Quercia nella porta maggiore di S. Petronio," *Il Comune di Bologna* (Sept. 1932), pp. 3–13.

Francovich, G. de. "Appunti su Donatello e Jacopo della Quercia," *Bolletino d'arte* (1929–1930), 9:145–171.

Frankl, P. "Die Italienreise des Glasmalers Hans Acker," *Wallraf-Richartz Jahrbuch* (1962), 24:213–226.

Fremantle, R. *Florentine Gothic Painters from Giotto to Masaccio.* London, 1975.

Freytag, C. "Beiträge zum Werk des Francesco di Valdambrino," *Pantheon* (1971), 29:363–78.

——"Italienische Skulptur um 1400: Untersuchungen zur den Einflussbereichen," *Metropolitan Museum of Art Journal* (1973), 7:5–35.

——"Jacopo della Quercia a Lucca," *La Provincia di Lucca* (1968), 8:96–101.

——"Jacopo della Quercia e i fratelli Dalle Masegne." In Chelazzi Dini, ed., *Jacopo della Quercia fra Gotico e Rinascimento. Atti* (q.v.), pp. 81–90.

——*Jacopo della Quercia: Stilkritische Untersuchungen zu seinen Skulpturen unter besonderer Berücksichtigung des Frühwerks.* Inaugural-diss. Munich, 1969.

Gai, L. *L'Altare argenteo di San Iacopo nel Duomo di Pistoia. Contributo alla storia dell'oreficeria gotica e rinascimentale italiana.* Photographs by A. Amendola. Turin, 1984.

Gallavotti Cavallero, D. *Lo spedale di Santa Maria della Scala: vicenda di una Committenza artistica.* Siena, 1985.

Garzelli, A. *Sculture toscane nel dugento e nel trecento.* Florence, 1969.

Gatti, A. *La basilica petroniana.* Bologna, 1913.

——*La fabbrica di S. Petronio: indagini storiche.* Bologna, 1889.

——*L'Ultima parola sul concetto architettonico di San Petronio.* Bologna, 1913.

Gauricus, Pomponius. *De Sculptura* (1504). Ed. by A. Chastel and R. Klein. Genève-Paris, 1969.

Gaye, G. *Carteggio inedito d'artisti dei secoli XIV, XV, XVI.* 3 vols. Florence, 1839–1840.

Ghiberti, L. *I Commentarii* (1450). Ed. by O. Morisani. Naples, 1947.

Gielly, L. "Jacopo della Quercia," *Revue de l'art ancien et moderne* (1921), 39:243–252.

——*Jacopo della Quercia.* Paris, 1930.

Gigli, G. *Diario senese.* Lucca, 1732.

Giglioli, A. "Una scultura di Jacopo della Quercia nel Museo del Duomo di Ferrara," *Rivista di Ferrara* (1934), 2:345–349.

Gilbert, C. "Tuscan Observants and Painters in Venice ca. 1400." In D. Rosand, ed., *Studi di storia dell'arte in onore di Michelangelo Muraro,* pp. 109–120. Venice, 1984.

Giorgi, G. *Le Chiese di Lucca; San Martino.* Lucca, 1971.

Glasser, H. *Artists' Contracts of the Early Renaissance.* New York and London, 1977.

Gnudi, C. "Communicazioni su Jacopo della Quercia," *Rivista lucchese* (1951), 5:9ff.

——"Intorno ad Andrea da Fiesole," *Critica d'arte* (1938), 3:23–29.

——"La Madonna di Jacopo della Quercia in S. Petronio di Bologna," *Atti e memorie della deputazione di storia patria per le provincie di Romagna,* n.s. (1951–1952), 2:325–334.

——"Per una revisione critica della documentazione riguardante la 'Porta Magna' di San Petronio." In R. Rossi Manaresi, ed., *Jacopo della Quercia e la facciata di San Petronio a Bologna,* pp. 13–118. Bologna, 1981. Also in *Römischer Jahrbuch für Kunstgeschichte* (1983), 20:155–180.

Goldner, G. R. *Niccolò and Piero Lamberti.* New York and London, 1978.

Gorrini, G. "Documenti di Jacopo della Quercia che ritornano a Siena," *Bollettino senese di storia patria* (1933), vol. 4 (n.s.), pp. 303–313.

Grande Mezzetti, L., "Teste quattrocentesche del Duomo di Lucca," *Rivista d'arte* (1936), 18:265–281.

Grazzini, S. "Martino di Bartolomeo." Tesi di Laurea. University of Siena, 1980.

Gualandi, E. "Di due lapidi sepolcrali ancora esistenti in S. Michele in Bosco di Bologna," *Atti e memorie della deputazione di storia patria per le provincie di Romagna* (1955–1956), vol. 7 (n.s.), pp. 336–358.

Guasti, C., ed. *Commissioni di Rinaldo degli Albizzi.* Florence, 1867–1873.

Guidicini, G. *Cose notabili della città di Bologna, ossia storia cronologica de' suoi stabili pubblici e privati.* 5 vols. Bologna, 1868–1873.

Guiducci, Anna M. "Il Maestro della Madonna di Lucignano e Domenico di Niccolò dei

Cori." In Chelazzi Dini, ed., *Jacopo della Quercia fra Gotico e Rinascimento. Atti* (q.v.), pp. 38–52.

Gundersheimer, W. L. *Ferrara: The Style of Renaissance Despotism.* Princeton, 1973.

Haftmann, W. "Della Quercia and Sienese Sculpture," *Magazine of Art* (1939), 32:508–511.

Haines, M. *The 'Sacrestia delle Messe' of the Florentine Cathedral.* Florence, 1983.

Hansen, S. *Die Loggia della Mercanzia in Siena.* Worms, 1987.

Hanson, A. Coffin. *Jacopo della Quercia's Fonte Gaia in Siena.* Oxford, 1965.

——"Jacopo della Quercia fra classico e rinascimento: Alcuni pensieri sui motivi di Ercole e Adamo." In Chelazzi Dini, ed., *Jacopo della Quercia fra Gotico e Rinascimento. Atti* (q.v.), pp. 119–130.

Hanson, B. "Fear and Loathing on the Trail of Missing Masterpieces," *Art Journal,* 1980, pp. 354–356.

Heimann, A. "Trinitas Creator Mundi," *Journal of the Warburg Institute* (1938), 2:42–52.

Herald, J. *Renaissance Dress in Italy, 1400–1500.* London, 1981.

Hook, J. *Siena: A City and Its History.* Worcester and London, 1979.

Huse, N. "Ein Bilddokument zu michelangelos' Julius II in Bologna," *Mitteilungen des Kunsthistorichen Institutes in Florenz* (1966), 12:355–358.

Jacobus de Voragine. *The Golden Legend.* Trans. by G. Ryan and H. Ripperger. 2 vols. London, 1941.

Jacopo della Quercia nell'arte del suo tempo. Mostra didattica. Florence, 1975.

James, E. E. C. *Bologna: Its History, Antiquities and Art.* London, 1909.

Janson, H. W. *Apes and Ape Lore in the Middle Ages and the Renaissance.* London, 1952.

——*History of Art.* Englewood Cliffs, N.J. and New York, 1962.

——*The Sculpture of Donatello.* Princeton, 1957.

Kauffmann, H. *Donatello.* Berlin, 1936.

Klapisch-Zuber, C. *Les maîtres du marbre carrare, 1300–1600.* Paris, 1969.

Klotz, H. "Jacopo della Quercias' Zyklus der 'Vier Temperamente' am Dom zu Lucca," *Jahrbuch der Berliner Museen* (1967), 9:81–99.

Kosegarten, A. "Das Grabrelief des San Aniello Abbate in Dom zu Lucca: Studien zu den früheren Werken des Jacopo della Quercia," *Mitteilungen des Kunsthistorischen Institutes in Florenz* (1968), 13:223–272.

Krautheimer, R. "Un disegno di Jacopo della Quercia," *La Diana* (1928), 3:276–279. Reprinted in R. Krautheimer, *Studies in Early Christian, Medieval, and Renaissance Art,* pp. 311–314. New York, 1969.

——"A Drawing for the Fonte Gaia in Siena," *Bulletin of the Metropolitan Museum of Art* (1952), 10:265–274.

——"Quesiti sul sepolcro di Ilaria." In Chelazzi Dini, ed., *Jacopo della Quercia fra Gotico e Rinascimento. Atti* (q.v.), pp. 91–97.

——Review of J. H. Beck's *Jacopo della Quercia e il portale di San Petronio,* in *Renaissance Quarterly* (1972), 25:321–326.

——"Terracotta Madonnas," *Parnassus* (1936), 8:5–8. Reprinted in R. Krautheimer, *Studies in Early Christian, Medieval, and Renaissance Art,* pp. 315–322. New York, 1969.

Krautheimer, R. and T. Krautheimer-Hess. *Lorenzo Ghiberti.* Princeton, 1956.

Krautheimer-Hess, T. "The Original Porta dei Mesi at Ferrara and the Art of Niccolo," *Art Bulletin* (1944), 26:152–174.

Kreytenberg, G. *Andrea Pisano und die toskanische Skulptur des 14 Jahrhunderts.* Munich, 1984.

Kris, E. *Meister und Meisterwerke: Der Steinschneide Kunst in der italienischen Renaissance.* 2 vols. Vienna, 1929.

Kristeller, P. O. "Augustine and the Early Renaissance," *Review of Religion* (1943–1944), 8:393ff.

Labarte, J. "L'Eglise cathedrale de Sienne et son trésor d'apres un inventaire de 1467," *Annales archéologiques* (1868), 25 (extract).

Lamo, P. *Graticola di Bologna, ossia descrizione delle pitture e sculture e architetture di detta città fatta l'anno 1560.* Bologna, 1844.

Landsberger, F. *Jacopo della Quercia.* Leipzig, 1924.

Lányi, J. "Donatello's Angels for the Siena Font: A Reconsideration," *Burlington Magazine* (1927–1928), 61:257–266.

——"Der Entwurf zur Fonte Gaia in Siena," *Zeitschrift für bildende Kunst* (1927–1928), 61:257–266.

——"Quercia Studien," *Jahrbuch für Kunstwissenschaft* (1930), 5:25–63.

Lazzareschi, E. "Angelo Puccinelli e gli altri pittori lucchesi del trecento," *Bulletino storico lucchese* (1937–1938), 10(3):137–164.

——"La dimora a Lucca di Jacopo della Quercia e di Giovanni da Imola," *Bulletino senese di storia patria* (1925), 32:63–97.

——*Lucca.* Italia artistica, no. 104. Bergamo, 1931.

——"Le opere lucchese di Jacopo della Quercia," *Illustrazione toscana* (1939), 25–28.

——Review of P. Bacci, *Jacopo della Quercia*, in *Bolletino storico lucchese* (1929–1930), 1/2:218–219.

Lazzarini, L. "Contributo all'identificazione del materiale lapideo delle formelle di Jacopo della Quercia sul portale di S. Petronio a Bologna," *C.N.R., Centro di studio-causa di deperimento e metodo di conservazione delle opere d'arte*, no. 17. Rome, 1972.

Liberati, A. "Chiese, monasteri, oratori, e spedali senesi," *Bulletino senese di storia patria* (1955–1956), 62/63:149–153.

Lightbown, R. W. *Donatello and Michelozzo.* 2 vols. London, 1980.

Lisini, A. Preface. *Cronache senese.* In vol. 15, part 6 of Muratori, ed., *RRIISS* (q.v.).

——"Notizie di orafi e di oggetti di oreficeria," *Arte antica senese* (1905), 2:645–678.

Longhi, R. *Officina ferrarese, 1934, seguita dagli ampliamenti 1940 e dai nuovi ampliamenti, 1940–1955.* Florence, 1956.

Longhurst, M. H. Notes on Italian Monuments of the 12th to 16th Centuries. 2 vols. London, 1963.

Lotz, W. *Der Taufbrunnen des Baptisteriums zu Siena.* Berlin, 1948.

Luccarelli, M. "Un tempio ermetico nel cuore di Siena 'Civitas Verginis.' La Loggia della Mercanzia," *Bulletino senese di storia patria* (1985), 92:93–106.

——"Un 'mutus liber' nel duomo di Siena," *Bulletino senese di storia patria* (1984), 91:7–11.

Lunardi, G. G. *Ilaria del Carretto o Maria Antelminelli? Ricerche e documenti.* Lucca, 1928.

Lupi, C. "Arte senese a Pisa," *Bulletino senese di storia patria* (1904), 11:355–425.

Lusini, V. "Dell'Arte del legname inanzi al suo statuto del 1426," *Arte antica senese* (1904), 1:183ff.

——*Il Duomo di Siena.* 2 vols. Siena, 1911–1939.

——*Il San Giovanni di Siena e i suoi restauri.* Florence, 1901.

——, ed. *La Cronaca di Bindino de Travale, 1315–1416.* 2d ed. Siena, 1903.

Luzi, L. *Il Duomo di Orvieto.* Florence, 1866.

Machetti, I. "Orafi senesi," *La Diana* (1929), 4:5–110.

Malaguzzi-Valeri, F. *L'architettura a Bologna nel Rinascimento.* Bologna, 1899.

——*La chiesa e il convento di Santa Maria in Bosco.* Bologna, 1895.

——"Contributo alla storia della scultura a Bologna nel quattrocento," *Repertorium für Kunstwissenschaft* (1899), 22:279–299.

Selected Bibliography

Malaguzzi-Valeri, F. "Sculture del Rinascimento a Bologna," *Dedalo* (1922–1923), 3(5):341–372.

Mancini, A. "Ilaria del Carretto o Caterina degli Antelminelli?" *Giornale di politica e di letteratura* (1928), 4:10ff.

——*Storia di Lucca*. Florence, 1950.

Manetti, A. *Vita di Filippo Brunelleschi, preceduta de la Novella del Grasso*. Ed. by D. de Robertis, notes by G. Tanturli. Milan, 1976.

Marangoni, M. "Una scultura quercesca," *Critica d'arte* (1954), 1:20–22.

Marcucci, R. "Tito Sarrocchi." In *Siena, tra Purismo e Liberty*, pp. 124–129. Milan-Rome, 1988.

Martini, A. Metrologia, ossia misure, pesi, e moneta. Turin, 1883.

Masini, A. *Bologna perlustrata*. Bologna, 1650.

Matteucci, A. M. *La 'Porta Magna' di San Petronio in Bologna*. Bologna, 1966.

——"Le sculture." In *Il tempio di San Giacomo Maggiore in Bologna, studi sulla storia e le opere d'arte: regestro documentario*, pp. 74–77. Bologna, 1967.

Mazzarosa, A. *Guida di Lucca*. Lucca, 1843.

Medri, G. *La scultura a Ferrara*. Rovigo, 1958.

Meek, Christine. *Lucca 1369–1400: Politics and Society in an Early Renaissance City-State*. Oxford, 1978.

Meiss, M. "The Altered Program of the Santa Maria Maggiore Altarpiece." In W. Lotz and L. L. Möller, eds., *Studien zur toskanischen Kunst—Festschrift für Ludwig Heinrich Heydenreich*, pp. 169–190. Munich, 1964.

——"The Yates Thompson Dante and Priamo della Quercia," *Burlington Magazine* (1964), 106:403–412.

Meller, P. "La cappella Brancacci, problemi ritrattistici ed iconografici," *Acropoli* (1960–1961), 3:187–227, 273–312.

——"Physiognomical Theory in Renaissance Heroic Portraits." In *The Renaissance and Mannerism: Studies in Western Art*, 2:53–69. 2 vols. Princeton, 1963.

Mellini, G. L. *Scultori Veronesi del Trecento*. Milan, 1971.

Mengozzi, N. *Il Feudo del Vescovado di Siena*. Siena, 1911.

Michel, A. "La Madonne et l'Enfant statue en bois attribuée à Giacomo della Quercia (Musée du Louvre)," *Monuments et mémoires publiés par l'Académie des Inscriptions et Belles-Lettres* (1896), 3:261–269.

Middeldorf, U. "Due problemi querceschi." In Chelazzi Dini, ed., *Jacopo della Quercia fra Gotico e Rinascimento. Atti* (q.v.), pp. 147–150.

——"Un rame inciso del Quattrocento." in DeLuca, ed., *Scritti di storia dell'arte in onore di Mario Salmi*, 2:273–289. 3 vols. Rome, 1962.

——*Sculptures from the Samuel H. Kress Collection: European Schools, XIV–XIX Century*. London, 1976.

Migne, J. P. *Patrologiae cursus completus. Series graeca*. 161 vols. Paris, 1857–1908.

——*Patrologiae cursus completus. Series latina*. 221 vols. Paris, 1844–1896.

Milanesi, G. *Documenti per la storia dell'arte senese*. 3 vols. Siena, 1854–1856.

——*Nuovi documenti per la storia dell'arte toscana dal XII al XV secolo*. Florence, 1900.

——*La scrittura di artisti italiani*, vol. 1. Florence, 1876.

——*Sulla storia dell'arte toscana*. Siena, 1873.

——ed. *Giorgio Vasari, Le vite de' più eccellenti pittori, scultori ed architettori, con nuove annotazioni e commenti*. 9 vols. Florence, 1878–1885.

Misciattelli, P. "Sculture inedite di Jacopo della Quercia," *La Diana* (1927), 2:188–192.

Monaco, G., L. Bertolini Campetti, and S. M. Trklja. *Museo di Villa Guinigi. Lucca, la villa e le collezioni*. Lucca, 1968.

Morisani, O. *Michelozzo Architetto*. Turin, 1951.

——"Struttura e plastica nell'opera di Jacopo della Quercia," *Arte lombarda*, anno X, volume fuori abbonamento *(Studi in onore di Giusta Nicco Fasola*, II, 1965), pp. 75–90.

——*Studi su Donatello*. Venice, 1952.

——*Tutta la scultura di Jacopo della Quercia*. Milan, 1962.

Moroni, G. ed. *Dizionario di erudizione storico-ecclesiastica da S. Pietro sino ai nostri giorni*. 103 vols. Venice, 1840–1861.

Morrona, A. Da. *Pisa antica e moderna*. Pisa, 1821.

Moskowitz, A. F. *The Sculpture of Andrea and Nino Pisano*. Cambridge, Mass., 1986.

Muciaccia, A. and F. C. Pellegrini. "Documenti inediti relativi alla caduta di Paolo Guinigi Signore di Lucca," *Studi storici* (1894), 3:229ff.

Munman, R. "Optical Corrections in the Sculpture of Donatello," *Transactions of the American Philosophical Society* (1985), 75 (part 2):1–96.

Müntz, E. *Les Arts à les Cours de Papes, Premiere Partie: Martin V–Pius II*. Paris, 1878.

Muratori, L. A., ed. *RRIISS (Rerum italicarum scriptores: Raccolta degli storici italiani dal cinquecento al millecinquecento ordinata da L. A. Muratori)*. New edition, ed. by S. Carducci and V. Fiorini. Città di Castello, 1900–1968.

Nardi, P. *Mariano Sozzini, Giurreconsulto senese del quattrocento*. Milan, 1974.

Neri Lusanna, E. "Un episodio di collaborazione tra scultori e pittori nella Siena del primo Quattrocento: La 'Madonna del Magnificat' di Sant'Agostino," *Mitteilungen des Kunst-historischen Institutes in Florenz* (1981), 25(3):325–340.

Nicco, G. [Fasola]. "Jacopo della Quercia e il problema del Classicismo," *L'Arte* (1929), 32:126–137.

——"Argomenti querceschi," *L'Arte* (1929), 32:193–202.

——*Le fontane di Perugia*. Rome, 1951.

——"Jacopo della Quercia," s.v., *Encyclopedia of World Art*, 4:286–295. 17 vols. Florence, 1961.

——*Jacopo della Quercia*. Florence, 1934.

——*Nicola Pisano*. Rome, 1941.

Nicolai, U. *I vescovi di Lucca*. Lucca, 1966.

Nicolosi, C. A. "Un gruppo di Jacopo della Quercia a Bergamo," *Rassegna d'arte senese* (1906), 2:125.

Nini, E. *Trattato delle famiglie nobili et huomini riguardevoli della città di Siena (1637–1639)*. MS., Biblioteca Nazionale Siena (B.IV.27).

Oakley, F. *The Political Thought of Pierre d'Ailly*. New Haven, 1965.

Palmieri, A. "Le strade medievali fra Bologna e la Toscana," *Atti e memorie della r. deputazione di storia patria per le provincie di Romagna (1918)*. Series 4, 8:31ff.

Panofsky, E. *Meaning in the Visual Arts*. Garden City, N.Y., 1955.

——*Studies in Iconology: Humanistic Themes in the Art of the Renaissance*. New York and Evanston, Ill., 1962.

——*Tomb Sculpture*. New York, 1965.

Paoletti, J. T. *The Siena Baptistry Font: A Study of an Early Renaissance Collaborative Program, 1416–1434*. New York and London, 1979.

——"Quercia and Federighi," *Art Bulletin* (1968), 50:281–284.

——Review of C. del Bravo's *Scultura senese del Quattrocento*, in *The Art Quarterly* (1973), 34:102–106.

——"Il tabernacolo del Fonte Battesimale e l'iconografia medioevale." in Chelazzi Dini, ed., *Jacopo della Quercia fra Gotico e Rinascimento. Atti* (q.v.), pp. 131–140.

Paoli, M. *Arte e committenza privata a Lucca nel Trecento e nel Quattrocento*. Lucca, 1986.

Paoli, M. "Un aspetto poco noto della scultura trecentesca pisana: la lapide sepolcrale con ritratto," *Antichita viva* (1982), 21(5/6):38–47.

——"Jacopo della Quercia e Lorenzo Trenta: Nuove osservazioni e ipotesi per la cappella in San Frediano di Lucca," *Antichità viva* (1980), 19(3):27–36.

——"Una nuova opera documentata di Francesco di Valdambrino," *Paragone* (1981), 381:66–77.

Papini, R. *Pisa*. 2 vols. Rome, 1910–1912.

Paribeni, R. *Jacopo della Quercia: discorso per il quinto centenario della morte, Palazzo Pubblico, Siena, il 18 settembre 1938*. Rome, 1938.

Partner, P. *The Papal State Under Martin V*. Rome, 1958.

Pecci, G. A. *Relazione delle cose più notabili della città di Siena*. Siena, 1752.

Perini, G. "La storiografia artistica a Bologna e il collezionismo privato," *Annali della scuola normale superiore di Pisa* (1981), 11(1):181–243.

Perkins, C. C. *Tuscan Sculptors*. London, 1864.

Perouse, G. *Le Cardinal Louis Aleman, Président du Concile de Bâle, et la fin du Grand Schisme*. Lyone, 1904.

Piano, C. "Lettera inedita di S. Bernardino da Siena ed altra corrispondenza per la storia del pulpito di S. Petronio a Bologna nel '400," *Archivium franciscanum historicum* (1954), 47:54–87.

——"San Bernardino da Siena a Bologna," *Studi francescani* (1945), vol. 42.

Piccinini, F. "Uno scultore Quercesco-Donatelliano ad Adria," *Ricerche di storia dell'arte* (1986), 30:99–103.

Piccolomini, P. *La vita e l'opera di Sigismondo Tizio (1458–1528)*. Siena, 1903.

Pierotti, P. *Lucca e l'urbanistica medioevale*. Milan, 1965.

Pines, Doralynn Schlossman. "The Tomb Slabs of Santa Croce: A New 'Sepoltuario'." Ph.d. diss. Columbia University, New York, 1985.

Pisetzky, R. L. *Storia del costume in Italia*. 2 vols. Milan, 1964.

Poggi, G. "La mostra d'antica arte senese," *Emporium* (1904), 20:31–48.

Polidori Calamandrei, E. *Le vesti delle donne fiorentine nel quattrocento*. Florence, 1924.

Pope-Hennessy, J. "A Jacopo della Quercia Exhibition," *Burlington Magazine* (1939), 74:36.

——*Italian Gothic Sculpture*. London, 1955.

——*Italian Renaissance Sculpture*. London, 1958.

——*The Study and Criticism of Italian Sculpture*. Princeton, 1980.

——*Sassetta*. London, 1939.

Prager, F. D. and G. Scaglia. *Mariano Taccola and His Book 'De ingenesis.'* Cambridge, Mass., 1972.

Procacci, U. "Niccolò di Pietro Lamberti detto il Pela di Firenze e Niccolò di Luca Spinelli d'Arezzo," *Il Vasari* (1928), 1:300–316.

Puccinelli, P. *San Riccardo e sua cappella*. Lucca, 1947.

Ragghianti. C. "Aenigmata Pistoriensia, I," *Critica d'arte* (1954), 5:433–438.

——"La mostra di scultura italiana antica a Detroit," *Critica d'arte* (1938), 3:170–183.

——"Novità per Jacopo della Quercia," *Critica d'arte* (1965), 12:35–47.

——"Sculture lignee senesi," *Critica d'arte* (1950), 8:480–496.

——"Su Francesco di Valdambrino," *Critica d'arte* (1938), 3:136–143.

Ratti, N. *Della famiglia Savelli*. Rome, 1795.

Raule, A. "Il portale maggiore di S. Petronio," *Strenna storica bolognese* (1960), 11:237–44.

Reymond, M. *La sculpture florentine* (see especially vols. 1 and 2). 4 vols. Florence, 1898.

——"La Sculpture florentine du XV siècle: Jacopo della Quercia," *Gazette des Beuax-Arts* (1895), 14:309–316.

Ricci, C. "Giovanni da Siena," *Arte antica senese* (1904), 1:247–310.

——*Il Palazzo Pubblico di Siena e la mostra d'arte senese*. Bergamo, 1904.

Richter, E. "Antonio Federighi, Sculptor." Ph.D. diss. Columbia University, New York, 1985.

Ridolfi, E. *L'Arte in Lucca studiata nella sua cattedrale*. Lucca, 1882.

Ridolfi, M. *Della Basilica di San Frediano in Lucca: Scritti d'arte e Antichità*. Florence, 1879.

Riedl, P. A. and M. Seidel, eds. *Die Kirchen von Siena*, vol. 1. Munich, 1985.

Rigoni, E. "Notizie di scultori toscani a Padova nella prima metà del quattrocento," *Archivio veneto* (1929), 2:118–136.

Rodolico, F. *Le pietre della città d'Italia*. Florence, 1953.

Rohault de Fleury, G. *Les monuments de Pisa au Moyen Age*. Paris, 1866.

——*La Toscane du Moyen Age*. Paris, 1874.

Roli, R. *La pala marmorea di San Francesco in Bologna*. Bologna, 1964.

Romagnoli, E. Biografia cronologica de'bellartisti senesi del secolo XII a tutto il XVIII. MS. (before 1835). Biblioteca Comunale di Siena, L.II. Reproduced stereotype edition, Florence, 1977.

——*Cenni storico-artistici di Siena e de' suoi suburbi*. Siena, 1836.

Rondelli, N. "Jacopo della Quercia a Ferrara 1403–1408." In *Bulletino senese di storia patria* (1964), 71:131–142 *Miscellanea di studi in memoria di Giovanni Cecchini, II)*.

Rossi, F. *Le contrade della città di Siena*. 2 vols. Siena, 1981.

Rossi, P. "L'Arte Senese nel Quattrocento," *Bulletino senese di storia patria* (1899), 6:3–17.

——"Jacopo della Quercia," *Bulletino senese di storia patria* (1905), 12:3–17.

Rossi Manaresi, R. and G. Torraca, eds., *The Treatment of Stone*. Bologna, 1972.

Rossi Manaresi, R., ed. *Jacopo della Quercia e la facciata di San Petronio a Bologna*. Bologna, 1981.

Rubbi, P. E. and C. O. Tassinari. *Guida alle gallerie e ai musei di Bologna*. Bologna, 1978.

Rubinstein, N. "Political Ideas in Sienese Art: The Frescoes of Ambrogio Lorenzetti and Taddeo di Bartolo in the Palazzo Pubblico," *Journal of the Warburg and Courtauld Institutes* (1958), 21:179–207.

Saalman, H. "Early Renaissance Architectural Theory and Practice in Antonio Filarete's *Trattato di architettura*," *Art Bulletin* (1959), 41:86–106.

Salmi, M., "La giovinezza di Jacopo della Quercia," *Rivista d'arte* (1930), 12:175–191.

San Bernardino da Siena [Bernardi Senensis]. *Opera omnia*. Florence, 1950–1963.

——*Operette volgari*. Ed. by P. Dionisio Pacetti. Florence, 1938.

Sanpaolesi, P. "Una figura lignea inedita di Jacopo della Quercia," *Bolletino d'arte* (1958), 43:112–116.

Santini, V. *Commentari storici sulla Versilia Centrale*. 6 vols. Pisa, 1858–1862.

Savioli, L. V. *Annali Bolognesi*. 6 vols. Bassano, 1784–1795.

Schneider, L. Adams. "Donatello's Bronze *David*," *Art Bulletin* (1973), 55:213–216.

Schubring, P. *Donatello: Des Meisters Werk*. Klassiker der Kunst in Gesamtausgaben, no. 11. Stuttgart and Berlin, n.d.

——"Das Grabdenkmal des Marco Pio in Carpi," *Mitteilungen des Kunsthistorisches Institutes in Florence* (1911), 1:15–21.

——*Die Plastik Sienas im Quattrocento*. Berlin, 1907.

Schwartz, H. "Jan Gossaert's Adam and Eve Drawings." In *Essays in Honor of Hans Tietze, 1880–1954*, pp. 171–194. New York, 1958.

Sciolla, G. C. "Due inediti di scultura toscana del Quattrocento a Roma," *Antichità viva* (1971), 10(5):35–38.

Seymour, C., Jr. " 'Fatto di suo mano,' Another Look at the Fonte Gaia Fragments in London

and New York." In A. Rosegarten and P. Tigler, eds., *Festschrift Ulrich Middeldorf*, pp. 93–105. Berlin, 1968.

Seymour, C., Jr. "Homo Magnus et Albus: The Quattrocento Background for Michelangelo's David of 1501–1504." In *Stil und Ueberlieferung in der Kunst des Abendlandes: Akten des 21. Internationalen Kongresses für Kunstgeschichte in Bonn, 1964*, pp. 96–105, Berlin, 1967.

——*Jacopo della Quercia, Sculptor*. New Haven and London, 1973.

——*Sculpture in Italy, 1400 to 1500*. Suffolk and London, 1966.

——"The Younger Masters of the First Campaign of the Porta della Mandorla, 1391–1397," *Art Bulletin* (1959), 41:1–17.

Seymour, C., Jr. and H. Swarzenski. "A Madonna of Humility and Quercia's Early Style," *Gazette des Beaux-Arts* (1946), 88:129–152.

Sforza, G. *Ricordi e biografie lucchesi*. Lucca, 1916.

Sheard, W. Stedman. *Antiquity in the Renaissance* (Exh. cat.). Northhampton, Mass., 1975.

Sigonio, C. *De episcopis bononiensibus libri quinque*. Bologna, 1586.

Silva, R. *La Basilica di San Frediano in Lucca: Urbanistica, architettura, arredo*. Lucca, 1985.

Sorbelli, A. *Bologna negli scritti stranieri*. 3 vols. Bologna, 1927–1929.

——ed. *Corpus chronicorum bononiensium*. Vol. 18 of Muratori, ed., *RRIISS* (q.v.).

Stella, P., ed. *Glossario latino emiliano*. Studi e testi, no. 74. Vatican City, 1937.

Strom, D. "A New Attribution to Jacopo della Quercia: The Wooden St. Martin in S. Cassiano in Controne," *Antichità viva* (1980), 19(1):14–19.

——"A New Look at Jacopo della Quercia's Madonna of Humility." Antichita viva (1980), 19(6):17–23.

——"Studies in Quattrocento Tuscan Wooden Sculpture." Ph.D. diss. Princeton University, Princeton, N.J., 1979.

Supino, I. B. "Andrea da Fiesole in Bologna," *Rivista d'arte* (1909), 4:228–232.

——*L'arte nelle chiese di Bologna*. 2 vols. Bologna, 1932 and 1938.

——*Jacopo della Quercia*. Bologna, 1926.

——"Una opera sconosciuta di Iacopo della Quercia: La Madonna di Corsano," *Dedalo* (1921), 2:149–153.

——"La pala d'altare di Iacobello e Pier Paolo dalle Masegne nella Chiesa di S. Francesco in Bologna." In *Memoria della R. Accademia delle Scienze dell'Istituto di Bologna*. Bologna, 1915.

——*La scultura a Bologna nel secolo XV*. Bologna, 1910.

——*Le sculture delle porte di San Petronio in Bologna*. Florence, 1914.

Symeonides, S. *Taddeo di Bartolo*. Siena, 1965.

Testi Cristiani, M. L. *Nicola Pisano Architetto Scultore dalle Origini al Pulpito del Battistero di Pisa*. Pisa, 1987.

Tizio, S. *Historiarum senensium* (ca. 1528). MS., Biblioteca Comunale Siena (B.III.5–18).

Toesca, P. *Il Trecento*. Turin, 1951.

Tolnay, C. de. *Michelangelo*. 5 vols. Princeton, 1943–1963.

——"Note sur l'iconographie des fresques de la Chapelle Brancacci," *Arte lombarda*, anno 10, volume fuori abbonamento *(Studi in onore di Guista Nicco Fasola*, vol. 2, 1965), pp. 69–74.

Tommasi, B. *Annali di Seina, 1402–1428*. Vol. 20 of Muratori, ed., *RRIISS* (q.v.).

Torriti, P. "Il nome di Jacopo della Quercia nell'Annuncianzione di San Gimignano." In Chelazzi Dini, ed., *Jacopo della Quercia fra Gotico e Rinascimento*. Atti (q.v.), pp. 98–100.

Toth, P. de. *Il beato Cardinale Niccolo Albergati e i suoi tempi.* 2 vols. Acquapendente, 1934.

Ugurgieri Azzolini, I. *Le pompe sanesi.* 2 vols. Pistoia, 1649.

Valentiner, W. R. "The Equestrian Statue of Paolo Savelli in the Frari," *Art Quarterly* (1953), 16:280–293.

——"A Statuette in Wood by Jacopo della Quercia," *Bulletin of the Detroit Institute of Arts* (1940), 20:14–15.

Van Essen, C. C. "Elementi etruschi nel rinascimento Toscano," *Studi etruschi* (1939), 13:497ff.

Van Marle, R. "L"Annunciation dans le sculpture monumentale de Pise et Sienne," *La Revue de l'art ancien et moderne* (1934), 55:165–182.

Venturi, A. "San Martino di Lucca," *L'Arte* (1922), 25:207–219.

——*Storia dell'arte italiana.* 11 vols. Milan, 1901–1948.

——"Una statua di Jacopo della Quercia nel Duomo di Lucca," *L'Arte* (1920), 23:160–161.

——"Una statuetta ignota di Jacopo della Quercia," *L'Arte* (1908), 11:53–54.

Weber, L. *San Petronio in Bologna, Beiträge zur Baugeschichte.* Leipzig, 1904.

Weber, P. *Geistliches Schauspiel und Kirchliche Kunst in ihrem Verhältnis erlätert an einer Ikonographic der Kirche und Synagoge.* Stuttgart, 1894.

Weber, S. *Die Entwicklung des Putto in der Plastik der Frürenaissance.* Heidelberg, 1898.

White, J. *Art and Architecture in Italy, 1250–1400.* Harmondsworth, 1966.

Williams, N. P. *The Ideas of the Fall and of Original Sin—A Historical and Critical Study.* London, 1927.

Wittkower, R. *Architectural Principles in the Age of Humanism.* 3rd ed. London, 1962.

——*Sculpture Processes and Principles.* London, 1977.

Wittkower, R. and M. Wittkower. *Born Under Saturn.* London, 1963.

Wolters, W. *La scultura veneziana gotica, 1300–1600.* 2 vols. Venice, 1976.

Wundram, M. "Jacopo della Quercia und das Relief der Gürtelspende über der Porta della Mandorla," *Zeitschrift fur Kunstgeschichte* (1965), 28:121–129.

——"Die Sienesische Annunziata in Berlin, ein Frühwerk des Jacopo della Quercia," *Jahrbuch der Berliner Museen* (1964), 6:39–52.

——"Toskanische Plastik von 1250 bis 1400," *Zeitschrift fur Kunstgeschichte* (1958), 21:243–270.

Zaoli, G. *Libertas Bononie e Papa Martino V.* Bologna, 1916.

——"Papa Martino V e i bolognesi, rapporti ecclesiastici-religiosi (anni 1416–1420)," *Atti e memorie della deputazione di storia patria per le provincie di Romagna* (1911–1912). Series 4.

Zucchini, G. "Catalogo critico delle guide di Bologna," *L'Archiginnasio* (1951/1952), 46/47:135–168.

——*Disegni antichi e moderni per la facciata di S. Petronio di Bologna.* Bologna, 1933.

——"Documenti inediti per la storia del S. Petronio di Bologna." In *Miscellanea di storia dell'arte in onore di I. B. Supino,* pp. 183–210. Florence, 1933.

——*Guida della basilica di San Petronio.* Rev. ed. Bologna, 1953.

——"Un opera inedita di Iacopo della Quercia," *Arte mediterranea* (July–August 1949), pp. 14–15.

——"Opere d'arte inedite," *Il Comune di Bologna* (1934), 21(2):23–46.

——"San Michele in Bosco," *L'Archiginnasio* (1943), 38:18–70.

Index

Bold page references signify illustrations. Personal names that include da or di or their contractions (degli, dei, delle, etc.) are entered in direct order, e.g., Arnolfo di Cambio; other names are entered in inverted order, e.g., Pisano, Nicola.